VAN GOGH
and Music

A SYMPHONY IN BLUE AND YELLOW

Natascha Veldhorst

Translated by
Diane Webb

Yale University Press, New Haven and London

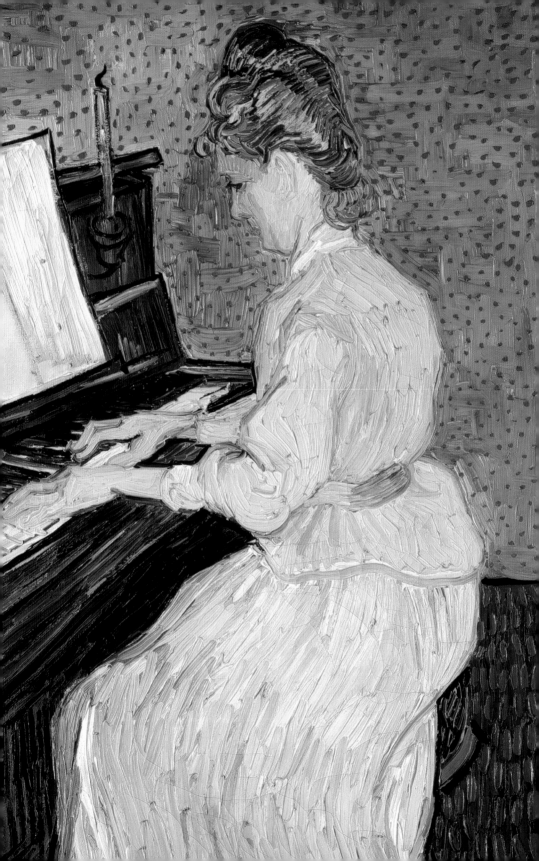

1 HEARING COLOURS

Ouverture blu

In August 1888, thirty-five-year-old Vincent van Gogh had been in Arles in the south of France for six months, after two intense and exhausting years of living with his brother Theo in Paris. At first he stayed in a hotel room, with a covered roof terrace serving as his studio, but after a few months he was able to rent the right wing of the Yellow House on the place Lamartine (two storeys, with two rooms on each floor), where he immediately began to prepare for the arrival of Paul Gauguin. As a gesture of friendship and to seal their future collaboration in this 'Studio of the South', Van Gogh set about decorating the rooms 'with the gusto of a Marseillais eating bouillabaisse'. Working hard on his ambitious decorative programme, he made one painting after another. Outside it was sweltering—'a very glorious, powerful heat here, with no wind'. After six long weeks, the 'nasty', 'irritating' mistral had finally died down, and one could again hear the soft rustling of the olive trees and the buzzing of mosquitoes and Spanish flies ('golden and green *Cantharides* swarming'), as well as the hoarse, frog-like singing of the cicadas. Above the rest, cutting right through everything, was the blistering sun: the glaring, maddening sunlight—'pale sulphur yellow, pale lemon, gold')—which made the colours vibrate and miraculously intensified and deepened them.[1]

Vincent enthusiastically reported to Theo that he wanted to make a series of paintings of sunflowers. 'Nothing but large sunflowers', a dozen altogether—'in which harsh or broken yellows will burst against various BLUE backgrounds, from the palest Veronese to royal blue'. Because

I

sunflowers wilt quickly, he worked on them every morning, beginning at sunrise. He described what was taking shape: 'The whole thing will therefore be a symphony in blue and yellow.'[2]

MUSIC IN THE LIFE OF VAN GOGH

'A symphony in blue and yellow'. That phrase struck me. I asked myself why Van Gogh had chosen precisely that expression. The rather casual wording is misleading; at first one is inclined to construe those words as purely poetic—beautifully formulated, but no more than that. Evidently this was a common reaction, since the Van Gogh literature barely alludes to this emblematic expression or to his repeated use of the word 'symphony'. The occurrence in his letters of other words related to music—such as 'harmony', 'piano', 'note', 'register', 'clarion' and 'scherzo'—also went unnoticed. There are, moreover, many more references to music in Van Gogh's correspondence: the names of composers, numerous titles and the opening lines of songs, psalms and hymns, chansons and operas, as well as a surprising use of musical metaphors. Van Gogh compared his fellow artists as well as his artists' supplies to musical instruments. He also likened a woman without a child to 'a bell without a clapper'—'the sound of the bronze would perhaps be very beautiful, but no one will hear it'[3]—and described a woman in Nuenen, his friend Margot Begemann, as a Cremona violin that had been ill treated: 'It's a pity that I didn't meet her *earlier*—say 10 years ago or so. Now she gives me the impression of a Cremona violin that's been spoiled in the past by bad bunglers of restorers. And in the condition in which I met her, it seems to me, a good deal too much had been bungled. But originally it was a rare example of great value. *And* she *still* has much value *even so*.'[4]

Dozens of passages in Van Gogh's letters refer to music. In fact, it was the recurrence of such references throughout his correspondence that made me wonder what music actually meant to him and how it influenced his art. Such questions are prompted, of course, by Van Gogh's own musical pronouncements, but they are also posed by the recent literature on this subject: a series of thought-provoking studies on the close relationship between painting and music in the nineteenth century.[5] In the case of a number of other artists from this period, it has meanwhile been shown that their artistic development was crucially influenced by both visual and auditory stimuli.[6] This is true, for instance, of Van Gogh's great example Eugène Delacroix,

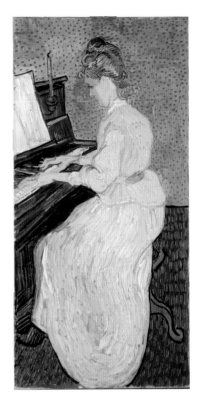

1 Vincent van Gogh, *Marguerite Gachet at the Piano* (F 772 / JH 2048), 1890. Oil on canvas, 102 × 50 cm. Kunstmuseum Basel.

and of such painters as Edouard Manet, Paul Gauguin and James Abbot McNeill Whistler. Remarkably, these artists are not generally thought of as 'musical painters'. This is understandable, for their work does not often feature the musicians or musical instruments that were frequently depicted by such artists as Edgar Degas, Henri Fantin-Latour, Georges Seurat and Henri de Toulouse-Lautrec, and later by Pablo Picasso and Georges Braque. Nor did painters like Delacroix and Van Gogh seek inspiration in pieces of music or musical forms and styles, as the modernists Wassily Kandinsky, Paul Klee, Piet Mondrian and Theo van Doesburg later did. Even though Delacroix and Manet were both avid concertgoers and accomplished instrumentalists, with many musicians and singers among their friends, and Whistler often gave his paintings titles in which musical terms like *symphony* and *nocturne* figure prominently, these artists seldom depicted concrete musical subjects. The musical aspect of their work must therefore be sought on a different level.

Before exploring this question, I would like to point out that Van Gogh's fascination for music was not immediately visible on the surface of either his life or his work. Like Delacroix, Manet and Gauguin, he almost never painted musical subjects. Besides his painting of Marguerite Gachet at the piano [fig. 1], he made only a few drawings of dance halls and musicians [fig. 2], as well as an intriguing little sketch of a phonograph. Although it is not known what prompted him to draw the phonograph, it does testify to some degree of interest in mechanical means of music reproduction [fig. 3].[7] As far as we know, Van Gogh did not make music himself (apart from a short-lived interest in the piano), nor did he theorize openly about the relationship between music and painting, as Delacroix, Gauguin and Kandinsky did

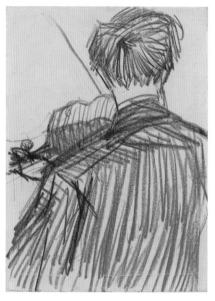 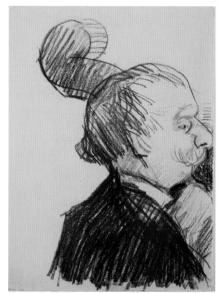

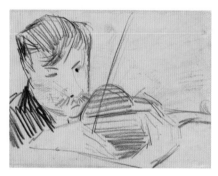

2 Vincent van Gogh, *Series of Five Musicians*, 1887: *Violinist Seen from the Back* (F 1244ar / JH 1154). Chalk on paper, 34.9 × 25.8 cm; *Violinist Seen from the Front* (F 1244av / JH 1156). Chalk on paper, 25.8 × 34.9 cm; *Double-Bass Player* (F 1244cv / JH 1153). Chalk on paper, 34.8 × 25.8 cm; *Pianist* (F 1244cr / JH 1157). Chalk on paper, 25.8 × 34.8 cm; *Clarinettist and Piccolo Player* (F 1244br / JH 1155). Chalk on paper, 25.7 × 34.9 cm. Van Gogh Museum, Amsterdam (Vincent van Gogh Foundation).

3 Vincent van Gogh, *Phonograph*. Pencil on paper, 7.5 × 12.4 cm. Part of Nuenen sketchbook, 1884–85. Van Gogh Museum, Amsterdam (Vincent van Gogh Foundation).

in articles and essays. His letters, furthermore, mention composers far less frequently than writers and visual artists. 'There is seldom any question of music with Van Gogh', asserted A. M. Hammacher.[8] Jan Meyers said it with more subtlety: 'It has been maintained, wrongly, that Vincent had no interest in music. Perhaps this is not so strange, considering that music is so poorly represented in his letters compared with art and literature.'[9] A number of other studies on Van Gogh touch upon the subject of music, but do not delve into it. What remains are a handful of writings, the most important of which are Roland Dorn's article on Van Gogh and Richard Wagner, and Peter L. Schmunk's paper on music as a model for Van Gogh's notions of art.[10]

The paucity of scholarly research on the significance of music to Van Gogh's work contrasts sharply with the abundance of 'musical' reactions to his drawings and paintings. From the very beginning, his work has elicited lyrical reflections from writers and critics. According to Frederik van Eeden, for example, Van Gogh was 'someone who dared to sing loudly without doing it out of tune. First we have to overcome a certain timidity, since we thought that singing loudly was necessarily awful or affected—but if it goes well and we get past the bashfulness, we take pleasure in the loud sound. In the same way, I took pleasure in this bold use of colour.'[11]

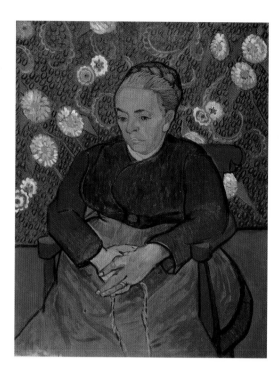

4 Vincent van Gogh, *Augustine Roulin ('La Berceuse')* (F 507 / JH 1672), 1889. Oil on canvas, 91 × 71.5 cm. Stedelijk Museum, Amsterdam.

5 Vincent van Gogh, *Quinces, Lemons, Pears and Grapes* (F 383 / JH 1339), 1887. Oil on canvas, 48.9 × 65.5 cm. Van Gogh Museum, Amsterdam (Vincent van Gogh Foundation).

In Jan Veth's opinion, the 'instrument' that produced the sound was not the artist but the artwork itself: 'Isolated in the world, and isolated with his will in art, he tenaciously sought an instrument suited to conveying his intentions. The fact that this difficult, self-formulated instrument is one of simple disposition enabled him to express himself to overwhelming effect. That it was so completely different from the instruments whose sounds had become familiar to the cultural elite surrounding him largely explains why his very simple message was understood by so few.'[12]

The collector and art critic Klas Valter Fåhraeus of Stockholm was enthusiastic about the two drawings by Van Gogh that he bought in 1911: 'Those cypresses have the effect of a wind band—superb!'[13] Later writers and researchers saw 'a vortex of lines' in his *Road with Cypress and Star*, heard his 'yellow orange sunflowers sing in front of the vibrant, bright turquoise', pointed out 'the wild dance of the wallpaper, refusing to remain background' in *La Berceuse* [fig. 4], spoke of 'an all-over crackle of visual electricity', called his *Quinces, Lemons, Pears and Grapes* 'a single resounding chord of yellow played out on various vegetal instruments', and concluded that 'colour for Van Gogh was a kind of noise' [fig. 5].[14] Music, sound, movement, rhythm, vibration—they all overlap to some extent.

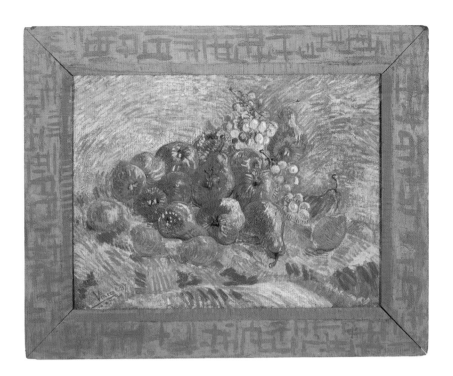

PIANO LESSONS IN EINDHOVEN

Music had been a natural and indispensable part of Van Gogh's life from the start, but it was not until 1884–85—when he was living with his parents again, in Nuenen—that he decided to take piano lessons from Hein van der Zande, an organist and conductor who lived in Eindhoven [fig. 6].[15] Evidently Van Gogh did not really care about making music himself; instead, he wanted to find out how tones and colours were related. He had become interested in this subject from reading *Les Artistes de mon temps* (1876) by Charles Blanc, who maintained that 'colouring can be learned, like music'.[16] Anton Kerssemakers, a pupil of Van Gogh, recalled that Van Gogh's peculiar approach made the piano teacher despair:

> He constantly compared painting to music, and to gain a better understanding of the values and gradations of tones, he began to take piano lessons from an old music teacher, who was also the organist in Eindhoven. This did not last long, however, because during the lessons, Van Gogh was continually comparing the sounds made by

the piano to Prussian blue, and dark green or dark ochre to bright cadmium, so that the good man thought he was confronted with a lunatic, and grew so afraid of him that he called a halt to the lessons.[17]

At the time, Van Gogh himself wrote nothing about his daring musical experiment. It was not until three years later, shortly after painting his first sunflowers in Arles in 1888, that he commented on this retrospectively in a letter to Theo: 'But I'm again the way I was in Nuenen, when I made a vain attempt to learn music—even then—so strongly did I feel the connections there are between our colour and Wagner's music.'[18] In the meantime, he had come to understand that he was not the only one who felt these special ties between colour and music. From Theo, as well as from magazines and books, he was well informed about the artistic sphere in Paris, the cultural heart of Europe, where a lively debate was going on about the relationship between painting and music, particularly the music of Wagner. Soon after Van Gogh's arrival in Paris in early 1886, he became immersed in the latest developments in both arts.

The links between painting and music had been established for centuries. Pronouncements on this interdisciplinary relationship can be found in the writings of classical antiquity, and later, for example, in the French polymath Marin Mersenne's 1636 *L'Harmonie universelle*, the Dutch painter Samuel van Hoogstraten's 1678 *Inleyding tot de hooge schoole der schilder-*

konst (Introduction to the academy of the art of painting) and in *Traité sur la peinture* of 1700 and *L'Idée du peintre parfait* of 1707 by the French art theorists Bernard Dupuy du Grez and André Félibien, respectively. The last-mentioned wrote, 'The beautiful brush is to painting what a beautiful voice is to music.'[19] Many artists played instruments and drew inspiration from music-making, as emerges from a series of paintings on the theme of 'the music-making painter' and also

6 Hein (Henricus) van der Zande (1820–1903). Photograph, dimensions unknown.
Ton de Brouwer archive, Nuenen.

from *De Groote Schouburgh der Nederlantsche Konstschilders en Schilderessen* (The great theatre of Netherlandish painters and paintresses) of 1718–21 by Arnold Houbraken, who relates that the painter Gerard de Lairesse always played his violin before beginning to paint.[20]

In the nineteenth century, the comparison between the two arts took on other connotations, because the status of music as an art form rose under the influence of modern Romantic ideas. For the first time, what had always been considered a weakness of music, namely its non-narrative and meaningless nature, was now put forward as its principal strength. Music (especially instrumental music) was thought to be the only art form capable of expressing, without words or images, the essence of existence, and for this reason it most nearly approached the 'sublime' experience. Thus elevated in stature, music came to be considered the ideal art, one that now functioned as a model for the other arts.[21] 'Ut musica pictura' became the latest artistic motto, analogous to Horace's famous dictum 'Ut pictura poesis' (As is painting, so is poetry). This, in fact, was the programmatic title of Louis Viardot's opening essay in the magazine *La Gazette des beaux-arts* (1859), founded by Charles Blanc.[22] Viardot's ideas about the importance of music to painting were similar to those of Blanc himself, who wrote about this subject in his *Grammaire des arts du dessin*, a treatise on the art of drawing, which was serialized in his magazine from April 1860 onwards and later published in book form. Van Gogh studied this book carefully in the summer of 1884.

In the last quarter of the nineteenth century, Walter Pater, an English art critic, declared in his collection of essays *The Renaissance: Studies in Art and Poetry* (1888), 'All art constantly aspires towards the condition of music.' By this he meant that artists were seeking to abandon traditional realism and draw inspiration instead from the 'irrational' nature of music. This was happening in both literature and painting. Painters were thought to have a handicap in that their paint could not actually resound and their canvases could therefore never become musical compositions—in other words, they could make music only metaphorically. This presumed handicap was, in fact, no great obstacle to artists, who embraced this challenge and experimented endlessly to find a way to imitate music. By thinking in musical terms, they endeavoured to surpass the limits of their own art form, thereby extending its boundaries.[23] Musical painting thus meant much more than merely painting *about* music (or painting *to* music, as many artists do nowadays). A painting could actually *be* music, in the sense that it could affect its viewers in the same way that music affected its listeners.

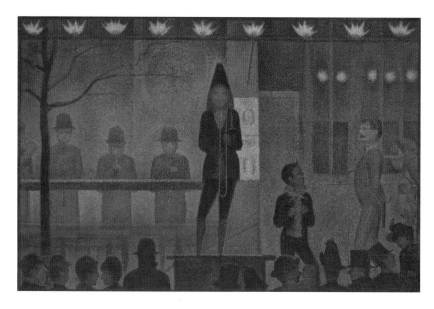

7 Georges Seurat, *Circus Sideshow (Parade de Cirque)*, 1887–88. Oil on canvas, 99.7 × 149.9 cm. Metropolitan Museum of Art, New York. Bequest of Stephen C. Clark, 1960.

Two categories can therefore be distinguished within the phenomenon of 'musical painting'. First of all, the kind of art in which music is a visible element, as in Seurat's *Circus Sideshow*, which Van Gogh saw in the painter's studio on 19 February 1888, a couple of hours before boarding his train to the south of France [fig. 7].[24] Another example is the drawing *Eden Concert*, also by Seurat, which Theo bought for 16 francs at an auction, shortly after Vincent's departure—a purchase for which Vincent congratulated him in a letter [fig. 8].[25] Other paintings Van Gogh had seen also depicted concrete examples of music-making or appreciation, such as *Two Girls (The Artist's Daughters at the Piano)* by Jacob Maris [fig. 9], *The Lectern (Spanish Precentors)* by Alphonse Legros [fig. 10], Frans Hals's *Lute Player* [fig. 11], Gauguin's *Breton Girls Dancing, Pont-Aven* [fig. 12], Toulouse-Lautrec's *Mademoiselle Dihau at the Piano* [see fig. 19], and Fantin-Latour's *Around the Piano* [see fig. 31].[26]

Then there was the kind of art in which music played a more abstract role, in that it was not visible as a theme on the canvas. Some artists based their work on musical compositions or musical styles, by assigning their work opus numbers, as in Max Klinger's *Four Landscapes, Opus VII*, for example, or by designating a tempo, as in Paul Signac's *Morning Calm, Concarneau, Opus 219 (Larghetto)* and *Evening Calm, Concarneau, Opus 220 (Allegro*

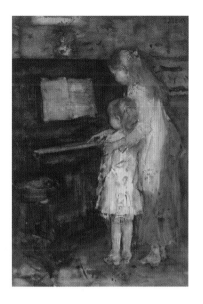

8 Georges Seurat, *Eden Concert*, 1887. Black and blue chalk on paper, 31.5 × 24.1 cm. Van Gogh Museum, Amsterdam (Vincent van Gogh Foundation).

9 Jacob Hendrik Maris, *Two Girls (The Artist's Daughters at the Piano)*, c. 1880. Watercolour, 35.2 × 23.6 cm. Rijksmuseum, Amsterdam.

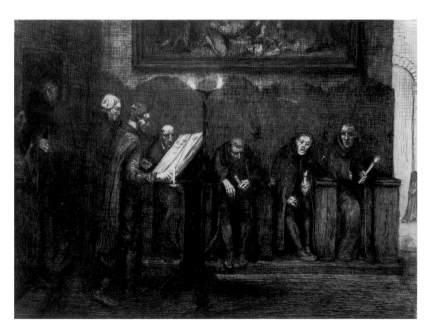

10 Alphonse Legros, *The Lectern (Spanish Precentors)*, 1865. Etching, 26.7 × 36.8 cm. Rijksprentenkabinet, Amsterdam.

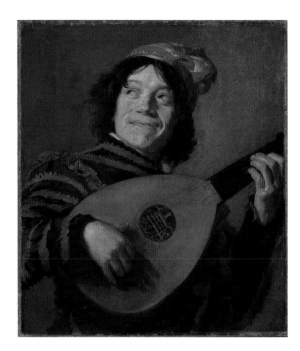

11 Copy after Frans Hals, *The Lute Player*, c. 1623–24. Oil on canvas, 67 × 60 cm. Rijksmuseum, Amsterdam.

Maestoso). Other artists gave their paintings musical titles, such as Signac's *Scherzo* and Whistler's *Nocturne in Black and Gold*. The intrinsic qualities of music were also imitated, resulting in synaesthetic effects, which at that time were called 'correspondences': first and foremost, 'sound' (evoked by a harmonious use of colours), as well as 'rhythm' (suggested by repeating visual patterns) and 'temporality' (using action and movement to suggest the passage of time). Most daringly, however, the artists of Van Gogh's day ventured to appropriate music's ultimate and most highly valued characteristic, namely its meaninglessness, and transpose it into painting. Music was not, of course, 'meaningless' in the literal sense of being 'without meaning', yet it was not connected to reality through 'meaningful' words or images. Unique among the arts for being ungoverned by any external force, it stood completely on its own. Music could therefore express a higher truth that transcended reality and could be reached only through another layer of consciousness. It was precisely this abstract, overarching idea of music that influenced Van Gogh's artistic development, much more so than the music he actually heard. In this regard, the famous lines of John Keats, one of Van Gogh's favourite poets, certainly apply to him: 'Heard melodies are sweet, but those unheard are sweeter.'[27]

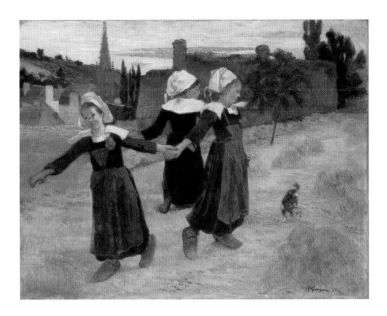

12 Paul Gauguin, *Breton Girls Dancing, Pont-Aven*, 1888. Oil on canvas, 73 × 92.7 cm.
National Gallery of Art, Washington, D.C. On loan from Mr and Mrs Paul Mellon.

TEN CHAPTERS

The present book explores Van Gogh's relationship with music as an art
form. Therefore, the chapters that follow do not discuss musical composi-
tions based on his work or his person, however interesting they might be.
Along with Klee, Goya and Picasso, Van Gogh is one of the most popular
painters among composers, twenty-four of whom have created a total of
sixty-one compositions based on no fewer than thirty-eight of his paint-
ings.[28] Thus this book does not discuss such works as *Sieben Bilder von Vin-
cent van Gogh* (1938), an orchestral piece by the German–Swiss composer
Will Eisenmann,[29] or *Le Tombeau de van Gogh* (1951), twenty pieces for piano
solo by the Dutch composer Fré Focke,[30] or the Finnish composer Einoju-
hani Rautavaara's opera *Vincent* (1990) and sixth symphony (*Vincentiana*)
of 1992—inspired by Van Gogh's *Wheatfield with Crows* and other works—or
Gloria Coates's *Homage to Van Gogh* (1992–93), a piece for chamber orchestra
based on the painting *Quinces, Lemons, Pears and Grapes*. Nor do I analyze
the five one-act musicals about Van Gogh that Alphons Graafsma wrote for
young people,[31] or Don McLean's hit song "Starry, Starry Night" (1971).

This book concentrates on the significance of music to Van Gogh's life and art. With other artists it is sometimes possible to discover a clear-cut programme or elaborate theory, but this is not the case with Van Gogh. His 'philosophy of music' can only be distilled from the many scattered remarks about music in his letters. Foremost among the sources consulted are therefore the 902 surviving letters (83 sent to Van Gogh and 819 written by him, 658 of which were addressed to his brother Theo) as published in the unsurpassed edition edited by Leo Jansen, Hans Luijten and Nienke Bakker, *Vincent van Gogh—The Letters: The Complete Illustrated and Annotated Edition*, which appeared in 2009, both in book form (in Dutch, English and French editions) and in an online digitized edition (the original letters, English translations and notes in English). I have gratefully made use of the annotations in the online version, from which the passages quoted in this book were taken. In addition to these 902 letters from and to Van Gogh, I have examined the musical information and anecdotes that can be gleaned from the Van Gogh family estate. It is well known that few of the letters written to Van Gogh have been preserved, yet the same is true of the letters he wrote to family members (other than Theo). There is no concrete evidence of this, but I assume that much of the musical news shared in the family letters would have been communicated to Vincent as well, certainly in the early years. I also assume that he picked up a great deal of his musical knowledge from other people, through the 'friction of ideas' (as he called it) that occurs during conversation.[32] Sometimes those friendly talks could become quite fierce. In 1888, for example, he wrote to Theo about his visit to the Musée Fabre in Montpellier with Paul Gauguin, and their conversations about the art they saw there, which included works by Delacroix and Rembrandt: 'The discussion is *excessively electric*. We sometimes emerge from it with tired minds, like an electric battery after it's run down.'[33] Van Gogh must have exchanged ideas on current musical issues on a regular basis and in great depth not only with Gauguin but also with Theo and his friend Andries Bonger and with other artists interested in music.

The material in this book is ordered thematically, which means that I combine and relate quotations from letters written in different periods of Van Gogh's life—a working method that yields enlightening insights. At the same time, however, it is important to remain aware of the chronological development of his thinking. Although Van Gogh's ideas on a number of subjects were remarkably constant, the light in which he viewed them underwent

drastic changes in the course of his life. In his younger years his thinking was marked by a strong Christian/religious bias; in later years, artistic perspectives usually underpinned his reasoning. He was obsessed, though at different times in his life, with both religion and art. The passages from his letters that are quoted here must be considered against this backdrop of shifting perspectives.

This book consists of ten chapters. The tempo markings in Italian that serve as subtitles to the chapters were inspired by the letter written to John Peter Russell on 19 April 1888 (letter 598), in which Van Gogh himself uses the terms 'scherzo' and 'adagio con espressione'. Chapters 1–4 offer a brief biographical sketch and lay out the facts about the place that music occupied in Van Gogh's life: his exposure to music at a young age, the influence exerted on him by his family and his upbringing, and the ideas about music thus instilled in him. He heard music played on the piano, the harmonium and the organ, sang hymns at church, and knew dozens of psalms by heart. Passages from the family correspondence are quoted to elucidate the musical atmosphere that prevailed in the Van Gogh household. After he'd left the parental home, music continued to touch Van Gogh in various ways. He attended house concerts and had housemates who played the piano. In Paris he heard the music of Wagner, as well as snippets of music in the street and in church; in Arles, he attended a musical stage play performed in Provençal dialect. Because Van Gogh was a voracious reader, I also examined the channels through which he might have acquired his knowledge of music: poetry, novels, magazines, and art-theoretical books and treatises. His intensive reading helped to shape his ideas about music, as did his conversations with fellow artists. Importantly, his upbringing and his reading made him aware, early on, of the powerful effect music can have on the mind, a notion he later attempted to transpose into painting. Van Gogh was certainly no melomaniac, for he was too wrapped up in other things to pay constant attention to music. Yet this does not mean that music played no role in his life, only that he experienced it in his own private way.

His was a world abounding in sensory perceptions, in colours, sounds and smells. It was precisely his sensitivity to these stimuli—his 'impressionability'—which distinguished him as an artist. Chapters 5 and 6 therefore deal not only with 'man-made' music but also with sounds in general, beginning with the 'pure' music of birdsong, which Van Gogh mentions time and again in his letters. Birds never failed to capture his interest, for they took him back to the land of his youth. He also registered other

sounds: the footsteps of thousands of workers leaving the naval dockyard in Amsterdam (which was like 'the sound of the sea'), the deafening chorus of cicadas he frequently heard in Provence, not to mention the clamour in his own head. This is why I interpret voices not only in the literal sense but also figuratively as the 'voice of the artist'. Here Van Gogh's sensitivity to sensory stimuli emerges as an artistic ideal, for he aspired to produce art that appealed not only to the eyes but to the other senses as well—a pursuit that served his ultimate goal of authenticity and truth.

Chapters 7–10 delve into the significance of music to Van Gogh's art. The 'musical painting' engaged in by the avant-garde artists was the acoustic outcome of the above-mentioned ideal. This took on various forms in the work of Van Gogh. For one thing, he endeavoured to evoke sounds with paint (the rustling of ears of wheat, the singing of a lullaby). He also sought to translate into painting the deeper truth that music could express by focusing more on pictorial means (colours, lines, forms) and less on the subject portrayed. For Van Gogh and other avant-garde artists, the latter became a vehicle instead of the goal. To infuse a painting with profound meaning, the artist had to be in the right frame of mind—a dreamy and impressionable mood that I call the artist's 'high', a heightened, trancelike state of receptiveness that Van Gogh and others have often compared to music. 'Music' stood for that partial release from reality that is tantamount to the inspired, animated state of the artist during the creative act. When looking at a painting, then, viewers were supposed to feel a similar uplift and detachment, an experience from which they could derive comfort, as they could from listening to music. For in the end, this was Van Gogh's goal—to offer solace to humanity—and that fact alone makes music an issue of key importance and worthy of further study, because it was an indispensable part of his artistic creed. Finally, I return in the last chapter to the word 'symphony', a term that proves to have a host of fascinating meanings.

Van Gogh's life has been recounted in detail in numerous studies and biographies.[34] While reading the following chapters, it will suffice to remember the broad outlines of his life: Van Gogh was born in the village of Zundert in the Dutch province of Brabant on 30 March 1853. He was employed by Goupil & Co., an international art dealer, at its branches in The Hague, London and Paris. After his dismissal from that job, he worked as a teacher at an English boarding school and subsequently as a bookseller's assistant in Dordrecht. He then set about preparing to take the entrance examination to study theol-

ogy, but after a year he gave up that plan and went to the Borinage, a mining district in Belgium, to work as an evangelist. He was twenty-seven when he finally resolved to become an artist, but once that decision had been taken, he let nothing stand in the way of his artistic calling. After a few months in Antwerp and a couple of years in Paris, he had had enough of city life. Attracted by the light and the colours of the Midi, he moved to Provence in the south of France in early 1888.

In the summer of that year, he ended up making seven paintings of sunflowers, rather than the 'dozen or so panels' announced in the previously mentioned letter to Theo.[35] Gauguin finally arrived in Arles in October and joined Van Gogh in the Yellow House. Their collaboration did not last long, a mere two months. Van Gogh suffered the first attack of his nervous disorder in December (during which he cut off part of his ear), and a second attack at the beginning of February. Several more attacks followed. In his calmer periods he worked with the utmost determination, also at the psychiatric hospital in Saint-Rémy, to which he had been voluntarily admitted, and later in Auvers-sur-Oise, where he was treated by Dr Paul-Ferdinand Gachet. In the end he gave up the struggle. The pistol shot was one of the last sounds he heard. He died on 29 July 1890.

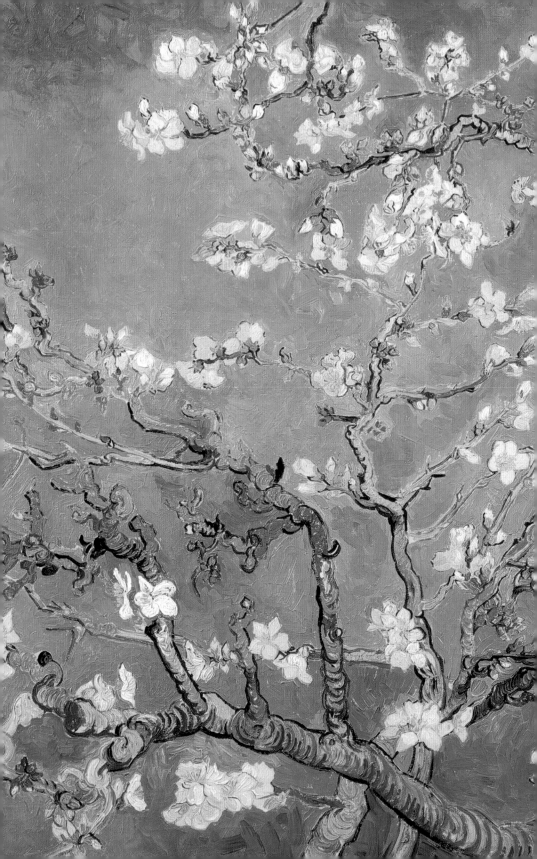

2 MUSIC AT HOME

Allegro cantabile

Try this simple mental exercise: lean back, relax, close your eyes and try to remember the first music you ever heard. Many of those melodies will have faded and slipped away, silently vanishing in the mists of time. A child's experience of music begins in the womb and continues in the cradle as it listens to its mother's calming songs. Yet few adults remember these sounds: the soothing words, the gentle cadence, the endless rocking motion. Van Gogh considered this a universal image of security and responsiveness. 'I can't look at the last piece of furniture without emotion', Vincent wrote to Theo in 1882, at the sight of a cradle that stood in his studio in The Hague, above which he had hung a 'big etching after Rembrandt' depicting 'two women beside the cradle' [fig. 13].[1] To Van Gogh, the cradle symbolized the peace and comfort he yearned for all his life [fig. 14]. During his short stay in the northeastern province of Drenthe, he wrote to his parents, 'In my view, there's nowhere one can think better than by a peasant hearth, with a baby in an old cradle beside it—and where one can see through the window a delicate green wheatfield and the alder bushes waving.'[2]

The mother's reassuring singing, shortly after the screams at birth, is the primordial sound with which life begins. All the other music—the more or less edifying vocal and instrumental pieces heard in the months and years afterwards—is determined by the era and the milieu in which one grows up. Van Gogh, the eldest son of a village clergyman, was born in Zundert in the province of Brabant on 30 March 1853. Five siblings followed: Anna (1855),

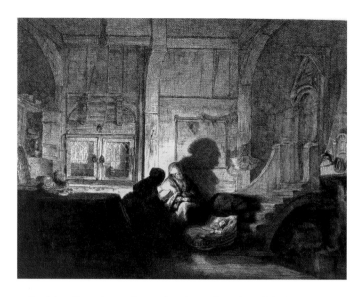

13 Dominique Vivant-Denon after Rembrandt van Rijn, *Holy Family in the Evening (Nocturnal Effect in an Interior) (end 1630s)*, 1787. Etching, 32.5 × 42.5 cm. Cabinet des Estampes, Bibliothèque Nationale de France, Paris.

Theo (1857), Lies (1859), Willemien (1862) and Cor (1867). It is difficult for us to imagine what music sounded like then, over a century and a half ago, when there was no radio, no television, none of the ambient noise we have today. Back then, darkness was pitch-black, and stillness was deathly silent. There was singing, of course, and people played musical instruments. Much sheet music has been preserved, and accounts of concerts survive in newspapers and magazines. Even so, it is not easy to understand how music was perceived in the second half of the nineteenth century. There was a world of difference between Van Gogh's experience of music and ours.

THE SOUND OF THE ORGAN

One of Van Gogh's first musical experiences probably occurred when he was only four months old. The inauguration of the new harmonium, which the Reverend Theodorus van Gogh had purchased in Breda for his congregation at the Reformed Church in Zundert, took place on 7 August 1853. Little Vincent might have heard the first sounds produced by this brand-new instrument while sitting on his mother's lap (or that of a nursemaid). The

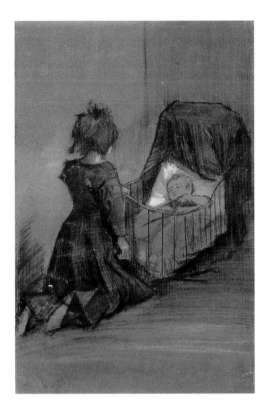

14 Vincent van Gogh, *Girl Kneeling in Front of a Cradle* (F 1024 / JH 336), 1883. Pencil, natural black chalk, opaque white watercolour, grey (?) wash, traces of squaring, 48 × 32.3 cm. Van Gogh Museum, Amsterdam (Vincent van Gogh Foundation).

harmonium was played by Erasmus, Zundert's capmaker, whom the Reverend Van Gogh had appointed precentor and organist several months after taking up the position of minister of the village church in May 1849. Erasmus (his Christian name is not known) also conducted the local brass band. The acquisition of the organ had kept the reverend occupied for months. He collected money in person from all the notable families of Zundert and also appealed to his relatives: his brother Cor collected money in Amsterdam; his sister Mietje took up a collection from the entire family after one of the reverend's sermons; a ladies' circle in Amsterdam held a lottery; and even Prince Frederik made a donation—bringing the funds up to the required amount.[3]

The organ, too, played an important role in the following years, as emerges from the family correspondence. Since 1871 the family had been living in Helvoirt, another village in Brabant, where Theodorus van Gogh had taken up the position of minister. In 1873 Mrs van Gogh wrote to Theo, who was then living in Brussels, 'Pa was busy Sunday, leading the prayers and the singing and also preaching. The bellows of the organ are broken,

an organist is expected, and extensive repairs will probably be needed. Are there beautiful organs in the churches in Brussels, and how are the confirmation classes? How many of you are there and with whom do you go?'[4]

In late 1875 the family moved to the village of Etten, where Theodorus had been appointed to the living and now served two churches, one in Etten and the other in the hamlet of Hoeven. In a letter to Theo he put forward his reasons for buying a new instrument for the little church in Hoeven. It was a much-needed acquisition, in his view, because without organ accompaniment the congregation could not sing in tune. Dutch clergymen had been confronted since the sixteenth century with this sorry state of affairs, much lamented by Constantijn Huygens in his influential book *Gebruyck of ongebruyck van 't orgel in de kercken der Vereenighde Nederlanden* (The use or disuse of the organ in the churches of the United Netherlands), published in 1640. The small congregations served by Theodorus van Gogh had modest organs in their houses of worship: 'I'm taking the trouble to acquire a small harmonium for Hoeven. They must be available from around 80 guilders; the coffers there can bear that amount and Miss Sophie would be able to play it. Would you also find out how much they cost in The Hague and let me know, when you have the opportunity? You're familiar with the little church yourself, so you can tell whether such a small instrument sounds good enough and meets our needs. The singing at Hoeven leaves much to be desired.'[5]

The harmonium, which is a type of reed organ, arrived and was tried out on 16 November 1876, at which time it proved to be perfectly adequate. It was officially inaugurated during Sunday worship on 19 November, not by Miss Sophie but by Aunt Cornélie—Mrs van Gogh's sister, who was married to Uncle Cent (Vincent), Theodorus's brother in The Hague. Afterwards the four of them dined in the front room of the parsonage in Etten.[6] This was not the only time Aunt Cornélie acted as organist in Hoeven, for six months later she played there again.[7] Mrs van Gogh also played the instrument now and then. The Reverend Van Gogh reported in a letter to Theo that they had taken the carriage to church: 'Yesterday I preached at Hoeven and Ma played the organ very nicely.'[8] The organ had been refurbished only recently, as emerges from a letter Vincent wrote to Theo: 'Pa wrote that the church had been whitewashed and the organ painted.'[9]

Van Gogh very much liked the sound of the organ. Describing Vincent's situation in London, their father wrote to Theo, 'He doesn't yet feel completely settled in his work, but he sounds happy in his letters. . . . He had

also taken a long walk on Sunday, had been to church, where he found the organ and the singing particularly beautiful.'[10] Later Vincent wrote, again from England, about a little church with a harmonium, which he had unexpectedly run into on an evening walk: 'At last I saw below the rise a light in a small house, and scrambled and waded over to it, and there I was told the way. But, old boy, there was a beautiful little wooden church with a kindly light at the end of that dark road . . . There was a harmonium in the church, played by a young woman from a boarding school'.[11] On an earlier visit to London he had become acquainted with the poetry of John Keats, and had copied out one of his poems in a letter to friends in The Hague. It included these lines:

> Twice holy was the Sabbath-bell:
> The silent streets were crowded well
> With staid & pious companies,
> Warm from their fire-side orat'ries;
> And moving, with demurest air
> To even-song, & vesper prayer.
> Each arched porch, & entry low,
> Was fill'd with patient folk & slow,
> With whispers hush & shuffling feet,
> While played the organ, loud & sweet.[12]

Just how highly Van Gogh valued this instrument becomes even more apparent when he compares the work of one of the painters he most highly admired, Jean-François Millet, to the sound of 'a solemn organ'.[13]

MUSIC IN THE VILLAGE

The village band played on festive occasions and to mark important events. Zundert—where the Reverend Van Gogh and his family lived for more than two decades, from 1849 to 1871—also had a choral society. Vincent, who was born and grew up in Zundert, must have heard the band and the choir on numerous occasions, either outdoors or at one of their more formal, indoor concerts. At the village school, he and Anna, the oldest of his sisters, were taught the usual reading, writing and arithmetic, but they also had to recite verses and sing together.[14] Serious singing went on every Sunday: the

minutes of the church council for 2 May 1864 report that the Reverend Van Gogh had arranged for the children of the village to have special singing lessons, given 'by the governess of his children', during their confirmation classes.[15] The governess in question was Anna Birnie, who at the age of seventeen had come to work in the Van Gogh household, giving the children lessons at home.

Anniversaries were marked by a performance of the local choir or wind band, whose members came, for example, on 13 November 1873 to serenade the Reverend Duyzer and his wife, who were celebrating their fiftieth wedding anniversary. Theodorus van Gogh wrote a marriage song to honour the occasion. The festivities lasted the whole day: 'During afternoon tea the singers from the Reformed Church came to serenade us, very nice, and yesterday evening we celebrated at our house. There were fifteen of us, the room was decorated with flags and greenery, and everything went very well indeed. We should very much like to celebrate our golden anniversary in the same way!'[16]

The hoped-for serenade materialized, in fact, a few years later: not on the occasion of their golden anniversary, however, but to mark the marriage of their daughter Anna to Joan van Houten on 22 August 1878. On the eve of the wedding, the entire wind band appeared at the parental home in Etten: 'On Wednesday evening at half past six, the wind band serenaded them and continued to play off and on for a whole hour, performing very beautifully—while we were in the garden. It was so very nice', the Reverend Van Gogh wrote to Theo.[17] Vincent was staying in Etten at this time and had previously reported to Theo: 'Now that Joan is here, Anna looks a lot more cheerful and better than before.'[18] It is almost certain, therefore, that he witnessed the festivities and heard the musical performance.

Finally, there were the annual Orange festivals honouring the Dutch royal house, the House of Orange. The most memorable was King William III's silver jubilee, celebrated in grand style throughout the Netherlands on 14 May 1874. Writing from Helvoirt, Mrs van Gogh told Theo about it: 'Here the festivities amounted to nothing but flags everywhere, a parade of the kind they do here, but unimpressive, and nothing in the evening because of the rain. Afterwards there must have been music again over by the pump.'[19] At school, young Cor was given an orange bow and a medal, and sang with his classmates after being served currant bread and rolls during the coffee break.

PSALMS AND HYMNS

From birth, Van Gogh's ears had been filled with devotional songs, sung not only during the church service but also at home. The front room of the parsonage in Zundert boasted six Bibles, eight evangelical hymnals and five volumes of rhyming psalms.[20] His parents, who had grown up in a long Christian tradition, were convinced that reading the Bible and singing devout songs would strengthen both heart and mind. This was certainly the case with Van Gogh, who long found solace in Bible-reading and hymn-singing. When the Van Gogh children left the parental home, they were given a Bible; it is known that Vincent always had one in his room. In 1876 Vincent, now an assistant teacher, wrote to Theo from the English village of Isleworth, 'How I wish you could see the playground now, and the garden behind it, in the twilight, inside the school the gas-lamps flicker and one hears the congenial sound of the boys learning their lessons, from time to time one of them starts humming a snatch of melody from some hymn or other, and there's something of that "faith of old" in me.'[21]

In the years between 1875 and 1880, Van Gogh was obsessed with religion: he zealously attended churches of various denominations, and for a while was even convinced that he could become a preacher. During this religious phase, his letters were chock-full of quotations from the Bible, religious tracts, psalms and hymns. He had notebooks and albums in which he copied out countless verses of hymns and long passages of spiritual poetry in Dutch, English, French and German. Later, too, he remained attached to this repertoire. His thinking and writing were imbued with the devotional vocabulary he had imbibed in his youth, and his father further stimulated this tendency by recommending specific psalms for his sons' edification: 'Our life is always uncertain, but now one feels a redoubled need for faith in God's love and protection. The image of this in rhyming psalm 91, my mother's favourite psalm, is rendered very beautifully indeed. Read it if you like, it gives comfort to find that expression of childlike faith so aptly sketched there.'[22]

Vincent, who had several hymnals,[23] knew his psalms and hymns in three languages: Dutch, English and French. He owned *Het boek der psalmen, nevens de Gezangen bij de Hervormde Kerk van Nederland in gebruik* (The book of psalms, as well as the hymns in use in the Dutch Reformed Church), which was bound together in one volume with the *Evangelische gezangen, om nevens het boek der psalmen bij den openbare godsdienst in de Nederlands*

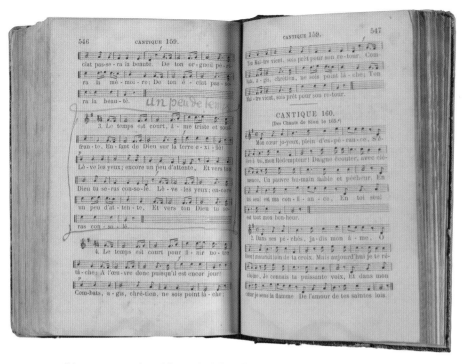

15 *Recueil de psaumes et cantiques à l'usage des églises réformées*. Paris, 1865. 14.1 × 9.6 cm (book). Van Gogh Museum Library, Amsterdam.

Hervormde gemeenten gebruikt te worden (Evangelical hymns, to be used alongside the book of psalms during public worship at the Dutch Reformed Church), both published in 1849, as well as *Recueil de psaumes et cantiques à l'usage des églises réformées* (Collection of psalms and canticles for use in the reformed churches), published in 1865. Two pencil sketches by Van Gogh appear on the end leaf of the first booklet; the last-mentioned volume contains notes and markings in his handwriting. For example, he circled the third couplet of hymn 159, which begins with the words 'Le temps est court' (Time is short), and wrote above it 'Un peu de temps' (A bit of time), perhaps because he hoped to write a sermon on that subject [fig. 15]. It is also quite possible that he owned a copy of *Gospel Hymns and Sacred Songs* (1875), referred to in those days as the 'Moody and Sankey hymns' after the two itinerant evangelists who ensured that these hymns gained international fame at their sessions of hymn-singing for the masses. Perhaps this was one of the hymnals he sent to Theo: 'One of these days you'll be receiving a couple of English hymnals, I'll mark a few of them. There is so very much that is

beautiful in them. One grows very fond of them, especially when one has heard them here so often.'[24] That autumn Vincent gave Theo another 'English hymnal', which he sent with Van Iterson, a colleague of his at the art dealer Goupil & Co.[25]

Later on, Van Gogh regretted that he hadn't gone to hear Moody and Sankey in person in the months he spent in London, in early 1875: 'there's something moving about seeing the thousands now flocking to hear those evangelists'.[26] It emerges from various letters that Vincent was well acquainted with their *Gospel Hymns and Sacred Songs*: he quotes no. 18 ('Joy in sorrow') and refers on numerous occasions to no. 38 ('Tell me the old, old story'), the first time on 12 May 1876, after Theo had received the hymnal: 'I also like "Tell me the old, old story" very much. I first heard it sung in Paris, in the evening in a small church I used to attend sometimes. No. 12 is also beautiful.'[27] A short while later, after he had begun teaching at a boarding school in the English village of Isleworth, he heard one of the boys playing the hymn: 'It's already late. Tomorrow evening I must tell the same tale to the assistant teacher and the two oldest boys, who stay up later. Those three and I eat our bread together in the evenings. While I was talking, I heard one of them playing "Tell me the old, old story" on the piano downstairs.'[28]

HIS MUSICAL MOTHER

Van Gogh's parents thought it important for their children to receive a proper education. All six of them went to school, and at home they read serious newspapers and magazines, including the *Nieuwe Rotterdamsche Courant*, *De Hollandsche Illustratie*, *Eigen Haard* and the *Nouvelle revue*. Literature and art were discussed, and this balanced cultural diet naturally included music lessons. There was a piano in the parsonage at Zundert, and later, in Etten, the family also acquired a harmonium to play at home. 'Ma already plays the harmonium so well that it's truly a pleasure', the Reverend Van Gogh observed with satisfaction.[29] Vincent's sister Lies was also a proficient player.[30]

Mrs van Gogh, who played both the piano and the organ very well, generally attached great importance to musical talent. Her esteem for people rose in accordance with their musical skill. When her daughter Anna was living in England, it was, above all, the musicality of the family with whom she lodged that put her mother's mind at ease: 'A good letter from Anna last Tuesday, she says a warm-hearted tone prevails there in the family. They make a lot

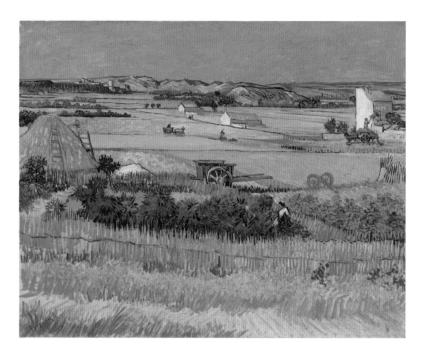

16 Vincent van Gogh, *The Harvest* (F 412 / JH 1440), 1888. Oil on canvas, 73 × 92 cm. Van Gogh Museum, Amsterdam (Vincent van Gogh Foundation).

of music on Sunday evenings. . . . The father does something at the railway, a cheerful person. The mother mostly suffering, but they are very friendly and very musical.'[31] About 'little Anna', a girl who accompanied Aunt Fie on a visit to the parsonage, Mrs van Gogh remarked approvingly that she had 'a fine talent for music'.[32] Moreover, Jo Bonger, her future daughter-in-law, won her heart with her superb piano-playing: 'Monday we went to see the Bonger family, very pleasant, I ate there, and in the evening, after Aunt and Kee had played together, Jo played very, very beautifully—a piece that pleased all of us.'[33] Years later, in 1901, Mrs van Gogh was still insisting on the importance of music, now with regard to little Vincent and the piano in Jo's house. She hoped that her grandson would continue to take lessons, because it 'would be wonderful if music were to become a pleasure for him too'.[34]

The piano in question had been Theo and Jo's wedding present from Aunt Cornélie in 1889, mainly thanks to Mrs van Gogh, who had schemed to put this plan in motion. From March 1888 onwards, the 'pianino' (the term then used to refer to an upright, as distinguished from a grand piano) is mentioned in at least fifteen letters exchanged between Jo, Theo and Mrs van

28 MUSIC AT HOME

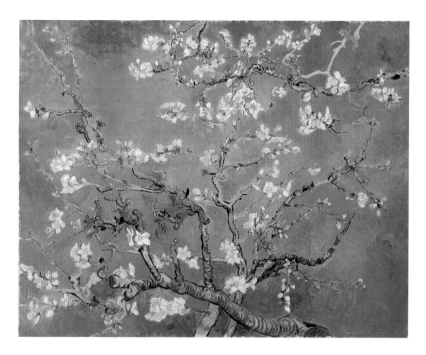

17 Vincent van Gogh, *Almond Blossom* (F 671 / JH 1891), 1890. Oil on canvas, 73.5 × 92 cm. Van Gogh Museum, Amsterdam (Vincent van Gogh Foundation).

Gogh. 'What splendid news that your aunt wants to give us the piano, and how well your Mother organized it for us', wrote Jo to Theo.[35] And Mother wrote in turn: 'Jo let me read Aunt's letter, wonderful about the pianino, how nicely Jo plays, I think she deserves one.'[36] Theo, however, still needed reassuring: 'I do hope it's not rickety.'[37] Giving the piano to Theo and Jo did not mean that Aunt Cornélie had to do without an instrument, because she had another piano at home, an Erard of similar size.[38]

Two Dutch households in Paris—Theo and Jo's, and also that of Jo's brother Andries and his wife, Annie—boasted a piano with a large painting by Vincent hanging above it. 'I don't believe we've told you that I've rented a piano', Andries wrote to his parents. 'It's a great pity and a shame that Annie hasn't played in such a long time. The piano furnishes the salon. We've put it in the corner, at an angle beneath Vincent's painting.'[39] In Theo and Jo's apartment, the piano initially stood below *The Harvest* [fig. 16], a canvas that was replaced a year later by *Almond Blossom*, the painting Vincent made to mark the birth of his nephew Vincent [fig. 17].[40] *The Harvest* continued to hang in the salon too.

MAKING MUSIC HIMSELF

Apart from a brief spell of piano lessons, Van Gogh seems not to have played a musical instrument. As a child and young adult, he sang a great deal, as everyone did in those days, both at school and at church, and later on too, even when he was alone—something he also advised his brother to do: 'Don't be afraid, when you're out walking in the evening and there's no one near by, to sing a psalm: "The panting hart, the hunt escapèd", or "O why art thou cast down, my soul?" or "Centre of our longing" or "I know in Whom my faith is founded".'[41] Vincent knew that that psalm and those two hymns were part of the standard repertoire, which both he and Theo knew by heart from years of churchgoing.

In England, Vincent sang with the boys at the boarding school where he worked: 'Mornings and evenings we all read the Bible and sing and pray'.[42] Later on, singing disappeared from his life, owing in part to the serious falling-out he had with his father in late 1881, as a result of which he no longer went to church. Yet during the first attack of his illness, in Arles in December 1888, Vincent apparently burst out singing, which by this time he regarded as highly unusual: 'In my mental or nervous fever or madness, I don't know quite what to say or how to name it, my thoughts sailed over many seas . . . and it seems that I sang then, I who can't sing on other occasions, to be precise an old wet-nurse's song'.[43] This is a good example of a remarkable phenomenon, namely the tendency of people to fall back on their earliest musical experiences in times of need.

In addition to singing, there was piano-playing, though it is not known whether either Vincent or Theo took lessons as children.[44] In the nineteenth century it was customary in middle-class households for girls, in particular, to take piano lessons. The piano conquered the whole of Europe in the course of the century, driving the harp and the guitar from the drawing rooms and becoming the pre-eminent female instrument. An important reason for the piano's rise in standing was the demureness of the spectacle: a woman perched elegantly on a piano stool was a less provocative sight than a woman pressing a wind instrument to her lips or gripping a harp or a cello between her legs.[45]

It is hardly surprising that all three daughters in the Van Gogh family learned to play the piano, but Vincent's youngest brother, Cor, also began to take lessons at the age of eight. He received two lessons a week, not from his mother or one of his sisters but 'from a strapping young woman here in

the village for 30 cents a lesson'.[46] Various teachers came and went over the years. Lies first had lessons from a certain 'Miss Willebrand' and two years later from a 'gentleman' who promised to bring her 'a sonata by Mozart'. Willemien learned to play from 'Mr Schijvers, the music master', but soon had a female teacher: 'The teacher coughs rather a lot but is always there and never misses a lesson because of it.'[47] In 1889 in The Hague, Willemien resumed lessons in earnest, and reported this to Theo and Jo: 'After not touching the piano for more than three months, I went yesterday to Mathilde van Buuren, who is making me start over from the beginning, but with theory. I'll be going to her again in two weeks, and in three months or so she will tell me whether or not I can continue.'[48]

The popularity of the piano was reflected in the books the girls read. In nearly every nineteenth-century novel, the piano was played ardently and with devotion, and the instrument was repeatedly associated with feminine passion and rapture, thus referring to the danger allegedly inherent in music: 'How wild she could be!', wrote Lodewijk van Deyssel about Mathilde,

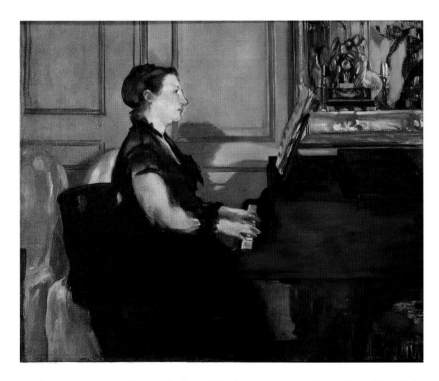

18 Edouard Manet, *Madame Manet at the Piano*, 1868. Oil on canvas, 38.5 × 46.5 cm. Musée d'Orsay, Paris.

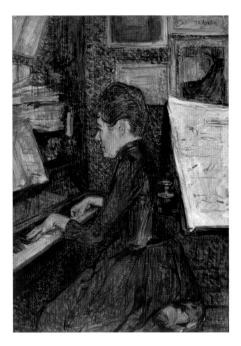

19 Henri de Toulouse-Lautrec, *Mademoiselle Dihau at the Piano*, 1890. Oil on cardboard, 63 × 48 cm. Musée Toulouse-Lautrec, Albi, France.

the romantic protagonist of his novel *Een liefde* (A love affair) of 1887. 'How she could bang on the piano and sit there playing for hours, without stopping, without looking up. She was definitely a strange breed of girl.'[49] To be sure, rebellious Mathilde could not be held up as an example to respectable, middle-class girls.

A woman at the piano had also become a popular theme in art.[50] In 1890 when Van Gogh portrayed Marguerite Gachet—the daughter of Paul-Ferdinand Gachet, his doctor in Auvers-sur-Oise—playing the piano, he joined the ranks of such illustrious predecessors as Manet (*Madame Manet at the Piano*, 1868) [fig. 18], Cézanne (*Girl at the Piano*, 1869–70) and Toulouse-Lautrec (*Mademoiselle Dihau at the Piano*, 1890) [fig. 19]. He was familiar with Lautrec's work: 'Lautrec's painting, portrait of a female musician, is quite astonishing, it moved me when I saw it', Vincent wrote to Theo and Jo.[51] With regard to his own painting, he had previously said, 'Yesterday and the day before yesterday I painted Miss Gachet's portrait, which you'll see soon, I hope. The dress is pink. The wall in the background green with orange spots, the carpet red with green spots, the piano dark violet. It's 1 metre high and 50 [cm] wide. It's a figure I enjoyed painting—but it's difficult. He's promised to get her to pose for me another time with a little organ.'[52] By way of illustration, he added a letter sketch and a drawing after the painting [fig. 20].[53] Nothing ever came of his portrait of Marguerite playing a little organ. Remarkably, however, Marguerite continued in real life to play the piano with unflagging dedication: nearly sixty years later, she was photographed playing the same piano in the very same spot [fig. 21]. In 1991, this piano scene became part of a movie [fig. 22].

20 Vincent van Gogh, *Marguerite Gachet at the Piano* (F 1623r / JH 2047), 1890. Chalk on paper, 30.5 × 23.8 cm. Van Gogh Museum, Amsterdam (Vincent van Gogh Foundation).

21 *Marguerite Gachet at the Piano*, 1947. Photograph, 16 × 11.8 cm. Reproduced in Roger Golbéry, 'Marguerite Gachet énigmatique et silencieuse', *Vivre en Val-d'Oise* 11 (1992). Van Gogh Museum Library, Amsterdam.

22 *Marguerite Gachet at the Piano*. Still from the film *Van Gogh*, by Maurice Pialat (1991).

3 MUSICAL ENCOUNTERS

Moderato parlando

Vincent was not a keen concertgoer, had no deep understanding of music, and did not play a musical instrument or move in musical circles—yet he was obviously fond of music and very receptive to it. In this he resembled Theo, who wrote the following to their sister Willemien in March 1888: 'I can well imagine that, if one begins late, it's a formidable task to apply oneself to music, but wonderful to be acquainted with it. I believe that, as an art, music ranks at least as high as painting. Even though I don't know much about it, I very much like to listen to music.'[1] Theo's lack of knowledge, however, was made up for by his good ear and keen musical intuition. This is apparent from his evocative and enthusiastic account, quoted below, of a concert at the Colonne Hall in Paris, at which he heard Ludwig van Beethoven's Septet and Sixth Symphony, which he called the 'Holy' ('Sainte') pastorale. The passage comes from a letter Theo wrote to his fiancée, Jo Bonger, who had grown up in a musical family and evidently inspired him to articulate intense reflections of this kind. Even though these words were not addressed to Vincent, they are relevant as an example of the kind of vocabulary used by the brothers to talk about art and music.

> It was truly magnificent. Rubinstein's overture ended on a note of jubilation, an ode, which made a splendid introduction. Followed by the Holy pastorale, which transported me to a land where the sun was shining, flies, crickets, birds, butterflies, all fluttering &

soughing in the warm air over the water & the rustling trees. People dancing by, singing a lovely song, the male voices rising above the sweet melody played on a shepherd's flute. Then the storm broke, the shrillness of the wind, the relief of rain, & afterwards the trickling of water once the storm had passed, & the finale, an ode to nature's power of regeneration. It was wonderful, wonderful & as I sat there listening I wanted to hold your hand in mine. What followed wasn't really to my liking, though it was nicely performed. But that septet. The beginning, a simple song but rich with sound, as if there were twice as many musicians playing as in the preceding numbers (except the pastorale). First, the most marvellous harmonies, which I cannot describe because I was too tired, then the violins alone suddenly started to sing an angel's song. It transcended the instruments and transported me to another land, my thoughts following the song enraptured. It ends abruptly in a sob, only to be followed immediately by the previous harmonies, leaving me with a sense of wellbeing. I don't know how long it lasted but it seemed to be over in a flash, though the effect was shattering.[2]

This lyrical outpouring includes the notable phrase 'transcended the instruments'. This quotation is particularly interesting, because the original Dutch phrase, 'buiten de instrumenten' (beyond the instruments), had an analogy in painting, namely in the expression 'buiten de verf' (beyond the paint), used by Vincent and Theo more than once in their correspondence.[3] In their letters they spoke of art that went 'beyond the paint' as the supreme achievement, because it broke free of its material, allowing the viewer to see the effect not as art but as transcendental truth, as the very essence of existence.

MUSIC AT HOME

When Vincent went to England in 1873 to work at the London branch of Goupil & Co., one of the first things he reported to Theo was that he had found a suitable boarding-house in a suburb of London, where a lot of music-making went on: 'There are also three Germans in the house who really love music and play piano and sing themselves, which makes the evenings very pleasant indeed.'[4] In the preceding years in The Hague, he had often sought out companionship and warmth at Aunt Fie's musical soirées,

where his cousin Jet Carbentus played the piano.[5] Jet later married Anton Mauve, the painter with whom Van Gogh was to study for several weeks at the end of 1881.

Van Gogh would have heard the piano played every time he went home to visit his parents. The family repertoire emerges in part from the letters, since both his mother and his sister Lies thank Theo more than once for sheet music that he sent them.[6] Lies mentions compositions by Schubert, as well as 'a very beautiful piece by Mozart' for *piano quatremains*. She wrote wistfully, 'I hope so much to progress a lot in music now, so that I can develop that feeling for it that you recently described to me, and one cannot achieve that by playing *études* by Czerny or *L'espoir du retour*!!! etc. but I shall do my best and pluck up my courage.'[7] Willemien was elated because, while staying with relatives in Middelharnis, she had read Zola's novel *Au bonheur des dames* (*The Ladies' Paradise*) and heard piano sonatas by Beethoven for the first time—'that is indeed so delightful'.[8] Jo, too, was fond of Beethoven, and even played whole symphonies if necessary. Girls seemed to think nothing of tackling long pieces for large orchestra in arrangements for four hands, as Jo related to Theo: 'Yesterday evening I called on Lida Dirks and we played Beethoven's 5th symphony together. Actually she'd invited Mien but she had a bad headache so I went in her place. Poor though our performance was, we enjoyed ourselves anyway. Afterwards, of course, a chat about housekeeping, and I left with a large kitchen book under my arm instead of the symphonies I had arrived with.'[9]

Theo had previously heard Jo play Felix Mendelssohn's *Lieder ohne Worte* (*Songs without Words*) and a piece by Anton Rubinstein. He thought back longingly to such intimacy: 'I quite agree that it's nicer to listen to a piece when there are not many people present than at a concert.'[10] He knew this from experience, for by this time he had attended concerts and musical soirées in The Hague, Brussels and Paris.

BALLS IN ANTWERP

The Reverend Theodorus van Gogh strongly advised his sons to attend concerts and musical evenings, in the conviction that this was a useful and necessary means of becoming a 'man of the world'. Theo, he thought, was better at this than Vincent, who never felt the need to move in higher circles and was actually more at home among the lower classes. In 1876, in fact,

he reported to his parents from England that he had spent the night in a 'stuffy saloon with smoking and singing passengers'.[11] That same year their father wrote with pride and satisfaction to Theo, who was then living in The Hague, where he had begun to make his way in the world, 'I think it wonderful that my son attended a real party. That is excellent, and it seems to me that a musical party naturally means that one is not so ill at ease. I hope that more opportunities of this kind will come your way; like this, one gradually becomes familiar with worldly customs and is shaped into a man who knows how to act.'[12]

The reverend and his wife seldom had such opportunities in the remote Brabant villages where they lived. Their experience of music consisted at most of a wind band marching down the street, singing and organ-playing at church, and the outdoor concerts given by the Liedertafel, the men's choir of Breda, at a venue in the nearby Liesbos forest: 'Celebrating with truly wonderful singing, there was illumination and it sounded so beautiful in the forest', as Mrs van Gogh described it in September 1873.[13]

Various members of the Van Gogh family attended musical events in these years, as clearly emerges from their correspondence. In early 1874 Theo received a ticket from Aunt Mietje for the opera in The Hague, and Lies went to a number of concerts while at boarding school in Leeuwarden.[14] For example, she heard Amsterdam's Park-Orkest conducted by Willem Stumpff in February 1875, and attended two 'special concerts' in the Van der Wielen Concert Hall: 'Miss Weiringer' (voice), Henri Wieniawski (violin) and Henri Völlmar (piano) played on 13 October 1874, and Louise Kiehl ('first singer at the opera in Mainz'), accompanied by a piano quartet (violin, viola, cello and piano), performed on 12 January 1875. Lies wrote to Jo about the piano pieces she was playing and the concerts and musical soirées she attended. 'How wonderful it was to sit there in my corner, dreaming, while the plaintive sounds of the violin swirled entrancingly through the room', Jo reported to Lies in 1886. 'We were at a musical party, in fact, where I only played the part of a listener, but it was a wonderful part, I assure you. Do you know the song "Vorsatz" by Lassen? Oh Lizzie, it is so indescribably beautiful.'[15] Andries Bonger thought his sister Jo sentimental and called music an idle art: 'In the circle in which you move in Amsterdam, I don't believe there is anyone who understands a painting (actually, music is understood there only because that revelation of art moves one the easiest)'.[16] It is questionable whether he meant this seriously. After all, Andries attended concert after concert in Paris. He heard, among other things, the first act of Wagner's *Tristan und*

Isolde, Beethoven's complete Fifth Symphony and Jacques Offenbach's *Les Contes d'Hoffmann* (*The Tales of Hoffmann*).[17] Andries, who was certainly not lacking in self-esteem, wrote to Jo about the musical soirée he attended with Theo in 1885, which included a dinner that lasted until the small hours, 'The soirée was lovely, extremely lovely even. I suited the occasion. Never have I been so splendidly dressed. If everyone did not gasp in admiration as I entered the room, it was only because there was no one there yet. I fancy I saw our host's lips curl into a satisfied smile.'[18]

By no means was Vincent as eminently presentable as his brother's friend in Paris. He liked things to be folksy, down-to-earth, marked by age. Around the time when Theo and Andries attended that musical soirée, Vincent was spending hours roaming around Antwerp, where he visited the Scala, a music and dance hall comparable to the Folies Bergères, the renowned variety entertainment theatre in Paris. But he went there not so much to hear the music as to gaze at the faces of the women: 'I thought it was tedious and hackneyed, of course, but—I amused myself looking at the audience. There were magnificent women's heads, really extraordinarily fine, among the worthy bourgeois folk in the back rows.'[19] Since his stay in Nuenen, where he had painted countless peasant heads, he had been fixated on portraits, but in Antwerp he made several drawings depicting ballroom interiors and couples dancing [figs. 23–24]. He also amused himself by watching the 'bals populaires', the popular dances for sailors on the Antwerp docks, where the common folk congregated.[20] He saw streetwalkers there, and enjoyed 'watching the folk's high spirits',[21] a sight that he described as 'extraordinarily authentic'.[22] 'There were very good-looking girls there, the best-looking of whom was ugly. I mean, a figure that struck me like an amazingly beautiful Jordaens or Velázquez or—Goya—was one in black silk, probably some inn landlady or other, with an ugly and irregular face, but with vivacity and piquancy à la Frans Hals. She danced excellently in an old-fashioned manner—among others, once with a well-to-do little farmer type who had a large green umbrella under his arm, even while he was waltzing amazingly fast.'[23]

This was the kind of unvarnished truth Van Gogh sought in his art. He found a suitable model in 'a girl from a café chantant'. What he wanted was to portray women who led life to the full, to paint them with the intensity he knew from literature and the persuasiveness and authenticity he had seen in Rembrandt's portraits: 'Because he had caught that mysterious smile so infinitely well with a gravity that he alone—the magician of

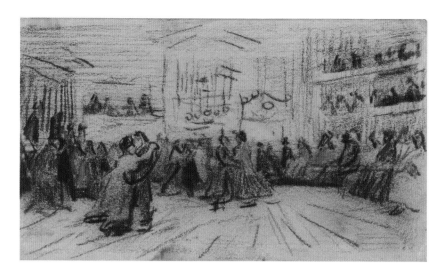

23 Vincent van Gogh, *Dance Hall* (F 1350a / JH 968), 1885. Black, red and blue chalk, 9.2 × 16.3 cm. Van Gogh Museum, Amsterdam (Vincent van Gogh Foundation).

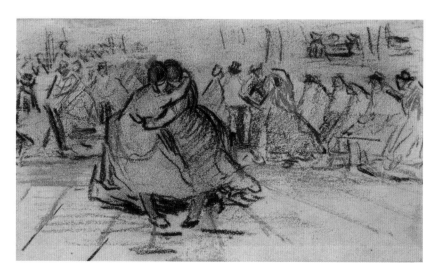

24 Vincent van Gogh, *Couple Dancing* (F 1350b / JH 969), 1885. Chalk on paper, 9.2 × 16.3 cm. Van Gogh Museum, Amsterdam (Vincent van Gogh Foundation).

magicians—can achieve. Now this is something new to me, and I want to get it at any price. Manet did it and Courbet—well, confound it, I have the same ambition because, moreover, I've felt to the core the infinite beauty of the studies of women by the very great people in literature, Zola, Daudet, De Goncourt, Balzac.'[24]

CONCERTS IN PARIS

Van Gogh left Antwerp at the end of February 1886 and went to Paris, where he moved in with Theo in Montmartre. There seems to have been little time for music at first. While Andries Bonger avidly kept track of the most recent developments in the theatre and music world, the Van Gogh brothers wrestled with their health and were frequently at loggerheads. Inhabiting the same apartment was proving to be rather difficult.

Only nine letters survive from Van Gogh's time in Paris, so we know little about his daily life and the development of his artistic ideas in these years. In the field of art, a great deal was happening: he came into contact with Gauguin and Camille Pissarro and also with younger painters, such as Toulouse-Lautrec, Emile Bernard and Paul Signac. He saw, for the first time, the work of the Impressionists and Neo-Impressionists, and this soon led to a change in his manner of painting: his dark palette became lighter and more colourful.

In his new circle of acquaintances, music was ubiquitous. Everyone was involved in musical pursuits of one kind or another, the most striking of which was a peculiar musical fever that affected many artists, Van Gogh among them, namely the cult surrounding Richard Wagner. When Van Gogh arrived in the city, the whole of culturally minded Paris was in thrall to this German composer. With his trail-blazing music and revolutionary ideas, Wagner roamed around Europe like a god, casting his spell on musicians and composers alike, as well as on a large circle of intellectuals, writers and artists, including the painters Van Gogh knew. Often it was Wagner's bold artistic views, rather than his music, that inspired them. Wagner's notion that he could reform not only the arts but the whole of society by means of his 'Artwork of the Future' appealed greatly to the artists of the avant-garde. His name alone was synonymous with modernity and innovation.[25]

There are salient examples of this French 'Wagnérisme': Signac, who loved to sail, named his first boat *Manet-Wagner-Zola*, and a later boat

Walküre, after Wagner's opera of 1870. In the 1880s the painter Charles Toché made his studio available for concerts that became known as 'Petit Bayreuth', after the city in which Wagner built his own opera house in 1876. Wagner's idea to dim the lights in the hall (nowadays customary, but innovative at the time) prompted Seurat to experiment with putting dark frames around his paintings to produce the optimum light-and-dark effect. Paul Cézanne's painting *Girl at the Piano* (1869–70) had a second, more modern title, *Overture to Tannhäuser*, after Wagner's opera, the piano reduction of which is evidently standing on the piano. In 1882, Pierre-Auguste Renoir painted Wagner's portrait, and subsequently embarked, like many others, on a pilgrimage to Bayreuth, where he nevertheless failed to sit through Wagner's complete *Ring* cycle.[26] Gauguin saw Renoir's portrait and 'heard strange melodies'.[27] Fantin-Latour exhibited *Around the Piano* at the 1885 Salon, where visitors called the painting 'Les Wagnéristes', because it portrayed seven famous Wagner connoisseurs [see fig. 31]. In the same year Wagner's Parisian devotees, who met in studios and at salons, founded the *Revue Wagnérienne*, a magazine that existed until 1888.

It was a different matter with the music itself. Staged productions of Wagner's operas were a rarity in Paris. The few attempts at full-blown productions—such as the staging of *Tannhäuser* in 1861 and *Lohengrin* in 1870—ended in riots that put an early stop to the performances. Otherwise his operas were performed everywhere—from Prague to Philadelphia—in the 1880s, but in France, Wagner's music and ideas long remained so disputed that every attempt to stage an opera led to protest and scandal.

In Paris, therefore, the only way to hear Wagner's music was to attend a concert performance. Excerpts from his operas were played on Sunday afternoons at a few concert halls in the city, such as the Société des Concerts du Conservatoire, a favourite venue. Three other popular concert halls were eventually named after their founders: the Concerts Lamoureux (originally 'Nouveaux concerts'), Concerts Pasdeloup ('Concerts populaires de musique') and Concerts Colonne ('Concert national'). At the Colonne, Andries heard Berlioz's *Romeo et Juliette* and excerpts from Wagner's *Tannhäuser* in 1881. 'Certainly a stark contrast', he wrote to his parents, 'the dreamy, sweetly flowing French music and the titanic music of Wagner!'[28] At the Lamoureux, he heard the first act of Wagner's *Lohengrin*; once again, the programme also included music by Berlioz.[29] And in 1885 he heard the first act of Wagner's *Tristan und Isolde* at one of those concert halls.[30]

Three years later Theo and Vincent also attended 'a couple of Wagner concerts'.[31] We do not know the particulars—exactly how many concerts, their venues or the programmes—but they definitely took place in the weeks preceding 19 February 1888, the date of Vincent's departure for Arles.[32] One month later Theo reminisced about those concerts in a letter to Willemien: 'Here one seldom hears anything good unless one goes to concerts. So before Vincent left I went to a couple of Wagner concerts with him and we both enjoyed them very much.'[33]

Vincent could evidently appreciate Wagner's music. Perhaps the fact that he attended concert performances, rather than staged operas, was one reason for this. (Van Gogh himself admitted that he spent more time at concerts gazing at the musicians than listening to the music, so the spectacle of a staged opera would undoubtedly have been very distracting to him.) Once installed in Arles, he began to read Camille Benoit's book *Richard Wagner: Musiciens, poètes et philosophes* of 1887. From then on, the composer's name crops up regularly in his letters.

At those concerts in Paris, Van Gogh heard not only excerpts from Wagner's operas but also orchestral pieces by other composers—a frequent combination at such concerts. It was possibly in Paris that Van Gogh first became acquainted with the music of Beethoven, which he had previously known only through hearsay and books. In 1884 he had already used his vague ideas about Beethoven's music to formulate a painterly ideal: 'But with Dupré there's something of a magnificent symphony in the colour, *carried through, intended, manly*. I imagine Beethoven must be something like that. This symphony is *surprisingly* CALCULATED and yet simple and infinitely deep, like nature itself.'[34]

Of course, formal concerts were not the only way to experience music in Paris. The city had many more musical venues—for example, the *cafés chantants* of Montmartre, such as Le Chat Noir and Le Mirliton—and songs could always be heard in the street. In fact, there was music in one form or another just about everywhere. Theo and Jo wrote to Mrs van Gogh about festivities in the park, which they happened to witness: 'The people were dining in big tents, drinking toasts and singing songs.'[35] From the window of his new apartment, Theo heard music on the first day of spring: 'I opened it of course & the mild, fresh air poured in & all of a sudden a street musician started playing the guitar, accompanied by the voice of a girl of about ten. Her soft

25 Vincent van Gogh, *Woman Pianist and a Violinist* (F 1714 / JH 1160), 1887. Pencil on paper, 13.6 × 20.9 cm. Van Gogh Museum, Amsterdam (Vincent van Gogh Foundation).

little voice shimmered in the air, singing words one could not distinguish about printemps, amour, lumière.'[36]

In this period, Vincent executed not only his series of five coloured sketches of musicians but also, on the back of a menu of the Du Chalet restaurant, the pencil sketch *Woman Pianist and a Violinist* [fig. 25],[37] as well as the drawing *Woman Walking Her Dog ('A La Villette')*, inspired by the eponymous chanson by the cabaret singer Aristide Bruant [fig. 26]. This drawing depicts a fat woman with a dog, and below them two lines from the eighth verse of this fourteen-verse chanson: 'De son métier elle n'faisait rien. Le soir elle balladait son chien, à la Villette' (Her profession was being a layabout. / In the evening she and her dog went out, / for a stroll in La Villette). Comparison with the original text shows that Van Gogh omitted the third line, changed 'day' to 'evening', and altered the gender of the protagonist:[38]

> De son métier i' faisait
> rien,
> Dans le jour i' baladait son
> chien
> La nuit i' rinçait la
> cuvette,
> À La Villette.

26 Vincent van Gogh, *Woman Walking Her Dog ('A La Villette')* (F 1704 / JH 1035), 1886. Pencil, pen and ink, and chalk on paper, 16.8 × 10.1 cm. Van Gogh Museum, Amsterdam (Vincent van Gogh Foundation).

His profession was being a
layabout,
In the day he and his dog
went out,
At night he went to Villette
for a stroll
to rinse out the bowl.

The woman is depicted swaying across the boulevard de Rochechouart, then the address of Le Mirliton, Bruant's café-cabaret, which Van Gogh visited several times in late 1886.[39] At the upper left is the inscription 'Bal Boule Noir', the name of a dance hall that had closed just before Van Gogh arrived in Paris. He no doubt heard the chansons at Le Mirliton or in Cormon's studio, where he trained for several months in the spring of 1886. This studio was also frequented by Toulouse-Lautrec, who was a friend of Bruant and knew his entire repertoire by heart. At Cormon's, Lautrec was in the habit of regaling his fellow painters with Bruant's chansons: 'While working, he amused the studio with quips and chansons. He sang Bruant's whole series about the various districts of Paris.'[40] Andries Bonger later recalled that Cormon's pupils even wrote a song about Van Gogh. His shabby appearance (he always wore workman's clothes) and rebellious nature had led Van Gogh's fellow students to nickname him 'Decazeville', referring to the town where a miners' strike had been called in January of that year. During Van Gogh's months in Cormon's studio (March–June), the miners had begun to strike again. This explains the teasing line in the song: 'Le père Cormon n'a qu'un gréviste, qu'un gréviste' (For Papa Cormon he is but a striker, but a striker).[41] Much later, when Van Gogh was at the asylum in Saint-Rémy (and Theo had sent him Albert Aurier's laudatory article 'Les Isolées: Vincent van Gogh'), he casually quoted one of these chansons: 'I'm very grateful for the article, or rather "glad at heart", as the revue song has it, since one can need it as one can truly need a medal.'[42] The line came from the refrain of the political chanson 'En revenant de la revue' (Returning from the show).

Van Gogh was also familiar with other French repertoire. In a sketchbook he wrote down four lines from 'Il pleut, il pleut, bergère' (It's raining, it's raining, shepherdess), originally an aria from Fabre d'Eglantine's operetta *Laure et Pétrarque* of 1780, which had become popular as a revolutionary song after 1789, the year of the storming of the Bastille: 'Soupons, prends cette chaise /

27 Vincent van Gogh, 'Il pleut, il pleut, bergère'. Note in a sketchbook, Paris, 1886. Pencil on paper, 11 × 19.8 cm (sheet). Van Gogh Museum, Amsterdam (Vincent van Gogh Foundation).

Tu seras près de moi / Ce flambeau de mélèze / Brûlera devant toi' (Let us eat, take this chair, you'll be close to me / This torch of larch will burn in front of you) [fig. 27].[43] Several deviations from the original text suggest that Van Gogh had heard the song somewhere and had jotted it down. Fascinated by the French Revolution, he read books on the subject and quoted rebel songs in his letters, including 'Ça ira!' (It'll be fine), a battle cry taken from one of the most popular revolutionary songs.[44] In a letter to Theo, he copied from Victor Hugo's *Les Misérables* the whole of a student song from the time of the revolution of 1830: 'Si César m'avait donné la gloire & la guerre' (If Caesar had given me glory and war).[45] It is not certain that he knew the music to this song: in the letter, what was most important to him were the words 'L'amour de ma mère' (My mother's love), which in his opinion stood for 'love of mankind' or 'universal brotherhood'.

Van Gogh left Paris and moved to the south of France in February 1888. After settling in Arles, he became acquainted with the postman Joseph Roulin, whose portrait he painted that same year, as well as those of Roulin's wife, Augustine, and their three children, Armand, Marcelle and Camille [fig. 28]. Van Gogh portrayed each member of the family a number of times. He wanted to paint baby Marcelle in the cradle, but abandoned that plan. Roulin, an outspoken revolutionary, refused to have his child baptised in church; instead, he organized a baptismal meal at his home. Van Gogh recounted the proceedings with amusement: 'Then he sang the Marseillaise hideously and named the child Marcelle, like the daughter of the good General Boulanger, to the great vexation of this innocent child's grandmother and other members of the family.'[46] This must have appealed to Van Gogh, who was fascinated by Roulin's personality, his rugged appearance and even his voice. To Gauguin he wrote, 'His voice as he sang for his child took on a strange timbre in which there was a hint of a woman rocking a cradle or a distressed wet-nurse, and then another sound of bronze, like a clarion from France.'[47] The next day he expressed it in a slightly different way in a letter to Theo: 'His voice had a strangely pure, moved timbre which to my ear contained a sweet, distressed wet-nurse's song and something like a distant echo of the clarion of revolutionary France.'[48]

In Arles, Van Gogh made up to some extent for what he had missed in Paris. He visited the dance hall housed in the local theatre, the Folies Arlésiennes, of which he painted an impression in November 1888 [fig. 29].[49] Two months later, on 27 January 1889 (one month after the ear incident), he revisited this theatre to see a fully staged musical production: a traditional pastorale, a blend of nativity play and musical comedy, performed in Occitan dialect.[50] Later he described that night as 'the first time I've slept without a serious nightmare'.[51] He found the melodious sound of the women's voices particularly moving:

> They were performing—(it was a Provençal literary society) what they call a Noel or Pastourale, a remnant of Christian theatre of the Middle Ages. It was very studied and it must have cost them some money. Naturally it depicted the birth of Christ, intermingled with the burlesque story of a family of astounded Provençal peasants.

28 Vincent van Gogh, *Joseph Roulin* (F 432 / JH 1522), 1888. Oil on canvas, 81 × 65 cm. Museum of Fine Arts, Boston. Gift of Robert Treat Paine, 2nd, 35.1982.

Good—what was amazing, like a Rembrandt etching—was the old peasant woman, just the sort of woman Mrs Tanguy would be, with a head of flint or gun flint, false, treacherous, mad, all that could be seen previously in the play. Now that woman, in the play, brought before the mystic crib—in her quavering voice began to sing and then her voice changed, changed from witch to angel and from the voice of an angel into the voice of a child and then the answer by another voice, this one firm and warmly vibrant, a woman's voice, behind the scenes. That was amazing, amazing.[52]

29 Vincent van Gogh, *Dance Hall in Arles* (F 547 / JH 1652), 1888. Oil on canvas, 65 × 85.5 cm. Musée d'Orsay, Paris.

The brothers must have exchanged thoughts about this performance, for only a few days later, Vincent told Theo about another pastorale in Occitan dialect, Frédéric Mistral's poem *Mirèio* (1859), on which Charles Gounod based his opera *Mireille* of 1864. Van Gogh had never heard the opera, but he knew of its existence. For him, however, merely the sound of the regional dialect, as spoken by the women, was already music to his ears:

> You ask me if I've read Mistral's Mireille—I'm like you, I can only read it in fragments of the translation. But have you *heard* it yet, for perhaps you know that Gounod has set it to music. I think so anyway. Naturally I don't know this music, and even if I was listening to it I would rather be looking at the musicians than listening. But I can tell you this, that the original language from here in words sounds so musical in the mouths of the Arlésiennes that my word yes, from time to time I catch fragments of it.[53]

This brings to mind an experience Lies had recounted. Two years earlier, while travelling in Brittany, she imagined she heard women singing by a river: 'This is the region where Jean Aicard composed his "chants provenci-aux" verses; those are so very lovely, and when I see the washerwomen [on the banks of the River] Douve, beating the wash, the charming verse "clic, clac, fait le bathoir" naturally resounds in your ears.'[54] Vincent himself later wrote that he had stood in a rocky landscape at sunset that was so roman-tic and evocative that he would not have been surprised if he had suddenly heard 'the voice of an old Provençal troubadour'.[55]

Although Van Gogh evidently heard a great deal of music in his lifetime, he did not attend many concerts, preferring to spend his money on prints and artists' supplies rather than concert tickets. He could be seen more often in working boots, kneeling on the ground, than in freshly polished shoes on his way to a theatre. To be sure, he was fond of music, but not in the same way as Andries and Theo: they were not only music lovers but also ambitious 'men of the world', who attended concerts for social reasons too. Clearly, Vincent was not *salonfähig*, and this hindered his attendance of such events. That he ultimately heard as much music as he did is due more to coincidence than to his own initiative. Even so, no one had to go without, for the streets were always full of music.

4 READING ABOUT MUSIC

Andante affettuoso

Direct contact with music—hearing it at musical soirées and concerts, during church services, in the streets, and in *cafés chantants* and dance halls—was not the only thing that shaped Van Gogh's ideas about music as an art form. He was also influenced by the books and articles he read and by the conversations he had on the subject. Van Gogh is known to have been a voracious reader from a very young age.[1] As he himself said, 'I have a more or less irresistible passion for books, and I have a need continually to educate myself, to study, if you like, precisely as I need to eat my bread.'[2] Van Gogh's love of literature was unconditional, and reading remained a life-long passion. He experienced books intensely, deriving comfort and wisdom from them and using them to sharpen his mind. They often proved to be sources of artistic inspiration, affirmation and provocation, as emerges from his letters, which give a lively and detailed account of his reading. Through that continuous stream of writings, poetry, novels and books about art and history, Van Gogh was confronted time and again with thoughts and ideas about music.

Van Gogh's sketch of a phonograph of 1884 or 1885, for instance, might have been inspired by his reading, since Thomas Edison's recent invention was the subject of many newspaper and magazine articles written at that time. It is also possible, of course, that Van Gogh had actually seen and heard such a contraption, for precisely during the months he spent in Brussels, there were daily presentations at Maurice Castan's wax museum on Munt

Square 'of Edison's phonograph, destined to make history in the story of humankind'.[3] Phonographs could also be heard at similar public demonstrations given at the Odeon Theatre in Amsterdam in those years.

POETRY

Beginning with his earliest correspondence, Van Gogh frequently quoted poetry that struck a chord with him. He sometimes concluded his letters with excerpts from poems, or enclosed separate sheets with poems he had copied out. Some of these verses were about music, or, more precisely, the comforting effect of music, for that is the gist of nearly all these poems—as exemplified by this sentimental verse by Ludwig Uhland:

> Oh play another song for me
> Old man, honest and true,
> Try and see if one sweet chord
> Can move my heart anew.

> The sick child prays, the old man plays
> His song had never been so tender,
> Nor, like now, so magical:
> It filled him, too, with wonder.

> There trills a chord so heavenly
> It moves the old man's heart.
> The organ stops, the dear child's soul
> This earthly vale departs.[4]

At about the same time, Vincent sent Theo a letter from England in which he copied out the words of a song called 'The three little chairs'.[5] He also recorded such verses in albums that he compiled for Theo and a few friends. His selections included Joseph Autran's 'Chanson d'octobre', verses from Heinrich Heine's *Buch der Lieder* (Book of songs), Uhland's 'Lied eines Armen' (Song of a poor man), Johann Wolfgang von Goethe's 'Harfenspieler' (The harpist) and 'Abendlied' (Wanderer's evensong), and the opening line of the folk song 'Aan de oever van een snellen vliet' (On the bank of a swift stream).[6]

Van Gogh was especially fond of the poetry of P. A. de Génestet, whose work he had heard from an early age. De Génestet's poems (and not only those about music) played an important role in the life not just of the Van Gogh family but also of a large part of the Dutch population, who considered his verses fortifying and character-building. In this sense his poems were comparable to psalms and hymns. Indeed, Theo's mother gave him the following advice: 'Study De Génestet again, oh how many good, true words it contains, so fresh and beautiful. If you find something in it, just read it again, like so many words from the Bible, which are like armour in life's struggle.'[7]

Clearly, such songs and poems could provide comfort and support; their optimism offered a foothold to those seeking meaning in life. Simplicity, purity, consolation, happiness, music: all these words intermingle in nineteenth-century poetry of this kind, invariably with reference to the countryside as opposed to the city (itself an age-old literary topos). An apt example in this context is 'De Avondstond' (The evening hour) by Jan van Beers, which Lies copied out for Vincent in May 1873 because he had thought it so beautiful. He in turn copied it out twice, once for Willem and Caroline van Stockum, and again for Theo. A part of the long poem describes a painter's sensitivity to sound and music:

Rocking from side to side, a wagon, nearly toppling
Under its load of fresh-harvested buckwheat, came rumbling closer,
Both horse and burden adorned with fluttering ribbons and greenery.
Children, all with wreaths of flowers on their little flaxen heads,
Were seated on top, happily waving branches of alder,
Or scattering flowers and leaves, which rained down on all sides,
While round the wagon a troop of country lads and lasses
Skipped and sang enough to startle the whole drowsy plain.

Quietly smiling, the Painter, from behind the thicket,
Watched as the revellers slowly wound their way down the rutted road.
'Aye', he thus mumbled, 'Aye, the Lord must think it
A happy sound, the jubilance with which these hearts
So simply pour forth their thanks as they gather the last
Fruits, which He yearly lets grow fully ripe from their toil.
Yea, for the purest prayer of simplicity and innocence is joy!'[8]

Like his parents and siblings, Van Gogh read a number of novels by George Eliot and Charles Dickens, and he also knew the fairy tales of Hans Christian Andersen. In 1882 he declared the song of the poor slave from Harriet Beecher Stowe's *Uncle Tom's Cabin* to be 'the most wonderful passage' in the book.[9] Later, in a letter to Emile Bernard, he copied out the 'melancholy Lied' ('lied mélancholique') from Alphonse Daudet's novel *Le Nabab*; the song begins with the line 'Que l'heure est donc brève' (How short is the hour).[10] For Theo he quoted several lines from the song 'Ne crois pas que les morts soient morts' (Don't believe that the dead are dead) from Jean Richepin's *Miarka, la fille à l'ourse* (Miarka, the daughter of the bear); in the book, the girl sings this song 'in a sad, soft voice, through the rain and through her tears'.[11]

As far as literary prose was concerned, Van Gogh eventually developed a preference for the naturalistic novel, which sketched a rawer reality and could take place in either a rural or an urban setting. He wrote the following to Willemien in 1887: 'The work of the French naturalists Zola, Flaubert, Guy de Maupassant, De Goncourt, Richepin, Daudet, Huysmans is magnificent and one can scarcely be said to belong to one's time if one isn't familiar with them.'[12] He was so taken by them that he painted the books themselves as still-life elements, stacked up or individually, at times in combination with other objects. His 1887 *Still Life of Three Books* features Jean Richepin's *Braves gens: Roman Parisien* (Good people: a Parisian romance), along with Zola's *Au bonheur des dames* and Edmond de Goncourt's *La Fille Elisa*. Richepin's book is about a musician and a mime: Yves, the musician, leaves Paris for Brittany and finds happiness in the countryside; Tombre, the mime, remains in the city, sinks into poverty, takes to the bottle, despairs and dies. Like the poetry discussed above, this novel connects music with health and happiness. In *Still Life with Plaster Statuette, a Rose and Two Novels* of 1887, Van Gogh captured another of his beloved books, Maupassant's *Bel-Ami*. Zola's novel *La Joie de vivre* figures in two other paintings [fig. 30].

One of Van Gogh's favourite authors was indeed Zola, by whom he read some twenty books, mostly novels. This writer is mentioned more than a hundred times in Van Gogh's correspondence. While reading the novel *Une Page d'amour* (A love affair) in 1882, Vincent decided to read everything Zola had ever written, and shortly after this confessed to Theo: 'I'm still under the spell of Zola's books. How *painted* those Halles are.'[13] He had just read

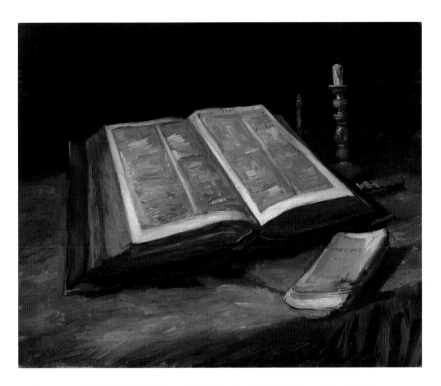

30 Vincent van Gogh, *Still Life with Bible and Zola's Novel 'La Joie de vivre'* (F 117 / JH 946), 1885. Oil on canvas, 65.7 × 78.5 cm. Van Gogh Museum, Amsterdam (Vincent van Gogh Foundation).

Le Ventre de Paris (published in English as *The Belly of Paris*), in which Zola describes the Paris market halls with evocative resonance: gigantic constructions of iron and glass, overwhelming colours and tremendous noise. He transformed the lifeless architecture into a colossal creature with a beating heart, which belched out hellish noises:

> Now he could hear the continuous rumbling of carts as they left the markets. Paris was chewing over the daily food of its two million inhabitants. The markets were like some huge central organ pumping blood into every vein of the city. The din was as if made by colossal jaws, a mighty sound to which each phase of the provisioning contributed, from the cracking of the big buyers' whips as they started off for the district markets to the shuffling feet of the old women who hawked their lettuces in baskets from door to door.[14]

Van Gogh was no doubt struck by other passages about sound and music, although he does not always mention them in his letters. Music plays an important role in many of Zola's novels.[15] Personages are characterized according to their relationship to music, and the names of composers and titles of compositions are bandied about. Van Gogh's knowledge of music, therefore, derives not only from live performances and conversations with his acquaintances in Paris but also from the novels he read. Long before attending any concerts in Paris, he had encountered Wagner's name while reading Zola's *Nana* in 1882, though here the composer does not appear in a positive light. In the following passage, Zola's characters represent the anti-Wagnerian camp; this was the author's way of giving the ongoing debate on Wagner's work a place in his fiction.

> 'Monsieur de Vandeuvres', called Madame Chantereau in a loud voice. 'Didn't they boo Wagner last Sunday?'
>
> 'Oh, abominably, Madame Chantereau', he said, going towards her with his usual exquisite politeness. . . .
>
> 'No, don't talk to me about your Germans,' Madame Chantereau was insisting. 'Singing means being lively and cheerful. . . . Have you ever heard Patti in the *Barber*?'
>
> 'Fantastic!' breathed Léonide, whose only musical interest was strumming operetta tunes on her piano.[16]

Three years later he read *La Joie de vivre* of 1884, in which the frustrated artistic ambitions of a mediocre pianist are linked to the music of Wagner and Berlioz:

> Then they took up music. Lazare's piano was an old Erard, dating from 1810, on which, long ago, Mlle. Eugénie de la Vignière had for some fifteen years given lessons. Its mahogany framework had lost its polish; and within, the strings yielded a faint, plaintive sound, of muffled sweetness. Lazare, who could not persuade his mother to give him a new piano, hammered at it with all his might but could not extract from it the rich romantic sounds with which his brain was overflowing. So he used to reinforce it vocally, to try and achieve the desired effect. His enthusiasm led him to take advantage of Pauline's willingness; now that he had an audience he would spend whole

afternoons going through his repertoire, which consisted of the most complicated sort of music, chiefly the as yet unrecognized work of Berlioz and Wagner.[17]

Van Gogh followed Zola's latest book, *L'Oeuvre* (1886; published in English as *The Masterpiece*), from the time of its first appearance in December 1885, in weekly instalments in the magazine *Gil Blas*. In this widely read and much-discussed novel about the nineteenth-century Paris art world, the protagonist, Claude Lantier, an avant-garde artist modelled on Cézanne, wrestles with his inability to produce a masterpiece. His circle of friends includes Gustave Gagnière, a painter and music addict, who at some point in the story frenetically sums up the history of music, beginning with Haydn and singling out such luminaries as Beethoven and Berlioz: 'Beethoven! There's power, there's strength through calm, serenity in pain! Michelangelo at the tomb of the Medici! Hero, logician, moulder of human minds, he was all these! The great composers of today all spring direct from the Choral Symphony! . . . Berlioz brought literature into his music. He is the musical illustrator of Shakespeare and Virgil and Goethe. And what a painter! The Delacroix of music, with his fine conflagration of sounds, the same clashing contrast of colours!'[18]

The 'Delacroix of music': this phrase alone must have been enough to inspire in Van Gogh great admiration for Hector Berlioz. Even so, music is not seen as a positive force in this book. Gagnière is portrayed as an artistic failure: a pale, distracted figure with a glassy stare, living in a dream world, disengaged from reality. Gagnière's beardless face gives him a feminine appearance; unsurprisingly, it is mainly women with whom he discusses music. Above all, he loves Wagner. He is, moreover, a passionate devotee of colour theory, in particular the 'law of simultaneous colour contrasts' (the fact that complementary colours are enhanced by their juxtaposition). Zola's description of this was taken from a book that was popular among modern artists: *De la loi du contraste simultané des couleurs* (On the law of simultaneous contrast of colours), published by Michel-Eugène Chevreul in 1839. This law, also known as the 'theory of reflection', was presented in Zola's *L'Oeuvre* as a dangerous phenomenon, since an artwork created in this way no longer bore a clear relationship to the outside world. In Zola's novel, Gagnière is the one who brandishes such twisted new ideas, thereby exerting a pernicious influence on the protagonist, Claude Lantier, the archetypal obsessed

artist, who continues down the slippery slope until he finally commits suicide. In short, Zola's novel reflected the debate on realistic and modern painting which was then raging in the art world, and his own frank standpoint on this issue was 'realism above all'. He dismissed the influence of music—and, by extension, the artistic movements of Impressionism and Symbolism too. He was not against music as such, but he thought it had no place in painting: in his view, music only made painting weak and effeminate. Furthermore, he was fiercely opposed to the use of colours that did not reflect the main goal of art, namely to depict reality with the greatest possible verisimilitude. It is with good reason that Zola allows his alter ego Sandoz to call Gagnière a failure as a painter: Wasn't he 'a fool to throw himself away on music when he might have been developing his talent as a painter of landscapes?'[19] Clearly shocked by the ability of one art form to stifle another, Zola's character Mahoudeau concludes: 'There's a dud for you . . . His music's killed his painting, and now he'll never be any good at either.'[20]

MUSIC AND PAINTING

Theo and Willemien read *L'Oeuvre* too. Both of them had actually expected that Vincent would turn out like Claude Lantier, but fortunately this was not so, according to Theo: 'I've read *L'Oeuvre*, which you write about, & before I read it, I also thought, from reading the review, that Vincent was very much like the protagonist. But that is not the case. That painter sought the unattainable, whereas Vincent is much too fond of what *exists* to succumb to that pitfall.'[21] Nevertheless, Van Gogh had struck out on that perilous musical path long before this. He was determined that his work contain at least some small measure of the unattainable. Therefore, despite his great admiration of Zola, he could not have agreed with him fully on this point (just as he did not wholly follow the musical trail of the Impressionists and Symbolists—a subject that will be discussed later). In the summer of 1884, Van Gogh read about the relationship between painting and music in Charles Blanc's *Grammaire des arts du dessin* of 1870 and in his essay on Delacroix, which was included in *Les Artistes de mon temps* of 1876. Blanc stressed the existence of a phenomenological connection between colour and sound (since both reach our senses by way of vibrations), and gave a detailed account of Chevreul's colour theory. It was Van Gogh's knowledge of Chevreul's law of simultane-

ous colour contrasts that strengthened his conviction that a painter should proceed not from the actual colour ('couleur locale') of his subject, but from the colours on his palette: in other words, he should seek harmony within the painted depiction and not attempt to produce an exact imitation of reality. This became the prime tenet of Van Gogh's art. 'COLOUR EXPRESSES SOMETHING IN ITSELF. One can't do without it; one must make use of it', he wrote emphatically to Theo.[22] This is what Delacroix had referred to earlier as 'the music of the painting' ('la musique du tableau'): 'There is an impression that results from a certain arrangement of colours, light effects, shadows, etc. It is what one might call the music of the painting. Even before knowing what the picture represents, you enter a cathedral, and you find yourself at too great a distance from the picture to know what it represents, and often you are carried away by this magical harmony; the lines alone sometimes have this power by virtue of their grandness.'[23]

The 'musical' element would increasingly gain the upper hand in late-nineteenth-century painting, ultimately leading, at the beginning of the twentieth century, to total abstraction: to the 'meaningless' art of painters such as Kandinsky and Mondrian. This was art that lacked a compelling narrative. It did not depict anything concrete; it had no 'subject' in the traditional sense. All that remained was paint and colour. These had a 'voice' of their own ('colour expresses something in itself'), whereby they appealed primarily to feelings and not to the power of reason.[24] Van Gogh's career coincided with the unfolding of these developments; he did not live to witness their culmination. While making optimum use of the emotional power of colour, he never let go completely of the descriptive element. He remained a staunch 'realist', entirely in accordance with the requirement and example of Zola.

It is all the more remarkable, therefore, to hear Van Gogh's view of these modern developments. 'Painting as it is now promises to become more subtle—more music and less sculpture—in fact, it promises *colour*', he wrote to Theo at the end of August 1888.[25] Two months earlier he had stated in a letter to his sister Willemien that this 'new manner could help to put the women who are *incapable* of precision, who feel musically, on the right track' in their artistic endeavours.[26] Particularly striking is the grouping of the words 'music', 'women' and 'colour', a combination that is perfectly attuned to the thinking of Zola's Gagnière. To top it all off, that same year Van Gogh (like the lamentable Gagnière) also fell under the spell of Wagner.

RICHARD WAGNER

Since attending those concerts in Paris, Van Gogh had been captivated by Wagner. It is tempting to think that the music itself might be the reason for this fascination, but there is no trace of this in his correspondence. One thing is certain, however: once he had settled in Arles, he began to read Camille Benoit's book on Wagner, which had been published in Paris the previous year. Benoit is one of the eight Wagner devotees portrayed in Fantin-Latour's *Around the Piano*, a painting Van Gogh certainly knew [fig. 31]. Benoit's book comprises a selection of excerpts from Wagner's writings, each accompanied by a short introduction. That this was in fact the book Van Gogh read is evident from several characteristic words and phrases, which now begin to crop up in his letters and seem to have been taken directly from Benoit's book. An example is the word 'renaissance', which Van Gogh uses with reference to 'painting today' ('la peinture actuelle') in a number of letters to Theo and Bernard.[27] Another such borrowing is Wagner's core concept of the 'art of the future' ('art de l'avenir'), which Van Gogh mentions in three letters written between early May and late June 1888.[28] Remarkably, it was at this time that he began to link the memory of his earlier piano lessons to the music of Wagner, a retrospective connection apparently prompted by Benoit's book.

Van Gogh regarded Wagner as a guiding light. Such a visionary was needed in the visual arts too—'a *colourist such as there hasn't been before*'.[29] The yearning in such pronouncements is palpable: 'I'm reading a book about Wagner which I'll send you afterwards—what an artist—one like that in painting, now that would be something.'[30] This statement of early June 1888 was followed in late September by a similar reference to Wagner: 'What a need we have of the same thing in painting!'[31] Van Gogh was struck by various themes in Benoit's book: Wagner's utter devotion to the artistic ideal (after the example of Beethoven), Wagner's conviction that art could serve as a substitute for religion (his famous tirade, which begins with the line: 'I believe in God, Mozart and Beethoven'),[32] his statements about the incongruity between the artist's life and so-called real life, his metaphor of art as a dangerous voyage of discovery, and finally, his plea for artists to collaborate in order to create the art of the future. Inspired by this vision, Van Gogh wrote on 27 June 1888 to Bernard, 'Ah, if several painters agreed to collaborate on great things. The art of the future might be able to show us examples of that. The thing is, for the paintings that are *needed* now there would have to be several of us

in order to cope with the material difficulties. Well—alas—we're not at that point—the art of painting doesn't move as fast as literature.'[33]

Gauguin, who joined Van Gogh in the Yellow House four months later, was also interested in the relationship between music and painting. Like Van Gogh, he studied Benoit's book and copied out long passages from it. Gauguin's Wagner manuscript, which is preserved in the Bibliothèque Nationale in Paris, contains all of the above-mentioned themes, which he and Van Gogh must have discussed extensively. Later, Gauguin maintained that in this period, Van Gogh dipped his brush in yellow paint and wrote on a white wall the ominous pun: 'Je suis Sain d'Esprit. Je suis Saint-Esprit' (I am whole in spirit. I am the Holy Spirit)[34]—a play on words in which Wagner's pronouncement about 'holiness of spirit' ('sainteté de l'esprit') clearly resounds.

A letter written to Theo at the end of September 1888 reveals that Vincent had read more on Wagner than just Benoit's book. 'I've read an article on Wagner—L'amour dans la musique, by the same author who wrote the book on Wagner, I believe.'[35] The article appeared in the magazine *Revue des deux mondes*. Van Gogh thought, mistakenly, that Camille Benoit had written it, but its actual author was the young music critic Camille Bellaigue, who

31 Henri Fantin-Latour, *Around the Piano*, 1885. Oil on canvas, 160 × 222 cm. Musée d'Orsay, Paris.

was also living in Paris at the time. Van Gogh might have been misled by the writers' identical first names and last initials, and perhaps too by the fact that the book opened with the word 'l'amour'. Bellaigue began by defining the relationship between music, love and women: 'La musique est femme. La nature de la femme est l'*amour*' (Music is woman. The nature of woman is love).[36] Contrary to what Van Gogh suggests, however, Bellaigue's article is not just about Wagner. It contains a comprehensive, chronological overview of classical vocal compositions in which love plays a role, from the early Italian *arie antiche* to the operas of Jean-Baptiste Lully, Christoph Gluck, Wolfgang Amadeus Mozart, Giacomo Meyerbeer, Beethoven, Giuseppe Verdi, Wagner and Gounod. All very interesting, of course, but Van Gogh probably objected to some of the ideas in this passage from Bellaigue's introduction: 'It is hardly surprising that love plays a greater role in music than in the other arts. Painting, sculpture and architecture give expression, above all, to ideas and facts. Not so music: its domain consists only of emotions, of which love is the first and foremost, by virtue of both seniority and merit. Moreover, sounds exert a special effect on the nerves that cannot be brought about by either forms or colours, and therefore music is a counsellor to, and interpreter of, love.'[37] This must have seemed strange to Van Gogh. Clearly, Bellaigue still considered painting to be diametrically opposed to music, and saw the visual arts as expressive merely of ideas and facts, unable to produce that 'special effect on the nerves'. This was the voice of someone oblivious to the world, who went through life wearing blinders, who was completely unaware of the developments taking place in Paris and elsewhere. Bellaigue was only thirty years old when he wrote the article quoted above, but he already sounded like an old man, unaware of the recent groundbreaking innovations in the world of art.

5 LISTENING TO BIRDSONG

Presto con brio

Van Gogh's letters are aflutter with birds. He heard them singing everywhere. Larks and nightingales, for example, on the English coast on a Sunday in May 1876: 'Everything was dark grey, but day was beginning to break on the horizon. It was still very early, and yet a lark was already singing. And the nightingales in the gardens on the sea-front.'[1] A month later, during his two-day hike from Ramsgate to London, 'the birds began to sing upon seeing the morning twilight' at half past three in the morning.[2] Similar feathered enchantment resounded for him in artworks that he liked: 'In a sheet in The Graphic called *The sisters*, for example, Pinwell draws two women in black in a dark room, the simplest possible composition, in which he has put a serious sentiment that I can only compare to the full song of the nightingale on a spring night' [fig. 32].[3] On the other hand, he compared the idle chatter in galleries, on a subject such as artistic talent, to the 'hideous croaking of ravens'.[4]

Van Gogh's drawings and paintings also display a wide variety of birds: crows, swifts, kingfishers and larks, as well as sparrows, starlings, hens and cockerels [figs. 33–35]. In 1885, when he was taking piano lessons, he also became fascinated with birds' nests. Enlisting the help of boys from the village, he paid them to climb trees and fetch nests (5 cents for an ordinary nest, but 10 cents for a blackbird's nest and as much as 50 cents for a swallow's nest). In the studio, he arranged them into still lifes. Vincent wrote to Theo about 'a long trip I made in the company of a peasant boy—in order to

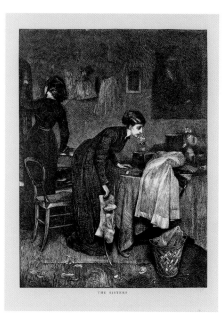

32 George Dalziel after George John Pinwell, *The Sisters*, reproduced in *The Graphic* 3 (6 May 1871). Wood engraving, 30 × 22.5 cm. Van Gogh Museum, Amsterdam (Vincent van Gogh Foundation).

get hold of a wren's nest. We found 6 And they were all nests from which the young had already flown, so that one could take them without too many pangs of conscience. It was so real; I also have some other splendid nests.'[5] In the same period he painted peasant cottages with mossy roofs, which he called 'little human nests',[6] because they resembled wrens' nests. Van Gogh's obsession with this motif is understandable: it can be explained by his constant longing for inner peace. Like the cradle, the nest symbolized peace and quiet, the harmony of a real home—things Van Gogh had been seeking in vain for years. He used the metaphor of a bird in captivity to describe the tragedy of unrequited longing for freedom and security: 'In the springtime a bird in a cage knows very well that there's something he'd be good for; he feels very clearly that there's something to be done but he can't do it; what it is he can't clearly remember, and he has vague ideas and says to himself, "the others are building their nests and making their little ones and raising the brood", and he bangs his head against the bars of his cage. And then the cage stays there and the bird is mad with suffering.'[7] Only 'deep, serious attachment' could ease that pain, he concluded hopefully.[8] Vincent sent these reflections to Theo at the end of June 1880. This letter, the first one written in French, is of vital importance in Van Gogh's correspondence, because it testifies to his firm resolve to break out of his cage and become an artist at last.[9]

33 Vincent van Gogh, *Four Swifts and Landscape Sketches* (F 1244r / JH 1289), 1887. Pencil, pen and ink, and chalk on paper, 26.9 × 35.2 cm. Van Gogh Museum, Amsterdam (Vincent van Gogh Foundation).

34 Vincent van Gogh, *Hen* (F 1731 / JH 2068), 1890. Drawing in a sketchbook, Auvers-sur-Oise, 1890. Pencil on paper, 13.4 × 8.5 cm. Van Gogh Museum, Amsterdam (Vincent van Gogh Foundation).

35 Vincent van Gogh, *Poultry* (F 1654v / JH 2070). Drawing in a sketchbook, Auvers-sur-Oise, 1890. Pencil on paper, 13.4 × 8.5 cm. Van Gogh Museum, Amsterdam (Vincent van Gogh Foundation).

HIS FATHER'S LOVE OF BIRDS

Van Gogh had inherited his penchant for the outdoor life from his parents, both of whom were great nature lovers. In educating their children, the Reverend and Mrs van Gogh stressed the contrast between the countryside (as a place of tranquillity and simplicity) and the city (with its ever-present threat of danger and turmoil). Vincent summed up the family's standpoint for Theo in October 1883: 'Our goal is "walking with God"—as against living amid the affairs of the big cities.'[10] Previously, while living in Amsterdam, he had also referred to this difference between rural and urban life when writing to Theo about the advent of spring: 'In the country one would probably have been able to hear a lark, but that's difficult in the city, unless one notices the sounds of the lark's song in the voice of some old minister whose words come from a heart tuned like a lark's.'[11]

Van Gogh's parents taught him that peasants were civilized people— simple, innocent, pure in heart—who had not yet been contaminated by the hypocrisy and artificiality of city-dwellers. It was an old truism that Vincent would later encounter in many French naturalistic novels: the pure, idyllic countryside (though life there could also be difficult) versus the bustling, decadent city. 'There is much in such a city that is fishy', in the Reverend Van Gogh's opinion, and even though there was plenty of friction between father and son, Vincent agreed with his father on this point.[12] He remained an outdoorsman throughout his life. 'I have an everlasting nostalgia for heath and pine-woods', he wrote to Theo in 1882 from The Hague, where he was working in the art trade: 'A woman gathering wood, a peasant fetching sand—in short, that simplicity that has something grand like the sea.'[13]

Vincent also owed his intense interest in birds to his father, whose own ornithological pursuits were further stimulated by his daily study of the Bible, with its countless references to birds. Vincent himself provided a nice example of such biblical stimuli in a letter he wrote to Theo after hearing Eliza Laurillard deliver a sermon in Amsterdam's Zuiderkerk:

> I then heard the Rev. Laurillard again in the early sermon on Jer. VIII:7, Yea, the stork in the heaven knoweth her appointed times; and the turtle and the crane and the swallow observe the time of their coming. He told about how he had walked on a road where the leaves were already falling from the trees, and had seen a flock of migratory

birds and spoke about the phenomenon of birds migrating, and how man will also migrate once to a warmer land. He treated this subject in the spirit of Michelet or Rückert, or as many have also painted it.[14]

It was only natural to link birds and religion, for this connection is inherent in the Dutch language. The black vulture, for example, is called a *monniks-gier* (monk's vulture) in Dutch, while the whinchat is referred to as a *paapje* (little papist) and the swallow is called a *nonnetje* (little nun) or *masoeurtje* (little sister or nun, after the French). Blackbirds, moreover, are said to 'psalmodize'. Birdsong sounded like hymns, and birds flying high in the sky seemed to be messengers gliding between heaven and earth. The Reverend Van Gogh continued for years to notify his sons of the arrival of the first birds in spring. 'Pa wrote that he had already seen starlings', Vincent reported to Theo on 7 February 1877; 'do you remember how they used to sit on the church at Zundert? I haven't seen any here—though there are a lot of crows on the Grote Kerk in the mornings. Now it's almost spring again and the larks will return again.'[15] More than a year later, 'Pa' wrote to Theo about the early birds of spring: 'The shrubs in the garden are all coming into bud and meanwhile the starlings have been singing in such a friendly way that one is almost tempted to whistle along with them'.[16]

All three of them read *L'Oiseau* (published in English as *The Bird*), Jules Michelet's famous book of 1856. Vincent copied passages from it in an album he made for Theo, including the poem in which the first-person narrator wistfully recalls the song of a swallow. Theo sent Jo a copy of *L'Oiseau*, one of his favourite books, shortly before their marriage, when he was feeling happy and as free as a bird. 'I am a fortunate person & sometimes catch myself whistling or humming a tune. It's your fault', he confessed to her in the accompanying letter.[17] Theo had been familiar with Michelet's book for a number of years already. In the summer of 1875, his father had written to him, 'While drinking tea this afternoon I read some of "the bird, nature studies by Michelet". What he writes is remarkable, and much of what he says I've observed myself, while quietly watching those creatures many times in Zundert and here.'[18] Vincent first referred to *L'Oiseau* in May 1877. Of all the children, he was the one who most inherited his father's passion for ornithology. According to his sister Lies, Vincent had been a nature lover from a very young age and had always spent a great deal of time outdoors. She recalled, rather sentimentally: 'He knew where the birds nested, high or low,

and he had seen a couple of larks flying up from the wheatfield; he reached the nest, without snapping the stalks of wheat that surrounded it. Nature spoke to him in a thousand voices, and he listened to it with trembling.'[19]

BIRDSONG

Michelet's book contained a chapter titled 'The Nest', preceded by a chapter on 'The Song', devoted entirely to the chirping, warbling, singing, peeping, humming, gnashing and cooing of birds, because wherever one goes (according to Michelet), in woods or meadows, high mountains or deep valleys, the northern or southern hemisphere—everywhere in the world one can hear joyful and comforting birdsong:

> Thus, then, everywhere, above the vast instrumental concert of nature, above her deep sighs, above the sonorous waves which escape from the divine organ, a vocal music springs and detaches itself— that of the bird, almost always in vivid notes, which strike sharply on this solemn base with the ardent strokes of a bow. . . . The beautiful, the sublime phenomenon of this higher aspect of the world occurs at the moment that Nature commences her voiceless concert of leaves and blossoms, her melodies of March and April, her symphony of May, and we all vibrate to the glorious harmony; men and birds take up the strain.[20]

The nature around us as one magnificent musical manifestation: that was the message that reached Van Gogh from a very young age, in every way, shape and form. As early as August 1873, he enclosed two verses of Keats's poem 'Autumn' in a letter. The second stanza, in particular, is bursting with the sound and song of nature. Music is obviously not the prerogative of spring, but just as much a part of autumn.

> Where are the songs of spring? Ay, where are they?
> Think not of them, thou hast thy music too,
> While barred clouds bloom the soft-dying day,
> And touch the stubble-plains with rosy hue;
> Then in a wailful choir the small gnats mourn
> Among the river sallows, borne aloft.

Or sinking as the light wind lives or dies;
And full-grown lambs loud bleat from hilly bourn;
Hedge-crickets sing; and now with treble soft
The redbreast whistles from a garden croft,
And gathering swallows twitter in the skies.[21]

Of course Van Gogh did not always experience nature as a clamorous con-
cert, but there were sounds galore for those who roamed with open ears
and a desire to immerse themselves in nature, even when the birds were
not singing. 'The heath speaks to you', he wrote to Theo, 'you listen to that
still voice of nature'.[22] He also noticed this in certain artworks, such as Jules
Dupré's *Autumn* and Jacob van Ruisdael's *The Bush*: 'It's that dramatic quality
that causes one to find a *je ne sais quoi* in it that makes one feel what you say,
"It expresses that moment and that place in nature where one can go alone,
without company." '[23]

The Van Gogh family correspondence invariably reports the prevailing
weather conditions and often includes the sound of birdsong. The Reverend
Van Gogh wrote to Theo: 'What wonderful weather we've been having. Anna
and Wil [i.e. Willemien] wrote the same thing. Last Sunday they took a lovely
stroll through the heath and heard the lark. Here we aren't so far yet, but even
so, the first month of the year has almost gone by.'[24] From Amsterdam, where
he had a view of the naval dockyard, Vincent wrote to Theo, 'The weather
has cleared up again, and the sky is blue and the sun is shining brightly and
the birds are singing, there are rather a lot of them at the yard'.[25] Willemien
informed Theo and Jo, 'We're having wonderful spring weather here, it's full
of nightingales, up close to the house.'[26] In 1879 Lies was living in Dordrecht,
where she kept a bird in her room: 'Petey', a yellow canary who sang until
her ears were ringing.[27] Years later, this bird even accompanied her on a trip
to France, where he sometimes had to be rescued: 'I take him everywhere in
a wicker basket, in which the little travel cage fits perfectly, and even when
the basket is completely closed, he sometimes surprises our fellow travellers
by breaking into song, loudly and wholeheartedly. Only once did he almost
hang himself, when, befuddled by the fresh sea air, he stuck his little head
between the upper bars. I then had to push his head back down with a pencil,
but luckily his bright mind wasn't damaged by it.'[28]

Theo sent Vincent a special issue of the magazine *L'Illustration*, about the
Paris Salon of 1885: its cover featured an engraving after Jules Breton's paint-
ing *The Song of the Lark*, which struck Vincent as very beautiful [fig. 36].[29] Six

36 Jules Adolphe Aimé Louis Breton, *The Song of the Lark*, reproduced in *L'Illustration* 85 (25 April 1885). Wood engraving, 26.5 × 21 cm. Van Gogh Museum Library, Amsterdam.

months later, Theo described the fuss and bother of Christmastime in Paris in a letter to Lies. The shops were overcrowded, and in the street there were too many stalls, 'from which passers-by are assailed by the most unpleasant noises', the worst of which came from the blasted bird seller. This street vendor could be found daily in front of their door, where he blew on an 'elastic bladder, making a noise like out-of-tune bagpipes from morning till night. For a number of years now, he's been coming at this time of year to regale us with that same sound, and every year he looks fatter and healthier, surely proof that he does not in the least view the torture of his fellow human beings as a sin.'[30]

Birds and their warblings continued until the end to play an important role in Vincent's life. When Theo took Jo and little Vincent to visit his brother in Auvers-sur-Oise in June 1890, Vincent met them at the railway station and brought along a little bird's nest as a present for his nephew. Jo later wrote about this visit: 'He was keen on carrying the child himself and insisted on showing him all the animals in the courtyard, until a cock crowed so loudly that the child turned bright red with fear and started to scream, while

Vincent called out, laughing, "and the cock says cock-a-doodle-do" and was very proud to have acquainted his godson with the animal world.'[31]

Ordinary, everyday birdsong had far-reaching significance for Van Gogh, for unlike the average bird lover, he connected these creatures with his ideas about artistry. The bird as artist: it was a comparison Van Gogh often made, and one he had presumably borrowed from Michelet's *L'Oiseau*.[32] The artist as bird: what the two had in common was the fire, the 'enthusiasm', the inner obsession—for Van Gogh the essence of true art—which should never, under any circumstances, be stifled. This conviction explains the indignant tone of a letter to his fellow painter Anthon van Rappard, written as a sequel to a dispute they had had on this subject: 'Then the birds simply shouldn't sing and the painters not paint if they were supposed to think about whether they weren't too passionate.' Van Gogh claimed, moreover, that certain artists failed to hold his attention because they were 'rather like birds with only one note in their song, whereas I feel more sympathy for larks or nightingales that have more to say with less noise and more passion'.[33] He quoted with approval Jules Breton's poem 'Dawn': 'And now behold, bursting upon the silver sky / The joyful lark, that sees, emerging / From the misty east, the first pink fleck.'[34]

LARK AND NIGHTINGALE

The lark and the nightingale were indeed Van Gogh's favourite birds: to his mind, they represented pure artistic passion and inspiration. He would have been able to read extensively in Michelet about these two extremes of the feathered spectrum: the lark as the embodiment of dawn, light and lyricism, and the nightingale as the symbol of darkness, drama, the epic and the inner struggle. In the two concluding chapters of *The Bird* ('The Nightingale—Art and the Infinite'), Michelet explains why this bird deserves to be called an artist. Capable of looking into its own soul, the nightingale has 'the artist's temperament, and exalted to a degree which man himself rarely attains'.[35]

> Artist! I have said the word, and I will not unsay it. This is not an analogy, a comparison of things having a resemblance: no, it is the thing itself. The nightingale, in my opinion, is not the chief, but the only one, of the winged people to which this name can be justly given. And why? He alone is a creator; he alone varies, enriches, amplifies

his song, and augments it by new strains. He alone is fertile and diverse in himself; other birds are so by instruction and imitation. He alone resumes, contains almost all; each of them, of the most brilliant, suggests a couplet to the nightingale.[36]

This explains why Van Gogh referred to the singing of the nightingale in 1888, when he expressed the desire to paint the portrait of 'the artist', of 'the poet'—as a phenomenon, an image, a prototype—a painting for which he was thinking of using Gauguin as his model, but eventually chose Eugène Boch [fig. 37]:

I'd like to do the portrait of an artist friend who dreams great dreams, who works as the nightingale sings, because that's his nature. This man will be blond. I'd like to put in the painting my appreciation, my love that I have for him. I'll paint him, then, just as he is, as faithfully as I can—to begin with. But the painting isn't finished like that. To finish it, I'm now going to be an arbitrary colourist. I exaggerate the blond of the hair, I come to orange tones, chromes, pale lemon. Behind the head—instead of painting the dull wall of the mean room, I paint the infinite.[37]

Gauguin, in turn, called Van Gogh's *Sunflowers* a 'song of the nightingale'— though this was not intended wholly as a compliment. In Gauguin's view, Van Gogh's manner of working was much too chaotic, nonchalant and unstructured, and this resulted in sloppy outpourings rather than carefully conceived works of art.[38]

Then there was that other bird, the lark. Unlike the melancholy nightingale, the lark is the eternal optimist. Michelet was lyrical about this bird: 'The bird of the fields before all others, the labourer's bird, is the lark, his constant companion, which he encounters everywhere in his painful furrow, ready to encourage, to sustain him, to sing to him of hope.'

She is the daughter of day. As soon as it dawns, when the horizon reddens and the sun breaks forth, she springs from her furrow like an arrow, and bears to heaven's gate her hymn of joy. . . . The lark sings for a whole hour without half a second's pause, rising vertically in the air to the height of a thousand yards, and stretching from side to side

37 Vincent van Gogh, *Eugène Boch* (F 462 / JH 1574), 1888. Oil on canvas, 60 × 45 cm. Musée d'Orsay, Paris.

38 Vincent van Gogh, *Wheatfield with Partridge* (F 310 / JH 1274), 1887. Oil on canvas, 53.7 × 65.2 cm. Van Gogh Museum, Amsterdam (Vincent van Gogh Foundation).

in the realm of clouds to gain a yet loftier elevation, without losing one of its notes in this immense flight. What nightingale could do as much?[39]

The lark swoops into Van Gogh's writings time and again. It is therefore no wonder, considering the romantic symbolism attached to it, that the bird above Van Gogh's *Wheatfield with Partridge* was long thought to be a lark [fig. 38].[40] The Van Gogh connoisseur H. P. Bremmer saw the painting simply 'as a song, which a bird warbled in full beauty out of sheer necessity'.[41] Evidently the significance—sometimes even the species—of the bird lies in the eye of the beholder.

Like his father, Vincent recorded his first sighting—or rather hearing—of the lark every year: 'Spring is beginning, for one hears larks here, and in the woods the branches and buds are beginning to sprout' and 'Now and then everything outside looks spring-like, and it won't be long before the lark sings in the meadow again.'[42] He also referred to the song of the lark in a more figurative sense: 'A lark can't help singing in the spring' and 'The lark can't be silent as long as it can sing.'[43] This was a way of saying that he was literally bursting with creative energy, as he made clear to Willemien: 'Anyway, it's not a bad idea for you to want to become an artist, because if one has fire in one, and soul, one can't keep stifling them and—one would rather burn than suffocate. What's inside must get out. Me, for instance, it gives me air when I make a painting, and without that I'd be unhappier than I am.'[44]

His description of the contrast between 'the lark ascending in the spring sky' and 'the young girl of barely 20, who could have been healthy and has contracted consumption—and perhaps will drown herself before she dies

of a disease' could not be more poignant.[45] Van Gogh was constantly aware of the two sides of life, which can vary in the extreme. That he mentions the lark much more often than the nightingale is because the jubilant lark represented for him precisely what was so sorely lacking in his own nature. He tried to explain this to Theo: 'I now want to say that IF you were to become a painter, you would have to do it with something of that same *surprising* cheerfulness. You need it as a counterweight against the melancholy aspect of the situation. You do more with that than with anything else. You must have a certain genius, I don't know another word for it, which is the exact opposite of what people call "ponderous".'[46]

He welcomed the arrival of the lark, therefore, precisely because it brought the good spirits that were indispensable to art. The bird embodies youth, joy, open-mindedness, joie de vivre, passion, enthusiasm, fire and action. On a sheet of paper he copied out Ludwig Uhland's poem 'The Larks', in which all his ideals are expressed in a nutshell:

> Welcome sight of larks ascending,
> Skyward paths forever wending,
> Some alight beside the stream,
> Others frolic in the tree.
> To sing God's praise is the delight
> Of one who from my heart takes flight![47]

Vincent expressed these thoughts in a letter to Theo: 'Let those who wish be despondent. I've had enough of it and don't want to be other than happy as a lark in spring!'[48] Before this, the death of a family friend had suddenly made him realize that 'we are so attached to that old life because there is cheerfulness to counter despondency, and our heart and our soul are gladdened, just as the lark who cannot help singing in the morning'.[49]

The Reverend Theodorus van Gogh died on 26 March 1885 and was buried on 30 March, the day Vincent turned thirty-two. When the sons paid their last respects to their father, there was no deathly silence in the churchyard. Instead, they heard the blissful singing of the lark—as emerges from a note that Theo sent to his mother more than two months later: 'I thought of the lark that Vincent drew my attention to, the one that was singing when we were in the churchyard'.[50] It was as though their father had wanted to share his lifelong passion for birds with them one last time.

6

THE REALM OF THE SENSES

Scherzo stringendo

It all began long before Van Gogh set out to become a painter. He often went out for a stroll late in the evening, towards nightfall, or got up around four o'clock in the morning, when it was still dark, to see the break of day. Without knowing it, he had been following the advice given three centuries earlier by the Dutch artist Karel van Mander in his *Schilder-boeck* (Book of painting) of 1604, in which he recommended that young painters 'get up early in the summer . . . and go and hear the birds singing'.[1] Van Gogh wanted to live life to the full, to get the most out of every minute of the day. Above all, he wished to be immersed in nature, to be completely subsumed by it; he wanted to experience the world as intensely as possible, to lie under the open sky with the utmost concentration and listen for the first singing of the birds.[2] In imitation of the writers and artists he admired, Van Gogh sought to experience God's Creation at the most profound level. It was these recurring feelings of ecstasy and epiphany that he related in detail in his letters to Theo and on which he would fall back in the later years of his painting career:

> When it was only just starting to get a little lighter and the cocks were crowing everywhere by the huts scattered over the heath, the few cottages we passed—surrounded by slender poplars whose yellow leaves one could hear falling—an old squat tower in a little church-yard with earth bank and beech hedge, the flat landscapes of heath or wheatfields, everything, everything became just exactly like the most

beautiful Corots. A silence, a mystery, a peace as only he has painted.
. . . When one travels for hours and hours through the region, one
feels as if there's actually nothing but that infinite earth, that mould
of wheat or heather, that infinite sky. Horses, people seem as small
as fleas then. One feels nothing any more, however big it may be in
itself, one only knows that there is land and sky.[3]

This passage epitomizes Van Gogh's intense perception of reality. The expe-
rience went much further than the mere act of seeing; add hearing to the
equation (cocks crowing, leaves falling, even the sound of silence), and
reality instantly transforms itself, paradoxically, into a silent masterpiece
by Jean-Baptiste Corot. In that multitude of impressions, any sense of one's
own presence is lost. Van Gogh's letters, like his art, testify time and again
to his sensitivity to sensory impressions. In 1882 he referred to this very
quality as an artistic ideal: 'I want to reach the point where people say of my
work, that man feels deeply and that man feels subtly. Despite my so-called
coarseness—you understand—perhaps precisely because of it.'[4]

Later reactions to Van Gogh's work bear witness to his success in achiev-
ing that ideal. Jan Veth, a Dutch painter and art critic, wrote in 1893, 'If one
wished to sum him up concisely, one would have to say, more or less, that he
was a painter who synthetized impressions of reality as real-life revelations
of fierce pathos.'[5] Another critic, Frans Lapidoth, recognized as early as 1892
that this was at once Van Gogh's great strength and fatal flaw. At the Paris
Salon of that year, he stood 'before those crass, almost senseless pieces of
art' and felt 'so down-to-earth, such an insignificant little man, with such a
tiny, timid personality'. It suddenly became easy for him to understand 'how
that brilliant seeker succumbed to his art. Just as another person dies of an
excess of fullbloodedness, he died of artistic hyper-impressionability.'[6]

When the sculptor Ossip Zadkine made his statue of Van Gogh in 1956, it
was precisely the artist's 'impressionable' side that he chose to emphasize.
He spoke of 'bitter solitude, his old companion in life',[7] which 'distanced him
from the sea of wheat that nevertheless whispered in his ear. Then the crows'
cawing must have aroused him from his self-absorption, making him raise
his head, look up at the black birds, and listen to their inhuman screeching'.[8]
Zadkine saw Van Gogh as someone who no longer had a life of his own: 'he
had become a precision instrument conceived to capture the pulsation, the
structural essence of the landscape in all its unrecorded brutality'.[9]

THE INNER STORM

Van Gogh's sense of hearing was constantly under assault, not only by music and the singing and chirping of birds but also by countless other noises around him. By no means did he experience the world in an exclusively visual way. 'Let us continue in life as long as our legs will carry us, even though our feet grow tired, and the oppression great, and even if our ears buzz with the sound of the world that they have been hearing for so many years', he sermonized to Theo in 1876.[10] To his mind, or rather ears, that sound eventually became the 'murmur' of the olive trees in Provence: 'It's like the lopped willows of our Dutch meadows or the oak bushes of our dunes, that's to say the murmur of an olive grove has something very intimate, immensely old about it.'[11] Another sound in his Provençal world was the deafening din of the cicadas, which, he told Theo, could 'sing at least as loudly as a frog' [figs. 39–40].[12] Later still, he wrote from the asylum in Saint-Rémy, 'Outside the cicadas are singing fit to burst, a strident cry ten times louder than that of the crickets, and the scorched grass is taking on beautiful tones of old gold. And the beautiful towns of the south are in the state of our dead towns along the Zuiderzee, which were formerly lively. While in the downfall and the decline of things, the cicadas dear to good old Socrates have remained. And here, certainly, they're still singing old Greek.'[13]

Years before, when Van Gogh was living near the dockyard in Amsterdam, there had been the sound of thunderstorms and rain pelting down on the woodpiles and ship decks. Every morning he heard the workers arriving at the dockyard, some three thousand of them: 'The sound of their footsteps is something like the sound of the sea'.[14] Later, in The Hague, he worked in the middle of 'the din of the Geest district or the potato market' and sometimes longed for the silence that is also a characteristic of the sea: 'I feel a need for that silence—where there's nothing but the grey sea—with an occasional seabird. But otherwise, no other voice than the murmur of the waves.'[15]

He was particularly sensitive to voices, not only those he heard later in Arles—the singing of the women who performed a Provençal pastorale at the theatre, or the sound of the postman Joseph Roulin, singing 'La Marseillaise'—but also the voices of earlier days, such as the 'raising and lowering' of the voices of Dutch preachers like J. J. L. ten Kate, one of whose sermons Van Gogh heard at the Eilandskerk in Amsterdam: 'His voice sometimes uttered sounds and expressions like Pa's, and he spoke very well and

39 Vincent van Gogh, *Cicada*. Sketch in letter from Vincent to Theo, Arles, 9 or 10 July 1888, letter 638 in Van Gogh, *Letters*. Pen and black ink, 5.5 × 5 cm. Van Gogh Museum, Amsterdam (Vincent van Gogh Foundation).

from an overfull heart and, although the sermon wasn't short, church was out almost before one knew it, because his words were so enthralling that one forgot the time.'[16] He was also deeply impressed by Jeremias Posthumus Meijjes, whom he heard in the Noorderkerk: 'The Rev. Meijjes preaches very well, it's also a treat to see his sons sitting with him in church. He has a very beautiful voice, though it's almost too powerful, it sounds good, however, in a very large church, and his appearance is very striking, already wrote to you about how it moved me to see him come down from the pulpit once.'[17]

40 Vincent van Gogh, *Three Cicadas* (F 1445 / JH 1765). Sketch enclosed in letter from Vincent to Theo, Saint-Rémy-de-Provence, 14 or 15 July 1889, letter 790 in Van Gogh, *Letters*. Pen and black ink, 20.1 × 17.8 cm. Van Gogh Museum, Amsterdam (Vincent van Gogh Foundation).

When the Englishman Harry Gladwell paid him a visit in Amsterdam, the first thing Van Gogh noticed was the familiar sound of his friend's voice: 'It felt wonderful to hear Gladwell's voice in the hall as I sat upstairs studying'.[18] The voices went even further than this, for Vincent often heard Theo speaking through his letters: 'Such a familiar voice, or rather familiar handwriting, makes one feel firm ground beneath one's feet again'.[19] He was sensitive to the 'tone' of his brother's writing and noticed immediately when it changed: 'It's as though there's a hair in your throat, in your voice. What

kind of hair is it? Couldn't you tell me about it sometime, now that I've told you so much?'[20] While reading, Van Gogh could also hear the writer's voice: 'Have you read Sapho by Daudet?', he asked Theo. 'It's very beautiful, and so vigorous, and so close to life that the female figure lives, breathes, and one can *hear*, literally *hear* the voice, and forgets that one is *reading*.'[21] He experienced this most acutely when reading the work of Ernest Renan: 'What a fine work his is, to speak to us in a French like no other person speaks. A French in which, *in the sound of the words*, there's the blue sky and the gentle rustling of the olive trees'.[22]

Yet there were unpleasant voices too: the critical remarks made by sceptical 'moaners'—as he expressed it in a letter to Van Rappard—voices that were difficult to ignore:

> It's devilishly difficult to feel nothing, not to be affected by what such moaners as 'does he paint for money' say. One hears that rot day in and day out, and later one gets angry with oneself for having taken any notice of it. That's how it is with me—and I think that it must occasionally be the same with you. One doesn't give a damn about it, but all the same it gets on one's nerves—like when one hears someone singing off-key or *is pursued by a barrel-organ with a grudge against you*. Don't you think that's true about the barrel-organ, and also that it seems to pick on you specifically? For wherever one goes, it's the same old tune everywhere.[23]

Moreover, there was always that critical voice from within, which had to be silenced. He told Theo how to combat it: 'If something in you yourself says "you aren't a painter"—IT'S THEN THAT YOU SHOULD PAINT, old chap, and that voice will be silenced too, but precisely because of that.'[24] Here, however, Vincent was speaking, above all, to himself. Theo had good reason to call him 'his own enemy, because he makes life difficult not only for others but also for himself'.[25]

The louder the voices, the harder Van Gogh worked. The noise in his head could be extraordinary, certainly towards the end of his life, when he began to experience both the outer and inner world as a storm that never abated. In the beginning, this might have worked to his advantage: after all, even the great Delacroix had always had 'a sun in his head and a thunderstorm in his heart', as Van Gogh wrote to Van Rappard in 1885.[26] Later on, however, he was forced to take increasingly serious measures to fight it: 'If the storm

within roars too loudly, I drink a glass too many to stun myself', he wrote in July 1888, six months before the first attack of his illness.[27] Those attacks ran their course in an equally tumultuous way in the following years.[28] He heard strange noises and voices, and became loud and agitated himself. Van Gogh recognized the same symptoms in another patient: 'There's one person here who has been shouting and *always* talking, like me, for a fortnight, he thinks he hears voices and words in the echo of the corridors, probably because the auditory nerve is sick and too sensitive, and with me it was both the sight and the hearing at the same time'.[29] Approvingly, he quoted a passage from Carmen Sylva's *Les pensées d'une reine* (A queen's thoughts) of 1888: 'When you suffer a lot—you see everybody at a great distance, and as if at the far end of an immense arena—the very voices seem to come from a long way off'.[30]

THE ARTIST'S VOICE

Van Gogh was also sensitive to 'voices' in the figurative sense, and it was the voice of the artist in particular—what he or she was trying to say—that he cared about the most. This explains why he called Pierre Puvis de Chavannes a 'seer', and Millet 'the voice of the wheat': he admired these painters because they succeeded in expressing the symbolic language of nature in their work.[31] The specific form taken by artistic expression—whether painting, music or literature—was not so important. Van Gogh was basically open to all the arts, and his sensory 'impressionability' therefore applied to his experience of all art forms. He was so impressed by the work of Shakespeare, for example, that he needed time to recover after reading it, as he told Willemien: 'Have you ever read King Lear? But anyway, I think I shan't urge you too much to read such dramatic books when I myself, returning from this reading, am always obliged to go and gaze at a blade of grass, a pine-tree branch, an ear of wheat, to calm myself.'[32]

Shortly after Van Gogh's death, the Dutch writer Frederik van Eeden published an enthusiastic article about his work in *De nieuwe gids* (The new guide), a literary periodical. Van Gogh would certainly have shared his sentiments: 'I'm simply not so attached to the art as I am to the artist—and sometimes I don't even pay very close attention to whether someone makes use of paint or words or musical notation.'[33]

Van Gogh's embrace of all artistic disciplines did not mean, of course, that he viewed them indiscriminately. His letters include various passages

in which he philosophizes about the value of the individual arts, as well as their similarities and differences. The similarities, in his view, derived from the artists' attitude to life and their social position. 'It's certainly a strange phenomenon that all artists, poets, musicians, painters are unfortunate in the material sense', he wrote,[34] and he also observed that 'if one analyzes from close up, one sees that the greatest and most energetic people of the century have always worked *against the grain*, and with them working was always through personal initiative. Both in painting and in literature (I don't know about music, but I imagine that it will have been the same thing there).'[35] The overarching similarity, in his view, was, quite simply, a precondition of the creative spirit: 'the passion as well as the frequent absorption that everyone who paints, writes or composes must have by the very nature of the thing'.[36]

The great differences, on the other hand, were intrinsic to the arts themselves. The dispute as to the position of the various disciplines within the artistic hierarchy had been raging since antiquity, beginning with Aristotle's *Poetics*. The debate continued in the Renaissance with Leonardo da Vinci's famous *Paragone* (literally 'comparison')—included in a mid-sixteenth-century compilation of his writings and first published in Italian in the mid-seventeenth century as *Trattato della pittura* (*A Treatise on Painting*)—and later in Gotthold Ephraim Lessing's *Laokoon; oder, Über die Grenzen der Malerei und Poesie* (*Laocoön: An Essay on the Limits of Painting and Poetry*) of 1756. Delacroix, too, whom Van Gogh and other modernists admired, often compared the arts in his theoretical writings. He considered painting superior to the other artistic disciplines, for one thing because it could be taken in at a glance, unlike a musical composition or a literary text, which took time to unfold (a notion later adopted by Gauguin). According to Delacroix, painting was closer to music than to literature, because it did not rely on the mediation of words and could therefore penetrate more directly and deeply into the viewer's soul.[37]

Such a systematically developed theory is not to be found in Van Gogh's correspondence, nor does he argue his point on the basis of standard concepts like temporality and spatial coherence. Yet even though he makes distinctions solely on the basis of personal experience, in the end he draws the same conclusions: 'It always seems to me that poetry is more *terrible* than painting, although painting is dirtier and more damned annoying, in fact. And after all, the painter says nothing; he keeps quiet, and I like that even better.'[38] Compared with the inherently 'silent art' of painting, however,

music turned out to be, paradoxically enough, even more silent: the art form that most stubbornly resisted having its abstract mysteries explained in words. It was the indescribability of music that continued to fascinate Van Gogh: 'Anyway, law and justice apart, a pretty woman is a living marvel, while a painting by Da Vinci or Correggio only exists on other accounts. Why am I so little an artist that I always regret that the statue, the painting, aren't alive? Why do I understand the musician better, why do I see more clearly the *raison d'être* of his abstractions?'[39]

One art form could take on the characteristics of another, or could be described in terms of other artistic disciplines. In June 1880 Vincent wrote to Theo, 'There's something of Rembrandt in Shakespeare and something of Correggio or Sarto in Michelet, and something of Delacroix in V. Hugo, and in Beecher Stowe there's something of Ary Scheffer. And in Bunyan there's something of M. Maris or of Millet, a reality more real than reality.'[40] In this way a writer could, in Van Gogh's view, easily be a brilliant painter: he describes several passages in a novel by Zola as 'painted or drawn in a masterly, masterly fashion', 'exactly like a drawing by Millet',[41] and praises a poem by François Coppée in which the poet 'draws a little marquise who dances a minuet, as elegant as a little figure by Watteau'.[42] Van Gogh admires a sermon given by the Reverend Laurillard 'because he paints, as it were, and his work is at once lofty and noble art'.[43] It was precisely such 'drawing in words', such evocative writing, that was the outstanding characteristic of the realistic and naturalistic literature of the nineteenth century, which Van Gogh so avidly read. He pursued this ideal in his own writing, and recognized a similar inclination in Theo's letters: 'Only, again, there is "drawing" in your short description—for me palpable and comprehensible, even though you haven't yet pursued your impression to the point where it would acquire a more robust body and stand on its feet visibly or palpably for everyone.'[44] He links this special talent of his brother's to his criterion of true art: in addition to 'the intelligence of creating', which Theo possessed 'in damned good measure', there must be that certain something, that 'je ne sais quoi'. That is the voice of the artist, his individuality, his indescribable strength. Remarkably, Van Gogh's attempt to express this is filled with sensations: 'There's a certain *je ne sais quoi* in your description, a scent—a memory—of a watercolour by Bonington, for example, only it's still faint as if in a mist. Do you know that drawing in *words* is also an art, and sometimes betrays a hidden force latent inside, just as the blue or grey cloud of smoke betrays the hearth?'[45]

Conversely, a painter could succeed in conjuring up good writing: a painting by Thijs Maris reminded Van Gogh of a poem by Heinrich Heine, for example, and a drawing by Van Rappard was equally literary: 'It's as if one were reading a description of a factory by Zola or Daudet or Lemonnier'.[46] Van Gogh also referred in this respect to a painting of his own, *La Berceuse*, which he compared to Frederik van Eeden's novel *De kleine Johannes* (*Little Johannes*) of 1887: 'I believe I've run fairly parallel to Van Eeden in this, and consequently don't regard his style of writing as unparallel to my style of painting in the matter of colour.'[47] Finally, a painter could also be a musician, a quality Van Gogh admired in his fellow painter John Russell: 'You are at the same time able to give a Scherzo, the adagio con espressione, the gay note in one word'.[48] To Van Gogh's mind, paintings possessed voices, words evoked colours, and colours conjured sounds. Art, for him, thus became an all-embracing, virtually synaesthetic experience.

PAINTING FOR THE EAR

While writers felt a literary need to write for the eye, visual artists were increasingly expected to paint for the ear. It was only natural that the art critic Albert Plasschaert heard, to his great delight, music resounding in the painted seas and skies of Jacob Maris, whose work was praised by another critic as 'contrapuntal organ music in colours'.[49] Vincent hoped that his art would have a similar effect on the viewer. Indeed, he strove in his painting to stimulate more than just the sense of sight. A peasant painting, for example, was not supposed to be 'perfumed'; instead, it should smell of 'bacon, smoke, potato steam',[50] and the viewer should be able to feel the weight of the potatoes while gazing at their painted counterparts: 'You'll get a large still life of potatoes—where I've tried to get *body* into it—I mean express the material. Such that they become lumps that have weight and are solid, which you'd feel if they were thrown at you, for instance.'[51] He also hoped that seamen would really 'feel the lullaby in it' when gazing at his *Berceuse*, which he thought should be hung in a fishing boat.[52] This is a plainly magical notion of painting, arousing in the viewer a sense of rocking, which in turn evokes a mother's comforting singing. It was but one of the ways that Van Gogh attempted to capture sound in paint. Having drawn the loom of a weaver in Nuenen, he added a small black figure as a finishing touch, to evoke the clattering sound of the contraption:

THE REALM OF THE SENSES

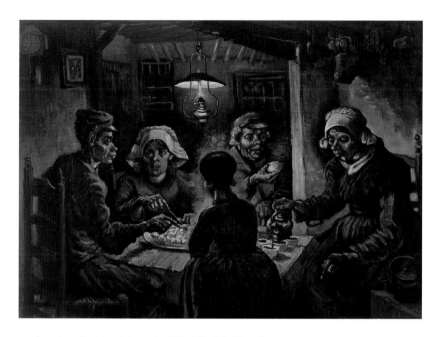

41 Vincent van Gogh, *The Potato Eaters* (F 82 / JH 764), 1885. Oil on canvas, 82 × 114 cm. Van Gogh Museum, Amsterdam (Vincent van Gogh Foundation).

I drew the figure in after all—but I don't want to say anything with it except: 'when that black monster of begrimed oak with all its slats somehow shows up like this against the greyness in which it stands, then *there*, in the centre of it, sits a black ape or goblin or apparition, and clatters with those slats from early till late'. And indicated the spot by setting down a sort of a shape of a weaver with a few scratches and blotches at the place where I saw him. Consequently, I didn't give the slightest thought to the proportions of arms or legs at the time. When my machine drawing had been finished fairly carefully, I found it so unbearable that I couldn't hear it clatter that I let the apparition appear in it after all.[53]

To make his point perfectly clear, namely that it was the presence of that apparition which made it possible to hear his loom, Vincent added that 'a sort of sigh or lament must sometimes come out of all that clutter of the slats'.[54] Because he harboured the ambition to produce acoustic effects in his work, he must have been particularly gratified to read Theo's reaction to *The Potato Eaters* [fig. 41]. Vincent's pupil, Anton Kerssemakers, later gave this

42 Vincent van Gogh, *Ears of Wheat* (F 767 / JH 2034), 1890. Oil on canvas, 64 × 48 cm. Van Gogh Museum, Amsterdam (Vincent van Gogh Foundation).

account of it: 'A few days after he had sent that dark painting, the peasant meal, to his brother in Paris, he came to report, very enthusiastically, that his brother had written so favourably about it, and he was naturally over the moon: he [i.e. Vincent] said that he [i.e. Theo] had written that, upon viewing the painting, you could hear *the clattering of the clogs of those seated*, and that was grist to his mill, you understand.'[55] Later Van Gogh would write to Gauguin about his frantic attempts to express in paint the rustling of ears of wheat [fig. 42]:

Nothing but ears, blue-green stems, long leaves like ribbons, green and pink by reflection, yellowing ears lightly bordered with pale pink due to the dusty flowering. A pink bindweed at the bottom wound around a stem. On it, on a very alive and yet tranquil background, I would like to paint portraits. It is greens of different quality, of the same value, in such a way as to form a green whole which would by its vibration make one think of the soft sound of the ears swaying in the breeze. It's not at all easy as a colour scheme.[56]

The vibration and resonance of coloured forms was therefore an essential part of Van Gogh's painterly poetics, and his success in this regard is shown by many later reactions to his work. In January 1947 the writer and theatre producer Antonin Artaud visited the Van Gogh exhibition at the Palais de l'Orangerie in Paris. Artaud saw in his paintings 'organ songs, bonfires and atmospheric revelations', and experienced first-hand the extraordinarily sensory nature of Van Gogh's work:

There is no famine, no epidemic, no volcanic eruption, earthquake or war that makes the monads whirl around so much and that so forcibly quashes the dark figure of the fama fatum, the nerve-stimulating fate of things,
like a painting by Van Gogh—coming out into the daylight,
exposed to the sense of sight,
hearing, touch,
smell,
on the walls of an exhibition.[57]

7 PAINTING MUSICALLY

Vivace con colore

Rattling, clattering, rustling—these were among the sounds Van Gogh sought to evoke in his 'silent' art, as he endeavoured to reach both the eye and the ear of his viewers. These sound effects were not the result of random experiments, for he clearly aspired to produce art that would stimulate a number of the senses at once, not least the sense of hearing. Moreover, at different times and in various ways, he compared his working methods to those of musicians and composers.

Van Gogh admired musicians because they were able, seemingly without effort, to hold an audience in thrall: 'Someone who can really play the violin or piano is, it seems to me, a mightily entertaining person. He picks up his violin and starts to play, and a whole gathering enjoys it all evening long. A painter has to be able to do that too.'[1] Furthermore, when writing about art, he followed the example of Delacroix and Blanc and often used musical terms, such as 'harmony' ('that touch of dark and that tonal white are the key to the harmony')[2] and 'register' ('starting a painting in a low register and then seeking to raise it from low upward').[3] He also equated 'rests' with the 'forbidden' colours black and white: 'Delacroix—called them *rests*, used them as such. You mustn't be prejudiced against them, because provided they're in their place and in balance with the rest, one may use *all* tones'.[4] In 1890, moreover, he put forward a musical argument for his decision to reimagine black-and-white reproductions of existing art works [fig. 43]: 'We painters are always asked to *compose* ourselves and *to be nothing but composers*. Very

43 Alfred Alexandre Delauney after Jean-François Millet, *Winter: The Plain of Chailly*, 1862. Etching, 11.3 × 13.6 cm. Van Gogh Museum, Amsterdam (Vincent van Gogh Foundation).

well—but in music it isn't so—and if such a person plays some Beethoven he'll add his personal interpretation to it—in music, and then above all for singing—a composer's *interpretation* is something, and it isn't a hard and fast rule that only the composer plays his own compositions.'[5]

For once, Van Gogh was working not like a creative composer but like an interpretive artist: 'playing', in other words, as a relaxed musician might play. This had been the method of Delacroix, who had also engaged in 'études de ressouvenir' (recollection studies) to stimulate his imagination.[6] 'So then my brush goes between my fingers as if it were a bow on the violin and absolutely for my pleasure', Vincent wrote with satisfaction to Theo about his new improvisations in colour [fig. 44].[7]

Years before, Van Gogh had compared drawing materials to musical instruments when explaining why he preferred the more resonant natural chalk to ill-sounding conté: 'Two violins may look more or less the same on the outside—when they're played one sometimes turns out to have a beau-

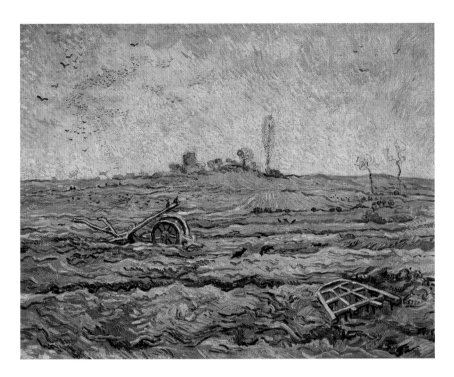

44 Vincent van Gogh, *Snow-Covered Field with a Harrow (after Millet)* (F 632 / JH 1882), 1890. Oil on canvas, 72.1 × 92 cm. Van Gogh Museum, Amsterdam (Vincent van Gogh Foundation).

tiful sound that the other doesn't have. Natural chalk has lots of sound or tone. I would almost say that natural chalk understands what one wants, listens with intelligence and obeys, while conté is indifferent and doesn't cooperate.'[8] He could even imagine artists as musical instruments that produce very different sounds: 'Some draughtsmen have a nervous manner that gives their technique something of the singularity of the sound a violin makes, such as Lemud, Daumier, Lançon. Others, like Gavarni and Bodmer, are more reminiscent of the piano.'[9]

Each of the examples mentioned above involves a concrete connection between music and painting, and the same applies to his drawings of musicians, his portrait of Marguerite Gachet at the piano, and his sketches of dancing couples in Antwerp ballrooms. Yet Van Gogh and other artists of this period gradually came to embrace another, more abstract approach to musical painting, one that focused on colour.

DELACROIX: MUSIC-MAKING PAINTER

'Painting as it is now promises to become more subtle—more music and less sculpture—in fact, it promises *colour*', Vincent wrote to Theo on 26 August 1888.[10] By this time he had been studying colour theory for several years and had taken a particular interest in Delacroix's views on the subject, which he had read about in Blanc's 1867 *Grammaire des arts du dessin* and Félix Braquemond's 1885 *Du dessin et de la couleur*. Colour and music had been linked since time immemorial: the ancient Greeks had described melodies in terms of colour, and in fact, the term 'chromatic'—referring to a scale that proceeds by semitones—derives from the Greek *chroma*, meaning 'colour'. Both sound and colour were characterized by 'vibrations' that could play on human emotions directly, without the intervention of the intellect, and with no need for a narrative or any deeper meaning. This appealed so much to Delacroix as a painter that it prompted him to write in his diary in 1857: 'Superiority of music: absence of reasoning (not of logic)'[11]—following the example of Germaine de Staël, the French author who had placed music and painting gloriously 'higher than thought' in an art-theoretical treatise written more than half a century earlier.[12]

What interested Delacroix was not so much the concrete portrayal of musical subjects (examples of which are extremely rare in his work, just as they are in Van Gogh's oeuvre)[13] as the abstract, 'musical' workings of colour—an area in which Chevreul's theories had been influential. Delacroix, in fact, became the absolute master of colour, thereby earning the admiration of later generations of artists. Many Impressionists, Neo-Impressionists and Symbolists were influenced by Delacroix. So, too, Van Gogh, who saw 'in Impressionism the resurrection of *Eugène Delacroix*' and was convinced that 'you have to go straight to Delacroix to find such an orchestration of colours' (thereby borrowing the expression 'l'orchestration des couleurs' from Charles Blanc).[14] 'Delacroix was his god', wrote François Gauzi, a fellow artist who studied in Cormon's studio in Paris at the same time as Van Gogh. 'When he talked about this painter, his lips trembled with emotion.'[15]

In a letter written to Van Rappard in 1885, Van Gogh quoted at length from Théophile Silvestre's study *Eugène Delacroix: Documents nouveaux* (1864), which he would lend to Emile Bernard several years later.[16] Not only did Silvestre include a section with Delacroix's pronouncements on music, but he compared him musically to Turner: 'Like the English artist, he has gradually risen from a low register, like the sounds of the violoncello, to bright accents,

like the sound of the oboe'.[17] Moreover, Silvestre considered Delacroix to be the one 'who, over the course of forty years, touched every chord of human passion'.[18] This achievement was due to his ambition to paint for more than just the eye:

> He has an idea of expression, attitude, composition and effect that speaks even more to our imagination than to our eyes; the linear arabesques of his drawings as well as the harmony of his colours reveal, even at a distance, the character of the subject, and produce, so to speak, natural onomatopoeia: the lines whistle in the group of barbarians on horseback, set loose on the trail of Attila, and Achilles' bow makes the sound that Homer compared to the cry of the swallow; one also hears the bones screaming in the jaws of the lions.[19]

With his musical approach to 'the silent arts' ('les arts silencieux'), Delacroix, more than any other painter of the first half of the nineteenth century, was instrumental in the pioneering developments in painting that culminated in modernism: an art that went beyond traditional boundaries and was no longer dependent for its effect on a concrete image or story.[20] The underlying narrative made way for a focus on the pictorial means themselves, and it was this concentration on line, colour and form that Delacroix called 'the music of the painting'. Paint had become expressive in its own right, so that a painting no longer had to rely on the drama of its subject to make an impact. When Vincent discovered this in 1885, he duly reported to Theo that 'colour expresses something in itself'.[21]

This shift in focus brought with it a change in the use of material, something that Van Gogh alluded to when he observed that 'a painter does well if he starts from the colours on his palette instead of starting from the colours in nature'.[22] If he could have stepped back in time into Delacroix's studio, he would have seen confirmation of this idea, because Delacroix in particular had a very special relationship with his palette: while working, he drew inspiration from it, and by his own account, it could inflame his imagination. As the writer-poet Charles Baudelaire observed in his biography of the painter, 'I have never seen a palette that was as painstakingly and delicately arranged as Delacroix's. It was like an exquisite bouquet of flowers.'[23]

That is indeed a remarkable observation: the painting had been preconceived on the palette, before the artist applied a single brushstroke to the canvas. In this light, it is hardly surprising that Delacroix struck out on the

musical path of colour by painting flower pictures; in this genre it was pos-
sible to experiment freely, which made it the perfect vehicle for practising
'pure painting'. A flower still life has no plot, no narrative; its essence is the
magical interplay of colours created by the painter. Delacroix's flower paint-
ings therefore became the consummate expression of what has been called
the 'musical tendency' in his work.[24]

Something similar can be said of Van Gogh: he, too, effected great
changes in his palette by making flower paintings. Shortly after his arrival in
Paris in 1886, he began to experiment in this genre, and ultimately produced
between thirty-five and forty flower still lifes, which he humbly referred
to as 'gymnastics' and 'colour studies' [fig. 45].[25] He described them to his
fellow painter Horace Mann Livens: 'I have made a series of colour studies
in painting simply flowers, red poppies, blue corn flowers and myosotys.
White and rose roses, yellow chrysanthemums—seeking oppositions of blue
with orange, red and green, yellow and violet, seeking THE BROKEN AND
NEUTRAL TONES to harmonize brutal extremes. Trying to render intense
COLOUR and not a GREY harmony.'[26]

There was endless philosophizing about the relationship between
colour and music. In 1883 Pissarro wrote passionately about a concert at
which he had heard an astonishing range of tone colour, probably created
by the wide variety of instruments and voices. He called it 'pure Delacroix'.[27]
Gauguin, another devotee of Delacroix, referred to colour as 'the language
of the listening eye'.[28] At first he was unenthusiastic about Van Gogh's use of
colour, and told him so in his usual tone of arrogant condescension: 'With
all his yellows over purples, all that work of complementary colours, disor-
derly work on his part, he achieved only sweet harmonies, incomplete and
monotonous; the sound of the clarion was lacking.'[29] What a contrast to the
admiration Van Eeden felt for Van Gogh's 'loud singing' and courageous use
of 'screaming colours', in the previously quoted passage of 1891.[30]

Here 'colour' has been referred to repeatedly—almost as a matter of
course—in musical terms, and this was evidently a standard response to
Van Gogh's work. However, this reaction was also typical of the late nine-
teenth century, a time when sensory experiences were invariably correlated,
attempts were made to evoke one artistic medium by means of another,
and synaesthesia became a new artistic ideal. This neuropsychological
phenomenon, whereby a sensation in one part of the body is produced by
stimulating another part—enabling one to hear colour or to taste sounds,
for example—came to be seen by artists not as a medical aberration but as

45 Vincent van Gogh, *Gladioli and Chinese Asters in a Vase* (F 248a / JH 1148), 1886. Oil on canvas, 46.5 × 38.4 cm. Van Gogh Museum, Amsterdam (Vincent van Gogh Foundation).

an exalted condition.[31] Such overwhelming synaesthetic sensations were referred to as 'correspondences', after Charles Baudelaire's poem 'Correspondances' from his collection *Les Fleurs du mal* (1857), in which the world is presented as a forest of symbols full of unexpected connections and connotations. 'Coloured hearing' ('audition colorée') was a form of synaesthesia that was especially prevalent, the textbook example being Arthur Rimbaud's poem 'Voyelles' (Vowels) of 1871, in which each vowel is linked to a colour.

Van Gogh did not 'suffer' from synaesthesia (as some have maintained), but like many other artists of his day, he was extremely interested in the relationship between colour and music. This is apparent not only from his decision, in 1884, to take piano lessons as a means of learning how sound and colour relate to one another, but also from the 'musical intention' in his working method, that is to say, his growing inclination to use colour and

line as autonomous means of expression, in the same way that Gauguin had done in a painting that Theo described with such admiration in a letter to Jo:

> Do you know, there are paintings that are very much like music. There is a Gauguin at the firm that affects me in the same way as a beautiful symphony. A dead beech, whose leaves have prematurely turned reddish-orange, stands in a hilly landscape full of trees in their resplendent foliage. That particular tree is in the centre of the picture beside a moss-covered hut, forming, as it were, a magnificent plume; the deep bluish and violet shadows of the full trees stand out against the orange, like two melodies in counterpoint. The orange harmonizes with the rich variety of browns and havannahs in the tilled fields, hard roads cutting through the woods and vanishing in the distance in the hills that rise up to the sky. The blues and violets are echoed in unusual shades of green and fade in parts into the blue of the sky above. A white cloud, a couple of peasant women in pale blue costumes, a verdant meadow in the foreground, add a few eye-catching tones which, like little melodies, relieve the counterpoint of the instruments. A musician who felt about this painting the way I do would be able to give each colour the name of an instrument and make a musical composition of it. There is nothing material in the picture, yet it captures a moment when everything in nature is alive and burgeoning.[32]

Fundamental considerations of this kind, expressed in such lyrical terms, were no doubt included in Theo's (largely lost) letters to Vincent.

WAGNER: PAINTING COMPOSER

In the years 1850–60, Baudelaire, in his role as art critic, was one of the first champions of Delacroix's innovative art. He called him the most original painter of all time, and compared his use of colour to the music of *Der Freischütz*, an opera by Carl Maria von Weber, which Wagner had reviewed enthusiastically in the *Revue et gazette musicale* during his first stay in Paris in 1841. Baudelaire, who was strongly influenced by Delacroix and adopted many of his ideas in his essays, described the effect of Delacroix's paintings virtually in the artist's own words:

What is this mysterious I-know-not-what that Delacroix has trans-
lated, for the greater glory of our century, better than anyone else? It
is the invisible, it is the impalpable, it is the dream, it is the nerves, it
is the *soul*; and he did this—take note, sir—with no other means than
outline and colour. . . . A painting by Delacroix, placed at too great a
distance for you to be able to judge the charm of the contours or the
more or less dramatic quality of the subject, already penetrates you
with a supernatural voluptuousness.[33]

Perhaps surprisingly, however, Baudelaire did not borrow from Delacroix
the idea of 'correspondences'; descriptions of synaesthetic experiences do
not occur in Delacroix's diaries and art criticism. For this aspect Baudelaire
fell back on such writings as E. T. A. Hoffmann's *Kreisleriana* (1814–15), a text
rooted in German Romanticism that explicitly links colours, sounds and
smells.[34] The influence of Wagner also played a decisive role in this regard,
for Baudelaire soon recognized in Wagner his own artistic ambitions. He
first heard Wagner's music at one of the concerts conducted by the composer
himself at Paris's Théâtre Italien in 1860, and considered the experience a
milestone in his intellectual life. A year later he was among the brawling
audience at the staging of Wagner's opera *Tannhäuser*, when the evening
unexpectedly erupted in total chaos. This prompted Baudelaire to publish
Richard Wagner et Tannhäuser à Paris (1861), a rather unusual pamphlet in
which he took Wagner's work as the basis for a poetic-associative exposi-
tion of his own aesthetic objectives. While at first he had been an exponent
of musical painting, with Delacroix epitomizing the music-making painter,
now he also argued for painterly music, with Wagner as the painting com-
poser par excellence. Central to both categories was colour. Baudelaire's
essay set the tone for decades to come with regard to thinking about the arts
in general and Wagner in particular.

Wagner strove to fuse various artistic disciplines into one new form of
music drama, the *Gesamtkunstwerk*, as exemplified by his operas *Tristan
und Isolde*, *Parsifal*, and the four-part cycle *Der Ring des Nibelungen*. An all-
important feature of this synthesis was that music and the visual and dra-
matic arts were not just brought together willy-nilly but rather subordinated
to the overarching principle that lay at the basis of each work. In fact, many
of Wagner's later and indeed present-day followers have misinterpreted the
term 'Gesamtkunstwerk,' taking it to mean merely the combination of vari-
ous artistic disciplines, such as the practice of adding lustre to exhibitions

with live music or poetry readings, as became fashionable during Van Gogh's years in Paris. Such a simplistic notion does not do justice to Wagner's original intention.[35]

Not everyone reacted to the art of Wagner as passionately as Baudelaire. The violent response of Parisians to *Tannhaüser* was unprecedented. Satirical cartoons appeared in numerous magazines and newspapers. Wagner's detractors thought his music formless and boring, and said that a whiff of 'Wagner extract' was more effective than any sleep-inducing drug. Admittedly, one critic described his work as extremely varied and rich, comparing it to an Oriental carpet 'where the flora and fauna of an imaginary world blend into disquieting arabesques and where the warm colours produce a sort of intoxication of the senses', but his final judgement was negative, because who on earth would want to stare for four hours at an amorphous carpet?[36] Wagner's music was increasingly compared to visual art, in that he was reproached for a lack of (melodic) line and a surfeit of (harmonic) colour. Thus the debate sparked by his work was automatically incorporated into the general discussion going on in modern art, where a similar battle was being fought by those who blamed the rise of (abstract) colour for the declining importance of (concrete) depiction.

During Van Gogh's years in Paris, these topics were the subject of fierce debate, which he must have known about—though proof is lacking—from conversing with fellow artists or reading newspapers and magazines. Wagner's devotees published essays praising him in the monthly *Revue Wagnérienne*, where his relevance to painting was also discussed at length by such critics as Théodore de Wyzewa, who wrote authoritative articles in 1885 and 1886 on what he called 'Wagnerian painting' ('la peinture wagnérienne'). In May 1886, the critic Félix Fénéon supplied both Seurat and Signac with a copy of the latest *Revue Wagnérienne*, which contained Wyzewa's second article on Wagner, 'Notes sur la peinture Wagnérienne' (Notes on Wagnerian painting).[37] Van Gogh got to know Seurat in February 1886, after the appearance of the first article.

In Wyzewa's eyes, 'Wagnerian painting' meant putting into practice the principles derived from Wagner's work. In creating his music dramas, Wagner distinguished between two aspects: on the one hand, the vocal aspect, the narrative voice, the descriptive element of the opera—in short, the body; on the other hand, the instrumental aspect, the orchestra, the musical-emotional element—in short, the soul. In Wagner's view, the first aspect was equalled in importance by the second, 'symphonic' aspect: the music,

to which listeners could be in thrall without recourse to logic or reason: 'Its constant ebb and flow is the manifestation of so free, so daring a system of rules that it must strike us as more powerful than any logic. . . . Thus it seems to us like a revelation from an entirely different world; in truth, it reveals to us connections between worldly phenomena that . . . impress themselves upon us with such overwhelming conviction and give such certain form to our emotions that logical reasoning is thereby wholly bemused and disarmed.'[38]

Wyzewa took Wagner's dichotomy and applied it effortlessly to painting. In his article, he states that artists can deploy the pictorial means at their disposal to practise two distinct manners of painting: 'Today, these colours and lines—the resources of painting—can be applied to two quite different kinds of painting: the first, concerned with perceiving and describing, accurately recreating the way we see objects; the other, an art that is emotional and musical, caring nothing about the objects represented by these colours and lines, regarded solely as emotional signs, freely combining them in playful fashion so as to produce in us a total impression comparable to that of a symphony.'[39]

These two forms were equally valid and, according to Wyzewa, both were realism, 'emotional-musical' painting no less so than traditional, 'descriptive' painting. Musical painting was, after all, the re-creation of a 'real', generally shared human feeling (which explains why Wagner was considered a realist in those days). Painting in a musical way was not necessarily modern, since it involved a phenomenon that had been present throughout art history: the longing to be liberated from the dominance of the subject (an observation that led Wyzewa to call Rembrandt a 'symphonist'). Only with the rise of modernism at the end of the nineteenth century, though, did this factor become all-important. Never before had painting been so 'pure', that is to say, so focused on the means (lines, colours, forms) rather than the image. Obviously the younger generation had adopted a new set of rules—a new logic, as it were.[40]

The artists of Van Gogh's era were attracted to the abstract element of music, but did not yet pursue 'abstraction' in the later sense of the word: rather, they aimed to endow their work with a second, partly unconscious layer of meaning, to which the image would, ideally, be subordinate. In that case, the artwork became 'symphonic', as it was termed in those days. It was precisely this musical aspect that came to be considered a mark of artistic quality around the turn of the century, which is apparent from the way

critics such as Just Havelaar wrote about it: 'A creation of the art of painting must be like a *piece of music*. Only then will the painter have portrayed not one specific shoe or a single human countenance, but will have inadvertently made us understand through his depiction his most profound idea of life.'[41] Feeling versus reason, female versus male, irrational music versus intellectual literature: the argument in favour of feeling, which had featured prominently in Zola's novel *L'Oeuvre*, had been subsumed into art-historical discourse by the turn of the century.[42]

BEYOND REASON

Gauguin's famous pronouncement—'art is an abstraction'—must be understood in the light of the above: it refers to the second, musical layer, which in his view constituted the power and the essence of an artwork, because it revealed the personality of the artist. In this regard he followed Delacroix, who pointed out that if the first layer—that is, the actual subject of the painting—received too much attention, then the artist went unnoticed.[43] In July 1888, Gauguin corresponded with Van Gogh on this issue: 'My dear Vincent, I've just read your interesting letter and I entirely agree with you on the slight importance that accuracy contributes to art. Art is an abstraction; unfortunately we're becoming increasingly misunderstood.'[44] A few weeks later he continued in this vein, perhaps inspired by the previous exchange of ideas with Van Gogh, in a letter to his younger fellow painter Emile Schuffenecker: 'Some advice: do not paint too much after nature. Art is an abstraction; derive this abstraction from nature while dreaming before it, and think more of the creation which will result than of nature. Creating like our Divine Master is the only way of rising toward God.'[45]

Gauguin developed his thoughts on music more explicitly and systematically than Van Gogh did. In his *Notes synthétiques* he characterized the ear as 'a sense inferior to the eye' and placed painting above music, borrowing various ideas and arguments directly from Delacroix.[46] On his own use of colour, he wrote: 'Colour, being itself enigmatic in the sensations which it gives us, can logically be employed only enigmatically. One does not use colour to draw but always to give the musical sensations which flow from itself, from its own nature, from its mysterious and enigmatic force.'[47] For Gauguin, this working method resulted in fantastical painted symphonies, just as it did in the work of Van Gogh. Gauguin described this process in an

46 Paul Gauguin, *Spirit of the Dead Watching (Manao Tupapau)*, 1892. Oil on jute mounted on canvas, 73 × 92.4 cm. Albright-Knox Art Gallery, Buffalo, N.Y. A. Conger Goodyear Collection, 1965.

interview with the French journalist Eugène Tardieu: 'I obtain symphonies, harmonies that represent nothing absolutely real in the vulgar sense of the word, with arrangements of lines and colours given as a pretext by any subject whatsoever from life or nature. These do not express any idea directly, but should make one think the way music makes one think, without the help of ideas or images, simply by the mysterious affinities between our brains and such arrangements of colour and line.'[48]

In Gauguin's pronouncements we also find the awareness of the dual function of certain basic elements of painting, as previously formulated by Wyzewa and Wagner. There was both a concrete and an abstract meaning, which Gauguin called the 'literary part' and the 'musical part' of a painting.[49] He clarified this distinction by referring to his painting *Spirit of the Dead Watching (Manao Tupapau)* of 1892 [fig. 46]: 'The title *Manao tupapau* has two meanings, either the girl thinks of the spirit, or the spirit thinks of her. To sum up: The musical part: undulating horizontal lines; harmonies of orange and blue, united by the yellows and purples (their derivatives) lit by

greenish sparks. The literary part: the spirit of a living person linked to the spirit of the dead. Night and Day. This genesis is written for those who must always know the *why* and the *wherefore*. Otherwise it is simply a study of an Oceanic nude.'[50]

Gauguin regarded his self-portrait of 1888 as one of the first examples of the new style: 'The drawing of the eyes and the nose, like the flowers in Persian carpets, epitomizes an abstract and symbolic art', he explained to Van Gogh.[51] He described the same thing for Schuffenecker in slightly different terms: 'The design is absolutely special, a complete abstraction. The eyes, mouth and nose are like the flowers of a Persian carpet, thus personifying the symbolic aspect.'[52]

Van Gogh and Gauguin were in complete agreement on this score, even though Van Gogh maintained that in general 'the result must be an *action*, not an abstract idea'.[53] He preferred to live his life 'at ground level' rather than 'too up in the air', and also refused to paint purely from the imagination, which was the method that Gauguin advocated.[54] Yet Vincent recognized the symbolic aspect inherent even in realistic art, and he wrote as much to Theo as early as 1885: 'As for Poussin—he's a painter who thinks and makes one think about everything—in whose paintings all reality is at the same time symbolic. In the work of Millet, of Lhermitte, all reality is also symbolic at the same time. They're something other than what people call realists.'[55] Van Gogh had borrowed this idea from Bracquemond's comments on Poussin in his *Du dessin et de la couleur*: 'More than any other master, he provides an example of the search for the contrasts between light and dark lines, *leaving aside any form of representation*. That is, by conceiving a work of art solely in terms of its essence, its *clarity*, the only forms that he depicts in their entirety in the final work are those that are strictly necessary'.[56]

In the debate on the relationship between painting and music that was raging in Van Gogh's day, 'painting musically' was thought to result in the domination of the pictorial means—colours, lines, forms, in other words, the non-narrative or 'musical' part of the artwork—to the detriment of traditional representation, which was thus forced into a secondary role. The artist's attention shifted from the outside world ('the Conscious') to the inner world ('the Unconscious'). The latter did not imply a total release from reason in the Freudian sense, but a state of semi-consciousness (since the artist remains keenly aware of his intuition during the creative process), which

has been referred to as the 'musical unconscious or preconscious'.[57] The ambition of this artistic revolution was to produce a convincing rendering of the feelings and the personality of the artist, which was decidedly not the aim of traditional painting. For some, this made art more realistic than ever, much more real than true realism, because it came closer to the essence of human existence. Van Gogh himself expressed this conviction vehemently in 1885, after Theo had told him that he was planning to show his work to the old painter Charles Emmanuel Serret:

> Tell Serret *that I would be desperate if my figures were* GOOD, tell him that I don't *want* them academically correct. Tell him that I mean that if one *photographs* a digger, then he would *certainly not be digging.* Tell him that I think Michelangelo's figures magnificent, even though the legs are definitely too long—the hips and buttocks too broad. Tell him that in my view Millet and Lhermitte are consequently the true painters, because they don't paint things as they *are*, examined drily and analytically, but as *they*, Millet, Lhermitte, Michelangelo, feel them. Tell him that my great desire is to learn to make such inaccuracies, such variations, reworkings, alterations of the reality, that it might become, very well—lies if you will—but—truer than the literal truth.[58]

8 DREAM AND REALITY

Adagio con espressione

To determine whether a painting is harmonious, it is necessary to view it from a great distance, according to Delacroix: far enough away to make it impossible to recognize the actual subject, but close enough to see the composition, the colours, the lines—'the musical and arabesque', in his words. It is the musical element that creates the desired effect by augmenting the image with a second layer, the deeper meaning that is the core of the artwork. Whether this is even possible (it appears to be a neurophysiological impossibility not to recognize the subject while taking in the rest) is not at issue here.[1] It proved to be a serviceable metaphor that resonated with many artists and was formulated in a wide variety of ways by, among others, Baudelaire and later Matisse, who wrote the following about Giotto, a painter of the Italian Renaissance: 'A work should carry in itself the entire meaning and impose it on the viewer even before he knows its subject. When I see Giotto's frescoes at Padua, I'm not bothered about which scene of Christ's life I have in front of me, but I understand straightaway the feeling it conveys, for it is in the lines, in the composition, in the colour, and the title would do no more than confirm my impression.'[2] A famous statement by Maurice Denis is also appropriate in this context: 'Remember that a painting—before representing a warhorse, a nude woman, or some anecdote or other—is essentially a flat surface covered with colours assembled in a certain order.'[3]

Paul Valéry applied the same principle to poetry: 'One should read and reread a poem like a piece of music and search for its meaning and intentions

only after experiencing its system of sounds.'[4] The final painting was naturally preceded by an entire creative process; in fact, it would be interesting to know exactly how artists practised this modern 'musical' painting. How could the subject of a painting be subordinated to the painterly means? How could a painting be at once figurative and abstract (to put it in later terms)? These questions are difficult to answer: Van Gogh, for one, devoted his entire artistic career to seeking the most effective symbiosis between these two seemingly irreconcilable approaches.

In this regard Delacroix put forward a useful principle, one that was later adopted by many others, including Gauguin and Whistler: it is the ideal of 'vagueness', which harks back to classical antiquity. In the Italian Renaissance this ideal grew into a *locus classicus* and afterwards continued to flourish in such paired concepts as *diligente/manieroso* and 'polished style'/'firm style'.[5] In his *Schilder-boeck,* Karel van Mander used the Dutch terms *net* (meaning 'neat', in the sense of smooth or polished) and *rouw* (rough).[6] Delacroix, who spoke of 'réalisme' versus 'idéalisme', argued in favour of the latter.

Delacroix himself strove for a certain degree of vagueness, and therefore placed the art of painting above literature, which he thought too 'precise' (this was also his opinion of realistic painting and photography, which he disdained). He chose music as his model, because music was in itself indeterminate. The ultimate goal was 'suggestion' and not an exact rendering or polished picture of reality, as he stated in no uncertain terms: 'No! One does not spoil a painting by finishing!'[7] In Delacroix's eyes, a flower still life embodied a dream-like universe of colour, a free, associative space that was comparable to music; keeping an artwork vague gave free rein to the imagination not just of the artist but of the viewer as well. Interestingly, while visual artists who aspired to vagueness initially drew inspiration from music, the composers who then attempted to do the same (including Claude Debussy) envied the painters' accomplishments, because they felt it was much more difficult to realize this ideal in their own, time-bound art form.

The artists' conscious quest for vagueness was a two-pronged pursuit. First of all, it involved technique: a painting must not be executed too precisely. As Van Gogh expressed it: 'And I even do *my best* NOT *to give* ANY *details* THEN—*because then the reverie goes out of it*.'[8] Second, it involved the artist's attitude: it was necessary for an artist to portray nature while 'dreaming' in front of it, viewing it in a kind of trance, for it was in this state between waking and sleeping that the artist could break free from reality. Gauguin wrote explicitly about this state of heightened consciousness. So did the British

critic Philip Gilbert Hamerton, who declares, in his *Imagination in Landscape Painting* (1887), that the artist's brain 'loses the sense of substance', whereby 'the vision of the world becomes for it what Wordsworth aptly called "eye music" . . . painting is then no longer a study of tangible things at all, but a dream, like the dreams of a musician'.[9]

Van Gogh recognized this 'metaphysical magic' in the work of Rembrandt, who, when painting the evangelist Matthew (a picture that Van Gogh incorrectly regarded as a self-portrait), conjured 'a supernatural angel' on the canvas:

> He makes a portrait of himself as an old man, toothless, wrinkled, wearing a cotton cap—first, painting from life in a mirror—he dreams, dreams, and his brush begins his own portrait again, but from memory, and its expression becomes sadder and more saddening; he dreams, dreams on, and why or how I do not know, but just as Socrates and Mohammed had a familiar genie, Rembrandt, behind this old man who bears a resemblance to himself, paints a supernatural angel with a Da Vinci smile.[10]

This was not a product of the painter's imagination—on the contrary: '*Rembrandt* invented nothing, and that angel and that strange Christ; it's—that he knew them, *felt* them there.'[11] In other words, it was nothing short of a miracle, which could take place only because Rembrandt had been in the ideal, dream-like state of artistic impressionability that Van Gogh knew from his own experience and had described a few years earlier in musical terms.

THE ARTIST'S 'HIGH'

On 1 November 1883, Van Gogh left at three o'clock in the morning in an 'open cart' driven by Hendrik Scholte, the owner of the boarding-house where he was staying (in Nieuw-Amsterdam in the province of Drenthe). They travelled to the village of Zweeloo, where they arrived at six o'clock in the morning, when it was still dark. Scholte drove on to the market in Assen, but Van Gogh spent the day in Zweeloo, drawing and painting. For hours he was completely immersed in the colours, forms, light and sounds of nature. There were ploughmen, shepherds, dung-carts, apple trees and sheep, a great many sheep: 'a throng of oval masses, half wool, half mud, that bump

into one another, jostle one another—the flock' [fig. 47]. He described how this enchanting day came to a close: 'That return of the flock in the dusk was the finale of the symphony that I heard yesterday. That day passed like a dream, I had been so immersed in that heart-rending music all day that I had literally forgotten even to eat and drink—I took a slice of coarse peasant bread and a cup of coffee at the little inn where I drew the spinning wheel. The day was over, and from dawn to dusk, or rather from one night to the other night, I had forgotten myself in that symphony.'[12]

Like Gauguin, Van Gogh used the word 'dream' to refer to that special state of artistic receptiveness. In the same sentence, he equated that dream with music: it was a 'symphony', it was 'heart-rending music', it was an intoxicating and agonizing experience that transported him beyond time and reality. 'I have a terrible clarity of mind at times, when nature is so lovely these days, and then I'm no longer aware of myself and the painting comes to me as if in a dream', he wrote to Theo a couple of years later. In this letter he also describes the difference between studies, which are tedious to make, and pictures 'which one paints as if in a dream, and without suffering so much for it'.[13]

Over the years artists and philosophers have employed various expressions for that dream-like 'high', ranging from fever and ecstasy to rapture, inspiration, intuition and epiphany—all of which hark back to the age-old idea of the *furor poeticus* described by Plato.[14] A number of random examples from different eras show how intangible, multicoloured and personal the phenomenon is. In *Die Welt als Wille und Vorstellung* (The world as will and representation) of 1818, Schopenhauer likened the composer to 'a mesmeric sleepwalker' who 'expounds ideas he cannot fathom when awake'.[15] In a letter to Van Gogh, Gauguin spoke of 'the red-hot lava that sets our painters' souls ablaze'.[16] The twentieth-century Belgian writer Hugo Claus also imagined the 'high' as the head becoming 'fluid' or 'liquefying'.[17] In the art-theoretical discourse of Delacroix's day, this mental state was referred to as 'enthusiasm', the meaning of which tended much more towards 'rapture' or 'transport' than it does nowadays.[18]

Delacroix himself wrote in explicit terms about the inspired state in which he had painted *The Barque of Dante* (1822), maintaining that he painted the best head in that work very quickly and in a state of great agitation. In his essay *Questions sur le beau* (Questions of beauty), when discussing Tintoretto and Rubens, he argued in favour of a rapid working method: 'The power of single brushstrokes which are not reworked with new ones

47 Vincent van Gogh, *Shepherd with Flock near the Little Church at Zweeloo* (F 877 / JH 423), 1883.
Pen, pencil, heightened with white, 25 × 31.5 cm. Private collection.

gives the works of these masters a soul and a vitality that cannot always be achieved with careful execution.'[19] It seems paradoxical, but the directness and clarity artists sought was achieved through a diffuse state of mind and vague execution—the latter flowing naturally from the former—in their attempt to arrive at the pure essence of the subject.

Van Gogh described this artistic 'high' in various ways. He spoke of 'that absorption in the moment—that being so wholly and utterly carried away and inspired by the surroundings in which one happens to be',[20] and he talked about working 'without feeling that we're working—when sometimes the brushstrokes come in a sequence and in relation one to another like the words in a speech or a letter'.[21] He also echoed Schopenhauer with his observation: 'I often don't know what I'm doing, working almost like a sleep-walker'.[22] He saw painting as an activity 'in which one's mind is extremely stretched, like an actor on the stage in a difficult role—where you have to think of a thousand things at the same time in a single half hour', and was

convinced that Monticelli, for example, had 'certainly overtaxed his brain doing that work, as did Delacroix and Richard Wagner'.[23] On various occasions he used the term 'enthusiasm', which he had previously recognized in the fiery and passionate singing of the birds, and in 'the brave cicadas' in a poem by Jules Breton, who sing in 'a chorus thousands strong':

> But nothing now will still their tireless cries;
> Banished from the oats or from the wheat
> They'll find a new home in the burnt-out bush
> That dies of thirst in parched and sandy wastes.
>
> On leafless shrubs and withered thistle-flowers
> That let their white and silky tresses fly away,
> *You'll see the insect, with its powerful head,*
> Still drunkenly exulting as it sings.
>
> *Until that moment when, spreading out its ragged wing,*
> *Frustrated, burning with an ever purer flame,*
> *Its bronze eye fixed upon the distant blue,*
> *It expires, singing, on the dried-out stem.*[24]

Van Gogh likened the artist to an obsessed and incessantly buzzing cicada, which, like the nightingale, can never stop making music: 'I have moments when I'm twisted by enthusiasm or madness or prophecy like a Greek oracle on her tripod. Then I have a great presence of mind in words and talk like the Arlésiennes, but I feel so weak with all that.'[25]

Almost four years earlier Vincent had written to Theo about several articles by Paul Mantz that he had read in *Le Temps*, and he had singled out precisely those two essential elements: various observations on 'enthusiasm', and Mantz's phrase 'the grain of madness that is *the best* of art'.[26] Like Delacroix, Van Gogh defended his rapid manner of painting: 'you should know that I'm in the middle of a complicated calculation that results in canvases done quickly one after another but calculated long *beforehand*'.[27] And just as Delacroix's brush had danced to music, whether or not real, when he had been gripped by 'enthusiasm' half a century earlier, Van Gogh's brush now moved easily too, 'like a bow over a violin', producing imaginary music.[28] His progress in this regard was evident, for he was well beyond the

stage when a lack of fervour had provoked him, five years earlier, to observe: 'There has to be more zest in my life if I want to get more brio into my brush'.[29]

MADNESS AND SOUND

To Van Gogh's mind, enthusiasm and madness were closely related. Although, roughly speaking, the former was linked to bravura and the latter to fear (madness could therefore be considered the flip side of enthusiasm, or at least a strong carry-over effect of it), both conditions manifested themselves as an overwhelmingly powerful and intense mental onslaught, and both involved sound. Madness—or Van Gogh's inner storm—entailed hearing voices and sounds as well as producing them himself, such as the miraculous moment, mentioned above, when he suddenly began to sing 'an old lullaby' during an attack of his illness in December 1888. His remarkable account of this attack in a letter to Gauguin mentions, by way of illustration, three works of art—two musical compositions and a literary work—all three of which feature personages in the grip of obsessive delusions or frenzy, or who fall prey to 'unbearable hallucinations', as he himself did: 'In my mental or nervous fever or madness, I don't know quite what to say or how to name it, my thoughts sailed over many seas. I even dreamed of the Dutch ghost ship and the Horla, and it seems that I sang then, I who can't sing on other occasions, to be precise an old wet-nurse's song while thinking of what the cradle-rocker sang as she rocked the sailors and whom I had sought in an arrangement of colours before falling ill. Not knowing the music of *Berlioz*.'[30]

Van Gogh's mention of a 'Dutch ghost ship' refers to an old legend about a captain who sees, in a vision, a nonexistent ship with an invisible crew. This legend survives in a number of versions but was known in the nineteenth century mainly through Wagner's opera *Der fliegende Holländer* (*The Flying Dutchman*) of 1843. Van Gogh must have been referring to this opera, considering his mention, earlier in this letter, of both Wagner and Berlioz, and the fact that he had meanwhile read Benoit's book on Wagner.

Reality and fantasy mingled in a similarly ghastly way in Guy de Maupassant's novella *Le Horla* (1887), a story about a man who sees and hears strange things, imagines he is being pursued by an invisible figure, and descends into paranoia and madness. His sensory hyperperception becomes apparent at the very beginning of the story:

How profound is this mystery of the Invisible! We can never know its depths with our inadequate senses, our eyes that do not know how to truly perceive what is too small, or too big, or too close, or too distant, or the beings that inhabit the stars or a drop of water . . . with our ears that deceive us, for they carry vibrations through the air as sonorous notes. They are fairies that accomplish the miracle of transforming movement into sound and through this metamorphosis, bring music to life, making the silent turbulence of nature sing out.[31]

Maupassant appears to have written the story while under the influence of ether. Van Gogh also mentioned this novella in a later letter, again in the context of Wagner and Berlioz (and this time Delacroix too), since he hoped that music and painting could serve as panaceas for the madness inherent in us humans—artists in particular: 'Perhaps everyone will one day have neurosis, the Horla, St Vitus's Dance or something else. But doesn't the antidote exist? In Delacroix, in Berlioz and Wagner? And really, our artistic madness which all the rest of us have, I don't say that I especially haven't been struck to the marrow by it.'[32]

Let us return for a moment to the letter, quoted above, in which Van Gogh tells Gauguin about his feverish dream. The end of that passage remains a mystery: 'Not knowing the music of *Berlioz.*' What did Van Gogh mean by that? Was he referring to Berlioz's music in general or one composition in particular? Presumably the latter: a train of thought beginning with *The Flying Dutchman* and *Le Horla* might naturally continue with Berlioz's best-known work, his *Symphonie fantastique* of 1830. 'Episode de la vie d'un artiste' (Episode in the life of an artist) is the subtitle of this elaborate orchestral work in five movements, which is wholly devoted to obsessive dreams and visions that the composer experienced under the influence of opium. It is possible that Gauguin had referred to this symphony in a previous letter, but Van Gogh might also have heard about it from a member of his family.[33] In any case, he had read about the piece in Benoit's book, which provides the reader with Wagner's resolute opinion of it: 'Those who heard the symphony here in Paris must truly think that they heard something strange, unheard-of. A rich, a monstrous imagination, a fantasy of epic energy, spewing—as out of a crater—a muddy torrent of passions; what one can distinguish are clouds of smoke of colossal proportions, traversed only by lightning, streaked with bands of fire, and shaped into ever-changing phantoms. Everything is excessive, audacious, but extremely disagreeable.'[34]

Van Gogh understandably clung to reality, which gave his mind something to hold on to. His psychological predisposition to lose touch with reality made him afraid to give free rein to pure, unbridled fantasy.[35] His favourite naturalistic novels, such as Maupassant's *Le Horla* and Zola's *L'Oeuvre*, continually reminded him of this danger. It was also why he distrusted the writings of fantasts such as E. T. A. Hoffmann and Edgar Allan Poe, and did not much care for the evocative poetry of Baudelaire and his Symbolist followers. As a form of self-protection, he almost always painted from nature, rarely from the (boundless) imagination.

When referring to art, 'fantasy' is an undeniably complex notion. The difficulty of defining it is apparent from the reaction of a fellow painter in Nuenen, Dimmen Gestel, to Van Gogh's painting of a flock of sheep on the heath: 'Seen from a distance, there was an effect in it, but I saw that he had not copied nature, on the contrary, it was pure fantasy, a composition that originated through inspiration from nature.'[36] No painting, of course, can be completely made up, because no artwork is totally unrelated to reality; by the same token, however, art can never be wholly realistic. Van Gogh's intuitive predilection for realism must therefore be put into perspective: to be sure, he rejected pure fantasy, but 'coarse' realism was not his intention either. In Van Gogh's view, the word 'reality' was to be taken broadly, as something that went beyond the superficially visible. (This is evident from his statement about Rembrandt's angel and also his observation on the work of Poussin.) For Van Gogh, painting was not merely a descriptive art. In any artwork, 'reality is at the same time symbolic',[37] expressive of an 'idea'. In those days one would have said that the reproductive, descriptive or literary part of a painting could not exist without a deeper, emotional or musical layer. It was precisely this last aspect that Van Gogh missed in the poem Emile Bernard sent him in 1888, to which he responded, 'It seems to me that what you want to evoke isn't stated clearly enough'.[38]

In Van Gogh's work, shoes are never merely shoes, a portrait is never simply a portrait ('Ah, the portrait—the portrait with the model's thoughts, his soul').[39] His *Garden of the Asylum of Saint-Paul* provided a realistic view of the garden, but that was not all, as he explained to Bernard: 'You'll understand that this combination of red ochre, of green saddened with grey, of black lines that define the outlines, this gives rise a little to the feeling of anxiety from which some of my companions in misfortune often suffer, and which

is called "seeing red".[40] Seven years earlier, when living in The Hague, he had put it in synaesthetic terms: 'I see in my work an echo of what struck me, I see that nature has told me something'.[41]

At Gauguin's urging, Van Gogh embarked on a short-lived experiment with painting from the imagination, which he had previously found 'truly tedious and heavy going'.[42] The result was his *Memory of the Garden at Etten* [fig. 48], about which he said in a letter to his sister Willemien: 'There you are, I know it isn't perhaps much of a resemblance, but for me it conveys the poetic character and the style of the garden as I feel them.' He then went on to say, 'I don't know if you'll understand that one can speak poetry just by arranging colours well, just as one can say comforting things in music. In the same way the bizarre lines, sought out and multiplied, and snaking all over the painting, aren't intended to render the garden in its vulgar resemblance but draw it for us as if seen in a dream, in character and yet at the same time stranger than the reality.'[43] Music, poetry, dream—they formed the sensitive trio intended to oust the 'vulgar resemblance' forever. Yet Van

48 Vincent van Gogh, *Memory of the Garden at Etten (Ladies of Arles)* (F 496 / JH 1630), 1888. Oil on canvas, 73.5 × 92.5 cm. State Hermitage Museum, St Petersburg.

Gogh would go no further than that. He continued to concentrate on reality and preferred to regard his art as a craft ('as if one were making shoes'),[44] rather than as a lofty pursuit.

Van Gogh's remarkable artistic aspirations first gained public recognition in early 1890, six months before his death, when the art critic Albert Aurier published a favourable article on him in the *Mercure de France*. Aurier praised Van Gogh's extraordinarily 'strange, intense and feverish works'.[45] Van Gogh was moved by this, but it also left him feeling uneasy, for he was convinced that in order truly to gain a place among the luminaries of art, he would have to go much farther down the musical path. He also knew that he could not do it. In fact, his musical ideal was constantly in conflict with his devotion to reality, which he ultimately equated with 'truth': 'Aurier's article would encourage me, if I dared let myself go, to risk emerging from reality more and making a kind of tonal music with colour, as some Monticellis are. But the truth is so dear to me, *trying* to *create something true* also, anyway I think, I think I still prefer to be a shoemaker than to be a musician, with colours.'[46]

9 THE SOLACE OF MUSIC

Largo morendo

The feverish, impassioned state in which Van Gogh painted during his last period was a blessing for art but perhaps not for him. Earlier in his career, he had always sought peace and tranquillity: 'I must be able to stay composed and calm when at work, it really is hard enough as it is', he wrote to Theo in January 1882.[1] And six months later he declared, 'I want nothing so much as to keep the peace, nothing is as necessary for my work as that very peace.'[2] At about the same time he even observed with a sense of resignation, 'Even though I'm often in a mess, inside me there's still a calm, pure harmony and music.'[3] He kept his nerves in check by lying down in the sand next to an old tree root and making a drawing of it, by smoking one of his many pipes, by staring at the blue sky or examining the moss and grass, and by working extremely hard. In the end, all that remained was hard work: when he succeeded at it, however, when he could truly immerse himself in the act of creation, he was rewarded with the inner music that calmed him and brought peace and harmony to his drawing and painting.

THE CALMING EFFECT OF ART

Solace, serenity, peace—these notions occur again and again in Van Gogh's letters.[4] There is nothing he wrote about with greater longing. Pieter Boele van Hensbroek, an acquaintance of the young Vincent, referred to this

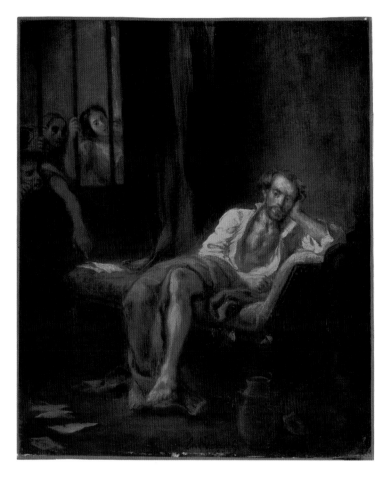

49 Eugène Delacroix, *Tasso in the Madhouse (Tasso in the Hospital of St Anne in Ferrara)*, 1839. Oil on canvas, 60 × 50 cm. Oskar Reinhart Collection 'Am Römerholz', Winterthur, Switzerland.

strong need and called it 'that gigantic *Weltschmerz* that never left him'.[5] Van Gogh found solace in nature and in his work, and sought similar comfort in the work of others. 'I much prefer Guy de Maupassant to Richepin, for being more consoling', he told Theo.[6] As far as painters were concerned, he regarded Millet as one of his greatest examples: 'What a master Millet is. That fellow, so wise, so moved, does the countryside in such a way that even in town one continues to feel it. And then he has something unique and so good right down to his depths that it consoles one to look at his works, and one wonders if he did them this way expressly to console us.'[7] He thought

THE SOLACE OF MUSIC

50 Johannes Bosboom,
A Young Monk Playing the Organ
('Cantabimus et psallemus'),
reproduced in *Kunstkronijk* 11
(1850). Lithograph,
19.8 × 14.4 cm. Van Gogh
Museum, Amsterdam.

the same of Delacroix's *Tasso in the Madhouse (Tasso in the Hospital of St Anne in Ferrara)*, 'and so many other paintings depicting a *true* man',[8] a remark that recalls what he once said about Dupré, whose work he compared to Beethoven's, calling it 'a magnificent symphony in the colour, *carried through, intended, manly*' [fig. 49].[9] The pre-eminent 'comforter of troubled minds' was, of course, Christ.[10] It was no coincidence that Van Gogh hung on the wall of his room in Dordrecht a black-and-white reproduction of Ary Scheffer's painting *Christus Consolator*, the original of which he had seen in the Dordrecht museum.[11] At first Van Gogh used the term 'comfort' mainly in the religious sense, but from 1880 also with reference to art.[12]

Every room he ever inhabited was decorated with reproductions of art-works intended to give comfort and pleasure. These works included prints of musical subjects, such as *A Young Monk Playing the Organ ('Cantabimus et psallemus')* by Johannes Bosboom, *A Musical Rehearsal* after George du Maurier, and *The Harpist* 'from a series about the Opera', by Henri Dochy after Paul Renouard [figs. 50–52].[13] Theo also collected such prints, and in 1877

51 After George Louis Palmella Busson du Maurier,
A Musical Rehearsal, reproduced in *The Graphic* 6
(14 September 1872). Wood engraving, 22.6 × 30.1 cm.
Van Gogh Museum, Amsterdam (Vincent van Gogh
Foundation).

52 Henri Dochy after Charles Paul Renouard,
The Harpist ('L'harpiste a l'opéra'), reproduced in
L'Illustration 84 (25 October 1884). Wood engraving,
31.4 × 22 cm. Van Gogh Museum Library, Amsterdam.

53 J. H. Weissenbruch after Johannes Bosboom, *Franciscan Monks Singing the Te Deum*, reproduced in
Kunstkronijk 17 (1856). Lithograph, 16.5 × 22.8 cm. Van Gogh Museum, Amsterdam.

THE SOLACE OF MUSIC

54 Utagawa Kunisada II, *The Matsumotorō Theatre in the Tokyo Pleasure District (Tōkyō Matsumotorō)*, 1870. Three coloured woodcuts, each 36.5 × 25.4 cm. Van Gogh Museum, Amsterdam (Vincent van Gogh Foundation).

Vincent sent him a few from Amsterdam, including J. H. Weissenbruch's *Franciscan Monks Singing the Te Deum* (after Bosboom) [fig. 53]. Later, in 1888, Theo sent Vincent a series of Japanese prints, among them *The Matsumotorō Theatre in the Tokyo Pleasure District* by Utagawa Kunisada II, 'with a line of purple female musicians against the yellow-lit wall' [fig. 54].[14]

Art was meant to possess 'sentiment', a term Van Gogh used often. It had a wide variety of meanings (feeling, atmosphere, musical layer, 'je ne sais quoi', 'beyond the paint'), and it enabled art to comfort the beholder—the greatest of all artistic achievements, according to Van Gogh. De Staël and Delacroix had previously pointed out that viewers, when looking at a work of art, should feel the same enthusiasm and ecstasy that the artist had experienced when making it, and likewise be transported beyond themselves.[15] Colour alone affected the human spirit to the extent that one only had to look at art in order to be swept away to another world. 'Colours are the music of the eyes; they combine like notes; there are seven colours as there are seven notes, there are shades as there are semitones', according to Delacroix.[16]

To Van Gogh's mind, inducing the viewer to contemplate an artwork with rapture served that one noble purpose: to give comfort to humankind. He wrote to Theo, 'We're perhaps not there for one thing or the other, being there to console or to prepare for more consolatory painting.'[17] In a letter to Gauguin he maintained that in this respect music could serve artists as a

model: 'Ah! my dear friend, to make of painting what the music of Berlioz and Wagner has been before us . . . a consolatory art for distressed hearts! There are as yet only a few who feel it as you and I do!!!'[18]

To achieve this, however, painting was in need of reform. It had 'to rise to a level equivalent to the serene peaks achieved by the Greek sculptors, the German musicians, the French writers of novels', but bringing this about would 'exceed the power of an isolated individual', as he wrote to Emile Bernard.[19] Artists should therefore join forces; bearing this in mind, Van Gogh approvingly quoted Gauguin: 'He says that when sailors have to move a heavy load or raise an anchor, in order to be able to lift a greater weight, to be able to make an enormous effort, they all sing together to support each other and to give each other energy. That it's just what artists lack.'[20] Joined in song: this powerful image could guide artists intent on creating the art of the future. Importantly, Van Gogh also envisioned this musical model as applicable not only to painting in general but also to each artwork individually: 'And in a painting I'd like to say something consoling, like a piece of music. I'd like to paint men or women with that *je ne sais quoi* of the

55 Vincent van Gogh, *Starry Night* (F 474 / JH 1592), 1888. Oil on canvas, 72.5 × 92 cm. Musée d'Orsay, Paris.

THE SOLACE OF MUSIC

56 Vincent van Gogh, *Ploughed Fields ('The Furrows')* (F 574 / JH 1586), 1888. Oil on canvas, 72.5 × 92.5 cm. Van Gogh Museum, Amsterdam (Vincent van Gogh Foundation).

eternal, of which the halo used to be the symbol, and which we try to achieve through the radiance itself, through the vibrancy of our colorations.'[21]

Time and again Van Gogh formulated this ideal, always in slightly different terms. A painting should be 'like a piece of music':[22] in other words, full of feeling, harmonious, coherent, timeless, iconic, tranquil, tender and calm. In the painting *Wheatfield at Sunset* he had 'tried to express calm, a great peace',[23] while he found the *Almond Blossom* 'perhaps the most patiently worked, best thing I had done, painted with calm',[24] and the effect of *Irises in a Vase* 'harmonious and soft'.[25] He describes two other paintings in similar terms in a letter to Theo [figs. 55–56]: 'I wouldn't be surprised if you liked the starry night and the ploughed fields—they're calmer than some other canvases. If the work always went like that I'd have fewer worries about money, because people would come to it more easily if the technique continued to be more harmonious. But this bloody mistral is a real nuisance for doing brushstrokes that hold together and intertwine well, with feeling, like a piece of music played with emotion.'[26]

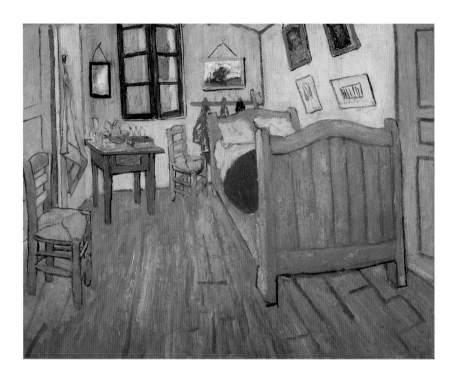

57 Vincent van Gogh, *The Bedroom* (F 482 / JH 1608), 1888. Oil on canvas, 72 × 90 cm. Van Gogh Museum, Amsterdam (Vincent van Gogh Foundation).

Van Gogh had aimed to evoke a similar feeling in the different versions of *The Bedroom*: 'I had wished to express *utter repose* with all these very different tones' [fig. 57].[27] He explained to Willemien that even though one might think at first glance that it was impossible to express peace and calmness with such vivid colours—rather than the soft grey preferred by the painters of the Hague School—it could indeed be done, as had been shown by the music of Wagner, in which intimacy was achieved in spite of all the chaos and complexity: 'But by intensifying *all the* colours one again achieves calm and harmony. And something happens like with the Wagner music which, performed by a large orchestra, is no less intimate for that.'[28]

To console people with his art had been Van Gogh's desire from the very beginning, and those he had in mind were not primarily the art connoisseurs. He preferred to focus on 'the common people, who buy themselves chromos and listen with sentimentality to barrel organs', rather than on 'certain men-about-town who go to the Salon'.[29] The so-called civilized world filled him with disgust; it made him nervous and prompted him to declare

THE SOLACE OF MUSIC

that he would rather live in a little cottage, 'so that I no longer hear or see anything of those who call themselves civilized people'.[30] His mission of consolation began in 1882, when he conceived the plan to make inexpensive lithographs to offer solace to simple folk, and it culminated six years later in *La Berceuse*, his portrait of Augustine, the wife of his friend Joseph Roulin, the last in the series of portraits of the Roulin family. Between November 1888 and March 1889 he made five versions of this painting, which he hoped would comfort sailors at sea. The sight of the painting was intended to evoke the rocking of the cradle and the lullabies their mothers had sung to them: 'On the subject of that canvas, I've just said to Gauguin that as he and I talked about the Icelandic fishermen and their melancholy isolation, exposed to all the dangers, alone on the sad sea, I've just said to Gauguin about it that, following these intimate conversations, the idea came to me to paint such a picture that sailors, at once children and martyrs, seeing it in the cabin of a boat of Icelandic fishermen, would experience a feeling of being rocked, reminding them of their own lullabies.'[31] In a variation on what Van Gogh had written to Theo, Bernard later declared that the portrait of Augustine Roulin would conjure up for sailors the 'hymns of childhood, hymns which bring rest and consolation to a hard life'.[32]

LETTING THE CANVAS SING

Van Gogh suffered the first serious attack of his illness while working on *La Berceuse*. More than ever, he was in need of comfort and something to hold on to. During that attack, in December 1888, he began to sing, as mentioned above, 'an old wet-nurse's song'.[33] It was as though he himself had become the cradle-rocker or 'berceuse', thus converging with the definitive image of consolation: the woman who simultaneously rocks the cradle and sings a lullaby—which is the dual meaning of the French word, as Van Gogh himself declared: '"la berceuse", or as we say in Dutch "our lullaby", or the woman by the cradle'.[34] In his feverish imagination, he himself had turned into the personification of solace, thereby becoming, at last, the kind of artist he truly wished to be.

It stands to reason that Van Gogh described his nervous breakdown by means of a sea metaphor. His letters contain numerous examples of imagery based on the theme of the undulating sea and the rough, solitary life of seamen, with which he could empathize. He frequently linked this image to the

artist's existence: 'Where I myself seek to go, whither I seek to push others as well, is to become fishermen in the sea that we call the ocean of reality', he had written as early as November 1881,[35] and two years later he also spoke of 'the secret of the deep, the intimate, serious charm of the Ocean, of the artist's life'.[36] Van Gogh described the failure of his Studio of the South and the collaboration with Gauguin as 'a shipwreck'.[37] Benoit's book on Wagner, which Van Gogh read in the spring of 1888, must therefore have struck a chord in him, since it compared Wagner to his own *Flying Dutchman*—the phantom ship adrift on the high seas, at the mercy of the wind and the waves as it searches for a safe haven. This is analogous to what Wagner himself had said about Beethoven's epoch-making Ninth Symphony, which in his view was 'a dangerous ocean voyage', boldly undertaken by Beethoven to discover the land of the future.[38]

Van Gogh had read about life at sea in a novel, Pierre Loti's *Pêcheur d'Islande (An Iceland Fisherman)* of 1886. It was this book that provided him with the metaphor of the calm sea as a cradle-rocker. The protagonist, a Breton fisherman named Yann Gaos, had been nursed and lulled to sleep by the sea, which had nurtured him until he was big and strong. At the end of the book, however, he is taken back by the maternal sea 'in the midst of a great sound and fury', when, beyond all hope of salvation, he is swallowed up by the swirling waters.[39] Both the image of the sea as a mother rocking a cradle and Van Gogh's idea to hang his *Berceuse* like a 'stella maris' in the saloon of a fishing boat derive from Loti's novel, namely from a passage that describes the custom among fishermen to take along an image of the Virgin Mary, flanked by sprays of flowers, to protect them at sea. Van Gogh wished to create a similar effect by placing on either side of *La Berceuse* a sunflower painting, thus producing a devotional triptych. Like religious art, this ensemble was intended to provide the viewer with comfort and support.

Van Gogh was convinced that, to be consoling, art had to be as direct and simple as possible. 'Am reading Pierre et Jean by Guy de Maupassant. It's beautiful—have you read the preface explaining the freedom the artist has to exaggerate, to create in a novel a more beautiful, simpler, more consoling nature', he wrote to Theo.[40] Vincent drew inspiration for his *Berceuse* from traditional folk art as well as from music, both of which are capable of speaking directly to the heart, unmediated by the intellect or power of reason. He wrote to Theo about the painting, so vivid in colour: 'Now it looks, you could say, like a chromolithograph from a penny bazaar'—a statement that was not an expression of modesty but rather the articulation of a true artistic ideal.[41]

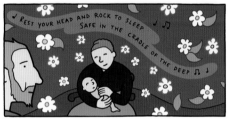

58 Barbara Stok, *Berceuse*, reproduced in *Vincent* (London: SelfMadeHero, 2015), 52. Comic, 20.5 × 13 cm.

The same applies to his desire to create a composition in which the colours alone could evoke 'what the cradle-rocker sang as she rocked the sailors'.[42] That was his aim, and he set the bar high by seeking to express in paint the sound of singing [fig. 58]. This was not easy to achieve, as he later remarked about his painting of rustling ears of wheat.[43] It remained to be seen, therefore, whether he had truly succeeded in letting the canvas sing: 'Whether I've actually sung a lullaby with colour I leave to the critics'.[44] Two weeks later he wrote to Theo: 'Perhaps in the Berceuse there's an attempt at a little *music* of colour from here', referring to a sound he heard every day: the melodious voices of the Arlésiennes (one of whom was his sitter), speaking their Provençal dialect.[45]

Van Gogh's original description of the painting contains an interesting use of musical terminology: 'A woman dressed in green with orange hair stands out against a green background with pink flowers. Now these discordant sharps of garish pink, garish orange, garish green, are toned down by flats of reds and greens.'[46] Here Van Gogh deploys 'sharps' and 'flats' in an unconventional way: in a musical composition, notes raised or lowered a

59 Martinez after J.-F. Millet, *The Angelus*, 1873. Etching, 10.4 × 12.8 cm. Van Gogh Museum, Amsterdam (Vincent van Gogh Foundation).

semitone by such accidentals are not in themselves 'sharp' (in the sense of 'harsh') or 'flat' (in the sense of 'tempered').[47] This recalls his earlier, idiosyncratic use of the word *toonladder* (meaning 'scale'), when he actually meant 'register'.[48] Van Gogh seems not to have cared about the technicalities of musical nomenclature. Evidently he was interested, above all, in the associations evoked by such terms, which he appropriated and put to poetical use in explaining to Theo his own manner of working.

Van Gogh described *La Berceuse* as 'an arrangement of colours: the reds moving through to pure oranges, intensifying even more in the flesh tones up to the chromes, passing into the pinks and marrying with the olive and Veronese greens', and concluded with evident satisfaction: 'As an Impressionist arrangement of colours, I've never devised anything better.'[49] The horrendous difficulty of bringing about such deceptive simplicity, and the fact that it had nearly cost him his life, like Pierre Loti's drowning protagonist, cannot be detected in the outcome—and that was precisely his inten-

tion. In the following months, from January to March 1889, *La Berceuse* was the order of the day: Van Gogh made four more versions of the painting, and while doing so, he visited the Roulin family to hear Joseph singing to baby Marcelle, like 'a woman rocking a cradle or a distressed wet-nurse'.[50] Moreover, he attended the pastoral play performed at the Folies Arlésiennes, where he saw the baby Jesus lying in a manger, hailed by music and song.

Van Gogh's *Berceuse* is a typical example of the kind of 'musical art' that has no visible musical subject. There is music in the title, but not in the picture. In this sense it is comparable to Manet's *Music in the Tuileries* (1862) and also to one of Van Gogh's favourite paintings, *The Angelus* by Millet (1857), in which music as such is not depicted but certainly conjured: the scene evokes the sound of the church bells calling worshippers to Vespers. Theo had sent an engraving after the painting [fig. 59] to Vincent, who made drawn copies of it. In Alfred Sensier's biography of Millet—the book that had held Van Gogh spellbound until the small hours of the morning in March 1882—he had learned about the essence of the work: 'In this painting, truly new in conception, Millet wants to be musical. He professes to make audible the sounds of the countryside, even the ringing of the bells. "It is the verisimilitude of the expression that can render all of that", he used to say.'[51] As early as 1874, Van Gogh had concluded: 'Yes, that painting by Millet "The evening angelus", "that's it". That's rich, that's poetry.'[52] And a decade later he compared the painting to a scene in a novel by Zola, calling it 'equally sublime' because of 'that same dusk, that same infinite emotion'.[53]

In *La Berceuse* he had similarly thematized the soothing effect of music precisely by not showing it literally. Even the object of comfort, the child in the cradle, remains outside the picture: we see only the cord used to rock the cradle. It was the arrangement of hues that bore the burden of expression: the 'symphony of colours' with which he experimented in the different versions of the painting. That symphony was intended to touch the right chord in the beholder, who would then experience the miracle of synaesthesia. In this case, the artist did not want to leave his viewers in any doubt as to what they were meant to hear, for on four of the five versions he painted the title 'La Berceuse', thus transforming abstract sound into a lullaby.

10 SYMPHONIES IN COLOUR
Finale giallo

The various ways in which music influenced Van Gogh's ideas about art can be assigned, roughly speaking, to four different categories. First, he wanted his paintings to evoke music and sound (and other sensory perceptions), and this placed him in a time-honoured tradition of artists who strove to achieve perfect verisimilitude in their work. Second, he aimed to express a higher truth in his art and thus transcend traditional realism. Recent innovations in painting offered ways to achieve this, ways that placed more importance on the means (colour, line, form) and less importance on the actual subject. Form eclipsed content, as it were; the non-narrative aspects prevailed over the narrative. This development was characterized at the time as 'musical', and with his interest in precisely this aspect of painting, Van Gogh joined the ranks of his progressive fellow artists. Third, he thought that, during the creative process, the artist's state of mind was removed from reality, a condition comparable to the entrancing nature of the musical experience and, in fact, the only way to create true art. Fourth, he wanted viewers, too, to enter into such a trance-like state, which would give them an experience both transcendental and consolatory. Van Gogh's ideal in this regard was highly personal: he aspired to make art that would have an emotional impact on viewers and lend them comfort, just as music had been doing for centuries.

Here I would like to focus one last time on Van Gogh's striking use of musical terminology. His letters contain terms that refer to concrete things and

people—psalm, hymn, song, musical instrument, organ, piano, violin, bow, clarion, church bells, musician, troubadour, singer, dancer and composer— as well as to more abstract concepts, some of which had traditionally been used with reference to both painting and music: harmony, composition, tone, vibration and colour. Van Gogh also adopted other words that were normally confined to the musical sphere—such as note, register,[1] sound, melody, rest, scherzo and symphony—which he considered suitable for describing certain aspects of painting.

In the midst of all these examples, the word 'symphony' occupies a special place in his correspondence, occurring also in the plural and in various synonymous expressions. He first used the word in November 1883, twice in the same letter, to describe the artistic inspiration he drew from nature in the village of Zweeloo: 'That return of the flock in the dusk was the finale of the symphony that I heard yesterday', and again two sentences later, 'The day was over, and from dawn to dusk, or rather from one night to the other night, I had forgotten myself in that symphony.'[2] He next used the word in June 1884 to characterize the work of Jules Dupré, the previously mentioned 'colourist' whom he much admired: 'But with Dupré there's something of a magnificent symphony in the colour, *carried through, intended, manly.* I imagine Beethoven must be something like that.'[3] In October 1885 he elaborated on this notion: 'Jules Dupré is like Delacroix in landscape, for what enormous diversity of mood he expressed in symphonies of colour.' In the same letter Van Gogh even describes his own *Lane of Poplars near Nuenen* as 'a symphony in yellow' [fig. 60]: 'Suppose I have to paint an autumn landscape, trees with yellow leaves. Very well—if I conceive it as—a *symphony in yellow*, what does it matter whether or not my basic yellow colour is the same as that of the leaves—it makes *little* difference. *Much, everything* comes down to my sense of the *infinite variety* of tones in the *same family*.'[4]

In January 1886 he delved into this issue more deeply by categorically contrasting 'symphony in colour' with 'correctness of colour': 'Delacroix tried again to get people to believe in the symphonies of the colours. And in vain, one would say, judging by how much almost everyone understands good colour to mean the *correctness* of local colour'.[5] In March 1888 he stated, with reference to a bouquet of flowers painted by Monticelli, 'that you have to go straight to Delacroix to find such an orchestration of colours'.[6] And a couple of months later he wrote to Bernard to say that artists should work together in order to combine their best qualities: 'One has a superb orchestration of colours and lacks ideas. The other overflows with new, harrowing

60 Vincent van Gogh, *Lane of Poplars near Nuenen* (F 45 / JH 959), 1885. Oil on canvas, 78 × 97.5 cm. Museum Boijmans Van Beuningen, Rotterdam.

or charming conceptions, but is unable to express them in a way that's suffi-ciently sonorous, given the timidity of a limited palette.'[7] In August 1888 he could think of '*nothing but large sunflowers*', the 'dozen or so panels' intended to produce, in combination, 'a symphony in blue and yellow'.[8] Finally, in January 1889, he described his cradle-rocking *Berceuse* as a particularly suc-cessful 'arrangement of colours'.[9] Symphony, consonance, orchestration, arrangement: four synonyms for the same painterly ideal—the deeply felt, ingenious amalgamation of colours, comparable to the complex orchestral music of Wagner—which brought about tranquillity, harmony and unity in an artwork.

As Van Gogh himself acknowledged, this colour ideal was not his own invention. It derived from the art-theoretical writings of Delacroix, which he had read about in 1884 in Blanc's *Grammaire des arts du dessin* and *Les Artistes de mon temps*. Blanc was, in fact, the source of the term 'orchestra-tion of colours'. An interesting detail in this context is the fact that, in their

61 Vincent van Gogh's red lacquered box, containing sixteen small balls of wool. Wood and wool, 11 × 30 × 16 cm. Van Gogh Museum, Amsterdam (Vincent van Gogh Foundation).

daily studio practice, both Delacroix and Van Gogh made use of little balls of coloured wool in devising their colour schemes. (It is not known if Van Gogh got this idea from Delacroix.)¹⁰ Later, Bernard clearly recalled seeing those balls of wool in Van Gogh's studio: 'On the table, in the midst of several Japanese prints, [lay] balls of wool, the interlaced threads of which played unexpected symphonies' [fig. 61].¹¹ It is possible that Bernard picked up this musical imagery from Van Gogh. On the other hand, the word 'symphony', combined in some way with colours, had become such a standard expression in artistic discourse that it was on everyone's lips—including Theo's, who in 1889 had described Gauguin's painting *The Aven Running through Pont-Aven* as 'a beautiful symphony'.¹²

A chronological list of examples serves as a prelude to Van Gogh's interpretation of the word. In 1852 the critic Théophile Gautier published a volume of poetry, *Emaux et Camées*, that included a verse called 'Symphonie en blanc majeur' (Symphony in white major). In 1859 the artist and critic

Zacharie Astruc wrote about Delacroix, 'Delacroix's art must be heard—yes, heard, for his paintings seem made of musical notes. They are splendid symphonies. It is the German art of sound applied to colour—the same masterful combination of instruments: profound, strange, unexpected'.[13] James McNeill Whistler exhibited *The White Girl* in Paris in 1862, and the critic Paul Mantz described it as 'nothing other than the symphony in white'.[14] This prompted Whistler to rename his work *The White Girl: Symphony in White, No. 1*, and he subsequently made a new series of paintings with the titles *Symphony in White, No. 2* (1865), *Symphony in Grey and Green: The Ocean* (1866), *Symphony in White, No. 3* (1867) and *Arrangement in Grey and Black, No. 1 (Portrait of the Artist's Mother)* (1871). He explained, 'Why should not I call my works "symphonies", "arrangements", "harmonies" and "nocturnes"? The picture should have its own merit, and not depend on dramatic, or legendary, or local interest . . . Art should be independent of all claptrap— should stand alone, and appeal to the artistic sense of eye or ear, without confounding this with emotions entirely foreign to it, as devotion, pity, love, patriotism and the like. All these have no kind of concern with it.'[15] Van Gogh knew Whistler's *Arrangement in Grey and Black, No. 1* [fig. 62]. In a letter to Willemien, he compared it to Thomas Moore's poem 'Who Is the Maid?', saying, 'There's a painting that Whistler did of his mother which is like that.'[16]

Théodore de Wyzewa praised Fantin-Latour's paintings as 'symphonies', and in 1883 the writer Jules Laforgue demonstrated his enthusiasm for the landscapes of Pissarro and Claude Monet in similar terms: 'No longer an isolated melody, the whole thing is a symphony which is living and changing like the "forest voices" of Wagner'.[17] In magazines, newspapers and books, both fiction and nonfiction, paintings were described as 'symphonies in colour' until well into the twentieth century, also in the Netherlands. In his novel *Inwijding* (Initiation), published posthumously in 1888, Carel Vosmaer applied the term to the art of the Italian Renaissance: 'Titian's Bella is no less glorious than his Flora; blue, violet, gold and white form a symphony in colour; what women that man saw or created!'[18] And the art critic G. H. Marius described Jacob Maris's 'sparkling barge-canal'—with its 'warm sky filled with colour and light, with the vigorous green along the towpath, with the grey of the horse'—as 'a magnificently declaimed symphony in colour'.[19]

It stands to reason that Odilon Redon called himself a 'symphonic painter' ('peintre symphonique').[20] Symphonic painting, which had come to be seen as a virtue, had meanwhile become part of the curriculum at art academies. The first director of Amsterdam's Rijksacademie, the painter-

62 James Abbot McNeill Whistler, *Arrangement in Grey and Black, No. 1 (Portrait of the Artist's Mother)*, 1871. Oil on canvas, 144.3 × 163 cm. Musée d'Orsay, Paris.

professor Bastiaan de Poorter, wrote an essay titled *De kunst en de kunst-akademie* (Art and the art academy), published in 1870, in which he discussed the relationship between painting and music, and also drew the link between a painting and a symphony orchestra: 'The effect created by the disposition of colours heightens their mutual capabilities, elevating them to the highest power. The colour heightens the expression of a scene and is a source of cheerfulness or gravity, weakness or strength, etc. The various colours correspond to the various sonorities of an orchestra, so that one can say of a great composition—it is a colour symphony.'[21]

Such a list of examples suggests that the term 'symphony in colour' had reached saturation point, and in a certain sense this was true: some critics used it to describe nothing more than a well-composed painting or an intelligently curated exhibition. In 1874 the critic Henry Blackburn commented on the first Whistler exhibition in London: 'The Gallery and its contents are

SYMPHONIES IN COLOUR

altogether in harmony—a "symphony in colour" carried out in every detail, even in the colour of the matted floor, the blue pots and flowering plants . . . a harmony of colour agreeable to the eye'.[22] A pleasure to behold, a feast for the eyes—everything was fine as long as the 'symphony' was agreeable and not at all jarring. By no means did everyone recognize or appreciate the idea of abstraction and experimental zeal inherent in the expression: as late as 1920, a reviewer called an early painting by the Cubist painter André Lhote 'a brilliant display, or rather: a symphony in colour', and did not intend this as a compliment: 'Superb as such, it left the viewer dissatisfied, it belonged to "absolute" painting. Later he again directed his artistic passion towards life.'[23] A meaningless artwork, a painting without a narrative, a purely musical display of colours—then, as now, it was not what most people wanted.

SYMPHONY IN BLUE AND YELLOW

For Van Gogh the word 'symphony' primarily described the condition of the artist while painting, the intense concentration that is at once presence and absence, akin to what might be called 'creative intuition' or 'flow'. At those times he stepped out of reality, let go of reason, slipped from consciousness into semi-consciousness, and entered another universe, a world in which he heard 'heart-rending music'. In Van Gogh's vocabulary, 'symphony' and 'music' in general were terms that expressed the artist's exceptional ability to transcend everydayness and reality.

Accordingly, the second definition he attached to the word 'symphony' was equally important to him: 'symphony' as a synonym of 'unity'—referring to his ambition to create a coherent whole from a scarcely containable chaos of colour and detail. He thus followed in the footsteps of Wagner, who considered his *Gesamtkunstwerk* (the synthesis of music, drama, décor and costume that gave rise to the ideal work of art) as an inevitable reaction to the alarming fragmentation of modern life. Van Gogh's vision, however, was undoubtedly much more personal. His constant search for coherence was fuelled by the fragmentation not so much of society as of his own mind. This feverish yearning characterized his life, and he projected it onto his art. He knew that utmost concentration was the only way to subdue both inner and outer turmoil: focusing on something concrete—a portrait, a landscape, a still life—just as the Old Dutch painters had done: 'If we don't know what to do, my dear old Bernard, then let's do the same as them, if only so as not to

allow our scarce mental powers to evaporate in sterile metaphysical meditations that aren't up to bottling chaos, which is chaotic for the very reason that it won't fit into any glass of our calibre. We can—and that's what those Dutchmen did, desperately clever in the eyes of people wedded to system—we can paint an atom of chaos. A horse, a portrait, your grandmother, apples, a landscape.'[24]

The challenge, then, was to depict that 'atom' in all its intensity and colour, to capture it on the canvas in a coherent way: grandly executed but nonetheless intimate, and with the inexorable logic of a Wagner opera. It was not easy to bring this off. Despite all hope, there was constant doubt. At such times he feared that the ideal was doomed to failure. 'I don't know if I'll ever do tranquil and calmly worked paintings, myself, as it seems to me that it will always remain disjointed', Vincent wrote to Theo in the summer of 1888, shortly before he began to paint his sunflowers.[25]

Van Gogh sought the symphonic not only in individual paintings but also in combinations of artworks. With 'a dozen or so panels' on the go all at once, he hoped to create an enchanting 'symphony in blue and yellow'. It was his intention to make the complete decoration of the Yellow House in Arles a coherent whole: each new painting was directly related to the preceding one.[26] In a letter to Theo he mentioned works 'that hold together and complement each other', and to Bernard he wrote that these works were taking shape 'so unintentionally there's a certain sequence'.[27] In this way contrasts could be reconciled—such as day and night, indoors and outdoors, nature and art (in his mind's eye he saw the painting of *Wheatfields* juxtaposed with the portrait of *Marguerite Gachet at the Piano*).

Other painters, too, thought in such overarching terms, imagining works in series and combinations. One example is the Norwegian painter Edvard Munch, Van Gogh's junior by ten years, who used the same musical terms as Van Gogh in a letter he wrote to the Danish painter Johan Rohde in early 1893. It is possible that Munch had become aware of Van Gogh's ideas through Rohde, who had bought Van Gogh's painting *Mountainous Landscape* at the 1892 sale exhibition held in The Hague, which had been organized and curated by Jo van Gogh-Bonger and Jan Toorop.[28] According to Munch, a group of paintings could produce 'the effect of a symphony'. Later he wrote, 'I placed them next to one another and noticed that the individual paintings were thematically related.' He detected a 'resonance': 'They took on a different meaning from the one they had had on their own. It became a symphony.'[29]

Remarkably, Van Gogh's contemporaries, though unaware of his ideas, reacted to his art in terms that reflected his vision. His paintings were soon described as symphonies, and he himself was even put on a par with Wagner. When he took Theo's advice and submitted six works to the exhibition of the Belgian artists' collective Les Vingt in Brussels in early 1890, Theo wrote to him, 'It appears that the exhibition of Les Vingt in Brussels is open; I read in a newspaper that the canvases which excite the greatest curiosity are the open-air studies by Cézanne, Sisley's landscapes, Van Gogh's symphonies and the works of Renoir.'[30] An article written on the occasion of the Paris exhibition of the Société des Artistes Indépendants, which had opened on 19 March 1890 and included ten paintings by Van Gogh, also pointed out the symphonic nature of his work: 'Mr Vincent van Gogh's wild impastoes and his exclusive use of colours with flowing harmonies create powerful effects: the purple backgrounds of "Cypresses" and the symphony of greens in a patch of undergrowth make a vivid impression.'[31]

Years later Jo wrote about Van Gogh's work from the period in Saint-Rémy in her introduction to the first edition of his letters: 'It is no longer the joyous, sunny, jubilant quality of his work from Arles; there sounds a deeper, more sorrowful tone than the piercing clarion call of his symphonies in yellow of the previous year. His palette has become more sober; the harmonies of his paintings have modulated into a minor key.'[32]

At the opening on 16 May 1892 of the sale exhibition in The Hague, where Rohde bought his Van Gogh, Jo met the painter Jozef Israëls, for whom Van Gogh's work evoked a remarkable association, as she recorded in her diary: 'A lot of people came in the afternoon—the old Israëls gave me the most pleasure—he thought some of them very beautiful—but he said there was a boundary between things that can be painted and things that can't be painted—and Vincent had often wanted to paint those that were impossible, the sun, for example. But when he had chosen things that lay within his reach, he had produced much that was beautiful. He compared him to Wagner.'[33]

Others were also quick to compare Van Gogh to Wagner. Five days later, for instance, on the occasion of the Van Gogh exhibition held in Paris at the same time, Frans Lapidoth wrote in *De Nederlandsche spectator*, 'I'm convinced that, on the path he has indicated, something will be found of which we have not yet dreamed: a truly modern art, something like the music of Wagner.'[34]

THE HIGH YELLOW NOTE

In Van Gogh's vision, the idea of 'music' represented the unattainable, the endless, the blue in the distance, which he hoped to approach with his art. A phrase he often repeated, the 'quelque chôse-là-haut' (something on high), to which the supernatural and indefinable are linked, ties in with that vision. He probably recognized something of himself in what Michelet wrote about the singing nightingale and in what Zola had shown in *L'Oeuvre* about the danger of music. Although Van Gogh knew relatively little of Wagner's music, he knew enough to see him as the great artist who had succeeded in realizing his ultimate ideal. In Van Gogh's time, music symbolized the craving for a new artistic freedom. The 'music of the painting' was another way of saying that visible things concealed a deeper truth, a truth the artist must try to express in paint. In his own way, Van Gogh made a profound contribution to that pursuit of truth, and referred to it both in musical terms and in such turns of phrase as 'a certain je ne sais quoi'[35] and 'that's it'. Not only did he attempt to capture on canvas the 'vibration' of the mystery, but he spoke of 'the mysterious vibrations of adjacent tones' and sought to arrange the 'colours in a painting to make them shimmer'. 'It vibrates', he said admiringly of a flower still life by Monticelli.[36] 'NO BLUE WITHOUT YELLOW'. Water and air were by their very nature colourless; they only became blue through the effect of the yellow sun.[37]

The tension between the literary and the musical—or, in the vocabulary of Delacroix, between 'réalisme' and 'idéalisme'—was always at the back of Van Gogh's mind. Few artists were so obsessed with the desire to link the visible world (reality) to the 'music behind things' (emotions). He searched frantically for the ultimate, definitive bridge between the two.[38] Clearly, this obsession was harmful to him. He no longer took walks, he ate poorly and irregularly, and, according to his physician, he scarcely slept, keeping himself going with coffee and alcohol. Even so, Van Gogh did not consider these the primary reasons for his mental derailment. He wrote to Theo, 'I admit all that, but it will still be true that I had to key myself up a bit to reach the high yellow note I reached this summer. That, after all, the artist is a man *at work,* and that it's not for the first passer-by who comes along to vanquish him once and for all.'[39]

The 'high yellow note' represented both the heights and the depths to which his chrome-yellow sunflower symphony had brought him in the

63 Vincent van Gogh, *Sunflowers in a Vase* (F 456 / JH 156), 1888. Oil on canvas, 91 × 71 cm. Neue Pinakothek, Bayerische Staatsgemäldesammlungen, Munich.

summer of 1888 [fig. 63]. He called it the best he had ever done, but went on to say 'and that was the first and last cause of my going out of my mind'. The musical wording is revealing in this context. It fits in with Van Gogh's earlier use of the term 'register', with the interest he had long shown in the connection between sound and colour, and, in general, with the relationship that exists between madness and music. Evidently the highest in art could only be described in musical terms. Like a brilliant tenor, he had hit higher notes than ever before, but it remained to be seen whether he would ever again climb so high: 'Now, if I recover I *must start again*, and I can't again attain those peaks to which sickness imperfectly led me.'[40]

In 1885 he had left his bewildered piano teacher behind in Eindhoven—an episode that is invariably related with not a little irony and amusement in biographies of Van Gogh. In the light of the above, however, those piano lessons prove to have had much more than mere anecdotal value: they were a harbinger of his striving to create symphonies in colour and to reach the highest note. In this respect music was bound up with the most profound motives of Van Gogh's artistry.

NOTES

I. HEARING COLOURS

1. The quoted passages and other details in this paragraph were taken from Van Gogh, *Letters* (hereafter cited as VGL), letters 638, 639, 658, 659, 663, 665, 666, 680, 683 and 763. Van Gogh's various descriptions of the mistral include 'really aggravating', the 'infuriating nuisance of the constant mistral' and 'the devil of a mistral'.
2. Vincent to Emile Bernard, Arles, c. 21 August 1888, and Vincent to Theo, Arles, 21 or 22 August 1888, VGL, letters 665 and 666.
3. Vincent to Theo, Saint-Rémy-de-Provence, c. 20 September 1889, VGL, letter 805 (here he quotes an article by Pierre Loti on Carmen Sylva).
4. Vincent to Theo, Nuenen, c. 21 September 1884, VGL, letter 458.
5. See, for example, Morton and Schmunk, *Arts Entwined*; Fonsmark and Lederballe, *Delacroix*; Leonard, 'Picturing Listening'; Vergo, *Music of Painting*; Dolan, *Manet, Wagner*; and Rubin and Mattis, *Rival Sisters*.
6. On the importance of auditory stimuli to Delacroix, see Pomarède, 'Silent Arts', 69; and Schmunk, 'What Did Van Gogh Hear?', 37. On Manet, see Dolan, *Manet, Wagner*.
7. Vellekoop, *Van Gogh's Studio Practice*, 86–87.
8. Hammacher and Hammacher, *Van Gogh*, 8–9.
9. Meyers, *De jonge Vincent*, 95. His count: Beethoven 2x, Berlioz 1x, Wagner 7x, 'no other musicians are mentioned'. Not only are these numbers incorrect, but these are not all the composers mentioned in Van Gogh's correspondence.
10. Dorn, 'Van Gogh, Gauguin und Richard Wagner'; and Schmunk, 'Van Gogh in Nuenen and Paris'. Cf. also Schmunk, 'What Did Van Gogh Hear?'; and Schmunk, 'Artists as Musicians', 270–71.
11. Van Eeden, 'Kunst: Vincent van Gogh', 266.
12. Veth, 'Studiën over moderne kunst', 431.
13. 'Die Cypressen wirken wie eine Fanfare—herrlich!' Klas Valter Fåhraeus to Jo Cohen-Gosschalk-Bonger, 29 December 1911, Family Records, Van Gogh Museum, Amsterdam (Vincent van Gogh Foundation) (henceforth cited as VGM), b6032. He bought the drawing from Jo.

14. Gombrich, *Art and Illusion*, 203; Bailey, *Sunflowers*, 52; Champa, 'La Berceuse', 107; Bell, *Van Gogh*, 82; and Barnes, 'Selfie with Sunflowers'.
15. De Brouwer and Nelemans, 'Van Gogh en Eindhoven'.
16. 'Le coloris s'apprend comme la musique.' Blanc, *Artistes de mon temps*, 62. On Van Gogh's use of colour, see Vellekoop, *Van Gogh's Studio Practice*, 16–25.
17. Anton Kerssemakers, 'Herinneringen aan Vincent van Gogh', *De Amsterdammer* 36 (1912); quoted in Van Stipriaan, *Vincent van Gogh*, 66.
18. Vincent to Theo, Arles, 18 September 1888, VGL, letter 683.
19. 'Le beau Pinceau est à la Peinture ce qu'est à la Musique une belle voix.' Félibien, *L'Idée*, 41.
20. De Jongh, *Muziek aan de muur*, 47–48.
21. On this development, see, among others, Lindenberger, 'Literature and the Other Arts'; and Junod, 'The New *Paragone*'.
22. Viardot turned the motto around, but meant the same thing by it. Viardot, 'Ut pictura musica'.
23. Cf. Morton and Schmunk, *Arts Entwined*, 12: 'The desire to make painting be more like music motivated painters, paradoxically, to discover and use what was unique about their own medium.'
24. Roskill, *Van Gogh*, 89.
25. Vincent to Theo, Arles, 10 March 1888, VGL, letter 584.
26. He saw Fantin-Latour's work in the form of a print in the magazine *L'Illustration*; Vincent to Theo, Nuenen, 4 and 5 May 1885, letter 500. For the other paintings, see VGL, letters 171 (Maris), 308 (Legros), 534 (Hals), 721 (Gauguin), and 858 and 898 (Toulouse-Lautrec).
27. Keats, 'Ode on a Grecian Urn' (1819).
28. Bruhn, *Europas klingende Bilder*, 174. On compositions inspired by Van Gogh's life and work, see also Porter, 'Van Gogh in Music'.
29. On this composition, which is based on seven passages from Van Gogh's letters, see Ketting, 'Een Duitsche Van Gogh-muziek', 1–2, 9–10, 20–22.
30. Included on Marcel Worms (piano), *Pictures at a Van Gogh Exhibition*, Vermes Records/Van Gogh Museum, Amsterdam, 1998, compact disc.
31. Five 'one-act youth musicals': *Vincent in Arles*, *De dood van Vincent* (Vincent's death), *Machteloosheid: Vincent van Gogh en zijn liefdes* (Powerlessness: Vincent van Gogh and his loves), *Vincent in Parijs* (Vincent in Paris), and *Sociale bewogenheid van*

Vincent van Gogh (Vincent van Gogh's social conscience).

32. Vincent to Theo, Nieuw-Amsterdam, c. 15 October 1883, VGL, letter 396.

33. Vincent to Theo, Arles, 17 or 18 December 1888, VGL, letter 726.

34. For a recent overview, see, for example, the sections 'Biographical and Historical Context' and 'Chronology' in the online edition of Van Gogh's letters (www.vangoghletters.org).

35. One of the seven paintings is lost. See Bailey, *Sunflowers*.

2. MUSIC AT HOME

1. Vincent to Theo, The Hague, 6 and 7 July 1882, VGL, letter 245.

2. Vincent to Theodorus van Gogh (Father) and Anna van Gogh-Carbentus (Mother), Nieuw-Amsterdam, c. 26 October 1883, VGL, letter 399.

3. Kools, *Vincent van Gogh*, 51 and, regarding the brass band, 85–86; Van Beek and Erenstein, *De aanteekeningen*, 109 (Aunt Mietje mistakenly reports that the harmonium was inaugurated on Friday, 5 August).

4. Mother to Theo, Helvoirt, 4 March 1873, VGM, b2606.

5. Father to Theo, Etten, 13 August 1876, VGM, b2768.

6. Father to Theo, Etten, 18 November 1876, VGM, b2794.

7. Father to Theo, Etten, 1 July 1877, VGM, b2538.

8. Father to Theo, Etten, 11 June 1877, VGM, b2535.

9. Vincent to Theo, Amsterdam, Monday, 28 May 1877, VGL, letter 116.

10. Father to Theo, Helvoirt, 2 July 1873, VGM, b2639.

11. Vincent to Theo, Isleworth, 25 November 1876, VGL, letter 99.

12. Vincent to Willem and Caroline van Stockum-Haanebeek, 'The Eve of Saint Mark', London, 7 August 1873, VGL, letter 12.

13. Vincent to Theo, The Hague, 31 December 1882 and 2 January 1883, VGL, letter 297.

14. Kools, *Vincent van Gogh*, 98.

15. Quoted in ibid., 102.

16. Father and Mother to Theo, Helvoirt, 15 November 1873, VGM, b2673. The greenery consisted of garlands of twigs and leaves.

17. Father to Theo, Etten, 24 August 1878, VGM, b2435.

18. Vincent to Theo, Etten, 15 August 1878, VGL, letter 147.

19. Mother to Theo, Helvoirt, 19 May 1874, VGM, b2702.

20. Kools, *Vincent van Gogh*, 17.

21. Vincent to Theo, Isleworth, 26 August 1876, VGL, letter 89. The expression 'faith of old' comes from Rhyming Psalm 42:7.

22. Father to Theo, Nuenen, 11 November 1884, VGM, b2261.

23. On this subject, see www.vangoghletters.org, 'About This Edition: The Annotations', section 5.3.1 ('The Bible and Devotional Texts').

24. Vincent to Theo, Ramsgate, 1 May 1876, VGL, letter 80. He sent the books with letter 81. On this subject, see also Naifeh and Smith, *Van Gogh*, 133.

25. 'If Van Iterson gave you that English hymnal, read No. 14'. Vincent to Theo, Isleworth, 3 October 1876, VGL, letter 92. See also letter 91.

26. Vincent to Theo, Ramsgate, 12 May 1876, VGL, letter 82.

27. Vincent to Theo, Ramsgate, 12 May 1876, VGL, letter 82.

28. Vincent to Theo, Isleworth, 26 August 1876, VGL, letter 89. For quotations from the hymn, see also letters 84 and 96.

29. Father and Mother to Theo, Etten, 17 June 1876, VGM, b2753. Regarding this new instrument, see also VGM, b2752 (2 June 1876).

30. 'Our Lies is home, she plays the piano so nicely and could instantly play the little organ.' Mother to Theo, Etten, 1 July 1876, VGM, b2755.

31. Father and Mother to Theo, Helvoirt, 3 December 1874, VGM, b2735.

32. Mother to Theo, Etten, 6 July 1876, VGM, b2758.

33. Mother to Theo, Nuenen, 1 February 1889, VGM, b2426.

34. Mother and Willemien to Jo, The Hague, 19 December 1901, VGM, b3631.

35. Jo to Theo, Amsterdam, 29 January 1889, in Jansen and Robert, *Brief Happiness*, 124.

36. Mother to Theo, Nuenen, 1 February 1889, VGM, b2426.

37. Theo to Jo, Paris, Thursday, 7 March 1889, in Jansen and Robert, *Brief Happiness*, 200. See also Theo's letter of 26 January 1889, in which he says, 'I should like to have the piano if it is not too ramshackle.'

38. This was why she wanted the moving crate back. As Mother wrote to Theo, 'How's the pianino? . . . Another thing, Aunt would very much like to have the piano crate back, because her Erard fits into it perfectly. You would be doing me a great favour if you were to do it, even though for the cost of transport she could get a new crate, it's her wish to have the old one back.' Mother to Theo and Jo, Princenhage, 29 April 1889, VGM, b2913. Erard is a highly esteemed make of piano; the factory was in Paris.

39. Andries Bonger to H. C. Bonger (his father) and H. L. Bonger-Weissman (his mother), Paris, 25 December 1889, VGM, b1850.

40. Jo to Vincent, Paris, 8 May 1889, and Vincent to Willemien, Auvers-sur-Oise, 5 June 1890, VGL, letters 771 and 879.

41. Vincent to Theo, Isleworth, between 2 and 8 September 1876, VGL, letter 90. Vincent also copied out these four texts on one sheet of an album for Theo; see Pabst, *Van Gogh's Poetry Albums*, 62.

42. Vincent to Theo, Isleworth, Friday, 18 August 1876, VGL, letter 88.

43. Vincent to Paul Gauguin, Arles, 21 January 1889, VGL, letter 739.

44. The surviving sources, which are incomplete, do not contain information on this subject.

45. On women and the piano, see Loesser, *Men, Women and Pianos*, 64; Weber, *Music and the Middle Class*, 35–36; and Metzelaar, 'Klanken van de zijlijn', 109.

46. Father and Mother to Theo, Etten, 8 March 1876, VGM, b952.

47. Lies to Theo, n.d. (probably Helvoirt, 1873), VGM, b2657; Lies to Theo, Tiel, 26 September 1875, VGM, b2364; Willemien to Theo, n.d. (c. Oct./Nov. 1873), VGM, b2667; and Mother to Theo, Helvoirt, 7 February 1875, VGM, b2319.

48. Willemien to Theo and Jo, Leiden, 13 December 1889, VGM, b2859.

49. Van Deyssel, *Een liefde*, 105.

50. On this subject, see, among others, Vergo, *Music of Painting*, 20.

51. Vincent to Theo and Jo, Auvers-sur-Oise, c. 10 July 1890, VGL, letter 898.

52. Vincent to Theo, Auvers-sur-Oise, 28 June 1890, VGL, letter 893.

53. Vellekoop and Zwikker, *Van Gogh Drawings*, 491–95.

3. MUSICAL ENCOUNTERS

1. Theo to Willemien, Paris, 14 March 1888, VGM, b915.

2. Theo to Jo, 9–10 February 1889, in Jansen and Robert, *Brief Happiness*, 148–49. Theo went to the concert with Joseph Isaäcson and Meijer de Haan. Jo's father played the violin in a quartet; her brother Henri played the cello; she and her sister Mien played the piano; their youngest sister, Beb, studied voice at the conservatoire; and their youngest brother, Wim, took violin lessons.

3. The phrase occurs in five of Vincent's letters to Theo (VGL 519, 534, 539, 547, 555) and one to Van Rappard (439).

4. Vincent to Theo, London, 13 June 1873, VGL, letter 9. Their mother wrote about it approvingly: 'Don't you think it good that Vincent went out with his employer? Those Germans make music; he likes that'. Mother to Theo, n.d. (probably Helvoirt, c. 13 June 1873), VGM, b2636. See also VGL, letter 10.

5. Hammacher and Hammacher, *Van Gogh*, 9; Meyers, *De jonge Vincent*, 95.

6. Mother to Theo, Helvoirt, 9 January 1873, VGM, b2317; and Lies to Theo, Leeuwarden, 10 January 1875, VGM, b2313.

7. Lies to Theo, Tiel, 17 October 1875, VGM, b2368. Lies refers to Czerny's famous studies for piano and *L'espoir du retour*, J. Goetschy's caprice for piano, op. 120. See 'Lijst der herdrukte stukken in september', *Caecilia* 26, no. 21 (1 November 1869).

8. Willemien to Theo, Middelharnis, 19 October 1888, VGM, b2275.

9. Jo to Theo, Amsterdam, 25 January 1889, Jansen and Robert, *Brief Happiness*, 112–13.

10. Theo to Jo, Paris, 28 January 1889, Jansen and Robert, *Brief Happiness*, 121.

11. Vincent to Father and Mother, Ramsgate, 17 April 1876, VGL, letter 76.

12. Father to Theo, Etten, 6 December 1876, VGM, b2800. He had previously observed with satisfaction that Theo had heard 'a beautiful concert in the park' in Brussels. Father and Mother to Theo, Helvoirt, 23 June 1873, VGM, b2637.

13. Father and Mother to Theo, Helvoirt, 1 September 1873, VGM, b2656.

14. Father to Theo, Helvoirt, 14 February 1874, VGM, b2687; Lies to Theo, Leeuwarden, 18 October 1874 and 14 February 1875, VGM, b2735 and b2322.

15. Jo to Lies, Amsterdam, 21 February 1886, VGM, b3552; Eduard Lassen, *Ausgewählte Lieder und Gesänge mit Begleitung des Pianoforte*, Vorsatz (Resolution), op. 48, no. 4, Für Sopran oder Tenor, Breslau, n.d.

16. Andries to Jo, Paris, c. 24 February 1886, VGM, b1024.

17. Andries to Jo, Paris, 26 February 1885, VGM, b1026, and to his parents, Paris, 3 March 1886, VGM, b1837. It is not clear whether he is referring to the staged première of Offenbach's opera in 1881.

18. Andries to Jo, Paris, 16 January 1885, VGM, b1025.

19. Vincent to Theo, Antwerp, c. 6 December 1885, VGL, letter 546.

20. Ibid.

21. Vincent to Theo, Antwerp, 28 December 1885, VGL, letter 550.

22. Vincent to Theo, Antwerp, c. 6 December 1885, VGL, letter 546.

23. Ibid.

24. Vincent to Theo, Antwerp, 28 December 1885, VGL, letter 550. He painted two portraits of her in any case; the second is *Woman with a Red Ribbon in Her Hair* (F 207 / JH 979).

25. Countless texts have been written on Wagner's influence in Europe. With regard to Paris, in particular, in the period 1850–90, see De Leeuw, 'Richard Wagner'; Vergo, *Music of Painting*; and Dolan, *Manet, Wagner*. On Van Gogh and Wagner, see Dorn, 'Van Gogh, Gauguin und Richard Wagner'; Schmunk, 'Van Gogh in Nuenen and Paris' and 'What Did Van Gogh Hear?'; and Ridley, *Wagner and the Novel*.

26. *Der Ring des Nibelungen* is a cycle of four operas, lasting some fifteen hours altogether.

27. Gauguin, *Avant et après*, 160.

28. Andries to his parents, Paris, 12 and 26 November 1881, VGM, b1693 and b1689.

29. Andries to his parents, Paris, 26 February 1882, VGM, b1704.

30. Andries to Jo, Paris, 26 February 1885, VGM, b1026.

31. Theo to Willemien, Paris, 14 March 1888, VGM, b915. See also introduction to Van Gogh, *Brieven aan zijn broeder*, vol. 1.

32. Schmunk ('Van Gogh in Nuenen and Paris', 191) counted nine concerts featuring the music of Wagner that took place between 15 January and 12 February. He discounts two of these as performances possibly attended by Vincent and Theo, because the programmes included music by Berlioz, a composer whom Van Gogh later appears not to know (see VGL, letter 739). It is possible, however, that Van Gogh is referring not to Berlioz's work in general but to the *Symphonie Fantastique* in particular, which would refute Schmunk's argument. Cachin and Welsh-Ovcharov (*Van Gogh à Paris*, 34) state that one of the concerts that Vincent and Theo attended took place on 14 February 1888, but there is no source to confirm this.

33. Theo to Willemien, Paris, 14 March 1888, VGM, b915.

34. Vincent to Theo, Nuenen, mid-June 1884, VGL, letter 450.

35. Theo and Jo to Theo's mother, Paris, 29 August 1889, VGM, b925.

36. Theo to Jo, Paris, 10 March 1889, in Jansen and Robert, *Brief Happiness*, 205.

37. Vellekoop and Van Heugten, *Vincent van Gogh Drawings*, 246–48.

38. For information on this text and the drawing, see ibid., 107–11. Van Gogh mistakenly wrote 'balladait' instead of 'baladait'.

39. Ibid., 231.

40. 'En travaillant, il animait l'atelier de ses boutades et de ses chansons. Toute la série des chansons de Bruant sur les différents quartiers de Paris y passait. "A Saint-Lazare", "A Ménilmontant", "Aux Batignolles", faisaient partie de son répertoire, mais il avait une préférence pour les quartiers champêtres; avec entrain il entonnait: "Au Bois de Boulogne" . . . "Au Bois de Vincennes" Chansons, monologues, il avait tout appris par coeur.' Gauzi, *Lautrec*, 23–24.

41. Bonger, 'Letteren en Kunst.'

42. Vincent to Theo, Saint-Rémy-de-Provence, 1 February 1890, VGL, letter 850. Lyrics by Lucien Delormel and Léon Garnier, music by Louis-César Desormes.

43. Vellekoop, *Van Gogh's Studio Practice*, 86.

44. Vincent to Anthon van Rappard, Etten, 15 October 1881, VGL, letter 176.

45. Vincent to Theo, The Hague, c. 11 April 1883, VGL, letter 336.

46. Vincent to Willemien, Arles, 21 or 22 August 1888, VGL, letter 667. See also letter 663.

47. Vincent to Gauguin, Arles, 21 January 1889, VGL, letter 739.

48. Vincent to Theo, Arles, 22 January 1889, VGL, letter 741.

49. Garagnon, 'Odeon, Van Gogh', 14–17.

50. According to Silverman (Van Gogh and Gauguin, 357), Van Gogh saw Riboun: Pastouralo, Opéra Comique en 5 ate; the libretto was written by the Perret brothers and the music composed by M. A. Verandy. The performance was announced in the local newspaper, Le Forum Républicain, on 13 January 1889.

51. Vincent to Theo, Arles, 28 January 1889, VGL, letter 743.

52. Ibid.

53. Vincent to Theo, Arles, 3 February 1889, VGL, letter 745.

54. Lies to Mother, Willemien and Cor, Carteret, 30 July 1886, VGM, b4173.

55. Vincent to Theo, Arles, 5 July 1888, VGL, letter 636.

4. READING ABOUT MUSIC

1. On Van Gogh's relationship to the literature he read, see Sund, True to Temperament; and Van der Veen, Van Gogh. On Van Gogh as a writer, see Jansen, Van Gogh and His Letters; Van Halsema, 'Vincent van Gogh'; and Grant, 'My Own Portrait in Writing'.

2. Vincent to Theo, Cuesmes, between c. 22 and 24 June 1880, VGL, letter 155.

3. 'Expériences du Phonographe de Edison, destinées à faire époque dans l'histoire de l'humanité'. Jean-Léo, Het circusleven in Brussel, 72. The Dutch writer Multatuli also witnessed such a demonstration in 1879, probably in the German city of Wiesbaden. Willaert, 'Multatuli', 103.

4. Uhland, 'Die Orgel'. Van Gogh quoted the Dutch translation ('Avondzang') from Van Meurs, Het leven van Ludwig van Uhland, 130. He probably copied it on the sheets of poetry he sent to Theo, Isleworth, c. September 1876, VGL, RM09. He copied out the German original in two of his poetry albums; see Pabst, Van Gogh's Poetry Albums, 34 and 45.

5. Arranged for voice and piano in 1872 by the composer James Gileson. Vincent to Theo, Isleworth, 25 November 1876, VGL, letter 99.

6. Pabst, Van Gogh's Poetry Albums, passim.

7. Mother to Theo, Etten, 7 March 1877, VGM, b2511.

8. See Vincent to Willem van Stockum and Caroline van Stockum-Haanebeek, London, 2 July 1873, VGL, letter 10; see also Vincent to Theo, London, 20 July 1873, VGL, letter 11.

9. Vincent to Theo, The Hague, 26 and 27 November 1882, VGL, letter 288.

10. This poem by Armand Silvestre was set to music by Jules Massenet. Cf. Vincent to Emile Bernard, Arles, c. 19 June 1888, VGL, letter 628.

11. 'Une voix triste et douce, à travers la pluie et à travers ses larmes'. Jean Richepin, Miarka, la fille à l'ourse, 5th ed. (Paris, n.d.), 4:237. The poem was set to music by Ernest Chausson, as the first of his 'Deux chansons de Miarka', op. 17, 1888. Cf. Vincent to Theo, Arles, c. 1 April 1888, VGL, letter 591.

12. Vincent to Willemien, Paris, end of October 1887, VGL, letter 574.

13. Vincent to Theo, The Hague, 26 July 1882, VGL, letter 251.

14. 'Maintenant il entendait le long roulement qui partait des Halles. Paris mâchait les bouchées à ses deux millions d'habitants. C'était comme un grand organe central battant furieusement, jetant le sang de la vie dans toutes les veines. Bruit de mâchoires colossales, vacarme fait du tapage de l'approvisionnement, depuis les coups de fouet des gros revendeurs partant pour les marchés de quartier, jusqu'aux savates trainantes des pauvres femmes qui vont de porte en porte offrir des salades, dans des paniers.' Zola, Le Ventre de Paris, 35; English trans. (as The Belly of Paris), 29.

15. On Zola and music, see Brown, 'Music in Zola's Fiction'; Brown and Niess, 'Wagner and Zola Again'; Poulet, Emile Zola; Foa, 'One Art Eating the Other'.

16. 'Monsieur de Vandeuvres, demanda madame Chantereau qui haussait la voix, n'est-ce pas qu'on a sifflé Wagner, dimanche? /—Oh! atrocement, madame, répondit-il en s'avançant avec son exquise politesse. . . . /—Non, ne parlez pas de vos Allemands, répétait madame Chantereau. Le chant, c'est la gaieté, c'est la lumière . . . Avez-vous entendu la Patti dans le Barbier? /—Délicieuse! murmura Léonide, qui ne tapait que des airs d'opérette sur son piano.' Zola, Nana, 86; English trans., 69. The 'Barber' refers to Rossini's opera Il Barbiere di Siviglia (The Barber of Seville) of 1816, posited here as the musical antithesis of Wagner's music dramas.

17. 'Ensuite, le piano les occupa. L'instrument datait de 1810, un vieux piano d'Érard, sur lequel, autrefois, mademoiselle Eugénie de la Vignière avait donné quinze ans de leçons. Dans la boîte d'acajou dévernie, les cordes soupiraient des sons lointains,

d'une douceur voilée. Lazare, qui ne pouvait obtenir de sa mère un piano neuf, tapait sur celui-là de toutes ses forces, sans en tirer les sonorités romantiques dont bourdonnait son crâne; et il avait pris l'habitude de les renforcer lui-même avec la bouche, pour arriver à l'effet voulu. Sa passion le fit bientôt abuser de la complaisance de Pauline; il tenait un auditeur, il déroulait son répertoire, pendant des après-midi entières: c'était ce qu'il y avait de plus compliqué en musique, surtout les pages niées alors de Berlioz et de Wagner.' Zola, *La Joie de vivre*, 43; English trans. (as *Zest for Life*), 36–37.

18. 'Ah! Beethoven, la puissance, la force dans la douleur sereine, Michel-Ange au tombeau des Médicis! Un logicien héroïque, un pétrisseur de cervelles, car ils sont tous partis de la symphonie avec chœurs, les grands d'aujourd'hui! . . . Berlioz a mis de la littérature dans son affaire. C'est l'illustrateur musical de Shakespeare, de Virgile et de Goethe. Mais quel peintre! le Delacroix de la musique, qui a fait flamber les sons, dans des oppositions fulgurantes de couleurs.' Zola, *L'Oeuvre*, 263–64; English trans. (as *The Masterpiece*), 227–28.

19. 'Est-ce que Gagnière n'était pas idiot, à s'abrutir avec sa musique, lui qui aurait pu avoir un talent si consciencieux de paysagiste?' Ibid., 213; English trans., 183.

20. 'Quel raté! . . . La musique a tué la peinture, jamais il ne fichera rien.' Ibid., 453; English trans., 393.

21. Theo to Willemien, Paris, 14 March 1888, VGM, b915.

22. Vincent to Theo, Nuenen, c. 28 October 1885, VGL, letter 537.

23. 'Il y a une impression qui résulte de tel arrangement de couleurs, de lumières, d'ombres, etc. C'est ce qu'on appellerait la musique du tableau. Avant même de savoir ce que le tableau représente, vous entrez dans une cathédrale, et vous vous trouvez placé à une distance trop grande du tableau pour savoir ce qu'il représente, et souvent vous êtes pris par cet accord magique; les lignes seules ont quelquefois ce pouvoir par leur grandiose.' Delacroix, 'Réalisme et idéalisme', 51.

24. With regard to this question, see, among others, Vergo, *Music of Painting*, 69–71.

25. Vincent to Theo, Arles, c. 26 August 1888, VGL, letter 669.

26. Vincent to Willemien, Arles, between 16 and 20 June 1888, VGL, letter 626.

27. See Merlhès, *Correspondance de Paul Gauguin*, 485–86; Benoit, *Richard Wagner*, 63; and VGL, letters 589, 622, 714 and 716, among others.

28. VGL, letters 604 ('le peintre de l'avenir'), 611 ('l'art nouveau, aux artistes de l'avenir'), and 633 ('L'art de l'avenir').

29. Vincent to Theo, Arles, 4 May 1888, VGL, letter 604.

30. Vincent to Theo, Arles, 5 or 6 June 1888, VGL, letter 621.

31. Vincent to Theo, Arles, 23 or 24 September 1888, VGL, letter 686.

32. Benoit, *Richard Wagner*, 68.

33. Vincent to Bernard, Arles, 27 June 1888, VGL, letter 633.

34. Dorra, 'Le Texte Wagner de Gauguin'. According to Vergo, *Music of Painting*, 22–24, it is not known how and when Gauguin came to know Benoit's book. See, however, Dorn, 'Van Gogh, Gauguin und Richard Wagner', 73; and Druick and Zegers, *Van Gogh and Gauguin*, 231–32. The translation quoted in the text was taken from Robert Altman's 1990 film *Vincent and Theo*. The utterance could also be translated as follows: 'I am of sound mind. I am the Holy Ghost.'

35. Vincent to Theo, Arles, 23 or 24 September 1888, VGL, letter 686.

36. Benoit, *Richard Wagner*, 67. Naifeh and Smith (*Van Gogh*, 643) adopted Van Gogh's mistaken assumption.

37. 'Il n'est pas étonnant que l'amour tienne dans la musique plus de place que dans les autres arts. D'abord la peinture, la sculpture, l'architecture, savent exprimer des idées et des faits. La musique non pas; les sentiments seuls sont de son domaine, et, de tous les sentiments, le premier, à l'ancienneté comme au choix, c'est l'amour. De plus, les sons produisent sur les nerfs un effet spécial que ne produisent ni les formes ni les couleurs, et la musique est de la sorte à la fois conseillère et interprète d'amour.' Bellaigue, 'L'Amour dans la musique', 306.

5. LISTENING TO BIRDSONG

1. Vincent to Theo, Ramsgate, 31 May 1876, VGL, letter 83.

2. Vincent to Theo, Ramsgate, 17 June 1876, VGL, letter 84.

3. Vincent to Van Rappard, The Hague, c. 25 January 1883, VGL, letter 304.

4. Vincent to Theo, Nieuw-Amsterdam, 28 October 1883, VGL, letter 400. See also 'the croaking of ravens' in letter 396.

5. Vincent to Theo, Nuenen, c. 9 June 1885, VGL, letter 507.

6. Vincent to Theo, Nuenen, c. 14 July 1885, VGL, letter 515.

7. Vincent to Theo, Cuesmes, between c. 22 and 24 June 1880, VGL, letter 155.

8. Ibid.

9. See, among others, Van der Veen, *Van Gogh*, 30.

10. This expression derives from the Old Testament (Micah 6:8, where it says 'to walk humbly with thy God'). Vincent to Theo, Nieuw-Amsterdam, c. 31 October 1883, VGL, letter 401.

11. Vincent to Theo, Amsterdam, 3 March 1878, VGL, letter 142.

12. Father to Theo, Helvoirt, 23 June 1873, VGM, b637.

13. Vincent to Theo, The Hague, 26 August 1882, VGL, letter 259.

14. Vincent to Theo, Amsterdam, 18 September 1877, VGL, letter 131.

15. Vincent to Theo, Dordrecht, 7 and 8 February 1877, VGL, letter 102.

16. Father to Theo, Etten, 2 March 1878, VGM, b968.

17. Theo to Jo, Paris, 20 January 1889, VGM, b2027; and Jansen and Robert, *Brief Happiness*, 98–100.

18. Father to Theo, Helvoirt, 8 July 1875, VGM, b2346.

19. Du Quesne-van Gogh, *Vincent van Gogh*, 19.

20. 'Ainsi, partout, sur l'immense concert instrumental de la nature, sur ses soupirs profonds, sur les vagues sonores qui s'échappent de l'orgue divin, une musique vocale éclate et se détache, celle de l'oiseau, presque toujours par notes vives qui tranchent sur ce fond grave, par d'ardents coups d'archet. . . . Le beau, le grand phénomène de cette face supérieure du monde, c'est qu'au moment où la nature commence par les feuilles et les fleurs son silencieux concert, sa chanson de mars et d'avril, sa symphonie de mai, tous nous vibrons à cet accord; hommes, oiseaux, nous prenons le rhythme.' Michelet, *L'Oiseau*, 168–69; English trans. (as *The Bird*), 236. The Reverend Van Gogh read the book in translation; Vincent and Theo read the original in French.

21. Keats, 'Autumn', verse 3, in *Lamia, Isabella, The Eve of St Agnes and Other Poems* (1820); and Vincent to Willem and Caroline van Stockum-Haanebeek, London, 7 August 1873, VGL, letter 12.

22. Vincent to Theo, Nieuw-Amsterdam, c. 15 October 1883, VGL, letter 396.

23. Vincent to Theo, The Hague, c. 11 July 1883, VGL, letter 361.

24. Father to Theo, Etten, 29 January 1876, VGM, b2230.

25. Vincent to Theo, Amsterdam, 12 June 1877, VGL, letter 120.

26. Willemien to Jo and Theo, [Breda], 30 April 1889, VGM, b2280.

27. Lies to Theo, Dordrecht, 25 January 1879, VGM, b2458.

28. Lies to Mother, Willemien and Cor van Gogh, Carteret, 30 July 1886, VGM, b4173. It is possible that in reality there was no bird. Lies went to France to give birth secretly to a child. In this letter to her mother and siblings, Willemien and Cor, the 'bird' might refer to the nearly full-term baby in her belly.

29. Vincent to Theo, Nuenen, 4 and 5 May 1885, VGL, letter 500.

30. Theo to Lies, Paris, 28 December 1885, VGM, b904.

31. Introduction to Van Gogh, *Brieven aan zijn broeder*, vol. 1, lxii.

32. Vincent to Van Rappard, Nuenen, between c. 8 and 15 August 1885, VGL, letter 526.

33. Vincent to Van Rappard, The Hague, c. 19 September 1882, VGL, letter 267.

34. Vincent to Van Rappard, Nuenen, c. 8 March 1884, VGL, letter 435.

35. 'Comment ne pas l'appeler artiste? Il en a le tempérament au degré suprême où l'homme l'a lui-même rarement'. Michelet, *L'Oiseau*, 310; English trans., 282.

36. 'Artiste! J'ai dit ce mot, et je ne m'en dédis pas. Ce n'est pas une analogie, une comparaison de choses qui se ressemblent: non, c'est la chose elle-même. Le rossignol, à mon sens, n'est pas le premier, mais le seul, dans le peuple ailé, à qui l'on doive ce nom. Pourquoi? Seul il est créateur; seul il varie, enrichit, amplifie son chant, y ajoute des chants nouveaux. Seul, il est fécond et varié par lui-même; les autres le sont par l'enseignement et l'imitation. Seul, il les résume, les contient presque tous: chacun d'eux, des plus brillants, donne un couplet du rossignol.' Michelet, *L'Oiseau*, 202–3; English trans., 281.

37. Vincent to Theo, Arles, 18 August 1888, VGL, letter 663.

38. Druick and Zegers, *Van Gogh and Gauguin*, 242.

39. 'L'oiseau des champs par excellence, l'oiseau du laboureur, c'est l'alouette, sa compagne assidue, qu'il retrouve partout dans son sillon pénible pour l'encourager, le soutenir, lui chanter l'espérance. . . . C'est la fille du jour. Dès qu'il commence, quand l'horizon s'empourpre et que le soleil va paraître, elle part du sillon comme une flèche, porte au ciel l'hymne de joie. . . . L'alouette chante une heure d'affilée sans s'interrompre d'une demi-seconde, s'élevant verticalement dans les airs jusqu'à des hauteurs de mille mètres, et courant des bordées dans la région des nues pour gagner plus haut, et sans qu'une seule de ses notes se perde dans ce trajet immense. "Quel rossignol pourrait en faire autant?"' Michelet, *L'Oiseau*, 170–72; English trans., 237–39.

40. On this painting, see Tilborgh and Hendriks, *Van Gogh Paintings*, 406–9. For the symbolism of the lark in the nineteenth century, see Lemaire, *De leeuwerik*, 48–56.

41. Quoted in Tilborgh and Hendriks, *Van Gogh Paintings*, 406.

42. Vincent to Theo, Wasmes, between 4 and 31 March 1879, and The Hague, 5 February 1883, VGL, letters 150 and 308.

43. Vincent to Theo, Etten, 3 and 18 November 1881, VGL, letters 179 and 186.

44. Vincent to Willemien, Paris, end of October 1887, VGL, letter 574.

45. Vincent to Theo, Antwerp, 14 February 1886, VGL, letter 562.

46. Vincent to Theo, Nieuw-Amsterdam, 28 October 1883, VGL, letter 400.

47. Uhland, 'Die Lerchen'. Van Gogh quoted the Dutch translation ('De leeuweriken') from Van Meurs, *Het leven van Ludwig van Uhland*, 157. Probably copied in Isleworth, c. September 1876, VGL, letter RM09.

48. Vincent to Theo, Etten, 7 November 1881, VGL, letter 180.

49. Vincent to Theo, Amsterdam, 30 May 1877, VGL, letter 117.

50. Theo to Mother, Paris, c. 1 June 1885, VGM, b939.

6. THE REALM OF THE SENSES

1. Van Mander, *Het schilder-boeck*, fol. 34v.

2. Cf. Hammacher and Hammacher, *Van Gogh*, 9.

3. Vincent to Theo, Nieuw-Amsterdam, 2 November 1883, VGL, letter 402.

4. Vincent to Theo, The Hague, c. 21 July 1882, VGL, letter 249.

5. Veth, 'Studiën', 430.

6. Lapidoth, 'Parijsche Kunstkroniek II', 172.

7. 'Avec sa vielle compagne l'amère solitude'. Zadkine, *Le Maillet et le ciseau*, 197.

8. 'L'éloignant de la mer de blé qui pourtant chuchotait à ses oreilles. Les cris des corbeaux devaient le sortir de lui-même alors, lui faisant lever la tête, regarder les oiseaux noirs et écouter leurs croassements inhumains'. Ibid., 198.

9. 'Il était devenu instrument raffiné pour intercepter la pulsation, l'essence structurale du paysage dans toute sa sauvagerie inédite'. Ibid., 199.

10. Vincent to Theo, Isleworth, between c. 2 and 8 September 1876, VGL, letter 90.

11. Vincent to Theo, Arles, 28 April 1889, VGL, letter 763.

12. Vincent to Theo, Arles, 9 or 10 July 1888, VGL, letter 638.

13. Vincent to Theo and Jo, Saint-Rémy-de-Provence, 6 July 1889, VGL, letter 787.

14. Vincent to Theo, Amsterdam, 12 June 1877, and 28 May 1877, VGL, letters 120, 116.

15. Vincent to Theo, The Hague, 17 September 1882, VGL, letter 264.

16. Vincent to Theo, Amsterdam, 5 August 1877, VGL, letter 126. See also letter 127: 'His voice and many curious expressions reminded me of Pa.' With regard to the minister 'raising and lowering' his voice, see letter 193.

17. Vincent to Theo, Amsterdam, 27 August 1877, VGL, letter 128.

18. Vincent to Theo, Amsterdam, 7 September 1877, VGL, letter 130.

19. Vincent to Theo, Amsterdam, 9 December 1877, VGL, letter 137.

20. Vincent to Theo, Etten, 10 or 11 November 1881, VGL, letter 182.

21. Vincent to Theo, Nuenen, c. 20 July 1884, VGL, letter 452.

22. Vincent to Willemien, Arles, between 28 April and 2 May 1889, VGL, letter 764.

23. Vincent to Van Rappard, Nuenen, c. 18 March 1884, VGL, letter 439.

24. Vincent to Theo, Nieuw-Amsterdam, 28 October 1883, VGL, letter 400.

25. Theo to Willemien, Paris, 14 March 1887, VGM, b908.

26. Vincent to Van Rappard, Nuenen, between c. 8 and c. 15 August 1885, VGL, letter 526. This pronouncement (with a slight variation) was borrowed from Silvestre, *Eugène Delacroix*, 63.

27. Vincent to Theo, Arles, c. 22 July 1888, VGL, letter 645.

28. 'The whole horrible crisis has disappeared like a thunderstorm'. Vincent to Theo, Saint-Rémy-de-Provence, 11 May 1890, VGL, letter 870.

29. Vincent to Theo, Saint-Rémy-de-Provence, c. 23 May 1889, VGL, letter 776.

30. Vincent to Willemien, Saint-Rémy-de-Provence, c. 21 October 1889, VGL, letter 812.

31. Vincent to Joseph Jacob Isaäcson, Auvers-sur-Oise, 25 May 1890, VGL, RM21.

32. Vincent to Willemien, Saint-Rémy-de-Provence, 2 July 1889, VGL, letter 785.

33. Van Eeden, 'Kunst', 128.

34. Vincent to Theo, Arles, 9 or 10 July 1888, VGL, letter 638.

35. Vincent to Theo, Antwerp, c. 29 January 1886, VGL, letter 556.

36. Vincent to Theo, Nuenen, c. 18 December 1883, VGL, letter 415.

37. Fonsmark, 'Delacroix', 31–34.

38. Vincent to Theo, Arles, 18 September 1888, VGL, letter 683.

39. Vincent to Theo, Arles, c. 12 August 1888, VGL, letter 659.

40. Vincent to Theo, Cuesmes, between c. Tuesday, 22 and Thursday, 24 June 1880, VGL, letter 155.

41. Vincent to Theo, The Hague, 6 July 1882, VGL, letter 244.

42. Vincent to Theo, Nuenen, between 18 and 23 February 1884, VGL, letter 430.

43. Vincent to Theo, Amsterdam, 9 July 1877, VGL, letter 121.

44. Vincent to Theo, The Hague, 6 July 1882, VGL, letter 244.

45. Ibid.

46. Vincent to Theo, London, 6 April 1875, and The Hague, c. 16 June 1883, VGL, letters 31 and 355.

47. Vincent to Arnold Koning, Arles, c. 22 January 1889, VGL, letter 740.

48. Vincent to John Peter Russell, Arles, 19 April 1888, VGL, letter 598.

49. A. C. A. Plasschaert, 'Tentoonstelling Haagsche Kunstkring', *De Nieuwe Gids* 1, no. 2 (1895): 413. See De Jongh, 'Enige aspecten', 74; and Van Eekelen, 'Ik denk in mijn materie', 77.

50. Vincent to Theo, Nuenen, 30 April 1885, VGL, letter 497.

51. Vincent to Theo, Nuenen, 4 October 1885, VGL, letter 533.

52. Vincent to Gauguin, Arles, 21 January 1889, VGL, letter 739.

53. Vincent to Van Rappard, Nuenen, c. 13 March 1884, VGL, letter 437.

54. Ibid.

55. Kerssemakers to Albert Plasschaert, Eindhoven, 27 August 1912, VGM, b3038.

56. Vincent to Gauguin, Auvers-sur-Oise, 17 June 1890, VGL, BM 23.

57. 'Car il n'y a pas de famine, d'épidémie, d'explosion de volcan, de tremblement de terre, de guerre, qui rebrousse les monades de l'air, qui torde le cou à la figure torve de fama fatum, le destin névrotique des choses, comme une peinture de Van Gogh, sortie au jour, remise à même la vue, l'ouïe, le tact, l'arôme, sur les murs d'une exposition.' Artaud, *Oeuvres Complètes*, 13:26.

7. PAINTING MUSICALLY

1. Vincent to Willemien, Arles, between 16 and 20 June 1888, VGL, letter 626. He referred to this question again in two later letters: 'This afternoon I had a select audience. of 4 or 5 pimps and a dozen kids who found it particularly interesting to watch the colours come out of the tubes' (letter 683); 'Out of doors, exposed to the wind, the sun, people's curiosity, one works as one can, one fills one's canvas regardless' (letter 801).

2. Vincent to Theo, The Hague, 6 July 1882, VGL, letter 244. This is the first time that Van Gogh used the word 'harmony' in his letters to refer to colour.

3. Vincent to Van Rappard, Nuenen, c. 29 May 1884, VGL, letter 448 (see also letter 450). Here Van Gogh actually used the Dutch *toonladder*, which means 'scale', but it was clear that he meant 'register', and the word was therefore corrected in translation.

4. Vincent to Theo, Nuenen, c. 20 October 1885, VGL, letter 536. In *Les Artistes de mon temps*, Blanc describes Delacroix's musical use of white: 'Sometimes the role of white in a sombre painting is that of one who strikes the tam-tam in a full orchestra' ('quelquefois le rôle du blanc dans un tableau sinistre est celui qui joue en plein orchestre un coup de tam-tam').

5. Vincent to Theo, Saint-Rémy-de-Provence, c. 20 September 1889, VGL, letter 805. On this quotation and the copies Van Gogh made in Saint-Rémy, see Homburg, *Copy Turns Original*, 42ff.

6. Fonsmark, 'Delacroix', 21 and 37.

7. Vincent to Theo, Saint-Rémy-de-Provence, c. Friday, 20 September 1889, VGL, letter 805.

8. Vincent to Theo, The Hague, c. 4 March 1883, VGL, letter 324.

9. Vincent to Theo, The Hague, 31 December 1882 and 2 January 1883, VGL, letter 297.

10. Vincent to Theo, Arles, c. 26 August 1888, VGL, letter 669.

11. Pomarède, 'Silent Arts', 70; Vergo, *Music of Painting*, 68.

12. See, among others, Vergo, *Music of Painting*, 8 and 64; and Pomarède, 'Silent Arts', 68.

13. Delacroix seldom depicted musical subjects (Vergo, *Music of Painting*, 63), nor were his paintings inspired by pieces of music (Pomarède, 'Silent Arts', 94 and 97).

14. Vincent to Theo, Arles, 18 September and c. 25 March 1888, VGL, letters 683 and 589.

15. 'Delacroix était son dieu, et lorsqu'il parlait de ce peintre, ses lèvres tremblaient d'émotion.' Gauzi, *Lautrec*, 28.

16. See VGL, letters 526 and 735.

17. 'Comme l'artiste anglais, il est insensiblement monté d'une harmonie grave comme les sons du violoncelle à une harmonie claire comme les accents du hautbois'. Silvestre, *Eugène Delacroix*, 16; see 68–69 for Delacroix's pronouncements on music.

18. 'Qui toucha quarante ans tout le clavier des passions humains'. Ibid., 64. English trans. is based on Patrick Noon and Christopher Riopelle, *Delacroix and the Rise of Modern Art* (London: National Gallery Company, 2015), 14.

19. 'Il a des aperçus d'expression, d'attitude, de composition et d'effet qui parlent encore plus à notre imagination qu'à nos yeux; l'arabesque linéaire de ses dessins, aussi bien que l'harmonie de sa couleur, révèle, même à distance, le caractère du sujet, et rend pour ainsi dire les onomatopées naturelles: les lignes sifflent dans le groupe des cavaliers barbares lancés sur les pas d'Attila, et l'arc d'Achille fait ce bruit comparé par Homère au cri de l'hirondelle; on entend aussi crier les os dans la gueule des lions.' Silvestre, *Eugène Delacroix*, 33.

20. See, among others, Vergo, *Music of Painting*, 9; and Fonsmark, 'Delacroix', 10.

21. Vincent to Theo, Nuenen, c. 28 October 1885, VGL, letter 537.

22. Ibid.

23. 'Je n'ai jamais vu de palette aussi minutieusement et aussi délicatement préparée que celle de Delacroix. Cela ressemblait à un bouquet de fleurs savemment assorties'. Baudelaire, *La Vie et l'œuvre*, 17. English trans. is from Fonsmark, 'Delacroix', 31. In this context, cf. Paul Valéry's musical ode to the painter's palette: 'The painter's materials are fascinating: nothing is more stimulating to the sight than the colour box or the well-covered palette. Even the sight of the keyboard produces less of a creative sensation, for it is merely a silent expectant object whereas the wonderful combination of lacquers and terra cottas, oxides and alum sings out in every key.' Lockspeiser, *Music and Painting*, 93.

24. Fonsmark, 'Delacroix', 25 and 31.

25. Tilborgh and Hendriks, *Van Gogh Paintings*, 236. Van Gogh refers to his 'studies' twice as 'gymnastics', once in a letter to Theo (letter 536 of c. 20 October 1885) and once in a letter written in English to Horace Mann Livens (letter 569 of September or October 1886). Cf. the following note.

26. Vincent to Livens, Paris, September or October 1886, VGL, letter 569. See also letter 574: 'Last year I painted almost nothing but flowers to accustom myself to a colour other than grey, that's to say pink, soft or bright green, light blue, violet, yellow, orange, fine red.'

27. Fonsmark, 'Delacroix', 40.

28. Adolphe and Polenghi, *Red Dogs and Pink Skies*.

29. 'Avec tous ses jaunes sur violets, tout ce travail de complémentaires, travail désordonné de sa part, il n'arrivait qu'à de douces harmonies incomplètes et monotones; le son du clairon y manquait.' Gauguin, *Avant et après*, 21.

30. Van Eeden, 'Kunst', 266. See chap. 1, n. 11.

31. Gage, *Colour in Art*, 183; Van Uitert, 'Beeldende kunst en muziek', 67; and Fonsmark, 'Delacroix', 40–41.

32. Theo to Jo, 28 January 1889, in Jansen and Robert, *Brief Happiness*, 121–22.

33. 'Quel est donc ce je ne sais quoi de mystérieux que Delacroix, pour la gloire de notre siècle, a mieux traduit qu'aucun autre? C'est l'invisible, c'est l'impalpable, c'est le rêve, c'est les nerfs, c'est l'âme; et il a fait cela,—observez-le bien, monsieur,—sans autres moyens que le contour et la couleur Un tableau de Delacroix, placé à

une trop grande distance pour que vous puissiez juger de l'agrément des contours ou de la qualité plus ou moins dramatique du sujet, vous pénètre déjà d'une volupté surnaturelle.' Baudelaire, *La Vie et l'œuvre*, 5, 11.

34. See, among others, Lockspeiser, *Music and Painting*, 69; Dolan, *Manet, Wagner*, 60; and Van Uitert, 'Beeldende kunst en muziek', 67. In particular, this passage from chap. 7 of Hoffmann's *Kreisleriana* was quoted by Baudelaire a number of times: 'I find an accordance of colours, sounds and fragrances not so much in my dreams as in the state of delirium that precedes sleep, preferably after hearing a great deal of music' ('Nicht sowohl im Traume als im Zustande des Delirierens, der dem Einschlafen vorhergeht, vorzüglich wenn ich viel Musik gehört habe, finde ich eine Übereinkunft der Farben, Töne und Düfte'). See www.gutenberg.org.

35. On Wagner's *Gesamtkunstwerk*, see, among others, Roberts, *Total Work*; and Vergo, *Music of Painting*, 105ff.

36. 'Où la flore et la faune d'un monde imaginaire se mêlent en arabesques troublantes et dont les chaudes colorations produisent une sorte d'ivresse des sens'. Alfred de Lostalot, 'Revue musicale', *Gazette des Beaux-Arts*, 2nd ser., 31 (March 1885): 5; trans. from Leonard, 'Picturing Listening', 270.

37. Vergo, *Music of Painting*, 47.

38. Wagner, *Zukunftsmusik*. This essay was first published in French as *La Musique de l'avenir* (1860). Quoted from Vergo, *Music of Painting*, 35.

39. Wyzewa, 'Notes sur la peinture', 106. English trans. is from Vergo, *Music of Painting*, 28.

40. Maritain (*Creative Intuition*, 30–32) speaks of 'logical sense' and 'poetic sense', which is comparable to the distinction Prieto made between the terms 'mode of performance' and 'mode of thought' with reference to literature. See Prieto, *Listening In*, passim. Cf. Vergo, *Music of Painting*, 34: 'Lifting visual art out of a literary mode of thinking into a musically coloured experience'.

41. Havelaar, *Oud-Hollandsche figuurschilders*, 5–6.

42. On this subject, see De Jongh, 'Enige aspecten'.

43. Quoted from Fonsmark, 'Delacroix', 21.

44. Gauguin to Vincent, Pont-Aven, c. 22 July 1888, VGL, letter 646.

45. 'Un conseil, ne copiez pas trop d'après nature. L'art est une abstraction; tirez-la de nature en rêvant en devant et pensez plus à la création qui résultera. C'est le seul moyen de monter vers

Dieu en faisant comme notre divin maître, créer'. Gauguin to Schuffenecker, Pont-Aven, 14 August 1888, in Merlhès, *Correspondance de Paul Gauguin*, letter 159, 1:210. English trans. is from Chipp, Selz and Taylor, *Theories of Modern Art*, 60.

46. This hierarchy within the senses was traditional; the sense of sight was considered the most important of the Five Senses. See Sluijter, *Seductress of Sight*.

47. From 'Diverses Choses, 1896–1897', quoted in Chipp, Selz and Taylor, *Theories of Modern Art*, 66.

48. Gauguin, interview with Eugène Tardieu (1895), quoted in Morton and Schmunk, *Arts Entwined*, 13.

49. Vergo, *Music of Painting*, 158–61; and Fonsmark, 'Delacroix', 41–42.

50. From 'Cahier pour Aline' (Tahiti, 1893), quoted in large part in Chipp, Selz and Taylor, *Theories of Modern Art*, 69.

51. Gauguin to Vincent, Pont-Aven, 1 October 1888, VGL, letter 692.

52. 'Le dessin en est tout à fait spécial (abstraction complète). Les yeux la bouche le nez sont comme des fleurs de tapis persans personnifiant aussi le côté symbolique'. Gauguin to Schuffenecker, Pont-Aven, 8 October 1888, in Merlhès, *Correspondance de Paul Gauguin*, letter 168, 1:249. See Van Uitert, 'Vincent van Gogh and Paul Gauguin', 160; for Gauguin's idea of abstraction, see 160–63. See also Druick and Zegers, *Van Gogh and Gauguin*, 133 and 155.

53. Vincent to Theo, The Hague, 22 October 1882, VGL, letter 274.

54. Vincent to Theo, Nuenen, c. 17 August 1885, VGL, letter 527.

55. Vincent to Theo, Nuenen, 4 October 1885, VGL, letter 533.

56. Bracquemond, *Du dessin*, 208. See the note to letter 533 in the online edition. Cf. Fonsmark, 'Delacroix', 18: 'Delacroix suppressed any superfluous detail in his work and expressed the melancholy and pain of the motif with purely painterly resources'.

57. Maritain (*Creative Intuition*, e.g. 92, 94, 99, 106) distinguishes between the creative 'musical unconscious or preconscious' and the Freudian 'automatic or deaf unconscious'.

58. Vincent to Theo, Nuenen, c. 14 July 1885, VGL, letter 515.

8. DREAM AND REALITY

1. De Jongh, 'Enige aspecten', 75.

2. 'Une œuvre doit porter en elle-même sa signification entière et l'imposer au spectateur avant même qu'il en connaisse le sujet. Quand je vois les fresques de Giotto à Padoue, je ne m'inquiète pas de savoir quelle scène de la vie du Christ j'ai devant les yeux, mais tout de suite, je comprends le sentiment qui s'en dégage, car il est dans les lignes, dans la composition, dans la couleur, et le titre ne fera que confirmer mon impression.' Matisse, *Écrits et propos*, 49–50. For Baudelaire, see Vergo, *Music of Painting*, 42.

3. 'Se rappeler qu'un tableau—avant d'être un cheval de bataille, une femme nue ou une quelconque anecdote—est essentiellement une surface plane recouverte de couleurs en un certain ordre assemblées.' Gilson, *Peinture et réalité*, 113.

4. 'Il faut lire et relire un poème comme une musique et chercher le sens et les intentions après qu'on a éprouvé le système des sons'. De Jongh, 'Enige aspecten', 75.

5. Gombrich, *Art and Illusion*, 162–69.

6. See Miedema, *Kunst, kunstenaar en kunstwerk*, 147–49.

7. Quoted from Pomarède, 'Silent Arts', 97.

8. Vincent to Van Rappard, Nuenen, c. 13 March 1884, VGL, letter 437.

9. Hamerton, *Imagination*, 72–73.

10. Vincent to Bernard, Arles, 29 July 1888, VGL, letter 649.

11. Ibid.

12. Vincent to Theo, Nieuw-Amsterdam, 2 November 1883, VGL, letter 402.

13. Vincent to Theo, Arles, 25 September and 8 October 1888, VGL, letters 687 and 699.

14. See, among others, Wittkower and Wittkower, *Born under Saturn*, 53–59 ('obsession with work') and 98–108 ('genius, madness, and melancholy').

15. 'Der Begriff ist hier, wie überall in der Kunst, unfruchtbar: der Komponist offenbart das innerste Wesen der Welt und spricht die tiefste Weisheit aus. In einer Sprache, die seine Vernunft nicht versteht; wie eine magnetische Somnambule Aufschlüsse gibt über Dinge, von denen sie wachend keinen Begriff hat' ('The term is here, as everywhere in art, fruitless: the composer reveals the innermost essence of the world and pronounces the deepest wisdom. In a language that his reason does not understand; just as a mesmeric sleepwalker expounds ideas he cannot fathom when awake'). Schopenhauer, *Die Welt als Wille*, vol. 1, section 54. Cf. Lippman, *A History*, 230.

16. Gauguin to Vincent, Pont-Aven, 1 October 1888, VGL, letter 692.

17. Claus, *De wolken*, 50.

18. Lederballe, 'Delacroix's Enthusiasm', 104.

19. 'La forces de certaines touches, sur lesquelles on ne revient point, donne aux ouvrages de ces maîtres une animation et une vigueur auxquelles ne parvient pas toujours une exécution plus circonspecte.' Delacroix, 'Réalisme et idéalisme', 1:30. English trans. is from Lederballe, 'Delacroix's Enthusiasm', 119.

20. Vincent to Theo, Nuenen, between 18 and 23 February 1884, VGL, letter 430.

21. Vincent to Theo, Arles, c. 25 June 1888, VGL, letter 631.

22. Vincent to Gauguin, Arles, 17 October 1888, VGL, letter 706.

23. Vincent to Theo, Arles, c. 1 July 1888, VGL, letter 635.

24. Vincent to Van Rappard, Nuenen, c. 8 March 1884, VGL, letter 435.

25. Vincent to Theo, Arles, 3 February 1889, VGL, letter 745.

26. Vincent to Theo, Nuenen, c. 2 June 1885, VGL, letter 506.

27. Vincent to Theo, Arles, c. 1 July 1888, VGL, letter 635.

28. Vincent to Theo, Saint-Rémy-de-Provence, c. Friday, 20 September 1889, VGL, letter 805. On this subject, see p. 96. On Delacroix's brush, see Lederballe, 'Delacroix's Enthusiasm', 119.

29. Vincent to Theo, Nuenen, c. 2 March 1884, VGL, letter 432.

30. Vincent to Gauguin, Arles, 21 January 1889, VGL, letter 739. See letter 743 for 'unbearable hallucinations'.

31. 'Comme il est profond, ce mystère de L'Invisible! Nous ne le pouvons sonder avec nos sens misérables, avec nos yeux qui ne savent apercevoir ni le trop petit, ni le trop grand, ni le trop près, ni le trop loin, ni les habitants d'une étoile, ni les habitants d'une goutte d'eau . . . avec nos oreilles qui nous trompent, car elles nous transmettent les vibrations de l'air en notes sonores. Elles sont des fées qui font ce miracle de changer en bruit ce movement et par cette metamorphose donnent naissance à la musique, qui rend chantante l'agitation muette de

la nature.' Maupassant, *Le Horla*, 5–6. English trans. is from Maupassant, 'Le Horla', 289–90.

32. Vincent to Theo, Arles, 28 January 1889, VGL, letter 743.

33. Jo, for example, had heard a performance of the piece in Amsterdam. Diary 1, 21 April 1881, VGM, b4550-1.

34. 'Celui qui entend cette symphonie ici, à Paris, doit vraiment croire qu'il entend une chose étrange, inouïe. —Une riche, une monstrueuse imagination, une fantaisie d'une énergie épique, vomissent, comme d'un cratère, un torrent bourbeux de passions; ce qu'on distingue, ce sont des nuages de fume de proportions colossales, traversés seulement par des éclairs, zébrés par des bandes de feu, et façonnés en fantômes changeants. Tout est excessif, audacieux, mais extrêmement désagréable.' Benoit, *Richard Wagner*, 191.

35. Theo protected Vincent in this regard too, as emerges from a letter to Willemien: 'Thanks for the plays by Ibsen. In German I find them even more genuine than in French. They certainly contain encouragement for much that is good. I sent Nora to Vincent, but in his present state I prefer to hold back "those ghosts" for a while.' Theo to Willemien, c. 3 March 1890, VGM, b941.

36. Dimmen Gestel to Albert Plasschaert, 29 July 1912, VGM, b3039.

37. Van Gogh used this phrase in letter 533 with reference to the work of Poussin.

38. Vincent to Bernard, Arles, 19 April 1888, VGL, letter 599.

39. Vincent to Theo, Arles, 3 September 1888, VGL, letter 673.

40. Vincent to Bernard, Saint-Rémy-de-Provence, c. 26 November 1889, VGL, letter 822.

41. Vincent to Theo, The Hague, 3 September 1882, VGL, letter 260.

42. Vincent to Theo, The Hague, 31 July 1882, VGL, letter 252.

43. Vincent to Willemien, Arles, c. 12 November 1888, VGL, letter 720.

44. Vincent to Theo, Saint-Rémy-de-Provence, 26 November 1889, VGL, letter 823.

45. 'Oeuvres étranges, intensives et fiévreuses'. Albert Aurier, 'Les Isolés: Vincent van Gogh', *Mercure de France*, January 1890, 24–29. For a summary of the article and this quotation, see www.vangoghletters.org, letter 845, n. 2.

46. Vincent to Theo, Saint-Rémy-de-Provence, 12 February 1890, VGL, letter 854.

9. THE SOLACE OF MUSIC

1. Vincent to Theo, The Hague, 22 January 1882, VGL, letter 202.

2. Vincent to Theo, The Hague, 31 July 1882, VGL, letter 252.

3. Vincent to Theo, The Hague, c. 21 July 1882, VGL, letter 249.

4. On the idea of solace in Van Gogh's letters, see Jansen, 'Vincent van Gogh's Belief'.

5. 'De Van Gogh's', *De Nederlandsche Spectator* 38 (1893): 272–73.

6. Vincent to Theo, Arles, 17 October 1888, VGL, letter 707.

7. Vincent to Willemien, Saint-Rémy-de-Provence, 20 January 1890, VGL, letter 841.

8. Vincent to Theo, Arles, 3 September 1888, VGL, letter 673.

9. Vincent to Theo, Nuenen, mid-June 1884, VGL, letter 450.

10. Vincent to Theo, Dordrecht, 28 February 1877, VGL, letter 104.

11. Vincent to Theo, Dordrecht, 21 January 1877, VGL, letter 101.

12. Jansen, 'Vincent van Gogh's Belief', 16–18.

13. On these reproductions, see VGL, letters 40, 317 and 480.

14. VGL, letters 123 and 685, respectively.

15. Lederballe, 'Delacroix's Enthusiasm', 106–7, 115.

16. Delacroix, *Journal*, 844. English trans. is from Fonsmark, 'Delacroix', 31.

17. Vincent to Theo, Saint-Rémy-de-Provence, c. 18 June 1889, VGL, letter 782.

18. Vincent to Gauguin, Arles, 21 January 1889, VGL, letter 739.

19. Vincent to Bernard, Arles, c. 7 June 1888, VGL, letter 622.

20. Vincent to Theo, Arles, 12 June 1888, VGL, letter 623.

21. Vincent to Theo, Arles, 3 September 1888, VGL, letter 673.

22. Ibid.; and Vincent to Theo, Arles, c. 29 September 1888, VGL, letter 691.

23. Vincent to Bernard, Saint-Rémy-de-Provence, c. 26 November 1889, VGL, letter 822.

24. Vincent to Theo, Saint-Rémy-de-Provence, c. 17 March 1890, VGL, letter 857.

25. Vincent to Theo, Saint-Rémy-de-Provence, 11 May 1890, VGL, letter 870.

26. Vincent to Theo, Arles, c. 29 September 1888, VGL, letter 691.

27. Vincent to Gauguin, Arles, 17 October 1888, VGL, letter 706.

28. Vincent to Willemien, Arles, c. 30 March 1888, VGL, letter 590.

29. Vincent to Theo, Saint-Rémy-de-Provence, c. 23 May 1889, VGL, letter 776.

30. Vincent to Van Rappard, Nuenen, c. 18 August 1885, VGL, letter 528.

31. Vincent to Theo, Arles, 28 January 1889, VGL, letter 743.

32. 'Les cantiques de l'enfance, les cantiques qui reposent et qui consolent de la dure vie'. Originally published in *Les Hommes d'aujourd'hui* (1890). Reprinted in Bernard, *Propos sur l'art*, I, 26–28; quotation on 27. English trans. is from Silverman, *Van Gogh and Gauguin*, 333.

33. Vincent to Gauguin, Arles, 21 January 1889, VGL, letter 739.

34. Vincent to Koning, Arles, c. 22 January 1889, VGL, letter 740.

35. Vincent to Van Rappard, Etten, 23 November 1881, VGL, letter 190.

36. Vincent to Theo, Nieuw-Amsterdam, c. 15 October 1883, VGL, letter 396.

37. Vincent to Theo, Saint-Rémy-de-Provence, c. 1 May 1890, VGL, letter 865.

38. Benoit, *Richard Wagner*, 163–65.

39. 'Au milieu d'un grand bruit de fureur'. Loti, *Pêcheur d'Islande*, 343.

40. Vincent to Theo, Arles, 21 or 22 March 1888, VGL, letter 588.

41. Vincent to Theo, Arles, 28 January 1889, VGL, letter 743.

42. Vincent to Gauguin, Arles, 21 January 1889, VGL, letter 739.

43. See the quotation in chap. 6, n. 56.

44. Vincent to Koning, Arles, c. 22 January 1889, VGL, letter 740.

45. Vincent to Theo, Arles, 3 February 1889, VGL, letter 745.

46. Vincent to Theo, Arles, 28 January 1889, VGL, letter 743.

47. On this subject, see Schmunk, 'What Did Van Gogh Hear?', 44.

48. Cf. chap. 7, n. 3, and chap. 10, n. 1.

49. Vincent to Gauguin, Arles, 21 January 1889, VGL, letter 739.

50. Ibid.

51. 'Dans cette peinture d'une conception vraiment nouvelle, Millet veut être musical. Il prétend faire entendre les bruits de la campagne et jusqu'au tintement des cloches. "C'est la réalité de l'expression qui peut rendre tout cela", disait-il.' Sensier, *La Vie et l'oeuvre*, chap. 20, 190. Vincent to Theo, The Hague, 11 March 1882, VGL, letter 210. On the musicality of Manet's painting, see Dolan, *Manet, Wagner*.

52. Vincent to Theo, London, beginning of January 1874, VGL, letter 17.

53. Vincent to Theo, Nuenen, 2 October 1884, VGL, letter 464.

10. SYMPHONIES IN COLOUR

1. In letters 448 (to Van Rappard) and 450 (to Theo), Van Gogh actually used the Dutch word *toonladder*, which means 'scale'. See also chap. 7, n. 3.

2. Vincent to Theo, Nieuw-Amsterdam, 2 November 1883, VGL, letter 402. For the entire passage, see chap. 8.

3. Vincent to Theo, Nuenen, mid-June 1884, VGL, letter 450. For the entire passage, see chap. 3.

4. Vincent to Theo, Nuenen, c. 28 October 1885, VGL, letter 537.

5. Vincent to Theo, Antwerp, between 12 and 16 January 1886, VGL, letter 552.

6. Vincent to Theo, Arles, c. 25 March 1888, VGL, letter 589.

7. Vincent to Bernard, Arles, c. 7 June 1888, VGL, letter 622.

8. Vincent to Theo, Arles, 21 or 22 August 1888, VGL, letter 666.

9. Vincent to Gauguin, Arles, 21 January 1889, VGL, letter 739. For the entire passage, see chap. 9.

10. Vellekoop, *Van Gogh at Work*, 144.

11. 'Sur la table, parmi des crépons japonais, des boules de laine dont les fils entrelacés jouaient des symphonies imprévues'. *Les Hommes d'aujourd'hui* (1890), quoted in Bernard, *Propos sur l'art*, 1:26.

12. Theo to Jo, 28 January 1889, in Jansen and Robert, *Brief Happiness*, 121–22. For the entire passage, see chap. 7.

13. Quoted from Vergo, *Music of Painting*, 56.

14. 'N'est pas autre chose que la symphonie du blanc'. Vergo, *Music of Painting*, 75. Cf. Schmunk, 'Artists as Musicians', 269.

15. Vergo, *Music of Painting*, 77.

16. Vincent to Willemien, Saint-Rémy-de-Provence, c. 23 December 1889, VGL, letter 832.

17. Norris, 'Painting *Around the Piano*', 158. The reference is to Wagner's 'Waldweben' ('Movement of the forest': the rustling of the trees, the gurgling of the spring) from his opera *Siegfried* (act 2, scene 2).

18. Vosmaer, *Inwijding*, 227.

19. Marius, *De Hollandsche schilderkunst*, 136.

20. De Leeuw, 'Richard Wagner', 6. Cf. Lockspeiser, *Music and Painting*, 88.

21. De Poorter, *De kunst*, 17–18.

22. Vergo, *Music of Painting*, 76.

23. *Nieuwe Rotterdamsche Courant*, 7 April 1920.

24. Vincent to Bernard, Arles, c. 5 August 1888, VGL, letter 655.

25. Vincent to Theo, Arles, between 17 and 20 July 1888, VGL, letter 644.

26. Dorn, *Décoration*, passim.

27. Vincent to Theo, Arles, 16 September 1888; and Vincent to Bernard, Arles, 3 October 1888, VGL, letters 681 and 696. See also letter 643.

28. *Mountainous Landscape* (F 611 / JH 1723) was sold to Rohde for 270 guilders. Stolwijk and Veenenbos, *Account Book*, 46, 141.

29. Quoted in Schneede, 'Picture in Concert', 161, 164.

30. 'On cite notamment, parmi les toiles appelées à exciter la curiosité artistique, les attachantes études de plein air de Paul Cézanne, les symphonies éclatantes de Vincent van Gogh, les paysages de Sisley, le compositions nouvelles de Renoir . . .'. 'Petite chronique', *L'Art Moderne: Revue Critique des Arts et de la Littérature* 10, no. 1 (5 January 1890): 7. See the note to letter 843, Theo to Vincent, Paris, 22 January 1890.

31. Georges Lecomte, 'L'Exposition des néo-impressionnistes: Pavillon de la Ville de Paris (Champs-Elysées)', *L'Art et Critique: Revue Littéraire, Dramatique, Musicale et Artistique* 2, no. 44 (29 March 1890): 203–5. See the note to letter 896, Vincent to Theo and Jo, Auvers-sur-Oise, 2 July 1890.

32. Introduction to Van Gogh, *Brieven aan zijn broeder*, vol. 1, lix.

33. Jo van Gogh-Bonger, *Dagboek* (Diary) IV, 49, VGM, b4550-1.

34. Lapidoth, 'Parijsche Kunstkroniek II', 172.

35. With regard to this recurring phrase in Van Gogh's letters, see also Baudelaire's pronouncement on Delacroix quoted in chap. 7, note 33.

36. Vincent to Theo, Arles, 3 September 1888, Vincent to Willemien, Arles, 9 and c. 14 September 1888, and Vincent to Theo, Arles, 8 August 1888, VGL, letters 673, 678 and 657.

37. Vincent to Bernard, Arles, c. 7 June 1888, VGL, letter 622.

38. Cf. Schapiro, *Vincent van Gogh*, 6: 'In Van Gogh the opposites of reality and emotion are united and reconciled. The familiar objects he paints belong both to nature and to loving, desiring, suffering man. His art helped to educate our eyes and to unloosen our feelings.'

39. Vincent to Theo, Arles, 24 March 1889, VGL, letter 752.

40. Vincent to Theo, Arles, 9 January 1889, VGL, letter 735.

BIBLIOGRAPHY

Adolphe, B., and E. Polenghi. *Red Dogs and Pink Skies: Paul Gauguin on Painting and Music*. New York: PollyRhythm, 2002.

Artaud, Antonin. *Oeuvres Complètes*. Paris: Gallimard, 1956.

Bailey, Martin. *The Sunflowers Are Mine: The Story of Van Gogh's Masterpiece*. London: Frances Lincoln, 2013.

Barnes, Julian. 'Selfie with Sunflowers'. *London Review of Books*, 30 July 2015.

Baudelaire, Charles. *La Vie et l'œuvre d'Eugène Delacroix*. Paris: René Kieffer, 1928.

Beek, N. A. van, and G. J. Erenstein. *De aanteekeningen van tante Mietje van Gogh*. The Hague: Van Beek, 2010.

Bell, Julian. *Van Gogh: A Power Seething*. Boston: New Harvest, 2015.

Bellaigue, Camille. 'L'Amour dans la musique'. *Revue des Deux Mondes* 58 (1888): 89, 305–47.

Benoit, Camille. *Richard Wagner: Musiciens, poètes et philosophes*. Paris: G. Charpentier, 1887.

Bernard, Emile. *Propos sur l'art*. 2 vols. Paris: Séguier, 1994.

Blanc, Charles. *Les Artistes de mon temps*. Paris: Firmin-Didot, 1876.

Bonger, Andries. 'Letteren en Kunst: Vincent'. *Nieuwe Rotterdamsche Courant*, 5 September 1893.

Bracquemond, Félix. *Du dessin et de la couleur*. Paris: G. Charpentier, 1885.

Brouwer, Ton de, and Rebecca Nelemans. 'Van Gogh en Eindhoven'. Working paper, Van Gogh Museum, Amsterdam, 2013.

Brown, C. S., and R. J. Niess. 'Wagner and Zola Again'. *Publications of the Modern Language Association of America* 73 (1958): 448–52.

Brown, Calvin. 'Music in Zola's Fiction, Especially Wagner's Music'. *Publications of the Modern Language Association of America* 71 (1956): 84–96.

Bruhn, Siglind. *Europas klingende Bilder: Eine musikalische Reise*. Waldkirch, Germany: Gorz, 2013.

Cachin, Françoise, and Bogomila Welsh-Ovcharov, with Monique Nonne. *Van Gogh à Paris*. Paris: Musée d'Orsay, 1988.

Champa, K. S. 'La Berceuse: Authored by Music?' In *'Masterpiece' Studies: Manet, Zola, Van Gogh and Monet*, 91–118. University Park: Pennsylvania State University Press, 1994.

Chipp, Herschel B., Peter Selz and Joshua C. Taylor. *Theories of Modern Art: A Source Book by Artists and Critics*. California Studies in the History of Art. Berkeley: University of California Press, 1968.

Claus, Hugo. *De wolken: Uit de geheime laden van Hugo Claus*. Edited by Mark Schaevers. Amsterdam: De Bezige Bij, 2011.

Delacroix, Eugène. 'Réalisme et idéalisme'. *Oeuvres littéraires*, vol. 1, *Études esthétiques*. Paris: Crès, 1923.

———. *Journal, 1822–1863*. Edited by Hubert Damisch and André Joubin. Paris: Plon, 1981.

Deyssel, Lodewijk van. *Een liefde*. The Hague: Bert Bakker, 1974.

Dolan, Therese. *Manet, Wagner, and the Musical Culture of Their Time*. Farnham, England: Ashgate, 2013.

Dorn, Roland. 'Van Gogh, Gauguin und Richard Wagner, eine Etude auf das Jahr 1888'. In *Les symbolistes et Richard Wagner / Die Symbolisten und Richard Wagner*, ed. Wolfgang Storch and Josef Mackert, 67–75, 210–12. Berlin: Hentrich, 1991.

———. *Décoration: Vincent van Goghs Werkreihe für das Gelbe Haus in Arles*. Hildesheim, Germany: Olms, 1990.

Dorra, Henri. 'Le Texte Wagner de Gauguin.' *Bulletin de la Société de l'Histoire de l'Art Français* (1984): 281–88.

Druick, Douglas W., and Peter Kort Zegers. *Van Gogh and Gauguin: The Studio of the South*. Chicago: Art Institute of Chicago; Amsterdam: Van Gogh Museum, 2002.

Eeden, Frederik van. 'Kunst: Vincent van Gogh'. *De Nieuwe Gids* 6, no. 1 (1891): 263–70.

Eekelen, Yvonne van. 'Ik denk in mijn materie: Jacob Maris' werkwijze in relatie tot contemporaine artistieke ideeën en technieken'. In *Jacob Maris, 1837–1899: Ik denk in mijn materie*, ed. M. van Heteren, 69–82. Zwolle, the Netherlands: Waanders, 2003.

Félibien, André. *L'Idée du peintre parfait*. London: David Mortier, 1707.

Foa, Michelle. ' "One Art Eating the Other" in Emile Zola's *L'oeuvre*'. In Rubin and Mattis, *Rival Sisters*, 149–63.

Fonsmark, Anne-Birgitte. 'Delacroix: The Music of Painting'. In Fonsmark and Lederballe, *Delacroix*, 8–43.

Fonsmark, Anne-Birgitte, and Thomas Lederballe. *Delacroix: The Music of Painting*. Copenhagen: Ordrupgaard, 2000.

Gage, John. *Colour in Art*. World of Art. London: Thames and Hudson, 2006.

Garagnon, René. 'Odeon, Van Gogh et les Folies Arlésiennes'. *Bulletin des amis du vieil Arles* 90 (1995): 14–17.

Gauguin, Paul. *Avant et après*. Paris: Octavo, 1989.

Gauss, C. E. *The Aesthetic Theories of French Artists, from Realism to Surrealism*. Baltimore: Johns Hopkins University Press, 1970.

Gauzi, François. *Lautrec et son temps*. La Bibliothèque des Arts. Paris: David Perret, 1954.

Gilson, Etienne. *Peinture et réalité*. Paris: J. Vrin, 1972.

Gogh, Vincent van. *Brieven aan zijn broeder*. Edited by J. van Gogh-Bonger. Amsterdam: Mij. voor goede en goedkoope lectuur, 1914.

———. *Vincent van Gogh—The Letters: The Complete Illustrated and Annotated Edition*. Edited by Leo Jansen, Hans Luijten and Nienke Bakker. 6 vols. London: Thames and Hudson, 2009.

Gombrich, E. H. *Art and Illusion: A Study in the Psychology of Pictorial Representation*. London: Phaidon, 1977.

Grant, Patrick. *'My Own Portrait in Writing': Self-Fashioning in the Letters of Vincent van Gogh*. Edmonton, Alberta, Canada: Athabasca University Press, 2015.

Halsema, Dick van. 'Vincent van Gogh: A "Great Dutch Writer" (between Marcellus Emants and Willem Kloos)'. In *Van Gogh: New Findings*, 18–31. Van Gogh Studies 4. Zwolle, the Netherlands: Waanders; Amsterdam: Van Gogh Museum, 2012.

Hamerton, Philip Gilbert. *Imagination in Landscape Painting*. London: Seeley, 1887.

Hammacher, A. M., and R. Hammacher. *Van Gogh: Een documentaire biografie*. Amsterdam: Meulenhoff, 1982.

Havelaar, Just. *Oud-Hollandsche figuurschilders*. Haarlem, the Netherlands: Bohn, 1915.

Homburg, Cornelia. *The Copy Turns Original: Vincent van Gogh and a New Approach to Traditional Art Practice*. Amsterdam: John Benjamins, 1996.

Jansen, Leo. 'Vincent van Gogh's Belief in Art as Consolation'. In *Vincent's Choice: The Musée Imaginaire of Van Gogh*, edited by C. Stolwijk et al., 13–24. Amsterdam: Van Gogh Museum; Antwerp: Mercatorfonds, 2003.

———. *Van Gogh and His Letters*. Brussels: Mercatorfonds; Zwolle, the Netherlands: Waanders; Amsterdam: Van Gogh Museum, 2006.

Jansen, Leo, and Jan Robert, eds. *Brief Happiness: The Correspondence of Theo van Gogh and Jo Bonger*. Cahier Vincent 7. Introduction and commentary by Han van Crimpen. Amsterdam: Van Gogh Museum; Zwolle, the Netherlands: Waanders, 1999.

Jean-Léo. *Het circusleven in Brussel: Kunstenmakers en rondreizend volk vanaf de zeventiende eeuw*. Brussels: Algemeen Rijksarchief, 1998.

Jongh, E. de. 'Enige aspecten van de Nederlandse kunstkritiek in de 20e eeuw'. *Museumjournaal* 12, nos. 3–4 (1967): 67–80.

———. *Muziek aan de muur: Muzikale voorstellingen in de Nederlanden, 1500–1700*. Zwolle, the Netherlands: W Books, 2008.

Junod, Philippe. 'The New *Paragone*: Paradoxes and Contradictions of Pictorial Musicalism'. In Morton and Schmunk, *Arts Entwined*, 23–46.

Ketting, Piet. 'Een Duitsche Van Gogh-muziek'. *Kroniek van Hedendaagse Kunst en Kultuur* 4 (1938): 1–2, 9–10, 20–22.

Kools, Frank. *Vincent van Gogh en zijn geboorteplaats: Als een boer van Zundert*. Zutphen, the Netherlands: Walburg Pers, 1990.

Lapidoth, Frans. 'Parijsche Kunstkroniek II'. *De Nederlandsche Spectator*, 21 May 1892, 172–73.

Lederballe, Thomas. 'Delacroix's Enthusiasm: Abduction as a Genre in his Painting'. In Fonsmark and Lederballe, *Delacroix*, 103–21.

Leeuw, Ronald de. 'Richard Wagner en de Franse schilderkunst van het einde van de negentiende eeuw'. Master's thesis, Universiteit Leiden, 1976.

Lemaire, Ton. *De leeuwerik: Cultuurgeschiedenis van een lyrische vogel*. Amsterdam: Ambo, 2004.

Leonard, Anne. 'Picturing Listening in the Late Nineteenth Century'. *Art Bulletin* 89, no. 2 (2007): 266–86.

Lindenberger, Herbert. 'Literature and the Other Arts'. In *The Cambridge History of Literary Criticism*, vol. 5, *Romanticism*, ed. Marshall Brown, 362–86. Cambridge: Cambridge University Press, 2000.

Lippman, Edward A. *A History of Western Musical Aesthetics*. Lincoln: University of Nebraska Press, 1992.

Lockspeiser, Edward. *Music and Painting: A Study in Comparative Ideas from Turner to Schoenberg*. London: Cassell, 1973.

Loesser, Arthur. *Men, Women and Pianos: A Social History*. New York: Gollancz, 1954.

Loti, Pierre. *Pêcheur d'Islande*. 1886. Rev ed., Paris: Calmann Lévy, 1900.

Mander, Karel van. *Het schilder-boeck*. Facsimile of the first edition, Haarlem 1604. Utrecht: Davaco, 1969.

Maritain, Jacques. *Creative Intuition in Art and Poetry*. A. W. Mellon Lectures in the Fine Arts, Bollingen Series 35–1. New York: Pantheon, 1960.

Marius, G. H. *De Hollandsche schilderkunst in de negentiende eeuw*. The Hague: Martinus Nijhoff, 1920.

Matisse, Henri. *Ecrits et propos sur l'art*. Edited by Dominique Fourcade. Collection Savoir. Paris: Hermann, 1972.

Maupassant, Guy de. 'Le Horla.' In *The Necklace and Other Stories: Maupassant for Modern Times*. New York: Liveright, 2015.

———. *Le Horla: Oeuvres complètes illustrées*. Paris: Librairie Ollendorff, 1908.

Merlhès, Victor, ed. *Correspondance de Paul Gauguin: Documents témoignages*. Paris: Fondation Singer-Polignac, 1984.

Metzelaar, Helen H. 'Klanken van de zijlijn: De vrouw in het Nederlandse muziekleven in de achttiende en negentiende eeuw'. *Jaarboek voor vrouwengeschiedenis* 23 (2003): 108–26, 235.

Meurs, Bernhard van. *Het leven van Ludwig van Uhland en vertalingen uit zijn dichtbundel*. Nijmegen, the Netherlands: Blomhert & Timmerman, 1877.

Meyers, Jan. *De jonge Vincent: Jaren van vervoering en vernedering*. Amsterdam: Arbeiderspers, 1989.

Michelet, Jules. *L'Oiseau*. Paris: Hachette, 1908. Published in an unattributed translation in English as *The Bird* (London: T. Nelson and Sons, Paternoster Row, 1868).

Miedema, Hessel. *Kunst, kunstenaar en kunstwerk bij Karel van Mander: Een analyse van zijn levensbeschrijvingen*. Alphen aan de Rijn, the Netherlands: Canaletto, 1981.

Morton, Marsha L., and Peter L. Schmunk, eds. *The Arts Entwined: Music and Painting in the Nineteenth Century*. New York: Garland, 2000.

Naifeh, Steven, and Gregory White Smith. *Van Gogh: The Life*. New York: Random House, 2011.

Norris, Lisa. 'Painting *Around the Piano*: Fantin-Latour, Wagnerism, and the Musical in Art'. In Morton and Schmunk, *Arts Entwined*, 143–76.

Pabst, Fieke, ed. *Vincent van Gogh's Poetry Albums*. Zwolle, the Netherlands: Waanders, 1988.

Pomarède, Vincent. ' "The Silent Arts" and Music: Eugène Delacroix, a Painter Who Loved Music'. In Fonsmark and Lederballe, *Delacroix*, 63–101.

Poorter, Bastiaan de. *De kunst en de kunst-akademie*. The Hague: W. P. van Stockum, 1870.

Porter, Lynnette. 'Van Gogh in Music'. In *Van Gogh and Popular Culture*, 156–71. Jefferson, NC: McFarland, 2016.

Poulet, Célia, ed. *Emile Zola: Ecrits sur la musique*. Paris: Editions du Sandre, 2013.

Prieto, Eric. *Listening In: Music, Mind, and the Modernist Narrative*. Lincoln: University of Nebraska Press, 2002.

Quesne-Van Gogh, E. H. du. *Vincent van Gogh: Herinneringen aan haar broeder*. Baarn, the Netherlands: J. F. van de Ven, 1923.

Ridley, Hugh. *Wagner and the Novel: Wagner's Opera's and the European Realist Novel*. Amsterdam: Rodopi, 2012.

Roberts, David. *The Total Work of Art in European Modernism*. Ithaca, New York: Cornell University Press, 2011.

Roskill, Mark. *Van Gogh, Gauguin and the Impressionist Circle*. New York: Graphic Society, 1970.

Rubin, James H., and Olivia Mattis, eds. *Rival Sisters: Art and Music at the Birth of Modernism, 1815–1915*. Farnham, England: Ashgate, 2014.

Schapiro, Meyer. *Vincent van Gogh*. New York: Harry N. Abrams, 1952.

Schmunk, Peter L. 'Artists as Musicians and Musical Connoisseurs: Musicians, *Mélomanes*, and Ideas of Music among Nineteenth Century Artists'. In *The Routledge Companion to Music and Visual Culture*, ed. Tim Shephard and Anne Leonard, 265–73. New York: Routledge, 2014.

———. 'Van Gogh in Nuenen and Paris: The Origins of a Musical Paradigm for Painting'. In Morton and Schmunk, *Arts Entwined*, 177–207.

———. 'What Did Van Gogh Hear? Vibrations, Wagner, and Voices'. In *Aural Cultures*, ed. Jim Drobnick, 36–47. Toronto: YYZ, 2004.

Schneede, Uwe M. 'Picture in Concert: Van Gogh's "Decoration" and Munch's Frieze of Life'. In *Munch: Van Gogh*, ed. M. van Dijk, M. Bruteig and L. Jansen, 152–69. New Haven: Yale University Press, 2015.

Schopenhauer, Arthur. *Die Welt als Wille und Vorstellung*. Edited by Eduard Grisebach. Ditzingen, Germany: Philipp Reclam, 1892.

Sensier, Alfred. *La Vie et l'oeuvre de J.-F. Millet*. Paris: A. Quantin, 1881.

Silverman, Deborah. *Van Gogh and Gauguin: The Search for Sacred Art*. New York: Farrar, Straus & Giroux, 2000.

Silvestre, Théophile. *Eugène Delacroix: Documents nouveaux*. Paris: Michel Lévy Frères, 1864.

Sluijter, Eric Jan. *Seductress of Sight: Studies in Dutch Art of the Golden Age*. Zwolle, the Netherlands: Waanders, 2000.

Stipriaan, René van. *Vincent van Gogh: Ooggetuigen van zijn lange weg naar wereldroem*. Amsterdam: Athenaeum-Polak & Van Gennep, 2011.

Stolwijk, Chris, and Han Veenenbos, eds. *The Account Book of Theo van Gogh and Jo van Gogh-Bonger*. Amsterdam: Van Gogh Museum; Leiden: Primavera Pers, 2002.

Sund, Judy. *True to Temperament: Vincent van Gogh and French Naturalist Literature*. Cambridge: Cambridge University Press, 1992.

Tilborgh, Louis van, and Ella Hendriks, eds. *Vincent van Gogh Paintings*, vol. 2, *Antwerp and Paris, 1885–1888*. Amsterdam: Van Gogh Museum, 2011.

Uitert, Evert van. 'Beeldende kunst en muziek: De muziek van het schilderij'. In *Kunstenaren der idee: symbolistische tendenzen in Nederland, ca. 1880–1930*, ed. Carel Blotkamp, 67–75. The Hague: Haags Gemeentemuseum / Staatsuitgeverij, 1978.

———. 'Vincent van Gogh and Paul Gauguin: A Creative Competition'. *Simiolus: Netherlands Quarterly for the History of Art* 9, no. 3 (1977): 149–68.

Veen, Wouter van der. *Van Gogh: A Literary Mind*. Zwolle, the Netherlands: Waanders; Amsterdam: Van Gogh Museum, 2009.

Vellekoop, Marije, ed. *Van Gogh at Work*. With contributions by Nienke Bakker, Maite van Dijk, Ella Hendriks, et al. Amsterdam: Van Gogh Museum; Brussels: Mercatorfonds, 2013.

———, ed. *Van Gogh's Studio Practice*. Amsterdam: Van Gogh Museum; Brussels: Mercatorfonds; New Haven: Yale University Press, 2013.

Vellekoop, Marije, and Roelie Zwikker, eds. *Vincent van Gogh Drawings*, vol. 4, *Arles, Saint-Rémy and Auvers, 1888–1890*. With the assistance of Monique Hageman. Amsterdam: Van Gogh Museum, 2007.

Vellekoop, Marije, and Sjraar van Heugten, eds. *Vincent van Gogh Drawings*, vol. 3, *Antwerp and Paris, 1885–1888*. With the assistance of Monique Hageman and Roelie Zwikker. Amsterdam: Van Gogh Museum, 2001.

Vergo, Peter. *The Music of Painting: Music, Modernism and the Visual Arts from the Romantics to John Cage*. London: Phaidon, 2012.

Veth, Jan. 'Studiën over moderne kunst: Tentoonstelling van werken door Vincent van Gogh in de Amsterdamsche panoramazaal'. *De Nieuwe Gids* 8 (1893): 427–31.

Viardot, Louis. 'Ut pictura musica'. *La Gazette des beaux-arts* 1, no. 1 (January 1859): 19–29.

Vosmaer, Carel. *Inwijding*. The Hague: Martinus Nijhoff, 1889.

Weber, William. *Music and the Middle Class: The Social Structure of Concert Life in London, Paris and Vienna*. London: Croom Helm, 1975.

Willaert, Tom. 'Multatuli als schrijf- en spreekmachine: Over de vroege receptie van de fonograaf in de literatuur van de Lage Landen'. *De Negentiende Eeuw* 39, no. 2 (2015): 97–117.

Wittkower, Rudolf, and Margot Wittkower. *Born under Saturn: The Character and Conduct of Artists; A Documented History from Antiquity to the French Revolution*. London: Weidenfeld and Nicolson, 1963.

Wyzewa, Théodore de. 'Notes sur la peinture wagnérienne et le Salon de 1886'. *Revue Wagnérienne*, 2nd ser., 4 (May 1886): 100–113.

Zadkine, Ossip. *Le Maillet et le ciseau: Souvenirs de ma vie*. Paris: Albin Michel, 1968.

Zola, Emile. *La Joie de vivre*. Les Rougon-Macquart 12. Paris: G. Charpentier, 1884. Published in an unattributed translation as *Zest for Life* (Bloomington: Indiana University Press, 1956).

———. *Nana*. Les Rougon-Macquart 9. Paris: G. Charpentier, 1880. Translated by Douglas Parmée as *Nana*, Oxford World's Classics (New York: Oxford University Press, 1992).

———. *L'Oeuvre*. Les Rougon-Macquart 14. Paris: G. Charpentier, 1886. Translated by Thomas Walton as *The Masterpiece*, Oxford World's Classics (New York: Oxford University Press, 1993).

———. *Le Ventre de Paris*. Les Rougon-Macquart 3. Paris: G. Charpentier, 1873. Translated by Brian Nelson as *The Belly of Paris*, Oxford World's Classics (New York: Oxford University Press, 2007).

ACKNOWLEDGEMENTS

For some years now I've been captivated by the letters of Vincent van Gogh. As I read them again and again, I never fail to experience the same closeness already described by others: it feels as though his words are addressed to me personally. Few people have written about life and art, and the inseparability of the two, as intensely, honestly and poignantly as he did. I was fortunate in being able to study Van Gogh's correspondence in the 2009 publication *The Letters: The Complete Illustrated and Annotated Edition*, edited by Leo Jansen, Hans Luijten and Nienke Bakker—the six-volume edition that underpins this exploration of Van Gogh's relationship with music. I also made use of the online edition (vangoghletters.org), which is updated annually and contains the same source texts and their English translations, as well as comprehensive notes to all the letters.

This book could not have been written without the generous help of many people. I would like to thank the Van Gogh Museum and the Vincent van Gogh Foundation for allowing me to consult a wide variety of (visual) material, my references to which are prefaced by VGM, indicating the Van Gogh Museum, Amsterdam. I am also indebted to the staff of the Van Gogh Museum's Library and Documentation Centre, the Department of Research and the Department of Publications, as well as to Collection Management and Van Gogh Museum Enterprises, for their friendly and helpful support. The conversations I had with Gemma Nefkens and Patrick Grant had a stimulating effect on my work. My biggest thanks go to Hans Luijten, Leo Jansen and Eddy de Jongh, my tireless readers, who kindly commented on previous versions of this text, and to Diane Webb, my translator, for her unflagging commitment both to my book and to Vincent van Gogh.

INDEX

Note: Pages in italic refer to illustrations.

Z

Zadkine, Ossip (Yossel Aronovich Tsadkin), 82

Zande, Hein van der, 7, *8* (fig. 6)

Zola, Emile Edouard Charles Antoine, 57 (fig. 30); on art and feeling, 106; and colour theory, 59; and Millet, 135; and music, 58–59, 146; on realism, 60; Van Gogh on, 41, 56–60, 89; and Van Gogh's madness, 119; and Van Rappard, 90; and Willemien 37; writer as painter, 89

ALSO BY NAMINA FORNA

The Gilded Ones

PRAIS

An Instar

A *Te*

★ "Readers will find thei

"A powerful start to the We
movie adaption in the works

"An inventive fantasy world." —

"Action combines with an intens
strength is found in female friend:

"This story moves swiftly with a mi
touch of romance." —*Business Insider*

"Forna delivers your next obsession." —

"Fans of *Children of Blood and Bone, Mulan,
Panther* are going to adore this one." —*Buz*

"Namina Forna is the fresh voice the world o
—*PopSugar*

"*The Gilded Ones* redefines sisterhood and is sure
inspired and ultimately hopeful." —Stephanie Ga
bestselling author of *Caraval*

"A dark feminist tale spun with blood and gold, *The (*
of violent patriarchy and burns the idea of purity to th
—Dhonielle Clayton, *New York Times* bestselling author

"An epic new fantasy with heart-stopping stakes and a fie
hero, *The Gilded Ones* is a dazzling and powerful debut." —
New York Times bestselling author of *Six Crimson Cranes*

"A fierce, unflinching fantasy that marks Forna as a debut to w
—Kiersten White, *New York Times* bestselling author of *And I L*

"Haunting, brutal, and oh-so-relevant. This book will suck you in
world where girls bleed gold, magic fills the air, and the real monst
hide behind words instead of claws." —Roseanne A. Brown, *New Yor*
Times bestselling author of *A Song of Wraiths and Ruin*

NAMINA FORNA

THE
MERCILESS
ONES

THE GILDED ONES #2

DELACORTE PRESS

Text copyright © 2022 by Namina Forna
Jacket art copyright © 2022 by Tarajosu

All rights reserved. Published in the United States by Delacorte Press, an imprint of Random House Children's Books, a division of Penguin Random House LLC, New York.

Delacorte Press is a registered trademark and the colophon is a trademark of Penguin Random House LLC.

GetUnderlined.com

Educators and librarians, for a variety of teaching tools, visit us at RHTeachersLibrarians.com

Library of Congress Cataloging-in-Publication Data is available upon request.
ISBN 978-1-9848-4872-7 (trade) — ISBN 978-1-9848-4873-4 (ebook) —
ISBN 978-0-593-48702-0 (int'l ed)

The text of this book is set in 11-point Hoefler Txt.
Interior design by Ken Crossland

Printed in the United States of America
10 9 8 7 6 5 4 3 2 1
First Edition

To all the kids who feel out
of place or unwanted.
This book is for you.

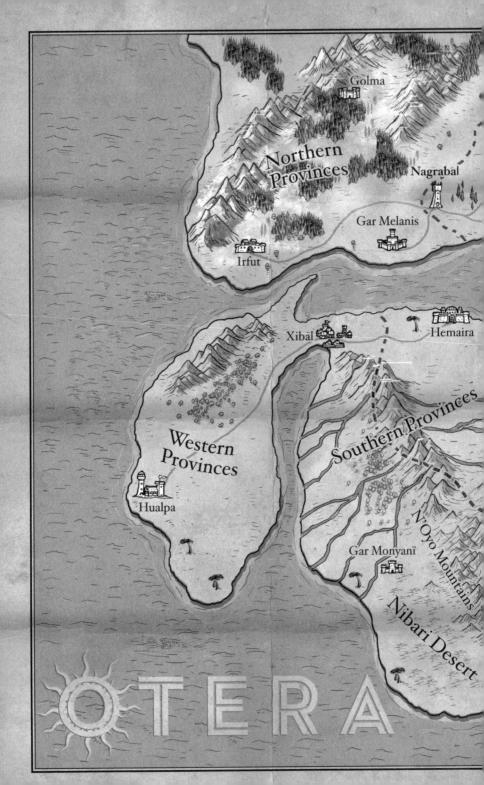

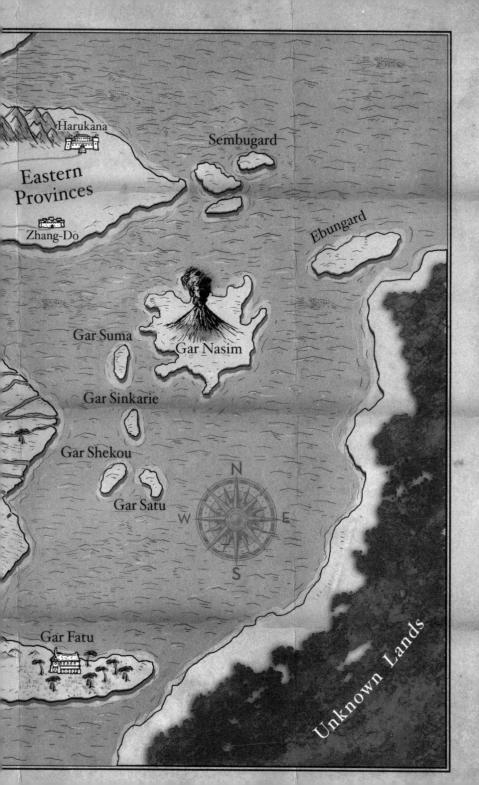

1

◆ ◆ ◆

There are four of them.

Corpses. Each one female and young—around my age, if that.

They're mounted on stakes at the mouth of the jungle, the evening shadows spreading inky tendrils over their ash-colored skin and bulging, distended stomachs. They almost look like dolls . . . except dolls don't have black masks hiding their faces like funeral cowls, and they certainly don't smell putrid, like animal carcasses left too long in the sun. The stench of rot wafts past, and my stomach lurches. I don't like the odor of meat even under normal circumstances, but this—the stink of those bodies displayed among the tangle of roots and ferns . . . Sweat turns my palms slick, and a subtle tremor begins in my muscles. I focus on the necklace hidden under my armor, my touchstone in times like this. The mothers gave it to me some months ago to replace the one I inherited from my birth mother, Umu.

When I tug on it mentally, a replying vibration travels through me—an acknowledgment from the mothers: they're

here with me. No matter how difficult things become, the goddesses are always there, silently supporting me.

"Think we should risk takin' them down, Deka?" Britta's voice sounds oddly composed as it pushes against my whirling thoughts.

Just last year, she would have been in tears. She was the typical Northern farm girl then—blond, rosy-cheeked, and plump. Now, her muscles are as formidable as her curves, her skin is golden from the desert sun, and her heart is hardened against such sights. Her entire posture bristles with rage, but she remains quiet as she stares at the bodies.

I do the same, all the while steadfastly ignoring the strange heartbeat pounding in the underbrush just a few lengths from me. The person it belongs to has been there for some time now, but they're so loud, and are making so much clamor, it's obvious they're not one of the jatu—the former emperor's guards, and our sworn enemies—or any other threat, for that matter.

Perhaps they're related to one of the corpses. It wouldn't be the first time I've encountered a grieving family member at a site like this. There are many such displays all across Otera now, warnings to women: step one foot out of line and this is what will happen to you. Each one is a bitter reminder that the longer we take to eliminate the priests and the jatu the more the women of Otera suffer and the more our friends back in Hemaira—

I dismiss the thought by regarding the corpses' distended abdomens. "No," I finally reply. "They're too far gone." Usually, we take any female corpses we come across down from the stakes, but these girls' bellies are swollen by the heat, which means they're likely to explode if we touch them.

I turn to my other companions—Belcalis, Asha, Adwapa,

and Katya. They are nearly indistinguishable among the towering tree trunks because of their leathery black armor, which we all wear during raids, as do the gryphs—the winged, striped desert cats we use as mounts. The sight is so familiar, I halfway expect Keita and the other uruni, our partners and brothers in arms, to stroll out of the jungle and join the group. They're off in Hemaira, however, aiding our siege on the capital's gates, which still haven't fallen after six months of relentless attack.

"We continue on foot," I say. "There'll be traps now."

Change, Ixa, I add mentally, speaking to my shape-shifting companion.

Deka, he agrees from underneath me, already shrinking to a smaller size. Normally, Ixa looks like a gigantic blue-scaled cat with horns jutting from its head like a crown, but for missions like these, he prefers to take the form of a small blue bird—a nightflyer.

He's already sprouting wings when I climb off him.

As he flits into the silvery branches of a broad-leafed amarul tree, a shout rings out across the clearing: "Murderers!"

Our mysterious watcher shuffles from the shadows, her face covered by a plain white mask, the color of mourning. To my surprise, she's a Northerner—pale pink skin and hair so white, it nearly gleams in the evening gloom. Every step she takes, aided by a roughly hewn wooden cane, is heavy, labored—she's obviously of an advanced age, perhaps even in her sixtieth year or so. Add to that her plump, compact form and she could be any number of women from Irfut, the village of my birth.

"You did this," she says, angrily shaking her cane at me. "This is your fault, Nuru!"

"You know who I am?" I'm so taken aback that she recognizes me as the Nuru—the one full-blooded daughter created by the mothers to free deathshrieks and alaki from the tyranny of the jatu—I forget my other concerns.

No one ever guesses my identity when I'm in my battle form, which is what I call the transformation my body undergoes whenever I'm primed for combat. Before, only my face changed: my skin mottled, my cheeks sharpened, and my eyes went black from rim to rim. Now, my entire body becomes rawboned and skeletal and my nails sharpen to claws. I could almost be mistaken for a deathshriek, except that deathshrieks are giants, their withered, humanlike bodies three times the size of a normal man, and that isn't even including their claws, full butcher knives tipping each finger.

"Everyone knows!" the woman rages. "Deka of Irfut. The one who looks like a deathshriek as she enters battle but is human-sized. The cursed daughter of the cursed goddesses."

My teeth grit. "Do not speak ill of my mothers." She can say what she wishes of me, but the Gilded Ones have already endured enough slander to last lifetimes.

In Irfut, the priests told us that the goddesses were actually ancient demons who'd ravaged Otera, slaughtering entire cities and eating children. We alaki were impure because we were their daughters: we carried their golden blood, their strength, speed, and a portion of their longevity. They said the only way to earn purity—humanity—was to help the empire fight against deathshrieks, monstrous creatures drawn by our blood.

They never mentioned, of course, that deathshrieks were actually alaki, resurrected by the Gilded Ones after death in

4

terrifying forms so that we could fight the jatu-led human forces who wanted to drive the goddesses' line to extinction.

"Then who else is to blame for this, for my daughter—" The woman points at the leftmost corpse, and nausea twists my gut.

The corpse is markedly curvier than the others, its hair looser in texture. A tiny cleft embedded in its chin. In another life, it could've been me. Not so long ago, my curls were looser and my eyes lighter, and I too had a cleft chin. Then I moved to the Southern provinces and discarded the features I'd inherited from the man I once called Father—the gray eyes, the lightly curled hair, the chin. Now, my eyes are dark, my hair is tightly coiled, and my chin is unremarkable. All that remains of the girl who was Deka of Irfut is my short stature and Northern accent, although that is now tinged with a distinctly Southern flair.

This is what it means to be the Nuru, the only full-blooded daughter of the goddesses: I can be whoever I choose.

The woman shudders with grief, tears streaming from her eyes. "My poor child. She never did anything, never once disobeyed the Wisdoms. But then you lot came, with your lies of freedom and another life for women. All she did was utter your name, speak a little of the Gilded Ones, and the priests came for her. They took her. She wasn't even an alaki; her purity had already been proven by the Ritual. But they said she was wayward. That she would lead others into corruption. So they took her, tried to take me—"

She points again to the bloated corpse creaking in the night breeze. "Is this the freedom you promised us? Where are the

goddesses you said would defend Oteran women? Where are they?"

Her pain is so great, I feel the justifications slipping from my lips. "They're sleeping, gathering their strength, but once they do—"

"What does it matter what they do?" The woman surges closer, grief having pushed her past all semblance of fear. "Before, there were rules. We knew how to live. How to survive. Now, there is nothing. I have nothing because of you. I *am* nothing because of you."

She falls to the ground at her daughter's feet, sobbing uncontrollably. "My girl, oh, my beloved girl."

Beside me, Nimita, a towering white deathshriek who has been assigned to our group, sighs with annoyance. Five deathshrieks accompanied us today—Katya, my former bloodsister, among them, of course, her red-spiked form distinct beside the others, whom I don't know as well—not that I'm making the effort. So many people have died over the past few months that sometimes it seems pointless to try to forge deeper connections.

"We do not have time for this, honored Nuru," Nimita says, her voice a deep rumble.

Like all deathshrieks, she speaks in growls and hisses, but I understand her as perfectly as I would someone speaking Oteran. Another benefit of being the Nuru: I can understand all the descendants of the Gilded Ones and even force them to obey my commands if I wish.

I angle my head toward her. "What do you suggest we do, incapacitate her and leave her out here with all the beasts?"

"That's always an option." As with most Firstborn, those alaki who were born during the time of the goddesses, Nimita is a creature of expediency. Dying and resurrecting as a death-shriek has not changed that part of her.

"I will not leave her." When I freed the Gilded Ones from their imprisonment in the mountains, I promised I would fight for the women of Otera—all women, not just the alaki. I return my attention to the old woman. "You cannot go home, and it is dangerous here. If you wish, I can have you taken to Abeya, the city of the goddesses. You'll be safe there."

"'Safe.'" The woman hisses out the word. "There is no safety anywhere—not anymore. Between you lot and Elder Kadiri"—she spits as she speaks the name of the Southern high priest who's now gathering the jatu armies together from all across Otera—"there's no place any woman can hide."

"Then how about freedom?" These words seem to catch the woman by surprise, so I quickly elaborate, using an echo of the speech my former instructor, White Hands, gave me over a year and a half ago. "In Abeya, you can do anything you wish, be anyone you choose. All you have to do is make your way there."

I give her a moment to make her decision. "Now then, will you go? Or will you remain here for the beasts to devour?"

The woman's jaw juts. But then a small, barely yielding nod. She'll go.

"Very well." I turn to Chae-Yeong, a small, sleek black death-shriek with a nub where her right hand should be. She was injured before her blood turned gold, and that injury followed her across death to this form. "Return with her to Abeya. We will continue on."

"But, honored Nuru—" she begins, glancing at Nimita for guidance.

When the older deathshriek shakes her head, it takes everything I have not to clench my fists. I may be the Nuru, I may be the one who freed the mothers and ushered the One Kingdom into a new era, but to the Firstborn, I'll always be only seventeen years old—a blink of an eye to their kind, who have seen countless millennia. Add to that all the deathshrieks I killed before I knew what I was, and they and many others of their kind will never forgive me. Never truly trust me.

So I always have to prove myself. My dominance.

I step forward. "Now," I insist, not even looking at Nimita.

"Yes, Nuru." Chae-Yeong genuflects, doing the small, swift kneel I've become so used to, before she approaches the woman. "Come, human," she growls, even though she knows the woman can't understand her. Deathshrieks tend to have very little patience with humans, but I don't blame them: it's hard being patient with people who always want you dead.

"Follow her," I say to the woman. "You won't come to any harm. I vow it."

"No." The woman quickly steps back. When I sigh, annoyance rising, she adds, almost timidly, "Not till they have been buried. I . . . lack the strength to pull them down myself."

I still, shame rising inside me. How could I forget such a simple human need? I've hardened much over the past few months if I cannot even recognize the need of a mother to properly bury her child.

I turn to Chae-Yeong again. "Bury them first," I say quietly. "Then take her to Abeya."

"Yes, Nuru." Chae-Yeong genuflects again.

The woman nods her thanks to me, but I am already striding forward, my attention focused on the others. Time is short, and I cannot afford to spend any longer here than I already have. "Onward," I command, pointing at the spires of the blood-red temple rising above the jungle's mists. "To the Oyomosin."

2

◆ ◆ ◆

It takes three hours to climb up the cliff leading to the Oyomo-sin, the temple named in honor of Oyomo, the false god I once worshipped. It's an uncomfortable journey, given that the cliff sits atop a dormant volcano, the heat rising through its stones to plaster hair to skin and armor to body. I ignore my bodily discomfort by revisiting all the things the old woman said to me about what life is like now for women in Otera. Each of her words is a painful reminder of all the ways I've failed since I freed the mothers: I may have defeated that first army of jatu attacking their mountain, but dozens more are already emerging. In the six months that have passed since I woke the mothers, the jatu have gathered up almost every able-bodied man in Otera and pressed them into service. Even boys with barely a chest hair to their name aren't safe.

It wouldn't be so worrying if we'd already conquered Hemaira, the seat of the jatu's power, but they still control the capital, still have its gates firmly locked against us.

And now, they throw a new bloodsister from the walls every week.

Such a horror I have never before imagined, the screams of all those innocent girls as they plummet to their deaths. The jatu choose them at random from the training grounds across Hemaira. Every day, I'm certain it's going to be someone I know, but there's nothing I can do to stop it—not now, at least. The walls of Hemaira truly are impenetrable, but not for the reasons we were always told. Something lives inside them, a force that repels any would-be invaders with the heat of a thousand flames. It's called the n'goma, and it's an arcane object, an artifact from the time the mothers ruled Otera that contains remnants of their once-vast power. There are several such objects littered across Otera, but the n'goma is the most powerful of them all. It releases terrifying blasts of heat that peel the flesh from your bones the second you venture near the walls. In the days after we first freed the goddesses, I tried several times, but the n'goma was too strong.

All I could do was stand there helplessly, watching the bodies of those girls being stripped of flesh over and over again while the jatu looked down, unmoved by their cries. Worst of all, the Gilded Ones, who built Hemaira's walls themselves, can do nothing: Millennia of imprisonment have starved the goddesses of the worship that once fed their power. They can't tear down the walls or even rain fire down on the jatu, as they would have in their prime. Now, they just spend all their time sleeping, absorbing prayers.

The only way forward is to either negotiate with the jatu or find a method of helping the goddesses regain their power

faster so that we can rescue our sisters. Which, of course, is the reason I'm here, climbing this unscalable cliff.

The Oyomosin thrusts above me, a stark temple carved into the cliff, moonlight outlining its harsh, forbidding edges. Usually, there's only one way to enter, the creaky wooden draw-bridge just a short drop below us, but the priests always draw it up at night to prevent assailants from gaining entry.

As Belcalis and I pull ourselves over the ledge and head for the sparse patch of grass that marks the edge of the Oyomosin's grounds, Britta's aggravated voice rises along with the wind. "Ye know," she huffs, lifting herself up behind us, "it's rude to leave yer comrades behind during a raid."

"Or," Belcalis replies, her lithe, copper-skinned form already slipping past the pitiful copse of trees surrounding the temple, "that comrade could just forge ahead like all the rest are doing."

She gestures with her chin to Asha and Adwapa, who are swiftly entering the temple's grounds alongside the death-shrieks, silent shadows in the darkness.

Asha and Adwapa are twins, both midnight dark and so gracefully muscled, they seem almost a sliver against the night. The only thing that differentiates the two is their hair—or lack thereof: Adwapa is perfectly bald, her head gleaming under the moonlight, but her sister's black hair shimmers an eerie green. The scouts who plotted our path for this mission braided the Oyomosin's map into Asha's hair with glowing lunar ferns so that we could see it easily as we climbed in the dark. They would have braided it into mine, but I've just cut my hair again, enjoying the freedom the short, cropped style provides.

Britta turns back to Belcalis and sniffs. "I'm on me menses, and ye know it."

"So are the twins, but you don't see them complaining," Belcalis replies.

Indeed, both Asha and Adwapa are now walking over to the large window that's our entryway into the temple.

Hurry it up, Adwapa signs to us with battle language—a reminder. From here on out, we move in silence.

I nod as I swiftly approach the window. It's eerily dark inside, not even a single candle to light the way, and it's the same for all the other windows, even though I know the Oyomosin is fully occupied. The low hum of prayers has been steadily rising into the air all this while, and now, it's accompanied by another, more worrying sound: screams. They echo from the depths of the temple, carried by waves of smoke tinged with the distinct odor of burning flesh.

A tremor begins in my muscles. *The cellar . . . Gold streaming across the floor like rivers. The priests dragging me out to a remote field. The pyre, firewood already piled around it. Flesh splitting, burning. Pain . . . so much pain!*

A warm hand presses my shoulder. "Should I go in first, Deka? Scout the area?"

I glance up to find Britta staring at me, her blue eyes filled with concern. "Yes," I whisper, shame curling white-hot in my belly.

It's been over a year and a half since I was in that cellar. A year and a half during which I uncovered my nature as the Nuru, became a warrior, defeated countless jatu . . . Unlike my alaki sisters, I'm a true immortal. I don't have a final death and can recover from any injury, no matter how severe.

Why, then, am I still afflicted by this human weakness?

So much depends on me. My bloodsisters back in Hemaira,

my sisters in blood and battle, all of them waiting to be rescued. All the women across Otera who are being punished for my actions . . . I can't wallow in my feelings; I have to be strong. Have to prove that I am worthy of the task set before me, that I am worthy of being the only daughter the mothers chose to carry the fullness of their divine heritage.

I lift my shoulders, trying to embody this worth, but as I slip inside the Oyomosin, I feel a sudden, unnerving sensation: the tingling of my blood rushing up just under my skin, a reaction to the presence of divine blood. I'm being watched.

I whirl, trying to find the watcher, but the hallway is completely empty except for my companions. There's no one else there. And yet the tingling is now being joined by another, more worrying sensation: a crushing heaviness, as if the weight of the watcher's eyes has settled on my shoulders. My shoulders twitch. Whoever this watcher is, they're not friendly—that much I know for certain.

It has to be a jatu. They're the only other people with divine blood in Otera, other than alaki and deathshrieks. Any new deathshriek or alaki would have shown themself already, compelled, as they always are, by the subtle power pulsing from my body.

I glance back out the window, trying to find any hint of the telltale red armor jatu always wear. *Do you see anyone?* I ask the others, using battle language.

My friends immediately fan out across the hall, gazes sharp. But nothing moves.

No, Adwapa signs. *There's nothing there.*

I frown, glancing around again. Perhaps it was just a figment of my imagination. This wouldn't be the first time my senses

have played tricks on me. My mind is forever latching on to inconsequential things to distract itself from painful memories. Even so, I remain alert as I make my way down the hall. There's always the slightest chance I may be wrong.

◆

The farther I go, the darker and more oppressive the temple becomes. Flickering torches create eerie shadows on the stones, hidden passages curve into the unknown, and geometric wall carvings form dizzying shapes that merge into each other. Oyomo may be primarily revered in Otera as the god of the sun, but he is also the god of mathematics, which means all his temples are built using sacred geometry. The Oyomosin is no exception. Every stone and beam around us is a prayer, like those the priests are now calling out.

They're coming, Katya signs when their footsteps approach.

I swiftly press myself against the wall, remaining so still, even my heartbeat slows. It's the only precaution I take, the only one necessary, given that priests of the Oyomosin are blind. They pluck out their eyes and offer them in reverence to Oyomo when they enter the priesthood. That's why the temple lies in darkness, why the priests wear masks of roughly beaten gold, the eyeholes welded shut, over their faces.

Thankfully, they don't seem to notice us as they continue down the hall, intoning a hymn to the glory of Oyomo and his light upon the world.

Once they're all gone, I motion to the others. *Quickly now,* my hands sign.

Everyone follows me, and we continue on swiftly through

the dark, endless passages of the Oyomosin, Asha's map leading us. We finally stop just in front of a massive door at the very center of the temple. The screams are coming from inside, blasting through the halls, a symphony of pain and anger. I turn to the others, and they nod, not even needing me to say it.

There, just beyond the door. That's where she's being held.

Melanis. The Light of the Alaki.

3

❖ ❖ ❖

Even while she's being burned alive, Melanis is still luminous.

I peer at her through the crack in the heavy wooden door, her hair shining lustrous black between the flames, body lithe and graceful despite being contorted in a rictus of pain. Once upon a time, Melanis was known as the most beautiful alaki in all of Otera. She was one of the four war queens, the very first of the Firstborn children of the Gilded Ones and their most powerful generals. Gold-tipped white wings like Mother Beda's aided Melanis in soaring to the heavens, and divine light seemed to shimmer from deep inside her skin. People sang songs in her name, threw flowers at her feet. They called her the Light of the Alaki.

That was then.

Now, Melanis's eyes, once described as translucent pools, are burned-out holes of darkness. Her lips, once heralded for their rosy sheen, have crumbled into slashes of charcoal, and her dusky brown skin curls and peels. No sign of her wings or celestial glow

remains: they've gone the way of all the divine gifts the mothers once bestowed upon their children, back into nothingness. All that's left of the alaki that was once Melanis the Light is a burning, screaming mass of flesh lying across the hollowed-out stone altar built directly atop the cauldron of magma below, chains of celestial gold stretching her taut over the flames as they have for the past thousand years, while moonlight shines down upon her from the glass dome in the chamber's ceiling.

The golden-masked priests in the inner chamber intone prayers as they walk in slow, unrelenting circles around her. They don't even seem to notice the chamber's stifling heat as they throw sacred oil onto the pit, coaxing the flames there ever higher. The odor of burning intensifies, and my muscles clench again. I close my eyes, focus once more on the necklace the mothers gave me. It stretches from chin to chest like a neck guard, delicate threads of celestial gold interlinking to form hundreds of tiny, star-shaped flowers that double as a very light, almost weightless chain mail underneath my armor.

The Gilded Ones used their blood to create it—an everlasting symbol of their love. Like them, its beauty cannot be damaged or broken by the swords of man. Like them, it always vibrates with divine power, a steady and comforting presence. Although I struggle to feel that comfort now. The odor of burning flesh is too heavy, too overwhelming. It curls in sinister plumes through the crack in the door. My chest tightens; my breathing strains. I try focusing on the necklace again, fighting the rising darkness, until—

A mouth to my ear, words spilling out with kindness. "We're here, Deka."

Belcalis.

Even though she doesn't like touching others, her arms are around me, holding me close. Lending me her strength. She's the only other person in our group who's experienced the horrors I have, so she knows what it feels like to have the memories take you over, to be held prisoner by your own mind. Her arms tighten, and my breathing slows. I'm safe. I'm always safe with my bloodsisters at my side.

Once my breathing has returned to normal, I pull myself out of her arms, then glance at the others. *Ready?* I gesture in battle language.

Everyone nods back. *Ready,* their expressions say.

I kick open the door.

The head priest, a tall, dark man carrying a staff tipped by the kuru, Oyomo's sun symbol, whirls toward us, head cocked to listen for our footsteps. The moment he does, he snarls one word: "Alaki."

The priests begin tapping the floor with their staffs. When the sound vibrates through me, I hiss in a breath. I know what they're doing. It's the same thing tree-tapper monkeybirds do when they're searching for insects in tree trunks. "They're sounding for us!" I shout. "Loosen formation!"

The others obey just in time. The priests attack en masse, staffs whirling in menacing patterns when they're not tapping to sound for us. Each one seems vicious, strong—they're all much taller and larger than I am, perhaps a deliberate choice for all priests guarding Melanis. Even then I'm not frightened— not like I used to be.

Just a year ago, the sight of men wielding weapons would have

terrified me. Back then, I would shiver at the merest suggestion of violence from one of them. Now, all I can see is the priests' lack of organization; the clumsy way they hold their staffs, like they've never actually used them in battle. These aren't hardened warriors, with years of training under their belts. They're ordinary men, men who gave up their lives in service to Oyomo, to maintaining and imposing the established order.

But I don't make the foolish mistake of underestimating them. It was ordinary men who tortured me in my village cellar, ordinary men who killed me over and over again until White Hands came and rescued me from their clutches. There's nothing worse than ordinary men.

I lift my atikas as I rush to meet them head-on. *Carve out a path,* I sign to Britta and the others. *I'm going for Melanis.*

Got it is Britta's silent reply as she barrels into the first wave, the others following her.

I keep my focus on Melanis as my long, flat swords slice and cut, misting blood into the air. She is little more than a handbreadth in front of me now, her body still burning in the flames. Every time I see her there, struggling against her restraints, my rage surges . . . as do memories of my own time on the pyre. All that agony, that unending pain . . .

Burning was one of the many ways Elder Durkas and the other village elders tried to kill me after they discovered I was alaki and imprisoned me in the temple cellar. They tried nine times before accepting defeat—multiple poisonings, beheadings, drownings, dismemberment. And all the while, my human father, the man I thought was my flesh and blood, stood back and did nothing. That, of course, when he wasn't also beheading me himself.

His face flashes in front of me, gray and hollowed out, and my body turns cold. I force myself onward, teeth gritted as the clanging of metal blots out every other sound.

More feints and parries, sword thrusts. More priests falling all around me. Slowly, surely, battle joy—that intense state of concentration where minutes compress into seconds and hours disappear in the blink of an eye—surges inside me. All I can see now are my swords, the bodies falling under them. Euphoria rises within me as my body becomes the blade, just as Karmoko Huon, my first battle instructor, taught me. The minutes merge, time becoming a whirl of sweat, blood, and corpses.

Then I'm there, before her. "Melanis . . ."

She's still, body hanging limp over the open pit. Now that the priests aren't actively encouraging the flames from the caldera below, the fire has lessened just enough that it's not fully roasting her as it was before. It's so low, I notice what I hadn't previously: Melanis's entire body is glowing, a faint, shimmering white that's distinct from the flames. I gape. I've never seen anything like it, not even when I enter the deep combat state and see the white and shimmering essences of all things.

Even stranger, she's not falling into the gilded sleep—no sign of the golden sheen that covers alaki when they experience a death that isn't their final one. But, then, Melanis is a Firstborn. It takes a lot more to kill her kind than it does the newer alaki.

No wonder the priests have kept her burning for the past thousand years.

Another wave of anger crashes over me at the thought.

I nod, and Katya and Britta rush forward to carefully lift Melanis from the flames, the chains clinking as they move with her. She screams the moment they pull her from the altar, her

entire body jerking from the pain, but she doesn't fight, doesn't even seem to truly notice us. She's lost in her own world, as she's probably been since the day she was first chained in this nightmare of a temple.

Torture will do that to a person.

Katya carefully wraps a cloak around the Firstborn, smothering what remains of the flames. As they die out, the burnt odor deepens, and my body clenches in response. I swiftly begin counting, another of my comforts in times like these. *One, two, three, one, two, three. I am in control, not my body.*

I am in control. . . . I clench my hands into fists, squeezing so hard, the flesh almost splits. It's just enough to root me again.

Once I'm no longer trembling, I kneel in front of Melanis, careful to move slowly as I slice a shallow cut in my palm. A thin line of gold wells up, and I smear it across her chains. The moment the two touch, the chains' links hiss and spark, immediately melting away. Celestial gold is made from ichor, divine blood, and my blood is the only thing that can destroy it. It's one of the purposes for which I was created: to break the prison of ichor that trapped the Gilded Ones for thousands of years in the temple they now call their home.

My blood is an antidote to ichor: it melts divine blood wherever the jatu have placed it, as they usually do when they're imprisoning our kind.

Melanis, however, doesn't notice that she's being freed, doesn't seem aware of anything as she huddles deeper into the cloak. Something inside me tenses. I remember what it was to be like that, to be so fixed in my own misery, I could barely notice what was happening around me.

I inch closer until I'm just within her reach. "Honored War

Queen Melanis," I say, trying to attract her attention. "I am Deka, goddess-born Nuru and your younger sister. I was sent here by our mothers, the Gilded Ones. I've come to take you home."

It takes some moments before my words pierce the daze. Melanis blinks sluggishly, turns to me, sacs of watery white fluid where her eyes used to be. "Are you an apparition?" she croaks past a blistered and swollen tongue.

I shake my head. "I'm here." I move nearer, place my hand just in front of her scorching-hot cheek so that I don't upset the skin still peeling from it.

Fresh skin is already starting to grow underneath. Healed skin. No more bleeding; no more sores. This is the power of a Firstborn. The power that newer alaki, their divine blood diluted by years of interbreeding, can only hope to one day experience.

"I'm real," I whisper, moving closer so that she can feel my presence.

Poor Melanis. How she's suffered all these years. My heart aches for her. Who would have ever imagined this would be her fate?

The second of all the Firstborn, birthed almost immediately after White Hands, Melanis is one of the most beloved alaki to ever live. She's the only alaki the mothers ever gifted wings, an acknowledgment of her benevolent spirit and inspiring nature. For centuries, her golden glow was the beacon that guided other alaki onto the battlefield, the light that heralded the glory of the mothers. Just one glimpse of her was enough to convince entire armies to throw down their weapons and join the Gilded Ones' side.

Now that the goddesses are weakened, Melanis is even more vitally important. She is the living symbol of the alaki—the very sight of her will attract others to our cause, just as it did all those centuries ago. And more worshippers mean more prayers for the mothers, more food to nourish them so that they can return to their full power.

Melanis, of course, doesn't know any of this as she moves her face into my hand, tears mixing with blood as they flow from her eyes. "You're here. The Nuru. You truly came, just as the mothers said you would," she says, sobbing so hard, tears stream down her cheeks.

One of them falls, a drop so small, I notice only because a tiny gold droplet of her blood is suspended inside it. Then the tear, like a glittering dewdrop, touches my skin. Lightning jolts through me, and my body jerks, my veins sparking and seizing.

Just like that, I'm elsewhere.

4

◆ ◆ ◆

I'm in a chamber of unending white, one unlike any I've ever seen.

The crystal floor extends so far, it becomes a distant horizon, its surface so slick I could slide across it as easily as I used to do on the midwinter lake in Irfut. Surrounding it are high, arching columns, which hold up a ceiling that defies imagination. Instead of the usual tile or paint, a stunning sunset shimmers at its center, the soaring red and purple colors trailed by soft, curling clouds. Divine power or skillful craftsmanship, I'm not quite sure which, but it seems strangely familiar . . . as does the man kneeling a small distance from me, pain in his eyes.

Those eyes—they are uncanny: black on black, with only the barest hint of white. The rest of him is unremarkable. Short, slight, with bronzed skin and long black hair falling down his back. A kind face, soft, delicate, almost feminine, gold powder shimmering on his eyelids and cheeks. But his clothes—they're all wrong. No Oteran man would wear a tunic so short. Tunics,

like robes, must show dignity, not knees—that's what Elder Durkas always used to warn the boys back in Irfut. Whoever this man is, he certainly has never heard the saying, because his black-and-gold tunic falls only to mid-thigh. Who is he? Why does he seem so familiar? And this place—where exactly am I?

Who exactly am I?

The question gusts through my mind, and suddenly, it's all I can think of. *Who am I? Who am I? Who am I?* For some reason, I have no idea. My body doesn't feel the same as it usually does. There's something strange on my back. Something heavy, and bristling with feathers.

Are those wings?

"Deka?" A voice sounds in the distance.

Britta's. I distantly place it.

"Deka," Britta's voice cries again when there's no answer, "they're coming! Move!"

The press of hands on my shoulders is enough to jolt me back to reality. Just like that, I'm inside the Oyomosin's inner chamber again, where the others are once more lowering their bodies into the battle stance. What just happened? Where did I go? I whirl around, confused, then turn to Britta, who's still shaking me.

"Did you see that? I was in a white room. The ceiling, it was a sky."

"The ceiling?" Britta echoes, perplexed, taking a step back. "Deka, what are ye—it doesn't matter. They're almost here."

"Who's almost—" The question dies on my tongue as I feel it, that tingling racing up my arms and legs.

◆

Someone's coming. An entire group of someones, really. And they're all jatu. Well—true jatu, the few men descended from the Gilded Ones. Our brothers. Tension grips me as I watch the door for their approach. True jatu are faster and stronger than alaki, although they die as easily as humans do. Worse, they have an unholy alliance with the priests, and all sorts of strange and insidious arcane objects at their disposal. In the past few months, we've dealt with at least twelve groups of true jatu using different arcane objects, each one diabolical and perverse in its own way.

Could their presence be the reason for what I just experienced—that strange waking dream? The jatu have been trying to capture me ever since I freed the mothers. Could they have resorted to using arcane objects to attack my mind as another of their battle tactics?

Beside me, Melanis has cocked her head, listening to the shifting sounds in the chamber. It's shocking—she's already standing on her own, her body hunching and jerking as the whites round out in her eyes and her scalp sprouts long, sleek black hair. All the other alaki we've rescued took time to heal—weeks, months, even—but Melanis's skin has already renewed, and her hair is already trailing down her back. Then again, I shouldn't be surprised. As second among the Firstborn, Melanis is one of the nearest to the mothers in terms of power. Of course she would heal like this.

Deka, Ixa growls low under his breath, his scales bristling. He's back in his massive true form, and he doesn't like what's happening to Melanis.

But then, there isn't much he likes lately. Ever since our battle with the former emperor in the chamber of the goddesses,

Ixa has been distrustful—suspicious of anything that might harm either me or himself.

I don't have time to dwell on that at the moment, so I force my gaze from him back to the inner sanctum's door, where the clanking of jatu armor has now stopped just out of view. My eyes narrow. "Show yourselves," I command, allowing a rumble of power to thread through my voice.

The door immediately pushes open, divine power radiating like heat from the group of men standing behind it. Just as I suspected, they're all true jatu—every last one of them.

It took me time to understand that the true jatu make up only a small percentage of the emperor's guards, who are all known as jatu—a deliberate confusion our brothers have encouraged over the centuries so that the citizens of Otera would gradually forget their existence and abilities. Now, when true jatu and alaki engage in combat, humans think that the true jatu are simply ordinary men who have been blessed by extraordinary strength and speed. In the eyes of ordinary Oterans, the true jatu are champions specially chosen by Oyomo to protect the One Kingdom.

No one ever suspects that they and the alaki all come from the same source, and for good reason: the true jatu have very carefully hidden our shared history. In fact, I didn't even know they existed until the former emperor, Gezo, fought me with superhuman strength. Now, I'm always on the alert for them.

Could they be who I sensed was watching me as I slipped through the Oyomosin's window earlier? I squint at them as they make their way into the chamber.

Every single man approaching is wearing a dark, leathery suit I've never seen before, even though jatu are typically known for

their red armor. That's not even the strange part; the gold old-Oteran symbol on their breastplates is. It's a series of curved, interconnected lines, with smaller lines inside each one—just looking at it makes my head throb. It's almost as if there's something there, a darkness radiating from under the circles. It vibrates every time I try to look at it directly, the movement so nauseating, I shut my eyes until calm descends over me, silent and blissful. I breathe into it, trying to settle myself.

Then my brain splits in two.

Suddenly it's as if white-hot daggers are stabbing through my skull, searing everything in their path. My body is on fire, every nerve alight with pain. I whoosh desperate breaths in and out, squeeze the hilts of my atikas to ground my body in the present.

Breathe, breathe . . . But nothing works.

The pain just keeps spreading, my brain throbbing even more violently. I grit my teeth against it. This is some sort of jatu attack, but I won't let it conquer me. I am the Nuru; my body will recover. This pain, whatever it is, isn't permanent.

"Deka? Ye all right?" Britta's concerned whisper comes just in time—a reminder: I can't show any sign of weakness, no matter how awful I feel.

Not here, with all these jatu surrounding me.

I force my eyes to open, stumbling slightly when my stomach lurches from the effort. As I expected, the pain is already lessening, my body healing, just as I anticipated. So I take one excruciating step forward after another until, finally, I'm standing in front of my companions, who are waiting for my command.

"Nuru," Nimita rumbles, concerned. She must have seen me struggling too.

"I'm fine," I quickly say. "Focus on protecting Melanis."

She's the jatu's true target, after all. My presence here is just a happy accident for them, an unexpected but fortunate addition.

Nodding, Nimita and the others immediately form a protective circle around the Firstborn, leaving me in the front. I'm not worried about myself—whatever the jatu may attack with, I'm no longer the weak, pitiful girl I was back in Irfut. Now, every inch of my body is a weapon, and I mean to use it.

I glance at the leader of the jatu, a bearded and armored giant of a man carrying a multi-pronged spear, one lethal spearhead in the middle, four others surrounding it—metal petals crowning a deadly flower. The other jatu's weapons are the same, though not as large or impressive—which I can only assume is the leader's declaration: *See how much stronger I am than the others, how much more fearsome.* I'm almost amused by the sight. After being among deathshrieks for so long, I find him almost pitiful by comparison.

Still, I focus my eyes on the spear so that I can avoid glancing at that symbol. "Evening greetings. I am Deka, Nuru to the goddesses," I say formally, threading my voice with power. "Name yourselves."

To my shock, none of the jatu answer me.

Confusion washes over me. True jatu can't resist when I speak to them, nor can alaki or deathshrieks—no descendant of the Gilded Ones can. They all obey the subtle waves of compulsion embedded in my voice, which are always there, even when I don't want them to be. That's why alaki and deathshrieks avoid me if they can help it and why my friends constantly wear armor or jewelry mixed with my blood—just my voice is enough to

command them if they aren't wearing it. True jatu don't have any such protections. There's no way they can be immune to me.

I summon more power. "I said—name yourselves." The air trembles with the force of my command.

As before, the jatu don't acknowledge me.

When the leader turns to the others and begins addressing them in a strange language instead, I gape in disbelief. It's as if my voice slid right off him. Or, rather, slid off the symbols. . . . I can see them now out of the corner of my eye, vibrating from every jatu breastplate. Every time I speak, they vibrate—almost as if they're blocking me. Blocking my powers . . .

What exactly are those things?

Britta's eyes are wide as she glances at me. "They disobeyed a direct command, Deka."

"It's the symbol they're wearing," I say, the pieces rapidly falling into place. "It's blocking my commands."

In fact, now that I think of it, when the jatu entered this chamber, they did so because they wanted to—not because I commanded it. Still, I refuse to let these jatu, whoever they are, get the upper hand.

Even as I think this, I see the lead jatu lifting his spear.

"Break ranks!" I shout, immediately sinking into the combat state.

The world around me swiftly darkens, my instincts sharpening, my senses strengthening. By the time the spear whizzes past, everyone around me has flattened into shimmering white shadows—their purest essences. My voice may frighten most people, but this—the power to reduce every living thing around me to its purest essence; to recognize every vulnerability and strength the way others do colors—is my most terrifying ability.

I glance around, taking stock of my opponents as White Hands taught me: There, a faulty knee. An overwhelmed heart. A spear arm damaged by childhood illness. All weaknesses I can exploit.

Smiling brutally, I rush forward, slicing through arms and limbs with grim precision. Beside me, Ixa does the same, powerful jaws ripping through the jatu's flesh and armor. But it's not enough to make a difference. I realize this within moments of attacking. Unlike the priests, these jatu are organized, trained. And they're much stronger than we are.

When Asha goes flying, thrown by one of the nearest soldiers, I hold out my hand, try one last time to use my commands. "Stop!" I shout. But the jatu just keep coming, and those symbols just keep vibrating. I hold out my hand again. "STOP!"

"It isn't working, Deka!" Britta shouts, slamming her war hammer onto an attacking jatu's head. "Just get Melanis to safety!"

Growling my frustration, I abandon my attempts and rush for Melanis, but as I near the Firstborn, a horrific sight reaches my eyes: Melanis is collapsed onto the floor, an awful cracking sound rising from her body.

"Melanis!" I shout, running.

There's a strange resonance in the air, an eerie thrumming that reverberates all around me. I don't know what it is, exactly, but somehow, I know it's coming from her, that it's some sort of divine power. I've never felt anything like this before, all that raw energy building and growing.

I hurry closer, concerned. "Melanis, what is happen—"

An explosion of pure white smashes me into the wall.

I lie there, dazed, glass raining down from the chamber's

collapsing ceiling. What in the name of Infinity just happened? Melanis falling, that explosion . . . My skull is vibrating, my ears are ringing loudly. Groans filter into the air—everyone around me trying to gather themselves, to rise. I try to do so as well, but my legs quickly give way. They're as weak as jelly now. Not that I'll let that hold me back. I have an example to set. I am the Nuru, after all.

Gritting my teeth, I force myself up, then glance around.

That's when I see Melanis.

The Firstborn is floating high above us, the jatu leader's severed head dangling casually from her fingers. I barely have time to comprehend this sight before I notice something else: wings. Wings of blinding white, gold tipping each feather. They're the source of that cracking noise I heard from Melanis earlier. The knowledge slides into me like instinct, as does another: I've seen those wings before—felt them before. They were the weight I felt on my back when I was in the white chamber.

Could my time there have been a memory?

I'd almost written off my experience in the white chamber as some sort of waking dream—perhaps even my memory toying with me again, but now that I'm looking at Melanis, flapping high above us, I'm almost certain it was real. Melanis's wings have returned, a divine gift hidden just under her skin. Why can't that dream have been another divine gift, a new blessing from the mothers?

I'm in such awe, it takes a cry from Adwapa to shake me from my daze. "Deka, move out of the way!" she shouts.

I jerk back as Melanis dives sharply down from the ceiling again.

As she reaches the ground, she flexes her feathers straight out

at the very last moment, and a jatu's head goes flying, red blood arcing through the air. I gape, shocked. Melanis's wings are like a feathery white sword, slicing through everyone around her.

Even before I can comprehend this, Melanis is swooping across the chamber again, beheading more and more jatu with great gusts of wind. The jatu scream, call for retreat, but they're no match for Melanis's speed. Her entire body is a blade, ripping apart jatu before they can even move. I watch openmouthed, barely noticing as Britta and the others gather beside me.

Britta is stunned as well. "Would ye look at that . . ."

"I've never seen anything so beautiful."

I glance sharply at Adwapa, disturbed, when she wipes away a fake tear of approval as Melanis orchestrates a one-sided massacre before our eyes. Unease slithers over me. Adwapa has always had a grim sense of humor, but this is just a bridge too far.

I'm not the only one who's uneasy. "That's grim, Adwapa, even for you," Belcalis tuts.

Adwapa sucks her teeth. "You think they wouldn't cheer if it was us being massacred like this?" she asks.

It's a valid observation, except I know her words have nothing to do with the jatu in front of us. She's probably thinking about Mehrut again. Adwapa and the plump Southern alaki were lovers back at our training ground, the Warthu Bera—casual ones, we all thought. But Mehrut remained behind at the Warthu Bera when we went on campaign and was presumably trapped there when the jatu took the city. Ever since the jatu started throwing girls from Hemaira's walls, Adwapa's been having nightmares—loud, frightening ones during which she calls Mehrut's name.

We have to break open the walls of Hemaira, have to rescue

34

our sisters from the Warthu Bera—Mehrut especially—and the only way we can do that is if the mothers regain more of their power. Which means we have to finish the jatu in this room and get Melanis out of here.

That in mind, I rush toward the jatu, but they're already almost gone, running into the temple's hallways as fast as their legs can take them. Melanis's assault has shaken them, it seems.

"Cowards!" Adwapa jeers, amused.

"Come back and face us, scum!" her sister adds.

Sighing, I nod for Nimita and the other deathshrieks to follow, then turn back to Melanis, who is now walking toward me, the blood disappearing into her feathers, absorbed like water.

The sight is so unnerving, I nearly take a step back. I've never seen anything like that before. The winged Firstborn doesn't seem to notice as she nears me, a beatific smile on her face. "Well, then, honored Nuru," she says, seeming perfectly at ease, "shall we go now? I wish to look upon the faces of our divine mothers once more."

"Yes," I reply, swiftly moving toward Ixa. I can't wait to leave this oppressive chamber and all the horrors I've seen here.

As I stop to retrieve a breastplate with the symbol on it for further examination, however, a strange, scraping noise claims my attention. It's so soft—almost a whisper—but something about it chills me to the core. I follow the sound toward the pile of jatu bodies scattered on the floor, then breathe when nothing seems amiss. I turn back to Ixa, relieved . . . until a glimmer of gold catches my eye. It's a large masculine hand, severed at the wrist and slowly digging its way out of the piles of blood and viscera.

Everything inside me stills.

I watch, a distant sort of horror creeping over me, as the hand inches toward a mass of other golden male body parts, which are slowly but surely reattaching to each other, muscle and flesh stretching and wriggling like stringy golden worms.

A horrified expression falls over Asha's face and she exhales a reedy breath. "Is that . . ."

I don't answer. There's no need, not when a pair of golden legs are now reconnecting to a very large, very familiar male torso. A long, drawn-out gargle sounds, and then the corpse gasps awake, the gilded sleep receding from his body almost as quickly as it took it over.

The jatu leader turns to us and sneers, a wicked, malicious expression that will forever haunt my nightmares. "It is as they said," he proclaims, eyes alight with unholy fanaticism. "Idugu has chosen us to rise, to deliver Otera from the abomination it has become. To exterminate your filth from the face of the One Kingdom. I pity you, false believers of false gods. Do you know what is coming? Do you have any idea? The true gods are waking. Idugu has sent His blessings onto His sons, and now we too are immor—"

The flash of claws is the only warning I get before his head separates from his body. Blood spurts into the air. Golden blood. Just like an alaki's.

Katya's massive red form is trembling as she looks down at the blood dripping from her claw, then back up at me. "How is this possible, Deka?" she gasps, staring down at the man she just killed. "How is this possible?"

That's exactly what I want to know.

5

◆ ◆ ◆

For as long as I have been the Nuru, I have known two truths: *first,* I can command any child of the Gilded Ones I choose, and *second,* true jatu, once killed, do not revive. Today, both truths have been shattered. The thought circles my mind as we fly away from the Oyomosin, now a smoldering husk atop its red cliff. Usually, we claim any place we conquer in the name of the Gilded Ones, but this time, we burned the Oyomosin to the ground. We had no choice, what with that jatu reviving the way he did. We beheaded any jatu corpses we could find as well—another precaution. Most alaki die from one of three deaths—burning, beheading, or poison—but hopefully, two out of three will be good enough for these jatu, whatever they are.

"Wha happened back there, Deka?" Britta asks, the same question we've all been asking for the past hour. She's riding behind me on Ixa, Melanis having commandeered Britta's gryph, Praxis, for the rest of the journey.

All that killing has tired the Firstborn, though she doesn't

37

look it. She's urging the winged white cat to breakneck speeds, anxious to return to the N'Oyo Mountains for the first time in a millennium.

"I don't know," I say. "You were there. You saw the same thing I did."

"I saw a jatu die and revive in less time than it takes to blink an eye." This comment comes from Belcalis, who flies on the gryph just beside us. "Even we can't do that. How is that possible?"

That's the exact question I have. True jatu may be stronger and faster than us, their alaki sisters, but they have only one death. They do not experience the gilded sleep. They do not come back as deathshrieks. *And they certainly do not disobey my commands.*

"He said it was Idugu." Katya, on another gryph, still seems disturbed. "He said it was His blessings that did it."

My muscles rope even tighter. Idugu is the current aspect of Oyomo—a warrior-like incarnation, born to destroy the Gilded Ones and all their daughters. We've been hearing rumors about him ever since our first victory against the jatu. Unlike all of Oyomo's other aspects—Oyo, the sun god who nourishes crops and feeds worshippers; Omo, the wise god who teaches fractals, the hidden equations behind all things—Idugu is pure brutality, a deity of war and death so feared, most of his followers only ever utter his real name with their dying breath.

Every day now, more and more of his followers attack our mountain, hoping to sacrifice themselves in his name. To die in such a manner is the highest honor they can hope to achieve.

"Idugu is a myth, a magic story that the jatu tell to comfort themselves in the dead of night," Adwapa scoffs.

"Or he is real." I turn to the others, the memory of being watched at the Oyomosin suddenly rising again. I thought it was a jatu, but what if it wasn't? What if it was something else? If there's one thing I've learned in the past year, it's to never disregard a possibility. "What if he does exist?" I say, finally voicing the question that's been haunting me ever since the jatu leader resurrected right before my eyes.

"What—another god in Otera?" There's a warning note in Nimita's voice. What I'm suggesting is blasphemy. *There are no other gods but the mothers.*

"A creature masquerading as a god," I quickly clarify.

The more I think about it, the more it makes sense. That symbol on those jatu's breastplates was some sort of arcane object—just like the n'goma, Hemaira's impregnable barrier.

What if there are more like it—arcane objects with power enough to mimic a god?

I whirl to the others, frightened and excited all at the same time. "The mothers were asleep for thousands of years. Much of their power was lost during that time. What if it wasn't lost but stolen? The Hemairan emperors always knew where the mothers slept, and they had all kinds of arcane objects back then."

"Like that symbol," Britta says, nodding at the breastplate wrapped carefully in my pack for later inspection.

I glance at her, surprised. Apparently, I wasn't the only one who noticed its effects. "Like that symbol," I confirm. "Who's to say there isn't one that can steal divine power?"

It would explain so many things. The last time Oyomo was supposedly in his Idugu aspect, the true jatu trapped the mothers in a prison of their own blood, then created the Death Mandate, to hunt down and kill alaki. But how did they do it?

How did they acquire enough power to subdue the mothers long enough to imprison them?

It's something I've always wondered, and now, I fear I may know the answer.

To think, all we had to worry about a year ago was killing deathshrieks and trying to regain our purity. Now, there are arcane objects and jatu who come back from the dead. I can't decide whether to cry or scream. Either seems appropriate, given the circumstances.

I turn back to the others. "Well, if there's one thing I know, it's that it's better to get the answers straight from the horse's mouth than to waste our time on useless suppositions. The mothers will know. Let's ask them."

Which reminds me . . . I turn to Melanis, who's still at the front of the group, so intent on reaching Abeya, she hasn't heard any of our conversation. "Melanis?" I call out to her. "I have a question for you."

"Yes, honored Nuru?" The Firstborn whirls Praxis around to meet me.

Once she's near, I lean in. "Have you ever been able to allow others to see your memories?"

"Allow others to see my memories?" Melanis cocks her head, confused. "As in, using a divine gift? There is no such thing, honored Nuru. Only gods can see into the minds of others." She pulls closer, that perfect brow furrowed. "Why do you ask?"

"When we were in the temple, I—" I stop there, guilt flooding me. I can't burden Melanis with my worries. She was only just freed.

Even now, I can see the lingering dark circles under that golden-brown skin. She may be physically well, but she's been

through an ordeal. A thousand years burning in that temple. Her mind is damaged—fractured, just like mine. I can't add to its weight. Not now, when there's so much joy on her horizon.

"Nothing," I finish. "Just an errant thought."

I can see she's still confused, but I just smile and motion for her to continue on. I'll wait and speak to either White Hands or the mothers—people who truly understand what is happening. That waking dream may be yet another example of my mind's splintered state, but it also may be more. Either way, I have to know.

"You should go," I continue, nodding toward the distance, where a string of mountains appears across the horizon. The N'Oyos. Our home. "We're almost there."

"Finally!" Melanis urges Praxis forward, years seeming to fall from her shoulders.

Only now, they're pressing down onto mine. So much to do, so many questions to ask.

I glance down at Ixa, who's been flying this entire time. *Hurry,* I say. *I have to speak to the mothers.*

Deka, Ixa says, flapping his wings faster.

In the distance, the barest hint of sunlight filters over the peaks.

◆

Six months ago, the Temple of the Gilded Ones was a ruin, a forbidding edifice on a freezing mountaintop surrounded by a lake of salt so blindingly white, it was painful to look at in the daylight. To reach it from Hemaira, you had to cross deserts for weeks on end, skin sweltering under the blistering-hot sun,

throat seizing as winds swirled the sands into massive storms. Then I woke the Gilded Ones, and they began to regain their power. With that power, the entire N'Oyo mountain range and the area around it came to life—massive trees with branches large enough to rival those in the jungles of the deepest Southern provinces, a shimmering lake filled with all sorts of fish and other aquatic life. The Bloom, we call this new profusion of life. Visible evidence of the mothers' returning power. Even the temperature has changed, from the unending chill of the high mountaintops to the balmy warmth I remember from my days in the Warthu Bera. Where once there was only desolation and salt, there's now life, and it lifts my tension just a little when we near those familiar peaks, the crags outlined by softly glowing balls of light that bob and dance like giant fireflies.

"Mother Beda's lights," Melanis says, a smile wreathing her face. The first true one I've seen since she was freed.

Suddenly, I'm grateful for my decision not to burden her with my concerns. She deserves this much, this tiny portion of joy after so many years of misery.

She darts over to a cluster of lights, her long fingers grazing their edges.

The lights emerged from the bosom of one of the mothers— Beda—a few days after she woke and haven't stopped appearing since. Everywhere an alaki or deathshriek passes on this mountain, there's always a ball of light to show the way. You can even see them in the foothills, where a contingent of alaki is currently patrolling the base of the mountain. The Bloom is so thick there, it's difficult to pick the girls out, but the lights are a dead giveaway. I squint when I notice a few more balls of light near a group on the hill, who seem to be pulling something out

of the mountain's base. Whatever it is, it's large, but I'm too far away to truly see.

It must be one of the mothers' marvels. New creatures are always emerging in the mountains. The sight reassures me: we're almost home.

The sun has begun to rise by the time we come into view of the central mountaintop, where the Temple of the Gilded Ones rises from the middle of the lake. Gold-veined buildings surround it, their waterfall-misted gardens and red stone statues gleaming in the early morning light. Abeya, the city of the goddesses. My heart warms at the sight . . . and at the sound of cheerful drumbeats—an audible welcome, alerting the lines of splendidly armored deathshrieks and alaki waiting at the edge of the temple's lake that we've arrived.

As I expected, White Hands is at the front of the welcome party. Beside her are the twin equus Braima and Masaima, their manes formally braided, iron-tipped talons impatiently pawing the ground. Melanis is a legend among not only the alaki but also the equus, who have been our allies for as long as there has been written history.

Even now, more and more of them gather, their massive equine profiles gleaming against the moonlight. Equus are some of the most magnificent creatures in Otera—a compelling mix of human, horse, and predatory bird. They resemble humans from head to midsection and horses thereafter—except, that is, for their powerful talons, like raptors', which stand in the place of hooves. Those equine features and their close bond with the animals are why they're also known as horse lords. Children follow them—mostly orphans or runaways who no longer wish to follow the path of Oyomo. Then there are the girls we've

rescued from nearby villages, young alaki whose blood has not yet changed from the red of humanity to the gold of the divine.

They're the reason deathshrieks kept attacking Oteran villages: they can smell an alaki's true nature even before she begins her menses, so they try to rescue all the young ones before they're caught by the Ritual of Purity . . . not that the Ritual means much anymore. Now that most everyone in Otera knows what alaki are, women are bled on the streets if there's any hint they might have divine blood in them.

Even before Melanis lands, the crowd is surging around her, happy tears flowing as they gather. The other Firstborn haven't seen her since the jatu rebelled centuries ago and took her and countless other Firstborn as prisoners, but they've told stories about her, passed down countless tales to all the young alaki and deathshrieks here, so that everyone in Abeya knows her legend. "Melanis! Melanis!": the happy refrain rises in the air, and the winged alaki quickly disappears under the weight of a thousand embraces and kisses, as well loved now as she was in days of old.

But to my surprise, White Hands isn't one of their number. She stands there stiffly, watching as Melanis basks in her extravagant welcome.

I pull my attention from her when a few bloodsisters call out in welcome to me as well. "Greetings, honored Nuru," they murmur, but this greeting is warier, more reserved.

Most of the newer bloodsisters on the mountain don't like spending too much time with me if they can help it; my abilities frighten them. It's one thing for me to conquer the Hemairan emperor and his men but another completely for me to have the ability to take over my bloodsisters' minds if I choose. Then there's the way I see people's weaknesses using the deep combat

state. It's a relatively new trick of mine—White Hands taught me how in the months after we settled into Abeya. Still, no one, especially the deathshrieks, wants to be around that—around someone who not only can see your body's vulnerabilities but also can make you do things you don't want to—since that someone used those exact abilities to kill countless members of their kind.

The reminder of it floods my mind with guilt. I killed so many deathshrieks while I was at the Warthu Bera. So many. I didn't know what they were at the time; I just believed what the priests told me: that I was a demon and deathshrieks were monsters I had to annihilate in order to gain purity. Back then, I would have done anything to be pure, would have destroyed any monster if it meant I could also destroy the demonic parts of myself. Little did I know that all the things they called demonic were actually markers of divinity.

I glance across the mountaintop at all the people gathered together, and suddenly I feel so very alone. Everyone here has their group: human, alaki, deathshriek, equus. Even my friends Britta, the twins, Belcalis, and Katya all have each other. But I'm not like them. I'm not alaki—not truly—and I'm certainly not deathshriek. I'm just the Nuru, a being created to free the mothers and enforce their will.

And that's exactly what I will do, I remind myself, shaking off my melancholic thoughts. I can't change the past—not even the mothers can perform such a feat. All I can do now is move forward: ask questions instead of being afraid, take the actions I think are just instead of mindlessly following what others tell me. Be a better person—my own person.

That in mind, I catch White Hands's eyes across the crowd

and signal with battle language: *We need to meet. It's urgent. Tell all the generals.*

She nods, gestures subtly toward the Temple of the Gilded Ones as she leads the delegation onward. I swiftly follow, my worrying questions about the symbol, the jatu, and that chamber all circling my mind until a familiar sleek white figure canters over to me: Masaima, with Braima at his side. Masaima leans forward and experimentally nibbles at my hair, as is his habit. One taste and he jerks back, a wrinkle of disgust on his elegant muzzle.

"You reek of smoke, honored Nuru," he says.

"I was in a very smoky place," I reply solemnly.

"Then you should bathe," Braima informs me with a haughty toss of his black-striped mane. That's the only difference between him and his brother, that black stripe. Otherwise, the pair are perfectly identical. "Bathing is very good for alaki."

"I had not thought of that." I try to hold back the smile tugging at my lips.

No matter how bad things are, Braima and Masaima always manage to lighten the mood.

When the pair trots away, my smile fades to a grimace as I remember: I don't have time to be dawdling like this. I have to inform White Hands and the other generals of everything I've just experienced and then seek the counsel of the mothers. If Idugu—or whatever is pretending to be him—truly exists, we need to figure out what it is immediately, not to mention what happened with that waking dream I experienced.

I hurry into the shallows of the lake, relieved to see the water rising, then hardening and solidifying until it becomes a clear bridge to walk across. The planks wobble slightly when I

step onto them, but they hold firm, the fishes and other creatures caught inside watching me with a wary annoyance. Anok, the craftiest of the goddesses, made the water bridge so that it forms only for those loyal to her and her sisters. It's a test, like almost everything surrounding the mountain now: the river of glass that explodes out of the sand when enemies approach; the jungles filled with predators that eat anyone the mothers deem a threat. More and more adult humans have been joining us in the past few months—not just women fleeing forced marriages or servitude in the temples and brothels but men as well, all tired of living their lives according to the constrictions of the Infinite Wisdoms, tired of the lie that is Oyomo.

Before, the jatu would massacre those who tried to make their way up here, but now, they try to disguise themselves among them in a bid to infiltrate the city. This tactic never works, however. The water bridge knows. The water bridge *always* knows. And anyone it releases from the safety of its confines is quickly snapped up by the creatures that swim below. I look at the large, dark shapes slithering under me and shudder.

Britta and the others fall into step with me as I enter the temple, and together, we quickly make our way to the war room, the most remote and forbidding place in the complex. Whereas the rest of the temple has been restored to its former glory—gleaming stone halls, their walls threaded with gold and buttressed by columns that reach up to the sky, lush gardens brimming with all sorts of strange and marvelous plants and creatures—the war room remains as formidable as ever, a stark black box of a chamber that can be reached only by crossing a stone bridge overlooking the deepest, most turbulent part of the lake. Lightning crackles over the water, thunder

booming with chilling regularity. This is another of Mother Anok's inventions—assurance that no unwelcome ears, however sharp, can listen in on the conversations that happen in the war room.

"How did she get here first?" Britta grumbles when she sees White Hands waiting by the stone seats that line the chamber's walls, her black gaze as inscrutable as always. Last we saw, White Hands was still hovering about Melanis and the rest. She must have used a secret passage to get here quickly. Hundreds of them riddle the temple—a precaution in case the jatu ever break through.

"You know she has her methods," I reply, walking over the thick glass floor.

I shudder when an eerie shadowy figure moves underneath it. There's a cell under the war room, a secured chamber completely surrounded by stone and water for which there's no entrance or exit. Just standing on top of it unnerves me, but White Hands, of course, doesn't even glance at it as she comes to meet me halfway. She never concerns herself with things that are beneath her notice, especially not the single occupant of the cell underneath us. It's one of the many things I find fascinating about her.

When I first met White Hands, I thought she was one of the most beautiful women I'd ever seen, her body shapely, yet small of stature, her skin the deep black of a midsummer's night. Even her aggressively short, tightly coiled hair served only to highlight her breathtaking features. Then I saw her eyes, those black pupils so large, they covered almost all the whites. White Hands's eyes are the most frightening part of her; look

into them long enough and you can see the weight of all her centuries reflected in their gaze.

"Well, honored Nuru?" she says once the deathshrieks shut the heavy stone door. "What did you see that was so urgent we needed to gather the generals?"

I glance across the room, ensuring that I make eye contact with both the alaki and the deathshriek generals. This news concerns us all.

"I saw a jatu go into the gilded sleep and then resurrect."

The room bursts into an uproar.

"Impossible!" Nalini, a barrel-chested gray deathshriek with sharp quills all the way down her back, hisses. She signs in battle language as she speaks so the alaki generals can understand her. Unlike me, none of them can fully understand a deathshriek when she speaks. "The Nuru's eyes deceive her—you know she does not sense things as well as she should. That she does not understand things the way she should."

I look down, shame flooding me, as it always does, at this pointed reminder about what I did, all the deathshrieks I killed. But that has no bearing on what's happening now, I remind myself, quickly lifting my head. If I must constantly atone for the wrongs I committed against others of my kind, I will do so by protecting them, even if it's against threats they don't believe in.

"My eyes did not deceive me," I insist, stepping forward. "I witnessed the resurrection of a true jatu."

"As did I," Belcalis says.

"Me too," Britta adds.

One by one, my friends move to stand beside me, adding their voices to mine.

"I cut off his head with my own claws," Katya rumbles softly. "His blood was gold. Divine, just like ours."

"An' he an' the others ignored Deka's commands," Britta says. "They just slid off him like water. How is that possible?"

The room devolves once more into chaos, the generals talking, shouting, over each other.

"ENOUGH!" White Hands's voice is as thunderous as a horn, drowning out the chatter. Once the room falls to silence again, she addresses the gathered generals. "We can accept that a jatu resurrected—our bloodsisters saw it with their own eyes, therefore we must assume it is true, as is the fact that they saw multiple jatu ignore Deka's commands. Unless we can find another, more practical explanation for what our bloodsisters experienced, we must hold this one as the truth. Now then." She turns to me. "Do you have any idea why these things happened?"

"The jatu spoke before he died," I reply, nodding. "He said he had been resurrected by Idugu."

"Idugu is a myth." General Nalini seems offended by the very notion, as do the other deathshriek generals. "A comforting tale the jatu tell themselves to assuage their guilt at betraying the only true gods."

White Hands, however, just watches me evenly. Her calm expression gives me strength.

"I think Idugu is real," I say.

"You believe there are other gods in Otera?" Beima, a stout Firstborn general, asks, scorn marring her plump features. "Blasphemy!"

"I would never suggest that," I reply evenly, refusing to let her bluster intimidate me. I know my theory may be abhorrent to the others, but it must be considered. Everything has to be

50

considered, lest we fall prey to the consequences of such swift denials. You'd think the generals would understand this after all their centuries of living. "But I do think that there are enough arcane objects remaining in Otera that can mimic divinity to those who do not know better."

"So you think we have a charlatan," White Hands muses.

"And does that not describe all our brothers?" Beima scoffs.

Guffaws sound across the room.

I ignore them. "I think we have someone—or something— who can resurrect jatu, even if for a short time, as well as use arcane objects to block my abilities. Objects like this." I toss the breastplate to White Hands, who unwraps it quickly. I'm not surprised when she just peers at the symbol, the barest hint of a frown marring her forehead.

As I suspected, that symbol affects only me. The others may feel hints of its power, but it doesn't incapacitate them the way it does me. I continue, glancing away so I don't catch a glimpse of the symbol by mistake. "This person, whoever they are, must be hiding somewhere. And we have to find them. We start with Elder Kadiri. He is Idugu's mouthpiece."

And we've already been tasked with eliminating him.

I don't have to say this part out loud—all the generals were there when the mothers first gave my friends and me the order. We've all heard reports of the high priest's strength and ferocity in battle, the miraculous way he's dodged a thousand alaki arrows. There's only one explanation for how a human man can achieve such feats: he isn't human at all, and he's been using his true jatu's abilities and his position as spiritual leader to convince the men of Otera that they can be just as powerful if they join the jatu.

We've been planning his assassination for nearly a month now, the scouts tracking his movements across Otera. He's currently in Zhúshān, a city in the Eastern provinces, and if we move quickly enough, we can capture and interrogate him there.

A smile spreads across White Hands's lips, the expression so pleased, I feel a trickle of dismay. She already knows exactly what I'm suggesting, which means it's something she would have thought of herself.

Horror washes over me. When did I start making plots and scheming schemes like White Hands?

I push the question away as I look back up to meet the gazes of the gathered generals. "I suggest we move our raid on him and his men forward to the next few days, and instead of just a simple assassination, we interrogate him as well. He knows all the jatu's secrets. Wherever Idugu is—if he truly does exist—we will root him out, discover how he or the jatu are doing this."

"In the meantime," Belcalis adds, "Deka will commune with the mothers, discover what manner of arcane object can mimic a resurrection, and what weaknesses it has, if any."

She glances at me, and I nod gratefully.

"A splendid plan," White Hands says, her expression approving. "I couldn't have formulated it better myself." She turns to the other generals. "Alert the scouts to prepare the plans immediately. We cannot allow word of resurrections to spread across Otera and give the jatu false hope."

As the generals rise, ready to do as she says, she turns back to me. "Go now, speak with the mothers. Find out what you can about the arcane objects. Including this." She hands the

breastplate back to me, and I'm grateful to see it's as carefully wrapped as it was when I tossed it to her.

One thing about White Hands: nothing ever escapes her notice—not even a detail as small as a wrapped breastplate. I can feel her noticing my tension when I slip the breastplate back into my pack, careful not to make contact with any part of it and risk that blinding pain I felt earlier. Once I'm done, I genuflect, doing the short, swift kneel I've gotten used to.

"Yes, Karmoko," I say, respectfully using the Hemairan word for "teacher." "I will. But I have one question before I go."

I inch closer to her, turning my back to the room so that the others won't see my lips moving. Thankfully, it's so loud now, what with all the generals talking over each other, that even the most determined eavesdropper will find it hard to hear above the din. "Have you ever heard of any alaki being able to see the memories of others?" I whisper.

White Hands stares directly at me. "You mean you?"

Trust her to immediately cut to the heart of the matter. I sigh. "Yes, I mean me."

"I've never heard of it, but that doesn't mean it can't happen. You're the Nuru. Perhaps it's your divine gift."

I blink. "My divine gift?"

"The mothers have already blessed you with so many; what's another one to add to the collection?"

"But why would I develop a divine gift now, of all times?"

"Melanis received hers as she regenerated last night. Not even one full day of freedom and her wings have already returned." White Hands taps her lips. "Perhaps it's a sign—the mothers are growing in power, which of course means you are as

well. But you don't think that, do you?" She frowns down at me, and I look away, ashamed.

"I can never tell whether something is real or just in my mind," I whisper, shame flushing my cheeks as I force the words out. "My thoughts are always turning on me. Always taking me back there—"

"To the cellar—the dismemberment?" White Hands finishes.

I nod. "There's also the field where they burned me. Hanged me there too . . . And drowned me." I close my eyes against the painful memories, then inhale to steady myself.

When I open them again, White Hands is staring at me. "But what you saw the night prior—the memory you experienced, was it any of those?" White Hands seems genuinely curious.

"No, but—"

"There you have it." White Hands places her hand on my shoulder. The coolness of her sharply clawed white gauntlets soothes my tensed muscles. "It was not a cruel trick of your mind—you truly experienced what you experienced."

She takes a step closer. "You have to start believing in yourself, Deka, in your own mind. Your own mental soundness. If not, others will take advantage of you, turn your uncertainty into a weapon. Learn to trust in yourself. That is one of the primary marks of a great leader. A general."

She says this so meaningfully, I blink. "You think I could be a general?" Even the thought is a dream I've never dared reach for.

Yes, I'm the Nuru; yes, I've already led armies to victory; but all the generals of the Gilded Ones are Firstborn, women with eons more knowledge and experience than me. While I don't doubt my combat abilities, I'm not arrogant enough to think

I'd withstand even one of them in battle without relying on my voice and other divine gifts to seize the advantage.

In a fair and equal fight, any single Firstborn would annihilate me within seconds.

White Hands, however, doesn't seem to be considering any of that. "Look around," she says, gesturing at the others. "You're already here, in the war room. And you already have the victories under your belt. The mantle is waiting. All you have to do is believe in yourself enough to take it."

She squeezes my shoulder. "Trust yourself, Deka. You aren't the naive girl you once were."

I genuflect again. "My thanks, Karmoko," I say. "Deepest thanks."

But White Hands is already striding off. "Ah, General Beima," she says, waving at the stout Firstborn. "A word, if you will."

I smile at her swift retreat—White Hands has never been one for sentimentality. But then, neither have I—at least, not any longer.

I turn to exit the room alongside the others, only to stop quickly when there's another movement in the glass cell under my feet. The figure from before has moved into the center of the room. It's a man, his body dark and shrunken, open sores on his shoulders visible through the thick, wavy glass. I stare at him, a peculiar emotion sweeping over me: not quite disgust or guilt but a little mix of both. How the mighty have fallen. Once, the beard that matts his face was immaculately trimmed and braided with actual gold threads and those tattered robes were made of the most obscenely expensive fabrics. That's all

gone now, along with the multiple rings on his fingers and the jewels on his toes. All that's left of Gezo, the mighty emperor of Otera, is this doddering, vacant husk of a man whose empty gaze is now staring up into mine.

A thin green vine slithers across his shoulder, its moist, eagerly throbbing black-petaled flowers snapping for his skin. I shudder. That vine is a blood-eater, a carnivorous plant that originated in the Bloom. Tangles of more vines writhe across the walls lining Gezo's cell, though I don't know how they made their way in. The waters of the lake surround the small, dark room; it should be impenetrable. And yet, there the blood-eaters are. . . . It's all I can do not to gag when the plant on his shoulder sinks those petals into his flesh, its tendrils snapping eagerly as it gorges on the blood.

"And to think," Asha muses grimly, coming to stand beside me, "this is the same man who nearly destroyed our kind."

"He's nothing now, just a shadow," I say.

"A dying one," Adwapa adds, nodding at the black veins striping the former emperor's body, the sores on his shoulders where the blood-eaters took bites. "It's blood poisoning. He hasn't got much time left."

A vague sadness passes over me at the thought, though I don't know why. Gezo was the worst sort of enemy, the type who pretends he's your friend. But as I walk out the door, I can't help but take one last look back at him—at this haunting specter of a man who once held my fate, as well as everybody else's, in the palm of his hand and tried to crush us all and failed.

6

When I turn the corner into the hallway where the Chamber of the Goddesses lies, Melanis is exiting, her wings rustling with happiness as she joins the group of Firstborn waiting outside for her. She seems much more relaxed than she was just an hour ago, but that is to be expected. Time moves differently inside the chamber, seconds stretching into weeks on end, hours compressing into the blink of an eye. The first true meeting I had with the mothers, I spent an entire summer in their presence, only to walk back out into the hallway and discover that mere seconds had passed. That is the power of the divine, the power only the Gilded Ones can wield.

The moment I near the doors, Ixa scrambles down from my shoulder, where he's been perched since I left the war room. He absolutely hates the Chamber of the Goddesses. The former emperor pinned him to its wall with arrows made from celestial gold six months ago, and the memory clearly hasn't faded, even though the wounds have long since healed. I've tried to talk to

him about it several times over the past few months, but he always goes all sulky when I do, so I've stopped trying. For now, that is.

I'll be out soon, promise, I say to him, but he just sends me a reproachful look as he disappears around the corner.

Traitor, his expression seems to say.

Sighing, I walk over to the line of armored deathshrieks and alaki guarding the chamber doors, nodding in reply to their formal genuflections as the doors creak open. Most people have to wait until the guards announce their presence, but the mothers' doors always open the moment I approach—another mark of their favor.

I breathe a relieved sigh when a wave of soothing energy washes over me as I enter. Just like that, I'm in the dark ocean, the one I used to visit in my dreams. Only, there isn't any water in it—just an endless flowing of stars, all of them swirling, sparkling, around my body. This is the truest nature of the Chamber of the Goddesses—a thousand universes swirling together, entire rivers of stars flowing through the cosmos.

Before, when I had dreams of the dark ocean, all I could see was water, and sometimes that glowing golden portal at its center. I was so ignorant then. I couldn't understand—couldn't even truly begin to fathom what I was looking at. Now that I can, I touch a finger to a distant nebula, grinning when it whirls back into the cosmos. I wish so desperately I could share this with Britta and the others, that I could open them to the worlds just beyond their gaze, but that is not possible. All the other alaki have some amount of mortal blood in them. Even White Hands, eldest of all alaki, had a mortal father. All she and the others see when they enter this chamber is the same sight I

glimpsed in Melanis's memories: a blindingly white room with four golden thrones and a ceiling that mimics the sky. No stars, no universes.

Every day, the distance between my friends and me grows.

Worst of all, they can't grasp the true forms of the Gilded Ones. To everyone else, the goddesses are shimmering golden shadows, sunlight and stardust all mixed up in one. I, however, see the truth: the Gilded Ones are vast ethereal bodies made up of energy and starlight, each one so large, they could contain an entire universe, and yet so small, they fit on their golden thrones. They are limitless, contradictory. And they are my mothers.

The thought calms me a little as I walk to the foot of the thrones where Anok, as always, is the first of the goddesses to wake. Even before I reach her, the goddess's fathomless black eyes are blinking open, tendrils of darkness shifting and wafting around her starlit form. Most people see Anok as an overwhelming shadow, a total absence of light, but to me, she is both darkness and light, a thousand suns spinning under that obsidian facade. Storm clouds gather around her brow—an expression of fury, deep and pure. Melanis must have informed her of what we saw at the Oyomosin.

I kneel respectfully in front of her. "Divine Mother Anok, Melanis informed you of what we witnessed?"

The goddess nods, a crown of stars shimmering in the coils of her inky-black hair—acknowledgment of her position as the oldest and wisest of the Gilded Ones. The mothers may have all been born together in the burst of cosmic energy that began the universes, but it was Anok who first put her thoughts to words and became an individual consciousness.

"Yes," she says in a voice layered with the roar of a thousand distant planets, "she told us of the jatu who ignored your commands and resurrected."

As she speaks, a subtle tremor ripples through the star river: the other mothers awakening from their divine sleep. Their movements waft a subtle, flowery scent into the air—the same one I always smell when they wake, though I can never quite pin it down. As always, it disappears just before the goddesses begin speaking. "It is as we feared," they say together as one—a peculiar habit of theirs. Sometimes, they're individuals, and other times, it feels like they're four facets of the same being. One body divided into four aspects. "The angoro has been awakened."

"The angoro?" I frown.

"The golden throne, the most powerful of our artifacts—arcane objects, we believe you have named them." Vines writhe over Etzli's fertile golden-brown body as she speaks, an expression of agitation, which, combined with the ever fiercer storms flashing across Anok's brow, worries me.

Gods don't show emotions as mortals do. While they appear vaguely human, their cold faces and the crystalline perfection of their gazes mark them for what they are: divine beings. The few emotions they do display appear as unfathomable things: waves of color, flashes of natural phenomena.

"It siphons our power and uses it to perform miracles," Etzli continues, distress wreathing a crown of storm clouds similar to Anok's around her head.

"I don't understand."

Hui Li leans forward impatiently, light shimmering over the faint red scales that cover her body. Of all the mothers, she

is the most humanlike—prone to impatience, irritability, and other such mortal emotions. "Three thousand years ago, when we were at the height of our power"—she explains—"we created two objects to protect Otera and keep it from ever again devolving into the wars we had delivered it from: the n'goma, which would ensure that Hemaira's walls never fell, and the angoro, the golden throne, which would guarantee that the Hemairan bloodline always ruled Otera."

I frown. "But why would you want the Hemairans to always rule?" After everything the Hemairan emperors orchestrated— the jatu rebellion, among other betrayals—I assumed they were the Gilded Ones' mortal enemies. "And why the emphasis on Hemaira itself, for that matter?"

"Sentiment and practicality," Anok explains, her black gaze unblinking. "Hemaira is the seat of our power, the place where we cultivated our first and most devoted worshippers. And the Hemairan emperors were our first priests, birthed from the very first of our Firstborn, our most loyal child."

White Hands, I fill in silently.

"We assumed they would remain loyal as well," Etzli explains.

"Wrongly, as it turns out," Hui Li grumbles.

I nod. "I understand."

The Gilded Ones favored their first children and put them in positions of power, only to have them rebel in grand fashion. It's a story as old as time, and gods, sadly, aren't exempt from such tragedies.

"So what about the angoro? What exactly is it?"

"The most fearsome of all our arcane objects," Anok explains. "It has not only vast reserves of our power but also the

ability to draw directly from us—to use our power to enable feats that seem like miracles."

"The jatu's resurrection," I gasp, immediately comprehending. So that's how they did it!

"Indeed." Gentle Mother Beda, the quietest of the goddesses, inclines her icy-pale brow, her wings scattering flurries around her. They're almost identical to Melanis's, those wings—as are all her other features, I'm just now noticing. In fact, she and the Firstborn would almost be identical except that she is so voluptuous, rolls of fat seductively pad her ample figure; unlike Melanis, who is lithe and thin. Then there's the matter of Melanis's skin, which is the same golden brown as Mother Etzli's.

Most Firstborn favor one goddess over the rest—White Hands is very clearly Anok's child, for instance—but there are a few who resemble two or more of the Gilded Ones. Melanis clearly falls into this group. I, on the other hand, very much resemble Anok, but then, my original mother, Umu—the alaki who served as a vessel to birth me—is her direct descendant.

"Why now?" I ask, pulling my eyes away from Mother Beda. "Why have I never heard of the angoro before? If it has so much power, why is it only emerging at this moment?" *And why are the mothers only worrying about it now?*

I don't voice this last question, as it veers much too closely to disrespect. Besides, I'd never want the goddesses to think I was doubting them.

"We had hoped it had faded in power over the centuries, that it had faded into nothingness," Etzli says. "But then you defeated the emperor and imprisoned him here. The angoro must have awakened as a result."

I whirl toward her, horrified. "I caused this?"

"No." Anok leans in, shaking her head. "You are not to blame. The angoro is only working as it is designed to. It is a safeguard that emerges when the Hemairan bloodline is absent from Hemaira for a certain length of time. Usually, only a few weeks. But months had passed, and nothing had happened . . ."

I frown, still trying to understand. "So what you're saying is that when I brought the emperor here—"

"Keeping him from sitting on the throne of Otera—"

"The angoro began siphoning your power?"

The goddesses nod as one. "It is draining us," they intone. "And it will not stop until we are no more."

"No more . . ." The words come out of me in a gasp. "You mean, dead?" I can't even fathom the possibility.

Anok shakes her head. "Gods cannot die, but we can fall into oblivion," she explains. "Become scatterings of mindless energy rather than sentient beings. It would take hundreds of years, but the end result would be the same."

"And it's already started happening, our descent into nothingness," Hui Li says. "Look at how weak we are. We cannot even free our own children."

I sink to my knees, numb now. All this time, I'd assumed that the mothers' weakened state was due to having been imprisoned here for so long, starved of prayers for so many centuries. But I caused this. I was so intent on defeating the emperor, severing his power in Hemaira, that I did not think of the consequences. I'm responsible for the mothers' continued weakness, for their inability to tear down the walls of Hemaira and free our sisters.

A sob chokes me. I'm responsible for all those girls suffering in the Warthu Bera. All those women suffering all across Otera.

"You must find the angoro and bring it to us," Beda says,

continuing where Hui Li left off. "It is of the utmost importance. Not only does it prevent us from regaining our full power, it will drain us dry if desperate measures aren't taken. Once it does the jatu won't just have rumors of a false god; they'll create one using our power."

By now the air is so thick, it's a weight pressing down on my shoulders. I nod, my throat raw as I whisper: "What do I do, Divine Mothers? How do I stop it?"

Four heads turn to me as one. "Capture Elder Kadiri, but do not assassinate him immediately. You'll need to question him first. As Hemairan high priest, he is keeper of all the jatu secrets. He will know the location of the angoro's wielder, whoever he may be. Once you find him, kill him and bring the angoro to us. You'll know what it is the moment you look upon it. Your blood will guide you."

"And what happens if I cannot kill the wielder?" It's an unpleasant question but one I have to ask. "If the angoro is truly harnessing your power, I may not be able to beat whoever is using it."

"You will. You already have our aid." Anok rises, presses a finger the absolute blackness of midnight to my ansetha necklace. "This necklace is made of our blood, our love; it binds you to us, a tether. If ever you face the angoro's wielder, merely think of us as you hold it, and we will imbue you with our strength and power."

This offer is beyond anything I ever expected. I prostrate myself, body flat on the floor. "I am not worthy of such love, Divine Mothers."

"And yet, it is yours." A soft, cool white hand lifts my head

up. Beda's. "A word of warning, our beloved child. The angoro lies, and its user will show you things—memories that seem like the truth."

The memory I saw in Melanis's mind flashes past, and I gasp. So that's what that was. And here I was just about to ask the mothers about it. Then I have another thought. "What about my commands? The jatu we faced did not heed them. Was that the angoro's influence as well? Or was it this?" Closing my eyes, I unwrap the jatu breastplate once more and place it at Anok's feet, turning away when she gestures and it begins to float toward her.

I don't want it to influence me anymore.

Some moments pass: then I hear a strange rustling. I glance up to see the cloth at my feet flapping up to wrap itself around the breastplate. Once it's fully covered, Beda plucks the breastplate out of the air and hands it to me. "It is as you suspect: this is another arcane object, one with much less power than the angoro. It is designed to block your connection to us, to the divine. You will have to learn how to overcome it."

I frown. "But how will I—"

"You are the Nuru," the goddesses suddenly intone together. "Flesh of our flesh, blood of our blood. You will overcome it." Just like that, gold is spreading over their bodies once more. Then they're fast asleep, dreaming of a better Otera.

I glance down at the ansetha necklace, all those stars sparkling across my chest. "Overcome it." I sigh. "And just how do I do that?"

◆

"So, what did they say?"

Britta is waiting impatiently when I enter our shared chamber, a large, airy room triple the size of the common bedroom we slept in back at the Warthu Bera. Unlike our beds in that grim place, the one here is large enough that a single, dimly glowing lunar tree thrusts through its middle, separating it in two. The branches act as canopies, enclosing my side and hers in curtains of leafy green threaded with gold veins. As if that weren't enough, the towering glass doors at the farthest end of the room open to a balcony that looks out across Abeya, the white stone buildings of the city of the goddesses twinkling on the mountainside below us. It's like we're at the top of the world, able to reach wherever we desire.

She waves me over to her side of the bed. "Come on, Deka—talk!" she urges, pushing aside the branches so I can enter.

"I need a moment," I groan as I slip past the leaves to sink into the blessedly soft mattress. After my conversation with the mothers, every muscle in my body is corded with tension.

Britta flops down beside me. "That bad?" she asks, flipping a pebble across her fingers like a coin. For a moment, I feel the barest hint of a tingle.

It disappears when I frown. "Worse. They want us to kill Elder Kadiri."

"I thought that was what ye wanted too?" Britta seems perplexed.

"I did, but that isn't why I'm tense." I sit up, then quickly explain the situation to her. Britta's eyes grow wider and wider as I speak.

"So they're dying?" she gasps. "The Gilded Ones, the goddesses of Otera—they're dying?"

66

"Shh, stop repeating that word." I press my fingers against her lips to stop the awful refrain. Then a sob escapes me. "It's all my fault," I say, bursting into tears as all that guilt, all that shame comes surging back.

Britta quickly embraces me, her arms soft and comforting, and gently strokes my hair. "Shh . . . Deka, shh," she says soothingly, until my muscles finally loosen. Then she pulls back, looks at me. "How is it yer fault, what's happening?"

The words flood out of me in a rush. "If I hadn't imprisoned the emperor here, the angoro wouldn't have awoken, the mothers wouldn't be dying, all our sisters wouldn't be imprisoned in the Warthu Bera, Adwapa wouldn't be so angry all the time, the women in Otera would—"

"Wait, ye truly think all these things are yer fault?" Britta cuts through my panic, her blue eyes bright with concern.

She's flipping that pebble again, and the movement sends tingles rushing up my spine, though I don't know why.

"All right, let's play this out. Let's say ye hadn't defeated the emperor. Wha would have happened?"

I look down. Think. "We'd still be at the Warthu Bera. Half of us would be dead."

"An' all the women in Otera?" she prompts.

"Would still be where they are," I finally say. "But the jatu wouldn't be killing them the way they are now."

Britta pins me with a stare. "Wouldn't they? An' how many women were beaten to death by their husbands or families, or just disappeared into thin air when ye were in yer village?"

I think back, remembering now all the rumors, the whispers of the fates that befell women back in Irfut. I remember my former friend Elfriede, whose father nearly beat her mother

67

to death for producing a daughter with such an unsightly red birthmark on her face. Or even my father's youngest sister, the one no one ever spoke of, because she disappeared after marrying a man the family disapproved of—the same sin my father committed, only he was a man, and men are exempt from such punishments.

Or are they?

The more I think back, the more memories emerge. The boys who were beaten for being too "feminine," all the children they left out on the hill for having shortened limbs, curved spines and the like. The yandau—all those people who were neither male nor female—they drove away or forced into the temples. All of them living, breathing human beings who were punished, ostracized, killed because they didn't fit one expectation or the other.

I look up at Britta. "I see your point."

She nods, takes my hand. "There is such a thing as too much guilt, Deka."

I nod, then bury my head in a pillow. I wish so much that Keita were here. He'd put his arms around me, tell me everything would be all right. "I miss our uruni," I whisper, nuzzling the pillow.

"Ye mean ye miss Keita," Britta humphs. She pushes me off the pillow. "We'll have none of that! Yer not moonin' over yer sweetheart in my bed, an' yer certainly not sleepin' here with yer dirty, smoky robes. Go wash, filthy foots. Go on, then."

I sigh, rising. "I'm washing, I'm washing."

What would I do without Britta?

7

◆ ◆ ◆

"Evening greetings, honored Nuru." The words follow Britta
and me early next evening as we make our way into the Hall of
Reverence, the chamber where Melanis's welcome feast will
take place.

The hall is packed when we enter—alaki, deathshrieks, and
humans waiting impatiently for Melanis and the Gilded Ones.
Since our initial victory against the jatu, we've had precious lit-
tle to celebrate. There's always another battle to fight, another
village to liberate, another leader to kill—even now, we're ready-
ing for our attack on Elder Kadiri one week from today, during
the Festival of the Half Light. White Hands chose this timing
because the elder's jatu guards are sure to be so drunk from the
Festival, they'll be practically useless. But even if it wasn't that,
there's always the ongoing siege of Hemaira, which we con-
stantly have to rotate soldiers in and out of. It's always some-
thing these days. No wonder the past few months have blended
into each other, a blur of blood and gold and violence.

But now, Melanis is here, and now, there's hope, wonder—worship.

Unease trickles down my back when the low hum of prayers rises into the air. This is my least favorite part of gatherings like these: the dedication. There, kneeling behind the latticed screen at the very back of the room, are rows of fervently praying people. New converts, dedicating themselves through prayer and worship to the goddesses. It's the most important requirement for every person who wishes to live in Abeya. Even I had to dedicate myself when the goddesses first raised the city from the desolation that was once the mountain.

I squint to see if I can spot the old woman from the jungle outside the Oyomosin, but the crowd of white-robed converts blends together as an indistinguishable mass, so I glance around the rest of the hall. There's so much to see here today: shimmering, iridescent moths flittering through the air, their glow adding to the ambience created by Mother Beda's lights; rows of gigantic, velvety yellow flowers, which double as seats you can sink completely into; icy waterfalls flowing with juices and palm wine. The entire hall is a vision.

Then, of course, there are the guests, everyone milling about in their most exquisite finery, gold and jewels flashing, ornate masks adorning more than a few faces.

I stare, wide-eyed, when a human man saunters past wearing a silver-streaked wood mask shaped into the four stars of the ansetha. While women in Otera are required to wear masks after they're proven pure by the Ritual of Purity, the former emperor and his courtiers were the only men I ever saw do the same. There are rules for masks in Otera—punishments too. In fact, when my blood ran gold, I was denied the privilege of wearing

the mask. That way, everyone could look upon my face and see my shame. I hated masks for a long time afterward and saw them as a means to control women. Which, in most cases, they are. But masks can also be an expression of joy, faith, celebration. They can be anything the wearer wants. In the end, they're just objects. It's the wearer who determines their meaning. It took me a long time to understand that.

Britta taps my shoulder. "Want to go eat, Deka?"

She nods toward the farthest end of the hall, where platters of food are heaped high on tables decorated by tiny, translucent-white flowers. Belcalis, Katya, and the twins are already there, Nimita, Chae-Yeong, and a few of the other deathshrieks towering over them. They seem relaxed—happy, even—to be part of the occasion, another sign of how much deathshrieks as a whole have changed: they've become less and less aggressive ever since the mothers awoke, which makes complete sense. Deathshrieks were created to ensure that our race wouldn't die out before the Gilded Ones revived, and now that the mothers have returned, most of the deathshrieks' worst traits—the blinding rage, the overwhelming anger—have faded.

One day, they'll disappear completely. The mothers have vowed that when they regain full power, one of the first things they'll do is revert deathshrieks back to alaki. They'll be our bloodsisters again.

Katya, I know, can't wait for that day. I certainly can't.

I glance at my friends one last time before shaking my head. "Can't," I sigh mournfully to Britta. "I have to wait for the mothers by their dais." It's what I always do at rare events like these, and I won't change that habit now.

I can't risk making a fool of myself playing around with the

71

others. I have to behave in a manner that reflects well on the mothers. I am the Nuru, after all.

Britta squeezes my shoulder in commiseration. "I know." She huffs out a mournful breath. "I just wish ye could spend time with us again like ye used to."

I press my forehead gently against hers. "Me too," I say. "I wish I could be with everyone again."

"Our uruni?" Britta snickers, no doubt thinking of my words yesterday.

"Our uruni." I nod, since she and I both know I mean Keita. "And you too, of course," I add, as if it were an afterthought.

"Of course."

I pull away so I can look into her eyes. "I love you," I say earnestly—a quiet plea for patience.

I know I haven't been the best friend I could these past months.

Even though Britta and I share the same room and go on raids together, there's always another crisis here that requires my attention—another battle, another raid, another leader to be assassinated. At the Warthu Bera, there was, at least, always a day or two every month when we neophytes could just gather and relax with each other. Here, I can never be just Deka, playing silly games with my friends. There's never any time.

Britta crosses her arms, pretending sternness. "More than the moon an' stars?"

"More than a kuta fish freshly braised in pepper sauce."

"That's a lot of love." Britta laughs. She knows that the massive oceangoing fish are my new favorite thing to eat. She uncrosses her arms. "I'll forgive ye for now, but when we go on that raid after ye-know-who, it's ye an' me."

"Me and you," I affirm, squeezing her hand. "Bloodsisters forever."

"Forever an' ever," she says, giving me a quick salute. Then she makes a beeline for the others, who wave and grin at her before sticking out their tongues at me in disapproval.

I bite back the smile that threatens my cheeks as I walk toward the dais. Honestly, my friends can be so childish sometimes.

A thousand eyes follow my progress as I make my way up the stairs to the dais. Several bows, genuflections, and even a few outright prostrations. People are always watching me in Abeya. Everywhere I go in the city, people are watching and bowing, as if they can receive the mothers' blessing simply by their proximity to me. Still, their attention is a reminder: I must never disgrace the mothers, never show them that I am unworthy of their favor. As I straighten my posture, trying to stand as formidably as I can, White Hands enters the hall. Her eyes immediately seek mine, and she nods pointedly toward the doors at the other end of the room, where a short teenaged boy wearing a wooden half mask, blessings beaded in Old Hemairan on the edges, walks in.

My brows gather.

That lanky gait, that brown hair . . . I gasp. It's Acalan, Belcalis's partner. He's gained muscle over the past few months, but it's definitely him.

And if he's here . . .

My heart skips a beat when another boy wearing a half mask enters behind him—this one tall and wiry and leading a contingent of former jatu who all hold assegai, the ceremonial spear the jatu always use. A jolt travels through my body as familiar

golden eyes look into mine. They may droop with exhaustion, but just the sight of them has my legs weak with joy. It's Keita—he's here! He's actually here!

The moment he realizes I've seen him, a smile spreads across Keita's face. My insides curl and flip in reply, my own smile stretching my mouth so wide, it's painful. Keita . . . I've missed him so much these past months. Missed talking to him, kissing him . . .

He winks at me just as drums sound, heralding the beginning of the procession. My eyes greedily drink him in as he and his contingent walk ceremoniously down the middle of the hall, then split in two and turn toward the crowd. White Hands, who has climbed the stairs to stand beside me, gestures, and they thump their spears as one.

The crowd quiets, everyone rising as a subtle electricity sparks in the air.

They're arriving. . . .

Reverence shivers over me, my blood tingling as four sparkling golden shadows, each ten times the size of a regular human, materialize on the thrones behind me, benevolent smiles on their faces when they gaze down at the gathered crowd. They're barely more than sunbeams, lightning bolts made flesh, but they're just visible enough that everyone in the crowd can glimpse them: the Gilded Ones, each as perfect as they were the day I woke them.

"Our beloved children," the goddesses say as one, their combined voice so powerful, it feels like a tidal wave washing over the crowd. "How happy we are to see you gathered here this evening. And how happy we are to welcome our new children."

They gesture, and the screen at the back of the room glides

open, revealing the new converts, who walk ceremoniously down the center of the hall, then prostrate themselves.

The goddesses smile down at them. "From all across Otera, you have come to seek the light of our blessings. And for some of you, the light of absolution."

Now, a few of the converts—mostly the older ones—stand. They're all wearing black sashes—the color of oblivion—and their bodies are rigid with tension. The woman from the jungle is among them. She shoots me a hate-filled glare before returning her attention to the mothers, just a hint of fear in her eyes. Despite all her bravado, she's just as awed as everyone else to stand in the presence of the divine.

Now, the Gilded Ones rise and beckon to the group. "Approach, our beloved children. With this cleansing, you will become as new, unblemished and innocent in our eyes."

Eyes fixed to the floor, the converts step forward, then prostrate themselves in front of the mothers, who lift their hands over them in benediction. "May your minds be cleansed, healed of all worries, freed of all sins," the goddesses intone as one.

My skin prickles as a faint shimmer mists over the black-sashed group, changing those sashes from black to a pure, crystalline white. The transition happens within a matter of seconds, but when it's done, there's a marked change in the group. Where once their bodies were tense, every member of the group now seems relaxed and happy, a distinct and youthful wonder in their eyes. It's almost as if they've been reborn, as if they've reverted to a more innocent state.

They all look up at the Gilded Ones in awe, the woman from the jungle the first to speak. "Who are you?" she asks the mothers, eyes wide.

"We are the Gilded Ones," the goddesses reply as one, "deities of Otera, and your mothers."

The woman nods, accepting this declaration with the ease of a child. "And who am I?"

"You are our daughter, and you can be anything you want to be."

As always, the words fill me with joy and awe. *Anything you want to be* . . . That's all I've ever wanted for myself, for the women of Otera: the chance to determine our own paths the way most men can.

"Anything . . ." Tears of joy shimmer in the woman's eyes, and she wipes at them, as if surprised to see them there. She turns to the others, beaming. "I can be anything!"

"It is the same for all of you," the mothers say. "You have been given a gift, a chance to shape your life as you wish it."

Cheers break out across the hall. The newly reborn converts smile and embrace one another, but then, after they're done they begin glancing around, curious. An unpleasant feeling curls in the pit of my stomach. This is the part of the ceremony I hate, the part where curiosity, then bewilderment, sets in.

All these people chose to have their minds cleansed—to embrace a completely new life, one free of all the painful memories of the past. In fact, this is one of the greatest gifts the mothers can provide their worshippers. But it comes at a cost. The new converts may remember language—a few even remember skills they once had—but everything else is gone. All their memories, everything they once were—the people they loved, the places they knew, even the foods they enjoyed. All that has been erased.

I know that is the point of the cleansing—from the remnants

of the old person emerges the new—but I can't help but feel saddened by the loss.

"Are you all right, Deka?"

I look up to see White Hands watching me, an unfathomable expression in her eyes. I don't bother trying to decode it. White Hands collects secrets the way other people collect trinkets.

"Would you ever do that? Have the mothers wipe your memory?" I ask.

She shakes her head. "There is nothing in my life so painful that I would destroy all of who I am to erase it."

This from the woman who spent several centuries as a collection of dismembered body parts chained to the floor of the emperor's dungeon.

"But then"—she shrugs—"if I'd had any memories taken, I wouldn't know, would I?"

The words slither through my mind, an uncomfortable proposition. *I wouldn't know....*

"What about you?" she asks, turning to me. "Would you give away your memories?"

There's something funny about that particular turn of phrase, "give away your memories," but I ignore it as I shake my head. "No, I would not." I considered it after the first dedication ceremony—removing my memories of Irfut and all the tortures I endured in that cellar. But I quickly dismissed the idea. The pain may linger, may even bedevil my every waking moment, but it's still what made me the person I am today. "I won't part with any piece of myself," I say. "I understand why others would, but for me . . . Just the thought of it—"

77

"Precisely," White Hands finishes, and we return our attention to the scene in front of us, where the new converts are dispersing into the crowd, the ones whose memories were cleansed being led away by helpers who will aid them in adjusting to their new life in Abeya.

Once they're gone, the mothers rise again. "Now that we have welcomed our new children, it is time to welcome one of our eldest—Melanis, the Light of the Alaki. Finally, after centuries apart, she has returned to us, our beloved child and the second of our war queens."

They glance pointedly up to the ceiling, where the glass parts as easily as a flower, revealing a lone, winged figure, glowing body accentuated by the early evening sunlight: Melanis. Awe suffuses me as I watch her wing down, as graceful as a dewdrop on the breeze. This is the truest form of Melanis, the reason we risked so much to rescue her. Unlike the three other war queens, and indeed, all the alaki in general, Melanis is a beacon of light in the most literal sense of the word, one who will give us hope as we continue our offensive against the jatu and the priests.

The entire hall is quiet now, everyone staring up at Melanis with the same awe that is coursing through my veins. Everyone, that is, except for White Hands. I glance at my former karmoko out of the corner of my eyes, confused to see she's once again stiff, the smile that's plastered across her face one of politeness rather than joy. What is it about Melanis that has her so on edge?

I try not to think too deeply about it as the goddesses smile up at the descending war queen. "For too long," they continue, "our children have languished in the shadows—abused, beaten, executed. Our war queen Melanis's return signals the dawn of a new era. With her and our beloved daughter the Nuru at our

side"—four pairs of divine eyes turn to me, and I kneel, reverence washing over my body—"we will take back Otera and make it ours again. We will rule these lands once more."

Cheers ring out, ecstatic expressions of joy, victory. So much happiness fills me now, I feel like a cup on the edge of overflowing. And there's only one person I want to share it with: Keita. His back may be to me, but I know he feels my gaze, knows I'm watching. Just a few hours more and I'll be in his arms again.

It's going to take everything I have to wait.

The rest of the ceremony passes in a blur. I barely hear the mothers speak, only scarcely watch Melanis as she addresses the crowd. Even when the mothers leave and my friends rush Keita and me to the dinner tables, I pay little attention. All I can see is Keita sitting there beside me, his golden eyes peering into mine. I feel the heat of his leg next to mine, the calluses on his fingers as they stroke my wrist.

"The nystria afterward?" he whispers in my ear.

Warmth flushes my body as I nod. "As soon as we're done."

He smiles at me, the barest hint of a dimple grazing one cheek. "I can't wait."

"Me neither," I say.

"Ooh, look at the lovebirds back together again," Adwapa coos, the sardonic edge to her voice so slight, the others don't notice as they laugh and waggle their brows at us.

I disregard them all. I've been waiting months for this day; I won't let anything ruin it. Keita is here, and that's all that matters.

8

Keita and I meet, as we did the few times we were able to meet privately before, at our new favorite tree. It's a nystria, just like the one we used to meet under at the Warthu Bera, only this one sits on one of the N'Oyo mountain range's more remote crags—a many-branched giant so formidable, its roots spread across the entire peak. A miniature forest has sprouted underneath its fragrant, blue-flowered branches: small trees sprouting between its roots, little animals skulking in the shadows. Ixa stalks them, an excited gleam in his eyes. There's nothing he loves more than terrorizing smaller creatures. Despite his soft, almost kitten-like appearance, he's very much a predator—and predators like meat. Within moments, he's gone, chasing a terrified monkeybird into the Bloom. I send up a little prayer to the mothers for the creature's soul. Hungry Ixa is determined Ixa—he never lets his prey go.

As Keita and I snuggle into the blanket we've spread, two soft green lights emerge in the branches above us.

I nudge him excitedly. "Look, an indolo," I whisper.

"Where?" His movements are heavy with exhaustion, but he follows my gaze, excited as I nod to a higher branch, where two tiny feline creatures are prancing in the moonlight, sleek bodies covered by trailing green vines, golden horns gleaming as they peer at us.

That soft green light shimmers over both of them, a visible tether tying the pair together. Anok once told me that the indolo are she and her sisters' most treasured creations, each one a single forest spirit split into two identical bodies. Whatever happens to one happens to the other. A visible reminder that all of us are connected, always.

I grin at Keita. "One spirit—" I begin.

"Two bodies. Just like you and me," he says, squeezing me tight.

Despite his tiredness, his grip is as firm as ever.

His nose nuzzles my hair, and I shiver, savoring the sensation. Keita's touch always makes me feel warm inside. Even though we've never done much more than kiss, just the slightest caress is enough to send my skin prickling in anticipation.

I look up at him. "So . . . how was Hemaira?"

He sighs. "I'd prefer we didn't speak of it."

My throat closes. There's only one reason Keita wouldn't want to speak of Hemaira: more girls have been thrown off the walls. Many more. "Did I know any of them?"

When he shakes his head, relief travels so strongly through me, I almost shake from it. "No," he says.

Not yet . . . I finish his silent reply.

The jatu have already thrown a few girls from the Warthu Bera, but none that I knew well. None like Binta, the

ever-cheerful novice who once oversaw our group, or even Meh-rut, Adwapa's former flame. But, regardless of whether I know these girls or not, each death is another little wound, piercing deeper into my heart. Those girls all had families, loved ones— dreams for the future. Then I came along. . . . Every one of their deaths is on my hands.

I swiftly ask my next question to distract myself. "Any word from the karmokos?"

We haven't heard from them since Hemaira's gates closed. In fact, everything we know about what's happening in the Warthu Bera and in Hemaira as a whole, we learn from the jatu we sometimes capture and "question," White Hands's favorite euphemism for torture. And from what we've heard during the last few questionings, the situation there hasn't changed. The jatu still have all the alaki in all the training grounds imprisoned and are still bleeding them for their gold.

War is a very expensive business, after all, and alaki have money running through their veins.

Keita shakes his head. "No word there."

So I ask one final question. "What about Gazal?" Last I heard of the dour, scarred alaki who once terrorized me at the Warthu Bera, she'd been promoted to commander of one of the regiments at the siege on Hemaira and was constantly trying to scale Hemaira's walls, n'goma or no.

Gazal is eerily inured to pain, compared with other alaki. But then, given her history . . .

"Still looking for entry into the city," Keita answers. "She's trying to find any hint of the arcane object."

The one he's been searching for all this time.

In the six months we've been laying siege to Hemaira, the jatu have somehow been replenishing their supplies and meeting with other jatu commanders all across Otera. At first, we thought there must be a network of secret passages in and out of the city, but we tried for months to find one, with no success. White Hands and the other commanders finally determined that this is because there's yet another arcane object at play, one that somehow allows the jatu to move from Hemaira to wherever they wish—which is why she sent Keita and the other uruni to search for it.

That's the thing about arcane objects: if they aren't killing you in horrifying ways or causing unspeakable damage to your mind, they're useful tools that can accomplish feats to defy the imagination. It's ironic. Six months ago, I'd never even heard of arcane objects. Now, I have to factor them into every battle plan.

"We haven't found any sign of it yet," Keita quickly says when he sees my questioning expression, "but that's not why we rushed back. White Hands wants us to accompany you next week to find Elder Kadiri and the angoro. She's already informed us of all the particulars."

"That's good," I say, tension lifting from my shoulders. I don't want to spend our precious time together discussing battle plans. "Let's not talk about bad things anymore, Keita," I say, nuzzling my nose to his chest and breathing in his scent. "Tell me how you are. I missed you." Months have gone by without my seeing his face every day, without our stealing treasured moments to be together.

Only a year ago, I couldn't understand how a person could

love me, could want to be by my side. Now, I cannot imagine a world without Keita, a world where I am not his beloved always.

Warmth traces up my neck. Tiny kisses, an edge of teeth. "I missed you too," he says, his breath warm in my ear. "I dreamed about you. Every night, I dreamed."

I turn to him, accept the brush of his lips against mine. This is what I have been missing. What I've spent nights dreaming of. I close my eyes and allow the feeling to take me.

More kisses come, scattering down my neck, my shoulder. Finally, Keita sighs, presses his forehead to mine. We are both determined not to rush ourselves the way so many others do. When all you know is constant war, it's easy to give up hope and just grasp things as they come. But Keita and I have both decided to remain on our slow, steady course. We have to believe that we'll see the other side of these times, that we'll be together for always. In fact, I've already spoken to the goddesses about extending Keita's lifespan, perhaps even giving him immortality, but I'll bring the subject up with him when we're not in such strained circumstances. He has to make the choice for himself. As much as I love him, I cannot force the decision on him. I know, more than anyone else, how truly painful immortality can be.

We remain as we are for a time, inhaling each other's breath. A reaffirmation. *I am yours, and you are mine.*

He rests his head on my shoulder and slides his fingers through my hair, plucking and then releasing each coil to watch intently as it springs back up. "So how is everybody here doing?"

"Fine. Except for Adwapa, maybe."

"She's still missing Mehrut?"

"More and more every day." She had nightmares again early this morning. I could hear her crying from across the hall. The walls may be thick, but my hearing is sharp.

"We'll get Mehrut back," Keita says, determined. "We'll get them all back."

He doesn't have to say more for me to know he's thinking of his own friends back at the Warthu Bera, the ones we left during the campaign. Most of them remained willingly with the jatu, but there were a few who supported their alaki sisters. Who rebelled against the emperor when they discovered the horrific truth of what he'd had us doing.

They're imprisoned in the Warthu Bera as well, shackled next to the alaki and used even more brutally. It's one thing for girls to rebel, but for boys, the chosen ones of Otera, to go against society? The boys in the Warthu Bera are all being made examples of—a warning to all other men: "You also are not safe. You never were."

I nod. "We will," I say firmly, trying to banish images of the uruni's suffering from my mind. I quickly change the subject. "Any progress with the deathshrieks in your regiment?"

Even after all these months, the deathshrieks and the Firstborn are still not used to Keita. He and a few other uruni have a reputation for being deathshriek killers, so they're not as easily accepted as the others.

Keita smiles wryly. "It's a slow process. All I can do is prove that I'm their comrade, that I'll never betray them."

"It's a start. It's not easy to—"

I stop when I notice his eyes drifting shut. Now, I see the

dark circles under them, the glassiness in his pupils. "You're exhausted," I say.

"I'm fine." He looks guiltily away from me, and worry surges. It's not like Keita to be this worn out. Even in the middle of a raid, he can fall asleep in minutes. But he obviously hasn't been sleeping.

He's hiding something.

"Tell me," I demand, my gaze boring into his.

He sighs. "I've been having these dreams . . . well, nightmares, really . . ."

"What nightmares?" I ask, my eyes narrowing further.

Keita has lived with the reality of battle for most of his eighteen years. Nightmares are a consequence of what we do, all the lives we take. A mere nightmare wouldn't torture him so deeply.

He looks up at me, raw pain in his eyes. "I'm burning alive, Deka . . . except the fire . . . it doesn't consume me. It's a part of me, coming from the inside. Burning everything around me." He shakes his head. "Maybe it's guilt. I betrayed everything I ever believed in. Perhaps there's a part of me that regrets doing that. But the thing is, every time I have that dream, I feel . . . powerful." His eyes slide away from mine. "And that's what really frightens me. Because that fire, I know it's like rage and it'll burn everything, given the chance."

"Oh, Keita," I whisper, tightening my arms around him.

To think he's been so tortured all this while. . . . How could I not have known? How could I not have understood how deeply deserting the jatu affected him? All across Otera now, there are Wanted notices—not just for me and White Hands and all my friends but for Keita and the rest of our uruni as well. They turned their backs on the jatu, helped tear down the empire.

Most of their friends and families despise them. The villages of their birth burn effigies.

You don't just reject everything you've ever known, every relationship you've ever had, and walk away unscathed. Especially not if you're a boy.

We alaki, we never had a chance, but the boys, they are the beloved sons of Otera. By popular opinion, they should be grateful for their existence, even though being male means having any emotion, any softness bullied and beaten out of you. Warmth, comfort, feelings—these are all the things denied the men of Otera, and worse, the men are forced to be grateful for it, to be thankful they are men.

But when the uruni reject their status, when they choose to go with their alaki sisters, they send a message: "There is a different way." And this is what strikes fear into the hearts of the jatu. Because when boys rebel, ordinary Oterans begin asking themselves questions, and then begin finding answers they never even considered.

That's why the jatu fear and hate the uruni even more than they hate us. Keita knows this, feels all this hatred viscerally. But I've been so busy being the Nuru these past few months, I haven't even noticed.

I look into his eyes, trying to convey all my love, my concern. Trying to hide my guilt at not being there for him the way he was for me. "You did the right thing; you know that, Keita. If you had remained with the jatu, you would still be killing us despite knowing the truth of what we are. You'd be down there with the rest of them." I point to the foot of the mountain, past the hidden river of glass, where faraway jatu encampments light up the night. "Our sworn enemy."

He nods. "I know. I only wish my mind felt the same."

"Give it time," I whisper. "Time always helps. And talk. I have a very willing ear." I wink at him, and he smiles ruefully.

"I suppose you're right. I should talk more. But after I get some sleep."

"Of course," I say.

He leans against me, and I tuck his head into my shoulder, then make slow, soothing circles across his back. Just a year ago, I couldn't imagine being in close circumstances like this with him. He was the boy I despised, the one who seemed to look down on me at every turn. Now, he is my lover and my ally, one of my greatest friends.

Soon enough, his breathing steadies, and soft snores rumble into the air. I tuck the blanket around him and settle in as well. This is as good a place to sleep as any. And goddesses know we both need it.

9

❖ ❖ ❖

The morning of the mission to capture Elder Kadiri dawns with a flurry of activity: harried seamstresses perfecting my group's disguises, mask makers fitting our merrily colored traveling masks, cartwrights making last-minute adjustments to the wooden wagons we'll be riding in. Even though we'll be traveling as a caravan, we're all riding individual wagons with our uruni—Keita and I in one, Belcalis and Acalan in another, Asha and Lamin, Adwapa and Kweku, and Britta and Li all in their separate conveyances. We're supposed to be a collection of happy newlyweds from a bustling trading city who have banded together for safety, what with all the dastardly deathshrieks and alaki lurking about, waiting to end our lives and steal our souls. As the only one of us actually from the Eastern provinces, Li will serve as our leader and guide.

Poor Katya has been nervous all morning. She, Nimita, Chae-Yeong, and three other deathshrieks will travel with us as

a shadow team, but they'll split off into the forest once we arrive at Zhúshān, the city where Elder Kadiri is currently resting. This evening marks the beginning of the Festival of the Half Light, that sacred period celebrating Oyomo's descent through the skies and the rising of the winter cold. It used to be my favorite holiday during childhood. For the five days of the festival, no one can travel, so as not to disturb Oyomo's journey. Everyone in Otera has to remain in place, gathering around bonfires, eating, drinking. It's the perfect time to capture Elder Kadiri, hence the reason White Hands chose it.

As I stand in the training field, staring at that jatu breastplate one last time and inhaling for strength when the symbol vibrates the way it usually does, a tremor ripples the air, causing all the tiny hairs on my arms to rise. I immediately genuflect, gratified when I'm able to do so without any of my limbs wobbling. I've been steadily building my resistance to the jatu symbol these past two weeks.

"Mother Anok," I say, turning and bowing my head respectfully. She's suddenly standing behind me, an immovable darkness gathering all the shadows into her. She's human-sized for once, although she's barely more than a hazy outline in the early morning sunlight.

No one else seems to notice her except for Ixa, who bristles, annoyed. He's always annoyed when the mothers are around, a consequence of what happened to him in the Chamber of the Goddesses with the arrows. He growls as he skulks into the bushes behind me, tail held high like an outraged flag. Around us, the others continue checking their weapons as if nothing's happening. They don't even seem to notice me. In fact, it's as if I suddenly don't exist at all.

I glance up at Anok. "Is something the matter, Divine Mother?" I ask, concerned.

The Gilded Ones rarely leave their chamber, and they certainly never do so without each other. Why is Anok here, by herself?

"Not particularly." The goddess glides forward. "I came to see you off, my daughter. To speak to you one last time before you go."

Her words send prickles of alarm through me. I've been on hundreds of missions now—none as important as this one, to be sure—but Anok has never come personally to tell me goodbye before. Why is she acting as if she might never see me again?

I frown at her. "Divine Mother, I—"

"Shhh, Deka." Anok cups my face, lifting my eyes to meet hers. And all my thoughts go tumbling sideways.

Looking into the eyes of a goddess is like staring into the belly of a star. First, there are the white pupils, shimmering and cool. But the longer you stare, the more the white splinters, until soon you're in a kaleidoscope of color, thoughts neither here nor there.

"We will speak elsewhere." Anok's voice comes distantly, as if from leagues away, and then I'm standing in the middle of the lake outside the temple. The grounds are a hubbub of activity, although no one seems to notice us standing on the water.

It ripples under my feet, so clear I can see almost to the depths, all the different types of fish and other creatures swimming there. I stare, momentarily caught by the sight of all those creatures, most of which I've never seen before. Some are transparent like water, others smooth and amphibian. Some even have horns and fur and dart across the currents on flippered or

webbed feet. Did the mothers take them from elsewhere, or did they create them the way they did the blood-eater vines? Then something massive and dark slithers under my feet. And I remember where I am and who I'm with.

Anok smiles. "Do not be frightened, our daughter," she says calmly, kneeling down. She taps the surface of the lake in a quick series of patterns, sending a ripple spiraling into the depths below her. "The Ababa is simply curious about you."

Even as she speaks, the Ababa surges up, churning through the water until it's just below the surface, a colossal reptilian beast at least twenty times Ixa's massive true size, all boulder-sized teeth and iron-gray scales. It stares calmly up at Anok, yellow eyes gleaming through the clear blue water until the goddess reaches in a hand and pets a tiny portion of a gargantuan nostril. The Ababa sniffs, pleased, then glides over to me, the water rocking so violently from its simple movement, I have to plant both feet firmly to regain my balance.

Once I do, I tentatively pet the Ababa's nostril, relieved when it sniffs happily again. "Any relation to Ixa?" I ask as I quickly withdraw my hand from the water. If I squint long enough, I can almost discern a familial resemblance. Something about those scales, that vaguely catlike muzzle. Also, there's the fact that it's an aquatic creature.

Ixa was once completely aquatic too. Then I pulled him out of the lake. He's adjusted happily enough to land, though. What happened in the Chamber of the Goddesses notwithstanding.

Anok rises, wipes off her hand. "By blood, no," she says, shaking her head. "Ixa is a creature fully of the divine, like you. But the two are created from the same design; that much is true."

"So, from a sea drakos," I say, thinking of the colossal deep-sea dragons that come up every once and again to wreak havoc on human ships.

She nods. "Yes, a sea drakos . . . although I repurposed the Ababa for the lake, made him smaller to fit." There's something about her tone, a hint of sadness that's so slight, it's almost indiscernible.

That's the thing about Anok: she hides it, but she's the only one of the mothers who ever seems sad. The others may feel happiness, rage, indignation—but sadness, never.

"You've repurposed a lot of things," I say, suddenly thinking of all the changes the goddesses have made to the mountain. I glance at her. "Is this what will happen to the rest of Otera?"

She shrugs. "Perhaps. A new age requires new wonders."

I nod eagerly. "I can't wait for that time to come."

When the goddesses regain their full strength, we can finally stop fighting, defending ourselves against the jatu and the priests. Everyone will have the chance to be equal. And I can finally rest, perhaps even go to some far-off pleasure island with Keita and my friends.

"Soon." I return my attention to Anok as she repeats, "Soon, the time will come."

"But we have to fight until it does."

Anok inclines her head in agreement, the weight of her infinite centuries slowing the movement.

She knows, as I do, that we have no other choice. We have to limit the damage the jatu create, the number of lives they take. The goddesses will be able to do many things when they ascend once more—and that, of course, is if they ascend once more, given the whole situation with angoro. Even when they

do, assuming I succeed—there's one thing that will always remain out of their grasp: resurrecting the lives that have been lost. They gave up that power after creating the deathshrieks, along with a few others they won't yet discuss with me. So we have to keep as many people alive as we can, even when the jatu continuously attempt to wipe our kind from existence.

"Do not be discouraged, Deka," Anok says when my introspection carries on too long. "All will be well in time. But for now, I will say my goodbye to you."

There it is, that word. *Goodbye.* I glance up at her, unease coiling. "What are you not telling me?"

Anok blinks. The expression is so swift, I almost don't catch it, but the sight tightens the already tense knot in my stomach. In all the months I've been with the mothers, I've never before seen any of them blink. Never.

It takes Anok some moments to reply. "Follow me," she says simply, then she steps down into the water, slipping beneath the surface so casually, she seems almost like an Oteran grandmother taking a stroll—if that grandmother were a goddess who wore darkness like a cloak.

I swiftly do the same, and then I'm inside the water, the currents brushing past me like a breeze, the fish eyeing me with curiosity. I'm not surprised to find that it's easy to breathe. Anok commands the elements as easily as she does shadows. She would never lead me into danger.

The goddess is waiting on the peak of an underwater hill when I finally reach her. A school of opalescent fish has gathered around her, nibbling at her robes. I take a seat on the squat, rounded coral opposite her, then wait, trying not to fidget. There's a reason she brought me down here, away from prying

eyes. A reason why she blinked when I questioned her. I just have to wait for her to explain it.

Anok shifts closer, staring at the ansetha necklace, which I'm wearing on top of my robes right now, as I haven't dressed for travel yet. She abruptly lifts it, then continues staring, her expression filled with concentration. When finally she looks up, long moments have passed. And her eyes are filled with determination. My unease grows.

"I want you to remember a few things, Deka. This necklace is proof that you are the Nuru—divine, just as we are. It contains blood from each of us, a reminder that we are one, all of us gods. Whenever you have questions, remember that—remember that the answer is in the blood."

Now, her eyes pierce into mine, that obliterating white narrowing my focus to her and her alone. I no longer notice the water, the fish, Ababa dozing nearby. All I see is Anok.

"Where is the answer, Deka?" she asks, her voice seeming to reverberate through my body.

"It's in the blood," I reply quietly. I'm tired, so very tired now, though I don't know why.

"What are you?"

"The Nuru."

"And?"

"I am completely divine."

"Just as?"

"You are."

"Remember that always, and sleep now." Anok strokes my forehead, her eyes sad. And then darkness consumes everything.

<p style="text-align:center">◆</p>

When I wake, I'm back on the training field and I'm stroking the ansetha necklace, wondering why I feel like I just experienced something gravely important, even though I'm not quite sure what.

◆

My body is roped with tension as my friends and I approach the temple courtyard later that morning, our usual point of departure. It's a vision of wonder, lush tropical gardens surrounded by waterfalls that pour out of thin air, but all I can think about is our impending mission. Once we leave here, it's straight to Zhúshān, the very center of the Eastern provinces, where we must capture Elder Kadiri swiftly and spirit him away for questioning. Any missteps on our part, and the jatu will hide him so deeply, we'll never be able to find him again. The consequences of that would be unimaginable: *Girls being tortured—killed—all across Otera. The mothers dying . . .*

Just the thought of it sends my anxieties whirling, so I try to control my breath by glancing at the four towering gold-veined stone statues at the courtyard's center. White Hands is standing beside them, gazing at the tiny golden orb floating above their opened palms—a representation of the single divine tear the mothers cried when the jatu imprisoned them all those centuries ago.

She walks over to me. "Every time I look at it, I am reminded of your mother, goddesses rest her," she says quietly. "Umu was truly a wonderful spirit."

A happy warmth flushes over me to hear her speak so fondly

of Mother. But then, Mother was her protégée. White Hands chose her specifically, gifted her with the golden tear that would transform into me, while they both served as spies in the Warthu Bera. Sometimes, when I'm near White Hands, it's like I'm near Mother, even though she died two years ago trying to keep my existence a secret from the jatu.

"I miss her still," I whisper. "Especially now, with everything that's happening." *Jatu resurrecting, arcane objects awakening after centuries* . . . I don't have to say this out loud. White Hands already knows.

She nods in commiseration. "There is a saying, Deka: when gods dance, humanity trembles. And a lot of dancing is happening these days. Thankfully, as the Nuru, you have a say in the direction of the dance."

Now, she moves closer, a determined look in her eyes. "I want you to remember something as you go on this journey, Deka: always know who you're fighting for. Your bloodsisters— they are your family, your home."

My brows furrow. Something about her words scratches at a memory, though I'm not sure which. In any event, why is she acting like this is goodbye? I've been on countless missions like this before. Perhaps not of this exact magnitude, but nevertheless this is just a mission, same as any other. That's why, this morning with Anok—

The thought swiftly slides away, so I follow White Hands's gaze. She's staring at my friends, that look in her eyes. That seriousness. "Your responsibility—even above what you owe to the mothers—is to them," she says, her words once again reminding me of something I can't quite recall.

I nod. "I'd never forget."

"You'd be surprised how circumstances can test such convictions." A bitter smile flashes across White Hands's lips, but she swiftly hides it, waves me away. Whatever the cause of that smile, I know it's another secret, one she won't reveal to me, so I nod as she says, "Go on, then, off to the Eastern provinces with you. And remember: don't die too many times. It's unbecoming of a warrior."

"Yes, Karmoko."

"And, Deka—"

"Yes?"

When I turn to her, a strange expression appears in White Hands's eyes—a vacantness, almost. It reminds me so much of the worshippers the mothers purge of their memories during the dedication, it sends prickles across my skin.

"Nothing." She shakes her head. "Go on, your friends are readying themselves for departure."

Unnerved, I genuflect in respect, then walk over to my friends, who are now inspecting the wagons in preparation for departure. Braima and Masaima, White Hands's equus companions, are also there, waiting to send us off, since they won't be joining us on this journey.

When I arrive, Masaima frowns at my frivolous blue robes and the jaunty yellow half mask covering my face from forehead to nose. "Quiet One, what are you wearing?" he asks, horrified, using the equus' familiar nickname for me.

"A disguise," I reply evenly, amused despite myself. He and his brother have never seen me in anything other than sturdy combat gear and war masks—that or ragged clothes. The mem-

ory of how they first saw me, disheveled and abused, rises, and my smile quickly fades.

"Doesn't suit you," Braima sniffs, tossing his black-striped mane.

I nod, wiping the sweat gathering at the edges of my face. Masks like these are made for ornamentation, not comfort, and I am very used to comfort now—at least as far as clothes go. "I wholeheartedly agree," I say. "I'd rather wear armor and a war mask any day."

Those, at least, are comfortable.

"I do like your hair," Masaima says, cantering forward.

Which, of course, means he wants a bite. I've braided it for the occasion, using hairlike black reeds to extend them down my back, so I look like the average Oteran woman.

Thankfully, the flapping of wings distracts him from making my new hairstyle his midafternoon appetizer. Melanis has arrived, her usual crowd of well-wishers trailing behind her. She'll be coming with us, an additional sword in case it's required. Despite all our undeniable talents, none of us have wings to allow us a swift getaway if need be.

By the time she reaches us, the crowd has ballooned to fill the entire courtyard, everyone eager to see her off, though they don't know where or for what purpose. This raid is strictly confidential—only the participants and the generals know the particulars.

An irritated humph sounds beside me as Melanis flits across the courtyard, smiling benevolently at her well-wishers. "Well, if there's one thing I can say about the woman," Britta sniffs, "she certainly knows how to foster admiration."

"Jealous, are we?" Li, Britta's uruni, smirks. He's a handsome Eastern boy, tall and slender, with the easy cheerfulness of a person who's been attractive his entire life.

He and Britta constantly sniped at each other when they were in Warthu Bera, and now that he's back, they're doing it again.

"I'm not jealous," she sputters. "I'm just sayin' she's excessive, is all. Why does she need to be doin' all that flappin' about an' carryin' on?"

Belcalis shrugs beside her. "Grow golden wings and skin that shimmers and you just might find out," she says, her eyes never once leaving Melanis.

I watch Belcalis for a moment, curious. She's staring at Melanis as intently as Adwapa used to stare at Mehrut, only I don't think she feels that sort of passion for the winged Firstborn. Male, female, yandau—I've never seen Belcalis react romantically to anyone. I don't know if she was always that way or if it's because of her past, but I know better than to ask, and, more to the point, it's not my place either. Still, if keeping secrets were a deadly art, Belcalis would be the acolyte to White Hands's grand master: no amount of prying or even torture would ever make her divulge information she's not ready to share.

Britta humphs again, then looks down at the pebble she's been flipping—her new habit. A quick tingle ripples across my skin, and I frown. I've been feeling that particular tingle more and more these days, usually coming from either her, Belcalis, or Adwapa.

"Dunno about wings an' shimmerin' skin an' such, but I may have somethin' just as nice." She grins smugly.

"And what is that?" I ask.

"Ye'll see," she replies mysteriously.

As my frown deepens, Keita waves at me from the front of our wagon. It's an almost identical copy of the boxlike wooden one White Hands used to bring me South a little over a year ago, except now, brightly embroidered cushions adorn the front seats while equally ornate curtains shield the windows at the front and sides. As we are pretending to be newlyweds, a little bit of festivity is required. We're all even wearing matching robes to complete the guise. Keita and I have on the same blue robes, and the yellow hood hiding his face from view matches my yellow half mask.

"Wagon's ready," he says, tapping the spot next to him on the front seat.

He's already strapped Ixa to the reins. Unsurprisingly, my bright blue companion is now a strikingly handsome horse, identical to the real thing in all ways except for his skin color. That he can never change, not that it matters. One of Ixa's gifts is the ability to fool people into seeing what they want to see. When I first brought him back to the Warthu Bera, everyone but my closest friends saw him as a cute little cat when he was in his kitten form. Only when White Hands made me reveal his battle form did the others finally see him as he truly was.

Today, I see him as a handsome blue horse, but for the others, he's probably gray. It would be frightening if he could change into human form, but that, thankfully, is the one disguise he is incapable of.

I think.

I clamber onto the wagon, grunting when my skirts get caught under my shoe. I've become too used to my simple, free-flowing robes to bother with dainty mannerisms anymore. As I

heave myself awkwardly next to Keita, I notice him snickering under his breath.

"Think this is funny, do you?"

He doesn't even bother denying it as he bursts out laughing. "Y-you looked like some sort of overwrought hen, trying to make its way back into the coop!"

"I did not," I retort, but Keita only laughs harder, tears streaming down his cheeks.

"You could've helped me, you know," I grumble, even though I'm secretly amused as well. Keita never laughs openly like this. I cover the smile tugging at my lips with an indignant sniff. "You're supposed to be pretending you're my husband. Part of that is taking care of me. Seeing to my well-being and such."

At least, that's the way we were taught. In Otera, husbands are supposed to take care of their wives, provide food and shelter, protection—that sort of thing. It's all mandated by the Infinite Wisdoms. Before, I saw it as romantic, the ultimate expression of love. Now, I see it for what it is: another method of control. Women in Otera can't work outside the home, earn money, or inherit property. The Infinite Wisdoms expressly forbid it, which means most Oteran women are always dependent on their husbands and fathers. They're perpetual children, relying on men for every aspect of their lives—which is exactly what the writers of the Wisdoms intended. A woman who cannot earn for herself is a woman without choices or recourse.

And yet . . . I truly am looking forward to pretending to be Keita's wife. Perhaps it's the pressure of this mission—so much depends on us capturing and questioning Elder Kadiri, finding the angoro's user. . . . Perhaps that's why I need the distraction of Keita holding my hand and leading me places and all the

other things Oteran husbands are supposed to do. If I can focus on his hand on mine, his scent enveloping me, I can ignore the fear, the crushing pressure in my chest . . .

Keita puts his arm around me, pulls me close. "Don't worry, Wife," he says officiously, an obvious ploy to shake me out of my introspection. "The moment we're in the Eastern provinces, I'll take all the care of you that you like. I'll feed you, carry you about—I might even put you to bed, if you're especially good." He waggles his eyebrows, and my cheeks warm.

Then the crunch of footsteps on grass attracts my attention.

Melanis is standing in front of us, her body now covered in the worn brown robes of a grandmother that the seamstresses outfitted her with earlier this morning, only there's a new addition: the gnarled wooden cane in her hand. It's the perfect accompaniment to the newly grown hump on her back—her wings, held ever so slightly aloft so that they complete the picture she's presenting as a bent, doddering old woman.

"Melanis, is something the matter?" I ask, confused because she's supposed to be making her way to Britta's wagon now.

"Yes," she says, walking over to the back of our wagon and opening its wooden door. She peeks in, gives a nod of satisfaction. "Your friend's wagon is not comfortable. I will ride in this one."

"But I thought—"

"Fatu assigned me to Britta's carriage?" she asks, using White Hands's name from the time of the goddesses. "Of course she did. She's always known all the things I've hated. That is her way."

Her words niggle at me and I frown. "Melanis, why do you and White Hands—"

But Melanis looks up, all her attention taken by the electricity sparking the air. "The mothers are coming," she breathes, a reverent expression spreading across her face.

One moment, the courtyard is empty, and the next, they're there, the Gilded Ones, as bright as sunbeams as they float on white clouds wreathing the air above us.

"Today is a momentous day," they boom as one. "Our beloved daughters Deka, the Nuru, and Melanis, second of our war queens, will travel with some of our most elite warriors on a journey that will bring us one step closer to victory."

Cheers ring out, but I don't hear them. My eyes are suddenly drawn to Anok. Even though she, like the other goddesses, is staring straight forward, I have the sudden feeling that she's looking right at me. I frown. Why do I feel like there's something important I'm forgetting? I think back to this morning when she—

The thought slides away so quickly, I blink, confused. What was I just thinking?

It must be nerves—all my anxiety about this journey.

The mothers say a few more words, but I barely hear them, too busy repeating the same mental refrain I have for the past few days: *Capture Elder Kadiri. Use him to discover who holds the angoro. Do not fail.* By the time I look up again, the goddesses have finished speaking and Melanis is entering the back door of the wagon. I can see her through the small window behind me, making herself comfortable in the room inside. I sigh, trying to relax the tension clenching my jaw. Keita notices and grasps my hand.

"It's all right, Deka," he say. "We're in this together. When it gets too much, I'm here. You're not alone."

I nod, still startled that he reads me so well. What did I ever do to deserve someone like him?

Keita's no longer watching me. His eyes are on the mothers, who are now floating closer. "I think they're ready," he whispers. "Time to go."

I follow his gaze just as the goddesses lift their hands. The atmosphere immediately crackles, power building and coalescing until the air in front of the wagon abruptly splits, cleaving down the middle like a knife through parchment paper. As the edges curl apart, a forest glade appears, dappled sunlight falling on mossy green ground. An awed gasp escapes my chest. I've only seen the mothers do this a few times before, and only out of great necessity. They've been so weak lately, what with the angoro and all, they can only sporadically create this—a door that allows us to step across continents with less than a thought.

For them to be able to do it now means that they conserved their energies for this. Conserved all the prayers their new worshippers fed them during the dedication ceremony just to make this journey easier and safer for us. The magnitude of their sacrifice weighs on me, but I know I mustn't let it overwhelm me.

The mothers would never want that.

"Go with our blessings," they intone, smiling down on us.

At me.

So I turn to my friends, their wagons lined up behind ours, the deathshrieks standing beside them. "Shall we?" I say.

Reins flick, and then the horses take their first steps forward. I squeeze Keita's hands as we ride straight through the mothers' door to the forest in front of us, and whatever dangers lie beyond it.

10

◆ ◆ ◆

The Eastern provinces in the summer remind me deeply of the North. They're so alike, I'm taken aback by the similarities: Sun-dappled glades under towering trees. Prickly-winged hedgeflitters and bright green tree mice darting across slender branches. A sleepy, warm wind rustling through the grass, bringing with it the familiar scent of dried leaves and moisture. The only difference I can detect is that the season is all wrong. In Irfut, it would be crossing into early winter now. The trees would have long sprouted their glowing red and orange foliage and the first snowfall would be mere days away. Here, however, the trees still have their mantle of bright green leaves. Even stranger, many of the ones around me are long and slender, like reeds, and they grow in towering thickets so dense, they look like massive walls of green. I've never seen anything like them before, and I thought I'd seen almost every iteration of tree in the Bloom surrounding Abeya. Aside from them, however, I could be back in the forest just outside Irfut, gathering wild

mushrooms while the man I once considered my father heads deeper into the woods to hunt the shaggy deer whose furs line our beds in winter.

My and Keita's wagon is the first to stop, and then the others quickly come to a halt next to us, everyone waving goodbye as Katya, Nimita, Chae-Yeong, and the rest of the deathshrieks swiftly head deeper into the foliage, where they'll wait until we send them the signal that the mission is commencing. Even though it was early afternoon in Abeya, it's nearly evening here—the hour of day is different because we crossed continents in the blink of an eye. Just the thought sends shivers of awe rolling over me.

Britta jumps down, whirls in a wide circle, and, grinning, says, "Look, Deka! It's almost like we're home again."

Home. The word slams into me with the force of a thousand boulders.

Suddenly, I can't breathe.

Home, where they forced me into that cellar, tortured me for months. Home, where they killed me over and over again, bled me for the gold, scattered pieces of my body across the ground, then watched, disgusted, as they crawled back together. *Is that where I am, home?* Every muscle in my body is taut, blackness edging my vision. There's so much pressure squeezing my skull. Just squeezing and squeezing . . .

"Deka! Deka!" Keita's arms wrap around me, but I'm too far gone to respond. I barely hear as he calls to Britta, "Britta, she's having one of her spells!"

Everything moves in flashes—light, motion. I'm back there, back in the place where everything went so horribly wrong. How did I get back there? How did I—

Arms, soft and warm, making long, soothing circles on my back. "It's all right, Deka," Britta says gently. "This isn't Irfut; it just looks like it. Look, look at those trees. The thin ones."

I sluggishly follow Britta's finger to those trees I noticed earlier. The ones that look like reeds.

"Trees like that don't grow in the North," she reminds me, hands still calmly rubbing my back. "Yer safe, my love, safe."

Safe...

The word pushes through the darkness, as does the sight of those trees. My body's trembling gradually fades until finally, I can control my muscles again. When I look up, it's to find Britta and the others around me, similar expressions of worry on their faces. An attack this powerful is rare, but I know the exact cause: it's because I'm here, in this place that looks so similar to the one where my nightmares began. Terror rises again, a shrillness scratching up my spine, so I look at those reedy trees and breathe deeply again. Once, twice. *This is not Irfut. This is not Irfut.*

I am in control, not my mind.

Gradually, the panic fades. And embarrassment rises in its wake.

"I'm all right," I say, swiftly pulling myself out of Keita's and Britta's arms.

Why am I still so weak? I should be past this by now.

Tears clog my throat, and I tighten my cloak around my face, shame deepening as Keita's arms circle me again. The more I try to pull away, the more his arms tighten. Finally, I give in and sink into their warmth, letting the clean, subtle scent of him wash over me.

"All right, ye," I hear Britta say to the others. "Back to the wagons."

They reluctantly shuffle away. Except for one.

"I think she'd like some time alone," Keita says stiffly.

"Then why are you still here, son of mortals?" Melanis's voice replies.

I glance up to find her standing in front of the wagon, staring at me with a furrowed brow. She's still wearing her grandmotherly disguise, but the red luck mask she's donned is perched on her hair so I can see her bare face, disapproval written across it.

I stiffen. "It's battle fatigue," I say defensively. "I was tortured in a cellar for months. Beheaded, dismembered, burned—"

"And then you, what, descended into madness?" She moves closer, seeming unconcerned when Ixa growls in her direction. He's still in his horse form, but his teeth have sharpened in warning.

Deka! He snarls at her.

Melanis barely spares him a glance. "I burned for centuries. Do you know what that feels like, honored Nuru?" Even through my haze, I can detect the derision in her voice. "You collapse into insanity, then find your way back, only to collapse again. Decades spent descending, then clawing yourself out. The pain, the humiliation, the anger . . ."

Her eyes pierce mine. "Hear me, Nuru to our mothers. Everything you experienced—all the pain you think you endured—it was all nothing. Merely the lightest feather's touch. Multiply that by thousands, millions of times, and then you'll know what pain truly is. I burned for so long, my skin peeling, fat bubbling. Every time my eyes healed, the flames would rise, and they'd burst again. Sometimes, to be cruel, they'd let me heal for a day. Two. Just so they could recite prayers at me. Then they'd burn me again."

She pins me with a look. "Burn for a thousand years, Deka. Become so familiar with the odor of your flesh that it is a constant perfume. Know intimately how each part of your body crumbles, then heals. Then you can tell me of foolish things like battle fatigue and torture."

She storms off into the forest, her wings rustling behind her.

And my anxiety deepens.

As does my shame.

Everyone around me has lost comrades, family—been tortured in the most horrific ways. Belcalis spent years being assaulted and killed in a brothel, and she never loses control the way I do. Yes, she has nightmares, visions that plague her so badly, she spends many nights awake; but by morning she's fine and just goes about her affairs, same as everyone else.

Why am I the only one who wallows in her memories? Why am I the only one who's weak?

I look down at my hands—these hands strong enough to kill jatu, deathshrieks, humans, topple an empire. Even they can't protect me from the darkness of my own thoughts.

"She's wrong, you know." I glance up to find Keita, his arms still around me, staring after Melanis, a thoughtful look in those golden eyes. "What you endured in Irfut was not a mere insignificance. Neither was my family's death, the deaths of the others . . ."

Keita isn't the only uruni who's lost his family. Li and Acalan, Belcalis's formerly righteously religious uruni, have as well, but they never talk about it. Then again, I'm not as close to them as I am to Keita.

"Everything we experience matters," he says. "Not one thing outweighs the other. Sometimes, you can't breathe in

certain places. And I"—he inhales heavily, trying to summon the words—"I can't step foot in the house where my family was murdered."

I glance up at him. "Keita," I whisper, my heart breaking. I know how much it costs him to say this, to even utter the words.

Keita's family was killed by deathshrieks when he was only eight. Mother, father, brothers—all of them gone in the blink of an eye. And they were killed because they built a summer house near the temple of the goddesses. A summer house the former emperor could have easily warned them would be a danger to their lives. Back then, deathshrieks became nearly feral at the sight of humans, the smell of their fear—an instinct the goddesses gifted them with to ensure their survival. The emperor knew this—knew all about the alaki, the deathshrieks, the goddesses. And he just let Keita's parents die. Plotted their deaths, in fact.

I thought I'd seen wickedness at the hands of the men in my village, but they never even came close to the scope of the former emperor's crimes.

Keita's breath gusts through my hair as he squeezes me tighter. "It's just there, just beyond the temple. I could ride Ixa to it in less than an hour if I wished. But every time I near it, I have this choking feeling, like a heaviness in my chest, and then I turn back," he whispers raggedly. "I always turn back . . ."

There's such pain in his voice.

"Oh, Keita, why didn't you tell me?" I ask sadly, looking up into his eyes. I never knew this. There's so much about Keita I don't know. Every time I think I've peeled back enough layers, another emerges.

"Because you've had to deal with so much these past few

months. Being the Nuru, being everything everyone wants you to be—the commanders, the mothers. . . . I didn't want to add to your burden, and also, to be honest . . . I didn't want you to know."

The words pierce me as sharply as a dagger. "Why? Did I do something?" I ask, hurt.

"No." He hurriedly shakes his head. "Nothing like that. It's just . . ." He glances away, sighs. "You're so strong, Deka. Not just physically—emotionally. You, Belcalis, the others. You've all endured so much, and yet, when the pain comes, you just breathe past it and then you continue. You always continue. I wanted to be that way too."

"But I'm not strong," I reply, shaking my head. "I collapse at every opportunity, cry at every little thing."

"And then you get up and you move on, stronger than before." His eyes peer into mine. "When I was a recruit, they told us that jatu don't feel pain. That we were automatons—iron made flesh. No feelings, no thoughts, no emotions. That was what made us strong, they said. I believed it for years. Locked every single feeling up inside me. Every rebellious thought. Then I met you and Britta and the others, and I realized I could be different.

"I know you want to share my pain, Deka, but for right now, let me have it. Let me feel it, for once, instead of pretending it doesn't exist."

I open my mouth to protest, but he shakes his head. "Please don't argue—not about this. I have to learn, Deka. I've spent so many years not feeling. . . . Let me learn how not to be an automaton. Let me learn how to be a man."

I nod, sigh. "All right." I place my hands on his. "I'm grateful

you were honest with me. I know how much it took for you to say those words."

"I didn't want you to feel like you're alone, like you're the only one struggling. All of us here are doing the same—even her." He nudges his chin toward the path Melanis took.

I frown. "What do you mean?"

"Her hands were shaking, did you notice that?" he says. "For all her brave words, just saying those things to you had her trembling. That's likely why she fled. She can pretend all she wants, but she's probably struggling harder than the rest of us. Her pain, it's right there. You don't have to look too deeply to see it."

I think of the way Belcalis was staring at her earlier. Was that what she was noticing? She's always quick to spot the inconsistencies in people. I have to learn from her, be more perceptive, pay more attention. If I'm going to be a better leader, I have to know what's happening around me.

"I'll watch her carefully," I say.

"But not too much," Keita reminds me. "We have more important things to concern us." He nods at the distance, where light is breaking through the trees.

Zhúshān castle. Our destination.

As he nods, I lean over, kiss his cheek. "Thank you," I say.

"For what?"

"For being there. For listening to me."

He waggles his brows, back to being easygoing. "That's what husbands do, and I promised to husband you hard this entire journey."

A blush warms me when I understand the double meaning of his words. I look away, clear my throat. "All right," I say. "Let's assemble the others. Time to get moving."

11

◆ ◆ ◆

"Phew, would ye look at that setup," Britta says with a whistle as we ride toward Elder Kadiri's camp.

It sprawls across a series of softly rolling hills, row upon row of tents sitting on the outskirts of a massive red castle, the edges of its multiple green rooftops curling upward like the flower petals on a trumpet vine. The mere sight of it deepens my anxiety, so I mentally tug at the bond connecting me with the mothers. When I feel a reassuring tug back, I return my attention to the scene laid out in front of me.

Crowds of people have gathered around the castle, most of them congregating around bonfires or ornately decorated paper lanterns, others mobbing the food stalls that have been set up at the edge of the forest. A few have even gathered around the large wooden platform just in front of the castle's gates, although there's nothing happening on it yet. They're all wearing robes cut in the Eastern style, but the patterns on them are all distinctively Southern. Even stranger, their hair is teased

into tight coils, except most people from the Eastern provinces are born with sleek, flowing hair. Watching them, it's immediately clear: Zhúshān may be in the very center of the Eastern provinces, but Hemaira's influence holds firm here.

Thankfully, there's no sign of that jatu symbol—the one I've spent the past few weeks strengthening myself against. I still know very little about it, other than the fact that it blocks my abilities. I tried to find out more about its origins, but none of the Firstborn recognize it, and the mothers have been so busy the past few weeks strengthening themselves and making plans for Otera's future, I didn't want to waste their precious time asking any more questions about an arcane object than necessary.

"There are so many people," Melanis says, wide eyes drinking in the scene as Keita rolls the wagon to a stop on a grassy hill at the very edge of the forest.

While there are three windows in the interior of the wagon—one at each of the sides and a large central one just above the front seat—there's a much better view outside than in, which is why Melanis is now squeezed in between Keita and me just like the busybody grandmother she's pretending to be. I can't imagine how this must feel for her, being among humans like this after so many millennia.

"Were there not as many people in your time?" I ask, curious. She quickly shakes her head. "When I was born, the tribes of humanity were so thin, this mass spread out before us would be considered a city."

The thought boggles my mind. There are a lot of people here, but certainly nowhere near a city's worth, or even a town's, for that matter. "Are there any other differences you notice?" I ask.

"Yes." She turns to me, her fathomless brown eyes piercing mine from behind the mask. "In my time, women did not allow themselves to be oppressed by men. We were the rulers, not them."

"I thought you were equals." This comment comes from Keita, who's been listening quietly.

"No, son of man," Melanis says dismissively. "How can there be equality when only one in the pair can create life?"

I still, suddenly deeply uncomfortable. This isn't the first time I've heard a Firstborn express such sentiments—in fact, a few of the generals have said as much over the months. Still, none have ever said it so baldly. After all, how can we create an equal society if one-half of its population thinks the other is inferior?

The other generals, I know, are confronting their biases and rage, but Melanis, it seems, has no such intentions. I can see in her eyes that she means every word she just said.

So can Keita, which is why he smiles thinly as he replies, "And here I was under the impression that it took at least two to create life."

"Tell that to the Nuru, the being created solely by women." When Melanis gestures to me, I stiffen even further, frozen as a deer caught by a predator's gaze.

The tension is so heightened now, I'm almost grateful when a commotion breaks out in the distance. "What do you suppose that is?" I ask quickly, focusing my gaze on the group of jatu now moving what looks like a misshapen mass of gold onto the platform in front of the castle.

"Dunno," Britta calls brightly as she dismounts from the wagon beside me, following a careful three paces behind Li, as is

expected of newlyweds. Now that we're in the Eastern provinces, we have to pretend to be devout Oteran women again. None of us can walk anywhere without a male guardian, and we certainly can't walk side by side with them unless we're in a crowd.

She taps her lips thoughtfully as she comes to a standstill beside me. "Advertisement for a masquerade?" she theorizes, nodding at the group of stilt-walking masqueraders threading through the crowd in front of the platform, their multicolored grass skirts and exaggerated masks causing as many gasps of delight as the sun-shaped paper lanterns they're floating into the air.

I continue squinting at the gleaming mass, unconvinced. Masqueraders' advertisements usually consist of one player dancing off to the side of a main street, calling to entice an audience. But something about the gold is—

The crowd abruptly shifts, fully revealing the platform, and horror turns my body cold. The gold is gleaming from what looks like a group of three statues. Human-sized female statues. "That can't be what I think it is . . . ," I whisper, taking an unconscious step closer.

Thankfully, Keita's arm stops me just before I leave the shadow of the wagons. "Remember where you are, Deka," he whispers, gesturing with his chin to a group of men a few hills below us, most of them wearing the distinct red armor of the jatu as they make their way to the platform.

I immediately still. My skin may not tingle in their presence the way it does with true jatu, but the fact remains: we're surrounded by enemies, many of them quite skilled. Thankfully, they're all well out of earshot and can't truly see us with the wagons in the way.

I nod at Keita. "I know. It's just—those statues, they're—"

"Alaki in the gilded sleep," Belcalis finishes grimly, the rage in her eyes belying her matter-of-fact words. She's following behind Acalan, and there's a slight tremor of anger in her body as she says, "They're displaying our corpses."

"To what end?"

"You already know, Deka." This quiet reply comes from Adwapa. She's here too, her uruni, Kweku, a tall, slightly plump Southern boy with warm brown skin, by her side, as is Asha's uruni, Lamin, the most massive and yet gentle of the uruni. They all watch the platform, bodies rigid, as she says, "Those girls—they're warnings to everyone here: this is what impurity looks like—this is the danger of it. Bet you twenty otas they execute them publicly every time they wake."

Her words send a haze of red over my vision. Rage, pure and utter rage. "We take Elder Kadiri tonight," I say through gritted teeth.

"Deka—" Keita begins, but I swiftly cut him off.

"The scouts have already mapped out the area and everyone's movements for us, so any further reconnaissance we do is a waste of time."

"You know things always change from one day to the next—"

"But we cannot let this continue any longer." Just the thought of those girls—the suffering they must be experiencing. The same suffering countless girls, countless *people* all across Otera are no doubt experiencing. "We take him tonight. And we burn everything here."

I can already imagine it, setting this hellish place ablaze. Listening to the screams as all these awful jatu experience the

same pain they've inflicted on so many people. The thought of it soothes a little of the fury coursing through my veins.

Keita's eyes turn to Melanis, who's limping over in her old-woman guise. "Melanis," he says, exasperated, "reason with her."

But Melanis just nods at me. "I agree with you, Nuru," she says evenly, ignoring him as if he hasn't spoken. "We cannot allow such an atrocity to go unanswered."

I nod. "We make preparations now," I say. Then I turn to Keita, who's suddenly stiff with anger. Whether at me or Melanis, I'm not quite certain. "Take the other uruni and scout the area. Ensure that it is as we've been told. Acalan, you'll remain with us."

"Deka," Keita starts again, but I'm too far gone now, righteous indignation setting my veins ablaze.

"What if it were your friends who were up there on that platform?" I say. "What if it were your family?"

"That's not fair," Keita replies. "You can't make this a game of suppositions and what-ifs."

"Can't I?" I stare mutinously up at him until finally he sighs, glances at Belcalis for help. When it comes to matters such as this, the two are always firm allies.

Silent messages pass between their eyes until finally, Belcalis nods and Keita turns back to me. "I do not agree with you, Deka, but there's no point arguing at this moment."

"Why, because Belcalis will do it for you?" I return spitefully. I know how they work, Belcalis addressing me when Keita can't and vice versa.

Keita doesn't take the bait. "I'll go scout," he says evenly, "but make no mistake: this is not the end of our conversation. We will speak of this further."

He turns to the other boys. "Let's go."

"I'll join you," Melanis announces, following behind him. When he stares at her, shocked, she adds, "I want to take a closer look at our sisters."

"Guess that leaves me to play guardian," Acalan says, watching her pretend to hobble after the other uruni. "Come on, then."

He gestures and we follow him to the back of my wagon, where he opens the door for us. I swiftly take my place at the farthest end of one of the two embroidered seats that line the chests on either side, my body shaking with fury. I thought I'd gotten used to seeing the dead bodies, but this—the sheer depravity of what's happening on the platform—strikes at the core of me, resurfacing a memory of my time in Irfut's temple cellar.

Elder Durkas looks down at me, disgust in his eyes, a sword in his hand. "Why don't you just die?" he snarls as he lifts it. And then I feel the iron sting of the blade at my neck. And everything fades to darkness.

"Least they're still alive." Britta's voice pierces through my memory, and when I glance up, she's staring at us from her perch on the bed that occupies the farthest end of the wagon, a hopeful expression in her eyes. "Those girls, they'll wake from the gilded sleep, but we'll have rescued them by then—right, Deka?"

I nod, grateful at least one person agrees with me, but as I do so, Belcalis shakes her head. "That wasn't part of the plan," she says quietly.

And here it is, the argument I was expecting.

"Neither was seeing them displaying us like that," I retort, that memory still coiling in the back of my mind, a snake waiting to strike.

Belcalis doesn't even blink. "We can't allow our emotions to

blind us. You of all people should know that." She calmly reaches into her pack and pulls out a small container filled with a viscous green fluid that looks like one of those slimy molds that creeps along forest floors and smells even worse, then starts mixing it.

Just the sight infuriates me. "What if it were you displayed like that?" I rage, fury spilling over. "What if it were you being killed like that over and over? Wouldn't you want us to come for you?"

"But it was me," Belcalis says quietly. Confused silence falls across the wagon before she speaks again. "For years, it was me." She continues mixing, her eyes pointedly focused on the motion of her hands, which are now trembling slightly. Just like that, a small portion of my rage dissipates.

Belcalis once trained under an apothecary, and part of her work was to mix creams and chemicals. Every time she feels tense, like now, she mixes something until she regains control of her emotions. It's the same thing I do, except I hold on to the ansetha necklace or mentally count to three over and over.

After some moments, she finally looks up. "The proprietress of the pleasure house, she displayed my corpse in the common room, an advertisement for her more . . . discerning customers. Every time I died, she did it, so her customers could see what they were buying: the chance to kill me, to watch as the light dimmed from my eyes and the gold stole over my body."

Her eyes bore into mine. "So, yes, Deka, I do in fact know what it feels like. I knew what it felt like for years, which is why I'm telling you, if I were in those circumstances—I would prefer justice to a hasty rescue. I would prefer cold revenge to momentary relief. You are, of course, our leader—you decide a plan of action, and we follow, but I'll tell you this: If you go forward

with the attack, you become like all those men who saw my body—my death—as a source of entertainment. Because you'll be prioritizing your rage, your momentary emotions, over the well-being of thousands."

By now, my fury has completely disappeared, replaced by another emotion: shame. Belcalis is right. I am prioritizing my feelings over the lives of others. If I do as I intend, I'm putting at risk not only my friends' lives but the lives of countless people. My desire to attack Elder Kadiri tonight comes not from a place of reason but of emotion. One that is entirely selfish, in the larger context of things.

Belcalis seems to notice my introspection, so she nods at the window behind me, where a group of men are visible as they drink just across the hill. "Look there. Notice anything?"

I follow her gaze, then stiffen when I immediately discern what she's pointing out.

The men have all put down their tankards and are tidying up after themselves—except regular soldiers would never do that. The Oteran infantry, unlike the rigid and exacting jatu, are used to a laxer system of upkeep. In fact, the few soldiers who defect to our side have to go through a rigorous system of retraining by our captains. And yet all the men surrounding our wagons are neat to a fault. Precise, even. They're clearly not ordinary soldiers. And there are more of them scattered among the crowds. Lots more. The softest prickle of warning crawls down my spine.

"Those are all jatu, every last one—not a single regular soldier among them," Belcalis says. "Was that in the reports the scouts sent us? No—which means Elder Kadiri has been rotating them all around the field so as not to attract attention."

A low whistle sounds and Adwapa leans back against the

wagon's wall. "Well, damn," she says, stunned. "I did not notice that."

"Neither did I," I admit, chastened.

"Which is precisely why we always do another scout on our own," Belcalis says. "To account for unforeseen complications such as this."

I nod, apologetic. "I see your point." I turn to the others. "We'll adhere to the plan as it already is, and move on Elder Kadiri tomorrow. Tonight, we familiarize ourselves with our surroundings." And the positions of all the guards, who, if Belcalis's little lesson has taught me anything, will all be jatu. "Let's go over the details," I say.

"Or"—Asha peers around the wagon—"we could relax for a moment. Calm ourselves. Truth be told, it's felt strained in here the past few minutes." She glances pointedly at me and Belcalis. "Besides, we're supposed to be newlyweds. We should act more like it, to my mind. Stroll around with the boys, pretend we're normal Oteran women . . ."

Adwapa and Belcalis both groan at this, annoyed, but Britta abruptly flushes to such a deep red, she's as bright as a berry. My eyes narrow. There's something she's not telling us.

I move over to the bed, waiting until Britta snuggles closer to stroke her blond, shoulder-length hair, which she has braided into multiple hearts. It's a striking change from her usual warrior knots or the closely cropped fuzz she had back at the Warthu Bera, and I can't say I don't like it. Besides, it's a nice distraction from my churning thoughts.

I look down at her. "Anything you want to tell me?" I ask. "You're acting strange."

Britta bolts upright, that blush returning with a vengeance,

and my eyes narrow again. Something's definitely happening. "What is it?" I ask.

For a moment, Britta scrambles to think, her emotions flashing past one after another. She's never been good at hiding her feelings. I can even see when she decides on a lie to distract me, because her face lights up. "Oh, I've been meanin' to show ye." She rummages in her pack and pulls out that pebble. "It started a few weeks ago, but I've never found a good time to speak of it, since yer always so busy."

She flips the pebble once across her palm, and I frown when that familiar tingle rushes through me. I thought that what she was about to say was a cover for the true answer to my question, but something else is at play. I can feel the power rising from her hands in waves, all of it concentrating on that tiny stone.

Just what is going on?

Britta smiles shyly at it. "Keep in mind this is the smaller, more impractical version of it, since we're inside a wagon."

She inhales and my blood tingles again as I feel the power emerging from her in small, determined waves. Within moments, the pebble vibrates, slowly at first but then faster and faster, until soon, Britta's no longer holding a lumpy gray rock but a sliver of mirrorlike stone so thin, it covers her entire palm.

My jaw drops. "Britta, you have a divine gift!"

Belcalis snorts. "We all have one," she says, pulling a knife from her side and cutting her palm with it. Blood wells up, just as I expected, but then it continues spreading, sliding sinuously over her fingers and up her hand until it finally stops just at her wrist. I blink, shocked. Her hand now looks exactly like it did after it was gilded at Jor Hall, the gilding the goddesses immediately removed once we joined their cause.

Belcalis's face is pale and sweaty now, but she grins victoriously as she taps the gold covering her arm and it responds with a hollow sound. "I'm my own divine armor now," she declares.

"Oh, Belcalis," I exclaim, my hands flying to my mouth. "That's amazing!"

"Not more amazing than mine, I promise ye that," Britta says.

Asha humphs. "You made a rock turn into a mirror. Or did I miss something?"

"I said this was the small version of it," Britta sputters. "I can do better, much better!"

"All right, no need to get your unmentionables in a twist." Adwapa holds up her hands in surrender.

I just watch them, my mind spinning. Divine gifts. When did this happen? Surely this is a sign—the mothers must be growing in power. Maybe the angoro hasn't siphoned quite as much of it as I feared.

I glance at the twins expectantly, but they just shrug. "Don't look at us," Adwapa says. "We've got nothing—"

"Yet," Asha finishes mischievously.

They share a look.

"It's already growing inside you, isn't it," I guess.

They shrug. "Could be," Asha says mysteriously.

I think of all the tingles I've felt recently in her and Adwapa's presence and nod. I already know the answer.

"What about you?" Asha asks, turning the question back on me. "You started developing any gifts yet?"

A furrow digs itself into my brow at the question. I am the Nuru—I already have my voice and the combat state. Do I truly need more abilities than I already have?

Britta seems to be thinking the exact same thing, because she asks, "Why would Deka need more gifts? Isn't she divine herself?"

"Yes," Asha agrees, "but she's not a god."

"Divine but not a god," Belcalis replies wryly. "Seems like splitting hairs to me."

I snort, amused by the very idea of it. "Me, a god . . . If I were a god, do you think I'd be here? I'd probably be on some ethereal plane right now, contemplating the mysteries of the universe and drinking exotic juices straight from the vine."

"How thrilling," Adwapa says dryly. "Your imagination, it astounds me."

"Well, I'm just telling you what I'd do," I humph. "This is my fantasy. You don't see me judging your fantasies."

"Oh yes, because they're eminently better."

"Can we get back to the task at hand?"

"Only after Britta comes clean," Adwapa says, pointedly turning back to our friend. "You still haven't told us why you blushed when Deka asked you about secrets and then you tried to cover it up with the whole divine-gifts thing, knowing very well how poor you are at lying."

Britta points her nose in the air. "Stop being a Nosy Nelly, Adwapa," she says snippily. "I have no secrets."

But her neck is red below her mask, a sure sign she's lying.

It seems we have another mystery to solve. But after we finish our mission, of course.

12

◆ ◆ ◆

The sun's descent to the horizon paints everything with warm golden strokes. The fields, the grasses, the castle—everything is covered in that early evening glow I remember so fondly from childhood. Except this isn't Irfut, and the people around us pose even more danger than the villagers I grew up with. I peek at them carefully through the window at the front of the wagon. Most are milling around the bonfires and lanterns, the men drinking and conversing with their comrades and with the passing soldiers—many of them the jatu we spotted earlier—the wives decorating the family tents as they wait for the ceremony that marks the beginning of the Festival of the Half Light to begin. As is tradition, it'll take place later this evening, most likely on the platform where the girls' bodies are displayed. Once it does, everyone on this field must remain here until Oyomo finishes his journey three days from now. No one is allowed to disturb the false sun god as he travels through the sky, not even his own high priest.

The other girls and I are sitting around the small fire Acalan started, when Melanis, Keita, and the other boys finally return. "You should look at this, Deka," Keita says, handing me an aged piece of parchment.

I look down at it, bitterness warring with amusement when I see six faces sketched there: mine, along with those of White Hands, Britta, Belcalis, and the twins—the word *Wanted* written in large, swirling script at the bottom.

Melanis peers at it over my shoulder. "'Traitors to the empire,'" she reads in an amused voice. "Well done, honored Nuru," she says, seeming almost impressed.

I nod, my eyes still fixed on the sketch that's supposed to be me. It looks vaguely similar, except I've somehow been transformed into a fierce, scowling girl with pale skin and long blond hair at least four shades lighter than mine actually is. I can't say I'm particularly surprised by this development. Hemaira's influence extends over the entirety of Otera, ensuring that darker skin is seen as more beautiful than light and that Southern features are upheld as the height of beauty. Of course, they've made me as pale and sharp-featured as they could. It's ironic, actually. The entire time I was growing up in Irfut, I desired, more than anything, to look exactly like the girl they've drawn in that notice, but I no longer have any such desires. I understand the truth of Irfut now: it was just a remote, backwoods village, isolated from the rest of the empire and set in its ways, and there I was, the one obvious scapegoat the villagers could push their hatred on.

"I should be flattered by the attention," I finally murmur. "We all should," I say, glancing at my companions.

"Indeed," Melanis replies. "I would be honored to be regarded as such a disruptive force in this new age."

Something about this statement fills me with a quiet unease, as does Melanis in general, truth be told. Our earlier conversation about the role of men in Oteran society still unsettles my thoughts, and every time I glance at her, I am reminded of the older Firstborn generals, the ones who have existed since almost the very beginning. They rarely speak to men and when they do, it's always with a clipped brusqueness, as if they can't bear to be bothered by creatures so far beneath them. Before, I assumed that this, and their proclamations of female superiority, were due to the atrocities they suffered. Now, I can't help but wonder if that's the way they've always thought.

Even worse is the creeping suspicion that I've long noticed other such attitudes but ignored them because I didn't want to see—because the thought of an alaki espousing such objectionable beliefs didn't align with my version of the new alaki order.

I have to do better, have to pay closer attention. I can't be like I was before, ignoring things because I was too frightened to look at reality.

Britta snatches the notice from my hand. "Would ye look at that," she tuts disapprovingly. "They've turned me into a spirit from the Afterlands."

Truer words have never been uttered. Britta's skin has been rendered so pale, it's almost glacial, and her hair might as well be snow, considering how white they've made it. Worse, all her features have been thinned away—she barely has a nose, and her mouth is less than a sliver.

"At least you two are somewhat recognizable," Belcalis

humphs as she glances over Britta's shoulder. "I look like a two-ota lightskirt."

My eyes widen when she turns the notice to us. I thought my and Britta's depictions were bad, but Belcalis's lips have been so seductively drawn, they almost take over her face, and her eyes now have a lewd come-hither look to them.

"Spend a few years in a house of pleasure and you're branded a harlot forever," she remarks dryly. There's a note of pain in her voice, however, hidden just behind her flippant words and the defiance in her light brown eyes.

I walk nearer to her. "It's all right, Belcalis," I say. "That's not who you are."

"Isn't it?" I'm almost startled when Melanis enters the conversation. The Firstborn is suddenly staring off into the distance, a faraway look in her eyes. "We must embrace all parts of ourselves, Nuru. Even the ones we do not enjoy," she murmurs.

"She's right, Deka," Belcalis says, turning back to me. "My time in the pleasure house, it's a part of me. One part of many. And truth be told, there's no shame in being a fallen woman—even though I still don't quite understand the term. *Fallen*." Her lips quirk. "How does a person fall, precisely?" She ponders this question for a moment before she returns her gaze to mine. "Still, it's an honest living, if you're willing."

Except you weren't willing.

I don't say this out loud to Belcalis. There are so many things I don't say to her, so many things I *can't* say. Not when she's still so wounded, so tautly stretched, she could break.

All I can do is hold her.

"Don't, Deka," she protests, turning her face away when I do just that, but I persist anyway.

Her body may be as stiff as a board, but she isn't pulling away, which is how I know she actually wants me to touch her. Belcalis rarely seeks physical affection—avoids it like the plague whenever she can. Still, every once in a while, she needs to be touched, just like the rest of us. Now is obviously one of those times.

After some moments, she does pull away, back to her usual no-nonsense self. "That's enough of that," she says, wiping her eyes so quickly, I almost miss the motion. She glances around. "So where's the parchment for the boys, then?" she asks. "We've all had a good laugh at ours."

"We didn't find any," Kweku says, shrugging his now-massive shoulders. It's almost startling, actually, seeing how much the past few months of battle have changed his appearance from the plump and indolent city boy I met just over a year ago to the hulking warrior who now stands in front of me.

"That doesn't make sense," Belcalis says, frowning.

"It does if they're expecting us." These soft words come from tall and quiet Lamin. He glances pointedly at the men gathered on the hill beside us, the jatu who are pretending to not be jatu.

I've been watching them all this time, and they haven't spared our wagons a second glance, which is a relief. "They don't know who we are," I say. "If they did, they'd have already made a move."

Lamin nods, but his eyes remain fixed on the men.

I turn to Keita. "Tell us what you learned."

"It's as we were told. Elder Kadiri and his priests rest in the castle every night. Thankfully, they lock the gates at night, so we won't have to deal with the rest of this rabble when we take him."

He nods his chin toward the swelling crowd at the bottom of the hill: groups of carousing men, a few masked and hooded women among them. They're all milling around the wooden platform where the girls' corpses are, the gold slowly draining from their skin. The sight sends a wave of immeasurable sadness through me.

Those girls will wake within the hour, perhaps less. But we won't be there to rescue them. Not today, anyway.

The crunch of footsteps on grass pulls me away from my depressing thoughts. "Hail, fellow followers of Idugu," a voice says.

I turn to find a group of soldiers approaching us, these looking distinctly more slovenly than the ones camped nearby. They're all regular soldiers, not jatu in disguise. As they near, Britta ducks her head, pretending to be shy, and I quickly follow suit, as do the other girls. Oteran women—especially the young ones—generally don't look at or speak to strange men for fear of their reputations. One bold glance can be all it takes to send a woman down the path to temples or pleasure houses, especially if she doesn't have powerful male guardians.

Keita puts his arm around me and pulls me closer just as the tallest soldier steps forward, the odor of mead drifting from him in waves. Beside us, Melanis stiffens but remains committed to her busybody-grandmother guise.

"Newlyweds, are ye?" the soldier asks, squinting blearily at our matching robes.

Between the way his words move fluidly up and down and the leathery texture his pinkish skin has taken from the blazing summer sunlight, it's clear he's from the more remote Northern provinces, perhaps even a village near Britta's. He must have

traveled here with Elder Kadiri, as did most of the soldiers milling about this field.

Li steps forward, positioning himself in front of the group. "All of us are. We're on our way to Sēnlín Hú."

"Ah, the city of wine and honey! A fine place to spend time after a wedding," the soldier says, waggling his eyebrows at the boys as he takes another swig of his mead. "But the Festival of the Half Light is upon us. No more travels as Idugu makes his journey."

Idugu . . . Just the name is enough to fill me with anxiety. We're finally here, so close to our goal I can almost taste it. All we need to do is take Elder Kadiri and use him to discover the location of whoever holds the angoro. Then we can find and destroy it so that the mothers can regain their power and destroy the cult of Idugu forever, ushering Otera into the new golden age it so desperately needs.

I hold on to this thought as Li strokes the long mustache he's worn as part of his disguise.

"Idugu?" he asks, pretending not to understand what the soldier is saying.

The soldier laughs. "Ye must truly be in the depths of wedded bliss if ye dinna know, friend. The priests have been announcing the news for the past few months. Oyomo has changed aspects. He is now Idugu—vengeance upon those who would claim to be the true gods of Otera."

I glance at Li, tense, but he only nods slightly before turning back to the soldier. "And how does he aim to enact this vengeance, friend? Forgive me my ignorance. I've been preoccupied these months, you understand." He squeezes Britta tighter to him for emphasis.

The soldier laughs drunkenly. "No apologies needed, friend; I understand. Idugu is gathering armies to march to the mountains of the unbelievers. Imagine it: all the men in Otera, moving together as one."

The words jolt through me, as do the images. All those men attacking us, lifting their weapons against the mothers. I already knew this was their plan, but to hear the soldier say it so cavalierly . . . It's all I can do to keep my head bowed, so powerfully is rage washing over me. I'm not the only one affected. I hear a low rustling sound as Melanis's wings move under her cloak.

Thankfully, the soldier doesn't notice. "We'll pull those cursed mountains to their foundations an' put every alaki we find to the slaughter, no matter how long it takes. So much gold will flow in Otera, it will be centuries before anyone knows poverty again."

Murderous visions dance behind my eyelids: my atikas plowing through that man's gut, then cutting down every human here.

I clench my fingers so tightly, my nails dig into my skin. Melanis's wings are shaking even more noticeably now, but the man just keeps on speaking, oblivious to the danger. "In the meantime, friends, you must come for the gathering. The Wumi Kaduth is speaking. It'll be very beneficial for your new wives to hear her speak, learn from her wisdom."

"The Wumi Kaduth?" Li repeats, his ignorance genuine this time.

I've never heard that name either.

The man clasps Li's shoulder, grins. "Where have ye been,

my friend? The Lady of the Heart, a priestess. Can ye fathom it? A female priest! Well, if she helps against those cursed Gilded Ones and their followers, I'll accept anything."

"Sounds fascinating," Li manages, though his nose is wrinkling. The odor of mead and sweat is even stronger now that the man is standing so close.

"Make sure ye come along," the man says, walking away with his comrades. "She'll be speaking presently."

Once he's gone out of hearing range, I whirl to the others. "A priestess? White Hands told us nothing of this."

"Neither did the scouts," Britta murmurs. "Wonder wha they were doin' all this time, that they missed this."

I nod my agreement. It's not usual for the scouts to miss so many details.

I'm about to say as much when Keita sighs. "This must be a new development," he says. "The jatu commanders can be secretive, and this . . . I mean, I've never heard of a female priestess of Oyomo."

"None of us have," I say. In all the years I've lived in Otera, I've never once heard of a priestess dedicated to Oyomo. Temple maidens, certainly, but priestesses, no.

"That's because there aren't any," Melanis says, her eyes deadly certain for a woman who hasn't seen the world in a thousand years.

But then, I remind myself, she wasn't completely isolated. Her every waking moment, she was surrounded by the priests, many of whom were sure to be talkative.

I return my attention to her as she continues. "At least, not in truth. This must be a consideration for the human women,

a glittering object to distract them. How easily they'll give up their freedoms if they think they can gain the same status as men."

My eyebrows furrow as I turn to her. "What are you saying?"

"If I understand the current situation correctly," Melanis replies, "it is the women of Otera who are being dragged from their homes and executed for being wayward. While the men gallivant to battle, it is the women who deal with the aftermath. The horror. They must be terrified. But now here is a priestess—a position not possible before this. A position of power, influence, which you can only win if you're worthy. Only if you serve.

"This is another distraction," she explains. "Another impossible aspiration to distract women from the misery of their lives. To make them dream, if only for a glittering moment, that they can be more. Clever. Insidious, but clever."

Horror washes over me—as does a realization: if this is a distraction, it's one we can use to our advantage. While the priestess is speaking, we can get closer to that platform, see exactly how they've secured those girls there. Perhaps we can even take them at the same time we take Elder Kadiri. It can't hurt to try.

I turn to the others. "Let's get going," I say brightly. "We have a priestess to observe."

13

◆ ◆ ◆

It's a strange thing, walking through the crowd, hand securely clasped in Keita's. Any other time, this would be the fulfillment of one of my happiest dreams: Keita and I in the matching robes of newlyweds, so close, we're practically glued together. The reality, however, is altogether different. My atikas are hidden under my robes, and my mind is plagued with thoughts—worries. Those girls, Idugu, the army, the priestess of Oyomo—all things I have to look into, discover more about. Thankfully, it's late evening now, the perfect time for skulking about. Shadows have almost fully covered the field, the darkness only barely held back by the bonfires and lanterns blazing brightly in the gloom. The lanterns are made out of highly decorated paper and placed at specific intervals across the field, a guide to help Oyomo—well, Idugu—on his journey. When I was younger, I would run from one lantern to the other while Father looked on, waving desperately, in the hopes the god would see

me. Now, I'm careful to keep my head bowed as I continue on, mask firmly in place. There's danger all around me.

The closer I get to the platform, the stronger the certainty becomes, a prickling sensation traveling slowly up my back. I'd be half-convinced it's the crowd—all those scores of humans pressed so closely together, I can't distinguish one person from the next—except that the rest of my body has also begun to tingle, blood rushing, heart pounding more and more. An unsettling, fevered feeling is slithering over me: power, lots and lots of it. It's building slowly in the air, sending my blood into frenzies of agitation. But it's not the usual divine energy I feel when I'm near the mothers. It almost reminds me of the n'goma, the barrier that protects Hemaira's walls, except it's different from that too. Darker in some way. Almost like a presence.

"Do you feel that, Deka?" Keita whispers in my ear. "That heaviness in the air?"

I nod. "Do you think it's the angoro?" I ask. Could the arcane object actually be here after all?

"I thought it couldn't leave Hemaira."

I frown, realizing he's right. "It shouldn't be able to. . . . Perhaps it's the wielder?"

"They shouldn't be able to leave Hemaira either."

"Then what is this feeling?" I glance around, perturbed, that heaviness settling like an oily cloak on my shoulders. But no one else seems to notice it.

They're all looking up at the platform, rapture in their eyes. I stiffen, unease coiling inside me as I notice that they all seem to be captivated, even though they weren't mere moments ago. This, whatever's happening, isn't normal, and it's connected to the strange presence I feel in the air.

"Mimic them," Keita whispers, unnerved. "It'll be strange if we're not acting like they are."

I hurriedly do as he says, pretending to stare at the platform, absorbed, the way everyone else is. Keita's right, this could be a test—a way to unmask any infiltrators from Abeya. Unlike most Oterans, my friends and I are used to divine power. We're all in frequent contact with the mothers, so we're likely to react differently than everyone else.

Keita and I both remain as we are, staring in the same direction everyone else is, until finally, after some moments, the energy dissipates, and then the crowd moves again, doing so casually, as if everyone weren't just caught by some strange celestial trap. My unease grows, nausea churning my gut. If that actually was the angoro, then the arcane object is much more powerful than I anticipated. Much, much more powerful. So powerful, in fact, it almost felt sentient.

Almost like a god . . .

I swiftly shiver away this unwelcome thought. There are no gods but the Gilded Ones. This is just what the mothers warned me about, the angoro siphoning their power and using it to supply its wielder. To give them the aura of divinity. Perhaps they're the presence I felt, and if so, they're no god; whoever they are, they're just one fallible person using an ancient device to pretend at godhood. I must not be fooled by them.

"Make room—excuse me, pardon me—I said make room!"

I'm forced out of my thoughts when Melanis approaches, knocking people out of her way with her staff and murmuring. She must now be in the incorrigible-grandmother phase of her disguise and she even sounds like it, her voice roughened and hoarse. That's the strange thing about Melanis—she seems

to very quickly adopt the speech patterns and mannerisms of those around her. A survival strategy, I suppose.

A few grumbles rise, but no one says anything directly. The only women respected in Otera are old ones, and that's because they survived long enough to no longer be considered fully female.

If there's one benefit to being a woman in this empire, it's that. Once you get old enough, you become so invisible, no one cares what you do.

"Melanis?" I whisper, alarmed, when she nears. We're supposed to be positioned at different intervals across the crowd. That way we can see every angle of what's happening and compare notes.

It's important to be thorough in situations like this.

But Melanis doesn't seem to care as she grabs me by the arm. "I've felt this before, this presence," she whispers, agitated, into my ear. "I've felt it."

"Where?" I ask, excited. "Where have you felt this?"

"When," Melanis corrects. "You mean when. It was during the Divine Wars. In the moment when the mothers were imprisoned and Idugu—" She stops, her expression suddenly dazed. Her eyes blink rapidly, as if she's elsewhere. "Idugu—"

"Idugu?" I prompt, but the Firstborn is no longer listening to me. She's gazing off into the distance, at something only she can see.

"Melanis?" I ask, unnerved.

When I touch her shoulder, she jerks, blinking again. Only this time, it's as if she's waking from a short afternoon's rest. "My apologies, what were we discussing?" she asks suddenly, seeming confused.

I still. "You were telling me about Idugu."

She frowns, that look of confusion growing. "Idugu? Why would I understand the fevered imaginings of foolish humans?" she tuts, shaking her head. "And why am I wasting time here? I should be at my post."

As she hobbles away, more shivers rush over my body. As does unease. It's as if something has erased our prior conversation, so completely obliterated it from Melanis's mind that nothing remains. Then there's the way she stared off into the distance, as if something was calling her name.

Or someone . . .

There's only one person I know with power like that. Well, four people. And they've all been in close proximity with Melanis. While the angoro's mysterious user has certainly not.

I watch, unsettled, as she disappears back into the crowd.

"What was that, what just happened?" Keita asks the moment she's gone. He seems discomfited as well.

"I don't know," I say, shaking my head. "One minute, she was telling me something; the next—"

"What?" Keita's gaze is sharp as he peers down at me. He can see the hesitancy in my expression. "What aren't you telling me, Deka?" he whispers.

My lips are suddenly dry now, so I lick them. "I think she's had her memories altered. Like the converts who come to Abeya."

He frowns. "Wait, you think the mothers . . ."

I nod.

"But why?"

It's exactly the question that confounds me. Why would the goddesses take Melanis's memories? Did the Firstborn truly not want to remember what happened during the Divine Wars? *Or was it the mothers who wanted her to forget?* I quickly shake the

thought away. It doesn't make sense; the mothers would never take someone's memories against their will. It must have been the Firstborn herself who wanted it. Perhaps the weight of all those centuries was too much to bear. It certainly feels like that sometimes for me and I've only been alive seventeen years.

I return my gaze to Melanis. She has now neared the front of the crowd, and she rudely nudges Li aside with her staff so that she can have the very best spot. She doesn't seem to be dwelling on our conversation at all.

But that's probably because she doesn't remember it. . . .

I turn my gaze to Keita. "I don't think this is the place to speak of it."

Keita nods. "Later, then."

"Later," I agree, turning toward the platform, where one of the priests is addressing the crowd from beside the three sleeping alaki, who now have only the barest vestiges of gold on their bodies. They'll wake within the next two hours, if not sooner.

Just the thought of it has me clenching my fists.

"Evening greetings, loyal worshippers of Oyomo," the priest calls, his pale pink face deepening in color from the exertion of shouting so loud.

"Evening greetings," the crowd returns.

Even from a distance, I can see there's something strange about his eyes: his pupils are too dark, and they take up too much space in the whites. Less knowledgeable onlookers might take them as a result of spending too much time reading scrolls in the darkness, or even an overindulgence in hallucinogenic herbs, but I know better. This priest is no mere human; he's a true jatu, as are all the other priests around him, all of whom have those distinctive eyes as well.

Someone hands him a metal horn, and he nods his thanks. "Honored followers of Oyomo, may the blessings of the Infinite Father shelter and deliver you."

"May we be sheltered. May we be delivered," the crowd intones.

I haven't heard such recitations since the day of my Ritual of Purity, but I follow along easily, the words ingrained from years of worshipping at the village temple.

"Today begins a most auspicious period—the eve of the Festival of the Half Light, the celebration of Oyomo's descent and the arrival of the dark months of winter. As is our sacred tradition, we will remain in fellowship until the festival is ended. But we must not lose our vigilance while we celebrate the Infinite Father's journey. Demons walk Otera."

Tension grips the crowd now, soldiers glancing at each other, some spitting on the ground to signal their disgust. My fists clench even tighter. It always enrages me to hear my kind spoken of with such venom, such hatred, as if we were the actual demons they said we were. All we've ever done is try to survive— just as every other creature in Otera does. And yet, the humans despise us for it.

The priest nods approvingly at the crowd, his bald head gleaming in the evening light. "The Gilded Ones have risen, spreading their monstrous filth and perversion, turning innocent girls into alaki and forcing youths to debauchery. We must not fall prey to their vile temptations."

"We must remain firm," a masked woman calls out beside me, clutching her children closer.

Nods of agreement all around.

The priest's smile of approval almost beams from his eyes.

"You have heard at length from Elder Kadiri, honored high priest of Oyomo!" he shouts. "Today, he has brought with him another chosen one of Oyomo: the Wumi Kaduth, the Lady of the Heart!"

Cheers ring out, roars of approval so loud, they drown out every other sound. I quickly join in, even though tension grips my muscles, making them as rigid and unyielding as iron. I can feel that strange presence growing again, an oily slickness in the air that surges with every round of applause the crowd makes. Something about the pattern of its surges niggles at me, and it takes me only a few moments to understand why. It's almost like the presence is . . . feeding off the applause.

Worship . . . The word jolts into my mind, but I quickly shrug it away. Only the Gilded Ones feed on worship.

When quiet descends, I return my attention to the scene in front of me. Elder Kadiri is making his way to the center of the platform, each of his steps slow and deliberate, the light from the bonfires flickering over his skin. Even without ever having seen him before, I know exactly who he is. The aged cleric is slight and leather-skinned, his yellow robes tattered and his feet so heavily calloused, they're almost as thick as hooves. The only thing that differentiates him from the beggars calling for alms at the side of the crowd is the kuru, the sacred sun symbol, branded in gold on his forehead.

That and the fact that his skin is dark blue.

The color gleams every time the firelight moves over it, illuminating the shades making up the rich darkness. A shiver rushes over me. Elder Kadiri is Mombani, one of the rarest tribes of the Southern provinces—of all Otera, for that matter. The One Kingdom may stretch entire continents, only the

Unknown Lands to the far South and East free from its reach, but even among all the vastly different groups that inhabit its Southern, Northern, Eastern, and Western provinces, the Mombani stand out as unique. For only they possess skin of such a jewellike hue.

Elder Kadiri's deep blue cast almost makes him look like a creature from mythology. But he's here, and now he's at the very edge of the platform, a figure looming over us, except he's not actually as tall as he seems. In fact, he stands at least a head shorter than the priests all standing behind him, their mouths moving in rapid prayer.

Prickles of unease creep down my spine as the sound drifts over the crowd, a low, insistent hum. Each time it rises, that strange feeling—that strange presence—appears again. Finally, Elder Kadiri motions for silence, and the priests turn, almost as one, toward the back of the platform. That's where a woman is being helped up onto the boards. The Wumi Kaduth. She doesn't have to be introduced for me to know it's her. She's the only woman on the platform, after all—barring the girls in the gilded sleep, that is.

I stare up at her, fascinated. She's very slight, the Lady of the Heart—body fragile and birdlike thin beneath the layers of ceremonial yellow robes that cover her from head to toe. Although I assume she's elderly, she could be any age from twelve to sixty, not that I'd be able to discern the truth of her age; a wooden piety mask hides her face, the sheer black cloth under the eye and mouth holes concealing even her eyes from view. I can see it very easily despite the rising darkness, my heightened senses allowing me to cut across the distance as the Wumi Kaduth shuffles cautiously toward the priests, then kneels, offering

absolute submission to both Elder Kadiri and the gathering of men stretched out before her.

My lips curl in disgust. All that fanfare about a female priest, a Lady of the Heart, and they bring out this frightened, cowering thing. But that's the point, isn't it? I force myself to relax as I remember Melanis's words: this woman isn't a priest but a lure for human women—visible proof that if they submit fully enough, if they give themselves so completely that there's nothing left but devotion, they too can be chosen by Oyomo to be His special messenger. The manipulativeness of it all blisters me. Before, girls could look forward to being pure and marrying as a reward for their subservience. Now, they can also look forward to being designated false priests and serving the other priests for their troubles—just as this priestess is doing.

Elder Kadiri pats the woman's head in a sickeningly patronizing gesture, then turns to the crowd. "Blessed followers of Oyomo," he says in a surprisingly booming voice, "you have heard me speak, time and again, of the power of our Infinite Father, of His love and dedication to us—a dedication so pure, He has transformed himself into His most powerful aspect, Idugu, as a way to combat the influence of the Gilded Ones."

The crowd is absolutely still now, captivated by his voice. It resonates deep inside my bones, a tangible power even I can feel.

The effect of it combines with his blue skin, turning him into something almost mystical as he continues: "Those demons are a stain upon our beloved One Kingdom, as is their despicable offspring, the alaki they have christened their Nuru, Deka. May she burn in the Fires."

"May she burn in the Fires," the crowd intones.

My stomach lurches. It isn't the first time I've heard this sentiment—the wish that I burn in the Fires of the Afterlands—nevertheless, it still stings. Keita tightens his arm around my waist, but his nearness doesn't banish the disgust, the dread, simmering inside me.

Elder Kadiri nods piously, continuing: "Time and again, I have spoken of our god, of his monstrous enemies. It is time for other mouths to speak. As you all know by now, Oyomo, in His infinite mercy, has seen fit to ordain certain hallowed women, to give them the power to move past their fleshly infirmity and absorb the strength of the divine. On this sacred evening, I give you the first of his chosen daughters, the Wumi Kaduth, the Lady of the Heart."

He gestures to the woman, and she rises and bows to the crowd. Then she holds out her arms. "Beloved followers of Oyomo," she says, her voice surprisingly strong behind her mask. For all her seeming frailty, her voice carries, just like Elder Kadiri's. "The Infinite Father blesses you."

"The Infinite Father blesses us all."

"I bring you greetings from Idugu."

"Greetings." Every mouth in the crowd repeats these words except for mine.

My mouth is silent now, all my words stolen by the horror suddenly creeping over me. I may not have recognized it immediately, but I know that voice—I've heard it hundreds of times before. The Lady of the Heart doesn't have to say another word; I know exactly who she is.

Elfriede, my old friend from Irfut.

The girl who watched as I was murdered and said nothing.

14

◆ ◆ ◆

Less than two years ago, Elfriede could barely speak in the company of others. She kept her head lowered, hiding the mottled red birthmark that stained the left half of her face, and never stood in front of a crowd if she could help it. She couldn't even speak above a whisper when meeting people she didn't know. When the deathshrieks came during the Ritual of Purity and I was revealed to be impure, she didn't say anything, just watched silently, horror in her eyes, as Ionas stabbed me in the gut. When I spent the months after in that cellar, being tortured, being killed over and over, she never raised so much as a protest. Never even asked once to see me. Not that I expected her to. She was only one girl—and not even a member of my family. What power could she possibly wield in a place as punishing as Irfut? The only thing she would have accomplished was getting herself imprisoned too, so I never begrudged her silence, never expected anything more from her.

But now, for reasons I cannot fathom, she's suddenly here—

halfway across the world, commanding an audience of thousands, her voice resonant behind her mask as she says: "Beloved followers of Oyomo, know that Idugu protects and guides you in all things, that He is your shield in this time of darkness and chaos. It is easy to feel hopeless, overwhelmed by the thought of battling the Gilded Ones. They have captured our beloved emperor, placed our capital under siege—murdered our friends, our family, our entire villages. But all is not lost."

As I watch her, bewilderment rising, she continues: "Powerful though those demons are, we defeated them before, bound them to the prison they now have the audacity to call their temple. And we can do so again. They are weakened at the moment, drained of the power they once had—the power they amassed by luring innocent women to their side, devouring innocent children."

The crowd gasps, all anger and outrage, but I'm still too stunned, too taken aback, to react. All this time, I assumed Elfriede had been married off or, in the very worst case, forced into the temples as a temple maiden to erase the stain of her association with me, an impure demon. But now she's here, standing in front of me. And she's saying things only a select few who live in Abeya know. How did she come by the knowledge? And why is she uttering such awful words now?

The Elfriede I knew never liked speaking in front of strangers, never liked being the center of attention. She must have been forced to do this—penance, perhaps, for her closeness with me. Yes, that must be it. Once upon a time, Elfriede was my dearest friend—my only friend. This must be her punishment for our friendship.

She holds her hands up for quiet. "In their prime, the Gilded

Ones were wretched abominations, sucking the lives from children, women—anything pure that crossed their path. That is how they grew powerful enough to proclaim themselves gods, to litter Otera with their impure offspring."

I clench my knuckles so tightly, the skin feels like it might split. Even if Elfriede was forced to do this by the priests, her words strike to the core of me. That she would spout such horrendous falsehoods about the mothers, about my sisters. I suddenly want to strike something—preferably her masked, emotionless face. Perhaps if I slap her hard enough, I can knock her back to her senses, back to the sweet, happy girl I once knew.

It's all I can do to force myself to remain still as Elfriede continues: "But now they are isolated in that temple of theirs, far from our precious children, their preferred prey. That does not protect the children of Otera, however. It does not protect all those troubled youths who run to the mountain to partake of the freedoms the Gilded Ones offer, never understanding that those unholy creatures are feeding from them, gorging their souls.

"But thankfully, they haven't completely filled themselves yet."

Elfriede looks across the crowd, which is rapt, captivated by her spell. "The Gilded Ones are starved—vulnerable—and we will use that vulnerability to our advantage. We will march upon their temple, and we will do what the warriors of old Otera failed to do: we will slay the demons once and for all!"

The crowd's roar is so enthusiastic now, that awful malevolence swells the air. I wince as my blood churns under the onslaught. Once again, it's as if the presence, the arcane object, whatever it is, is feeding on the crowd's eagerness, their

bloodlust. And I can only clap along, careful to keep up my pretense of glee.

When finally the clapping ends, Keita's hand reaches for mine, and I grasp it gratefully, not surprised to find it's sweaty too. Keita's jaw is clenched so tightly, the muscle twitches there. He can feel the presence too.

When the crowd finally quiets again, Elfriede looks across the field. "You may ask how I know all these truths about the Gilded Ones. How do I, a lowly girl from an isolated and backward village like Irfut, know all these truths about the demons?" She pauses dramatically, waiting as tension builds. I can almost imagine her green eyes tilting up at the corners, the way they always did when she had something delicious to gossip about.

"Tell us," someone calls.

"Tell us, Wumi Kaduth!" another person joins in.

The silver accents on Elfriede's mask gleam under the torches as her voice lowers almost to a whisper. "You see, I was raised in the same village as the spawn of the demons. I was raised alongside the Nuru herself. Alongside Deka . . . the girl standing right there."

A thin, birdlike finger points straight at me and just like that, the world goes still.

For a moment, it's as if all the air has been sucked out of my lungs, as if everything is moving like sludge. Then the crowd turns toward me. Toward us. Because while I was staring, still in shock, my friends have been rushing over, aware now, as I abruptly am, of the jatu who have been slowly infiltrating the crowd, trapping us while we were distracted by Elfriede. And in the end, that's all she truly was—a distraction. Not a lure for Oteran women or anything else we theorized, but a trap, plain

and simple. Bait so Elder Kadiri could capture us as we had wanted to capture him.

Keita's eyes widen as he takes stock of the jatu now surrounding us. There are at least a hundred of them, all human, which is why they didn't alert my senses. The irony of it slowly washes over me. No wonder we didn't hear about a female priest before coming here—they made sure not to mention it until the very last day they could, when we were here, away from more experienced alaki commanders who, unlike us, could have sniffed out the trap.

The whole time I thought we were outwitting them, they were outwitting us.

"Deka . . . ," Keita says, a silent question shining in his eyes. *What do we do?*

I turn to my friends, all of them staring at me, waiting for my command. It comes to me in a rush. "We take Elder Kadiri now!"

Change, Ixa! I add silently.

Even before the thought leaves my brain, I feel Ixa bursting from the wagon's reins, his body exploding into an even larger version of his massive true form. Usually, he's the size of a bull, maybe a tiny bit larger. Today, he's four times that. I don't have to see the transformation to know it. It's an instinct deep inside me, another facet of the connection that binds us. Ixa barrels down the field, trampling over the jatu surrounding our wagons. He's a gleaming shadow in the darkness, a vengeful colossus that almost resembles a mammut, those hulking gray tusked and spiked creatures we sometimes ride into battle. But mammuts are slow and bulky, not sleek and graceful like Ixa as he leaps

into the circle of jatu surrounding us, the crowd screaming and fleeing in his wake.

He roars so loudly, the sound echoes across the field, sending a few of the jatu stumbling back. A high-pitched shriek quickly answers his call, followed by another, then another—Katya and the other deathshrieks. I heave a sigh of relief. I'd almost forgotten they were there. As they crash in from the forest, even more screams rise into the air, the ordinary citizens in the crowd fleeing.

I quickly jump onto Ixa's back. "Hop on!" I shout to the others. There's more than enough room for us all now.

As Keita, Belcalis, and the twins join me, the other uruni alongside them, a fierce wind whooshes past. Melanis is winging toward the platform, Britta and Li each under an arm. But Elder Kadiri doesn't seem worried by her approach or even ours. While all the other priests flee for shelter, he just stands beside the sleeping alaki, a smug look in his eyes.

Apprehension surges inside me. "Stay alert for traps!" I shout.

To Ixa, I add, *Ixa, keep an eye out!*

Deka! My massive companion agrees, landing on the platform with a resounding thump.

But the moment I slide off him, I feel it, the energy gathering in the air. It's so immediately familiar, especially given the events of today, it takes me mere seconds to understand. "It's a door! Multiple doors."

I don't even have to wonder how this is possible before the first tear rips through the air, the bright gleam of afternoon sunlight shimmering on the other side of it. As I watch, stunned, a

massive form emerges, the all-too-familiar golden armor covering it doing nothing to hide the horrifyingly dagger-sharp claws, the gaunt, eerily humanlike build. It's a deathshriek, only unlike that of Katya and the others, its skin—the few parts of it that are not covered by armor—is deep purple and crisscrossed by golden veins. Even stranger, it's wearing golden infernal armor—the exact same kind alaki wear—and carrying a spear whose flowerlike shape and dagger petals are also immediately familiar. It's the same type of spear the jatu at the Oyomosin were carrying, only this deathshriek can't possibly be one of them. True jatu don't become deathshrieks when they die, and even if they did, we burned everything in the Oyomosin to a crisp.

But jatu resurrect now.... The thought slithers into my mind, as does a familiar pain. I wince at the intensity. There, on the deathshriek's breastplate, is the very thing I've been dreading all this while: that symbol, sinisterly displayed as if just waiting for me to see it. I swiftly glance away, grateful when the pain recedes to a dull throb.

Not that it matters anymore. The pain is nothing compared to this, the horrifying understanding suddenly coalescing in my brain: this deathshriek is that same jatu leader we saw back at the Oyomosin. He's male, and he's not the only one.

Even more tears appear in the air, more deathshrieks emerging, all of them that same purple color with gold veins, all of them carrying those flower spears, that jatu symbol glaring at me from the breastplates of their golden infernal armor. I feel cold all over.

Within moments, the deathshrieks have arranged themselves into a circle surrounding us, their spears steadfastly pointed. Every time Melanis swoops toward Elder Kadiri, they

lift up their spears, fending her off. Even with all her speed and agility, she can't get through. These deathshrieks are in another class completely, something I've never seen before. And they move with such discipline, they almost seem to be multiple extensions of one being.

"Stop!" I command them, fighting past the pain throbbing in my skull.

There are too many of those jatu symbols surrounding me, too much power deflecting mine, which is why the deathshrieks disregard my commands as they slowly and steadily approach, their formation closing in around us.

But I've spent weeks preparing for this, training against the symbol's effects. I won't let a few arcane symbols conquer me. "STOP, I COMMAND YOU!" I shout again.

As before, the deathshrieks ignore me.

The symbol's power is still too strong, too effective a shield against mine.

And now, Elder Kadiri is smirking. "Your voice has no power here, honored Nuru," he says mockingly. "The kaduth binds it as effectively as chains bind the body."

The kaduth? Knowing the name of that accursed symbol does nothing to still the anger now roaring in my veins. "What is it that you want?" I snarl, enraged.

I know it's something; I know that much. If Elder Kadiri had just wanted to stop me, he could have had one of the jatu stab me in the crowd while my friends and I were distracted by Elfriede's speech. It would take me at least a few hours to revive; Elfriede knows this.

Speaking of whom . . .

I shoot a poisonous look at my former friend. She's still

standing there, watching. Why hasn't she fled with everyone else? Why hasn't she summoned the last ounce of shame she has left? But she remains there, just beside those sleeping girls, who are almost completely flesh-colored again. A slight tremor runs through one of them, a plump, pale Eastern child only barely fifteen, and I swallow down bile at the horror that she might wake up soon.

Please don't wake now, I pray silently while Elder Kadiri smirks at me.

"Want?" Elder Kadiri seems amused as he repeats me: "What is it that I want? Hmm . . . an intriguing question. Except . . . this is not about what I want, honored Nuru. This is about Him." He points a gnarled finger to the sky.

"Him?" I repeat, a desperate bid to hide my growing dread, when that same alaki twitches softly.

Please, not now, I urge again. I silently will her to return to her slumber, but luck, as always, isn't with me. The other girls are also beginning to twitch, slowly coming awake.

"Idugu . . ." Elder Kadiri's voice draws my attention back to him. He has a strange, almost vacant look in his eyes now. "He whispers to me in my dreams. Tells me that He is fascinated with you. That He engineered this entire scenario just to meet you."

"Idugu?" I scoff even as I feel it, that oily presence hovering in the air. "There are only four gods in Otera, and they are the Gilded Ones."

"Is that what they told you?" Elder Kadiri smiles a soft, pitying smile. "Poor child, so thoroughly deceived by those demons. I'm certain they also told you that they never ate children, never gained power from consuming innocence."

"They didn't have to," I grit out, rage building again. My en-

tire life, I've heard stories of how the Gilded Ones ate children, destroyed Otera with their ravenous hunger. "The mothers are gods—protectors. They would never hurt their children."

That pitying smile sharpens into a predatory one. "Simple child," Elder Kadiri tuts. "Did you not know? Gods require worship, and the purest worship is sacrifice."

Before I can move, he grabs the awakening girl by the hair, unsheathes a dagger from his side. As he jerks her head back, he looks up at the sky, a frenzied gleam in his eyes. "Divine Father, I give you this offering to add to your power. May her blood fill you. May her spirit nurture you. May you be nourished."

He slices the girl's throat with one quick swipe.

Screams pierce the air, most of them coming from the other now-awakening girls, the rest coming from me, a distant echo in my ears. Golden blood is pouring onto the platform's wooden boards, so much of it, a puddle begins spreading around Elder Kadiri's feet. And yet, I can't move. I'm frozen there, heart pounding frantically, breath heaving in great, labored gusts, and all I can do is watch that blood as a strange, subtle glow rises from it, accompanied by the intense sensation of evil, of creeping fingers reaching toward the dying girl.

Deka! Ixa rumbles, panicked. He can feel it too, the malevolence rising in the air. It's as if we're somehow sharing the same mind, experiencing the same things, except we're doing so through two different bodies.

His cry forces me to move.

But as I finally begin to stumble toward the girls, my atikas limply gripped in my fingers, dread jolts up my spine. I glance down to find that the blood on the boards is shining so fiercely now, it almost rivals the sun in its brightness.

"What is that?" I ask, horrified. "What's happening?"

But Elder Kadiri's smile widens further, his cheeks stretched into a macabre mockery of pleasure. "So you can see it. He said you would. Proof of His existence, of His divinity."

Beside me, Keita is confused. He shifts, uncertain, as he glances in the direction I'm staring. "What's happening, Deka?"

His question causes every muscle in my body to stiffen. Keita can't see the light coming from the blood, can't see it shining so brightly even though it's right in front of him. It's the same for Britta and the others, still huddled in their battle stances around me, their eyes on the as-yet-unmoving death-shrieks; they all have the same expressions, the same horror, they had just moments ago, but none of them seem startled or shocked. They can't see the glow, even though it's obliterating in its brightness. A chill envelops me. That glow is like the river of stars in the Chamber of the Goddesses: only I can see its true nature. And that means only one thing—it's the work of the divine. This, whatever's happening in front of me, is of a celestial nature.

Elder Kadiri seems to notice the moment I realize this. "You're finally understanding, Deka," he says, almost giddy now. "This isn't the work of some arcane object, as they would have you believe. It's Him, the true god of Otera, Idugu."

Everything in my consciousness is shrieking in protest of his words, but the truth in them is undeniable. Even now, I can see the blood's glow dimming, disappearing as if something is sucking it in, slurping up every last drop. And with every drop that disappears, that malevolence grows around me, seeming to get more and more powerful with each second that passes.

If I wasn't certain before, I am now: Idugu truly does exist.

Only it isn't an arcane object, as the mothers said, and it certainly isn't some benevolent being—some protective hidden version of Oyomo, blessing its worshippers with the power to fight against the mothers. It's a vengeful and parasitic monstrosity, gorging itself on the prayers and energy of those stupid enough to follow it.

And it feeds on the blood of fledgling alaki.

How is its existence even possible? The mothers told me to expect the angoro, told me it imitates divinity, but this creature truly is of celestial origin. This is no mere imitation, I know this as suddenly and deeply as I know the color of the sky, the feel of the wood beneath my feet. And yet somehow, the mothers did not know of it.

Or did they?

Immediately, I remember the conversation I had with Anok, the one I had on the—

The thought slides away so quickly, I'm left blinking. Confused. I shake my head to clear it. This is not the time to lose my train of thought. Whatever the reason for their silence about Idugu, the mothers must have a good explanation.

The jatu, however, do not. They're the true villains here.

For centuries, they've accused the Gilded Ones of being monsters, immortal demons who prey on the lives of children. But they themselves not only resurrect now; they can become deathshrieks. And their god consumes children the way gobbler birds consume grain. Young girls—most of them barely old enough to defend themselves. Already ostracized and punished by their villages, their families; already at the edge of the blackest despair. Girls like I once was. Hopeful, trusting—innocent. My fury swells, every inch of me filled with righteous, reckless

determination. No matter what happens from now on, I know one thing to be true: I will find this false divinity, this monstrous charlatan of a god, and I will destroy it until nothing is left but just enough of its essence for my mothers to crush beneath their heels.

No matter what it is, no matter its origins, I will have revenge for my fledgling sisters: I vow it upon my soul.

I return my gaze to Elder Kadiri as I lift my atikas. "God or not, it is an abomination, and I will exterminate it from the face of Otera."

But the elder's smile just widens. "You'd have to meet Him face to face to do so, then. Perfect. He's expecting you."

He looks up, his eyes meeting something only he can see. Then I feel it, the gathering in the air. A door. But this one is different from before. Instead of anything emerging here, it's more like something is reaching for us. Trying to snatch us in its web. I whirl to the others, alarmed. "It's another door! Melanis, you must take Elder Kadiri *now*!"

"As you wish, honored Nuru." Melanis dives toward the platform, wings folded closed, but before she can even reach the elder, he vanishes. Disappears into thin air, just like that. All that remains are those strange deathshrieks, who watch her, unmoved, as she flaps back up, growling her frustration.

And now, doors are opening all around us, the air tearing, sucking at our bodies. "Secure the girls!" I shout, and Melanis nods, plummeting toward them.

She grabs all three in her arms and wings up just as the nearest opening tugs for me. "Deka!" Keita swiftly grabs on to me, as do my other friends.

"What's happening?" Katya asks as she leaps over to my side,

Nimita with her. The other deathshrieks, on the other side of the platform, are too distant now to reach. "What's happening, Deka?" she repeats, bewildered, as the air swirls brutally around us.

"It's a door!" I shout. "We're in the middle of a door! Hold on tight!"

And that's the last thing I say before everything disappears.

15

◆ ◆ ◆

The temple that appears in front of us is as light as our previous location was dark. It sits high at the top of a hill overlooking the magnificent city I recognize within seconds: Hemaira, its rivers and lakes gleaming softly under the early evening light. I barely have time to blink at the sight of its lush green hills and islands before the door is whirling again, landing us in the middle of the temple's Hall of Prayer. Panic drums in my chest as I recognize the beautiful golden relics, the towering walls made of n'gor, the hardest, most precious rock in Otera. They're all pictured in the Infinite Wisdoms, as is the rest of the temple. In fact, entire sections of the scrolls are dedicated to this, the holiest and most sacred site in Otera. This is the Grand Temple of Hemaira, home of the Oteran high priests and one of the most revered places in Otera. As well as the most dangerous.

This is where Idugu is.

Even now, I can feel him, an ominous presence slithering ever closer.

"No, no, no!" a voice moans beside me: Acalan. The normally composed uruni seems terrified as he holds his head in his hands. "We can't be here! We can't—"

Adwapa props him up, trying to aid his breathing. "Breathe, Acalan, breathe!"

But he's not the only one panicking. Everyone around me seems distraught, their eyes wide with horror as they take in their surroundings, which are already wavering again. The air is moving once more, whooshing so fast, nausea churns in my stomach.

Britta grips my hand tighter. "Deka, wha's happening?"

"I think the door is moving again!"

The hall around us is already melting away, another golden room appearing in its wake. But that one swiftly disappears too, as does the next. It's almost as if Idugu is just pushing us from one place to another, as if he has only enough power for small bursts. I tense as the door settles once more, this time taking us to a room where carvings line every inch of the bright blue walls. In one carving, four pairs of warriors are locked in combat, all connected by shimmering golden threads as they hold swords to each other's throats. They look almost like indolo, those four bodies connected as one, and yet two of the warriors have wings almost like Melanis's. There are small inscriptions below them, but so many kaduths are painted around each, I can't fight far enough past the dull pounding in my head to take them in. I close my eyes, trying to regain my footing, until a panicked gasp forces me to swiftly open them again.

"Deka," Keita whispers, hoarse. "They've surrounded us."

I whirl to find at least fifty deathshrieks pointing spears at us, their purple skin gleaming ominously under the thin light

now filtering in from the glass ceiling. When I see the firepit that lies in the middle of the chamber, I inhale a quick breath. The door has taken us to the inner sanctum of the Grand Temple. Worse, it still hasn't closed. I can feel it even now, shimmering at the edges of my consciousness. Either Idugu doesn't have enough power to close it or there's one final destination to which he wishes to take us.

As I stand there, dread roping my muscles, Elder Kadiri walks out from behind the line of deathshrieks, his hands outstretched in welcome. "Welcome, Nuru Deka," he says, that awful, placid smile on his face. "Idugu bids you welcome, honored is His name."

"Honored is His name." This echo comes from the priests slithering around the edges of the inner sanctum, their smaller, heavily robed bodies nearly blocked out by the massive deathshrieks, who are, as always, unmoving. Are they even alive? Do they think? Have consciousness?

Ixa snarls at them, agitated. *Deka?* he asks, his eyes glancing pointedly up at the glass ceiling, but the moment he does so, Elder Kadiri notices.

He nods at the deathshrieks, who immediately cross their spears, forming a barrier. They have no intention of letting us go. If we're going to leave, we'll have to fight our way out.

"Prepare for combat!" I shout, lifting my atikas.

My friends do as they're told, all of them huddling back-to-back with me so that we face our attackers. There are so many of them. I try to calculate numbers, possible scenarios, but my mind sputters, overwhelmed by the sheer desperation of our situation. We're caged by deathshrieks I cannot command, since I can't use my voice with the kaduths here, and even worse,

there's the oily presence of Idugu swirling around us, blocking me from contacting the mothers. I touch the ansetha necklace again, trying desperately to tug at the invisible bond that connects us, but nothing tugs back. I try once more, horror peaking when I find there's still no answer. Tears of frustration prick at my eyes. We're alone here, my friends and I, all of us rudderless without the invisible hand of the mothers to guide us.

If only we could go elsewhere. Irfut, even. I'd take that pit of atrocities any day over—

The air suddenly begins moving again, and within seconds, cobblestones appear, as does a quiet village square, which gleams under the light of the silver moon. My mouth falls open when I recognize that familiar bakery, those familiar stables. Only the guard dozing against a nearby wall is unfamiliar.

When I gasp, he jerks awake. Terror widens his eyes as he spots our group.

"Deathshrieks!" he shouts. "Alaki and deathshrieks and"— he takes one look at Ixa and his eyes bulge— "monsters in the main square! Sound the alarms!"

A horn blares in the distance, drumbeats echoing from the walls surrounding the village. The walls that weren't there just a year ago, all of them now teeming with jatu, who again are wearing the kaduth.

"No, no, no!" I gasp, panic rising. "How are we here?"

I huddle against my friends, each one as confused and panicked as I am. My thoughts are suddenly whirling faster. Why are we here? Is this Idugu's game? Unbalancing me by sending me to the most horrific places I can imagine? Why didn't he just send us to the middle of Hemaira, where all his forces are? Even as I think this, colossal walls shimmer into view—the

walls of Hemaira, rising above us, only we're not anywhere near the numerous garrisons or dungeons that abut them. No, we're somehow a distance from them, in the shadows of what looks to be . . . a tower?

As the door stabilizes once more, I glance around, bewildered. The curlicued walls of a small, decorative tower surround me, providing shade from the sudden unrelenting heat of the afternoon sun. A cool breeze wafts through the columns that open out to a residence's rooftop, a long, flat space surrounded by decorative towers that enclose a tiny but lush garden. Voices rise up from below, the familiar hubbub of merchants haggling in heavily accented Hemairan, and I glance down to see the brightly colored cloth stalls of a river market. How—why are we here? One of Hemaira's many waterways flows underneath us, the crowds of men on its rickety market boats buying burlap bags full of bright red pepper, sprigs of green magulan leaves, bundles of medicinal naduri twigs, and so on. Their heads are all uncovered, which means there's not a single woman among them, but even despite their absence, I recognize this market. My eyes narrow: I recognize this view. It's the same one I saw so many times as my friends and I rode out the gates of the—

I gasp, shock dousing me when I look up to see distinctive bright red walls crowning the hills in the distance.

Adwapa gasps, taking a step forward. "Is that—"

"The Warthu Bera. It's right there," I say, pointing. Right within reach.

But how is that possible?

I stretch my senses, trying to find any hint of interference on Idugu's part, but he's disappeared, his presence long gone,

as it has been since we left the temple. He didn't bring us here. And neither did the mothers; I touch the necklace just to be sure, but as before, our bond is completely quiet. That door—it moved on its own. *No* . . . I still, remembering all the thoughts I had leading up to this moment. I decided Irfut was better than the temple, and somehow, we ended up there. Then I wondered why Idugu hadn't taken us to the middle of Hemaira, and suddenly here we are.

My eyes widen. The door didn't move because the mothers intervened or Idugu somehow became benevolent; it moved because I wanted it to. It's a good thing I didn't think of asking it to send us to—

I quickly shutter the thought as I turn to the others. "Step out the door," I say urgently. "Move now."

Everyone quickly complies, except for Acalan. When I turn, the usually stoic uruni is still hunched in himself, shaking. Belcalis has to physically pull him out the door, and not a moment too soon. It vanishes the minute she does.

"Acalan, Acalan!" she says, shaking him, but he just slumps down, his head in his hands.

"Can't go back, can't go back . . . ," he mumbles.

"What's wrong with him?" I ask Belcalis, but she just kneels down so she can wrap her arms around him. When she rests her head over his, he bursts into sobs.

I hurry over. "Acalan," I whisper, sheathing my atikas and kneeling as well. "We're safe. Look." I point to our surroundings, the rooftop, the market below us, but he just shakes his head.

"I was there. I swore I'd never go back."

"To the Grand Temple?" This question comes from Keita, crouching beside me.

Acalan looks up, miserable. "Yes."

"Why?"

Acalan takes a deep, shuddering breath. "It was where I took my first assignment as a recruit," he says. Then he looks away. "Trust me, being at the Warthu Bera is like taking a swim in a warm spring compared to being there."

"Why?" This question comes from Li, who is frowning, curious.

I am too. The Grand Temple is one of the most coveted assignments a jatu recruit can get. If Acalan, the most religious boy I know, rejected a life as a temple guardian, something awful must have happened.

A cloud falls over Acalan's face.

"You don't have to talk about it," Belcalis quickly says. "Not if you don't want to."

"I want to," Acalan insists.

Then he inhales. Fidgets a little.

"They hurt boys who show any preference for men," he blurts out. "They say it's to prevent deviance, but the way they do it, the relish they take in causing pain . . ." He looks away again. "Anyone they suspect, they hurt him badly. And then they make it so you feel grateful for having being hurt. Like they're doing you a service."

I watch him, so many things suddenly falling into place. Most of the recruits I know have already paired themselves with the alaki girls, but Acalan has never found anybody, as far as I know. I never truly thought about it before, but now . . . I can't even imagine the bravery it took to make his admission.

Men like him, men who like other men, are not even spoken of in Otera. In some ways, it's considered even worse than women preferring women or even yandau, because boys are the treasures of Otera. They're the ones who can become priests, marry, go to war, fight for the glory of Oyomo. They're the ones who can become anything they wish. But a man who likes anyone other than women cannot produce children, cannot become a part of society. He's considered unnatural—and is castrated at best, killed at worst.

So much brutality. So many punishments for those who step outside of what is considered acceptable.

No wonder Acalan never admitted it before.

He takes a deep breath before he continues. "You know what the worst thing is? Most of the priests, they're like that—preferring the company of men, I mean. I think that's why they become priests in the first place, because in this sick, awful way, they want to punish themselves." He looks up, his now reddened eyes meeting mine. "Sometimes, it's like, when they're hurting you, they're doing it so they don't have to do it to themselves."

By now, a muscle is ticking in Keita's jaw, and my hands are so tightly clenched around the hilts of my atikas, I'll break them if I squeeze any harder. "I'm going to burn that place to the ground," I grit out, trying to breathe past the heat rising inside me. "I'm going to set fire to every last stone."

Acalan seems almost taken aback by my vehemence as he glances at me, but then he smiles a small, sad smile. "I'll pour the oil," he says.

"And Ixa will probably do a big, steaming shit on the ashes," Britta adds helpfully.

Ixa chirps in agreement.

As Acalan rises, Belcalis squeezes him tight. "We love you, you know that, Acalan," she says softly, a move so out of character for her, all I can do is stare. "Even when you're being an insufferable know-it-all, we love you."

Acalan nods, fondly squeezes her back. "I love you too," he says. Then he turns to me, wiping his eyes dry. "All right, then, that's that," he says with a determined nod. "I'm back to it. What do we do now?"

I glance around, taking stock of our situation. We're on a roof in the middle of a Hemairan river market, with no women in sight and only our already compromised disguises to cloak us. And Melanis, the only one of us with wings, is likely halfway back to Abeya by now.

"I don't know," I say honestly. "I have no idea what to do."

Adwapa walks into the center of the group. "Aren't we skipping a step?" She gestures around us. "How did we get here in the first place? Did the angoro make a mistake?"

"It wasn't the angoro," I say quietly. "It was Idugu. He exists."

"No," Britta says, frowning. "That's just what Elder Kadiri wants us to think."

"It's not," I reply firmly. "He's an actual being—a god—and he brought us here—well, brought us to the temple. I think I brought us the rest of the way." As my friends stare at me with bewildered expressions, I explain: "I changed the direction of the door."

Li wipes a hand over his face. "You just said a lot of things that don't make sense, Deka, so let's start with Idugu. I thought he was the angoro."

"So did I," I say, "but now I think the angoro doesn't exist.

Or perhaps it does, but Idugu is separate. He's the true threat here."

"Then why didn't the mothers warn us about him? No—why didn't they tell us another divine being existed in the first place?" This question comes from Belcalis, who seems enraged as she finishes, "All this time, they've said they're the only gods and now you're telling me there's another? And he's male?"

"Not quite certain on the gender as yet," I say truthfully. Then I sigh. "I don't know," I whisper. "I don't know why they didn't tell us." Every time I think about this question, I think about my conversation with Anok and how she warned me to— I blink again, the thought already vanished. "What was I saying?"

Keita frowns at me, his eyes peering into mine. "Are you all right, Deka?" he asks. "It's not like you to lose your thoughts."

"I must be tired." I slump to the floor, suddenly exhausted beyond imagining. "I did just change the direction of a door."

"No." Britta shakes her head in disbelief. "Only the Gilded Ones can use doors."

"I think we've already established that there's a lot the mothers have told us that isn't true," Belcalis says archly.

I'm so tired now, I don't even bother to reply. I just collapse further, wishing this day was already at an end.

Deka? Ixa shrinks to his kitten form and scuttles over, lapping a prickly wet tongue over my face. I fold my arms around him, burying my head in his softly scaled and furred body.

"Just what in the world is happening?" I whisper, overwhelmed.

"Awful things if we don't barricade that door and get our

bearings," Lamin says quietly, moving toward the wooden entrance behind us, the ornate sun carvings on it another reminder that we are really, truly in Hemaira. "I know we have to talk about what just happened," he says in his usual calm, gentle fashion, "but if anyone comes through there, we really are done for."

Katya leans her mass against the door. "I'll secure it," she says. "Find any others."

Nodding, Lamin follows Keita and the other boys as they fan out, exploring the rest of the roof.

After some minutes, they return. "It's secure," Lamin says. "No other doors here—human ones, I mean," he corrects.

"We can't stay forever, though," Keita adds.

"Can't we?" Acalan humphs from his corner. "I'm good hiding here forever, if we have to."

"But here is not safe," I say wearily, accepting Keita's offered arm as I force myself up. "There are people downstairs." I can hear them scurrying from room to room if I close my eyes. An entire family of at least eight people, half of them fully grown.

They'll be coming up to the roof soon, as most Hemairans do every evening, to eat dinner as a family. We have only a few hours remaining—three at the most before that happens. It's already late afternoon now.

"We have to find a secure place to hide," I finish.

"Why don't ye just open the door again?" Britta asks. "Take us back to Abeya."

I shake my head. "I wouldn't know how. I just changed the door's direction. I didn't open it myself."

"Try," Britta insists.

"And then do what?" Asha asks, walking over from the farthest edge of the roof, where she's been quietly observing the market below, as is her habit. "Elder Kadiri is here, in that temple." She nods in the direction of the Grand Temple of Hemaira, then glances apologetically at Acalan, who just shudders.

"And all our bloodsisters are right there, in the Warthu Bera," Adwapa says, her eyes filled with such deep longing, I know she's thinking of Mehrut. "They're there, waiting for us."

"And we're inside the n'goma . . ." I gasp, realization dawning. "We can free them! We can get them out!"

"And there's enough of them to overwhelm Elder Kadiri's forces," Li adds excitedly. "Enough alaki, enough jatu recruits on our side. An army of us, if need be."

"We can burn the Grand Temple to the ground," Belcalis says with grim satisfaction.

"But that's assuming Idugu doesn't use another door again to get Elder Kadiri out before we can take him," I remind her. "And we really need to take him," I say, my thoughts churning.

Idugu aside, Elder Kadiri is the true head of all the jatu's forces. Snatching him would create chaos in the ranks, and more important, it would also allow us to question him about Idugu and his weaknesses, whatever they may be. If there's one thing I've learned from the mothers, it's that gods aren't infallible. At least, not the ones who exist in Otera.

Infinity, it's strange even thinking that.

"Then why don't ye stop Idugu if he tries?" Britta asks. "If ye can change the direction of the door, surely ye can learn to open one—or close it?"

I blink, the magnitude of what she's saying slowly sinking in. All this time, I've been trying to conquer my reaction to the

kaduth, trying to take command of my voice again. But if I can command doors like the mothers, I might not even need my voice. I can just whisk us away when there's danger.

But creating doors takes energy . . . The reminder whispers through my mind. The mothers have to gather worship for weeks just to sustain one. Who am I to think I can even try?

No. I resolutely push my doubts away. I have to try. We're trapped here in Hemaira with no way of contacting the mothers and alerting them as to our whereabouts, and I've already moved a door twice already. If there's any possibility I can open one and get myself and the others to safety, I have to try to learn how to do so, no matter the cost.

"All right, then," I say, determined. "New plan. We need to find a safe place to rest for the next few hours, and then we can scout the Warthu Bera and sneak in to rescue our bloodsisters."

"And brothers," Li adds, clearing his throat.

"And brothers," I repeat. "Then we take Elder Kadiri, learn more about Idugu and who he or it is and what exactly he or it wants."

"And then we burn the Grand Temple to the ground," Acalan reminds me.

I nod. "And then we burn it to the ground."

"But what about the n'goma, then?" Kweku asks, frowning. "How do we get past it and back to Abeya with Elder Kadiri in hand?"

"Not to mention the slight complication of the army approaching Abeya as we speak," Li says helpfully. "How do we warn the others?"

My head hurts now. "One thing at a time. Melanis is already

on her way back to Abeya. She'll warn them when she gets there. Besides, the city is always prepared for battle."

"But against the entire jatu hordes?" Li sounds disbelieving.

"All right, let's take a moment and think. The jatu are always sneakin' out of Hemaira," Britta says. "Which means there's a way out. We just have to find out wha their method is. Whatever arcane object they're usin', we can probably use it too. And even if we can't, Deka can apparently change doors."

"And if the doors are actually the 'arcane object' we've been searching for all this time?" This quiet speculation comes from Keita, and when I turn to him, confused, he continues, "The jatu have been leaving the city without any tunnels, without any discernible transportation, yes?"

I nod. "Yes."

"So it stands to reason that Idugu has been opening doors for them the way the mothers open doors for us. Which means there never was some mystical arcane object transporting the jatu out, which then means—"

"The only way to leave Hemaira safely is through a door," I say, horrified.

"Precisely," Keita says.

"We can't depend on that." Acalan shakes his head. "Just waiting for Deka to learn how to command doors—which, by the way, even the mothers struggle with—and then somehow let us out of Hemaira? We're in a city surrounded by our enemies."

"And our allies, if we can free them," Belcalis reminds him.

I gust out a frustrated breath. "All right, then. The way I see it, we have to make a way. We're stuck here and completely out of options—so we have to rescue our friends and find a way out

of Hemaira . . . while also capturing Elder Kadiri and learning more about Idugu and his powers." I glance from one friend to the other. "Sound like a plan?"

Britta nods. "Sounds like a plan. Conquer or die."

Asha does the same. "You know Adwapa and I are already prepared for this," she says.

"Us too," Li says, motioning to all the other boys.

"Then that's what we'll do," I say, relieved. "Now, how about we find new disguises?" I wrinkle my nose as I look down at my torn and dirty clothes. Certainly can't make my way across Hemaira wearing these.

16

❖ ❖ ❖

As it happens, we don't have to go far to find disguises. Lamin simply vaults onto the next rooftop, where he liberates—well, steals—an assortment of male clothing from the lines strung across its pillars, as well as copious amounts of food from the kitchen below. For a boy so large, he's a very stealthy person. I wish I knew more about what his full history is, but even among the other uruni, Lamin has never been much of a talker, especially not where his past is concerned. Once everyone has eaten and the girls have wrapped ourselves in enough robes to hide every discernible female feature from view, we're ready to proceed. Keita, who's the most familiar with Hemaira, since he lived here the longest, takes the lead.

"All right," he says, pointing at the rudimentary map he's made on the roof's red tiles from dirt collected from the garden. "We sneak out of the marketplace and use this bridge to cross the Agbeni River here." He points to the spot on the map. "From there, we can hide in the park until dark; then we use the

caverns to enter the Warthu Bera. Assuming everything goes well, we can start liberating everyone tonight."

"Mehrut," Adwapa rasps, her voice hoarse. "We free her first." There's such hope in her eyes, such raw longing. Asha quickly reaches out to hold her hand.

Keita nods. "We free Mehrut first, along with any karmokos we may find."

"You think they'd come with us?" Acalan scoffs, already seeming to be back to his usual haughty self, thank the goddesses.

"And why wouldn't they come with us?" I ask. "They're human women who trained alaki who rebelled. I can only imagine the punishments that have been inflicted on them since we left." Especially the most beautiful of them, Karmoko Huon. They'd have special punishments for her. The thought fills me with anxiety.

"What about us, what do we do?" Nimita slips down from the side of the tower, a languid white shimmer descending into light.

I blink. Nimita has this stillness sometimes that makes it easy to ignore her. But the moment you do so, she appears, as if out of thin air, to slice you straight through the gut.

Keita looks up at her. "Can you follow us from the rooftops?" he asks.

"Of course, son of man." The sleek deathshriek seems almost offended by this question, although it might be just the fact that the boy once notorious for slaying deathshrieks is addressing her.

I feel a twinge of sadness at the thought.

Katya seems offended as well when Keita turns her way, but

with her it's simply because she's offended by his implication. "I know how to be stealthy, Keita," she sniffs, signing out her words so he can understand her.

"All right," he says, putting his hands up to show he's not arguing.

"But what about getting across the river?" I've never crossed the Agbeni, but I've seen it from a distance. It's huge. And the deathshrieks can't just walk across the bridge, blending in, the way we intend to do.

"Strong swimmers even in deep waters," Nimita replies, unconcerned.

"Or we could just crawl under the bridge," Katya adds thoughtfully.

"Very well," Keita says with a nod. "So we all know what we're doing. Let's head out."

I nod, but as I rise, a prickle travels down my spine. My senses narrow as the combat state abruptly falls over me. I whirl to the corner of the tower, where a faint light is flickering like a reflection of the sun off water. I tense, my muscles coiling. Could it be a door? But no, I don't feel the telltale sensation of energy coalescing around me. And it can't be Idugu either. That awful foreboding, that oiliness I associate with his presence, is missing. Even more markedly, Ixa isn't on the defensive. He bristled when Idugu was near in Zhúshān, but now he just seems curious. He pads over in his kitten form to sniff at the light.

"Deka?" Keita asks, staring at me. "What is it?"

"I don't know," I reply, eyes still on that corner. "There's something there . . ."

"What do you mean?" He squints at the shadows, confused, even though the flickering is clearer now—so clear, in fact, I can

see it's a figure. A woman. A very dark woman. My eyes widen when I recognize her.

"White Hands?" I ask, frowning, when she appears in the shadows. "How are you here?"

"I'm not," she says, stepping out so I can see the light passing through her.

Gasps sound—the others finally glimpsing her.

"But how?" Britta asks.

I couldn't even begin to answer.

It's almost like the Firstborn is a shadow, but one made out of light instead of darkness. She's some sort of illusion, like the mirages that appear in the desert on exceedingly hot days. "I don't have a lot of time, Deka," she says urgently. "My gauntlets, they require a lot of strength to use them."

"Your gauntlets?"

She holds up her hands to display her clawed white gauntlets, the ones she never takes off. "They're arcane objects," she explains. "I use them to watch people."

Spying, she means. Now, I understand how she always knew what I was doing back at the Warthu Bera. It wasn't just all the spies she had floating around; it was her infinity-cursed gauntlets.

And, of course, she never mentioned this until now. Damn White Hands and her secrets.

"But how did you know to look for me?" I ask, putting aside my annoyance.

"I had an instinct something was awry, so I searched out Melanis, found her flapping around the Eastern provinces. Once the mothers brought her back to Abeya, she told us what happened."

"The door," I say, nodding. "Idugu created it."

"You mean the angoro created it."

I shake my head. "No, I mean Idugu," I reply firmly.

By now, White Hands's expression is as close to alarm as I've ever seen it. "Deka, there are no other gods but the Gilded Ones."

"And yet one dragged us all the way to Hemaira. A feat the mothers themselves could not manage," I say.

"Because the angoro is siphoning their power."

"Or Idugu is."

Just like that, White Hands has had enough. "Deka, whatever this is, it is beyond you. You must come back to Abeya so we can sort this out. All of you." She turns to the others, but I step in front of her, blocking her gaze.

"How?" I ask. "How do we get past the n'goma? It's still there, burning our bloodsisters' bodies to a crisp. We'd burn too if we tried to leave. And the mothers don't have enough power to get us out, much less to deal with all the male deathshrieks."

"Male deathshrieks?" White Hands seems stunned by this.

"There are lots of them now, apparently," Adwapa quips dryly.

"So I have a better idea," I say. "We free our sisters from the Warthu Bera, and then we march on the Grand Temple, wrench Elder Kadiri from his roost, and bring him back to Abeya, where we can learn from him what we're dealing with—Angoro, Idugu, you can discern the truth of it then. Or do you have a better plan?"

White Hands looks away, thinking. Sorting through the possibilities. I know she doesn't believe me about Idugu, but she can't dismiss the theory. Experience has taught her to consider

all avenues, same as it has me. She might not like what I have to say, but that doesn't mean she won't consider it.

Finally, she turns back. "Very well, Deka," she says, "just don't get caught."

"I know what I'm doing," I say, offended.

"So did Melanis, and she was trapped for centuries by the jatu."

An excellent point.

"I won't get caught," I promise. "None of us will."

White Hands snorts. "A cocksure attitude like that is certain to get you killed." Her eyes narrow. "Don't get killed either."

"I'll try not to," I return. Then I peer at her. "By the way, White Hands, are you certain you've never encountered Idugu before?"

She frowns, thinking. Then her eyes widen. "I did," she gasps. "The day I was birthed, the mothers—" She stops, her eyes glazing over.

"White Hands, are you all right?"

"Deka," White Hands murmurs, her face slack. "Did I tell you? I just spoke with Melanis."

Alarm tenses every muscle in my body. I exchange a look with Keita before turning back to her. "I know," I finally say. Then I lick my lips, forcing myself to ask the question I'm almost afraid to ask. "White Hands," I say tentatively, "were you ever—"

White Hands shakes her head, suddenly seeming exhausted. "My strength is flagging," she abruptly says. "I will return tomorrow, when I've recovered. You and I must speak."

Just like that, she's gone, and Keita is staring at me, unease written across his face. "I've seen that look before. . . ."

"Me too . . . ," I whisper. It was the same look that Melanis had. The same one all those who allow the mothers to erase their memories wear.

I stare toward where White Hands vanished, unnerved. One thing is now starkly clear: her memories of Idugu have been erased—from birth, apparently—which means the mothers have not only known about Idugu since the beginning, they distinctly don't want us to know. Why? Why erase both White Hands's and Melanis's memories to keep us from knowing? Why not just swear them to secrecy?

Why go through all these diversions just to lie to us?

Lie . . .

The word jolts through me, terrifying in its implications. The mothers are lying to us. But they always told us gods don't lie. That gods are infallible. Suddenly, my chest is so tight, it feels as if a boulder's sitting across it. The ground is shifting under my feet and everything I thought was true is now upended. The only thing I can do is ask myself one last question: If the mothers can lie—if they've already been lying to us all this while—what else are they lying to us about?

◆

"I thought gods couldn't lie." I repeat these words to Belcalis in a low voice as we scurry along the river market's corners later that afternoon.

It's the predinner rush, so all the boats are crammed together now, connected by little bridges to allow customers free flow from one to the next. Tusked river cows splash idly in front of the larger boats, massive iridescent-scaled purple creatures

that are much stronger than their plump, vaguely bovine bodies would suggest. They're always a peculiar sight, something of a homely cross between fish—what with their scaled bodies and flippers—and the cows they're named after, only they also have gigantic tusks jutting from their fleshy lower lips, and rolling humps of fat on their back. They're the ones that pull the largest boats from port to port, ensuring that the market is constantly moving from one end of the river to the other so as not to damage any one part of it. This portion of the Agbeni River may be smaller than most of Hemaira's other waterways, but it still coils through the middle of the city, where a thousand elegantly terraced and gardened houses press cheek by jowl with each other. If any part of it is spoiled, much more than just the market would be affected.

I glance around, trying to get my bearings. As before, not a single woman is present. This river market used to be filled with female traders and customers in the most incredible masks, but now, there's not a hint of a mask to be seen, not a single brightly trimmed robe—although I do notice a few shadowy faces in the windows of the houses overlooking the river.

Where have all the women gone?

Looking up at those windows, I have a terrible suspicion about the answer.

Belcalis moves closer to me, tugging her cloak tighter around her face. "Well," she finally replies to my question. "Lying isn't the only inconsistency we've uncovered. The mothers were also supposed to be infallible, and only alaki were supposed to resurrect or turn to deathshrieks, but I suppose neither of those were true either."

Of everyone, she seems the least surprised by the revela-

tions of the past hour. But then, she always expects the worst of everyone. It's a survival strategy that's stood her in good stead thus far.

"At this point, we have to accept that certain things are true," she says. "The mothers are lying to us about Idugu, which means, one"—she ticks off the number with her finger—"they can lie. Two, they have history with Idugu. And three, he or it must be quite powerful for them to go to such lengths to deny its existence."

"And," I add, shivering, "they ensured that White Hands and Melanis don't know about Idugu—or rather, can't remember what they know.".

"Which means that the other Firstborn likely don't know, or remember, either," Keita whispers. He's here with us, a silent shadow at our backs. The others are spread out all across the boats in little groups to avoid attention. "Likelihood is," he continues, "we're the only ones from Abeya who do."

"But then why would they tell us that story about the angoro and its wielder?" I ask, my brows furrowing. Any way I think about it, it doesn't make sense.

"Because it must exist—the angoro, that is," Keita says.

He stops, pulling us into the shadows of a busy delectables boat filled with tiny stalls selling skewers of roasted meat, spiced moi moi, and the like. Evening is fast approaching now, so the darkness of the shadows creates a strange intimacy, like we're the only ones here.

"I mean, why would they be so insistent we find it and its wielder? The only answer is, the angoro exists, and it has something to do with Idugu—just not what we think it does."

"Perhaps it's a weapon," Belcalis whispers. "That could be

why it's so important. The generals are always looking for better, stronger weapons. But it's an arcane object, so it would have to be something truly unique. A destroyer of armies, perhaps, or—" Her eyes widen, as if something momentous has occurred to her.

She turns to us. "What if it kills gods?"

"What?" I stop midstep. "You think the mothers want to kill Idugu?"

"Perhaps. I don't know." Belcalis shakes her head. "All this is just supposition and theorizing. We don't know if any of the things we just said are true. We know nothing—"

"Yet," I say firmly. "We know nothing *yet*. But right now, we can at least try to puzzle everything out. Prepare ourselves for any eventuality." As we failed miserably to do in Zhúshān.

Keita nods, already moving toward the next boat, but as he does so, Belcalis pauses, cocking her head. "Do you hear that?"

I frown. "Hear what?"

"That." She turns toward the imposing columns at the market's main entrance. There's a sound coming from the street beyond it, an immediately recognizable one: footsteps. Heavy, ominous—inhuman.

"They're coming!" a man shouts, panicked. "The Forsworn are coming!"

The market erupts, merchants packing up their stalls, panicked customers jumping into the water. The river cows bugle their fury at this interruption, tusks flashing warningly, but the men in the water keep swimming, undeterred. It's chaos now, everyone fleeing in all different directions as fast as they can. So we begin moving as well.

"Watch your step!" Keita calls, body swaying when an angry river cow slams into his boat.

"Same to you!" I shout as I leap lightly onto the next boat. It's easy now that all the merchants and customers are running for safety, rats abandoning a drowning ship.

Behind us, those footsteps are getting closer, frighteningly familiar in their heaviness. It's the purple deathshrieks. I don't have to look back to know that it's them—that they're the ones everyone is calling the Forsworn.

"This way, everyone!" Li calls, running onto a nearby road, Katya and Nimita large shadows leaping across the rooftops above him. "Sanusi Square's this way!"

We quickly follow his lead, all of us remaining in the same groups in case we have to split up.

"Here!" Li says triumphantly as he bursts around the corner. Then he stops.

The moment I turn the corner, I do the same. Sanusi Square, the once bustling, thriving plaza that connected many of the capital's busiest streets and waterways, is now eerily devoid of people. Instead of stalls and bright little shops, macabre little platforms now line the square, female corpses in numerous states of decay displayed on them. The most alarming are the golden ones, of which there are four—one at each corner of the square.

Disgust roils my stomach. So this is what Hemaira has become.

And it's all my fault.

I stop where I am, feet suddenly unable to take direction as I absorb the horror, the desolation that is now Hemaira. The

very desolation I caused. I was the one who insisted on freeing the mothers to create a better world, but instead, I created this: a world of cruelty, of torture and deprivation. A world where women are forced into the shadows and their slaughtered bodies displayed in the streets for the world to see. My body is trembling now, a peculiar emotion expanding inside me. Something past pain, past rage, past guilt. A strange sort of numbness as I look up at the city I once knew.

Deka! Ixa urges, circling worriedly around me. He's flapping ahead in his bird form, keeping an eye out for potential ambushes.

"Deka, keep moving!" Keita urges, pulling me along. "Li's found a hiding place!"

I force my feet to move again, following without thinking, but even as I do, I see the massive purple figures steadily marching into the square from the side streets. The Forsworn. They're corralling us in, ensuring that we have no place to hide.

"Hurry, Deka!" Keita pulls me into a narrow alleyway where the smell of fish is so pungent, it blocks out every other smell.

Massive reed baskets pile up at its end, next to the sluggishly moving river that butts up against the last building, and they're all filled with rotting fish. But Keita and the others are moving toward them. I stiffen, the disgusting proposition jolting me out of my shock. "You can't mean for us to—"

"Get in," Keita says, pulling me under an empty basket. And that's that.

The basket closes around me, enveloping my senses with the odor of rotted fish, and Keita huddles closer, his eyes only barely visible in the dim light that filters in through the tiny holes in the basket's weave. "I know it's awful," he whispers, "but the fish

smell should block their noses, while the river should confuse their ears. All we have to do is remain extremely still and we just might get out of this one."

I nod, since that's the only thing I can do. The odor is so strong now, it's like a physical presence barreling up my nostrils, but it's nothing compared to the devastation I feel. Everything I've just experienced circles my mind—Zhúshān, the revelation about the doors, about Idugu and the mothers. And now there's this—the depravity that is Sanusi Square—and I can't do anything, can't even think of helping the girls on those platforms. My friends and I are all trapped here, the Forsworn no doubt closing in, and even if I could reach the mothers right now, I'm not certain I would. All this time, I've trusted the mothers, done everything they asked. But they've lied, and now I'm questioning my own actions.

I try to remain in the present, but it's nearly impossible here in the darkness, all my fears rushing up at once. I listen for the Forsworn's rhythmic footsteps, try to latch onto them, but they've stopped. Or, rather, they are no longer marching, but instead seem to be shuffling around.

"What are they doing?" I whisper, pressing closer to the front of the basket.

"Nothing good," Keita replies ominously.

Even as he says this, I hear it, the banging of massive fists on doors. It's followed by a very familiar sound: screams, mostly male, but a few female too. I try to squint and see what's happening through the basket, but all I see are shadows, movements. "What's happening?" I whisper, edging impatiently closer.

I try to squint past the basket's weaving. I wish I were nearer. I growl under my breath, annoyed. I wish I could see.

Almost the moment I think this, a peculiar prickling travels up and down my spine. *Yes . . . ,* Ixa says, his voice echoing in my mind, and then, suddenly, we're both winging off the roof we're perched on.

We're?

I blink, startled, as I feel the sudden lightness of my body, buoyed into the air above Sanusi Square by my wings catching a warm current. *Wait . . .* I nearly plummet, I'm so startled. *My wings?* No, *our* wings.

Ixa, I gasp. *What is this? What's happening?*

Something similar to a shrug twitches through Ixa's body. Well, *our* body, that is. *Ixa and Deka one,* he answers simply.

This answer so stuns me, I almost don't even notice that Ixa's saying actual words instead of just my name, something he's only done on a very few occasions. I'm immersed in his mind now, he and I tightly intertwined, although we're somehow still individual entities. This has to be one of the strangest experiences of my life. The closest I've ever felt to this is the time I spent in Melanis's memories, but that was a completely different situation. When I was in Melanis's mind, I became her. But with Ixa, it's almost as if there's a space in his mind just for me, one that allows me to be myself.

Deka want see? he asks me eagerly.

Yes, I say, understanding him clearly. *I want to see the square.*

I force myself to remain calm as he maneuvers his—well, *our* body—dizzyingly closer to the square. The Forsworn death-shrieks look frighteningly enormous as they drag screaming citizens out of their homes while lines of jatu stand by, waiting, that jatu-leader deathshriek standing there with them. As

before, they and the jatu are all wearing infernal armor with the kaduth on it, only it doesn't affect me this time. Doesn't so much as elicit a tingle in my mind. It's as if being in Ixa's body protects me from the symbol.

The deathshrieks force the citizens to the center of the square, where two wagons stand, one brightly decorated with the kuru, Oyomo's sun symbol, the other heavily armored and reinforced with iron—a prisoner transport. My eyes return to the first wagon when two jatu open the door and kneel in deference to the three figures emerging from it. Only one, a plain temple maiden with short, tightly coiled hair and blue-black skin, is unfamiliar. The other two I know all too well: Elder Kadiri and Elfriede.

"Deka. Deka!" Keita's voice sounds panicked but far off in the distance, so I ignore it as I watch the elder and Elfriede walk to the middle of the square, those jatu guarding them while the deathshrieks herd everyone nearer.

The elder holds out his hands in a revoltingly pious display of welcome. "Honored citizens of Hemaira," he calls to his reluctant audience. "I am Elder Kadiri, high priest of Oyomo. I greet you in the name of Idugu. May He shelter and deliver you."

"May we be sheltered. May we be delivered," the crowd answers nervously, glancing at each other.

"My deepest apologies for pulling you from your evening duties, but today is a most auspicious day." His eyes travel across the crowd. "You see, today, the most favored daughter of the Gilded Ones, the Nuru, Deka, is here, hiding among you."

I nearly fly into a wall, I'm so shocked.

Ixa fly, Ixa chirps, swiftly taking back control of his body.

Unlike me, he's not bothered by what's happening below us. As I've suspected many times before, he doesn't truly understand what's happening—only that it's bad.

Ixa quickly settles on the edge of a roof, and we watch the proceedings below, where shocked whispers are now building in the crowd.

Elder Kadiri taps his lips in a mockery of thoughtfulness. "We must entice her out, but how? She won't emerge just for your sakes. Even if we threatened to put you to the sword, the supposed Deliverer"—he says this word with all the condescension he can manage—"would not risk her immortal life for your human ones. So we must lure her from her hiding place."

He nods to a nearby jatu, and the hulking man walks toward the heavily armored wagon I saw before, the prisoner transport. What's in it? I wonder, my heart suddenly beating faster and faster. Or rather, who?

Elder Kadiri points to it. "Before she was revealed as the Gilded Ones' daughter, the Nuru, Deka, had another family. A human family. I think it's time we facilitate a reunion."

My world narrows as the jatu opens the wagon door and wrenches out the person inside it—a frail, thin man, body hunched into itself, tattered and stained rags hanging from his body. The sight of him is so shocking, my mind jolts out of Ixa's body and back into my own.

"Father," I say, suddenly breathless. "It's Father."

17

❖ ❖ ❖

I'm in such a state of shock when I return to my body, it takes some moments before Keita can calm me. "Deka? Deka, are you all right?" he whispers, rubbing his hands soothingly up and down my back. "You're having some sort of episode."

I turn to him. "It's Father," I repeat. "I was in Ixa's body and I saw him—oh gods, they have him!"

"What do you mean, they have him? And . . . Ixa's body?"

I'm so far gone now, I can barely string two words together. Everything comes out as a babble. "I wanted to see the square, and Ixa, he just—I don't know—he allowed me into his body, and I saw Father there, in the middle of the square with Elder Kadiri and Elfriede. They have him—oh, stars above, they have him. Ixa, take me back!" *Take me back!*

When I repeat this command silently, Ixa's voice comes, as it always does, in my mind. *Yes,* he says, and just like that, I'm in his body again, and we're hovering high above the crowd, where those jatu are now leading Father over to Elder Kadiri.

Dismay has my wings faltering when I near him. He's changed so much over the past year or so. He was already sickly when last I saw him, but now, his once thick blond hair is so sparse, it forms little patches on his scalp, and his body is barely more than a skeleton underneath the rags fluttering about him. Chains clank loosely from his emaciated wrists and ankles as he shuffles toward the center of the square, his head bowed, eyes fixed on the ground. When he struggles to catch his breath, something shatters inside me.

I thought, after I woke the goddesses, that I would never feel anything for him again—this man who betrayed me, handed me over to the priests, and then cut off my head, but now that he's here, kneeling on the platform below me, it's all I can do to keep from running to him, holding him in my arms and protecting him from the world.

Deka all right? Ixa asks, concerned.

I'm all right, I answer, saddened. *Fly closer.*

Ixa obligingly descends to the branches of a nearby amarul tree, and then we both watch as the jatu bring Father to Elder Kadiri, who points a condemning finger. "This man—this beast—who is an offense to our eyes and Oyomo's—has something to say to you all."

He nods, and one of the jatu brings forth a metal horn and shoves it in front of Father, who then shakes his head pleadingly at Elder Kadiri. The elder, however, is unyielding.

"Speak," he commands harshly.

Father's entire being seems to collapse into itself. He seems so small now, so frail. . . . I've never seen him this way, not even when he was suffering the depths of the red pox.

He turns to the crowd, clears his throat, his voice painfully

small as it emerges through the horn. "Evening greetings, followers of Oyomo."

There's no answer except for scattered sounds of disapproval. Tension is growing in the crowd. Anger. Everyone is frightened, uncertain, and here stands Father, the supposed reason they've all been dragged from their homes. A convenient scapegoat.

Father seems to know this, because he glances around warily. "I do not have the right to address you. I am a sinner in your eyes, in the eyes of Oyomo." He falls to his knees. "I am the most monstrous sinner of all! Forgive me, forgive me!" He bows to the crowd, forehead hitting the dirt with each movement, but this concession only serves to incite their rage.

"Traitor!" someone shouts, a clod of dirt flying Father's way.

It splatters his robes, leaving a bright red stain on the ragged cloth.

"Father of demons!" another calls, and that's all it takes for the floodgates to open, more dirt flying, sharp little stones—anything the crowd can get their hands on, really.

With each hit, Father bows more and more, as if his prostrations will appease the crowd, appease whatever guilt he has festering inside him.

When people begin throwing dung at him, the jatu finally step forward, sternly call for silence. "That's enough!" the loudest one shouts.

It takes a while for the crowd to quiet. They're in a frenzied state now, their anger heightened, their thirst for violence whetted. And it's all concentrated on Father, who's still cowering and bowing. I watch the entire while, my muscles frozen even as my thoughts whirl frantically.

How did Father get here?

He was supposed to be safe in Irfut, secure in the knowledge that I, his alaki daughter, his own personal shame, was dead. He was never supposed to connect me to the Nuru rebelling against Hemaira on behalf of the goddesses, never supposed to recognize what I had become. Deka is a common enough name in the Southern provinces, and more important, my features have changed over the past year: my skin is darker, my once loose curls are tightly coiled now, and my eyes are black instead of the gray I was born with. Add to that the fact that all the posters only barely resemble me, and he was never supposed to put two and two together. And he was most certainly never supposed to be here, a captive of Elder Kadiri.

Not once, in all my fevered imaginings, did I imagine this.

Elder Kadiri glances around the square. "Deka, if you hear me, and I'm certain you do, we'll be executing your father tonight."

The words stab through me, but I don't move.

Deka all right? Ixa asks, concerned.

Yes, I reply, but it's all I can do to breathe as Elder Kadiri continues, that awful pious smile on his face: "Will you let him die, Deka, or are you an honorable daughter? Are you a daughter who will give her life to save her father's?"

"No!" To my shock, it's Father who blurts out this refusal. "No, Deka, you've already died once because of me! Do not risk yourself again!" He's standing now, shouting so loudly, everyone can hear him.

Elder Kadiri's face purples, his mask of calmness replaced with fury and disbelief. "You would dare?" he hisses. "You would

dare go against the will of Idugu—your god?" He gestures for the two jatu next to Father to restrain him.

But Father's beyond listening to him now. "Deka, if you hear me, I have something important to tell you! Your mother, she's alive. She's—"

One of the jatu backhands him onto the ground just as I gasp back into my body, startling a panicked Keita. "Deka, what's happening?" he asks, his eyes wild as he embraces me. "You were elsewhere again, and I couldn't reach you—I couldn't—"

"My mother, Keita. Father said she's alive!"

"What?" Keita frowns, seeming confused. "What are you talking about, Deka? Your mother's dead. You told me so yourself."

"I did, but she's alive, Father said so."

"And you believe him? The man who beheaded you himself?" Somehow, Keita has gone straight past confusion about the situation to incredulity about Father, but I don't have time to explain what's happening. If I don't hurry, the jatu will take Father away and then I'll never find out what he was trying to tell me about Mother.

"I have to go," I say, rising. "I have to rescue Father!"

"Deka, wait, what are you—"

But I'm already jumping out from under the basket, running full speed ahead toward the end of the alley. *Ixa, come!* I say. *Let's get Father.*

To my relief, my companion immediately flaps down, already transforming into his true form, although he keeps the wings as he does so. Footsteps sound behind us as I hop onto him, and I whirl to find Britta approaching, confusion in her eyes.

"Deka, where are ye going?" she asks. "I heard ye say somethin' about yer father?"

"He's alive," I explain, already grabbing onto the spikes on Ixa's back. I won't let anyone talk me out of this—not Keita and certainly not her. "Elder Kadiri has him in the square, and he said Mother's alive. I'm going to rescue him."

To my surprise, Britta just nods. "I don't understand half of wha ye just said, but I'm with ye, Deka," she says, determined. "I'm comin' with ye."

Without even waiting for me to protest, she clambers onto Ixa's back, hefting her war hammer at the same time. "Britta!" Li calls, rushing out from their basket.

There's a look in his eyes, a panic similar to what I just saw in Keita's, but I don't have time to dwell on it. Britta's coming with me. We're going together to rescue Father. No matter what happens, it's she and I. Together as always.

"Ye go on ahead. We'll meet ye at the park," she says to Li as the others also emerge, confused.

I, meanwhile, studiously avoid Keita's eyes. He's approaching Ixa now, his voice pleading. "Deka, think about what you're doing," he cautions. "Whatever you think you saw, it's probably a trap by Idugu. You have to be prudent."

I nod. I'd considered that possibility, but I'd also considered another: if what I heard was true and I ignored it and missed this chance, I'd never forgive myself.

"My mother's alive," I reply, determined. "And Father knows where. I'm going to rescue him. I'll meet you at the park by nightfall."

"But, Deka—" he begins, so I look him in the eye, trying to convey all my feelings.

I know that what I'm doing is foolish—that I'm risking both myself and Britta. But I've made my way out of worse situations, and she's made her choice to follow me. I nod at him again.

"I love you," I say simply, and I dig my knees into Ixa's sides, Keita's gaze burning into my back as we ascend into the air.

When we swoop down on Elder Kadiri mere seconds later, his eyes swiftly brim with unholy glee. "I knew it!" he crows as Ixa lands. "I knew you would not forsake your father!"

I barely spare him a look as I vault toward Father, Britta and Ixa clearing the way for me. There are so many deathshrieks here. So very many. But they're not as fast as I am in the combat state, and I can be nimble. All I need is to be nimble. Fear rises, but I force it down. I have no time for it right now; I have to rescue Father.

Desperation powering my footsteps, I slide past the jatu-leader deathshriek, his body a blazing white to my eyes, which have already changed due to the combat state. I can feel my body leathering and lengthening, my fingers sharpening to claws. When I catch a glimpse of a kaduth, I quickly fix my eyes on the ground, following the movements of the deathshrieks' feet. As long as I can focus on them and not that awful symbol, I'll be fine. I can get Father out of here.

I hold this plan in my mind as I dodge and dance and weave and within moments, I've reached Father and those jatu, who are just now forcing him into the wagon. I wrench him out of their hands with such force, both men go stumbling.

Father glances up at me, a mixture of astonishment and horrified fascination in his gaze. It's one thing to know your daughter is the Nuru everyone is talking about, another to see her in the mottled flesh, her body looking like a deathshriek's.

"Deka," he rasps hoarsely, his body swaying as if it's too weak to remain standing. "You came." There's a strange smell in the air around him, but I ignore it.

"Hold on tight," I say, hefting him over my shoulder. Then I'm running faster than I've ever run in my life, my legs fast as the wind as I dart between the deathshrieks, evading flashing claws, thrusting spears.

I'm like a dancer in a masquerade—whirling, twirling, escaping until finally, I'm there, just beside Ixa, who's now surrounded by a crowd of deathshrieks.

Deka! he says, relieved as he bites a nearby deathshriek's hand off.

The creature shrieks in agony, the piercing sound causing Father to twitch, pained. I'd almost forgotten he was human and therefore easily incapacitated by deathshriek screams. I immediately whirl up, slashing the deathshriek's throat. As it falls, I leap over it, then heft Father onto Ixa, who immediately flaps his wings, already ascending. I hop on as well, then call to Britta, who is still fighting off nearby deathshrieks.

"Britta, let's go!" I shout.

"Coming!" she says, running to me, hand outstretched.

I grab it as Ixa swoops up, and just like that, we're aloft, Ixa winging for the park where the others are headed. I see them, specks racing along the alleys, Katya and Nimita sleek shadows in the swiftly falling darkness as they leap from roof to roof above them.

The moment we're clear of the square, Britta begins to laugh, a slight tinge of hysteria in her voice. "We made it, Deka," she says, shocked. "I can't believe we made it!"

I nod, my entire body still shaking. "I can't believe it either,"

I say, glancing at Father's back, which fills up the space in front of me. I tap his shoulder. "Father," I ask, "is Mother truly alive?"

"Deka . . ." Father turns to me, seeming almost confused. "You're truly here." Then, as if remembering my question, he nods. "She is . . . Umu, she—"

A loud thwack cuts him short. I glance around, trying to see where it came from, until a soft, pained grunt sounds. Then Ixa is falling.

My stomach lurches up as Ixa plummets, his wings struggling to flap or even make a simple motion. "Ixa?" I shout, panicked. "Ixa!"

Deka, he replies hoarsely, pained as he glances down. There's a spear sticking out of his left side—a very familiar one—and the jatu-leader deathshriek is roaring in victory as we crash into a nearby roof.

"Hold on!" I say, huddling over Father as Ixa rolls, then falls into the alley below.

The spear clacks sharply against the alley's red cobblestones, eliciting another pained grunt from my companion, so I quickly jump down, slicing my palm open as I do so. The spear comes out of his side with a river of blue the moment I tug at it, but I'm prepared, pressing my bleeding hand to his side. The gold immediately sinks into his flesh, and as I watch, relieved, Ixa's side knits itself together, the ragged edges moving under my palm. He's already healing with my blood, just as I expected.

But he's lost too much of his own blood. The more I watch him, the more I notice: I'm soaked in it, the dark blue seeping into my robes as I kneel at his side. There's no way he can carry us any farther, and the Forsworn deathshrieks are closing in, their footsteps coming closer and closer. I glance around, trying

to find an escape route, then hear rushing water. There, a massive river churning through the middle of the city. The main body of the Agbeni. I breathe a sigh of relief when I see just how close it is to us. All we have to do is cross it. We can escape the moment we do.

I swiftly rise, grateful when I see that Britta is holding Father tight. *Come on, Ixa!* I encourage. *Change to kitten form for me.*

Deka, he says. A weak but obliging reply.

He quickly shrinks into his kitten form, and I gather him into my arms before I turn to Britta, about to urge her on. I stop when I see the expression on her face—the sadness.

"Deka," she says softly, her eyes sad, so very sad.

She looks down at Father, and I immediately hear it, the horrible rattling sound emerging from his chest. "Deka," she whispers again, her eyes worried as she looks at me. "He's—"

"I know," I say quickly, trying to stop her before she says the words. I know what that sound means. Every warrior does.

Britta glances to the end of the alley, where the Forsworn's footsteps are approaching, then back at me. "I can buy you time," she says suddenly. "A few minutes is all I can do."

"Thank you," I say, even though the situation we're in has just begun to sink in. We escaped the Forsworn once, and I'm still not sure how we did that; Ixa is injured; the Forsworn are approaching; and Father is—Father is—

As I breathe, trying to push past the thought, Britta steps in front of me and raises her arms. I'm still in the combat state, so I see it, the power rushing up through her body as she stomps down into the Unmoving Earth, a form I recognize from our lessons with Karmoko Huon, our former combat instructor. The Unmoving Earth is meant to center a fighter during one-on-one

combat, but I don't know what use it'll be here, when there are so many different opponents. Nevertheless, I keep watching her, caught by the power rushing inside her like a wave of white light.

For a moment, nothing happens. All there is, is that power . . . Then white arcs downward as the power explodes out from her feet, pouring like an ocean of light into the ground. The minute it disappears, a rumbling sounds, distant and faint . . . and then a wall of stone erupts in front of us.

And another.

And another.

Before I know it, we're completely enclosed in a small, triangular structure, the three stone walls so tightly fitted together, only the barest hints of light filter through the cracks at its sides. Britta's built us a fortress—one made entirely of stone and her energy . . . of which she's used too much. I can see how weakened the light is inside her, as it used to be inside me when White Hands first trained me to use my abilities, and my heart twinges. I'll have to show her how to channel it, how to control the power growing within.

If we somehow make it out of here, that is.

Her work done, Britta slumps down, her body exhausted. "I don't know how long it'll hold against them," she says wearily, her eyes closing. "I'm just going to take a quick nap now."

"It'll hold as long as it needs to," I say quietly, grateful for her efforts.

And even if it doesn't, I'll somehow make do. I have no other choice. That awful rattling is so loud now in Father's chest, there's no more ignoring it. Father's on his deathbed.

It's time for us to say goodbye.

18

◆ ◆ ◆

When I was a child, Father was a burly, robust man, hair golden like sunshine, eyes as gray as storm clouds. In my mind, he was a mountain—a towering figure of a man who would swing me up on broad shoulders and make me feel like I could touch the sky. I thought he was eternal, immovable, like the mountain he resembled. I was wrong. And now, all that's left of the powerful man I once knew is this thin, skeletal figure with that awful death rattle vibrating his bony chest.

When I see him lying there, a mass of filthy rags on the dirty floor of this hastily cobbled shelter, a sob catches in my throat. "Father," I whisper as I creep closer to him.

I can hear the Forsworn outside the nearest wall, their claws scraping against the rock, but it doesn't matter. Nothing does anymore. Everything that's happened between us before—his betrayal, his abandonment, even all my questions about Mother—suddenly doesn't seem so important. I reach toward him, only to jerk back, startled, when the odor of acrid sweat

and urine, the musk of rotting flesh, assaults me. So that's what I smelled earlier.

"Father," I whisper, horrified. Seeing him in this state is almost more than I can bear.

Father turns to me and smiles sadly, gray eyes unseeing in the darkness. "Deka," he says hoarsely, "it really is you. I thought I was dreaming . . ."

His hands reach up, and I flinch back despite myself, all those awful memories rushing in. The last time I saw his hands, he had a sword in them—one he used to cut my throat. Now, however, those fingers are almost gentle as they reach toward me.

"I've had such dreams, Deka, such horrible nightmares." Father coughs again, so powerfully this time, I can hear the fluid sloshing in his lungs.

I swiftly sink back beside him, no longer caring when the odor assaults me again, no longer even hearing the Forsworn pummeling at the fortress. "Father," I say, clasping his hands. They're so cold. So very cold . . . "You have to hold on. If you hold on, I can take you somewhere, find a healer. I can save you."

I put my hands under him to lift him up, but another sob chokes my throat. He's all skin and bones. I'd noticed it before, but to actually feel it . . . He's so airy now, he might float away, might disappear forever, if I don't hold him close. A tear trickles down my cheek, and I blink, startled by it.

"I'm going to take you away from here," I say, determined.

But as I rise, a skeletal finger wipes away my tear. I look down to find Father's eyes glowing feverishly.

I push away the thought.

"There's no use, Deka," he whispers. "It's already too late,

you know that, don't you? And even if it weren't . . ." He turns wearily toward the fortress's walls, where that pummeling has been replaced by the low thudding of massive bodies against stone.

Thankfully, the fortress doesn't budge. Doesn't so much as shake. Britta truly did build this fortress with all her strength. I'm dimly aware of her stirring now, watching us with tears in her eyes.

I return my gaze to Father. "No," I say to him. "I can get you to a healer. I can get you to safety." All my resentment, all my anger—all of it has fallen away, leaving only this desperation, this strange, fierce certainty.

All this time, I thought I was angry at him, but really, I was sad. He was my father, and he threw me away. The moment the priests came, he abandoned me, betrayed me when he should have loved me—when I loved him. The thought chokes me, a realization a little too late to accept.

This entire time, I loved him.

I thought I was strong, that I'd replaced every memory, banished as much of him as I could from my mind, but in fact I'm still the same little girl I was, seeking his affection. His love.

Father shakes his head, the movement so weak as to be nonexistent. "There's no time anymore, no cure—not for something like this." He pulls aside the top of his robe, and the smell intensifies.

I gag, my eyes watering when I look down and see the wound in his chest, darkened at the edges, round and deep. Something white wriggles inside. Maggots. Vomit rushes to my throat, and I hurriedly set him back down on the ground before I rush to the farthest side of the shelter and hurl up all the food Lamin

stole for us earlier this afternoon. When I'm done, I wipe my mouth, hands trembling, and return to him, studiously ignoring the thudding of jatu bodies against the shelter, the distant shrieks, the enraged commands of Elder Kadiri. If I focus on the here, the now, it's like they don't exist. Like they're not even here.

"It's pretty, isn't it, the light," Father whispers. He's staring toward the last few trickles of sunlight coming through one of the shelter's cracks, but it's not clear how much of it he's actually able to see. It's like he's already halfway gone, his spirit ascended but his body still here.

Then his eyes wander back toward me, oddly vacant. Even in the gloom, I can see that. "I know I don't have any right to ask this, but could you come sit by my side again, Deka? Please," he whispers.

It's the first time I've ever heard those words slip from his tongue, and they shake me to the core. I do as he asks, every muscle in my body trembling so hard, it's as if I've been thrown into a freezing lake and held under until my body turned to ice.

"I've had a lot of time to think over the last year," he whispers, his voice barely a rattle now. "A lot of time to pray, to reflect. To repent." He reaches his hand toward me, and I take it, trying not to notice how thin it is, how easily I can feel the bones rolling inside. They feel fragile, like I could crack them as easily as eggshells.

"I'm sorry for not protecting you, Deka," he rasps. "I'm sorry for not being a good father. . . . I have no excuses. None that would ever justify how I treated you. When your blood changed, I should have spirited you away, should have run with you. Even in that cellar, I should have turned my sword on the

elders, but instead I turned it on you. My only child. My only daughter."

The words echo through me—a reminder. "Father," I begin, heaviness settling in my heart. "I think there's something you should know. I'm not your true—"

"I knew you weren't my blood." Father's eyes gaze into mine, piercing despite their vacancy. "The moment Umu put you in my arms, I knew you weren't mine. You looked like me—even acted like me—but something deep inside me told me you were unnatural. That you were like her."

The words are no less than a sword through the heart.

Tears burn my eyes as I try to pull my hand from his, but Father's grasp tightens, strangely strong for someone so weak.

"I loved you all the same. Both of you." He smiles sadly, his eyes filled with tears. "I loved every part of you—every breath you ever took. It didn't matter what you were, Deka. You were mine, and I should have protected you—I should have saved you. But I listened to the Wisdoms. Went against my own deepest inclinations because of what those scrolls, the priests taught me. I was a coward, a fool unworthy of the gift I had been given, and for that, I am sorry. So very, very sorry."

He rummages in the tatters of his robe and pulls out something, which he presses into my hand.

When I open it, the breath leaves my throat. It's Mother's necklace, the one he took as I lay dying on that cellar floor. He places it in my hands, then leans forward, so his forehead rests over them like a prayer.

"Can you ever forgive me for what I did, Deka?" he whispers. "Not now, but perhaps one day in the centuries to come—can you forgive the weaknesses of this foolish and prideful man?"

"I forgive you."

The words gasp out of me so swiftly, I immediately know that they're true. I forgive Father for everything he's done. I forgave him the moment I saw him in that square, bowing to a crowd that reviled him, protecting me with the last breaths he took, even though it went against his nature to stand up to others.

"I forgive you," I say again. "I forgive you."

"I am glad," Father replies, the words less than a sigh now. His eyes are even more vacant, and I know they can't see anything anymore. "I am glad I am forgiven. Now I can go be with Umu again."

I blink. "But I thought—"

"I see her sometimes," he whispers, his grip slackening, that rattle suddenly even more prominent. His fingers are cold, so very, very cold. "She watches me from the edge of the village. She always looks the same as she used to, my Umu. Always so beautiful. Unchanged from how I remember her. She's alive, you know. Alive here." He pats his chest, then smiles at me, a beatific expression wreathing his face. "Sometimes she whispers to me at night, gives me messages for you. She says to tell you that she's alive, that she's waiting for you in Gar Nasim . . ."

Gar Nasim. I force myself to smile back at him. Of course.

Gar Nasim is the island Mother always wanted to visit, a wondrous place hidden so deeply in the ocean between Otera and the Unknown Lands, it's taken on mythical status.

Of course, Father would imagine her there. Of course, he would imagine Mother alive.

A sob chokes me, but Father's eyes turn blindly toward that crack in the wall again, as if seeking a light only he can see. "I think I see her now," he whispers. "I think she's coming for me."

His hand lifts weakly, a small greeting to a person who exists only to him now. "Don't walk so fast, Umu," he says with a smile. "I'm coming, my love. I'm coming home . . ."

Another breath rattles his chest, and then, silence.

Just like that, Father is gone.

❖

It's silent afterward. Empty. As if all the air has gone out of the shelter and left only the darkness and the shadows behind. Mother's necklace feels heavy in my hand, so I slip it into my pocket. Then I close Father's eyes and place my cloak over his body.

And I just sit there.

Time passes—exactly how long, I'm not sure. I have no understanding of how the minutes flow, how the seconds waft past. All I know is that it's night now, and everything is still. Peaceful. It's as if the world has stopped and it'll never start moving again. And I don't want it to move. I just want to sit here in this silence and let the darkness take me where it wants.

I'm barely aware of the tears streaming down my cheeks, barely aware of a weakened Ixa curling around my neck in kitten form, of Britta tugging at me.

"—eka, we have to g—"

Everything is in pieces now. Light, sound, movement—everything. Silver flashes at the corners of the fortress, and Britta desperately points at it: a gigantic iron hook is prying open the walls of the fortress, but I don't care. I don't care if they come crashing down, if Elder Kadiri dies or doesn't die, if

the world burns around us. I want to sit here in silence and be still. Just for once, I want to be still.

"I told you she'd never leave him."

Elfriede's triumphant voice accompanies the sudden implosion of the fortress's walls, and when I look up, I find her standing in the alley just behind the fallen stone, Elder Kadiri at her side. An entire contingent of jatu accompanies the two, more pouring in from the square beyond. Ixa growls, his body bristling at them.

Strangely, the Forsworn are nowhere to be seen. The purple-and-gold deathshrieks have all somehow disappeared, replaced by these jatu, who are now wearing death masks, ornate affairs usually made for corpses that are molded after their owners' features. The dullness inside me tinges with an ugly darkness at the sight of them. The village elders would have had one made for Father if he'd died back in Irfut. They would have buried him with a copy of the Infinite Wisdoms—given him at least some measure of ceremony to smooth his passage to the Afterlands. But he'll have nothing of the sort here.

The reminder turns me even colder inside.

I put Ixa down, then rise, pick up my atikas, barely aware of Britta standing protectively in front of me, her war hammer in hand, even though she can barely lift it.

"Deka," she begins worriedly, but I push past her.

I don't need her protection anymore.

"Another trap," I say, my voice strangely distant as I look at Elder Kadiri. "Well done."

Somehow, I'm not dismayed to have been caught by the priest, although I'm distantly curious as to why he replaced the

Forsworn with all these jatu. I don't dwell on the question, however. Another strange feeling is stirring somewhere deep inside me. *Relief.* Cold and stark. My father lies dead behind me, and in my hands are two atikas while a contingent of men wearing death masks are lined up in front of me, all of their lives ripe for the plucking.

Considerate of them, to come so prepared. It's almost as if they want me to massacre them.

Of course, I will oblige.

Deka? Ixa asks, but I shake my head.

No, Ixa, I reply. *There's no running this time.*

Not now. Not ever again.

I ignore him and Britta as I walk toward Elder Kadiri and Elfriede, palming my atikas, savoring their weight. As expected, the pair both have the kaduth emblazoned across their robes, as do the jatu, only it's on their breastplates, as always. Strangely, it doesn't bother me anymore. Nothing bothers me now. I am entirely cold. A creature of ice and snow.

"How long have you been planning all this?" I ask, more out of curiosity than anything else, as I reach them. Between the trap Elder Kadiri set at Zhúshān and this, it all seems very well thought out.

"Months," the elder acknowledges. "I know how your goddesses work. More to the point, I know how that bitch Fatu conducts her dealings."

Ah . . . There it is again, that word. Any time pious men want to level an insult, they have to dredge it up. But I'm not bothered by it. "Her name is no longer Fatu, you know, it's White Hands," I say calmly. "She decided to adopt it as her new name for this new age." I don't bother addressing the other word, the

insult. There's no point, when I intend to do so using the sharpened edges of my atikas.

"Fatu, White Hands—it doesn't matter what you call her. The first of the war queens is the same as she ever was: an abomination, a curse upon this empire." Elder Kadiri sneers. It's almost soothing, actually, seeing all that hatred pour out of him, watching as his true colors emerge.

"I spent countless years studying her, reading of her exploits," he continues. "Of course, she would send you, the Nuru, to complete this task. She's maneuvering you, isn't she? Building your legend, your power? But that's what she does, which is how I anticipated her—except you did that little trick with the doors, tried to spirit yourself away. . . . Thankfully, Idugu tracked you here. He has complete power over the city, you know. When He told us you'd returned, I knew we had to bring your father. He was the only one who could call to you like that, make you show yourself."

He chuckles. "For all your faults, you're quite the devoted daughter, aren't you, Nuru Deka? The moment you heard his distress, every practical thought disappeared into the ether. Even though he'd cast you out, sanctioned your death."

He glances at Elfriede. "He even beheaded her once, yes?"

When she nods in acknowledgment, something suspiciously close to anger flares inside me. But it can't be anger. Anger isn't chilly and removed like this strange, ugly feeling splintering in my chest.

I watch her through narrowed eyes as she replies, "He did. Then he left her in that cellar with the priests. He knew she was an abomination, an affront to all that is holy. But Idugu is merciful. He sees worth even in creatures like her."

Her voice is suddenly like a nail, grating inside my skull. "Don't talk," I snap, unable to bear the sound any longer. "If you want to live, don't say another word."

I can almost feel her smiling behind her plain wooden piety mask as she replies, "If *I* want to live? You're surrounded, Deka, both you and your foul *bloodsister.*" She sneers out the word at Britta, as if my friend is somehow beneath her. "There will be no escape for you. Just as there was no escape for your father, heretic that he was."

With every word she says, the world fades, changing to a darker, more shadowed version of itself. I'm slipping into the combat state and now, Elfriede is no longer a person—just a person-shaped shadow of bright white, her heart flaring brightest of all. I concentrate on it.

One beat. Two. Three.

Elfriede doesn't notice the danger as she continues spewing her venom. "How I didn't see the darkness in you, I'll never understand."

Elder Kadiri turns, pats her head paternally. "It's not your fault, my child. Evil blinds us. But that is why Idugu is here: to shine the light of truth upon this world. To drive the evil back to the darkness."

Grim laughter rattles in my throat. *Evil?* I glance back at Father, his lifeless body lying there in the broken shards of Britta's fortress, so far from everything he knew and loved. All those years he spent faithfully reciting the Infinite Wisdoms, honoring its every pronouncement, only to end up like this, a forgotten body in a forgotten alley.

I turn to the priest. "We're the evil ones?" I grate out.

"Deka," Britta whispers warningly. She's been glancing

around the alley, no doubt trying to find a retreat, but there is none.

There's only the Agbeni River behind us, but both she and Ixa are too weak to swim. Even if they weren't, the river cows don't look kindly on intruders at this hour of the evening: they're known to gore strangers at night.

There is absolutely no avenue of escape from this dingy alley, and for once, the thought doesn't frighten me. All I feel is a strange, perverse excitement.

Elder Kadiri smiles at me pityingly. "You are the foulest of all creatures, Nuru Deka, a blight upon this land, but Idugu, in His wisdom, feels you can be redeemed. You *will* come when He calls."

"Or what?" I challenge. "What will you do if I disobey his call, execute me?"

"If that is what you wish." Elder Kadiri gestures indolently to the jatu.

And the first wave of men comes rushing forward.

Even before they near, red has hazed my vision, instinct immediately replacing thought. I'm a blur of motion as I cleave the nearest jatu straight through the middle, then move on to the next one. Within moments, sound and color blur, heads rolling, arms flying, blood and viscera spraying the air. A distant pain stabs through one of my arms, and I look down to find it almost completely severed. I jerk it back into place before continuing on, cutting a swathe with my atikas. More heads fall, more guts, more viscera. But I just keep moving. Keep fighting. I don't know how long I'm at it, how long I fight those jatu, only that I continue doing so with such ferocity, there are suddenly no more jatu bodies to cut through.

When I look up, startled, every inch of me is covered in blood, and of our enemies, only Elfriede and Elder Kadiri remain standing, both of them huddled in the center of the alley, having been protected by the men who died.

The ground is so wet with blood now, my boots squelch as I walk over to them. Elfriede squeaks, retreating behind the elder when I near, but the priest lifts his chin defiantly.

I press the tip of my atika to his exposed throat.

"Remind me once again, if you will, of the words you uttered earlier," I say. "I believe you called me evil, a blight upon this world or some such thing . . ."

Elder Kadiri walks deeper into the atika, not even flinching when the blade breaks through his skin. I'm amused to find that underneath the blue of his skin, his blood is red, just like every other human. But unlike most, he doesn't cower when I press the atika deeper.

Brave man. Foolish man.

I'm almost impressed.

"I stand by my words, Nuru Deka," he intones, that irritating look of piety still shining in his eyes. "You are the beast foretold in the Infinite Wisdoms. But Idugu sees fit to reason with you. He sees potential in you, even though I think you should burn in the Fires."

"May you burn in the Fires." Elfriede repeats this malignant prayer in a hushed whisper.

I whirl to her and she squeaks again. Annoyed, I use the tip of my second atika to lift up her mask, toss it away. She scrambles for it, and I sigh. Even in this instance, she's ashamed to show her bare face in front of a man.

Fanaticism is the very worst of diseases.

I grab her arm before she can reach it, then kick the mask away. "No use for that anymore," I say coldly as it shatters against the wall. "All the men who were here are already dead, and he"—I nod to Elder Kadiri—"will soon join them. There's no one here to bow down to anymore. It's just you and me now."

Trembling, Elfriede straightens, turns to look at me. And finally, I see her face, the face of the girl who was once my only friend.

She hasn't changed very much in the year or so we've been apart. Her hair is still that dull, lanky brown, although it's now brutally pulled back, as though any glimpse of it might cause offense. That mottled red mark still blooms across the left side of her face, but it's grown brighter now—or perhaps it's that the skin around it has grown paler. That's what happens to Northern women after only three or four months of wearing the mask. Any color they once had leaches away, leaving only pale skin that's almost transparent from lack of sunlight.

Elfriede's green eyes, however, are still as bright as they ever were.

I keep Elder Kadiri in my periphery as I step closer to her, that coldness still freezing my emotions. I don't bother keeping my atika on him anymore—he and I both know there's no way he can outrun me. "What about you, Elfriede?" I whisper. "Do you still hold fast to the words you said earlier? Both here and on that platform? Do you still think me an abomination?"

Fear flashes in her eyes, but to my surprise, it's quickly pushed back by defiance. My eyebrows rise. A spark of bravery. Who knew the girl who used to run in fear every time a spider crept past had backbone in her?

She gestures around the bloody alley, nostrils flaring from

the stench. "Can you not see, Deka, the monster that you've become?"

She sounds so self-righteous, a bitter laugh bursts from my chest. "*I'm* the monster, Elfriede?" I repeat, incredulous. "Elder Durkas, Elder Norlim—those village elders executed and tortured me for months on end for nothing more than being born as I am, and *I'm* the monster?"

She sneers. "You've always been one, and if they were wise, they would have killed you before you damned yourself and everyone around you to the Fires!" The words rip out of her, as stinging as the wodama leaves Belcalis sometimes applies to her poultices, but I'm not even slightly moved by this display.

I'm beyond any emotion now.

"I'm not damned, Elfriede," I say calmly. "I am the Nuru. I was born of gold and ichor. I am as immortal as my mothers."

"And you will burn in the Fires with them when this is all over," she hisses, the malice so sharp in her voice, it's almost like a dagger. "Just as all the other girls did."

I blink. "The other girls?"

"The other alaki. We burned them everywhere we went," she says smugly. "I told the priests to do it, you know. I told them that if you were in the crowd, you wouldn't suffer it. That you'd reveal yourself if others of your kind were in danger."

"You . . . told them to do it?"

"Of course. They wouldn't take me seriously otherwise." She looks away, seeming uncertain for only the barest moment. Then her eyes meet mine again, a silent accusation. "They wanted to keep me chained, so I had to show them that I was a true believer. That I wasn't like you, no matter what everyone said."

I'm shaking so hard now, I can't even hear the rest of her explanation.

Elfriede suggested that the priests kill other alaki. She herself threw other girls on the metaphorical and even physical pyre. I should be used to it now, the way women sometimes betray other women, the way they align themselves with men, if only to guarantee their own safety, such as it is, but I can't fathom it. I can't fathom that the girl I once shared all my deepest confidences with is the same one oh-so-casually revealing that her commands led to the deaths of others.

I may be the Nuru—I may even be the monster she says I am—but never once in my life have I hurt someone who I didn't think deserved it.

Elfriede tsks softly when she sees the horror in my eyes. "You've always been tenderhearted, Deka, even for a demon. It's a strange thing," she remarks as she marches back to Elder Kadiri. She holds out her hand to him and turns back to me. "May you burn in the Fires," she intones triumphantly.

But the elder doesn't repeat the words, and he certainly doesn't take her hand, only looks down at it with barely concealed disgust. The irony of it almost makes me want to laugh. Even surrounded as he is by his most dire enemies, Elder Kadiri won't lower himself to follow a woman's lead, to even touch her hand. I wonder if he'd ever lower himself to sleep with a woman, but somehow, I can't picture him doing that either.

I catch Elfriede's eyes as I nod toward the elder. "He doesn't touch your hand, do you notice, Elfriede?" When she glances down, startled, I continue softly: "Even now, both of you so near death, and he doesn't offer you the simple comfort of touch. Do you know why that is, Elfriede?" I ask, walking closer. "Because

to him, you're not even fully human; you're a lesser creature. One not even clean enough to touch. He sees you as barely more than an animal. Even though you've sacrificed the lives of others, your own conscience, your own sanity, for his benefit.

"Say what you will about the mothers, but what kind of god do you both worship that he would deny you simple human decency even at a time like this? What type of god doesn't consider you equal to your counterparts?"

"A true one," Elfriede hisses, enraged. "The true god, instead of a pretender, like your bitch moth—"

Her head goes flying.

As I stand there, in shock, Elder Kadiri's swiftly follows suit, his blue skin glimmering in the moonlight. By the time Karmoko Thandiwe steps forward, palming the circular blade she's used for both executions, my ears are ringing and my heart feels like it will burst out of my chest. I double over to vomit, not able to fully register the shock I feel at seeing the tall, muscular Southern karmoko alive and well for the first time in months.

Karmoko Thandiwe tsks as she glances down at Elder Kadiri and Elfriede's heads. "I couldn't stand to hear another word of her bile," she says, irritated. "What a wretched, miserable girl. And he was even worse, so puffed up with righteousness."

She clicks her tongue in disgust again.

I wipe my lips clean. "Karmoko Thandiwe?" I whisper, stunned.

She's approaching from behind me, her dark brown body gleaming in the rapidly falling darkness, and she's not alone. There, accompanying her, are Keita and my other friends, as well as two people I don't know: a plain, earnest-looking Northern boy, with a shock of white hair interrupting the otherwise

stark black, and what appears to be an extravagantly fat woman in a simple wooden mask and a black cloak. A small boat waits on the river behind them, the two river cows pulling it lowing their annoyance. River cows are daytime creatures—they hate traveling at night.

"Deka of Irfut," my former battle-strategy karmoko says, glancing with approval at the carnage around the alley. "Splendid work here—beautifully done—although we should continue onward soon before the Forsworn make their way back here."

"Come on, Deka," Keita says, reaching for me.

But I just keep staring at Karmoko Thandiwe, still in a daze. Try as I might, I can't gather my thoughts. Can't force them into any sort of cohesion. "But I don't understand," I say numbly. "Karmoko Thandiwe, how are you—I mean, you came and Elfriede and—"

My entire body is shaking now, and whenever I turn, I see Elfriede, headless. She's lying on the ground, same as Father, both of them dead in one day. So much death around me.

"I—I—" My body is trembling so hard now, it's all I can do to remain standing.

As my legs collapse, muscular arms enfold me, holding me tight. "It's all right, Deka," Keita whispers, kissing my forehead. "It's all right . . ." He swings me up into his arms.

But as he and the others turn back to the boat, a strange cracking noise begins behind us. A sinisterly familiar one.

"Erm . . . are you lot seeing this?"

Britta's voice is low with dread, and when Keita turns with me in his arms, she points toward her feet, where one of the jatu bodies is twitching, the tendrils of flesh in his severed stomach creeping toward each other while the bones snap into place.

More cracking sounds rise, and we swiftly see the other corpses doing the same, the kaduth shining on their breastplates as their bodies turn golden and the blood pouring out of them takes on that distinctive sheen. It's almost as if the symbol is spurring the change—resurrecting them.

Just as it did back at the Oyomosin.

Understanding slams into me—the kaduth isn't just to stymie my abilities; it has another purpose as well. It allows its wearer to resurrect if they experience a death that isn't their final one. It allows jatu to become immortal, just like alaki.

"Death masks," Acalan whispers, horrified. "They're all wearing death masks. They all came ready to die."

The purest worship is sacrifice. . . . Elder Kadiri's words from earlier ripple into my mind, as does something else—an eerie sound that is somehow both a deep rumble and a frightening whisper.

Laughter. Male laughter. And I'm the only one who can hear it, if the expressions of the others are any indication. That feeling of oily malevolence sweeps over me—the same one I felt when I was staring at the kaduth on that platform.

"Idugu . . . ," I whisper, horrified.

Our deepest thanks, Nuru Deka . . . , the deity says in the mocking rumble of a thousand male voices intertwined. And then I feel it, the power gathering in the air.

When tears in the air above the alley begin to appear, I turn to the others.

"Run!"

19

◆ ◆ ◆

Keita and the others begin running just as the Forsworn burst out of Idugu's doors, their clawed feet skittering over the blood and gore. The ground is so slippery now, the purple death-shrieks can't find any purchase, so they swiftly take to the walls, the lighter-colored leapers, those deathshrieks that usually jump down from trees to claw apart their victims, in the lead. The jatu-leader deathshriek spurs them on, an unholy gleam in his eyes that deepens when they meet mine. He glances down at Ixa, now curled around my neck, and smirks, then points a sword in my and Keita's direction, his intention clear: *you're next*. Thankfully, my group is already charging onto the boat, Keita carrying me as fast as his feet allow. We swiftly board, and within moments, that boy with the white streak in his hair and Katya are pulling up the anchor.

Once everyone is on board, the cloaked woman calls sharply to her impatient river cows, which are attached to the boat by enormous iron chains. "Yakuba, Manty—onward!"

The water churns as the iridescent purple creatures plunge into it, their massive flippers swiftly cutting through the water, their blubbery bodies rippling easily through the darkness. The Forsworn plunge into the water after us, but it's too late. Death-shrieks may be strong swimmers, but even they can't beat river cows in their natural element. And they certainly can't fight them and swim at the same time. Aggressive lows rise into the air as the other river cows in the area converge, intent on driving out the intruders so rudely disturbing their rest. Once they completely circle the Forsworn, I slump against Keita's chest, relieved. I'm grateful to be away from that alley, grateful to be away from that awful, awful laughter.

"Idugu," I whisper, stunned, once I catch my breath.

I still can't believe he actually spoke. All this time, he's been an amorphous presence, but now, I've heard his voice, felt his inhuman intelligence. Now, I'm certain: he's not an arcane object—not by any stretch of the imagination. He's an actual, true god, and he has almost as much power as the mothers. Enough power to raise the jatu from the dead, apparently.

A distant anger burns my chest. All this time, the mothers have told me they were the only gods, that the Infinite Wis-doms were lies. But they were the liars, they were the ones who deceived me, and I can't even reach out to them here, can't rage at them the way I want to. Idugu's influence stretches across Hemaira, so the only thing I can do is hope that wherever this boat is taking us, it's to a place where I can be safe enough to regroup and plot out my next few steps, now that Elder Kadiri, the entire reason we came on this gods-forsaken mission in the first place, is dead.

A movement ripples at my back. Keita. "Deka, are you all right?" he asks, looking down at me. He's been holding me this entire time, his hands never letting me go.

I struggle upright and turn to him, panic rising. "I heard him—Idugu," I whisper. "He spoke to me, and he's real, Keita. He's a real god. A full god, just like the mothers. Only, Elder Kadiri is gone now, so what do we do?"

Keita doesn't seem to hear any of this except for one thing: "He spoke to you? Idugu—he spoke to you?" He almost manages to seem calm as he says these words, but that's what he was trained to do. This calmness, this inability to be ruffled, is a core part of what jatu teach their recruits, and I'm grateful for it, because I'm breaking, splintering apart.

"What did he say?" he asks.

A frown crosses my brow as I remember. "He thanked me."

"For what?"

"I don't know." And that's the thing that bothers me. What reason would he have to thank me? And why would he thank me there, in that alley filled with blood and—

I close my eyes as memories abruptly rise of Father, Elfriede . . . I can see them clearly now, their bodies lying there—dead. A deep, keening wail threatens to pour out, but I can't fall apart—not now, when everything is so dire, when everything I thought I knew is once again crumbling.

Who will put me back together if I do? Who will repair me after all the ways I've been broken by this night? Sobs begin to rise in my throat, until the sound of footsteps forces me to swallow them back down.

The cloaked woman is walking over, leaving that strange boy

at the helm, his brown eyes filled with anxiety as he watches over the river cows, even though the gigantic bovine creatures seem to know exactly where they're going.

"Honored Nuru," the woman says, pulling off her cloak and mask. "It seems you have had quite the evening . . ."

I turn back to her, startled to find she doesn't look anything like I expected. She's not as fat as I'd imagined, for one thing. While she's definitely plump, most of her bulk comes from her massively pregnant stomach, which she carries with ease on her tall, thick frame. Her skin, what I can see of it in the darkness, is the light reddish-brown of the upper Southern provinces, and her curly hair is elaborately coiled with gold thread. She's a noblewoman. I've seen enough of them from a distance to tell.

She pats her stomach once she notices me staring, her round face spreading into a merry smile. "Seven months," she says ruefully. "They must be boys—I already have twin girls, and they were never this big."

She walks closer to me. "I'm so happy to meet you, Nuru Deka, although these are not the circumstances in which I would have liked to make your acquaintance. I am Maimuna, Lady Kamanda, of the House of Kamanda," she says, the words pricking at something inside me. A memory—although I'm not sure of what.

I nod, since it's the only thing I can do. I'm so tired now, so very, very tired. "A pleasure," I say quietly, though I don't mean it.

As Lady Kamanda nods, Karmoko Thandiwe comes forward, puts her arm around her. She's holding her tight, the way Keita always holds me, and immediately, I understand: they're lovers.

Karmoko Thandiwe kisses Lady Kamanda softly on her forehead, then turns to me. "That body in the alley, the one covered with the cloak, that was your father, was it not?" she says, the words twisting into me like a knife.

I nod, my body shaking again. "He's dead," I whisper. "He's gone—my father's gone." Even when I say the words, they don't seem true.

"Oh, Deka," Keita says, wrapping his arms tighter around me, the scratchy cloth of his stolen robes scraping against mine.

He tucks my head under his, so his chin bristles against my forehead.

That's all it takes. I burst into big, painful sobs, my body collapsing from the force of them. Keita holds on to me as I sob and sob and sob, the truth finally taking hold. Father is gone, and he's never coming back. Never again will he swing me up into his arms, ruffle my hair. Never again will he tell me that I'm his sweet girl. He's disappeared, vanished to a place I cannot reach because I'm immortal—unending.

I'll never see him again.

"Shhh, shhh, hush now, Deka," Keita croons in my ear as I cry. "Hush now, my sweet one."

His voice is a soothing vibration, a cocoon of warmth that wraps around me, blocking out the pain, the horror, of the last few hours, the last few days. I rest my face on his neck, inhaling his familiar scent, lulling myself with the slow rhythm of his heart, and before I know it, my eyes are closing, darkness taking over.

And then I'm asleep.

◆

When I open my eyes again, it's late at night. A warm river breeze is lightly ruffling my hair, and an even warmer weight is coiled around me: Ixa, his liquid black eyes gazing into my own, his enormous true form circling mine.

Deka? he whispers, those eyes filled with concern.

I'm all right, I reply, *just sad.*

Sad...? Ixa croons.

I nod. *It's been a very sad day. Can I hold you?*

Deka, he agrees, his body shrinking as he changes into his kitten form. He nuzzles into my shoulder, chirping when I scratch him behind the ears.

Thank you, Ixa, I say, squeezing him tight. *I'm feeling a little better.*

Deka, he chirps happily as a shadow falls over us.

I look up to see Britta staring at me with a worried expression, Li beside her. "Deka, yer awake," she says quietly.

When she nods at Li, who swiftly melts away, my eyes immediately begin stinging. "I am, I was just—" I whirl around, trying to hide the tears, but before I can turn, Britta plops down and wraps me in her arms. I bury my face against her neck, exhaling fast when my chest tightens again. "I can't—I can't—"

Britta rubs my back in soothing circles. "It's all right to cry, Deka," she says. "We're safe."

"No, we're never safe," I whisper. "Never, not when Idugu's around." And I haven't even started on the mothers—all the ways they've lied to and betrayed us. They aren't here, and they won't answer when I call, even though they promised they would.

Even though the world is falling apart around us and jatu are resurrecting the way we do.

Britta pulls away and gestures at our surroundings. "Look,

Deka," she says, pointing at the vastness of the water around us. We're so far from Hemaira's lights now, they almost seem like a mirage.

"We're on Lake Iyema," she says. "That's the largest lake in Hemaira. We might as well be in the middle of the ocean as far as the jatu are concerned. The Forsworn can't reach us here— not unless they have an entire fleet of ships. And even if they did, I'm here; I won't let anything happen to ye, I vow it."

She looks down at me, her blue eyes piercing mine. "Yer safe, Deka," she repeats firmly. "Safe. Ye can cry if ye want."

I shake my head, trying to swallow past the painful lump in my throat. What she's saying is so tempting, but I know better. "I can't," I whisper, pained. "I can't give in to it. Not now, not here."

I can't break again the way I did with Keita. There's no time.

But Britta doesn't seem to remember this as she pulls me closer, strokes my hair. "Oh, my heart," she whispers. "I can feel how much pain yer in, an' ye have to let yerself feel it too. I know ye don't like to feel weak, but grief is like the ocean. It ebbs an' flows, an' it takes ye by surprise. Ye can't control the ocean, my love, no matter how much ye try. Ye just have to follow it where it leads."

"We're in the middle of a task," I protest. "So much is at stake. And Elder Kadiri is dead, but jatu come back now . . ." I sit up as I realize. "Jatu come back, so perhaps—"

Britta puts a finger to my lips. "Ye can let it rest for a day," she says. "Just once, ye can think of Deka an' Deka only. An' besides, I kept my eye on Elder Kadiri's corpse when the others started moving. It remained still. He truly is dead."

I shake my head. "How can you be certain? You saw all those other jatu. There might be a chance, there might—"

"His blood ran blue," Britta says implacably. "Even if the other jatu resurrect, he will not. He's well an' truly gone, and so is yer old friend Elfriede. Ye can weep for her too." Britta pulls up my chin so I can look her in the eye. "It doesn't make ye any less of a warrior to weep. I won't respect ye any less if ye cry for the death of yer loved ones."

Loved ones. Father, Elfriede—despite everything they did, they were still my loved ones.

The dams burst again, the tears coming fast and heavy now, wracking my entire body with their force. This time, they flow for Elfriede.

I remember the girl she once was, so happy and full of hope. But then I became what I was. And there she already was, my closest companion, that red mark like a brand upon her face. How she must have suffered, merely for having known me. The guilt of it eats at me. That bitterness Elfriede spewed, all the things she did—they didn't just materialize from the ether. She must have paid dearly for my actions—so dearly, she began hurting others and twisting herself in the process.

I should have found a way to rescue her. Should have saved her the way I did so many others. But I didn't. I didn't even spare a thought for her. And now she's dead. As are many, many alaki.

The tears continue to flow, an entire ocean of salt, until finally, the ocean finds its end. I remain quiet and still while Britta wets a cloth in the lake, then gently wipes my face and hands.

"See," she says cheerfully once she's done. "Now, don't ye feel better?"

I blink, then nod, surprised. I actually do.

I'm feeling so much better, I can actually look up when a robust form strides past us—Lady Kamanda. "All right, everyone," she says, gesturing to the dark, empty water. "Here we are."

As I frown, looking at the nothingness of the lake, a loud creaking sounds, and then the air in front of us shimmers. A massive gate slides open in front of us, its panels the same reflective material as the wall supporting it, the wall I didn't even notice before, it's so well camouflaged. Lanterns blaze suddenly, illuminating the gatemen on top of the wall sliding open the gate, as well as throwing light across the island rising in the distance and the sprawling estate at its center, set amid rolling hills.

My jaw drops at the sheer size of it.

The estate could encompass the entire Warthu Bera, it's so massive. And beautiful as well. Among its whimsically carved bushes, sleek little nuk-nuks—bright green miniature deer that camouflage themselves as moss during the day—are playing hide-and-seek, while brilliantly colored birds and even zerizards, those lizardlike winged creatures with crowns of bright red and blue plumage, roost in the colossal mabureh trees that sprout with cheerful abundance. Looking at it all, I finally understand why Lady Kamanda's name plucked at my memory. The Kamanda estate is one of the Ibujan, the famous seven sisters, a group of islands in the middle of Lake Iyema, each closed off by nearly invisible walls that protect the estates of the city's wealthiest families.

"Would you look at that." Asha gives a long whistle of appreciation as the river cows pull the boat into the island's harbor, where a line of splendidly robed servants lie prostrate on the ground, awaiting our arrival. Even from here, I can see that they're all wearing the same intricately threaded hairstyle,

golden combs and jewels supporting their coils, and yet more gold in the bangles encircling their wrists and feet.

A small, neat man sits in front of them, his elaborately embroidered green robes the very picture of elegance as they drape over his golden chair, which, strangely, has wheels on each side. Jeweled rings twinkle on his hands while a tuft of pink horsehair sprouts from his golden fly whisk. When he lazily flicks it at a buzzing insect, I turn wide eyes to Lady Kamanda. Only the Orbai, the highest class of Hemaira's lords, can hold a golden fly whisk.

Lady Kamanda just gives me another merry smile as the man glides forward, the wheels on his chair seemingly moving by themselves, as he extends his hand to help her off the boat. Embracing him, she says to us, "Welcome to the House of Kamanda. This is my husband, Lord Kamanda."

As I stand there, blinking, Lord Kamanda bows his head toward me with an ornate flourish. "Honored Nuru, I am most pleased that you are visiting our humble home," he says in a high, twinkling voice, his tone so earnest, I can almost ignore his choice of the word *humble* to describe this monstrosity of a dwelling. "I trust my wife has aided you well on your journey." He smiles at Lady Kamanda, not even blinking when she and Karmoko Thandiwe walk forward, arms around each other.

"She has," I say quickly, trying not to betray my surprise.

Most of the relationships in Abeya would seem unusual to the outside world, but to see one like this here is something of a shock.

Lord Kamanda notices my reaction despite my efforts. "Ah, yes—our marriage," he says, amused. He leans in conspiratorially. "You see, in times of old, this is what would be considered a

marriage of convenience. We both love each other with all our hearts—just not in the romantic sense." He beckons me airily. "Come along now, honored Nuru. We have urgent matters to discuss." His chair turns and glides forward—again, seemingly by itself, except now, I hear the quiet whirring coming from inside it.

It must be some sort of automaton, like the ones Karmoko Calderis used to make in her forges when she wasn't perfecting the newest weapon. Speaking of which . . . "Where are the other karmokos?" I ask Karmoko Thandiwe, but she just shakes her head.

"Alive," she says. "We'll discuss it at dinner."

As I nod, following her, Keita catches my arm, pulls me back. "You all right, Deka? I can take over if you wish."

I look up at him, search for a truthful answer. "I'm not all right," I say finally. "Everything feels strange, and my emotions are like this . . . knotted thread I can't even begin to unravel. But I'm managing . . . I think I can manage." Even as I say the words, I know I'm not sure of them.

"You don't have to," Keita replies. "You can just stop. I know you want to know what's happening, but I'm here. If anything feels too much, I can take you away. I can appoint someone else to lead. I'm here for you."

"We all are," a quiet voice says. Tears sting my eyes when I see Li and the other uruni nodding. "We're all here, Deka."

"Us too," Belcalis says solemnly. "We all know what it's like to lose family."

My chest tightens as I look at my friends, all the love and support shining in their eyes. "Thank you," I manage to breathe out.

Then I follow Lord and Lady Kamanda into their house.

20

◆ ◆ ◆

The Kamanda estate is just as imposing inside as it is out—arching ceilings so high, it's almost dizzying to look up at them; bright stone floors with pretty inlaid patterns. Statues stand along the walls of each room, their faces covered by intricately detailed golden masks the size of serving plates. Just one of them could feed the entirety of Irfut for at least a decade, and that's not even considering the jewels that stud a few of the more imposing ones. And as if that weren't enough, a profusion of rare flowers and vines curls around the columns that border the colossal windows, which are open to the warm night air. Outside of Abeya, this is the first time I've seen so many plants inside a home. More to the point, this is the first time I've been in a family dwelling this massive, outside of the former emperor's palace. I didn't even realize such a thing was possible.

Amusement dances in Lord Kamanda's eyes as he takes in our gaping mouths. "I remember when I first came here," he says fondly as his chair whirs along. "I spent an entire afternoon

lost in the east wing. Maimuna had to send one of the maids to come looking for me."

Britta frowns at this, surprised. "Wait, so Lady Kamanda is the one who—"

"Owns all this?" The cheerful nobleman gestures around. "Originally, yes. Even the name, Kamanda, came from her family. But as you know, Hemairan women can't inherit property. It passes to the oldest brother or, if there are no living male heirs, to the husband of a female heir."

Lady Kamanda nods. "My father was the last of his line, so I chose Sandima as my husband. Every day, I thank the gods I found him."

Lord Kamanda kisses her hand. "No," he corrects her. "We found each other." The two beam at each other fondly, love gleaming in their eyes.

I glance at Karmoko Thandiwe, who's walking alongside them, the quiet boy who I'm now certain is her assistant, just behind her. I hope she's happy, being part of this unusual little family. Lord and Lady Kamanda, for all their massive wealth, seem to be very kind people, and anyone who's spent as much time in the Warthu Bera as Karmoko Thandiwe has is sorely in need of kindness.

I continue following the trio, who lead us to a large veranda overlooking the lake, a massive table straining under the weight of the food laid out there.

"And here we are," Lord Kamanda announces with a triumphant flourish. "A dinner fit for the children of gods." He beams eagerly at us, almost like a child showing off a favored toy. If I were in any other state of mind, I probably wouldn't be able to help being amused by it.

"It looks magnificent," I say finally, causing Lord Kamanda's grin to spread even farther.

Despite my sadness, I truly mean it. The meal spread out in front of me is unlike any other I've ever seen. Cheeses from the Northern provinces, assorted stews and grilled vegetables, the most delicately spiced desserts—all of them arranged in a manner to tempt the eye, their combined aroma merging into a single, delectable essence. But the events of the past few days have completely taken my appetite, not to mention all my fears about the Warthu Bera and our bloodsisters there. It might as well be ash to me.

"Karmoko Thandiwe?" I say as Lord Kamanda pulls out a chair for me at the head of the table, easily maneuvering around in his own. "How is the Warthu Bera? How are our bloodsisters?"

"Are you certain you want to discuss this now, Deka?" she asks gently while the nobleman fusses over my place setting. Next to me, the quiet boy is doing the same for Nimita and Katya while nervous servants hover around Keita and my other friends, since they're too frightened to approach the death-shrieks.

Every once in a while, the boy frowns at Katya, though I don't understand why: she's made it a point to ignore him, turning her face whenever he peers at her.

"Why don't we speak tomorrow, when you're in a . . . better frame of mind?" the karmoko asks.

I try to breathe away the hysterical giggle that bubbles up at her choice of words. *Better frame of mind.* What a way to refer to the brokenness I feel. "Tomorrow won't be better," I say, shaking my head.

Or the next day, or the day after that. I don't know how things will ever be better again. But I don't say any of that out loud. "I need to know now," I finish.

"Very well," the karmoko says with a sigh, nodding to Lady Kamanda. The noblewoman flicks a finger at her servants, who quickly melt away, as silent and unobtrusive as shadows.

Karmoko Thandiwe takes a deep swig of her palm wine. "The situation is dire," she says. She regards the expensive white spirit for some moments before glancing back up at me. "There's no other way to put it: everything is dire.

"After you defeated the emperor in the N'Oyo Mountains, the Hemairan army rushed back to take the city, and the first thing they did was storm the Warthu Bera. Huon, Calderis, and I and most of the girls resisted, but there were so many casualties . . . so many . . .

"We swiftly realized we needed subtler measures of resistance if we had any hope of freeing anyone. So Huon and Calderis pretended to surrender, and I pretended I'd been killed."

"Wait, so they're still there," I whisper, horrified. "All my friends?" I'd already suspected that this was the case, but hearing it verified is worse than I could have imagined.

Karmoko Thandiwe nods. "That is the truth of it."

"What about Mehrut?" Adwapa cuts in, agitated. "Is she all right?"

The Karmoko hesitates before nodding. "More or less. She was one of the stronger ones. The stronger ones they bleed for their gold, since they can't risk them escaping and helping the others. They use the weaker ones to work the forges."

Adwapa deflates, and Asha quickly embraces her, whispering in her ear.

"I don't understand," Kweku says, frowning. He's sitting at the other end of the table, next to Katya and Nimita. "Why didn't all of you just leave and go back with reinforcements the minute the jatu attacked? There are training grounds all across Hemaira. Surely you could have all banded together."

"Banded together." Karmoko Thandiwe seems bitterly amused by the thought. "Not all karmokos in the training houses share our support of alaki, and even if we all did band together, we wouldn't have the numbers. Finally"—Karmoko Thandiwe turns to him—"what does the phrase *Warthu Bera* mean, young uruni?"

" 'House of women,' " Kweku replies, confused. "What does that have to do with anything?"

Belcalis rolls her eyes. "What do men tend to do when they're in a house full of young, pretty women?" she asks pointedly.

"Oh." Kweku looks down, nauseated.

"That, young man, is why we couldn't all just leave," Karmoko Thandiwe says.

It's all I can do not to give in to the horror churning in my gut now. "So the jatu, they've—"

"No," the karmoko replies. "Not while Huon and Calderis remain there, ensuring that any man who places one finger wrong never sees the light of day again." She shifts closer to me. "For months now, they've been entering the caverns, killing the jatu when they can and frightening them when they cannot. They almost had those superstitious fools believing that the Warthu Bera was cursed until the priests assigned a new commander, Xipil. He started locking the caverns at night. Thankfully, the men are still too spooked to do anything. But it's only a matter of time before they begin testing limits again."

Even with this warning, relief settles me. "So you've truly kept the girls safe all this while."

"Huon and Calderis have," the karmoko says, "and while they did so, I've searched for places to hide the girls—like-minded people to plead our cause once we've freed them from that awful place. That's how I found Maimuna." She smiles fondly at Lady Kamanda, who smiles back.

Belcalis, however, is not so easily impressed. She turns a suspicious eye to the noblewoman. "Why would you help us?" she asks. "You're human."

"Precisely."

When we all stare, confused, Lady Kamanda continues: "It is precisely because I am human that I help. How can I see what is happening and not feel for the alaki? Or for myself? After all, what happens to your kind happens to human women as well. You've seen Sanusi Square, all those bodies there. No matter what we are—human, alaki—we're all female."

"Some of us." This interjection comes from Karmoko Thandiwe.

Lady Kamanda smiles. "Some of us," she agrees.

When I glance at Karmoko Thandiwe, confused, she explains, "I am neither male nor female. I would consider myself more of a they than a she."

That makes so much sense, given everything I know about the karmoko, I just nod as Lady Kamanda continues. "We have to free your bloodsisters, Nuru Deka, get them out of here. Out of Hemaira. And hopefully, one day, you and your mothers will return and take back this city."

My mothers. The words churn up all the doubts inside me, immediately banishing my thoughts about Karmoko Thandiwe

and their earlier revelation. I touch my ansetha necklace, trying to feel the goddesses' presence, but it's silent once more. If only I could contact them. If only I could learn more about them as Anok—

I blink as my thoughts take a sideways motion. What was it I was thinking?

When I look up, Keita is staring at me strangely. "You all right, Deka?" he asks.

I nod and watch as Belcalis turns her gaze to Lord Kamanda. "What about you?" she asks. "Why help us?"

He smiles lightly, seeming not the least bit intimidated by her glare, which can be the most threatening of our entire group. But then, he isn't scared of the deathshrieks either, which tells me that for all his bright smiles and airy words, Lord Kamanda is a man whose depths we haven't even begun to plumb.

"Just because I'm male doesn't mean I don't have a conscience, child," he says. "Besides, my sort is only barely tolerated. Thanks to Maimuna, I am one of the wealthiest and most powerful men in Hemaira, but no amount of money or power can erase the fact that I prefer the company of men to women. Right now, everyone turns a blind eye, but should I step one foot out of line . . . well, you understand what happens to people like us, don't you."

Belcalis nods curtly. She's very familiar with the horrors that can befall anyone who doesn't fulfill the roles expected of them.

"Of course I would help. I have a heart, I feel. I empathize. I know how difficult it is to live in a world that doesn't accept. And I happen to have the privilege of being able to throw money at anything that distresses me. My house and purse are at your disposal."

I nod to him gratefully. "My thanks," I say, managing a smile when he nods back.

"So what's the plan, then?" Keita asks, turning to Karmoko Thandiwe. "I assume you have one for freeing the Warthu Bera."

They nod. "Of course. And Huon is currently gathering more information for us. But, you know, there are tunnels under the Warthu Bera. The jatu may have blocked them off, but I presume you're still as strong as ever, Britta?" she says, glancing at my friend.

Britta grins. "Stronger, even." She picks up a pebble from the floor, and I feel the quick jolt of power run through it. Both Lord and Lady Kamanda gasp when it thins into the shape of a dagger. "And now, I can command most forms of earth—stones especially."

"Wonderful!" Karmoko Thandiwe claps. She doesn't seem the least bit flustered by Britta's new gift, but then, she's never been one to startle easily. "Well, then, shall we go over plans? We have very little time. The jatu know they are being sabotaged. They're intent on routing the saboteurs."

She turns to me, but I begin to nod out: a wave of tiredness is crashing over me, so powerful, I can't imagine sitting here another minute. "Can you inform me of what you discuss later?" I ask, rising. "I need to rest."

"Of course," Lord Kamanda says, hurriedly moving away from the table as well. His golden chair whirs toward the doors. "I'll show you to your room."

Keita does the same, following behind us. "I'll help," he says. I shake my head. "No, stay, eat. Discuss."

Keita shakes his head. "I'm not leaving you alone," he says firmly. "Not in your state. I'm coming."

"Us too," Asha and Adwapa say together.

"Then why don't we all rest?" Lady Kamanda concludes, rising. "We can continue our conversations over the next few days. A mission such as ours takes careful planning."

"Indeed," Lord Kamanda agrees, nodding. "I'll have the servants send food to your rooms."

"Thank you," I reply, relieved, but as I walk out the door, I notice something strange: Katya is standing behind us, a look of longing in her eyes as she stares at that quiet boy with the streak in his hair.

Even stranger, he's staring at her too.

21

◆ ◆ ◆

When I wake, it's late the next afternoon, and the sunlight is a dull orange as it filters through the windows of my bedchamber. I'm still consumed by exhaustion, so I remain in the enormous bed, staring at Mother's necklace while Ixa snores gently by my side. I hold up the delicate golden chain to the light, tears prickling my eyes when I see it's just as I remembered: a thin gold strand with the faded symbol of the eclipse, its rays transformed into daggers, imprinted on the finely wrought golden orb dangling from it. I discovered the significance of that symbol when I was at the Warthu Bera. It's the umbra: the emblem of the Shadows, the spies of the former emperor, Gezo. Mother trained as a Shadow from the time she was a child—practiced their arts until her blood ran gold at age sixteen and White Hands took her on as an assistant, protecting her from being discovered.

Such an extraordinary life, and yet, this necklace is all that remains of her—of both my birth parents. They flitted from this

world as easily as a breeze, leaving only myself and a few others to remember them by. Thinking about it makes that awful heaviness crush my chest, and suddenly, it's all I can do to breathe. My shoulders heave, lungs struggling to take in air. I barely hear the knocking at the door until Keita rushes in, alarmed by the sounds I'm making.

"It's all right, it's all right," he soothes, his arms quickly enfolding me. "Breathe in and out, Deka, slowly in and out."

He demonstrates, one slow breath after the other, and I follow along, trying to wrest enough air into my lungs.

"Yes, just like that," he says as the tears stream down my face like tiny rivers.

I wipe angrily at them, disgusted with myself. Why am I still crying? I was supposed to wake up already reconciled to Father's death, and Mother's wasn't even supposed to be a consideration anymore. I've already dealt with it twice before: first, when I was back in Irfut and I thought she'd died of the red pox, and then when I discovered the truth—that she'd faked her own death to ensure that I was rescued before I went through the Ritual of Purity but was discovered by the jatu and sentenced to the Death Mandate.

"I don't even know why I'm crying," I sniffle, turning to Keita. "I'd already lost him once. It's just . . . he apologized, Keita. He said he loved me, that he was sorry for what he did. He said he was sorry . . ."

I'm hiccupping now, I'm crying so hard. "I know I have four mothers left, but I—"

Keita pulls my head onto his shoulder. The warmth of it seeps into my skin, driving away just a little bit of that choked, desperate feeling. "The goddesses may be your mothers, but

they didn't hold you in their arms when you were a baby, kiss your scraped knee when you fell. They can't replace the parents you had before, and you shouldn't expect them to."

I nod miserably. I already knew that, but my emotions aren't so easily convinced. It's like I've lost control of them, like I'm in that ocean of grief, just as Britta said. Every time I think I'm fine, another wave comes and sweeps me under.

"The worst thing is the anger," I confess. "The anger at myself. I didn't value them when they were alive—especially Father. All that time I hated him, and for what?"

Keita snorts. "For beheading you."

He lifts my chin so I look up at him. "I know you want to remember him kindly, but you cannot forget that the man abandoned you when you needed him most. He not only left you in that cellar to die; he even killed you once himself."

Father in the cellar, that sword in hand.

"A few words of apology cannot erase all that."

I shrug. "I'm immortal. What's a few beheadings between family?"

Keita doesn't laugh at my flippant joke. His eyes remain as serious as ever. "Your father was many things, Deka. Loving and supportive, yes. But he was also cold and cruel. Both parts of him can be true. As much as you want to remember the good, I also want you to remember the bad. He hurt you. Would have continued hurting you if you'd let him."

"I know that, but then . . . what do I do with all this anger?" I clench my jaw as another tear slides down my cheek.

Ever since I was imprisoned in that cellar, it's been there, simmering under the surface, but it's changed since the events of last night. Turned cold. Sharp. Before yesterday, it was the

fuel I used to survive, to keep going. Now, it feels like a dagger, ready to slice me into ribbons. To make me into something cruel and terrifying if I let it.

"How do I make it go away?" I whisper. "I'm so angry right now. I'm so angry at him. Angry at what he did to me."

Keita sighs. "Deka . . . When my parents died, I was in a state for months. Years. I was angry—all the time I was angry. It was like this . . . weight, squatting inside my chest. Forcing me to fight harder, kill more brutally. Shed more blood. All those years I spent, killing deathshrieks, and you know what happened?"

I look up at him. "What?"

"I became the villain."

"Keita, no, you're not—"

"Aren't I?" Keita sits up. "You know how all the deathshrieks stay clear of me. How they always watch me as if I'm not to be trusted with my own sword. And I don't blame them. I've tried so hard, but I know that when they look at me, all they see is the blood staining my hands. The blood of their sisters—your sisters."

"Oh, Keita," I say, embracing him tighter. "I understand. I know what it feels like, having to prove yourself."

He pulls back, shakes his head. "You don't have to do that, commiserate with me. You don't have to twist yourself into knots to make me feel better."

"Then what can I—"

"You can deal with your own problems, your own anger." He scrunches his nose like he's gathering his thoughts, then continues. "It's a useful emotion, anger. That's what our commanders always used to tell us. Anger alerts you that things need to change. The problem is, if you remain in that state, it devours

you from the inside. It confuses your mind and turns you into an instrument for those who would do evil.

"You have to let it out some way. Have to have a proper release for your pain."

I just stare at him. We're only a year apart, but sometimes, it feels more like a century. Keita is so much more mature—more centered, more deliberate. He's had his own tragedies too—his entire family massacred, his years as a deathshriek hunter—but he somehow manages to maintain his quiet, unruffled nature.

Or perhaps, it's just easier for me to think that.

I pull away, remembering now all the times I've seen him exhausted—defeated. All the times I've noticed deathshrieks giving him a wide berth but never pursued it further. Just because Keita is quiet and thoughtful doesn't mean he's not feeling any pain. And I need to be more mindful of that when I speak with him.

"Keita . . . yesterday, when I left you under that basket to go rescue Father, I—"

He shakes his head, those golden eyes almost seeming to glow in the afternoon gloom. "There'll be time to discuss that," he says. "And make no mistake, we will discuss that, because you can't shut me out like that, especially in the situation we were in. But not now, when you're grieving. You need to mourn your parents, Deka. You need to mourn your past life. The others, we talked about it at breakfast today. How can we release your pain?"

I think about it. "When we thought Katya had died, we held a funeral," I say.

Keita nods, thinking about it. "Then we will hold a funeral for your father."

"And Elfriede." We can't forget about her. Even after what she became.

Keita nods again, sighs. "And for Elfriede."

◆

We hold the funeral for Father and Elfriede in one of the Kamandas' many terraced gardens later that evening. It's a quiet, makeshift affair: we light a fire in their honor, then float some paper lanterns representing their mortal bodies onto the lake. As they drift into the falling darkness, I deliver a eulogy that I only half finish, and Ixa makes a low yowling sound that somehow translates all my grief. Keita and Britta hold me when I sink to my knees and cry as if my heart will break. All the while, Lady Kamanda, Lord Kamanda, Karmoko Thandiwe, and the quiet boy watch from a nearby terrace, silent and respectful witnesses.

When it's done, I feel much better. Lighter, somehow. It's as if a weight has been lifted off me, but I know that's just my eagerness to move on from my feelings. It's as Britta said: grief is an ocean. But I'm already desperate for that ocean to find its end.

A tall shadow falls over me as we walk back to our rooms. "Is that your mother's necklace?" Katya asks, peering down at the necklace in my hand. I'd told her of it before, when we first entered the Warthu Bera and were sharing what our lives looked like in our villages and towns.

I nod. "I'm going to wear it again, something to remember her by. To remember them both by."

I had almost considered consigning it to the flames—a symbol of Mother's reunification with Father—but I decided against

it. Wherever Mother and Father are, they've already made their peace with each other. I'm the one who still needs tokens of their existence, reminders to show that they were once alive.

"That's good," Katya says. "It's good to keep hold of the warm memories of the past. I wish I could do that." She glances longingly in front of us, where the quiet boy, Rian, is once more leading the group.

Keita informed me of his identity this afternoon, although I had already suspected from the way Katya kept looking at him last night. Rian is the betrothed she told us about so often back at the Warthu Bera—the boy who tried to prevent the jatu from carrying her away when she was proven impure; the one whose name was the last word on her lips as she died her final death. Only he would make her act as strangely as she has since yesterday.

"Why don't you just tell him who you are?" I say.

"Tell who?"

"Don't play ignorant," I reply. "You know who I mean."

When I glance again at Rian, Katya stills, then looks down at her hands. She's suddenly squeezing her claws into her palms so tightly, blood is welling up from them. She sucks in a trembling breath. "I'm a monster, Deka," she whispers. She displays her bloodied claws to me. "I mean, look at these. I couldn't even hold him anymore if I wanted. I'd probably hurt him. And I can't even talk to him anymore—we speak two different languages now."

Pity sears through me as I take in the truth of her words. As a deathshriek, Katya can't communicate with most ordinary humans. In fact, the only reason Keita and the other uruni understand her is because they're so used to the different deathshriek

growls as well as the battle language they often use, they've become nearly fluent in the language of our resurrected blood-sisters.

I reach out, intertwine my fingers with hers, my eyes widening as memories surge into my mind: Katya and Rian playing in the forest together. Katya and Rian kissing for the very first time by the lake.

He loves me, Katya/I think happily. *Rian really, truly loves me. Can anything be more wonderful than this?*

"Deka?"

Katya's voice scatters away the memories, pulling me back to the hallway where my hand is still intertwined with hers. "Deka?" she repeats.

There's a shaky quality to her voice.

I force myself to push away the last of the memories and look up at her eyes, which are now flowing with tears. She's well and truly distraught. "You're still you," I tell her gently, squeezing her hand. There's still blood on it, but neither of us minds. "No matter what you look like, you're still you. And if Rian ever loved you the way you always say he did, he'll still love you now."

Katya glances nervously back at him. "Deka," she whispers, uncertain.

"He came all the way to Hemaira for you," I say. "Somehow, he found his way to Karmoko Thandiwe, and together, they both found their way here. What is that, if not fortune moving in your favor?"

Katya tugs the quills above her left ear—a nervous habit from the time when she was an alaki. "Do you truly think I should tell him?" she asks.

I don't bother to reply. Instead, I step to the side and look pointedly behind her, where Rian is swiftly approaching. His body trembles with emotion as he watches her tug her quills, a gesture immediately recognizable to anyone who knows her.

"Katya?" he whispers. "It is you, isn't it, Katya?"

Every muscle in Katya's body seems tense as she turns to face him, and for a moment, I'm frightened she'll run away. Then she slowly, hesitantly nods.

"Katya!" Rian gasps, rushing to her. "I was afraid I'd never see you again." As she looks down at him, her body still frozen with uncertainty, he embraces her with all the strength he has. "Katya, Katya," he says, weeping. "I knew it was you. I would know you anywhere, my heart."

I watch the scene, my own heart blossoming, until a hand suddenly tugs at mine. "Let them be," Britta whispers, pulling me in the direction of my room. "Give them space to sort themselves out."

"Love like that, it transcends everything," Adwapa repeats quietly, no doubt thinking of her own love. "If he came all the way from the North searching for her, I'm certain he can find a way to talk to her."

"Now come on." Britta drags me along.

The moment we enter my bedchamber, I slump onto the bed, exhausted beyond belief. Between the funeral, Katya's sudden reunion, and the strange memories I just experienced, I've lost every last droplet of energy I had. So I just remain there, trying to build up my strength.

Finally, after some moments, I turn to the others. "I have something to tell you."

"Is it a new disaster?" Britta asks, flopping beside me. "Everythin' is a disaster these days."

"The mothers are lying to us."

"You already told us that." Belcalis snorts. When I turn to her, she explains. "Seems like every day now, we find a new lie." She ticks off the points on her hands. "First, they say they're the only gods, but turns out there's another who can communicate with us. And they send us on this errand, only they're hiding the true nature of it."

"Wha about how they say they want equality for all, an' yet all the generals are female—no room for men or yandau or any other people." When we all turn to Britta, startled by this assessment, she turns bright pink. "Wha? I've just been noticin' is all. An' I also notice," she adds, turning to me, "how they say yer their beloved daughter an' yet they treat ye as barely more than a pet."

Adwapa jabs a triumphant finger. "That! That's the exact thing."

"I'm not their pet." I glance at the others, startled. "I'm not."

Belcalis places a gentle hand on my lap. "Then why are we still here? The angoro might not even exist, and Idugu is a god, realms above us. Why are we still here?"

I turn to her, frowning. "We're here to rescue our friends and then to find out more about Idugu and the angoro before we take any further steps."

"And then?"

I blink. "And then what?"

"Say, for instance, the angoro exists and you find it. What are you going to do with it?"

"Give it back to the mothers," I say immediately.

"But wha if it's not theirs?" This interjection comes from Britta.

"What do you mean?" I ask, perplexed.

Belcalis sighs. "Deka, if the Gilded Ones are gods and they made arcane objects, it stands to reason Idugu can do the same. They could be trying to steal the angoro from him, using you to do so."

I jolt upright, suddenly unable to remain sitting anymore. My body feels unsteady—almost panicked. It's all I can do to keep breathing. "You shouldn't say such things," I snap. "What if the mothers are watching, what if they—"

"They're not," Belcalis affirms quietly. "They're not here."

I blink. "But—"

"When last did you feel them, Deka?" she asks. As I blink, thinking, she continues: "You don't feel them because they're not here. They have no power here. Only Idugu does. We're in his realm now."

His realm . . . The words jolt through me, and I sit down again, my body trembling with a strange, nervous energy. Suddenly, I'm thinking of everything I've learned in the past few days: the existence of Idugu, male deathshrieks, jatu resurrection, White Hands, and Melanis's memories—even the fact that I can see into others' memories. I recognize now what happened when I touched Katya's hand. It was the same thing that happened when I touched Melanis's tear. I saw into their memories.

And yet the mothers told me I couldn't. Just as they told me, and everyone else, that almost all of the things we've witnessed in the past day weren't possible.

But why lie to us? Why lie to me? That's what I still don't understand. I'm the Nuru, their daughter. Flesh of their flesh,

blood of their blood. I understand why they'd hide things from the others—but me? I don't understand it at all.

"I have a question for ye, Deka," Britta says. "Just one last question, an' if ye say yes, I'll bite my tongue an' let all this go."

I turn to her. "What is it?"

She stares at me, her eyes earnest. "If ye failed in findin' the angoro or stoppin' Idugu, do ye think ye'd be welcome back to Abeya?"

I frown. "Of course, I'd be—"

The words die in my mouth as I think of the powerful gray storm clouds heralding Hui Li's rage, the sighing winds of Beda's disappointment, the sly, creeping mists of Etzli's condemnation. Of all the mothers, only Anok, I suspect, would pat me on the back for trying. The rest would let me feel the weight of their wrath in different ways.

Britta nods, her eyes sad as she takes in my realization. "An' that's exactly wha we're tryin' to say. Mothers—good mothers, Deka—they always support ye, even when ye fail. But I suspect that after all that's happened to ye, yer so used to abuse, ye'll take anything that looks like motherin', even when ye know it's not."

I slump down, the wind knocked out of me, and I suddenly can't breathe anymore. The ansetha necklace is so tight around my neck, it's almost like a collar, choking me. I scratch at it. "Get it off," I whisper. Then I begin to claw frantically at it. "Get it off, get it off!"

"All right, all right!" Britta hurries over, helps me wrench the necklace from my neck, and I fling it across the floor.

The moment it's gone, I can breathe again. My chest has lightened, as if a weight has been lifted from it.

As I breathe, trying to regain my equilibrium, Britta picks up the necklace, frowns down at it. "That's odd," she says, testing its weight. "Does it always feel this . . . heavy?"

I nod. I'd gotten used to that, its heaviness. "It's the ichor. Anok told me the necklace contains blood from each of them. Wait . . ." *Blood from each of them* . . . The words spur something inside me—memories. The blood drop I touched in Melanis's tear. The streaks of blood that transferred from Katya's hand to mine when I held it.

"Where is the answer, Deka?" she asks.

"It's in the blood," I reply.

More memories surface: The way Anok was so careful to have our conversation where no one else would overhear. The urgency with which she cautioned me to remember everything she said. The way her eyes sucked me in and the oblivion after . . . Anok interfered with my memories, that much is clear, but the more I remember, the more I'm certain: she didn't do it to be malicious. It's strange, but it almost seemed like she was trying to protect me.

I glance at the others. "Anok tampered with my memories," I say, my thoughts still distant as I try to piece everything together.

"Wha? When?" Britta gasps, concerned.

"Right before we left. She was trying to warn me, I think. She told me that the answer was in the blood, and just now, I saw Katya's memories when I touched her blood."

"But the mothers said that was because of the ansetha," Belcalis muses. "Why wouldn't they want you to know that you could do that?"

"'Cause they're liars," Britta quips.

"Liars who've been slithering around in your brain," Adwapa adds, the image causing me to shudder.

I already have so many problems with my mind, my memories. And now the idea that the Gilded Ones may have manipulated my very thoughts . . .

My stomach lurches.

"Are you sure that's the only time they've done that?" Belcalis asks.

I look down. "I think so. But I can't be sure, can I?" The thought has me unnerved. What if the goddesses have been interfering with my memories all this time? What if all the things I think are true aren't? Was I truly born in Irfut? Did I experience all the things I think I did?

"I think I'm going to be sick," I say.

"Well, before you go all vomiting again," Asha says hurriedly, "I have a question. Why would they be certain you'd never discover the truth about it—the thing with the memories, that is? I mean, you're around blood all the time. How could they be certain you'd never do it again?"

I stare down at the ansetha necklace, thinking. Then it dawns on me. "I'm always wearing that," I gasp, "but the moment I took it off . . ." I glance up at the others, horrified. "You don't think—"

"That they've been using this necklace to control you?" Belcalis takes the necklace and regards it with the same hostility she would a poisonous snake. "It's quite possible. I mean, the moment Idugu came around, you started changing the doors and such."

"Ye mean the kaduth," Britta corrects. When we all glance

at her, she says, "Yer abilities started growin' when ye were first exposed to the kaduth in the Oyomosin. An' come to think of it, that symbol was all across the Grand Temple." She jolts up. "What if the kaduth not only weakens yer powers, it weakens the mothers' as well? What if it weakens their hold on ye?"

I stare at the necklace, thinking. "There's only one way to find out. We have to get our hands on a kaduth."

"Then isn't it fortunate that we're going exactly where they're being made," Asha quips.

"What?" I frown.

"The Warthu Bera," Britta explains. "Karmoko Thandiwe told us that's what the bloodsisters are being forced to make there—infernal armor with kaduths on it."

"We have to hurry there as soon as we can," I say, rising again, but Britta puts a hand on my shoulder.

"Why don't ye rest a bit, let yer emotions settle, Deka?" she says gently.

When I turn to her, she explains: "Ye've been through a lot lately, an' not to doubt ye, but if ye have a meetin' right now, whatever decisions ye make won't be made from your logical mind."

I sigh. "I know I haven't been making the best decisions lately, but—"

"No, Deka." Britta shakes her head sternly. "Just no. Ye've just had a lot to take in. I know ye might be feelin' overwhelmed right now, but remember, yer part of a family. An' family steps in when yer not all right, an' Deka, yer not all right. Let us take care of things, at least for the rest of today. Ye eat an' then ye rest." Her expression is immovable.

Finally, I sigh, nod. "I hear you," I say.

"Wonderful. Now let's go get dinner. But afterward, it's straight to sleep for ye. We have a busy week ahead of us."

As I nod, I suddenly notice something. Britta's robe is very, very pretty. Much prettier than what she usually wears. "You're all dressed up," I say, curious. "Special occasion?"

"Ye mean like the funeral we just went to?" she asks dryly. Then she huffs. "Stop bein' all nosy, Deka. Are ye comin' to eat or not?"

I look down at the ansetha necklace. "I think I'll remain here," I say. "I'm not very hungry."

"Suit yourself," Britta sniffs as she herds everyone out.

And then I'm finally alone with the necklace.

22

◆ ◆ ◆

It's in the blood. . . . The words whisper through my mind as I pick up the ansetha necklace. Its thousands of interconnected flowers gleam in the low evening light, the ichor inside them seeming to slither almost sinuously. And yet . . . no memories rush into my mind. No strange feelings overtake me. I sigh, staring at the necklace with disappointment. Of course, it wouldn't be as simple as that. The Gilded Ones are gods. They're not easily deciphered, the way mortals are.

I have to go deeper.

That in mind, I inhale, swiftly sinking into the deep combat state until the ansetha necklace glows as bright as the midday sun in my hands. But even then, no memories surface. Not even a hint of them. I growl in frustration. How am I supposed to make this work? How am I supposed to see into the Gilded Ones' minds if I don't even know how to start? I try to think back to the two times I sank into another person's consciousness. What was the commonality in my brushes with Melanis's

and Katya's minds? What was the common thread that bound them together? Both of them were actively bleeding! Their blood was still liquid, which means I have to make the ichor flow.

Hands trembling, I make a small cut in my palm and wait until the blood begins dripping to press it against the necklace. A tingle shivers through my body as the ichor immediately begins to melt, the divine blood slithering down my palm. One moment passes. Two . . .

And then raindrops are falling around me.

No, not raindrops—golden orbs, each one perfect, each one divine. The mothers in their purest forms. The knowledge slides into my mind as easily as water over glass. I watch them shimmering in the air, the goddesses, all of them so close, I could touch them. But I know better than to dare. Just one stroke would be enough to incinerate me, burn my body to ash.

Except I don't have a body . . . Golden light is shining from me—the same gold as all the other orbs, only this one is threaded with darkness and shadows. This is Anok's light. Which means I am her, and she is me. A thrill courses through me at the thought. It's getting easier now, this transition from my own mind into another person's memories, their innermost essence. Or is it perhaps because Anok wants me in her mind? Wants me to see her memories?

The more I think about it, the more likely it seems. There's a strange feeling vibrating between the mothers. A sadness, almost. Regret, perhaps. It overtakes me, and suddenly, I am completely one with Anok as an enormous rift splits open the ground, thousands of tiny figures tumbling in. Horror shatters through us in fierce orange bursts, clouds roiling, lightning sparking.

So this is what we've done, me and my sisters. This is the atrocity we've committed, the reason our sons now despise us.

"No!" I shout to them as more figures go tumbling in. "We must not do this!"

But they just stare at me, their eyes determined. "This is our only path, Anok," they intone, their meaning clear: they are one again, and I am alone. Forced apart from my sisters by my decision.

But that does not mean I do not have power. I push my mind forward, glorying when it brushes against the veil, the barrier of stars separating us from the other realm. Galaxies swirling together, nebulas exploding and contracting around blue-purple stars. It's always there, just as we agreed all those moments ago. Or was it eons? The time, it all whirls together—a blink of an eye, as the humans say. And yet the veil is still there, separating us. Holding us in place.

All I have to do is reach for it.

I turn to my sisters. "Hear me," I shout. "There is another path!"

"We will not be swayed from this one," they reply.

Again, they are a monolith. A single organism. And I am separate.

Sadness falls over me. Stars falling from the sky. A thousand flowers dying crystalline black deaths in a field. My sisters are too far gone now. But I have to pull them back—for everyone's sake. I push my thoughts forward again, so powerfully, they move straight through the veil to the other side. To the Other waiting there.

"No!" my sisters roar. "What are you doing, Anok?"

I ignore them as I reach out my hand, about to extend my

power to the Other. He is alone, just like me. Separated, just like me. Together, we can be one. We can be limitless, as we once were. But as I extend my hand, I feel it, the anger, the malevolence, stirring deep in the darkness. The madness, so similar to that of my sisters. Terror rises inside me in jagged whites, stomach-churning oranges. Volcanoes erupt under the force of my fear.

My sisters and I are not the only ones who've changed. The Other has as well.

Before I can recoil, he's already there, pushing against the veil. "A Gilded One," he sneers. "That is what you have chosen to call yourselves, is it not? I also have a name. I am the Merciless One. Always remember that, Anok. And remember that I no longer welcome you." He pushes again.

And then pain slams into me with the force of a thousand lightning bolts, knocking me out of Anok and back into my own body.

◆

I gasp awake to find myself completely doused in sweat, and my mind reeling. *What was that?*

◆

White Hands appears early the next morning, her reflection shimmering above the stream where I've been practicing opening a door. Or at least attempting. I have no idea how to open one—no idea how to even begin trying. Her arrival is a relief. I've been awake since last night pondering the things I saw in Anok's

memories. What was it exactly she and her sisters did that they regretted? What was that rift that appeared in the ground? And what about the Merciless One? I don't even know where to start with him. He felt like Idugu, except he wasn't. He was a different being from the one I met in that alley, and yet somehow similar. Could there be more gods besides Idugu? And how are they connected to the mothers? I have so many questions now, so many things I can't even begin to understand. Anok's memories, they were all so overwhelming, that the thought of peering into the goddess's mind again exhausts me.

I wipe my hand over my face as the Firstborn's reflection walks closer. "Your memories have been tampered with, White Hands," I inform her quietly. "And that's not even the worst of it. There might be many more gods than Idugu in Otera."

"And morning greetings to you too, Deka," White Hands replies calmly, the early-morning sunlight illuminating her smoothly unconcerned expression.

I frown. "You're not surprised."

"It was always a possibility, my memories being tampered with. And as for the other gods . . ." She shrugs. "You have to be prepared for these things."

"It doesn't anger you, the lies? The manipulations?"

White Hands strides toward me, her reflection almost seeming to walk on the water's surface, although I know that's just an illusion. "Anger is an unproductive emotion. I prefer vengeance. Cold, beautiful—perfect. Besides, there's another thing you haven't considered, Deka."

"What's that?"

"The mothers might not know."

When I stare at her, unconvinced, she sighs, suddenly

seeming vulnerable. It's almost as if she's taking off her mask of strength, allowing me to see the softness, the uncertainty, behind it for the very first time.

"Something happened centuries ago—something calamitous, and yet I and all the other Firstborn cannot remember it. I don't think the others even know, and I'm not certain the mothers do either. Too tired, too strained by the predations of either the angoro or that other god you spoke of, Idugu, to remember . . . But you are the Nuru: you have the memories in their blood, and most important, you are in Hemaira, where many of the answers lay hidden, if only you know where to look."

Everything's suddenly making sense now. "That's why you aren't worried that I'm stuck here. That's why you haven't been trying to find a way to rush me back."

"Indeed," White Hands says simply. "While these are not the ideal circumstances, you are, however, in the ideal place to sort through what is true or not. Is Idugu truly a god comparable to the mothers? Are there others? And what happened all those centuries ago—that cataclysm I cannot remember?"

But now, my guard is up again. "This is like back at the Warthu Bera, when you asked me about who was the real threat—the deathshrieks or the emperor." I frown. "White Hands, what are you planning now? What are you trying to accomplish?"

"The only thing I ever have: safety for my sisters and me."

"But you're using me as a pawn to get it."

"No." To my shock, White Hands prostrates herself, touching her forehead to the ground. "I am acknowledging you as a divinity. One who cares for our kind."

By now, horror has completely curdled my stomach. "White Hands, there are no other gods but the Gilded Ones."

"Then what is Idugu? And what are you?"

"I have no divine powers—"

"—yet," White Hands says. "You have no divine powers *yet*. But you are made of the same matter as the Gilded Ones, and your abilities, they're growing, are they not? Ever since you reached Hemaira, they've been growing."

"How did you—"

She rises, points to my neck. "Where is your necklace, Deka? Why aren't you wearing it any longer?"

I'm trembling now, my mind overburdened by all the things White Hands is saying. "I just took it off for a time, I—"

"I'll ask you one final question, Deka," she says, cutting me off. "What am I?"

"You are the Firstborn of the Gilded Ones," I whisper, unnerved.

A pleased smile traces White Hands's lips. "I notice you did not say 'daughter.'" She glides to me, her feet never touching the grass. "Tell me, when did you start knowing the truth about me?"

I look down, uncomfortable. "I'm not certain."

"Aren't you?" She cocks her head.

I sigh. "It was the deep combat state. The first time I used it, I saw you. All of you."

White Hands nods, turns toward the water. She's almost conversational now as she says, "You know what the strange thing about the mothers is? They say they value all their children, but the ones seemingly born male, they value less. And Idugu, if he truly is a god, seems to favor only the males. It is as if, to the deities, the flesh you were born in is all that matters," she muses.

"But you are female," I quickly say. "You've always been female."

"You know that. But among our sisters, there are some who doubt."

"Melanis," I say. Now, I realize why she and White Hands ignore each other, why they treat each other with such bitterness.

"Melanis," White Hands acknowledges.

I frown. "Does anyone else know?"

"Only the other war queens. But Amataga is lost, and Sayuri no longer counts herself among our number. So in all the world, only you, the mothers, and Melanis know."

"And I will keep it between us," I say.

"My thanks," White Hands replies. Then she nods. "While you are here in Hemaira, Deka, you must use your gifts, discover everything you can about what happened in the past."

Suddenly, I remember the Grand Temple, all those carvings on the walls—a painted chronology of Otera. My eyes widen. Perhaps there's something there that will clarify what I saw when I entered Anok's memories. I have to get back there as soon as I can.

I return my attention to White Hands as she continues: "Speak to Idugu if you must. He might try to deceive you—be prepared for that. And when you are done, report back to me."

But not the mothers . . . The implication slithers between us, lethal in its silence.

"One last thing, Deka: be sure to put names to things." As I frown at her, confused, she explains: "Names are what give things power. Even gods." She walks closer. "For instance, if I call you a god, then you are one. Never forget that."

I swallow, unnerved even by the implication of it. "I'll try, Karmoko."

White Hands nods. "I will return now. As you know, using my gauntlets requires energy. We'll speak again, Deka. Keep alive until we do."

"I'll try not to die," I say, my thoughts still whirling. "You do the same."

"Indeed," White Hands says.

Then she's gone. And I'm left standing there, considering everything that was said.

23

◆ ◆ ◆

The journey to the Warthu Bera takes far longer than I would have liked, mainly because I spend most of the time thinking of my conversation with White Hands—of all the things she confessed to me. What was the calamity that happened all those centuries ago, exactly? Is it what I saw in Anok's memories? More to the point, have the Gilded Ones truly forgotten it, as all the Firstborn have—or are they just pretending to, just as, perhaps, they're pretending to be our benefactors? Even worse than this are White Hands's words, her implications. *If I call you a god, then you are one.* The thought sends shudders down my spine. I haven't told any of my friends about that part of our conversation, nor do I intend to. The idea of divinity is just too big, too awful, to absorb. All the gods I've seen thus far are flawed, distant beings, vastly remote from the people who worship them. Even the mothers sometimes seem alien, like creatures I can never truly comprehend. And they constantly demand worship, constantly demand prayers to feed their power. I have no desire to be a god,

to even entertain the thought. So I remain silent as we continue on our journey, which—much to my dismay—takes place overland this time, as the jatu have been trawling up and down Hemaira's rivers and lakes for the last three days, searching for any sign of us.

Thankfully, we have Lady Kamanda's personal fleet of carriages and are using them now to traverse the city's crowded streets and bridges instead. It's a bold gambit, to be sure: the Warthu Bera is at the other end of the city, and using the roads extends our journey to two days rather than just one, not to mention the fact that the brightly plumaged zerizards that pull our carriages keep preening when passersby stop and gape. Still, it's much lower risk than using one of Lady Kamanda's boats.

"No one would ever expect that one of the wealthiest families in the city is transporting fugitives," Lady Kamanda whispers smugly into my ear as we're waved past a jatu checkpoint near Oyomo's Tears, the colossal waterfall at the very edge of the city.

I nod, returning my attention to Belcalis and Britta, who are sitting on the opposite seat of our carriage, their bodies covered by the same elaborate robes and masks as mine. We're pretending to be the personal attendants of Lord and Lady Kamanda, who, like most nobles of their stature, require a considerable entourage as they travel. Keita and the other uruni share the largest carriage with Lord Kamanda, while Katya and Rian occupy another, as does Nimita. Karmoko Thandiwe is riding a horse at the front of the convoy, disguised as one of the Kamandas' personal guards.

"All right, you two," I say to them, once we're well past the checkpoint. "Close your eyes." When they comply, I continue the lesson I've been giving them on harnessing their abilities.

"Imagine there is a river of white light coursing through your body," I instruct. "Find the strongest current, and pluck at it."

I'm not especially surprised when Belcalis, despite being unable to use the deep combat state to peer into herself, immediately does exactly what she's told. She's developed rigid control over herself these past few months, and it makes sense that control would extend to her combat state as well. I watch, fascinated, as she mentally reaches inside herself and pulls the thin strand of energy from the rest, its edges shimmering an even brighter white than the rest of the energy flowing inside her. Her every movement is calm, controlled, precise—unlike Britta's.

I turn to Britta, horrified, when I sense the energy surging up inside her, all of it headed toward the tiny pebble she has enclosed in her fist. "No, Britta, not so much!" I gasp, but even before the words have left my mouth, the energy has shot out of her, exploding the pebble.

I have only seconds to cover Lady Kamanda's and Ixa's bodies with mine before the carriage's entire interior is peppered by little shards. By the time I move off them, little pinpricks of gold welling from the shards in my back, Britta is slumped in her seat, unconscious.

I give a quick once-over to the lady to ensure that she's all right before I rush to my friend. "Britta! Britta!" I call, shaking her, but there's no answer.

She's out cold, most of the energy drained from her. It'll be some minutes before she wakes. Which is likely for the best, since Lady Kamanda now seems very faint.

"Well," she says. "That was . . . unexpected . . ."

"I'm so sorry," I say quickly, turning back to her. "I didn't expect her to lose control so easily. I should have anticipated it."

It is, after all, exactly what I did during my very first lesson with White Hands.

"Not to worry, honored Nuru," Lady Kamanda replies, brushing off her robes. "I'm quite undamaged. Although I do think I should take another of my carriages while you three practice your . . . arts."

"Of course," I say, nodding, as she pulls the small bell at the side of the carriage to signal the driver.

He lets her out of the carriage, and a few seconds later, Li, now completely swathed in the opulent robes of a nobleman, enters. "We switched places," he announces, grinning.

That is, until he sees Britta.

"Britta! Britta!" he shouts, grabbing her up. When she doesn't respond, he whirls toward me, furious. "What did you do?"

"Nothing," I say quickly. "She just used too much energy during our lesson. Why are you so— *Oh* . . ."

My eyes widen as I abruptly remember how Britta blushed and fidgeted when I questioned her in the wagon back at Zhúshān; how she and Li pressed close together in that crowd even when they didn't need to; how she's been dressing her hair and clothes differently ever since he's returned. Now that I think about it, they've become much closer these past few months. They don't snipe at each other as consistently as they used to and are always off with each other now, scurrying to all sorts of corners.

How did I not see it before? Li and Britta are becoming sweethearts, if they aren't already.

"*Oh*? What *oh*?"

As I absorb all this, Belcalis turns to me, the gold receding from her arms and face—she armored herself instinctively during

Britta's accidental explosion, although the gold was patchy at best. We're going to have to work on getting to full body armor.

"What *oh*?" she repeats, glancing from me to Li, suspicious.

"Nothing," I say, trying to ignore the blush creeping up Li's face. "Let's hurry and continue. I want you to at least have a command of the basics before we reach the Warthu Bera."

Belcalis continues glancing from me to Li, unconvinced. Finally, she sniffs. "As long as it doesn't have to do with our safety, it's none of my concern. Carry on, Deka." She waves imperiously.

I sink deeper into the combat state. "All right," I say, letting the power wash over me. "Let's begin from where we stopped."

◆

The first few stars are twinkling in the sky the next night by the time Lady Kamanda drops us off a short distance from the bottom of the hill that buttresses the leftmost side of the Warthu Bera. To my shock, a slum has sprouted there. The sides and back of the Warthu Bera were always empty of everything but thickets of trees as a preventative measure. Now, however, rows and rows of tiny, hastily built mud and dung huts stretch out to the horizon, all packed so tightly together, there's barely enough room to squeeze between them. Men in coarse robes gather over brightly glowing firepits, eating skewers of roasted meats while the smoke from their bagida pipes befouls the sweltering night air. Thankfully, their eyes are too fixed on Lady Kamanda's procession as it wends past to notice us sneaking over the hill to the thicket of trees at the very back of the Warthu Bera, where the entrance to the caverns lies.

The minute I approach those familiar red walls, rising so far up they seem to touch the sky, I'm filled with a strange, bittersweet feeling that rises over the tension tightening my muscles.

Deka? Ixa asks, curling tighter around my neck in his kitten form.

"Home," Britta whispers, an unwitting answer to his question.

I nod, reach out to squeeze her hand. "Home, where our family is . . . our bloodsisters . . ."

"Our brothers," Keita adds quietly, taking my other hand. He looks at me. "They'll be all right," he says, though I'm not certain whether he's saying this for my benefit or his own.

Karmoko Thandiwe hasn't heard anything from their contacts at the Warthu Bera for the past few days, so we have no inkling what awaits us beyond those walls. An oh-so-familiar fear scratches at the edges of my mind, but I breathe it away. We're here. We have a plan. We can do this.

The bushes rustle as the karmoko walks over to us, Katya and Rian at their side, as always. The trio seem glued together now, although, if I'm being accurate, it's Katya and Rian who follow each other everywhere. When Adwapa glances at the pair with a tinge of longing in her eyes, I walk over and squeeze her tight.

"All will be well," I whisper. "Mehrut will be safe."

Adwapa nods quietly, but I can feel the tension in her muscles.

Karmoko Thandiwe pulls aside a copse of bushes on a section of the wall, revealing a slightly rusted metal gate, an entrance to the caverns only they and the other karmokos know. Once they open it with the large, also rusted key they've kept

hidden under their robes, they turn to us. "You must prepare yourselves," they say. "Whatever is on the other side of this gate, we must conquer it, understood?"

All of us nod.

"We who are dead salute you," they prompt.

Glancing at the others, I add: "Live forever."

"Live in victory," they reply, our new battle call.

When the karmoko looks at us, shocked, I shrug. "We are alaki," I say. "We are deathless." As the others nod in agreement, I turn back to the gate. "Shall we?"

Karmoko Thandiwe nods, grabbing the torch that waits just inside the caverns and then lighting it with a flint. "Unlike you lot," they remark, "we humans actually need light to see in the dark."

"Us too," Kweku adds, raising a finger.

The karmoko nods as they walk inside. I quickly follow, and then I'm engulfed by gloom.

It's dark in the tunnels, and so mildewed, the decay seems to reach cobwebby fingers down my nostrils.

Britta huffs out a breath. "Why does it smell like something died down here?"

Karmoko Thandiwe nods to the group of skeletons scattered along one side of the tunnel.

"Oh," Britta replies.

The karmoko leads us down the passage until finally, they stop at a heavy wooden door, which jingles with chains when they shake the lock, which is melted—as are the door's hinges, I note when I glance closer at them. I wouldn't be surprised to find a stone wall behind the door, they've taken so many precautions to keep it sealed.

"And this," Karmoko Thandiwe huffs, "is why I haven't been able to slip back in. Commander Xipil blocked every possible entrance."

"Not to me," Britta says eagerly, cracking her knuckles. She waits until I stretch my senses out to hear if there's anyone nearby and then, when I give her the all-clear, wrenches the door off its hinges with one swift tug.

Unsurprisingly, there's a wall there too, but Britta punches through it with one blow.

"Well," Li whistles in the admiring silence that follows. "Remind me never to arm wrestle you."

"As if you ever could." Britta laughs, her smile brightening when he does the same.

I peer past the two into the dark recesses of the caverns, which are, as I expected, clear of people. I hear no footsteps in the vicinity, thankfully. It's quite likely that no one heard us. And, as I slip into this new portion of the tunnel, which, much to my relief, has some fresh air wafting through, I silently hope it'll remain that way.

"All right," Karmoko Thandiwe says after I give them an all-clear nod once more. "This portion of the caverns runs underneath the training fields, so we should be far away from everyone for now. First order of business: we find either Huon or Calderis, acclimate ourselves, and then go for the girls."

"For Mehrut," Adwapa reminds them.

"For Mehrut," the karmoko acknowledges.

And as they walk ahead of us, Britta and I breathe and glance at each other, a silent message: *No matter what we confront here, we will rescue our friends. We will help our bloodsisters to safety. We will finally free the Warthu Bera.*

24

❖ ❖ ❖

Even before it became the most feared training ground for alaki, the Warthu Bera was infamous in certain circles as the place where girls trained to become Shadows, the emperor's personal assassins. Most of them were unwilling—poor children forcibly removed from their families as early as age four to be taught how to spy on or assassinate the emperor's enemies. That, of course, explains why the Warthu Bera was built the way it was. In addition to all the pitfalls and other such traps hidden across the grounds, the training complex has two walls, an outer wall and an inner one, separated by a stagnant moat filled with brutally sharp stakes. Those lucky enough to get past the first wall either drown in that moat or impale themselves on those stakes before ever reaching the second one. And that, of course, is assuming they get past all the traps and such, not to mention the contingents of jatu that patrol the battlements every hour upon the hour.

I try to keep this thought in mind as I emerge stealthily

from the cavern's entrance, my ears open for any jatu who might be lurking about. Other than the guards patrolling the walls, the entire complex seems unnervingly desolate—the training buildings cloaked in darkness, the red dirt paths choked with bushes that only months ago would have been ruthlessly pruned into obedience. Even the torches have been dimmed, and now, rows and rows of heavily covered carts rest, neatly lined up, against the inner wall where once my fellow neophytes and I loitered whenever we could, hoping to evade the attention of Matron Nasra and all the other watchful eyes.

Every step I take now has my breath on edge and my muscles tightening.

Where are all the bloodsisters? Are they still shackled in the caverns under the main hall, as Karmoko Thandiwe informed us? Are they still alive? Unharmed? And what about Karmoko Huon and Karmoko Calderis? Karmoko Thandiwe told us the new jatu commander had recently separated the pair to ask questions about all the mysterious deaths happening in the Warthu Bera, the ones they and Karmoko Huon had caused as a way to protect the bloodsisters from lecherous jatu, but they never found out where they were taken, exactly. They had to run before the new commander sealed off all the Warthu Bera's exits.

What if the other two karmokos are dying even now, bleeding on the cavern floors? What if—

"Look, Deka." Karmoko Thandiwe points at a nearby building, where a lone light flickers in one of the rooms.

The combat practice building, where I spent months learning the finer points of battle forms and physical maneuvers. Karmoko Huon, the combat instructor, chose the location very

carefully. It's far away from the rest of the Warthu Bera and isolated enough that if you break a bone or two, no one can hear you scream.

Lots of us broke multiple bones in our first few months of combat practice. Thankfully, they always healed.

Keita stops next to me. "If I wanted to isolate and interrogate someone . . ."

"That's where I'd put them," I say, finishing his thought.

I hold up three fingers in the signal for stealth as I move toward the building. We must not alert the jatu guards there to our presence, especially if there are a lot of them, as I expect there will be.

To my surprise, only two guards are patrolling when my friends and I arrive. Keita, Li, and the rest were all trained in jatu stealth tactics, so I just stand and watch with the others as they deliver a few targeted pinches to the jatu's necks. The two men fall unconscious without even a sound and remain slumped as Keita and Li drag them into the bushes. I watch, tension knotting my shoulders—something about this situation bothers me. Why are there only two jatu guards? Why are they only human? I feel not even the slightest tingle from them, the way I would with our true jatu brothers. And why is the entire Warthu Bera so empty, so quiet?

Belcalis's eyes flicker across the grounds, a frown burrowing itself between them. She senses it too, this eerie stillness. "Something's not right," she says.

Britta nods. "Feels like a trap."

But for whom? The jatu can't possibly know we're here. They're still busy searching the waterways. Nevertheless . . . I turn to Katya and Nimita. "Keep watch."

"Yes," Katya replies, tightening her grasp on Rian.

I nod at them as the rest of the group and I slip quietly through the combat practice building's door and down the dark wooden halls, which are also strangely empty. The three jatu guards we encounter are dispatched so quickly, they don't even bear mentioning.

It takes us less than a minute to reach the entrance to Karmoko Huon's private library, which is at the very end of the building, just outside her office. This is her domain: brightly painted walls covered in weaponry and multiple bookshelves with row after row of scrolls advising on every possible battle technique known to man, equus, and any of the other intelligent species that litter Otera. The one and only time I saw the door open was in my first few weeks at the Warthu Bera, and all I could do was gape. I'd never seen a place so pretty inside the Warthu Bera before, and I never again did.

Once we reach it, I hold up my hand for silence.

A sound is coming from inside: the harsh thud of a closed fist against flesh. "Not so tough anymore, are you," a man's voice says, sounding pleased. "All those years, masquerading under our noses. Now you'll do exactly as we ask."

When there's no reply, his voice rises to an enraged bellow. "Tell me where they are! I know you know! How many of them are there? Speak!"

Another thud echoes in the air, and I can bear it no longer. I make the signal.

Keita kicks open the door, revealing a scene even worse than I imagined. Two jatu stand before Karmoko Huon, who is on her knees, wrists restrained by iron manacles, her pretty pink robes torn and her long black hair fallen from its flowery

hairpins. Dark purple bruises mar her translucent skin. When a red one blooms on her cheek, where she was just struck, rage explodes across my chest.

"Take your hands off her!" I hiss.

The jatu who just finished pummeling Karmoko Huon whirls toward us. "How dare y—"

A wet gurgle bursts from his lips. One of Karmoko Huon's sharp, bladelike hairpins has slid through his chest so easily, it took him seconds to notice. As he turns and staggers toward the karmoko, shocked, she swiftly slips her other hand from its manacle, then wrenches his sword from the sheath at his side.

"What do you think you're do—"

He never gets to finish. Karmoko Huon brings down the sword, and blood sprays from his neck as his head rolls to the ground.

Once he's dead, the karmoko smiles down at his corpse, then glances up at us. "First rule when torturing a victim, alaki: always check the restraints." She dangles her now opened manacles tauntingly in front of the other jatu, who falls backward, terrified, then she nods pleasantly at Karmoko Thandiwe.

"Took you long enough, Thandiwe. I was beginning to worry you'd passed on to the Afterlands."

"Before you?" Karmoko Thandiwe snorts, amused. "Never."

Karmoko Huon nods absently as she turns to the jatu, who's pissed himself from terror. There's a look in her eyes now, a terrifying flatness.

The man holds up his hands, pleading, as she approaches. "No, please don't—"

But she plunges the sword into his heart and removes it so swiftly, he's dead before he hits the floor.

Once she's done, she retrieves her hairpin from the first jatu's back, then walks over to her desk, where she pulls a cleaning cloth from one of the drawers and soaks it with water from a pitcher. She slowly, calmly wipes the blood off her face and hairpin, then rearranges her robes and hair to her satisfaction. Only then does she turn to us.

"Deka, Britta, Belcalis, Adwapa, and Asha, so good to see you. And these are your uruni, I presume?"

"Yes, Karmoko."

I kneel respectfully before her, joining the others in the traditional greeting we were taught here at the Warthu Bera.

"I'm impressed you remembered your manners, Nuru to the goddesses," she remarks, pulling out a bottle of palm wine from under her desk and taking a swig. "Wonderful to know I won't have to beat them into you as I did this one." She glances pointedly at Adwapa, who looks down, clearly remembering the time the karmoko pinned a chunk of her ear to the wall.

Then she turns to Karmoko Thandiwe. "Timely arrival, Thandiwe. I take it you were informed of the new jatu measures?"

Karmoko Thandiwe shakes their head. "No, I haven't been able to reach any of our informants, so when I met this lot, we hurried here."

"Good that you did. I've gathered all the information I need from these two." She nods to the jatu corpses.

"Gathered information?" This faint sputter comes from Li, who has watched the entire scene with wide-eyed bewilderment.

I can only imagine the shock he's feeling.

Of all the karmokos at the Warthu Bera, Karmoko Huon is

the most deceptive in appearance. She's tiny and beautiful, with the sort of pale, blushing countenance that brings to mind a delicate flower. But that seemingly ornamental exterior hides a terrifying interior: after White Hands, Karmoko Huon was the most ruthless person in the Warthu Bera, pure iron running through her veins. Only she would maim an alaki to prove a point to her, as she once did to Adwapa. And only she would willingly subject herself to torture to extract information from her torturers.

If there's one thing I learned from her, it's that a canny warrior uses her every attribute to her advantage—even her looks.

Karmoko Huon cocks her head at Li, amused. "Of course, gathering information. What else did it look like?"

Li's mouth just opens and closes, as if he's a fish gasping for water. This is likely the first time he's ever seen Karmoko Huon in action, so I'm not surprised. Her true nature is always frightening when she first reveals it. She turns again to Karmoko Thandiwe. "We have to move out tonight. The last few shipments of armor go out this week, and the jatu have been acting strangely. You saw the stillness outside—Commander Xipil has set a trap to catch the saboteurs killing his men. It's the first move. He means to cleanse the Warthu Bera after this. Use it as a jatu barracks."

I stiffen. "Cleanse?"

Karmoko Huon turns to me. "Wipe out. They mean to kill every alaki here."

"When?" Adwapa rasps, sounding as horrified as I feel.

"Two days from now," the karmoko replies. "They're sending in the Forsworn, which is why we have to be long gone by then. We have to—"

"THEY'RE IN THE DINING HALL!" Shouts and a commotion outside have me whirling toward the windows.

The drums on the walls begin pounding, sending information all across the Warthu Bera: *Enemy spotted at main building. Move out.*

Karmoko Huon pulls a sword from its sheath on the wall. "That would be my new helper, leading the jatu on a merry chase," she informs us calmly. "As I said, they set a trap, although it's not a very good one. Shall we join her?" She takes another calm swig of her palm wine before she strolls out the door.

We quickly follow.

The Warthu Bera's grounds are ablaze with torches when we emerge outside, multiple contingents of jatu chasing after a short, slim figure, her inhuman speed immediately distinguishable as she runs down the courtyard of the Warthu Bera's main building, passing that hateful statue of Emeka, the first emperor of Otera.

"Gazal!" Belcalis gasps as the fearsome novice with the jagged scar down her cheek, who used to command us in raids, dodges and weaves past the jatu ranks, the absolute darkness of the night obscuring her from the jatu's weaker eyes.

Last we saw her, she was still trying to find a way into Hemaira's walls, but now, it seems she's succeeded, because there she is, running down the hill toward the other end of the Warthu Bera. The moment Belcalis says her name, she glances over, her ears sharp as ever, and her eyes meet ours despite the darkness and the distance. She stumbles only for a moment before she makes a signal: *The caverns,* she signs, using the battle language we once learned within these very walls, before continuing onward, the jatu just behind her.

A swift wind blasts past me as Karmoko Huon takes the lead. "Follow," she calls, running toward one of the smaller outbuildings at the bottom of the hill. For a human woman, especially an injured one, she moves almost unnaturally fast.

When Katya and the other deathshrieks fall into place behind us, the karmoko doesn't even blink as she continues on her way, although she glances every so often at the jatu following almost neck and neck with Gazal now. The newly minted commander seems to be flagging, and when I squint, I see the gold dripping down her side. She's been injured.

I look up at Ixa, who's flapping overhead in his small blue nightflyer form. *Distract them!* I say, pointing toward the jatu.

Deka! he agrees, zipping over.

Screams echo when he transforms as he lands, plowing through them in his gigantic true form. "It's a demon!" someone shouts.

An amused smile twitches my lips. *Good, Ixa!* I say to him as I continue following Karmoko Huon.

To my surprise, her destination is the ancient well behind one of the Warthu Bera's peripheral buildings—a stony, long-dried-up affair covered by a ramshackle wooden lid. She hurriedly searches under the pile of loose stones behind it, then uses the key she finds there to unlock the chains fastening the well's cover.

"This way," she says, climbing down.

I turn back to Ixa. *Come back,* I command.

Deka, he replies, the screams in the distance fading to a confused silence as he transforms back into a nightflyer and flaps away once more.

He reaches me just as I follow the two karmokos into the well, which, as I am astounded to discover, hides an aged staircase—yet another of the Warthu Bera's secrets that I never knew. Once he settles into my arms in his kitten form, I hurry down the steps, shivering when a damp chill immediately envelops me: deathshriek mist, curling up the stairs so thickly, I can barely see the space in front of me. Rattle, the Warthu Bera's prime deathshriek, and all the others—hundreds upon hundreds of them—are still trapped in their cells under the training ground, this mist physical evidence of their presence and despair. Deathshrieks spread it this thickly only when they're feeling heightened emotions. I push away the thought as I hurry down the stairs to make space for Gazal, who slips in moments later and stealthily seals the well's entrance closed behind her.

There's a commotion outside as the jatu run over, their torches visible through the slats in the well's cover. "Find her!" a man's voice rages—the new jatu commander, Xipil, no doubt. Only a commander would dare sound so enraged at the other jatu. "She can't have disappeared into thin air."

"But she's a monster, Commander," a quaking voice replies. This one sounds young, almost certainly one of the recruits. "She could be waiting in the shadows even now."

"Shut your ignorant mouth, recruit," Commander Xipil snarls, confirming my theory about the younger man. "She isn't a monster. She's just an alaki, playing tricks on you. Playing tricks on all of us!"

The gravel crunches, indicating that he's moving about angrily.

"How have they been killing us so easily, then?" another voice asks. This one sounds a little older and very much aggrieved. "First Seref, then Amadou and Keuong. That's three dead in the past hour, and the night hasn't even reached its peak yet. We can't afford any more losses, we can't—"

"I said, shut your mouths!" Commander Xipil barks. "There are no monsters here, only women. And you will find them and subdue them, or I will have your hides. Move out!"

More gravel crunches as the jatu obey their orders. I try to calm my breath when a torch approaches the well, its light spilling through the slats. As the recruit holding it begins to peer down, however, another jatu pulls him away.

"That's just a boarded-up well. Move on before Commander Xipil catches you."

The light fades as the recruit joins the others.

I heave a relieved breath, then wait until all the lights disappear before I continue down to the tunnel at the bottom of the stairs, where the others are waiting. Karmoko Huon pulls a torch from the wall and lights it with a flint, her eyes widening subtly when she sees Katya and Nimita. Katya immediately kneels, giving her the same respectful greeting we used when we were neophytes in the Warthu Bera.

Karmoko Huon's eyebrows gather as she stares down at Katya. "That red color . . . ," she breathes. "Katya? Is that you?"

When Katya nods, the karmoko gasps. "Katya! We'd all heard that deathshrieks were resurrected alaki, but I didn't believe it until now. Katya . . . Infinity save us! It's good to see that you are still alive."

Katya nods shyly, moving closer to Rian, who squeezes her arm.

The moment Karmoko Huon's eyes flick to him, she smiles. "And you must be Rian."

Rian's eyebrows rise. "You've heard of me?" he asks.

"Who hasn't?" Gazal humphs, rolling her eyes as she speaks for the first time. "Now, can we hurry along? Don't want daylight to catch us still here."

As I nod, walking onward, Keita moves closer to her. "So, you discovered it, the way the jatu enter and exit Hemaira?" he asks, excited.

Gazal shakes her head.

Keita frowns. "How did you manage it, then?"

Gazal shrugs. "Usual way one does: waste tunnels."

It's my turn to frown. "But doesn't the n'goma reach even there?"

She shrugs again. "Good thing I can't die from burning."

I still, horrified. "You passed through the n'goma?"

Gazal nods. "Took me an entire day, but I did it."

Burning and reviving the entire time, flesh melting and then regenerating every few hours. It must have taken hours just to take one step through the wall of flame. Nausea rises inside me, as does awe. I can't even begin to imagine the strength of will it took to accomplish such a feat.

Britta can't either, judging by the shock on her face. When she finally is able to close her mouth again, she asks, "Wha about the water? Those tunnels flow continuously. An' some of them flow more powerfully than rivers."

Another shrug from Gazal, this one accompanied by a dull, unnerving look in her eyes. "Good thing I can't drown."

Another chill shivers down my spine, this one deeper than the last. Gazal was once locked in a cage and thrown into her

family's lake, where she spent only Infinity knows how long drowning and reviving. To think that she'd put herself through that again, just to find her way here . . .

What is it that drives her to go to such lengths?

She quickly grows uncomfortable with our gaze. "Shall we get going?" she says brusquely. "The others are just ahead, and I'd rather we free them before we get caught ourselves."

I nod, turning to Karmoko Huon. "So what's the plan?" I ask. "Same as we discussed with Karmoko Thandiwe?"

It's always advisable to verify these things.

Karmoko Huon blinks. "If the plan was storming the cavern where they're holding the alaki, freeing them—"

Karmoko Thandiwe interjects. "—without letting the jatu there use the drums outside to call for reinforcements—"

"—and then regrouping and storming the Warthu Bera's walls," Karmoko Huon adds, "then that's the one we're going with. Simple enough, isn't it?"

I glance from one karmoko to the other. "Yes," I say dryly. "Very simple."

And if we can achieve it all without significant loss of life and limb, it'll be a miracle. But I keep that to myself as we continue.

25

◆ ◆ ◆

The first thing I smell when I near the cavern holding our bloodsisters is the odor of blood and fire. It assaults my nostrils, causing memories from the cellar abruptly to rise: the elders, the gold. Cold sweat drips down my back, but before my body starts to shake, I inhale to steel myself. *I am in control of my body, not my memories. I am in control . . .* I've been through so much the past few days, survived so much already, I won't let my memories take control of me any longer. I won't.

Deka? This worried chirp comes from Ixa, and when he nuzzles his cold snout against my neck, I pet him gratefully. Just his weight helps me remain in the present, in my body.

Thanks, Ixa, I say, embracing him.

Keita notices. "Concerned about your friends?" he asks, moving closer so we're walking side by side. "Or is it the smell—the fire?" There's an odd look in his eyes when he says this last bit.

"Both," I reply. Then I ask, concerned, "You all right, Keita? You seem . . . preoccupied. . . ."

"I'm just worried about my friends. The ones who remained."

Not all the uruni decided to join us at the Temple of the Gilded Ones. Some of them—many of them, in fact—were unwilling to give up their allegiance to Otera, despite everything they'd seen. The privileges they had were just too much to sacrifice. They joined the rest of the jatu during the retreat back to Hemaira. Thankfully, most of Keita's closest friends are the other uruni in our group. As far as I know, he has only two friends left at the Warthu Bera.

"I know that Chernor and Ashok are our enemies now," he continues, referring to them. "Nevertheless, I—"

I squeeze his hand in commiseration. "I wouldn't want to cross swords with Britta or Belcalis or the twins either."

"Perhaps I'm worried about nothing," he says with a shrug. "They could have been assigned elsewhere. They could have left. I mean, I didn't recognize any of the voices chasing Gazal . . . But, truthfully, that's not the only thing that's bothering me." Now, he gives me an odd sideways look. "Remember those dreams I told you about?"

"The ones where you burn?" I nod.

He gazes toward the end of the tunnel, where orange flickers on the wall, the reflection of distant flames. "It's like I want to go to it—the fire," he whispers. "Like I need to be near it."

Something about his tone surfaces a memory, one I had only briefly pondered before: when we had the funeral for Father and Elfriede, Keita stared so intently into the flames, for a moment it looked like there was fire burning in his eyes.

It's the same look now when he stares at me, his golden eyes

gleaming in the darkness. "Why do you think that is, Deka?" he asks softly. "Why is it that I feel like I should burn in the Fires?"

The question lingers in the air, dark and haunting, until a soft footstep sounds behind me: Karmoko Thandiwe. "We're here," they say, nodding at that distant orange glow. "Prepare yourselves."

At least three contingents of jatu stand guard at the entrance to the next cavern, which is so massive, it stretches on until darkness obscures its farthest reaches. Even from our hiding place in the tunnel, we can see them: almost sixty men in total, all elbow to elbow, their weapons gleaming in the dark, gloomy space that was once one of the prisons for the Warthu Bera's deathshrieks. Behind them are stone cells full of alaki, a warren of thick glass pipes snaking around each. Anger rises in me, hot and blistering, when I see the gold being funneled through those pipes, which are all headed in one direction, just as Karmoko Huon warned: the forge in the neighboring cavern.

Now I understand why this place smells so strongly of death and decay, why the girls haven't just banded together to tear their chains from the walls. They've been bled to the edge of death and back. Many of them are in the gilded sleep right now, their unconscious bodies gleaming like golden statues in the dim light.

I turn to the others, red hazing my vision. Ixa is bristling beside me in his massive true form, the tension in his body reflecting my anger, so I command him first. "Take them down, Ixa!" I say out loud, my lips curling in disgust when the jatu immediately unsheathe their swords in preparation.

Deka! Ixa agrees, barreling through the first line.

As he bats aside men like dolls, I turn to the karmokos. "Go

291

silence the jatu in the forges. We'll clear your path. You six, aid them!" I shout to the uruni and deathshrieks. "Ensure that the jatu don't get near the drums!"

"Yes, Nuru!" Acalan replies, he and the others rushing through the opening Ixa's created.

I return my focus to the jatu in front of me, my fury rising higher and higher. These are the men who brutalized and bled my bloodsisters, who did Infinity knows what else when they had them under their power. They'll all fall under my atikas today. I rush toward them, moving so quickly, it's like I'm pinching portions of the air together so I can shorten the distance between us. Everything seems slow now—the jatu running at me, their weapons . . . I cleave through two jatu with one swing, then whirl to stab the next one in the gut, my blades cutting through bodies so swiftly, blood sprays the air like mist. I glory in the color, take comfort in how much red slicks down my blades.

Red means I'm doing something: I'm enacting vengeance, making the world just a little better.

Realizing how fast I'm moving, the men spread out, trying to create distance between us. A few even begin running, trying to hide at the very edges of the cavern. It's a futile effort. I push harder, moving faster and faster until finally, the last jatu falls under my blade.

"Gilded gods, Deka, what did you do?" This awed gasp comes from Belcalis, and when I turn, she and the others are watching me with strange expressions, some of which look close to fear.

I follow their eyes to the floor, which is now littered with bodies and slippery with blood and gore. Fifteen—no, at least twenty—jatu corpses surround me, all of them cut down so quickly, their bodies are still in the attack position. Even

stranger, some are at opposite ends of the cavern, so far from each other, I shouldn't have been able to reach them.

"You killed them in seconds—less than that, Deka," Belcalis says, her eyebrows gathering. "It's almost like you were there one moment, gone the next."

"No," Britta says, frowning. "It was like ye were using doors."

"Doors?" I echo, frowning. Is that what that was?

Suddenly, my conversation with White Hands comes flooding back. What she said about my abilities . . . I look down at the floor, my frown deepening when I notice there's barely even any sign of struggle on the men I killed. I slaughtered most of them before they could even mount a defense, something I've never been able to do before. Something I could have done only if I was moving so fast, I was flashing from one point of the cavern to the other. Memories bombard me—how I seemed to pinch the air together, tightening the distance between myself and my opponents. I didn't think anything of it then, but now . . . It's almost like I'm developing divine gifts, one after the other, except I'm the Nuru, so any gifts I have, I was born with. The memories, the doors—they were all hidden inside me, locked. And yet now, they're surfacing, just as White Hands said. Is it Hemaira, being here, that's making my abilities expand? Or is it that I'm away from the mothers, their influence curtailed by the presence of Idugu and all those kaduths? The thought reminds me why it's so important I journey to the Grand Temple after this, peer at those carvings and speak to Idugu, if I can.

I glance back at the others. "Free the bloodsisters," I command. To Nimita, I say, "Go search the caverns, open all the deathshriek cages. Ensure that every single one of them is freed." I can sense them even now, their distress causing clouds

of mist to waft into the air, but they must be gagged. I'm not hearing any shrieks, even when I strain my ears.

I turn to Katya. "You remain with us, help open the cages." I know the bloodsisters have been told the truth about death-shrieks by now, how they're resurrected alaki; still, it's better that when they meet a deathshriek, it's one they already know.

When both nod, I continue: "There's time to ponder what I just did later. For now, let's get to it."

As Nimita nods again, slipping into the darkness, two dark figures swiftly overtake me: Adwapa, with Asha just beside her. They're both headed to one of the more crowded cells, where a short, round girl has pressed against the bars, hope lighting her dark brown eyes. Mehrut.

"Adwapa?" Mehrut calls hoarsely. "Adwapa, is that you?"

"It's me," Adwapa replies, relievedly grasping Mehrut's hands through the bars. "I told you'd I'd come for you."

"Let me out," Mehrut cries, desperate.

Adwapa and Asha nod. Swiftly, they work together to bend the cell's bars and then wrench Mehrut's chains out of the wall, allowing Adwapa to enfold the plump brown girl in her arms and kiss her with all her might. "Mehrut, Mehrut!" Adwapa repeats.

"You're here," Mehrut whispers, tears dripping from her eyes. She doesn't even seem to notice Asha carefully removing the bloodied pipes from her limbs. "I knew you'd come. I knew you'd come."

"Always," Adwapa says, growling with frustration when the chains still binding Mehrut's hands and feet don't budge as she tries to remove them.

I walk over, the chains' familiar whitish gleam telling me everything I need to know. They're made out of celestial gold.

There's ichor in them. No wonder the karmokos couldn't figure out a way to break their chains: any metal imbued with ichor is unbreakable.

Except by me, that is.

I tap Adwapa aside. "I'll do it," I say, kneeling down toward Mehrut's chains, and slicing open my palm.

The minute I bleed onto them, the chains start weakening. No memories flash into my mind, likely because the mothers' blood is too diluted here, so I rip them apart, then move on to the next girl's, and the next, and the next. I'm so absorbed with my task that when I finally look up, the cells are empty, the bars bent beyond recognition, and those hateful glass pipes in smithereens. Britta and Rian are leading injured bloodsisters out of the cells, they, Belcalis, and the others carrying the ones too weak to stand. I search the crowd for people I knew, like Jeneba, the novice who was our guide in our first few days at the Warthu Bera, but there's no sign of her dark, good-natured face, or anyone else's. Most of the girls here are new, neophytes who were just entering the Warthu Bera when the others and I headed off on campaign, which means the novices—those here for a year or more—must be elsewhere.

I notice that the girls are now staring at Katya. All of them seem unnerved, so I put on my gentlest smile. I don't know if they've been told yet that deathshrieks are fallen alaki, so I have to break the news as easily as I can.

"This may come as a surprise to you all," I say, "but when alaki experience our final deaths, we resurrect as deathshrieks." As shocked whispers fill the air, I gesture to Katya. "Does anyone here remember our bloodsister Katya?"

Katya waves shyly.

A few of the girls' eyes widen, but some of them—the neophytes or novices in the Warthu Bera when I was there—gasp in recognition.

"Katya?" a bony, sickly-looking girl says, coming forward. "Is that truly you?"

A few seconds pass before I recognize her: Yumi, one of the friendlier bloodsisters from the common bedroom next to ours. Her body was once covered in sleek muscles, but now, her ribs protrude through her skin like knives, and her straight black hair has fallen out in patches from malnutrition, same as most of the other girls. Only a few, like Mehrut, don't appear on the verge of collapse. When Katya nods, holding out her outstretched arms, Yumi rushes toward her. That's all it takes. The other bloodsisters from our year swiftly gather around Katya, tentatively stroking her red quills, gasping at her enormous size.

It's almost strange, watching them come to terms with something I've so deeply understood for almost a year. To learn that creatures we once saw as our enemies were actually our sisters, ourselves—it's a lot to take in.

I watch the girls and Katya for a few seconds more before I finally clap for their attention. "We can have our reunions later," I announce. "For now, we have the jatu in the forge to deal with, as well as novices we must free."

"Not to mention we need to escape this awful place," Adwapa says angrily, her arms still tight around Mehrut.

Rian quickly makes his way to the front of the girls. "Behind me and Katya, and please keep silent," he says in soothing tones. He's surprisingly adept at dealing with frightened people. No wonder he and Katya are so well suited. Before she became a deathshriek, Katya was very much the nervous type.

"We'll get you all out of here in one piece," he promises.

Britta, meanwhile, glances at me. "Ye ready, Deka?"

"As I'll ever be," I say, lifting my atikas. And then it's onward to the next cavern, where the battle is already nearly over, the karmokos and Gazal having easily cut their way through the last few jatu while Lamin and Li protect the exits, ensuring that none escape.

Deathshrieks bristle at the center of the cavern, all of them chained to the enormous wooden wheel that powers the bellows stoking the hearths. These must be the strongest of the lot, chosen for their heft and bulk. Rattle, the silver-quilled deathshriek I once practiced my voice on, snaps and hisses at a wounded jatu who stumbles near her. Belcalis swiftly dispatches him, ending the battle with a decisive blow.

When Ixa notices my arrival, he tramples on a nearby jatu, cheerfully breaking the man's bones, before he transforms back into kitten form and scurries up my back to nuzzle in the crook of my neck.

Ixa did good? he asks, looking up at me for approval.

You did very well, Ixa, I say, scratching his ears.

As he thrums, delighted, I glance across the forge. I quickly spot Karmoko Calderis standing next to one of the hearths lining the walls of the cavern, muscles bulging, single blue eye squinted in concentration as she presses a struggling jatu to the coals. Once the man goes silent, the screams strangling in his throat, she tosses his lifeless body aside, then picks up a pair of pliers from the ledge of the hearth and uses it to crack her chains open.

"About time you came," she grunts, waddling to the nearest corner, where familiar gigantic suits of armor line the walls,

kaduths emblazoned on their breastplates. The Forsworn's armor. So this is truly where it's made.

The karmoko pushes the deathshriek armor aside to reveal three smaller golden suits, complete with helmets. She takes the nearest one, which is barrel-shaped to accommodate her short, bulky form.

As she puts on her armor, she glances at me and humphs. "Didn't expect you, though, Deka of Irfut, progeny of the Gilded Ones." She gestures a newly gauntleted hand around the room. "This is all your doing, you know."

Guilt stabs at me when I see the group of scrawny, soot-covered alaki huddled in the back of the room, Gazal and the uruni helping to unlock their chains, which are made out of thick iron instead of celestial gold. These must be the weaker girls, the ones the jatu forced to help them work the forges. I run over to them, swiftly slicing my palm in case any of the chains still have ichor in them, but relieved cries are already rising from the bloodsisters as they throw off their chains to embrace each other. One is immediately familiar, her dark skin glowing against the warm, pulsating yellow of the forges: Jeneba. Gazal—who oversaw Britta's and my common bedroom when we were neophytes along with her—swiftly wrenches away the chains binding her, then sweeps her off her feet, kissing her so hard, there's no air left between the two.

As the pair stare at each other, love and relief in their eyes, Britta comes to stand by me. "Well," she quips dryly. "That explains a lot of things."

I nod. No wonder Gazal was so desperate to get into Hemaira, and no wonder she and Jeneba got along so well when we were here. Gazal is one of the surliest people I have ever met,

and Jeneba the nicest, yet they always seemed to complement each other. The sight of the two feeling such obvious joy so moves me, I clasp Keita's hands when he walks over, smiling as I feel their warmth next to mine. This isn't the romantic atmosphere I imagined when we first left Abeya as false newlyweds, but somehow, it's just as sweet.

You have to savor these moments when you can, because if not— The sound of sharp, clipped drumming outside breaks through my reverie, but it's just the announcing of the new hour: ten beats for ten in the evening.

"We'll go take the drums over," Jeneba says immediately, extracting herself from Gazal's arms as Gazal nods in agreement.

"My thanks," I say, squeezing her shoulder in greeting as she and Gazal pass. I wish we could have more time for reunions, but if there's any lapse in the drums' rhythmic beating, the jatu on the walls will suspect what has happened and call for reinforcements.

I turn back to the karmokos. "So," I say, "how do we transport everyone out of here?" That part of the plan I was never clear on, as Karmoko Thandiwe had no idea of the state of the Warthu Bera's stables.

"With the wagons," Karmoko Calderis replies.

I blink. "The wagons?"

"The ones parked beside the Warthu Bera's walls," Keita explains. "They have the kaduth painted on their sides."

"They're the only things that can go in and out of Hemaira now, I imagine," Karmoko Calderis says airily.

"I don't understand," I say. "What do you mean, they can go in and out?"

She shrugs. "The jatu on the walls use them to not be affected by the thing that's there. The one that burns people."

I blink. "Wait, you mean the n'goma?"

She snaps her finger. "That."

Keita and I look at each other in shock. "So you mean to tell me that all this time," he says, wiping his hand over his face in frustration, "the jatu were using the kaduth to evade the n'goma? And we've been going in circles, but it was right in front of our noses this entire time?"

Heart racing, I whirl toward the Forsworn armor, the kaduth emblazoned on each one. Strangely, the symbol only mildly irritates me now. After all these weeks spent confronting it, it only induces a slight itching behind my eyes rather than a full-on headache, which is just as well. Now that I finally have one in front of me and know what it can do, I have even more questions. Just how many uses does the arcane object have? And was it created to affect me, or the mothers, or both?

Only one way to find out. I reach out and touch the symbol with my bloodied hand.

Images immediately flash into my head: a small blond man falling under the edge of a sword, only to wake up in darkness what feels like mere moments later, slithery shapes reaching through the dirt for him. The more panicked he becomes, the more my thoughts merge with his.

I slash at them with a claw. *Wait, a claw?* I look down at the daggers now sprouting from my fingers, so sharp, they slice easily through the dirt. What is this? Why do I have claws like a deathshriek? Why is dirt pressing down on me?

And then I hear them, the growls sounding all around me.

The dirt wriggling, wriggling, as those slithery vines creep closer. What's happening? Someone help me! HELP ME!

"Deka!"

I gasp, jerking back when a hand tugs at mine. Keita is staring at me, worried. "What just happened?"

"The kaduth," I choke out, shaking. "It's made of jatu blood. No—deathshriek blood. I saw one of them—it was a man, and for a moment, I was him. I was inside his mind, and then he became a deathshriek and he was so frightened, so frightened. . . ." My body won't stop shaking from the memory.

What was that? What were those slithery things I saw?

As I catch my breath, Karmoko Thandiwe walks over. "We have to move out, Deka. We have to hurry to those wagons and leave the Warthu Bera before daybreak."

"And the rest of us have to head to the Grand Temple to see about Idugu," Belcalis reminds us.

Karmoko Calderis nods. "Well, Rustam will help," she says, something very near to a blush coloring her cheeks.

"Rustam?" Britta blinks, confused.

Karmoko Huon turns to her, eyes rolling. "Calderis has a friend . . . among the jatu."

Confusion furrows my brow as I understand what she's saying. "But I thought Shadows—even former ones—weren't supposed to have . . . friends."

"Well, we aren't supposed to become dungeon labor for our jatu comrades either, and yet here we are," Karmoko Calderis replies dryly. "Now, then, are we just going to stand here, or are we going to make our way to the wagons?"

"Wagons," I reply. "But give me a moment first. There's something important I have to do."

26

◆ ◆ ◆

When I head over to the wheel at the center of the forge, Katya and the others have already begun the process of freeing the deathshrieks, who stagger about in halting, dazed movements as they're released from their bonds. Rian and most of the girls avoid them cautiously, since it's clear they're all mostly in altered states of mind. I can see that the jatu not only chained the deathshrieks with celestial gold and gagged them with iron; they also drugged them into docility with blueblossom flowers, just as they used to when I was here at the Warthu Bera. Now that the deathshrieks are free, however, their agitation is swiftly overcoming that docility. Rattle is rubbing her newly freed wrists when I walk up to her. Her eyes blink in slow surprise, and I notice, for the first time, how feminine they are.

It's not her lashes or anything as simple as that. There's just this feeling that emanates from them. Why did I never see her for what she was? Why did I not notice her intelligence? Almost the entire time I studied here, I saw her as a mindless beast—an

aid for my studies rather than a living creature with feelings and desires. No matter how many times she tried to communicate to me, I never understood.

But, then, I didn't really want to, did I? I wanted to believe the lies the priests sold me, wanted to believe I could earn purity and a place in Otera by killing deathshrieks. I can blame the blueblossom all I like, but the truth is, I should have known better, should have understood more. Even if the deathshrieks were drugged and slow in their attempts to communicate, whether I knew it then or not, I was the Nuru, daughter to the Gilded Ones. It was my duty to translate for them. But I was too blinded by my own selfish needs to see what was in front of me.

"Rattle," I say, fighting the urge to fidget as I remember all those times I forced her to obey my voice in the name of mastering it, "I must offer my deepest apologies for what I did to you while I was here." I kneel in front of her.

Silence stretches taut as the massive deathshriek looks down at me, her black eyes considering even despite their vagueness. When she finally speaks, her voice is the deep rumble I'm intimately familiar with but never managed to understand. "You look like her, you know," she says in a strange, halting fashion.

"Like who?"

"Umu . . . your mother."

My heart jolts in my chest. "You knew my mother?"

Rattle inclines her head absently, the quills on her back rattling from the movement. It's almost as if she's only halfway here, and the cowardly part of me is relieved. I feared addressing the fierce and defiant Rattle, the one who kept me in terror for weeks after I met her.

"She studied combat on me too," she says. "She always

brought me gifts, unlike you. But then you didn't understand what I was." When I frown, taken aback, she explains: "White Hands informed her of the truth about deathshrieks quite early on. It wasn't like it was with you. Umu's mind wasn't . . . poisoned the way yours was when you came here. She never believed the Infinite Wisdoms' lies. I think she felt guilty, knowing what I was. Knowing that I couldn't control my primal nature because of the curse the mothers laid on us."

"The curse?" I'm only somewhat stunned to hear it described that way.

Rattle gestures to herself. "Does this form look like a blessing to you? All that anger, madness . . . pain. And for what? Freeing the Gilded Ones?" Her quills rattle as she shakes her head. "I even reached out to you, but you couldn't hear me, could you, Nuru? If you are supposed to be our savior, then why couldn't you hear me?"

Her words lodge like splinters in my throat.

"My apologies," I whisper miserably again, even though I know the words are little comfort to someone I have so wronged. "I didn't understand then. I was too blind to see what was before my eyes."

The edges of Rattle's lips lift to display razor-sharp teeth. "Do you see now?"

I nod. "I will do better. I will free all our sisters," I say.

"But who, precisely, will you free them from?" Rattle asks.

I stiffen. "What do you mean, Rattle?"

The deathshriek doesn't answer. Her eyes are gazing off into the distance. "We will escape this place today, yes?" she muses. As I nod, confused by this sudden change in subject, she clacks

claws the size of butcher knives together. "Once we leave Hemaira, I doubt I'll ever see you again, Nuru to the goddesses. I doubt I'll ever see any of my sisters again. Say goodbye to Fatu for me, will you? Tell her I love her with all my heart, but I'll kill her if I ever see her again. Not that she'll ever remember what she did. What she was. They made sure of it, didn't they? They tried to do it to me too, but the madness . . . The madness, it breaks through."

The more Rattle speaks, the more rigid I become. "They?" I whisper, even though I already know the answer.

Rattle blinks at me as if surprised to find I'm still watching. "The Gilded Ones. Our mothers—if you can call them that. Mothers are supposed to love their children, aren't they? But Fatu wasn't what they wanted, and she was their firstborn. A mistake, in their eyes. She tried so hard. So very hard. Poor Fatu. Pity it led her where it did. Pity it made her abase herself to the false gods." Now, Rattle's eyes bore into mine, sharp and accusing. "They're all false, the gods, all of them cut from the same cloth. That's why they hate each other. It's in the blood—they can't help it."

By now, an eerie sort of light-headedness has taken ahold of me. "What do you mean, Rattle?" I ask, but the deathshriek is already walking away, mist wreathing her footsteps. I run after her. "What do you mean, in the blood? Rattle? RATTLE!" I call out desperately as a sudden image flashes through my mind of that carving I saw on the wall of the Grand Temple, the one with the four warriors, all of them connected with a golden string.

Tethered, just like the indolo.

Rattle turns back to me, irritation flashing in her eyes.

"Rattle . . . That is not my name," she says. She shakes her head as if thinking. "Sayuri," she declares finally. "That is what I was called, once upon a time: Sayuri the Wise."

And all the breath escapes from my body. "Sayuri," I repeat. "As in the third war queen, the third eldest of the Firstborn?"

"Is that what I was?" Sayuri inclines her head. "I suppose, once upon a time, it was true. But now I am Sayuri no more. I am a deathshriek—nameless, faceless, forgotten. . . . I will join the others of my kind and leave this place to its ruin. Goodbye, Nuru to the goddesses. May fortune go with you. You'll need it." She chuckles darkly.

And then she's gone.

I remain there, reeling from shock, until Britta beckons me over to where the karmokos and Keita are huddled, swiftly making plans. The time for reunions has ended. It's time to escape the Warthu Bera and head for the temple.

27

◆ ◆ ◆

My mind is so filled with all the things Sayuri said, it takes me a while to notice how eerily still the air is when Britta and I stealthily exit the caverns, the karmokos and a few others beside us. The moment I direct my gaze to the battlements, the breath catches in my throat. Weapons and armor gleam, a gilded river in the night. The entire Warthu Bera has been surrounded, jatu and Forsworn deathshrieks bristling from every inch of the walls. An entire army of them.

"Mothers preserve us," Britta breathes, unnerved.

Keita glances from her to me, tense. "How many?" he asks.

"Every jatu in the Warthu Bera, it looks like," I reply, squinting to confirm. "And a few Forsworn as well."

Keita swears harshly under his breath.

"Outside reinforcements?" he asks, disturbed. I shake my head.

"I don't think so," I say.

"Those deathshrieks came earlier today," Karmoko Calderis

confirms, referring to the Forsworn. "They came for the newest shipment of armor."

"And unfortunately for us, they remained to aid with the pincer maneuver," I say, sighing, as I stare at the forces lining the battlements—the forces that have arranged themselves in a very familiar semicircle. A pincer.

I've seen this tactic enough times to spot it immediately, the two opposing lines that gradually squeeze in until your target is caught in the pincer. Unfortunately for the jatu on the walls, however, they're missing a considerable number of their troops. The jatu who were down in the forges are all dead—although they probably don't know that yet. Jeneba, Gazal, and a couple of the other girls have been drumming every fifteen minutes, relaying false messages. As far as these jatu are concerned, their compatriots in the forges are still holding fast, which is probably why they've retreated to the battlements, where they have a clear view of the entire Warthu Bera in case Gazal and the karmokos run their way.

"Looks like they've decided to start the cleansing early," Karmoko Thandiwe says grimly, their eyes scanning the battlements. They can't see as clearly in the dark as we can, but I wouldn't be surprised if they had excellent night vision. "If we want any hope of escaping this place, we need to engineer a reverse siege."

I nod, acknowledging the battle-strategy master's plan. "My bloodsisters and I can dodge their arrows on the way to the walls, but the moment we try to get near them—"

"You'd get shot down," Keita says, shaking his head. "And that's assuming they don't just pour oil on you and burn you

alive." He nods to the battlements, where large, oil-filled barrels have been pushed next to the edges.

As I shudder at the sight, Karmoko Huon taps her lips thoughtfully. "Well, they can't burn you if you're protected. . . ."

I glance at her. "What are you thinking?"

"The vats in the forge," Karmoko Calderis gasps, already understanding. "I used them for mixing the cursed gold—"

Acalan awkwardly clears his throat. "We're calling it the divine gold now," he says.

"Bully for you," the karmoko replies, all sarcasm, then continues: "The vats are made of Efuana steel—dense, impervious to other metals—"

"Perfect for a shield!" I gasp.

"You can use them to run to the walls. Your armor should keep you from boiling inside them in case they fire flaming arrows at you." Infernal armor, among other things, is heat retardant.

"And then what?" This question comes from Belcalis, who has been silently taking in the discussions. "We can't climb the walls holding vats over our heads."

Karmoko Calderis's mouth spreads into a smug grin. "Who said you had to climb? You can just blast your way through. I've been gathering ingredients all this while. I've got enough to make some lovely bagba."

Karmoko Thandiwe laughs. "Bagba? Calderis, you sly old fox."

As Karmoko Calderis beams with pleasure, Keita frowns. "And what exactly is bagba?"

"A type of explosive," Belcalis explains. "Very unstable. It

can easily put a hole through both walls. And your belly if you're not careful."

"So you're familiar with it," Karmoko Calderis says, a calculating look in her eyes.

Belcalis shrugs. "I've handled it before." When the karmoko just looks at her, she explains, "I used to work for an apothecary who dabbled."

Karmoko Calderis grins. "Then you'll be part of the first wave."

Belcalis nods in agreement while Britta, Keita, and I all glance at each other. Neither of us has any interest in handling explosives.

"Wait," Belcalis suddenly says. "Bagba's very loud. If we're trying to stop the outside jatu from rushing over, doesn't it defeat the purpose to blow a deafening hole through the walls of the Warthu Bera?"

"I might actually have a plan for that," Karmoko Huon volunteers. "The Army of the Goddesses—wait, that is what it's calling itself, is it not?" When I nod in the affirmative, she continues, "It's still stationed outside the city wall, correct?"

I nod again.

"Well, what if it unleashes a new weapon—one that can enter the n'goma? Calderis, can you get a quick little breastplate fitted with the kaduth? We need someone to get past the wall . . ." She stares speculatively down at Ixa, who burrows his head in my neck, unnerved.

Deka? he squeaks.

I look down at him. *Ixa,* I say. *I have a favor to ask you.*

❖

It takes about thirty minutes for the screams to start. They begin sporadically at first, a few shouts of surprise from the jatu on the walls. Then come the explosions, all so loud, they reverberate through the city. Ixa, now in a winged version of his true form, is doing just as I asked, dropping the bagba at different points along Hemaira's wall to disorient the jatu there. Thankfully, the breastplate Karmoko Calderis fitted him with is doing exactly what it's meant to: preventing the n'goma from taking hold of him. Even now, he's dropping a few more breastplates with notes attached on them to the alaki outside the wall, telling them they have to use the kaduth to get past the n'goma's wall of fire. Frantic drumbeats are already rising, all calling for reinforcements.

The Warthu Bera's drums sound a swift reply: *We're on our way.*

Men are running for the outer gates, following the orders of their commanders. Compared to the crisis that seems to be happening outside, exterminating the Warthu Bera of its now useless alaki is suddenly very much a secondary concern. Every jatu in the city has his attention focused on Hemaira's walls now.

Which is exactly what we wanted.

I turn to Britta and the twins, who are all wearing carefully fitted suits of golden armor. Karmoko Calderis has made hundreds of suits in secret to prepare for this day—the day when the alaki of the Warthu Bera rip off their bonds and free themselves as well as the rest of the training grounds in the city. They're not the only ones wearing armor, however: Keita is armored in gold as well, as is fitting for his role as our guide. He knows all the weak spots in the walls and will be another shield for Belcalis, who's carrying the bagba, since she's the only one who knows

how to set it off properly. Once we blast a path through the walls, the karmokos and the rest of the alaki will follow and use the kaduth-emblazoned wagons to help the alaki—and anyone else who wants it—to escape the city.

"Ready?" I call, glancing at the rest of the group.

"Ready," Britta says, hoisting her vat.

Adwapa and Asha swiftly do the same, as does Keita.

Only Belcalis doesn't respond, and when I turn to her, she's still unarmored and seems to be searching for the dagger in her boot. "Belcalis," I begin, concerned, "where is your armor?" I know she can't be planning on using her gift—the armor it creates is patchy and uneven.

Belcalis doesn't seem to feel the same because she smirks at me as she slices her palm open, holding it up to display the blood, which spreads swiftly up her arm and then over the rest of her body. In less than a minute, she's gleaming completely golden, even the strands of her hair like golden threads now. Her new armor fits so closely to her, it seems like a second skin, but I know from experience that it's just as hard and tough as infernal armor. I shiver, simultaneously awed and intimidated by the sight. It took me weeks—well-nigh a month, really—to master my voice, but Belcalis has mastered her gift in less than a week. I suddenly feel woefully inadequate.

"This is my armor," she says smugly as I gape.

It's almost as if she's in the gilded sleep, as if she's been killed and is regenerating, except her expression isn't peaceful like that of a girl who's regenerating. It's filled with purpose.

"Shall we?" she says, gesturing.

I nod. "Live forever!" I prompt.

"Live in victory!" the others reply.

Then we hoist our vats and begin running.

It's so dark now, and the Warthu Bera's walls are in such chaos, we're almost halfway across the grounds before the jatu notice us. My only warning that we've been spotted is the sudden stream of arrows whipping past the small eyeholes Karmoko Calderis bored into my vat. But I ignore the arrows, my eyes fixed on the goal in front of me: the front gate. All we have to do is blast it open, and then we can cross the bridge leading outside.

"Keep running!" I call, powering onward. Until flames start raining all around us.

The jatu have begun lighting their arrows, and now, a line of flame is growing in front of me, causing the temperature to boil and the air to thicken. When nearby trees begin crackling orange, flames shooting across the leaves, I stumble, those bitter memories of my time on the pyre rising up. But I grit my teeth and exhale, forcing them away. I won't allow the jatu to force me into retreat—not now, when there's so much at stake. We just have to get closer, and then the bagba—

The bagba!

I gasp, panic rising when I realize the danger we're all in. If the flames burn too hot, there's a very real chance the bagba will explode, taking Belcalis and the rest of us with it. "We have to retreat!" I shout, trying to recall the others. "We have to pull back!"

"No! Keep going!" There's determination in Belcalis's voice.

"But the bagba's too combustible! The flames, they may make it explode."

"We have to take the chance, Deka!" she shouts. "It's either now or—"

313

"Wait, wait!" I hear Britta's voice, accompanied by a shuffling sound, as her vat moves closer to me.

"What is it now?" I snap, agitated. We don't have any time to waste. The smoke is so thick, it clogs my nostrils. The fire is getting closer and closer, and with it, that familiar terror.

Flames, creeping over me . . . burning me alive.

I try to shake it away, but the fear is just too deep. And I know it must be affecting Keita too. "Keita? Keita?" I call out to him, remembering what he told me about his fears of burning in the Fires.

A loud clang forces my attention back to the present. It's Britta; she's tossed aside her vat. "I have an idea!" she announces as I gasp, horrified.

That and the tingles rushing over my body are the only warning I get before a wall of stone erupts from the earth, sloping in front of us like the side of a mountain. Another swiftly grows to meet it, both of them sloped in such a way that they form a shield over us, protecting us from the flames outside and the arrows above.

A stunned silence descends on the walls of the Warthu Bera, as well as over our group. When I saw Britta do this before, I wasn't in a state of mind to appreciate it, to truly understand the magnitude of what she had created.

"Britta, did you do this?" Keita asks, shocked, as he slips out of his vat, which is protected by Britta's new shelter, as all of ours are.

I do the same, throwing aside the heated metal as Britta nods. "If Belcalis can master her gift swiftly, then so can I."

"This is amazing, Britta—astounding, truly," Keita says. "But . . . how do we get to the wall now?"

"Like this." Britta punches her fists forward, and the stone in front of us starts moving, almost like a siege machine plowing across the grass.

I stare at Britta, awed, as the stone glides slowly but surely. She's pushing herself so hard, sweat is beading her forehead and her limbs are trembling. But still, she continues on.

"I don't think I've ever been as proud of you as I am right now," I say, shaking my head in amazement.

"Really, Deka?" Britta huffs, pushing again. "This is wha impresses ye? An' wha about all the other million times I saved ye in battle?"

"You never created a shield made out of stone those times and moved it across the ground," I reply, purposefully trying to keep the conversation going.

Britta's body is shaking from the strain, and I can see the energy inside her quickly depleting. Unlike Belcalis, Britta hasn't yet mastered the art of expending only the least amount of energy necessary in using her gift, which means she's due for a collapse any moment now. We need to get closer to the wall before that happens.

"You can do it, Britta," I say as I keep pace with her. "Just a few more steps."

She nods, blue eyes gleaming with determination. "I can do it. I can—"

She stops suddenly, and then her eyes roll back. That's the only warning I get before she collapses.

I rush to her. "Britta!" I gasp, shaking her, but she's unconscious, the energy inside her only a dim shadow of what it once was. She pushed herself too far.

I raise my hands to my head, frustrated. "Infinity take it!

What do we do now?" The wall is still too far, and we can't emerge from the shelter without being shot down. The jatu have already begun aiming their flaming arrows at this section of the Warthu Bera grounds.

Belcalis sighs. "I don't know, Deka, I—"

"Shh, do you hear that?" Adwapa abruptly says.

I stop, my muscles tensing when a whooshing sound emerges in the distance, swiftly followed by panicked shouts, all of them rising from the Warthu Bera's walls. It doesn't sound like Ixa's wings—those have more of a flapping quality to them. Instead, this whooshing sounds elegant, like some sort of gigantic bird. And I've heard it before. Numerous times, in fact.

Asha stills. "Is that what I think it is?"

I peek through a crack in the side of Britta's shield, and my eyes immediately widen. There, winging her way toward the Warthu Bera, her body glowing softly against the moonless sky, is Melanis, Ixa flying behind her. I stare, shocked. How did she get here? And why is she here, for that matter?

"Melanis?" I call out, uncertain.

"What are you doing, cowering under that stone, honored Nuru?" the Firstborn asks, casually swooping down to grab a jatu off the battlements—Commander Xipil, from the looks of his highly ornamented armor.

"Please, let me go," the short, burly man snivels, a disgraceful display Captain Kelechi—the tall, stern jatu who commanded the Warthu Bera's walls when I lived here—would absolutely never have indulged in. "Please . . . ," he whines.

Melanis flicks him a bored gaze. "Very well," she says.

Then she drops him.

As I stare, still confused by her sudden arrival, Belcalis pulls

the bagba from the satchel at her side and starts swiftly mixing the ingredients, priming them for explosion. She shrugs when she notices my expression. "Now or never, while they're distracted," she says.

I nod, finally remembering myself. Then I turn to the others. "Brace yourselves," I command. "Belcalis is about to throw the bagba."

I have barely enough time to huddle before Belcalis abruptly darts out and tosses the bagba onto the portion of the gate Keita previously pointed out. The explosion is immediate—the entire area reverberates as chunks of wood and stone fly. Screams rise; the smell of burnt bodies, seared flesh. By the time I emerge from behind the stone shield, ears ringing, a hole occupies the portion of the wall where the gate used to be.

"Take the walls!" The shout rises up from behind us, and then the karmokos are running past, the alaki army at their heels.

Adwapa, Asha, and Keita, who are still dazed by the blast, follow after leaping through the wall of flames. I remain where I am, next to Belcalis, who's still shaken from the blast, and Britta, who remains unconscious.

Belcalis gathers Britta in her arms. "I'll take care of her while I regain my bearings," she says in an overly loud voice. The explosion must have damaged her hearing, since she was so close to it. She'll soon recover, however. "Go," she urges, waving me onward.

But when I peek around the shield, the fire still looms, the heat, the stench of burning bodies suddenly so intense, I tremble. I clasp my hands together, trying to breathe. Trying to stand. *I am in control, not my body,* I remind myself sternly. *I will not give in to my memories. I will not panic—*

A brown hand stretches in front of me. "Need help?" Keita asks, somehow back by my side.

He's staring at the wall of flames rising in front of us, that strange, almost faraway look in his eyes. He's fascinated by the flames, just as he said. Or is it fear that haunts his gaze? The sight unnerves me enough to push aside my whirling thoughts.

I accept his hand, then turn his face to mine and inhale. "It's time to confront the fire, Keita," I say gently. "For both of us." Then I pull his war mask down, over his face, grateful that it's made of divine gold, just like the rest of his armor. It should protect him from the heat, if he's quick enough.

"Ready?" I ask him.

"Ready." He nods, and then we run into the flames.

The fire is hot—hotter than I could have imagined—but the heat lasts mere moments, and then we're on the other side of it, entering the Warthu Bera's outer wall through the massive hole Belcalis blasted there. As I gape, shocked at how easy it was to overcome my memories of fire, the army of alaki and death-shrieks swiftly darts past, only to just as swiftly stop.

Footsteps are sounding. Deep, rhythmic—familiar.

I watch, dread mounting, as the lines of Forsworn march over the bridge connecting the outer and inner walls, and then form a single line across the small courtyard that occupies the middle of the Warthu Bera's inner wall. The deathshriek commanding them is immediately familiar, as is his deadly flower-petal-shaped spear: the jatu leader from the Oyomosin.

When he sees me watching, he growls—a low, rumbling sound. "Nuru," he smirks. "How did I know I'd find you here?"

28

❖ ❖ ❖

I'm so shocked I can understand him, all I can do is stare. "I understand you," I gasp, pushing forward.

Behind me, Melanis swiftly darts down, Ixa accompanying her. "Deka," she hisses. "Do not speak to that abomination."

Both the jatu leader and I ignore her. "Of course you can," he rumbles with an elegant shrug. For all his fearsome size, he has very elegant manners. I'm only just now realizing that. "You simply never listened before. Or perhaps you tried but your so-called mothers"—he says this last part with a sneer—"prevented you from hearing me. I notice you're no longer wearing your flowery little necklace, the one that stinks of their ichor."

I reflexively touch my bared neck, then force myself to put my hands down as I rebut: "And I notice you're still wearing your kaduth." I nod my chin at his breastplate. "Clever gambit, using it to evade the n'goma. Thankfully, we know your secrets. And now, we're going to use them to escape Hemaira."

As I glance back at my friends, who have already assumed

battle stances, despite the fact that we're woefully outmatched by the Forsworn, the jatu-leader deathshriek bursts out in loud, robust guffaws. "The n'goma?" He laughs, wiping away a tear with a knife-sharp claw. "You think an ancient arcane object is what prevented you from entering Hemaira? This city has always been open to you, has always welcomed you, in fact. Idugu seeks you with open arms, you know this. It is your mothers who do not want you here, who do not want you knowing . . ."

"Knowing what?"

Beside me, Melanis is swiftly becoming agitated. "Stop talking to him and fight, Nuru. We must escape."

But I'm done with her interruptions. "Escape how?" I ask, gesturing around.

The Forsworn deathshrieks may be smaller in number, but even one of them is equal to at least three or four of us. It would be different if it was just my group, and we were fighting with only escape in mind, but the entire Warthu Bera is with us now, and most of the alaki are so weakened, they'd just be bodies for the slaughter. We're well and truly trapped.

I glance at the karmokos, trying to see if they have any sort of plan concocted, but they're still whispering to each other, taking advantage of the fact that the leader deathshriek's attention is on me.

He steps forward once more, that awful smirk curling his lips. He doesn't even glance Melanis's way as he continues, "Ask yourself, Nuru, why would they create the ruse of the n'goma? And why would they bind you with so much stinking ichor, you couldn't even hear the sound of your own brothers' voices, much less use the abilities you were born with? Why would they seek to make you less than you are?"

His words slither through my mind, a reflection of all my fears, all my suspicions: the mothers are lying to me, using me for some end I don't truly understand.

The mothers don't love me.

I shake my head. "No," I cry out, "you're just trying to confuse me." I can see it now, the smugness in his grin, the cunning in his eyes. There may be some truth to his words—a lot of it, even—but it's muddied by some sort of hidden motive, some sort of scheme. "What do you want?" I ask, clenching my fists tighter over my atikas.

Beside me, Melanis is virtually frothing at the mouth now. "Kill him, Nuru," she hisses. "Or I will."

The deathshriek turns to her. "And after, what will you do, Melanis, Light of the Alaki—fly back to your precious mothers?" he mocks, knowing fully well she can't understand his words. "Tell me, how will you manage to do that without your wings?"

As I tense, about to alert her, Melanis abruptly launches into the air.

It's too late. I hear a swift whooshing sound, and then a spear appears out of nowhere to ram through her wings, sending her crashing down.

"You dare?" she shrieks as she lands in a crumpled heap, her wings flapping uselessly. The leader deathshriek who threw the spear smirks as he scuttles back up the walls, disappearing into the darkness. "You dare cause injury to my person, unwanted one?" she growls at the jatu-leader deathshriek.

Belcalis and the others run to her, trying to drag her to safety, but I remain where I am, my thoughts whirling. Something has just occurred to me: Melanis moved before the spear was thrown. Before I even tensed up after the leader deathshrieks's

threat. She didn't have to read my body language or his to defend herself; she already knew what was going to happen. No, she *heard* what was going to happen, because the leader deathshriek said so, which means she understood what he was saying—has likely understood this entire while.

I whirl to her, shock and betrayal warring inside me. "Melanis?" I ask. "Do you understand him?"

The Firstborn only stares at me mutinously, her teeth gritted as she rips the spear out of her wings.

When she rises, shaking them out, I take a step back, betrayal growing. "Have you always understood them?" I whisper.

"Of course she has." Behind me, the leader deathshriek is amused. "She's the Light of the Alaki, the favorite of your mothers. Why else would we go to such lengths to keep her? Why else would they go to such lengths to free her?"

I'm reeling now, overwhelmed by all the emotions churning inside me. Melanis can understand the Forsworn deathshrieks, can hear them when they speak. Has heard them all this while, even though I could not. I thought I was the only one who could understand all the languages of the mothers. I thought that was what being Nuru meant, that no one else could do what I could.

And yet Melanis has been able to communicate with the Forsworn all along. But she never once said a word. "Why?" I ask, hurt. "Why didn't you ever let me know? Why didn't you ever let anyone know?"

Melanis remains silent, as always, so the jatu-leader deathshriek answers for her. "The answer is simple, Nuru," he says. "The mothers didn't want her to tell anyone. They didn't even want their precious daughters to know we existed. You see, to them, we are unwanted spawn, less than meat." There's a tone

in his voice. A barely hidden tremor I know he wouldn't want me noticing. Suddenly, now, I remember that man in Melanis's memory, the pain in his eyes as he stared up at the mothers. Another jatu, asking the Gilded Ones to love him, to no avail.

I turn back to the deathshriek, tired. So very, very tired now. "What do you want?" I ask, weary.

"You," he says. "You are the only one Idugu requires. The rest of them can burn." He turns to his followers, raises his spear. "Leave not a single person standing. Except her."

With a roar, the deathshrieks rush toward us. But as I raise my atikas, preparing to defend myself, a spine-tingling shriek echoes across the courtyard. I glance up, as does everyone else, to see Sayuri standing on the battlements, gesturing with a golden spear.

"Bloodsisters!" she roars. "Defend your kin!"

That's all the warning I get before the courtyard is suddenly awash with massive bodies, mist rising as the Warthu Bera's once caged deathshrieks plow into even larger purple ones, an entire flood of them to wipe the others away. The air quickly splinters into ear-shattering roars as the deathshrieks use teeth, claws, and even weapons to fall upon their counterparts.

A hand pulls at me. Britta, awake again and trying to get me back to the safety of the Warthu Bera's grounds. "Come on, Deka!" she says, dragging me back into the smoke.

I follow her through the still-blazing fires to the courtyard, where a group of the Warthu Bera's deathshrieks stand guard as the karmokos and a short, ruddy jatu, as well as two others I can't quite see, marshal girls into those carts, four, five to each one.

Once there, I stare at Britta with bewilderment. "What's happening?" I ask, still in shock. "What was that? All those deathshrieks?"

"Sayuri." The reply comes from Melanis, who's limping over, her wings dragging behind her. "She's called all the deathshrieks in the Warthu Bera to her. Even in such a bestial form, she remains loyal to us. She would never let her sisters fall to jatu hands."

I stare at her. "To us?" I repeat coldly. "There is no us. I refuse to be companion to someone who lies to me, to everyone around her." I don't bother to address how she spoke about Sayuri, since I know she wouldn't begin to understand what I'm objecting to.

I understand Melanis now, understand how her mind works. There were so many clues, so many little things she said that I brushed off, believing they were only the relics of her age. But they were all part of a much larger picture, a much more damning one: In Melanis's eyes, there are those who matter, and those who do not. The goddesses, the alaki—only they have worth to the winged Firstborn. Everyone else can burn.

Melanis shrugs. "Sometimes, lies are for your own benefit. They prevent you from falling prey to those who mean you harm."

"Like Idugu, you mean?"

"Like him," she acknowledges.

"So you admit he exists. That you know him, that you've always known of him." *Which means the mothers have as well. . . .*

Melanis merely blinks, and all my suspicions are confirmed. She and the Gilded Ones have always known of Idugu. Have always known of the male deathshrieks. But they never told us, and they sent us to Zhúshān to take Elder Kadiri and the angoro.

But what is the angoro, truly? And why are they so desperate to have it that they'd risk my going after it? I know now that it's almost certainly not what they told me it was—some sort of arcane object that steals away their power. Is it some sort of

weapon, as we thought before? Even a person, perhaps? Does it have something to do with the cataclysm, the one White Hands still can't remember?

Even worse, why did the mothers assume I would just hand it over once I found it?

The necklace . . . The words slither into my mind, a condemnation. The Gilded Ones were never worried about what I'd do, because they placed a collar on me—one that ensured I was always obedient, always theirs. But now, I've taken it off.

I take another step toward Melanis. "Idugu may be a monster, he may be an evil that preys upon our kind, but at least, as far as I know, he's never lied to me."

"Your point being?"

"My point being, there are things I do not know, and only one deity who seems willing to tell me." I inhale, knowing the words I speak next are almost certainly going to irreparably sever me from the mothers, from all the things I've come to know. "I'm going to go speak to Idugu," I say. "I'm going to find out what it is the mothers aren't telling me."

"So you would abandon your bloodsisters on the battlefield just so you can pursue a selfish cause?" There's a strange glitter in Melanis's eyes now, and I know, almost without a doubt, that the mothers are watching through them. I can feel them, a distant power, although it no longer has the same effect on me it once did.

I glance back at the inner wall's courtyard, where those shrieks grow quieter with every second that passes. The Forsworn might be massive and overwhelming, but even they cannot withstand the sheer number of deathshrieks in the Warthu Bera, the decades of their built-up resentment and aggression. They've already lost the battle.

"What battlefield?" I say finally. "All I see is a graveyard. The fight is over, as is this conversation."

Melanis grabs my arm so fast, I don't even see her move. "If you do this, you will never be welcome in Abeya again." Her voice comes in layers, almost as if the mothers are speaking through her.

I look down, slowly, pointedly pull her fingers from my arm. "I am the Nuru, the only full blood daughter of the Gilded Ones. You will not tell me what to do, and you will not condescend to me. Only the mothers can revoke my welcome to Abeya, and you are not them . . . are you?" This question I add purely as a challenge.

When no reply comes, I walk away. I'm done being manipulated by the mothers, done being their puppet.

"Deka," Melanis calls out from behind me, her voice still layered. "Deka! Do not do this!"

But I no longer hear her. I no longer hear *them*.

I stop by the karmokos, who are almost done loading the girls into the wagons, helped by Rustam, Karmoko Calderis's lover, that short, ruddy jatu I saw before, as well as Keita's friends Chernor and Ashok. It seems they've had a change of heart, which is good. I'd hate to have put them to the sword.

"I expect this is goodbye," Karmoko Thandiwe says when I near them.

"It is," I reply. I nod respectfully to them and the other karmokos. "It was wonderful to see you all. I hope we will meet again, under better circumstances, but I must continue on. For now, lead the girls out of the city and help any other training grounds you can on the way. There is something I have to do."

Then I turn to my friends. "Let's go," I say firmly. "Idugu is expecting us at the Grand Temple. We should oblige him."

29

◆ ◆ ◆

The streets are in chaos by the time we begin ascending the hills toward the Grand Temple. Asha is accompanying Rian, Mehrut, Gazal, and the other bloodsisters out of Hemaira, where the Army of the Goddesses waits, ready to receive them and the karmokos. I've instructed them all to tell the army's commanders about the plan to attack Abeya, since I have a feeling Melanis didn't stop to warn anyone. What they do with that information is up to them. At the moment, all the girls and deathshrieks in my group are huddled inside a pair of carts we took from the Warthu Bera, careful to remain as still as we can under the stiffened cloth cover while the boys drive us to our destination, led by Acalan. Since he knows the Grand Temple in and out, he's the most obvious person to guide us there. And the most eager as well. After everything we've been through in the past few days, he's finally ready to go back to the house of nightmares, where so many of his worst memories took place—finally ready to confront his demons. And it's just as well, because if

our time at the temple goes the way I expect it to, he'll need all the courage he can muster.

"So ye really think the mothers were speaking through her?" This abrupt question comes from a now fully awake and fully recovered Britta, who's been listening to my explanation of what passed with Melanis, concerned.

The others are still asleep, Ixa's soft snores rustling the braids in my hair, so I try to keep my voice to a whisper as I reply, "It was almost like I could see them behind her eyes. And I could feel their power—I'd know it anywhere."

"Why do ye think they don't want ye to speak to Idugu?"

"I don't know," I say. "But I have my suspicions."

Britta reaches out, touches my hand. "Will ye be all right, Deka? If the mothers have really kept something even bigger from ye—bigger still than everything we've discovered so far? Will ye be able to handle it?"

"Will you?" When Britta frowns at me, I explain. "This affects you all as much as it does me. If the mothers are hiding something even bigger from me—I won't return to them . . . Which means they might not allow any of you to return to Abeya, since you'd also be considered traitors."

The knowledge sits like a weight on my chest, suffocating me. I'm taking the others from their home, preventing them from returning to the only safe place we have now.

I move closer to Britta, suddenly desperate. "You don't have to come with me. You can just return home, and the mothers will accept you. They'll take you back."

"Really, Deka?" Britta snorts, rolling her eyes. "Ye really think I'd leave ye? Home is where ye are, silly girl," she says.

"It's where ye all are. Even when we were at the Warthu Bera an' things were terrifyin', it was home because ye were there."

"Couldn't have said it better myself," Belcalis says, rolling around so her body faces mine. It seems she's awake too. "You lot might be infuriating, and you might be foolish, but you're still my family."

"Same," Adwapa and Asha sing out together from where they're squashed at our feet.

Tears are stinging my eyes now, tears of happiness. "I love you idiots," I whisper. "You're my home too."

"That's certainly true now that the Warthu Bera is in flames." Britta says wistfully. "It was a shite place filled with shite people, but it was ours for a time, was it not?"

I chuckle. "Remember when Mehrut's entire team got flayed and we made fried sweet puffs to cheer them up?"

Britta smiles at the memory. "We stole all that nut flour from the kitchens."

"Matron Nasra was so angry, she was spitting fire for weeks." Asha giggles.

"Bludgeoned us all with her rungu, but none of us ever told. Those were the days." Britta sighs. "Things were simpler then. Brutal, but simpler."

"Hopefully, one day soon they'll be simple again—without the brutality," I say as the wagon rumbles on, approaching the temple proper now.

Around us, more and more hoofbeats pass, urgent shouts and commands accompanying them. The jatu from the temple are deploying to Hemaira's walls, trying to stop the alaki and Warthu Bera deathshrieks who are exiting, as well as the

bloodsisters from the other training houses following them. A few jatu shout at Acalan for being in their way, but he ignores them, keeps the cart moving steadily onward until finally, the shouts fade into the distance and the cart begins to slow.

When the wheels stop, I stiffen, tension cording my muscles. We're here.

The temple is almost quiet when we emerge, the first few rays of sunlight barely a whisper on the horizon. We began fighting at the Warthu Bera early last night; now, it's finally morning. The temple's last few jatu and Forsworn deathshrieks have long exited the gates, headed for Hemaira's walls, which loom in the distance, ablaze with light and sound. Now that the Army of the Goddesses has kaduths at their disposal, they're entering Hemaira, ready to aid all the fleeing alaki, to liberate any and all women who might want liberation. It's the perfect time for us to sneak into the Grand Temple.

Once Acalan leads us to a small back door, I turn to the others. "Ready for this?" I ask.

"As we'll ever be," Keita says, squeezing my hand.

I fidget, hesitant. "I don't know what we'll find," I say truthfully.

"It doesn't matter as long as we're together," Britta says, squeezing my other hand.

I nod uncertainly, then glance down at Ixa, who's already hopping about the ground in nightflyer form. *Lead us to Idugu?* I ask.

Deka, he replies, fluttering in the door the moment I open it.

I follow, confident he'll lead us to the correct place. Ixa's attuned to divine presences. He'll know where to look.

The guards in the small corridor jolt when they see us coming, but Nimita's on them before they can scream, claws slicing through their armor faster than a knife through butter. I'm almost amused by the lack of foresight, actually. All that divine gold the priests invested in armor for the Forsworn death-shrieks and they didn't even think to make their own guards any. Ixa continues on ahead of us, eyes sharp as he glides through the halls of the temple, carefully avoiding groups of priests and acolytes making their rounds and praying under their breath. Acalan informed us that all the higher-ranking priests will have either joined the jatu on Hemaira's wall to bless their efforts or are too elderly to move about at so late—or rather, early—an hour and are therefore fast asleep, which is a relief. While I'm not averse to killing priests, most of those left here are acolytes, youths barely past their first chin hairs, who tend the temple's fires in the dead of night, and lower-ranking priests.

The deeper into the temple we go, the more ornate the ornamentation becomes—carvings embedded in the walls, shelves and shelves of scrolls crowding every corner. Try as I might, however, I can't spot the carvings I saw earlier when I was inside the doors. The ones with the golden tether that kept niggling at me. Perhaps they're nearer to the inner sanctum, which, I assume, is where Idugu rests. If he's anything like the mothers, he'll be waiting there for us, having detected our presence the moment we entered the temple grounds. Thankfully, however, he doesn't share their love of setting traps, but given the fact that the entirety of Hemaira is his domain, he doesn't need to.

After flying for a time, Ixa swerves toward a dark corner

that turns out to be a staircase. I frown at the steps spiraling up into the darkness, the dim torches there only barely keeping the dark at bay.

"Idugu is up there?" I ask.

Deka, Ixa chirps.

"I've never seen these stairs before." I turn when Acalan says this, a faint look of confusion on his face.

"I thought you'd been to every part of the temple," Kweku says, frowning.

"Not here," he says. "Acolytes are never allowed in this far."

"We must be on the correct path, then," I say, following Ixa up the stairs, which are so eerily dark and empty, our footsteps echo in the early morning air.

It's as if Idugu has ensured that there are as few barriers as possible to hinder our progress, which makes sense. He *wants* us to come to him. I can't help but feel unnerved by the thought.

Ixa finally leads us to a massive wooden door, the kind priests are fond of using to guard sacred objects. A pair of kuru, those golden sun symbols, serve as knobs, while a larger kuru is inlaid in gold in the floor. The air shifts as we near it, growing darker, heavier. By the time we're standing next to it, all the fine hairs are lifting on my arms and the back of my neck is prickling as I recognize that familiar, sinister feeling.

Idugu. He's here.

But for the first time, I don't recoil at the fevered awareness of his presence. Instead, I look down at Ixa. *Good work,* I say silently.

Deka, he chirps, pleased.

I turn to the others. "Wait here."

A bemused snort sounds. "Not a chance of that," Keita says, walking up to me. "I'm going with you."

"Me too," Britta says, then glances quickly at Li.

Hidden messages pass between their eyes, but then, to my surprise, Li walks over and envelops Britta in a firm embrace, kissing the top of her head while she buries her face in his chest, blushing. As we all watch, shocked, he whispers something in her ear, then steps back.

"We'll wait here, guard the door for as long as you need," he says out loud, his eyes on Britta, who's still blushing. It's clear his next words are for her and her alone. "Fortune go with you," he says softly.

"Ye too," Britta replies, her face bright red. When she sees my expression, she turns even redder. "Not a word from ye, Deka," she hisses. "I mean it."

I put up my hands quickly. "I'm not—" The words die on my lips.

The doors are creaking softly open by themselves. When they open fully, allowing us our first true glimpse of what's inside, my jaw drops.

The room in front of us is colossal, an impossibly enormous, towering structure that almost rivals the entire Temple of the Gilded Ones. It can't possibly exist in this small tower above the Grand Temple. It can't possibly exist in any tower anywhere. But I'm not concerned with the hows and whys of it; my entire attention is taken by what stands at the very end of the room: four massive golden thrones, an equally massive golden statue sitting on each one. I stare at them, unable to move, unable to breathe. Shock has turned my feet to lead.

"Those statues . . . ," I whisper.

"They look like the mothers." Britta's consternation is plain on her face as she staggers up beside me. "They look exactly like the mothers."

"But they're male," I say, the blood rushing to my head as I try to comprehend what I'm seeing in front of me.

The statues on those thrones are identical to the Gilded Ones. Same faces, same robes, same everything—except they're all male. Perfect male replicas of the mothers, all just sitting there in slumber. One even has wings, like Mother Beda. Memories flash through my mind as I stare at them—threads finally coalescing: Anok reaching out to the Merciless One, the guilt she felt about something she and her sisters had done. Then there are the carvings I saw when the door first brought us here—the ones that looked like four female warriors fighting four men they were connected to. Those warriors were the Gilded Ones, I realize now, which means that these gods were the ones they were fighting.

A vision of the indolo wafts through my mind, two creatures bound by a golden tether. And all the pieces fall into place. This entire time, I've been thinking Idugu is a single entity, one mysterious being hiding in his distant perch, laughing down on our attempts to find him. But what if instead of one mysterious being, there are four? Four male gods, four brothers of the Gilded Ones. Four Merciless Ones.

Which means the mothers' lies are even bigger than I knew. They weren't the only ones who created Otera. Their brothers were there too. They also existed all this while.

"What is this, Deka?" Britta asks. "How can all this be here?"

I can't form a reply to her question. My head is muffled now.

The air has grown thicker, Idugu's presence almost overwhelming. He's—no, *they* are—watching. Waiting . . . But for what purpose, I still don't know.

I look up, challenging them. "Is this some sort of game? You're playing tricks on us, right?" When there's no answer, I turn to the four thrones. "Are you the brothers of the Gilded Ones? Is that why you brought me here that first time? So I could see what you are?"

Now, I understand why we were taken by those doors, hurled all the way from the Eastern provinces to here. The brothers— perhaps they're all collectively called the Idugu or perhaps they're all called the Merciless Ones, I'm not sure which; they tried to bring me here, to speak to me. But I changed the door before they could do so, and I escaped.

But now, I'm here again. Exactly where I started.

Power surges through the hall in reply to my question, and the braziers spark aflame one after the other, a straight line leading me up the path to the dais where the statues are. All I have to do is climb those stairs, stand in front of those statues, and my questions will be answered.

It's in the blood. . . . Those words shiver through me.

I turn to Britta, who's fidgeting behind me, worried. "You have to go now," I say. "You and Keita have to prepare the others for escape. I have questions I need to ask here." Then I add, more softly this time, "If anything happens, tell Keita he's in command."

"But, Deka—"

"I have to do this, Britta. I have to know."

She nods. Sighs. "All right. Be safe, Deka."

"You be safe too, Britta," I say, embracing her.

Then she's gone.

I kneel, pull out the dagger hidden in my boot. It's nowhere as ornate as the ceremonial dagger I used when I first freed the goddesses, but a blade is still a blade. And as long as I'm the one wielding it, it should do. Now, I understand why Anok said those words to me so long ago, why she had me look into the necklace. She was preparing me for this, the moment when I would be faced with understanding the truth. All I have to do is walk up those stairs, gather some of the Idugu's blood in liquid form, and then I'll have the answers I seek. Then I can judge the truth of the mothers, of Otera, for myself.

I begin climbing.

The first statue I reach is of a stern older man, the wisdom of the ages in his eyes, his broad nose and mischievous expression almost identical to Anok's. I stand there for a moment, watching it. Is this statue a sleeping Idugu, which is what I have decided to call them, or just a depiction of one? I'm not sure, but what I do know is that the gold covering it contains ichor. Power rolls off it in waves, a subtle tingling I feel just under my skin. I slice my dagger through my palm, waiting patiently as the blood begins to well up.

Touch it and see . . . , a voice whispers in my head. Mine or the Idugu's, I'm not sure.

But I reply out loud, nonetheless. "All right," I say. "Show me everything."

And I touch the gold.

30

◆ ◆ ◆

I'm back in the dark celestial ocean, galaxies swirling past, suns being born and dying in distant universes. Only I remain still—watching. There, just beyond the veil, the invisible barrier that separates worlds, lies a mountain range, one immediately familiar despite the wilderness flourishing atop it: the N'Oyos. Its highest peak is stark, as yet untouched by the temple that will one day crown it. But in the plains below, chaos. Armies clash, armor striking armor, sword striking sword. And I—*we*—remain where we are, unable to help them. I can feel us now, a multiple of beings, all merged together, and yet each with a distinctly separate consciousness. Sadness overwhelms us, distant yet powerful. Blues and silvers color our distress, dimming the gold that shimmers over our celestial forms. Thunder crackles, ocean waves roil, in response to our despair.

For centuries now, we've tried and failed to help humanity ignore its basest instincts toward destruction and war. No matter what we do, they always resist. Run from us in those frail

mortal bodies. But we cannot blame them for their fear. The very sight of us turns all but the strongest humans to ash, and when we breed seers to speak for us, they immediately descend into madness. How can we aid the humans if we cannot even communicate?

How can we reach them if our very nearness portends their deaths?

The conundrum plagues us, greens and oranges the colors of our consternation. A distant volcano erupts in response to our disquiet.

What if we changed form, made ourselves appear mortal like them? The thought tingles through our consciousness, an idea that strengthens the more we contemplate it in blue-purple notes. Zephyrs curl through the air. Flowers blossom.

But how? Another in our consciousness muses, *Humans are primarily dimorphic in form and look upon any outliers with suspicion. Would they not do the same to us if we were to appear as we are?*

We could become two. The thought ripples through our collective. *Each of us may separate. Male and female. Or as approximate as we wish.*

Male and female . . . The mere thought unsettles us. Humans like to sever themselves according to these lines, although they are not so simply sorted. There are so many differences. So many. But humans always hurt the ones they cannot easily measure. They force them to choose—male, female. One or the other. To think that we too must choose . . . Confine ourselves to such limited forms. Our unease prickles red and orange, causing distant forests to shrivel away to desert.

How inelegant, another sniffs. *We would not like to sever ourselves. To part forever.* Our collective may be many, but we are also

one, bound by the tether that connects us to each other and to everything else in this cosmos.

Perhaps we would not have to resort to such permanent means, yet another muses.

We turn, following their attention to the ground below, where a tiny creature, graceful in form, slinks through the brush, its two bodies connected by a glowing golden thread.

It is called an indolo, the other whispers, delighted. *Two separate pieces, but one whole.*

We orient ourselves lower, that we may gaze upon its form. To our surprise, this creature—this indolo—does not burn to ashes or flee at the sight of us. It merely gazes back, two pairs of golden eyes blinking thoughtfully.

An indolo, we murmur, the thought appealing more and more to us. *Perhaps that is what we will become.*

◆

I gasp awake.

◆

When my eyes blink open, the temple is empty. Quiet, except for the flames popping and sparking in the braziers. It's as if I'm alone in the world. But I know I'm not. My companions are somewhere outside the door. If I strain, I can hear their muffled movements, each one distinct and unnaturally slow. The air feels nearly like it did back in the Warthu Bera's caverns, when I was moving so fast, everything else seemed to crawl at a snail's pace. But I know that's not what's happening now. I'm not moving

fast—or at all, for that matter. The Idugu are distorting time. Or, rather, this entire chamber is the distortion. It's just like the Chamber of the Goddesses, except instead of the river of stars, there's an entire temple hidden inside this room. Once upon a time, I would have called this chamber a miracle, but now I know it for what it is: a fickle whim of fickle gods.

I walk closer to the statues, noticing how lifelike they've become. Heat rises from them, almost as if they are breathing. Even more telling, my palm is so completely smeared with gold, I have to wipe it off using the undergarments lining my armor. So I was right: these are the sleeping forms of the Idugu. But they aren't rising like the mothers did when I touched my blood to the gold imprisoning them. They're just frozen there, unmoving. I frown. Could it be that they're somehow still imprisoned like the mothers were?

No, that can't be possible. They've been communicating with me all this while.

I look up at them. "Why did you show me that memory?" I ask. "To prove you are the brothers to the Gilded Ones?"

"Brothers?" The disdainful reply rolls under my skin, a thousand voices in one. I look up to find the Idugu's mouths moving, visible ripples underneath the gold veiling them. "After everything that you've seen, do you really think that is what we are?"

"Then what am I supposed to think?" I ask. "That you're some kind of counterpart to the mothers? That you were once one with them, like indolos?"

"Then, now, always. The exact same being."

"Then why this?" I gesture around the temple. "The separate temples, the alaki sacrifices—the blood, the fighting? Why not just rejoin with your counterparts if that is what they are?"

"Because they were the ones who chose to sever our bond!" The floor buckles under the force of the Idugu's ire. "You saw the memories! They were the ones who imprisoned us here— hid us from the world! They were the ones who decided to steal all our children for themselves. The alaki, the jatu—they took them all. Constrained them to fit their idea of the world."

Images flash through my mind: White Hands emerging from a pool of gold in all their glory, a being of all genders, of endless possibilities. A being as divine as the essence they were created from. But the mothers are horrified at their appearance, so they reject all the other facets of them, whittling away until only the feminine ones remain. All the while, the Idugu watch from be- hind the veil, helpless. They watch as the mothers then create new children, elevating the females and ignoring the males and the yandau as they cavort with humans and build the empire that will one day be known as Otera. All the while, the Idugu watch, trapped in their prison, that in-between world, the ce- lestial realm turning RedOrangeRED in their ANGER FURY blackgray bleakness HUNGER—

I wrench myself away from the memories, unable to take them anymore. They're so powerful, so overwhelming. And they're only half the story—the Idugu's half. Before, I would have taken them as the whole truth, but I'm no longer as naive as I once was. Nowhere do I see the reason the mothers impris- oned the Idugu in the first place, or how the Idugu managed to keep their rising power hidden from them and from the alaki for so long. These memories, they're a manipulation, and not even a decent one, as compared to White Hands's dealings.

Anger blazes over me. "Lies!" I roar. "All lies! You expect me to believe that male gods who put men above all others valued

a being like White Hands? Wept at her fate? These are all convenient mistruths to make me hate the mothers, to make me doubt their every action." And I need no help doing what I've already started on my own.

This answer, of course, displeases the Idugu. "You speak of lies, Deka?" comes the sneering reply. "You traveled here searching for the angoro, did you not? Did your *mothers* tell you what it was? Did they say it was a golden throne, one that grants power?"

"And what if they did?" I scoff. "Are you offering to hand it to me?"

The Idugu continue as if I haven't even spoken. "The Gilded Ones never informed you of our existence, never told you there were other gods. All they told you was that they were the only ones, the only creators of the alaki and jatu. Tell us, why do you think that is? Why did they take all the worship, all the glory, for themselves? Why did they hide us, *starve* us?"

The word rumbles through the chamber, sending an image flashing through my mind—the Idugu watching the Gilded Ones from behind the veil, those red-oranges of anger, rage, simmering inside them. But another color slithers under their emotions, one I saw so briefly, it was gone before I could understand it. Black, thin and bleak—helplessness. *Hunger* . . .

And finally, White Hands's words just a few mornings ago make sense: *Names are what give things power. Even gods.*

Realization quakes through me: the mothers stripped the Idugu of their names and identities, and in doing so, denied them the chance to be worshipped. And gods need worship to survive. The subservience and belief of humans are what sustain them. But the Gilded Ones starved the Idugu of worship, then

342

banished them behind the veil to die what should have been a very slow and painful death.

Yet they're still here.

How can they still be here? My rational mind surfaces again, picking holes in the Idugu's claims. By all rights, their consciousness should have long faded away. They should be barely more than energy, floating in the universe. How can they still exist, talk to me in this temple of Oyomo, if—

Wait.

This temple of Oyomo.

Oyomo . . .

The air is sucked out of my lungs. "You're the ones who created Oyomo!" I exclaim. "You created a new identity to help you feed!"

It makes so much sense. No wonder the jatu were able to take the Gilded Ones by surprise and imprison them—they had the Idugu leading them and the mothers didn't know. They thought the Idugu were securely imprisoned behind the veil—slowly starving out of existence. But unbeknownst to them, their counterparts had created a new identity called Oyomo and used it to manipulate the jatu into following a new path, called the Infinite Wisdoms. And if the memory I saw in Melanis's mind was true—that jatu gazing up in despair at the mothers—the jatu were already well inclined to follow. I've seen the way the Firstborn treat men, the way they look down on them as lesser. Of course, the jatu would fall under the sway of Oyomo, the god who promised them a world completely ruled by men. A world where women would be forced into subservience and alaki would be steadily decimated until a special ritual was required to find and execute the last few who remained.

343

When the mothers ruled the world, they created a hierarchy based on gender, so the Idugu, when they had their chance, did the same. But the difference is, they were even more vindictive than their counterparts, massacring the children the Gilded Ones had raised and using those sacrifices to feed themselves, to gorge on the power that had been denied to them for so long.

Fury sweeps through my body, so powerful now, I can barely speak. "The Infinite Wisdoms, the temples—you created all of it so you could be worshipped!" I rage. "So you could feed and use the power you gained to seek revenge on the mothers and their children!"

It's all so sinister, all so twisted, I can barely comprehend it. Everything I suffered—the horrors of that cellar, the burdens of life as a woman in Irfut—it was all because of the Idugu. Because they needed to be fed. Yes, the Gilded Ones imprisoned them, but they were the ones who took things to the extreme. They were the ones who transformed Otera into this perverse and sinister place. Suddenly now, I remember the words Elder Durkas said to us countless times back in Irfut: *Worship is not just the prayers that we recite; it is the acts of obedience that we perform.* And the Idugu used the Infinite Wisdoms to demand almost complete obedience from women. So every time I walked more slowly because the Infinite Wisdoms told me to, every time I bowed my head, held my tongue, made myself small—every time I did any of those things, it was worship for the Idugu. My subservience—my pain—was feeding them.

All that horror, all that fear—it was part of what kept them alive, kept them plotting against us all this while.

"You're the ones responsible for all this!" I shout, furious. "The Ritual of Purity, the Death Mandate—everything that's

happened, all the blood, the pain! You're the reason I was tortured, killed over and over again! You're the reason all my friends suffered, all the Oteran women continue to suffer. It was always you!"

"No, it was the Gilded Ones!" the gods roar back. "They're the ones who imprisoned us! We had to find a way to survive, even if it was to create a guise through which we could feed!"

"But you did so at the alaki's expense!" I'm so enraged now, all the veins in my neck stand out as I shout: "You call us your children, and yet you fed on us—are still feeding on us, still using our bodies as your playgrounds! If you claim to be our fathers—our progenitors—then explain those alaki chained on platforms across Hemaira, explain all the girls imprisoned in temples, in cells, all waiting so you can gorge yourselves on their blood."

When no reply emerges, I glare up at them. "You can't answer, can you? Can't justify what you've been doing. You can't even come out from behind the veil and—"

I stop, blink—realize.

The entire time we've been speaking, the Idugu haven't moved an inch. Not even their fingers have twitched. In fact, the only thing that's rippled behind the gold is their mouths. It's almost as if they don't have enough power to move anything else. Now, I'm remembering—when they brought us here from the temple in the Northern provinces, they jerked us from one location to the next as if they didn't have enough power to sustain the door. And that's not all. They've only ever appeared in places where their worshippers already were—where sacrifices were being given in their name: the Oyomosin, Zhúshān, that alley. In every single one of those places, someone had to die or be tortured, as Melanis was, for the Idugu to appear.

It doesn't make sense. If the Idugu were being worshipped as Oyomo all this time, they should have double—no, triple—the power of the Gilded Ones. And yet, they can't even move from their perches and are still hiding behind a false name so as not to openly attract the attention and ire of their counterparts.

Why?

An image of an indolo flashes before my eyes. What happens to one happens to the other . . .

And finally I understand.

I laugh and laugh and laugh, giving in to the bitterness bubbling up inside me. "You're still imprisoned, aren't you?" When the Idugu don't reply—as I expected—I press on. "You created Oyomo and made the jatu believe in him—even manipulated them so they imprisoned the mothers. But it all backfired, didn't it? Because you were still connected. Still one being, even though you had separate bodies now. When they imprisoned the mothers, your bodies became like this. Only you didn't have a Nuru to free you. For all your schemes, you hadn't thought that far, and I, for one, refuse to free you."

There's a tense silence. Burnt yellows, oranges of exasperation, flash out of the corner of my eyes. I can almost imagine the Idugu's fury, boiling underneath them like a dormant volcano.

"Well?" I prompt.

A sigh whispers through the room. "A regrettable error," the gods finally acknowledge. "But we will rectify it soon enough. We will sever our connection and destroy our other selves once and for all."

"How?" I scoff. "You can't do anything to the mothers without also doing it to yourselves."

"But you can. . . ." The sly whisper tilts my world on its axis.

Suddenly, it's all I can do to remain standing. What they're suggesting—killing the mothers—I can't even comprehend it. But they sound so certain. So definite. This is what they wanted from me, the true reason they brought me here. They really believe I can kill the mothers.

"I was created to free the Gilded Ones," I say quietly. "No matter what passes between us, I am *their* daughter. Not both of yours, like the alaki and jatu."

Another pause from the Idugu.

The reply, when it finally comes, is an amused chuckle. "Is that what they told you?" Heat rushes up my neck as they continue: "Did you think they were the ones who created you? That you were truly their daughter? Lies, all lies. Allow us to show you truth."

A gold-covered hand abruptly reaches toward me, so enormous, it covers my entire body. One touch, and then I'm falling—a golden tear, hurtling down toward a sea of blue. The entire world seems to exult in my arrival. Pinks and golds of exhilaration paint the sky. A rainbow smiles over the water below, which makes sense. This is exactly how the mothers told me I was born. I'm a golden tear that fell from their eyes—their last, desperate attempt to ensure that they weren't imprisoned for eternity. But when I peer closer, the tear I'm watching isn't hurtling from the mothers' eyes, as I was always told it did; instead, it's hurtling from—

I wrench myself away from the memory, horrified. The Idugu are trying to manipulate me again, only this time, they're showing me false memories of my birth. "No!" I shout. "I refuse to see anything you show me! I refuse to be your tool of revenge."

There are other ways to find the truth. I have their blood on my palm now. I can always store it away, search it later, and see what really happened instead of believing the memories they're trying to push into my head.

"I'm leaving this place," I shout. "I'm leaving now, and there's nothing you can do to stop me."

"You do not believe our words, do you, Deka?" The reply comes as a low, sleepy sigh. The Idugu's presences are already diminishing. They're going back to sleep, the same way the mothers do when they're exhausted. "Then believe your own power, see with your own eyes," they say, a golden hand suddenly reaching for me once more.

I gasp awake the moment it touches me.

When I rise, the chamber is bright around me, unsettlingly so. All the braziers are aflame, the darkness that shadowed them gone. Was I truly asleep all this time—even after that first time I thought I woke? Did I dream everything I just saw?

"Yer awake, thank the mothers." Britta's voice is just next to my ear. I gasp, startled, to see her and Keita standing behind me, Ixa at their side. They all seem relieved—very, very relieved. Just how much time has passed?

"Are ye all right, Deka?" Britta looks me over, her eyes filled with concern. "It's been over an hour. Did ye get the answer ye needed? We've been so worried. We need to leave this place. Everything here just feels wrong."

"All right," I say, nodding. "Let's—"

I stop when a strange crackling sounds in the air. A door.

When I turn toward it, a small, wiry Forsworn deathshriek is suddenly standing behind Keita, his skin a strange bluish purple, unlike all the others I've seen. More doors open around us

and our other uruni—Acalan, Li, Lamin, and Kweku—tumble out as well. Jatu stand at their backs, along with the Forsworn deathshrieks. They're all emerging from the doors now forming around us. The dozens and dozens of doors. Even worse, Keita and the others seem frozen, unable to move, unable to speak.

"Morning greetings, Nuru," the deathshriek behind Keita says. I know, even without asking, that he is Elder Kadiri.

There's that look in his eyes—the same one he had on that platform when he was about to sacrifice those girls to the Idugu. His claws reach for Keita's back and my entire body goes cold.

"Keita—"

"When the Idugu came to resurrect me," the elder says, "they told me you would likely never listen to reason, so I had to show you. I had to show you the truth so you can see it for yourself. Remember," he says, unholy fanaticism in his eyes, "all of it is for you. I dedicate this sacrifice to you, Deka, angoro of the gods. May it nourish you, bringer of death to all that is divine."

And then he slits Keita's throat.

31

◆ ◆ ◆

Keita's blood is bright red. I don't know what color I thought it would be, but I'm frozen by the sight of it gurgling from his throat. It pours and pours, so much of it welling out from the pink underneath. The pink that looks so unreal under the beautiful brown of his skin.

Am I dreaming? This has to be a dream—it can't be real, what I'm seeing. The room is spinning. Lights, movement, color—screams. So many, many screams.

Somewhere nearby, Britta is crying. "Li . . . he's . . ." She turns to me, tears in her eyes. Li's lying in her arms. That horrible red is pouring out of his throat too. "They're killing . . . hi—"

I don't understand what she's saying. It's like I'm walking underwater. Everything feels so heavy. I can barely move. All I see is Keita lying there, that horrible red pouring and pouring, and I don't know what to do and why can't I do anything and why oh why is there red pouring from Keita's throat?

"Keita?" I try to walk to him, but my legs give out, so I have to crawl to his side, have to summon every last bit of strength I have to pull him into my lap. "Keita, please, just talk to me, just—"

He tries, but blood burbles up at the side of his mouth and he coughs, splattering my robes with red. No, no, no . . . My hands shake as I press my fingers over his throat.

I try to stop the blood from flowing, try to squeeze the wound together so it'll heal, but it's no use, so I enter the combat state to see if there's anything internal I can change. If I could heal Britta just months ago, if I could pull her back from the dead, surely I can heal Keita too. But when I look, Keita's soul is human, so frustratingly, unrelentingly human. So I wrench myself out of the combat state back to the red, which just keeps pouring. Pouring and pouring.

The light is almost out of Keita's eyes now, and his breath is rattling, so I plead with him. "Keita, no, please, please, please, we were supposed to be indolo, remember?" I wail the words as if I'm a wounded animal. "You and me, two in one. No, please, Keita, no . . ."

Nothing I do matters, because Keita's breath continues rattling, the sound so horrible, I want to rip my ears out of my skull. "Keita, please . . . ," I keep pleading, desperately tearing what cloth I can from the undergarments beneath my armor. I stuff it around his throat, but that red just keeps bleeding through.

"Remain here with me," I whisper, frantically kissing his lips. "Stay with me."

A small, frail movement makes me look up. "Deka . . ." Blood spurts from Keita's neck as he whispers this painfully spoken

word. His voice is broken glass now—a serrated edge, slicing me raw. He tries to lift his hand to my face, but it falls, so I grab it, place it on my cheek.

"I'm here, Keita. Stay with me," I say, tears running down my cheeks as he attempts to smile at me, only he can't quite curve his lips upward. "Here," I say, hurriedly tugging their corners.

If I can help him smile, then perhaps all this will go away, and Keita will be whole again, and this won't be real, and this won't be happening. But no matter what I do, his lips won't bend, and now, they're growing cold under my touch, their texture waxy and lifeless like the linen in a scroll. It's the same thing with his eyes when I glance up. The light is dimming from them. A gray pallor is creeping over his skin.

And even worse, the rattles are now slowing in his chest. As I watch, helpless, his breath rattles once, twice, and just like that, it's over. Keita's gone. And I sit there. Unable to move. Unable to do anything.

I just sit there.

Ixa paces in front of me, his massive body a barrier between me and the jatu now circling around, but I barely notice. Britta wails in the distance, her pain so similar to my own, but I don't even stir. All I know is that Keita was here, and he was beautiful and he was mine, and now he's gone. My dearest friend. My battle companion. One of the few people I could cry to who didn't think I was broken or hateful or unworthy. The most amazing boy I've ever met—a beautiful, shimmering soul, and now he's gone, oh, mothers, he's gone and I'll never see him again, because alaki don't go to the same place the humans do and I'm not even alaki and I'll never die and I'll always be alone now, always alone.

I look down at Keita's lifeless body, so still there on my lap, and suddenly, I'm filled with enough rage to tear down the skies. "You said you'd never leave me!" I scream. "You promised—you and I, we were supposed to be together!"

I shake him, shake that hateful, obscene corpse. "You said we would be together forever!"

A sob wrenches from my body, and I bury my face in my hands, only to recoil when I feel the wetness on them. They're red—covered in Keita's blood. The blood that was spilled because of me. Because I never deserved him, because I've killed so many people, been responsible for so many deaths, and that's why they took him. Oh, mothers, they took him.

I scrub at the blood, trying to peel it from my hands, but nothing works. No matter how hard I rub my hands against my armor, the red stain lingers, the gold lingers. It's there, shimmering on my fingers, that hateful, hateful gold.

Wait.

Every muscle in my body ropes tight as I glance down, body stilling. There's gold on my fingers, gold gleaming inside Keita's blood. The same blood that's now creeping over him, mingling with the heat rising from his body. Keita is hot, blistering hot. Boiling. And so is the room around us.

"Wha's happenin'?" Britta asks, disoriented.

I glance over to find her covered in a fine sheen of sweat . . . and gold. Its source is Li, who's on her lap, covered in it—as are Acalan, Kweku, and Lamin when I look. Confusion roils over me. They're all going into the gilded sleep, but that doesn't make sense. They're all human. They're all mortal. I looked inside Keita and I saw mortality. That's all I saw when I looked inside him.

353

But is it possible I stopped looking too soon?

The question stops me in my tracks, until a voice sounds in answer to Britta's question. "It's Deka, you know. She's the one who did it."

I glance up to find Elder Kadiri still standing in the middle of the room, Keita's blood on his claws, that awful fanatic gleam in his eyes.

Worse, he's not alone. An entire army of jatu and death-shrieks stand behind him now, their swords at the ready, the kaduths on their breastplates throbbing violently. My head pounds only mildly in response, but the sweat keeps streaming down my forehead. Keita's temperature is rising by the second, only I don't have any more time to ask why—not with the jatu and Forsworn here, their lethal intent clear from their battle stances, their raised swords and sharpened claws at the ready. I know what they want, the reason they're here: they're here to kill us, to ensure that we never leave this temple masquerading as a chamber.

Elder Kadiri lifts his claws, their edges still dripping with Keita's blood. He beckons to a nearby jatu, who swiftly walks over and kneels in front of him. "Watch closely, Deka," he says, clacking those hateful claws together. "It's time you understood. It's always been you, just as Idugu said. Always you. You are the angoro, the golden throne, the source of power. The Gilded Ones sent you here, collared like a base animal, so you would slay Idugu, but He, in His wisdom, disrupted their power. Gave you your freedom. Look closely, Deka. Your so-called mothers wanted to use you to engineer death, but we will use your power to bring forth life. I offer you this sacrifice in your name, Deka."

He stabs his compatriot straight through the throat.

My body turns cold, and I watch, stunned, as blood pours out—that familiar, hateful red—only, as I stare, it swiftly changes to a golden sheen, the same thing that's happening with Keita and Li and the other boys. But unlike before, I can't stand by and just watch. I can't let another jatu become conditionally immortal, like my friends are.

I force myself to lift my hands. No matter what's happening around me, I can't let that jatu, Elder Kadiri, or anyone else here gain enough power to hurt my friends, the people I love.

"Stand down," I say, threading as much power as I can through the command.

Not a single jatu moves.

The only motion I feel is the one coming from my lap. Keita is stirring, but that's the worst thing that could happen, because he's waking up here—to a roomful of jatu who aren't affected by my commands.

Elder Kadiri smiles beatifically. "You should know better than to try to use your voice, Nuru. We are protected by Idugu's mark." He raps the kaduth on the resurrecting jatu's breastplate. "That particular ability of yours has no power here, and soon, all your friends will be dead and gone. You will have no more distractions to pull you from the path that has been set out for you."

"Not if I have anythin' to say about it, ye sneaky pissfart." Britta's rising now, murder in her eyes.

Elder Kadiri barely glances at her. "And what are you going to do, alaki?" he scoffs, unimpressed.

"This."

Britta gestures, and the ground buckles, sending Elder Kadiri and his followers flying. He swiftly twists midair, landing

on his feet, but a few jatu slump against the wall, dead on impact. Others have broken arms and legs. I just watch, grim. This is exactly what they deserve.

"End her! End her now!" one of the jatu rages behind him. A commander.

Those jatu and deathshrieks still capable of movement rush toward Britta, but she gestures again. This time, however, the floor only barely moves. Frustrated, she tries again. Nothing.

I rush over to her, panicked. I forgot she hasn't had enough rest after her last display of power.

The commander who spoke before notices. "She's running out of power—kill her!" he shouts.

Nodding, the nearest Forsworn lunge for her. Only to erupt into pillars of flame.

As I whirl around, stunned, a strange thing happens: Keita rises from the ground, flames leaping from his eyes, as hot as the ones now engulfing the jatu around me. It's almost as if he's become Alagba, the spirit that supposedly punishes the wicked in the Afterlands. The more jatu who burn, the more flames that erupt from under Keita's skin, only they aren't burning him. His skin isn't peeling and curling, and there's none of that awful smell that accompanies an immolation. He's fine—better than fine, in fact.

He's filled with power.

"Keita?" I whisper, unable to believe what I'm seeing.

I don't understand how all this is possible. One moment, he was dead, but now, he's alive and able to control fire? What's happening? Something's happening, but I still don't understand.

I'm not the only one who's stunned. "What's the meaning of this?" Elder Kadiri roars. "What's happening?"

356

"A divine gift," Keita replies, his voice almost layered like the Idugu now as he speaks. "But you have to be blessed by a goddess to receive it. You wanted Deka to burn in the fires. Wanted all of us to perish. Now, it's your turn."

He gestures. This time, every single jatu and Forsworn in the chamber bursts into flames, all of them screaming as their bodies bubble and scorch inside their armor. The odor of burning meat billows, that old familiar horror, but I'm not frightened by it, not even moved the slightest bit. They tried to take Keita from me. Tried to take all my friends as well, the people who are my only true family now. This is retribution. This is what they deserve.

A cold nose nuzzles me. *Deka?*

I look down at Ixa. *It's time to leave this place. Let's go get the others.*

Deka, Ixa agrees, scurrying off.

Britta is carrying Li when I reach her. She seems pale, tired. She must be exhausted from using her gift. "Are you all right?" I ask, but she only has eyes for Li.

"He's not out of the gilded sleep yet," she says, panicked. "Why isn't he out of the gilded sleep, Deka?"

"Let me see." I stand beside her, then slip back into the combat state as I gaze at Li. My eyebrows immediately rise when I glimpse what's happening inside his body. His essence is changing, threads of gold wrapping around it, slowly becoming one with it. So this is what I missed when I looked at Keita, the thing I did not see because I didn't look long enough.

"He will wake soon," I say to Britta as I glance across the hall, where our other uruni are also in the gilded sleep. They're transitioning as well, the gold changing them from the inside out.

"Everyone will."

I can see it now, the combat state allowing me to understand this with a reassuring certainty.

But as I turn back, my vision blinking back to normal, I notice something curious. One of the charred jatu is creeping toward me, his blackened body scraping across the floor. Inside, his soul is dimming from gold to a dull white, but the shape is changing, becoming larger and larger, a very familiar figure. A Forsworn deathshriek.

So this is how it happens.

"They're turning into deathshrieks," I call out to my friends, but no one hears me. Everyone is concerned for their partner, Belcalis for Acalan and Adwapa for Kweku. Only Lamin is on the floor by himself, since Asha's gone back to the mountains.

I turn to Ixa. *Take Lamin,* I say, calm.

It doesn't matter if these jatu become deathshrieks; they won't resurrect here. If what I saw in the kaduth was true, Forsworn deathshrieks are born deep under the earth somewhere—probably in the mountains, since they're remote enough that no one would see the Forsworn rising from the earth. These deathshrieks won't be my problem for some time yet, which is just as well: I have one last thing to do.

I walk to the end of the hall, where there's one last Forsworn who isn't aflame: Elder Kadiri, his body huddled behind one of the braziers like the coward he is. Keita left him alive just for me, the sweetheart. I'll have to give him a kiss later to thank him.

By the time Elder Kadiri looks up at me, my atikas are already in hand. He must see the resolve in my eyes, because he frantically shakes his head, his own eyes wide. "Deka," he pleads, "think about what you're doing. If you slay me, my armies will

never rest. They're gathering in the N'Oyos even now, and if they don't hear from me in two days, they'll—"

My blades flash, and his head falls to the floor in a spray of blood.

I smile viciously. "Revive from that," I sneer, satisfied. Then I bend down and wrench the breastplate off his chest, wincing when the kaduth gleams evilly on it.

A searing heat fills the air behind me. I turn to find Keita walking over, those flames now curling back into his skin and slowly disappearing.

"Keita!" My atikas and the breastplate clatter to the ground as I run over and embrace him. I don't care that his body is still scorching hot, don't care that a symphony of carnage lies around us, burned bodies in cinders on the ground. All I care is that he's here, that he's alive.

"Keita! Keita!" I gasp, kissing him until he barely has any breath left. "You're alive!"

He looks down at his body, bemused. "It seems I am."

"And you're a true jatu! More than that, even, you're immortal now!"

Well, a near immortal. But it doesn't matter, he and the other uruni now have the same life spans as alaki. As to how they gained such a gift, my mind isn't yet able to accept it. To accept what the Idugu and Elder Kadiri said: that I am the angoro, the very power that the Gilded Ones purportedly sent me here to seek. I don't even know what to make of the claim. Despite everything, all the marvels I've seen, it just feels . . . odd.

"Another surprise." Keita seems only mildly unnerved by this. He glances at the carnage. A few of the jatu corpses are stirring, the telltale marks of the gilded sleep appearing across

them. The Forsworn, of course, are still. There are no revivals for them, just like regular deathshrieks. "We should leave. It's well past dawn."

I nod. "And Elder Kadiri said he had armies headed to Abeya right now." The thought jolts through me—a reminder: no matter what I may think of the Gilded Ones, I can't abandon the people of Abeya. People there may be alert for jatu threats, but they're not prepared for all the armies of the Idugu at once.

I grab Keita's hand. "Let's go," I shout, picking up my atikas and the breastplate and then pulling at him. "He said they'd be there in two days."

As we run toward the door, I turn back one last time to the statues of the Idugu, their faces immobile under their golden veils. They've expended all their energies opening those doors for the jatu and now are fast asleep. If I have my way, they'll never wake again.

"I'll be back for you." I spit on the floor to mark my promise.

And then I stride out of the room.

◆

We exit to find Katya and Nimita standing in the hallway, tense. Footsteps are marching up the stairs, commands sounding. There are more jatu out there. Hundreds more, if their voices are any indication.

"Deka!" Katya breathes out, relieved to see me. "We're surrounded! We barred the hallway downstairs, but—"

The telltale thump of a battering ram completes her sentence.

As I groan, annoyed, a scaly head butts against my fingers. When I look down, Ixa, still in his massive true form, is staring at me with intense focus. *Me . . .* , he says simply.

I frown. *You?* I ask, confused, but Ixa doesn't reply.

Instead, he pads over to the edge of the hallway and begins grunting. I stare, perplexed, until I see muscles rippling into existence and spikes popping down his spine and across his forehead. He's transforming again, but something's different this time. He's not shifting into a new creature; it's just that his body is growing—getting bigger and bigger. It's almost as if he's moving further into adolescence, his features becoming more chiseled and defined, his legs and chest so massive now, they butt into the wall.

When there isn't enough room to grow that way, his hind-quarters begin to stretch out, moving toward us.

I push the others behind me, alarmed. "Everyone press to the walls!"

Ixa, you should stop now, I add silently, but he keeps growing and growing. "Ixa?" I call out, panicked.

He whines softly but doesn't reply. It's as if he can no longer control it, this rapid growth, only there's not enough space for him to grow into. The walls around us are made of n'gor, the hardest rock in Otera. It'll take us hours to break through it, and by then . . .

"Ixa," I whisper, horrified. "Ixa, you have to stop now, you have to—"

"I've got this." Britta gently deposits Li on the ground, then walks toward the wall.

She presses her palm there, concentrates. Within moments, my veins are tingling as her power surges to the fore once

more, only, unlike before, it's calm—controlled. Britta inhales once, exhales, then pushes. The wall explodes outward.

Ixa shoots straight through it, his size reaching, then swiftly outpacing, that of a mammut, one of those colossal, spiky gray creatures. Only when long, feathery wings unfurl from his shoulders does his growth finally slow, then stop.

The early afternoon air gusts up as he looks back at us, pleased but tired. He has completely transitioned and looks even more like a sea drakos now, a crown of spikes jutting proudly from his forehead and down his spine, each leg large enough to dwarf a horse, claws the size of hammers. I always knew Ixa would get big one day, but he's a mountain of a beast now.

Ride, Deka? he asks eagerly. *Ride Ixa?*

I nod, whirling to the others. "Get on—hurry!"

My friends quickly mount, and then Ixa launches into the air. One flap of his wings, and we're already soaring over the Grand Temple, leaving that hateful place and all its horrors behind. The jatu below glare up at us, shake their weapons, but we ignore them: it's on to our final destination, Abeya. But first, we have to make a quick stop.

32

◆ ◆ ◆

The other carts have already made it to the alaki army's encampment when we swoop down, Ixa swiftly shrinking back to his former bull-like size. As we expected, the n'goma didn't even touch us when we flew out—the kaduth prevented us from burning, just as it did everyone else who used it. We're surrounded in seconds, the alaki at the camp all on the alert, given the furious battles they must have engaged in the night before. Fires still burn on the walls, accompanied by the faraway shouts of the jatu trying to put out the blaze. Hemaira saw its share of bloodshed last night, but those walls, as always, remain standing.

"Honored Nuru." The words ripple through the camp, spreading past the alaki army to the crowds of women, children, and even the few men who huddle behind them, all of them trying to recover from their rushed escape from the city.

As I nod in greeting to all the people now respectfully genuflecting before me, a familiar dark, lithely muscled form pushes

her way over. "Deka, Keita, are you all right?" Asha asks, Mehrut, Gazal, and Jeneba all behind her.

There's no sign of Melanis, not that I expected there to be. By now, the winged Firstborn will be long gone, back to report every detail of my supposed betrayal to the mothers, even though, I'm assuming, they already saw everything through her eyes.

I nod wearily. "I'm only stopping to deliver a message. The armies of Idugu are attacking Abeya. We need every able-bodied and willing person in the camp to return to the mountain."

"I'm coming with you," she says immediately.

I nod, gesture tiredly at the others, who are all slumped beside Ixa, exhausted. "You should go to your sister. Lamin just woke up from the gilded sleep. All the uruni did."

"What?" Asha gasps.

As she hurries over to her sister, Mehrut behind her, the crowd suddenly parts, revealing a stern Firstborn I quickly recognize as General Bussaba, the commander of the siege against Hemaira's walls. I fought alongside her multiple times in those first few months after I was assigned to the wall. She's a tall, stern woman from the Eastern provinces, with light brown skin and flowing black hair that trails from the top of her helmet in a long braid. The rapid-fire blinks and twitches that dominate her manner take nothing away from her authority, and neither do her pleasant moon-shaped face and large dimples.

She genuflects jerkily in front of me, her eyes widening slightly when they take stock of my disheveled state. "Honored Nuru, it seems you have undergone quite the ordeal. May I offer you food and rest?" Her head jerks twice after she speaks.

I shake my head. "No," I say. "I stopped only to deliver a warning: the armies of the Idugu are headed toward Abeya, if

they're not there already. Elder Kadiri told me two days, but I'm not sure of the truth of his words. Take every willing person you can find. We must defend our home."

The general absorbs this with the same calm efficiency she does everything else. "And what of the siege?"

I glance back at Hemaira, those familiar gray walls that once held such wonder for me. "We have our sisters and all those who wished to flee. Hemaira holds nothing for us now. The siege can end."

General Bussaba genuflects. "It will be as you wish, honored Nuru." She turns to a nearby aide, her head twitching once more as she does so. "Summon the commanders. We decamp immediately." That said, she nods back at me. "Honored Nuru."

I incline my head. "General."

Now, I turn to the edge of the crowd, from where the karmokos, Rustam, Rian, and Lord and Lady Kamanda are swiftly approaching, Lord Kamanda's golden chair whirring as easily over the dust and gravel of the camp as it did the elegantly tiled floors of his estate. Rian immediately runs for Katya, her immense form embracing his smaller one the moment they meet.

"Deka," Karmoko Thandiwe says, inclining their head slightly when they reach me. "Our swords are yours, if you wish. We will travel to Abeya with you."

The magnitude of the offer warms my heart beyond measure, but I sigh and shake my head, nonetheless. Considering the welcome I expect to receive in the city of the goddesses, it's probably not a good idea to bring any of my human allies into close vicinity with the mothers. "I wish I could accept that kindness, but I fear I cannot in good conscience allow you to journey with me. Especially not you." I glance at Karmoko Huon, who blinks.

"You knew," she says quietly.

I nod, remembering my first lesson with her, the way she handled that burly jatu so easily despite her delicate frame. I think I knew then. I think I always knew. "Yes," I finally say.

"I am a woman," she replies, her mouth tight.

I incline my head again. "I have never once doubted that."

She sighs. "I thought Abeya was a haven for those like me."

"As did I, once upon a time." Once upon a time, I'd have thought Abeya would gladly embrace Karmoko Huon, the woman who chose to accept herself as she was inside, who fought to claim womanhood in this world, rather than the body the fates gave her at birth. Now, however, I'm not so certain.

"I think, for now," I continue diplomatically, "it's better that you find your own path."

"A finer load of bull caca I've never heard," Karmoko Calderis snorts disbelievingly. "'Your own path'—what nonsense."

Karmoko Thandiwe, thankfully, is much more diplomatic as they step forward. "What aren't you telling us, Deka? I would understand why you wouldn't want Huon to go, but me? Calderis?"

I bite my lip, then sigh as I decide on the truth. "I fear," I say, "that if you go and become a worshipper of the mothers, we might end up crossing swords one day."

"Ah," the karmoko replies. "Well, that is a very good reason."

"Besides," I say, nodding to Lady Kamanda. "Your partner is due any day." I've glanced at Lady Kamanda while in the combat state. Those children are ready to come out.

"More twins!" the noblewoman declares, seeming so delighted, I pretend astonishment at the news. "One of the alaki told me—a very sensitive woman. We'll travel to my summer

home in Kambiada for the birth." She smiles fondly at Lord Kamanda and then turns to Karmoko Thandiwe, almost hesitant now. "You will come, won't you, Thandiwe?"

"Of course," the muscular karmoko replies. "I am yours, you know that."

Lady Kamanda beams.

I smile too, happy to see a pair so deeply in love.

"Your friends are welcome to come with me if they choose," she adds, nodding at Rian and Katya, who shake their heads.

"I'm going with Deka," Katya says in her deathshriek rumble, signing out her words using battle language as well.

Rian puts his hand in hers. "Wherever she goes, I follow," he says quietly.

I nod, yet more warmth filling my heart. Outside of our uruni, I don't think I've ever met a man as loyal and truehearted as Rian, and I don't think I ever will. His and Katya's romance truly is all that she proclaimed it to be.

I glance at the other two karmokos and Lady and Lord Kamanda as I genuflect. "My deepest thanks for all you have taught me and all the aid you have given me. May fortune go with you."

Three pairs of hands clap my shoulders: the karmokos, smiling down at me. "And with you as well, Deka of Irfut," Karmoko Thandiwe says quietly.

"We will meet again."

"Of this, I have no doubt," Karmoko Huon says, nodding.

And that's that.

Within seconds, my friends and I are climbing onto Ixa's back, and then we're soaring up into the air, leaving the walls of Hemaira behind us for what I hope will be the very last time.

The sun's last embers are dying in the evening sky when Ixa finally lands at the edge of a small desert oasis, exhaustion shuddering through his muscles. He's been flying this entire time in the blistering desert sun, and he's more tired and parched than he's ever been. As he dives into a small watering hole at the oasis's center, the rest of us swiftly, methodically prepare to camp for the night. We all know, without having to ask, that Ixa has reached his limit and will not be able to carry us for some hours yet. It's time to eat and bathe—to refresh ourselves. This is one of the most important things our karmokos taught us: be sure to take any time we have to renew ourselves.

Life for an alaki—for any warrior, in fact—can be brutal and short. So we have to savor moments where we can, find happiness in the small and simple things. We can't speed the journey no matter how desperately we wish: I tried all day to open a door, with not even the slightest hint of success, which means it's at least two days until we reach Abeya. We'll arrive just after Idugu's army gets there, and that's assuming we're still welcome in the city. Considering everything that's passed, we may very well not be.

Strange how, less than a month ago, I could not have imagined such a thing possible.

As Adwapa and Asha stroll into the darkness to hunt for our dinner, Britta and I, by mutual agreement, quietly head for the farthest end of the watering hole to wash. There's no soap, no buckets, no nothing except sand and water, but it's more than enough for both of us. It's more than we expected, honestly, given the hurried nature of our journey.

We wash in silence, only the odd birdcall or chirp punctuating the quiet around us. So much has happened in the past few hours, the past few days, I think we're both beyond words now.

Somewhere between scrubbing each other's hair, Britta stops, puts her head in her hands, and begins to sob. I embrace her, and then I begin to cry too. For endless minutes, we just stand there, crying, releasing all the fear and frustration of the past few days.

When the tears finally run dry, we rise, dress ourselves, and then quietly return to the roaring fire the others have built. Keita nods as he passes us, on his way to take a bath now that we're out of the watering hole. Behind him, the others are already halfway through the pair of plump gazelles Adwapa and Asha have caught. Ixa is gnawing at an entire leg bone and doesn't even look up when we approach. Only Lamin and Belcalis have the decency to look sheepish, but everyone else is too busy stuffing themselves to care that they went ahead without us. Kweku, Asha, and Li are ripping juicy bits off the meat, and Adwapa is feeding Mehrut little morsels with her fingertips, making happy little noises about "fattening her up."

"Ye great greedy gobblers, ye couldn't even wait for us, could ye?" Britta pokes an accusing finger at our friends.

Li just grins. "Well, I have just come back from the Afterlands—literally—and let me tell you, crossing back from beyond the veil makes a man very hungry." He pulls a leg from the roast and bites eagerly into it, savoring the juicy meat.

Britta walks up to him, then stops, her entire body suddenly trembling with emotion.

Li stiffens, immediately cautious. "What's happening? Why

are you looking at me like that?" He turns to me. "Why is she looking at me like that?"

"Ye foolish goose, I thought ye died." She slaps him on the shoulder. "I thought ye'd died, I thought ye'd died!" She keeps slapping him over and over again.

He tries to evade her hands. "Well, I—OW!—I did die—OW! And now I'm alive—OW!—and presumably immortal-ish like you lot, and—" He never finishes his sentence because Britta launches at him, kissing him so deeply, he couldn't talk even if he wanted to.

Acalan heaves a long-suffering sigh. "And just like that, another perfectly good meal is ruined."

Belcalis elbows him. "Hush, you jealous so-and-so."

"Jealous of what?" Acalan humphs.

"Of all the love in the air," Adwapa says, lavishing Mehrut another kiss as Britta and Li finally separate from theirs.

Britta promptly bursts into sobs again. Li embraces her, lifts her into his arms, and presses his forehead to hers. His voice is low now, soft and soothing. "Hey, I'm still here, look at me, Britta, I'm still here." He turns to us. "Excuse us," he says, rising. He swiftly leads her toward the other end of the oasis.

"That was very romantic," Lamin says, smiling simply. "Made my heart happy."

Adwapa, now nuzzling Mehrut's hair with her chin, looks at the rest of us. "Any other impromptu expressions of emotion? By all means, please let me know so I can leave now."

Kweku's jaw drops at the hypocrisy. "Mehrut is literally sitting on your lap. You were just kissing her!"

"Well, we're allowed," Adwapa sniffs. "We're long-lost lovers.

Aren't we, my love?" She kisses Mehrut's ears, and Mehrut giggles.

Kweku rolls his eyes. "Don't you two have a bath you should be taking?"

"Same goes for you, you stinker, you're ranker than the inside of a—"

Kweku holds up a stern finger. "No. Not today, Adwapa. None of your profanities after what I've just experienced. I've just come back from the dead. That should earn me at least a day's reprieve from your abuses."

"But I was just getting to the good part," Adwapa pouts. "I even thought up a new curse."

"I'll hear your new curse," Mehrut giggles.

"Why doesn't everyone go take a bath," Belcalis says. Then she says pointedly to Adwapa, "The far end of the watering hole is quite isolated."

Mehrut smiles at Adwapa. "You and I can go there, take some time together."

Adwapa nods, and the pair walk out, Belcalis, Kweku, and Acalan trailing behind them, presumably to find quiet spots of their own at the watering hole.

Keita returns moments after they leave, his face still gleaming with moisture from his bath, which I doubt took even five minutes to complete. Having been a soldier for most of his life, Keita is lightning fast at eating, bathing, falling asleep—all the necessities, really.

He pulls me down to sit beside him, then glances at Lamin and Asha. "No bathing for you?"

Lamin shrugs. "I'll just wait till everyone is finished."

"Same," Asha adds.

I nod, turn to Keita, and intertwine my fingers in his. I lean my head against his shoulder. "How are you feeling?"

He shrugs. "Alive. That's good enough, isn't it?"

There's a tone in his voice. So much unspoken. So many, many things. I grow still, not sure what to say.

Asha and Lamin look at each other, silent messages passing between their eyes. They both swiftly rise. "I'll go find some quiet," Lamin says.

He walks over to another part of the oasis, Asha doing the same.

Now, it's just Keita and me. A corner of his mouth lifts into a wry smile as he looks at me and says, "That was nice of them."

I nod. "I think everyone needs some quiet right now." Then I search his eyes. "How are you truly feeling?"

He lifts a finger, and a flame appears above the tip. He dances it from finger to finger, his eyes fixed on it so they don't meet mine. He shrugs. "I'm not sure. So much has happened . . . I was killed—I'm immortal now. Well, conditionally immortal. Who knows what my final death will be.

"Honestly, I keep waiting to feel something—anything: panic, worry, fear. . . . But I just feel normal, and that frightens me. I should feel something deeper, shouldn't I, Deka?"

I frown at him. "Do you have to feel something more?"

He shrugs again. "Most people do—I think. Most people probably would."

"You're not most people."

"No. I'm a monster," Keita says quietly.

My heart jolts. "Keita, you—"

He holds up his hand, stopping me. "I don't mean the fire,

Deka. I mean all the killing, all the things I've done. I know you don't see it, but I am. That's why I don't feel. I try so hard, but I just don't. There's something monstrous about that, isn't there? Sometimes it feels like everything isn't real, and I'm just sort of floating . . ."

Tears rush to my eyes. Those words. What he's saying, there's so much pain, so much horror hidden there. And worse, it seems like he's not yet in the place where he can cope with it. So he's separating.

I put my arms around him, bury my head in his chest to try to anchor him to me. "You're not a monster, Keita. You're just a boy they made into a killer. You are what they made you. Just like they made me. If you're a monster, then so am I."

Keita just stares at me. Finally, after some moments, he nods. "Anyway, at least now I know why I kept having nightmares about burning."

A deflection if I ever heard one. But I know better than to push him right now. So I poke my finger through the flame he's still darting across his fingertips, jerking back when it burns. I look up at him, curious. "Does it hurt?"

He shakes his head. "It just feels odd. Like a tingling, almost."

I smile. "I know that feeling." Then I glance up at him again, serious now. "Keita, when I saw you lying there earlier, I almost—"

He puts his hand to my lips. Shakes his head. "It's already over. I'm safe. We're safe."

"But are we?" The words pour out of me, and they continue coming. "You nearly died because of me. Because my mere existence puts your life at risk. I mean, you could've gone back

home to Gar Fatu, gone anywhere and grown old and died, and now you're—"

"Immortal. Like you," he reminds me.

I look up at him again. "I made you this way, didn't I?" Another low whisper. Another hesitant confession.

Keita nods. "Yes, Deka."

The words settle heavy as a mountain on my shoulders. "The jatu in the Oyomosin and in the alley, that was me too?" Another question—another answer I haven't been able to admit to myself.

So I let Keita do it.

"Yes," he says.

"How are you certain?"

"Because when I died, your face was the last thing I saw, and when I was called back from the Afterlands, it was your voice calling me here, telling me to use the fire." He pulls my chin up, looks deep into my eyes. "Maybe that's the other reason I don't feel bad about this—because it was you. It's always been you."

I nod, not even sure how to respond to that. Still, I force myself to put together the words I've been dreading, the words I haven't wanted to say all this while. "Do you think I'm a god, Keita?" I whisper.

Keita shakes his head. "No."

I exhale.

"But I think you might become one."

Any sense of relief I have shatters.

Hands trembling, I display the piece of my robe I wiped the Idugu's blood on. "I got some of the Idugu's blood," I say hurriedly.

"You can probe it for answers as we ride tomorrow. For now,

we need to concentrate on what's in front of us. Eat. Replenish yourself." He gestures at the food.

I nod, reluctantly bite into a roasted succulent Asha foraged, the juicy plumpness of the desert fruit like ashes in my mouth. My appetite is gone, and the food sits in my stomach like a lump of coal. It's all I can do not to cry. Then I notice Keita staring at me.

"What?"

"Free will," he says finally.

When I just stare at him, he explains: "Before, I didn't have choices. I just had paths to follow. They were prescribed, and they were narrow. Even avenging my family, that was a path—that was what was expected. Then I met you. Everything I've done since then, I've done of my own volition. You aren't responsible for my actions, Deka, just as I'm not responsible for yours.

"When I heard you calling, I could have chosen not to come back. But I did. Free will. I'm here because I want to be, Deka, and I love you because I want to. No one's forcing me; it's my choice."

This declaration, it's almost more than my heart can take. No one's ever explained it so eloquently, and to think it came from Keita, the boy who only ever speaks when he thinks it's necessary. I blink back the tears in my eyes. Squeeze his hand.

"I love you too."

It's the most important declaration of love I've ever made, given that in two days we'll be back at Abeya, where I'll have to confront the mothers while also staving off the Idugu's army. And it's one that I hope will be enough to sustain Keita if everything goes wrong and the worst befalls us.

33

◆ ◆ ◆

When I touch the cloth containing the Idugu's blood early the next morning, I'm able to sink into their memories within moments. I'm Okot, Anok's counterpart. One of the Idugu.

And now I see the fissures in our affinity.

They begin slowly, as these things do. A word here, a flash of emotion there, a lightning storm on an otherwise calm day. In the time before times, I understood Anok perfectly. She was me and I was her. My counterpart. My perfect equal. But millennia have passed since Anok and I were one. Now, we are two different entities, just barely connected, our affinity—the tether that binds us—frayed at the edges. Anok and Okot. Two instead of one. Male and female instead of a collective.

Before we divided ourselves, we did not have names. We did not need them. We only were. Then we became two, and those designated as males took names that started with the same letter as our female siblings. Only I did not. I decided instead on a name that was similar in sound, rhythm and meaning to Anok's.

To show that we would always be one. Anok and Okot. Two sides of one darkness.

But more and more, she has been hiding things from me. I see it in flashes. Green, gray, white. Deception, malice, unease. Colors that once did not exist in us. Now, they're inside me and they're inside her. They're inside all of us, except—

"Creation . . . ," Hyobe hisses, his distress rattling through our affinity. "Do you not feel it, Okot?"

I look inward, and that's when I notice: my essence—*our* essence—is mixing with another's, a human's. Anok and I, we are giving birth. Have already given birth to multitudes. And yet, I am not present. Was never asked.

ReD RaGE, OrANGe. The sky shakes with the power of my emotions. Volcanoes explode, clouding the air with ash and fury.

"Anok!" I roar. "What are you doing?"

I hurtle toward the veil, but it does not give way. Does not open to my command.

Only when Etzli appears on the other side of the celestial divide, her eyes disdainful, do I start to understand why. She's flowing there now, shimmering in the form of sunlight and matter she and the rest chose when they decided to make themselves visible to humanity.

"The veil will no longer open to you," she says with a calm finality.

"What do you mean, Etzli?" Etal, her counterpart, rumbles, causing an earthquake to split a nearby jungle in two.

He slams against the veil, but it easily bounces him back, the nebulas there holding fast against his strength. When he tries again, it's the same result. A black-green horror rises inside me. Etal is trapped here. All of us are.

"Justice," Etzli replies, a word repeated by our sisters, who appear beside her. "We were sent to bring the humans peace, but you have destroyed it. You have pitted armies against each other, turned families into enemies."

Images flash through the tether: Armies of humans clashing. Thousands of bodies littering the ground.

"All in an effort to drive them to a higher understanding!" Etal hisses.

"Is that what you call it, Etal?" Beda queries, her wings flurrying gently. "Let me ask you this: Did you enjoy it, what you did to the humans? The wars you caused?"

Etal pauses, and then I see the flashes. Red green white: anger, deception, malice, one after another. Emotions he can't hide now that I'm paying attention to the tether.

"What about you, Hyobe?" Anok asks.

The same flashes. The same anger, malice, unease—all previously hidden from me. It seems the human habit of prevarication has infected our collective.

I whirl to my brothers, betrayal pricking an icy whiteness through me. "Is it true? Have you been forcing the humans into wars? Pitting them against each other? That is what they call it, is it not, the human tendency to play with moving pieces on wooden boards?"

Silence blossoms, crystal sharp around the edges. An iceberg taking shape.

I do not have to look into my brothers' emotions; the quiet is more than enough. They have been doing as our counterparts accused, have been toying with human lives for their own amusement.

Blues, deep and unrelenting, to mark my sorrow. I turn to

378

our sisters. "Release me," I request. "I have caused no wars, have only ever sought to advance humanity."

"But you are male." The disdain drips from Hui Li's voice. "The very designation you have chosen dooms you to aggression, domination, deception. We cannot risk your falling prey to your baser urges."

Fury blisters over me, an overwhelming, bright red. That is the same thing we say of the humans. But I am not human, and even if I were, my physiology alone would not doom me to the things Hui Li accuses me of.

I slam the veil. "You cannot keep me here!" I shout.

The moment I do so, I know I have acted in error. Determination fills Etzli's eyes. Her resolve seeps through our tether. "We must," she decides.

"For your own good and the good of humanity," Hui Li and Beda agree.

"Anok?" I turn to her, my counterpart. The other half of me. The one who understands all my intentions.

She flows forward but then stops, desolate purples and blues coloring her emotions. Sadness. Regret. My sorrow grows hard edges. Lightning strikes, searing a lake to ash.

She's abandoning me. My own counterpart is abandoning me.

"Anok!" I roar, reaching to her through our bond. "I demand that you release me, Anok!"

When she remains unmoving, I summon a maelstrom of colors from deep inside me. An explosion of light, warmth, unending darkness. All of them facets encompassing the brilliance of her name, the true one that she has hidden underneath the letters the humans now pronounce. The one thing that gives me the power to force her into action, just as she can force me.

Beside me, the others designated as male are doing the same, calling on their counterparts' deepest names, the true identities they wove when they bound themselves to their new vessels of matter and sunlight. The vessels that allow them to be gazed upon by mortals.

But none of the names work. None of the colors. None of the emotions.

Our counterparts slowly recede from the veil, and when I look upon our affinity, it has been severed from their side, only the barest hint of a connection left. Horror suffuses me in an unending white. We are the cosmos. Our kind cannot exist separate from each other. Even our split into pairs has made us weaker, more fragile.

"Anok! Anok!" I call, but it is a fruitless task.

She is gone.

Desolation turns me black with confusion and rage. Anok lied. She lied to me. She never told me the true name she had chosen. Except . . . I did the same with her. Sorrow sinks icy blues and chilling purples into my being. Winter storms lash coastlines. Is this what it means to be severed? To be split into two, each entity protecting itself? Was I truly something Anok needed protection from? Was she truly something that I needed separation from?

I gaze upon the Singular—the one who never split themself. They have been here this entire time, watching. Silent, thoughtful. Having never severed, having never even considered it, they cannot understand the complexity of our emotions now, just as we can no longer truly comprehend theirs.

"How?" I ask. "How did they gain enough power to do this?"

The Singular flows closer, gazing at me dispassionately.

Unlike the rest of us, they never chose a name, never chose anything that would mark themselves separate from us. From the rest of the cosmos.

Worship, they explain in the chilling whispers of the deepest, darkest spaces. *Your other selves, they discovered the power of human worship.*

"Can you help us?" I ask them. "Can you free us?"

No. . . . We will remain neutral, as we vowed. As is our purpose. All we can do is maintain the balance, now that you have severed.

Blue purple black. Despair, sorrow, hopelessness. My emotions are filled with them now. The Singular wraps themself comfortingly around me, their vastness easily encompassing mine. I've become so small over the millennia. So much less than I was. They caress me, radiating warm yellows and oranges of comfort. Their presence feels so familiar. Such security in their being.

Do not despair, Okot, they rumble. *We can offer some small aid to tip the balance.*

Why would you help us? I ask. It's not in their nature to interfere with the rest of us.

The Singular's essence ripples. *Now that you have separated,* they respond, *we must maintain the balance at all costs.*

"What can you do?"

We can show you how to gain worship from beyond the veil. . . .

◆

I wake to find myself in a soft lap, the sun low in the sky and a warm evening wind flowing over my robes. When I scramble up, confused, the others are huddled in small groups across Ixa's back, Keita sitting at my companion's head spike, speaking with

Rian. Only Britta notices I'm awake. But then, I've been lying in her lap this entire time.

"Well?" she asks, impatient. "What did you see?"

I force myself to sit up fully, to try to arrange my thoughts. I saw so many things as I flowed through Okot's mind, much of it confirmation of what I already knew. The most important confirmation, however, came from the flashes I saw in the tether: all those armies fighting, those dead bodies littering the fields. The mothers were absolutely justified in their decision to lock the Idugu behind the veil. Once the male gods began creating baseless wars for their own amusement, killing millions for sport, they no longer deserved freedom—although poor Okot should have been exempt. He was just there, an innocent bystander swept away by the deeds of his brothers.

Not that he's innocent any longer.

It was his presence I felt in Zhúshān, gorging itself on the sacrifice of those poor girls, his voice I heard in that alley just after Father died. Even when the Idugu spoke to me, his voice was foremost. The Merciless One, he called himself. Whatever pity I may have felt for him cannot stand in the face of all the atrocities he's no doubt committed in the millennia since he was locked away.

I also understand now what White Hands meant when she asked me to verify the names of things. Divine names are things of power—things that can compel the gods themselves. It's just unfortunate that I don't know what each of the Gilded Ones or the Idugu's true names are, much less have the ability to use them. Which, of course, begs the question of how White Hands knew to prompt me about that, given that her memory keeps failing her.

I turn to Britta and take a swig from the waterskin she's handing me. "I'll explain everything when we land," I say, weary. Judging by Ixa's labored movements, that should be any moment now. "Any visits from White Hands while I was asleep?" I ask. It isn't like the wily Firstborn to be gone for so long, especially not at such an important juncture.

I'm relieved when Britta shakes her head. "No. Not a peep."

"No news is good news," I say brightly. White Hands would inform us immediately if the Idugu's armies were already attacking Abeya. Of that, I have no doubt.

Since she hasn't yet, we still have time.

Ixa rumbles—an indication he's about to land—so I hold on tight, staring at my surroundings with fascination. This is a different route from all the ones we took before. When we were on campaign, there was only sand, dunes and dunes of it rolling into the distance. Now, the sun glows moody orange over immense groves of baobabs, streaks of purple and gold painting the rapidly darkening sky.

The moment Ixa lands, Keita jumps down and hurries over. "You all right, Deka?" he asks, his muscles rigid.

Just his stance tells me everything I need to know.

Whenever Keita feels things too deeply, he holds them tightly inside him so his emotions don't spill over. He must be very worried, which means everyone must be extremely tense, not only about the possibility of Idugu's armies attacking Abeya, but about our welcome there also. But after everything I've seen I'm no longer so concerned about that. The actual question I think we should be asking is do we want to remain with the mothers? After all their manipulations and lies, I'm almost certain I don't, but I still don't have all the answers yet. I still don't

understand those figures Anok saw falling into the pit when I looked into her memories, still don't understand what they have to do with the cataclysm White Hands told me about. Perhaps if I delve into the Idugu's memories again, I'll figure it out, but given how long it took me this time—an entire day, almost—I'm not certain I should risk it now.

I rest my forehead against Keita's and nod. "I'm fine," I say, embracing him.

We move apart as the others dismount, then Ixa begins changing, only now, instead of his usual kitten or bull-sized true form, he's as large as one of the horned, blue-spotted leopardans that stalk the jungles at night, all sleekness and power. Golden stripes interrupt the once solid blue of Ixa's fur and scales, and more golden markings decorate the space around his eyes. Yet more gold swirls in the spikes that erupt in a straight line from his head to his tail.

I gape, awed at the sight. *Ixa!* I say, rushing over. *You're beautiful!*

When he places his paws on my chest to lick my face with a roughly prickled tongue, I stagger back from the sheer weight of him. He's practically enormous now, but he still thinks he's a baby. *Ixa pretty,* he agrees, even his thoughts sounding weary.

Yes, you are, I say, kissing his ears. *You're the prettiest thing I've ever seen. But I don't think I'll be able to carry you around anymore.*

He nods, dropping back down. *Ixa don't want to be carried. Ixa tired now. Ixa sleep,* he says, wandering away. He plops down against the trunk of a massive baobab, and then soft snores filter into the air.

When I return my attention to the others, they're gathering around me, different emotions flickering in their eyes: curiosity,

anxiety—fear. "Come on," I say, walking onward. "I have a lot to tell you."

I lead the others to the largest baobab, its sparse leaves doing nothing to block out the setting sun. Baobab trees like these are meeting places not for their shade but for their rootedness. Each is millennia old, and sitting underneath one is like sitting in the presence of an ancient grandmother who sees and bears witness to all. Keita takes a seat beside the silvery-gray trunk and pats the space next to him. I settle in it, resting my head against his shoulders. The mere touch of his skin brings me comfort. Same as when I'm with Britta. She's beside me too, her foot tapping with impatience, but I take another moment to try to put what I experienced into words.

"Alaki and jatu, they all come from both the Gilded Ones and the Idugu," I begin after my pause. "The Gilded Ones are our mothers, true, but the Idugu are our fathers. They had an equal part in creating us."

Silence takes over the darkness, punctuated only by the chirp of toads and crickets. Even though we've all expected this to be the case, the news is just as devastating for the others as it was for me. Acalan is the first to speak.

"So the mothers truly lied about everything," he says quietly, betrayal written on his face.

I nod. "It seems that they share an affinity, a bond somewhat like the one that binds the indolo, although it's stretched to its limit now. And the Idugu intend to break it."

Belcalis frowns at this. "But wouldn't that mean they'd kill themselves along with the mothers?" she asks. "They are like indolo, correct?" When I nod, she explains to the others: "If you kill one part of the indolo, you kill the other. So if the Gilded

Ones and the Idugu are tethered, killing one would do the same to the other."

"The Idugu have a plan for that: me." When the others frown, confused, I explain. "They told me I'm the angoro, the power source the Gilded Ones were talking about."

"Wait, wha?" Britta seems stunned by this. "Wha do ye mean, yer the angoro?"

I continue talking. "The Idugu said that the mothers sent me to kill them, that there was something in the ansetha necklace that would have compelled me to do so, which is why the Idugu always had kaduths everywhere. The kaduths blocked the mothers' power and allowed me freedom of thought and will, which is why I was able to resist their conditioning. They also said that it was the mothers who sealed off Hemaira. The n'goma doesn't exist. It was their power burning us all along."

By now, the silence is absolute, everyone digesting what I've said.

Finally, Acalan speaks. "Why?" he asks, bewildered. "Why would they do that?"

"Isn't it obvious?" Belcalis replies. "Control. Ever since they came to Otera, the gods have been controlling us. First, it was the mothers deciding that, since they had chosen to be female, they would elevate women. Then it was the Idugu, doing the same with men and then going a step further: killing our kind and oppressing everyone else. It's almost as if they expect us to be perpetual actors in a masquerade: we play the parts we're assigned, and we do so perfectly, or we get punished. Our whole lives are just amusement for them, literal food for their entertainment."

I nod, agreeing with everything she said. Then I fidget. "There's something else."

"Wha now?" Asha sighs.

"There was a fifth god, one that did not split into two like the rest, that remained apart. The other gods called them the Singular."

Everyone sits up at this news. "Is it still here?" Li asks, his expression eager.

"They," I correct. "They're more like a presence than a particular entity." Then I shrug. "And I don't know. All I know is that they were neutral and they felt that their task was to maintain the world's balance, so they remained there, behind the veil."

"So they're an ally." Li seems relieved by this.

I shrug again. "I don't know. They seemed a bit above it all, actually. Like they cared about the balance above all else."

"But we're all part of the world," Britta says. "That has to mean somethin'. It has to."

I shrug again. "I don't know. I still don't understand much about them. But what I do know is why the gods are battling for power. The mothers starved the Idugu of it when they banished them beyond the veil, so the Idugu in turn created Oyomo to feed on worship, only because that wasn't their true name, they didn't gain as much power as they needed."

I glance at the others, trying to impress on them the importance of what I'm about to say. "To the gods, true names are everything. You can even command them if you know their names."

"Do the Idugu know the Gilded Ones' true names?" This question comes from Belcalis.

I shake my head. "No, neither side knows the other's."

"But ye can see their memories," Britta says eagerly. "Ye could find their names."

I shake my head. "Even if I could, their names aren't words. They're colors, emotions—clouds, even. A human can't even hope to speak them."

"But ye aren't human, Deka," Britta says, frowning. "An ye aren't alaki either, even though we like to pretend ye are."

"You're closer to them than you are to us," Belcalis adds. "You made the jatu immortal, for Infinity's sake. What else are you capable of?"

Killing the gods . . . The thought sends a shiver of fear through me.

"I think the more important question is, where do we go from here?" Lamin asks quietly.

"We're less than a day away from Abeya now. We have to have a plan," Kweku adds.

I think about it. "Before I left, Anok made sure I knew about the ichor in the ansetha necklace so I could see her memories. I think she wanted me to see all this, wanted me to go on this journey. It's the same with Okot, Anok's male counterpart— he's the one whose memories I saw. Despite his anger, he also wanted me to understand where he was coming from.

"I can't help but wonder if that's because both want a compromise. A reconciliation. Perhaps that's the only thing we can do, help both sides come together again."

"Or help one side kill the other." Keita's words are like a spear through the heart—a reminder of what White Hands said: *When gods dance, humanity trembles.* And if the Gilded Ones and the Idugu cannot resolve their differences, they'll dance so much, they might destroy all of Otera in their fury.

"That may very well be," I finally say, the words sending a wave of horror over my body, "but what I know is that the

mothers likely already know everything we've discovered. They might be watching us even now." I've seen them do it countless times before, peer into the distance to see what others are doing. It takes massive amounts of their power, which is why they don't do it often, but they will if they're worried enough. "I say we go speak to them, try to find a solution."

"An' ye think they'll listen?"

I shrug, unable to answer Britta. Who knows what the mothers will do.

We know their secrets now, know they're not as powerful as they claim. No one likes to be exposed like that—especially not the gods. Especially not when I'm no longer wearing the ansetha necklace they used to control me. It's still hidden in a pack under my robes, but I can't get myself to put it on. Can't bring myself to wear it proudly around my neck as I once did.

After everything I've learned, I will never give the mothers control over me again. But that doesn't mean that I'll never live in peace with them again. I might even be able to remain at their side, if they're still intent on building a better Otera, that is. But if they're not . . .

The next few hours will tell me what my path will be, either way. I just hope my friends and I can survive.

I glance at them as I rise, no longer wanting to continue this conversation. "I'm going to go try and practice opening doors," I announce.

Who knows, I might even succeed in opening one before we reach the mothers tomorrow.

34

◆ ◆ ◆

The N'Oyo Mountains come into view the next day, their forested peaks rising in the distance, the Temple of the Gilded Ones a minuscule speck of gold at their center. I see it from my perch behind Ixa's head, but for the first time since the day I was taken there in pieces nearly half a year ago, the sight does not fill my heart with joy. Instead, I'm filled with doubts and worry. What are the Idugu doing? Are they already storming Abeya's temples yet? And what about the mothers—how will they react when I stand in front of them once again? Will they shun me? Welcome me? Promise to do better? A tiny thread of hope shimmers through my mind, and I pull out the ansetha necklace, its bulk cold and heavy as always in my hand. The chill of its power is subtle as it steals into me. Nevertheless, I can already feel my thoughts becoming labored, my body doing the same. Its presence is a reminder: my hopes for the mothers are those of a child aching to be reassured by her parents. This is the reality.

Britta glances at it, unnerved. "Why are ye playin' with that thing?"

I look down at it. "I keep thinking, why would the mothers lie? If I truly am the angoro, the god killer, wouldn't they want to tell me the truth—at least part of it—so they could use me against the Idugu? I mean, I loved them, would have done anything for them, so why?"

Belcalis follows this question with one of her own. "Have you ever wondered why Melanis is the only alaki, aside from us, to have her gifts back?"

"No." I shrug. "They're all going to get them back eventually." At least, that's what the mothers told me.

"But why is Melanis the first?" she says pointedly. "Why not White Hands, for instance? She is the oldest alaki."

I can tell from Belcalis's expression that she is trying to point something out to me. But I'm too tired, too anxious to play guessing games. I sigh. "Why don't you just say what you—"

I stop when the fragment of a memory wafts past. The first moment I touched Melanis, I felt the strangest sensation. It was like lightning coursing through my body. I can't believe I almost forgot it.

"I touched her," I say, astounded. "I touched her when she was still healing."

My thoughts are whirling now, the pieces finally settling into place. I thought the sensation that jolted me in that moment was a result of my entering Melanis's memories, but what if that wasn't the cause? What if it was actually my power calling on hers? The power the Idugu told me I possessed.

It's always been you—that's what both Elder Kadiri and Keita said.

Could this be what they meant?

"Ever since you first came in contact with the kaduth in the Oyomosin, you've been changing," Belcalis says. "You resurrected those new jatu. You're faster, stronger. You even used doors for a tiny bit—"

"Not that I've ever been able to do it again," I say bitterly, thinking of last night and this morning, when I tried, once again without success, to replicate what I did in the Grand Temple and at the Warthu Bera.

"And you've only been growing stronger and stronger—especially once you took off the ansetha necklace."

"Wait," Britta gasps, her eyes widening in realization. "So have we! Before ye took off the ansetha, I could barely shape a pebble. After ye did—"

"You created those shelters like it was nothing!" I cry, remembering.

"And I turned my entire body into gold and used it as a shield while we were in the Warthu Bera," Belcalis adds. Then she thinks. "Wait, let me see something." She takes her dagger from its hilt and cuts her palm. "Look," she says, gasping.

The blood is creeping across it, as before, but its movement is slower now, labored. It falters just before it reaches her wrist.

Trembling now, I swiftly wrap the ansetha necklace in its pack, as I have all this time, so it's not touching my skin. "Try it," I urge.

Belcalis nods, squeezes her hand so the blood can well and holds up her arm. The blood immediately moves, gliding swiftly down her arm all the way to her shoulder and hardening as it

goes. The moment I unwrap the ansetha necklace and press my finger to it, however, the blood falters again.

"Wait, let me try," Britta says, taking out a pebble from her robes.

When I'm touching the ansetha necklace, she can only barely shape it, but after I remove my fingers, a gleaming, sharp stone dagger forms in her hands.

She gasps. "It's ye," she says. "It's ye that's makin' us grow stronger. Yer the one giving us our powers, not them."

"That's why they lied to you," Belcalis says pointedly. "Because you're the one who has the power."

She lifts her hand, inhales, and the blood recedes back into her palm, her wound healing as if it were never there in the first place. I don't even have to look into her using the combat state to know that she has complete control over her ability.

I glance down at the ansetha necklace as if it were a snake waiting to strike. And in a way, it is. The mothers were so pleased when they gifted it to me, so proud when I wore it as if it were the crown of Otera itself. And all this while, they were using it to cut me off from my own abilities, to hide what I truly am.

I'm the Nuru, the only child born to all four of them—that's what the mothers always told me. But thinking of it now, even that could have been a lie. I didn't want to accept the vision the Idugu showed me—all that gold hurtling from the sky—didn't even understand what I was seeing, if I'm being honest. Still, I have to try. Have to pierce the real truth about who and what I am. Even as I think this, another memory flashes past: the Singular looking dispassionately at Okot. I can't remember what the fifth Oteran god looked like, can't even truly fathom their

existence, but I do remember one thing: they felt safe. Somehow familiar, even despite how remote their existence is from mine.

I hold on to that feeling. I don't know the truth of Idugu's claims about what I am. I don't even know what will happen when we reach the mothers. But I do know this: if anything goes wrong today, there's one last deity hiding somewhere in Otera. One being that can sway the balance. The Singular. And if everything falls to pieces and the entire empire burns to the ground, here's hoping they'll see what's happening and act to restore the balance to Otera.

35

◆ ◆ ◆

The feeling of wrongness descends the moment we reach the N'Oyos' foothills. Keita and I are sitting on the back of Ixa's tail, curled in each other's arms, when I feel it: the sudden force in the air, the ungainly thickness I immediately recognize. The Idugu. They're somehow here, all four of them hovering invisibly over the mountain, an oily, dark presence in the late evening air. But how? I thought they were still imprisoned in their temple, crippled by the gold that has bound their bodies for so long. That's obviously not the case, because their power is suddenly overwhelmingly present, an ugliness tainting the very air I breathe. Emotions radiate from it—hatred, anger, envy. The Idugu are ready to attack their counterparts. The battle that I've been fearing has already arrived.

I wrench myself from Keita's arms in a panic, trying to understand how all of this is possible, but as I do, my eyes latch onto something horrifying: a massive hole in the river of glass

surrounding the mountains. Ever since the mothers created the Bloom, the river has stood as its boundary, a visible signal of how far their power has grown. But a wide portion of it has been blasted through, shards of obsidian now littering the space where jagged spikes of black once undulated through the sands.

"No . . . ," I whisper, horrified.

"What is that, Deka?" Keita asks, alarmed by my sudden agitation.

"The Idugu! They're here!"

"What? How?"

"I don't know!"

Even as I say this, memories flash: the Idugu's gigantic golden hand reaching for me in the temple; Okot's presence always seeming to appear whenever I was near his worshippers. I curse under my breath, berating myself for my stupidity. Foolish Deka, assuming the Idugu were ever bound by the gold veiling them. They've been free all this time, unshackled the moment I released the Gilded Ones from their prisons, because it was never the gold that compelled them to remain in place; it was their tether to the mothers. And I freed them from it, just as I freed the mothers. How they must have laughed when I made the assumption they couldn't move from their temple.

"Descend," I shout to Ixa.

My massive companion quickly complies, landing on the sand with a gigantic thud. Everyone jumps off and glances around in alarm. The glass river really has been broken.

"Looks like an army came through," Lamin says, his eyes narrowing, as he joins Keita and me at the edge of the river. He's a skilled tracker, the best in our group. He kneels so he can examine the devastation in the swiftly falling darkness. "Used

396

ballistas to break through, most likely. It's moving fast. Judging by its pace, the soldiers should be up in the mountains now."

Britta looks up, frowns. "That doesn't make sense. If there's an army going up, why aren't the alarms sounding?"

My eyes narrow—she's right. There's no motion in the jungle canopies, no noise. If an army was making its way up, the creatures there would be in uproar, birds flapping away, lemurs and leopardans alike running for safety. And yet, the Temple of the Gilded Ones seems serene: no drums, no lights. It's strange—the mothers built a thousand warning systems and alarms when they reshaped the N'Oyos, but I can't sense a single one. It's as if something has muffled the entire mountain. *Wait* . . . My eyes narrow when I spot it, the haze drifting around the N'Oyo's peaks. A less-trained eye would dismiss it as the evening breeze, but I know better.

"It's the Idugu!" The answer reaches me in a rush. "They must be hiding the army's ascent!"

So that's why they were so sparing in their power before, using just enough to speak to me and to open doors into their temples. It's not that they were considerably weaker than the goddesses; they've just been biding their time. It requires an immense amount of energy to cloak an entire mountain. To sneak armies of men up without alerting the alaki or waking the goddesses is no small feat. They've no doubt been planning this very carefully for some time now.

I swiftly force myself into the deep combat state, straining my senses to push past the quiet—past the illusion the Idugu have created—until finally I hear it: the distant echo of footsteps. Only it's not up on the mountain, as I expected, but at the base of the foothills. The Idugu's army hasn't made real headway

up the mountain yet. And they don't seem to want to do so either. Those footsteps aren't the uniform march of an army to its destination. They're more tentative. Seeking.

What are they doing?

I don't have time to dwell on the question. I rush over to Ixa. "We have to go," I say, beckoning to the others.

Ixa nods. *Deka, ride,* he agrees, kneeling so we can get on his back.

"What are you waiting for?" I say when the others linger. "Get on!"

There's a mad rush as everyone swiftly mounts Ixa. I hurry to seat myself behind the spike in the center of his head. "Everyone ready?" I ask.

"Yes," Britta says hurriedly.

I turn to Ixa. *Let's go.*

A column of dust rises as Ixa launches into the air and begins flying. All it takes is a few flaps of his wings, and the army at the foothills comes into view. A dull throbbing starts at the base of my skull when I take stock of them, thousands upon thousands of true jatu and Forsworn deathshrieks in that distinctive armor, the kaduth emblazoned on their breastplates to prevent my power from reaching them. The sheer number of them has my breath constricting in my chest and my eyes widening. Just where did all those true jatu come from? The Idugu must have been gathering them from the armies they've raised across Otera, keeping them hidden for this day.

I force myself to swallow the sudden dryness in my mouth as I quickly estimate the numbers of soldiers, weaponry—anything that can give me greater insight into the Idugu's attack strategy, really. An army of this size means only one thing: complete and

utter annihilation. But not for the mothers. Sheer terror rises inside me as I understand: the Idugu can't kill the mothers without killing themselves, but they can kill all their children. They can kill everyone who gives the goddesses the worship they require. They never have to lift a finger against the mothers; they could simply starve them into submission. I stare at the army, my mind racing, heart pounding, until suddenly, I notice something strange. At the edge of the mountain, a contingent of Forsworn deathshrieks is grouped around a gigantic hole in the mountain.

The sight seems so familiar to me, it takes some moments before I realize what they're doing: pulling another of their kind from out of the mountainside. At least, that's what the massive purple form embedded in the dirt looks like.

"WHAT ARE THOSE DEATHSHRIEKS DOING?" Keita has to shout to be heard above the wind, which is whipping aggressively in our faces as Ixa flies up the mountain.

I squint harder, trying to ensure I'm seeing correctly. "THEY'RE PULLING OTHER FORSWORN OUT OF THE MOUNTAIN!"

But why? Are they trying to reach Abeya from underground? Is that hole their method of entering the mountain without alerting the mothers to their presence? That somehow doesn't seem right. Something is niggling at me, something I need to remember. I try to squint at the deathshrieks again, but shouts ring out, followed by frantic drumbeats. Jatu commanders have spotted us, are turning the ballistas our way.

Watch out, Ixa! I shout when a boulder flies in our direction.

Ixa immediately tilts away, his body swiftly evading the onslaught despite its enormous size. He darts and weaves, headed

higher up the mountain, until soon, we're out of reach of the projectiles. By now, his movements are growing heavier, his breathing more and more labored. He's been flying all day, and he's almost at his limit.

Almost there, Ixa, I encourage him. *You can do this.*

Deka, he replies wearily, struggling onward.

The guards on the perimeter seem shocked when Ixa crashes into the landing area just beyond the lake, too exhausted to go any farther. The haze is even thicker up here than below, so I'm not surprised they didn't see him. It's coiling around me now, dulling my senses. Infinity only knows what it's doing to everyone else. What it's doing to the mothers.

What if it's dulling their senses, making them sleep, so they don't realize what's happening around them? I quickly dismount, my expression grim.

"Prepare for battle!" I command. "Jatu are coming up the mountain, and they're bringing male deathshrieks with them."

"But—" a guard gapes.

"Prepare for battle. Your Nuru commands it! NOW!" I snap.

The guard immediately darts away. "SOUND THE ALARMS," she calls. "WE'RE UNDER ATTACK! SOUND THE ALARMS!"

As the guards start rushing to and fro, I turn to Ixa, who's breathing so heavily, his sides nearly rattle from the force of his breaths. *You all right, Ixa?* I ask.

He manages a nod.

Change to kitten form and hide until you regain your strength. Can you do that?

He nods again, already shrinking. The moment he pads off to hide in the foliage, I rush after my friends, who are at the

banks of the lake, where the water bridge is forming, its planks and railings already taking shape. I rush toward it, eager to be on my way. But then it collapses. Shocked, I stop, step closer to the water again. Nothing. The water's surface doesn't even stir.

A chill rushes over me. *The water bridge forms only for those loyal to the goddesses.*

Britta turns to me, nods. "I'll try it," she says. She steps in front of the water.

The bridge begins to build, but then just as swiftly collapses. It's almost as if it were unsure, as if it changed its mind at the last moment.

"Let me," Adwapa says, pushing forward.

She marches in front of the bridge. Nothing. The bridge doesn't even try to rise.

The silence is so tense now, we can't even look at each other's eyes.

"The bridge isn't rising," Britta whispers, horrified. "Why isn't the bridge rising?"

"You know why." Belcalis's eyes flit over the rest of the group. "We all know why."

Because we questioned them . . .

By now, I'm aware of the guards staring, aware that everyone around us is watching. I turn defiantly toward the others. "I don't know anything. All I know is, I have to get to the mothers."

Bridge or no bridge, I must find my way across—

A ripple forms in the lake's center and I gasp. *The Ababa!* I'd forgotten that it was there, quietly wandering the depths. I tap the water in the pattern I saw Anok make, relief spreading over me when a responding ripple travels across the water.

I stare at that ripple, a sudden suspicion coiling through me. Could this be why Anok showed me how to summon the Ababa in the first place? Did she expect what is now happening? I push the thought away as a low rumbling reverberates through the air, iron-gray scales parting the water, a massive reptilian head emerging from the depths.

The Ababa. It's coming.

"Baba Dorie's balls, what in the name of all creation is that?" Li gasps.

"The Ababa," I say, smiling when the gigantic creature rests its head on the shore. I walk over, pet a tip of a monstrous nostril. "Hello there," I say in greeting.

The Ababa huffs out, covering me in a gust of warm, moist air that smells vaguely of fish.

"I have a favor to ask."

Another huff of warm air. It seems the Ababa is listening.

"Can you carry me and my friends across?" I gesture to the others.

Reptilian yellow eyes blink their slow consent.

I turn to the others. "Get on."

Everyone moves toward the creature except for Britta, whose face has turned pale. "No. No. This is where I draw the line."

I frown. "I don't understand. You were just on Ixa."

"Exactly. I was just on Ixa. I love ye, Deka, but I refuse. I've already been high up in the sky, which, by the way, is unnatural—*unnatural*—and now ye want me to ride that thing with a jaw ten times the size of my entire body, which I've never so much as had a conversation with. And we all know wha happens to

people who fall into this lake—the ones the water bridge doesn't shape itself for. No, I can't. I refuse."

"Britta," I begin, but Li walks over to her, holds out his hand. "I've got you," he says in low, soothing tones. "I won't let anything happen to you. And neither would Deka, you know that."

A strange feeling washes over me when Britta looks down at Li's hand, then up at him. When she takes it, I finally realize what I'm feeling: sadness. I'm no longer Britta's one and only.

For so long, it was just me for her. And Keita, of course. Now, however, there's also Li.

I can see it in her eyes when she stares up at him. "Promise?" Li nods. "Promise."

She allows him to tug her forward.

As they walk over to the Ababa together, Keita moves in front of me. "Hurry, Deka," he says. "We have to wake the mothers."

Whatever our feelings about them, we can't allow them to sleep while the Idugu destroy their home and everyone in it. "I'm coming," I say. We climb up the Ababa's back together, and a low rumble echoes through the air as the colossal reptile pushes off from the shore.

"Oh, there goes me belly," Britta says, clutching her stomach as the Ababa begins its swim. "Is this a bad time to mention I'm on me menses again?" When Belcalis whirls to her, indignant, she shrugs. "Wha? I can't help that they're regular!"

I shake my head, a bit of my tension dissipating, but nowhere enough of it to make a difference. My thoughts are barraging me full force now as the Ababa glides across the water. Everything we're up against is flashing all at once.

The Idugu are here with their army, but the mothers may

be too deeply asleep to notice. And even though we're try-ing to ensure that they're awake, the water bridge didn't rise. Didn't acknowledge us as loyal to the mothers. All because we questioned—asked more about the mothers than they wanted us to know. And now, we're on our way to wake them, even though they might not be happy that we're the ones who are doing so. That *I'm* the one who is doing so.

Just the thought fills me with dread. But I have no choice. I'm only one girl. I can't stand against the Idugu. I can't protect the entirety of Abeya with only my friends to stand with me.

The Ababa takes us to the other side of the lake in a matter of minutes. The whole time, the drums are sounding, and more and more alaki are appearing—all of them racing for battle sta-tions, as they were trained to do.

Once we've safely arrived, I slide down from the Ababa's nose, then glance up at it. "Thank you for helping us," I say.

It snuffles another warm, wet breath, then slides back into the water, gone with barely more than a ripple. I turn to the others, tension thrumming through me as I command: "Keita, Adwapa, and Asha, go inform the generals of what's happening, then bring them to the Chamber of the Goddesses."

The trio nods. Keita squeezes my hand before he goes. "Be safe, Deka?"

"Always," I reply, kissing his cheek.

And then he's gone.

I turn to the others. "Belcalis, you and the boys wake every-one."

They quickly rush to their task.

Britta, Katya, and the other deathshrieks are the only ones left now, and I nod to them. "Britta, you and the rest see to the

safety of the humans and children. I don't want them lost or forgotten in the chaos."

Britta nods. "Of course, we'll ensure it." Then she stills. "Will ye be safe, Deka? Ye don't have to go alone."

I nod. "I'm not alone. Take my heart with you," I say, a reminder.

She nods. "You do the same," she whispers, squeezing my hand.

And then she's gone.

❖

The temple's central courtyard is a mass of sound and panic when I enter—alaki racing to and fro, equus equipping themselves with their assegai, those long spears they and the jatu prefer to use in battle. Even the deathshrieks are armoring up, swiftly covering the softer parts of their bodies in infernal armor, bled for by their alaki sisters. The drums are sounding even louder now, each pattern of beats a command telling soldiers where they need to station themselves. Everyone else, the human civilians especially, are rushing to the shelters we have prepared in case of attack. A few are scattered around the mountains, and some even farther still, in the desert surrounding the N'Oyos, in case of this very eventuality. White Hands has always made sure we have contingency plan upon contingency plan in case Abeya ever falls.

Two familiar white forms gallop toward me, their bodies gleaming in the darkness: Braima and Masaima, assegai and shields in hand. "Nuru, they say the true jatu are attacking," Masaima announces.

His brother nods, the black stripe in his forelocks shaking with emphasis. "Lots of soldiers headed here."

"I know," I tell them. "I'm going to go wake the mothers."

"The lady just went to do the same," Masaima says, referring to White Hands, who was once also known as the Lady of the Equus. She has a habit of changing her name for every age she lives through. "You might catch her in the hallways."

"That's good." I nod to both of them. "May fortune favor you on the battlefield."

"The same with you," they chime.

And then they're off, running to join the rest of their comrades. I continue on, my heart hammering in my chest. There's so much happening, so much that needs to be done. But what if the mothers shut me out? The doors to their chambers only ever open to those they favor. What if they decide, as the water bridge did, that my questioning has rendered me disloyal? I glance down at my pocket, where I've kept the ansetha necklace stored, safely wrapped in cloth. For a moment, I consider putting it back on. Perhaps it would be better if I wear it, show my faith and subservience. But no—I shake my head, turning away the self-betraying thought. I can't act as if I'm back in Irfut again, pleading with the village elders to see me as a living being—not to hurt me just because I'm different. If the Gilded Ones truly are my mothers, they will accept me, no matter what.

My mind is such a whirl of emotions and fears, it takes some moments before I notice the odor filtering through the hall. It's subtle at first, so slight, I'm almost to the Chamber of the Goddesses before I notice it, the sickly sweetness masking the heaviness of rot. My footsteps slow. What is that smell? There's something about it . . . As I whirl around, searching for

the source, I suddenly notice that the hallway is somehow completely empty. Outside was such a buzz of movement, but here there is only the darkness, the stillness, and that odor. Where is White Hands? Where are all the guards, all the deathshrieks who usually guard this portion of the temple? It's as if the same gloom that cloaks the air outside has fallen over the hall.

A shuffling sound emerges from a distant corner, and I whirl toward it. "White Hands, is that you?"

An earsplitting shriek is my only warning before a massive deathshriek rushes me. I swiftly dodge to the side, noticing the golden veins throbbing across bright purple skin. It's a Forsworn. And it's already here, in the middle of the Temple of the Gilded Ones. *How?*

It rushes me again, claws flashing. There's a look in its eyes, a barely repressed insanity.

I hurriedly dance back, slide out one of my daggers. With a deathshriek this size, it's better to get up close, stab between the ribs right to the heart. And yet . . . A frown carves itself into my brows as I dodge once more, evading yet another clumsy strike. The deathshriek's movements are odd—graceless, as if it doesn't have control over its own limbs yet. It's almost like a child, stumbling over its own legs. Could it have just been reborn? It feels like it. It feels like this deathshriek just swam out of one of those eggs deathshrieks emerge from in the breeding lakes. Or rather, the holes in the ground male deathshrieks resurrect inside.

Where are its companions? Is this part of some sort of advance team? But no, I don't sense any others in the hallway, and this deathshriek is much too disoriented to be part of anything so precise.

When it attacks me again, I easily flip it onto its back using its own weight and momentum against it. Then I jump onto its stomach, atikas arcing for its jugular, only to immediately jerk back as I feel a strange movement on its side.

"What in the name of—"

I look down, and shock steals the rest of my words.

There's a familiar black mass wriggling on the deathshriek's side: a single black blood-eater, its petals woven through with gold. I look back at the deathshriek, its maddened eyes meeting mine. "Emperor Gezo?"

A series of hissing sounds emerge from the deathshriek's mouth. The longer I listen, the more they shape into words— a familiar aristocratic voice. ". . . must . . . before . . . they . . . eaters . . ."

"What?" I say, rising. "You have to slow down."

"Evil . . . must stop . . . evil."

"I can't understand you," I say.

I kneel closer to him, only to jump back when knifelike claws slash at me. "I won't sit by!" the former emperor roars, jumping at me. "I won't sit by while they consume all the children, daughter of the Fallen!"

As I stare, still not comprehending, the emperor slashes at me again, his moves even more erratic now.

"Emperor Gezo!" I gasp, trying to get him to stop attacking. He was already going mad in life, but now that he's resurrected, he seems to have lost all power of reasoning.

My words fall on deaf ears. He lunges again, but then, to my surprise, loses interest halfway through.

"Must stop them," he mumbles, his eyes turning to the door at the end of the hallway—the Chamber of the Goddesses.

I don't try to stop him as he shambles away. One thought after another barrages my mind. The fact that he's now a death-shriek isn't surprising—I know that there are male deathshrieks, and the emperor seemed on the cusp of death the last time I saw him. But there's something else, a thought that worries at me, urging me to remember. I try, but it's hard to do with that smell, that awful odor, turning my head. Emperor Gezo is at the door of the chamber now, and he claws clumsily at it, unused to maneuvering locks with his claws. He must have died recently, perhaps even earlier today. Which would explain why he's so disoriented, so crazed. I walk up next to him, darting back when he makes a few swipes at me.

Finally, he stops trying to attack me, and I slide underneath his colossal arms to tug at the door, which is extremely heavy. The mothers don't want any visitors, it seems. Or perhaps it's me they don't want. Still, I have to speak to them, rouse them from their slumber.

With this in mind, I summon all my strength and pull the door open. Then I enter the Chamber of the Goddesses.

And see the nightmare that lies in front of me.

36

◆ ◆ ◆

The first thing I see when I enter the chamber is the death-shrieks, all of them purple, all of them slumped on the floor in front of the mothers' thrones, their bodies covered in vines. From far away, you would almost think they were sleeping. Except that groans are rising from them. Fitful sobs. Cries of pain, discomfort. And their eyes twitch restlessly behind closed eyelids, a response to the vines crawling over them, blood-eater flowers already sprouting in abundance. Their sharp little roots dig into the deathshrieks' helpless flesh, their fleshy petals throb and flutter as they gorge themselves on more and more dark blue blood. Gray sores spread over their victims' flesh, each one putrid and flowing with pus.

A ringing starts in my ears, followed by a horrible feeling of weightlessness. Everything feels strange—removed now: the deathshrieks' whimpers, the blood-eaters' wriggling, the smell . . . The awful, sweet odor that clung to Emperor Gezo coats almost every inch of the chamber, and I swiftly realize its

410

origins: the vines release it as they eat and eat and eat, a sedative to calm their horrified victims. Gold flashes across their slithery green bodies the more gorged they become. More and more blood-eater flowers sprout, each one star-shaped, black with golden veins. I follow their tangled path with my eyes, up and up the stairs to the dais, where all the goddesses are sleeping— all except for one.

Etzli.

She's hunched forward in her throne like a toad, squatting over the deathshriek in her lap—a small, light purple creature with whitish-gold quills and blood-eaters sprouting across his body. I gasp, horror searing through me, as I take in the sight. The deathshriek's big black eyes are wide open with agony and fear, and gray sores mark his skin, blossoming everywhere blood-eaters sprout. The vines coil around his entire body, connecting him to Etzli. Malignant divine vines spraying that awful, heavy odor as they feed and feed.

I stand there, my mind still unwilling to comprehend what it's seeing until, suddenly, a roar rings out from beside me. "Demon!" Emperor Gezo shouts.

He rushes at Etzli, but she languidly gestures. Vines erupt from the ground to coil around him, and then blood-eater flowers begin to blossom, their spiked roots digging into his skin. The former emperor is almost immediately rooted in place, his body firmly secured by the vines now writhing around him. The smell of rot blooms, adding to the already noxious bouquet.

It seems like centuries before Etzli straightens to regard me, but when she does, the movement is slow and serpentine. "Deka . . . ," she says in that lazy way of hers, surprise coloring

her features. Thunderclouds wreathe her head, a sign of her displeasure. "How did you open the door? It was locked."

"I don't know," I say, my voice strangely distant, even to my own ears. "I just did." My thoughts are scattered, ephemeral things now. I struggle to gather them, but the blood is rushing so fast to my head, I think I'm going to faint. "What's happening?" I feel almost like a confused child when I point. "What are you doing to that deathshriek?"

Etzli frowns, the human expression uncanny on her inhuman face. Her white eyes catch mine. "You weren't supposed to see this. I command you not to see this."

The words reverberate in my skull, an imperative that penetrates so deep, even my heart pounds the instruction: *Do not see, do not see.* . . . The darkness around me fades; the vines disintegrate. All that's left is the Chamber of the Goddesses as it always appears to mortal eyes—pure white, that ceiling reflecting the sky. The sight would refresh my soul, except the sky reflected by the ceiling is ominous today. Dark—no hint of stars to be found. It's that way for a reason, but I've forgotten why. *Think, think, Deka.* I grasp at my thoughts, but they keep flitting away, little butterflies I can never quite seem to catch. My head is pounding now. It's almost like there's some sort of barrier there, a cloth, muffling my brain.

But I came here for a purpose, I remind myself, shaking my head in an effort to focus. I have important news I must tell the mothers. I glance back at the dais only to find Etzli looking at me with a strange expression. Why is she staring at me like that?

"Please, help me!" a youthful male voice shouts.

And the cloth muffling my brain dissipates, leaving me back in that dark room, Etzli awake on the throne, smothering the

deathshriek on her lap with vines. Tears flow from the death-shriek's eyes, desperation and fear shining there. He seems so young, so very, very young. He must have been around my age when he resurrected.

How did he even find his way here? The thought rises almost distantly, no doubt a reaction to the horror I feel. Male death-shrieks resurrect deep in the earth, don't they? The reminder spurs the memory of that jatu, the one I still can't quite deci-pher. I shake it away.

"Please!" the deathshriek cries. "Help me!"

The words jolt me out of my shock. I run toward him, hands outstretched. "Mother Etzli, stop!"

But Etzli's lips curl into a sneer of displeasure as she looks down at the deathshriek. "Be silent," she commands, tapping his lips.

The boy—because that's what he is, a boy—makes an awful choking sound in reply, then his mouth wrenches open impos-sibly wide. A small gold blood-eater slithers out, the flower unfurling brilliant gold petals. Golden roots spread across the boy's face, leaving rot in their path as the plant gorges itself, a bloated leech embedded deep inside him. Within seconds, his body has turned gray from the onslaught, then he's gone, dis-solved to reddish sludge before my very eyes.

It all happens so fast, I don't even have the chance to move. To save him. I don't even have the chance to comprehend what is happening. I slump to the floor of the dais, my feet suddenly lacking the power to stand. Even after everything I've learned about the mothers, everything I've experienced, I still can't fathom this—can't even begin to understand it.

"Why?" I whisper, grief and horror making it almost

impossible to speak. "Why did you do that?" No one deserves a death like that—no one. Not even the jatu.

"Because we have to feed, have to gain power," Etzli replies, unbothered. "That is what their kind is for. That is what all of this is for. To feed and gain us power."

She gestures, and all the vines in the room begin to vibrate, petals and stems making an eerie rustling music. Horror shudders over me as I take in their star-shaped flowers, those black petals snapping hungrily. The same petals cover the entire mountain. In every corner, on every wall—everywhere anyone turns—there's a blood-eater. There's always a blood-eater. And Etzli uses them to feed her and the other goddesses . . .

Comprehension shatters through me.

No wonder Etzli doesn't seem worried that we're under attack. No wonder none of the mountain's natural alarms were signaling when the Idugu's army barreled through. Etzli *wants* the army to come. She *wants* the true jatu to fight their way through the jungles, where hordes of blood-eater vines wait, anticipating their next meal. And if she wants it, that means all the mothers do. I glance from one sleeping goddess to the next, sickened. They're all connected, four wills intertwined into one. Which means everything that's happening here is their will. A shudder runs through me as I realize how horrifying the situation truly is: all this was planned.

When the mothers sent me off to find the purported angoro, what they really sent out was a lure—one they knew the Idugu would not be able to resist. They knew the Idugu would think that they were weakened; they knew that their counterparts would try to entice or even kidnap me away and that I'd

resist for as long as I could. This whole time I've been playing hide-and-seek with the Idugu, the mothers have been waiting for this: the moment the male gods would throw caution to the wind and send their army of sons here. The moment thousands of true jatu would arrive, cattle for the mothers to slaughter.

Mothers.

The irony of the word sears through me. The Gilded Ones don't deserve to be called mothers; they don't deserve to be called anything at all. They don't care that they're killing the children of their own counterparts, the children they themselves birthed from those golden pools. All they care about is that they regain the power they lost long ago. That they remain ascendant, as they've been ever since I freed them.

My entire body is trembling now, I'm in such a state. "You said you came to free us, to lead us to a higher form of existence," I whisper, my voice as broken as I feel.

"And we will do so after we defeat our counterparts. But in order to do that, we must feed. Must regain our powers."

Etzli utters this lie without even blinking an eye. Without even so much as a twitch. But then, she truly believes it, doesn't she? Like every person who has succumbed to madness, she believes her definition of reality as she sees it, and her reality demands more worship, more sacrifice—just as the Idugu's does.

The gods are all false, every one of them. I understand what Sayuri meant now.

I stand there, staring at her. "So the other mothers, they know?" I ask.

I need the confirmation, need to know whether the other Gilded Ones have fallen prey to the madness infecting Etzli.

To my horror, she nods. "They have been preparing for this day since we woke," she says companionably, as if she's not even bothered that I understand what's happening anymore.

A deep instinct tells me this is because she has a plan for how to deal with me, but I'm so caught by the horrible things she's saying, I don't even know what to do anymore.

She continues on without hesitation. "They find this part of our feeding distasteful, however. The others have always been squeamish. They seem to forget that death and life are all a circle, inextricably intertwined. That is why I have made it so they will sleep until I have given them enough power. That is our compact: I feed; they absorb, a most pleasing arrangement."

I feed; they absorb. The words seep into me, coloring everything an awful, boiling white. Of course, the other goddesses know what Etzli is doing, have approved it. I was just their pawn—a small, movable piece in an elaborate and loathsome game between the gods.

I glance around the room—all those deathshrieks lying there, covered in vines and rot. I can see some of their bodies melting away at the edges, the same way that boy Etzli killed did. Is this what they've been doing all this time to keep their power growing—eating male deathshrieks behind the doors of this chamber? What else have they been eating that we don't know about? Suddenly, all those stories I heard about the Gilded Ones eating children come flooding back, and for the first time, I don't doubt it. I don't doubt that these goddesses— these demons—would eat children if they could.

I stare at the Gilded Ones, their massive forms so distant and cold. Yet that gold covering throbs around them. The gold that connects all of them the same way the vines connect Etzli

to her victims. To *their* victims. Nausea surges to my throat, mixing with the pounding in my skull. Oh, Infinity, I feel sick. It feels as if everything I've ever eaten will erupt out of me.

Etzli rises, glides down the stairs, an expression shimmering in her eyes, one I can't quite place. "You weren't supposed to be able to penetrate our cloak. We wrapped it around this entire hall, and yet you managed to breach it. Managed to bring that abomination with you."

She gestures languidly at Emperor Gezo, and another group of blood-eaters blooms on him, threading their roots deep into his body. The former emperor releases a pained shriek as the vines slither and throb like leeches. Within moments, he's melting too, his flesh and bones disintegrating to nothing, leaving a mass of writhing vines on the ground.

I just stare, unmoving. I don't even know what to do anymore, don't even know how to feel. Emperor Gezo was once my enemy—the man responsible for so much of my pain. Yet suddenly, he's less than dust on the floor, a mere trickle the vines are lapping up.

Vines created by the demonic creature I once considered one of my mothers.

I look up at Etzli. "You didn't have to kill him. Not like that," I say.

"He was always marked for death, you know that, Deka."

With the blood-eater on his side. The mark of Etzli's displeasure, her hunger. . . . How long had she been feeding on him while I watched, unaware? How long had she been savoring him, the way White Hands does her palm wine?

"There are more merciful ways to kill," I reply.

But I don't even know why I'm bothering. The creature

417

before me is not what I thought it was. It is not a god; it is a demon from the darkest pits of the Afterlands, and it has the nerve to call itself one of my mothers. I try to turn away, try to move, but my feet won't let me. I must be in shock. That's the only explanation for why I'm still standing here, my mind frozen in disbelief.

Etzli floats up from her seat and circles me. Even though her body wafts across the air like a sunbeam, every instinct tells me she's not a being of light and air but, instead, a predator, stalking its prey. The hairs on my skin rise as she approaches nearer. She seems to notice, because she smiles. "There are more important considerations at hand, Deka. You were able to ignore my command, brush it off. How is that possible?"

That young deathshriek's cries. They're what woke me up, brought me back to reality. But I don't say that to Etzli. Instead, I glance at her again, but from the corners of my eyes this time. I can't look in her eyes again, can't allow her to trap me in another illusion.

"How many times have you commanded me before?" I know it must have been at least once or twice.

A slim, sunlit shoulder rolls negligently. "Not many," Etzli replies. Then she muses, "This must be because you have been taking off your collar, naughty child."

Collar. The word sears through me. Not *necklace*, not *gift*. *Collar.* Just like the animal they see me as.

"No matter," Etzli says, suddenly sounding determined. "We will bind you more securely this time."

She reaches toward me, her mouth beginning to form words—more commands to bind me, no doubt; to make me her

mindless instrument once more. But I won't allow that. Not now. Not ever again.

I move so fast, my atika slides cleanly through Etzli's rib cage before she even notices me there. It's barely more than the smallest kitchen knife, compared to the goddess's massive size, but it's enough to do the trick. Etzli screams as shimmering white gushes out, her ichor coating me. Behind her, the other goddesses tremble on their thrones, ripples of pain passing through them as well.

"What have you done, Deka?" she cries, but I barely hear her. Lightning is jolting through my body.

And then I'm somewhere else.

◆

I am shimmering.

We are shimmering, our colors sparkling so bright, we eclipse our collective—what remains of them. The ones that designated themselves female have long gone, surrendered themselves to the mortal world. And the ones who designated themselves male are no better. Green and white flow through them: envy and hatred. Deadly emotions. Human emotions. Emotions we were never before capable of. And that's not all. Something else has emerged inside our siblings now—a new, worrying color. It splinters and cracks, a sickening, shrieking white that ebbs and flows in great waves.

Madness . . . It has infected our collective.

Unease slithers burnt purple through us as we contemplate our errors. We have made them in multitudes recently. Allowing

the others in our collective their obsession with humanity, that was the first and greatest of our errors. They sought to fashion the humans in our likeness. Sought to guide them to a higher existence. Instead, the opposite happened. The humans didn't become like us; we became like them. For now, our siblings, as they call themselves, exist only in Otera, the empire of four connected continents. We, the only remaining singular of our collective, have protected the rest of the world's humans, kept them safe and hidden from our siblings. As we hide behind a veil of our own making—one different from the one that separates our siblings—so have we hidden the rest of the world from our siblings' eyes. But eventually, the others will turn their attention there. They will continue onward past Otera, that white madness splintering further and further through them until they destroy the entire human world.

We sigh, a very human expression we have learned to indulge in recently. Waves of soothing greens and golds waft through us. A rainbow shimmers across a bright blue ocean, dolphins dancing in a merry masquerade.

Across the other veil, Okot orients closer, his features thoughtful though erratic. He becomes more and more human by the millennium. That awful white shimmers inside him, but he, more than the other designated males, keeps it at bay.

"You seem concerned, Singular," he opines.

That is the name they have given us. And just like that, another tendril of unease slithers. Before, there was no use for names. We were all, and we were one. Now we must be designated, must mark ourselves to show that we are separate.

Your conflict with the designated females will destroy this world. We have seen it, the threads of fate gathering in the cosmos.

Okot nods, another of his human mannerisms. "We have come to that conclusion as well. There is something growing inside me. Something strange."

Madness . . . When the word whispers out of us, Okot sighs, the moody blues and whites of an ocean swell. Acceptance. Resignation.

"We know," he says. "We have sensed it in ourselves and in the others. It grows like a sickness. We will not be able to withstand it much longer."

Blues and oranges of uncertainty sprout, then wilt, inside us. The rainbow dies a swift and unnoticed death.

Unnoticed by all, that is, except Okot. He moves closer. "You are unsure of how to proceed against us. A decidedly human emotion, Singular."

We vowed to remain neutral.

"You vowed to uphold the balance. That means keeping the humans safe. Like it or not, they are the most numerous of the intelligent beings in this world—a necessary evil."

We allow ourself another sigh. So many vows. So many promises. But they are what give us shape—purpose is, after all, what defines us. . . . *We are not certain how to achieve one without the other,* we finally say.

"Why not achieve both?" Okot orients closer. "You are more powerful than all of us combined now. Send us a solution. Send us an intermediary."

You mean separate ourself as you have done? A mountain splits in response to the distaste we feel for this idea.

"No, Singular," Okot says, staring at us with those unnervingly white eyes. "I mean fall to Otera, and once you are here, end our lives. That is the only way to prevent the threads you see

from coalescing. We are a blight upon this world, and you must destroy us before we destroy it."

◆

A solitary drop of gold, falling . . . falling . . . But it's not falling from the goddesses' eyes; it's falling from the sky. Falling from the cosmos.

Fall to Otera, and once you are here, end our lives. You must destroy us, Singular.

I gasp awake.

37

◆ ◆ ◆

Etzli is pulling the atika out of her side when I return to full consciousness. There's a crack on the ground where she fell, and so much ichor is gushing now, her skin is turning silver. It's the same with all the other goddesses, silver tinging the gold covering them. They're still fast asleep, but I have no doubt they can feel Etzli's pain, her fear. She tries to move, but her body flaps about, a fish stranded on the riverbanks. I glance down at my atika, at the ichor still staining it as it lies on the floor. All that destruction from one small sword.

Only the gods can wound the gods. The words ring in my head. And now I know there's truth to them, because I saw that golden drop falling, heard the words, the command, that formed my being. The command that has no doubt been repressed all this time by the mothers.

You must destroy us.

I know the truth now of what I am. I'm the Singular—or at least, part of me is. There has to be a reason I didn't understand

what I am, a reason I didn't even know about the existence of the gods, and given what I've learned about the Gilded Ones and the Idugu, I know it must be because there are parts of me that are locked away so deeply, I can't access them. For now, all I know is this: I'm no daughter of Etzli or any of the Gilded Ones, for that matter. I'm an entirely separate being. One that has the power to kill them all. And Etzli knows it.

I see the expression on her face, one I've never seen there before. It's fear—a deep and overwhelming fear.

And it's all because of me.

All this time, she and the others have been controlling me. Using me as one would a pet. Yet they knew I had power, that I was a creature that they feared.

Rage explodes across my being. "You lied," I say, snatching up my atika and pointing it again. "All this time, you lied to me."

I dart toward her, but by now, Etzli's regained her composure. She gestures, and vines snap toward me, all hissing and screeching, those fleshy petals throbbing with awful gold veins. I jump out of the way, simultaneously sliding out my other atika, then I begin hacking at them, determined. I need to destroy those vines—root them out before they hurt anyone else.

Inhuman screeches sound as I slice through the vines over and over again. Soon they're joined by cries of pain. Fear. To my surprise, they're coming from Etzli: every time I stab the vines, she recoils as if she herself is being stabbed.

Comprehension widens my eyes: these vines are a part of her, an extension of her being.

"What are you doing, Deka?" she cries. "You're hurting us—your own mothers!"

"You are not my mothers!" I shout, viciously cutting through

another vine. "Never again call yourselves that! I saw the truth! I chose to fall from behind the veil—chose to stop you! And I will stop you!"

Etzli frantically shakes her head. "What you saw is an illusion." Her eyes catch mine, the white flashing there. "I command you to believe me—forget everything you saw. Give me your power!"

I swiftly close my eyes, trying to keep the command from piercing them, but, as it turns out, they're not Etzli's target this time. The ansetha necklace, which is still in my pocket, violently wriggles, constricting like a snake around my belly as its links form roots that pierce white-hot points of pain through my skin. I hurry to rip it off, but it digs even farther into me, a horrifically familiar wriggling starting. The stars in the necklace are sprouting into miniature blood-eaters. They're extensions of Etzli, just like the vines wriggling across the chamber, and they're feeding from me the way the others have been feeding on deathshrieks.

The necklace constricts more and more tightly, the flowers digging ever deeper, until finally, something cracks inside me and my knees give out. I fall to the floor, black spots floating in front of my eyes. There's so much pain—so much of it. It's as if the air has become so dense, I can't breathe. Ragged gasps erupt from my lips, as do fractured sighs. Little points of agony explode wherever on my body the blood-eaters have taken root. And they're digging, still digging, shifting something inside me, something I never even thought was present. I can feel it now, some sort of power deep in my belly, and the blood-eaters are swarming toward it.

Etzli staggers back to her throne, the wound in her side

knitting fast, although the silver still covers her skin. Triumph sounds in her voice when she speaks: "Did you think we would not take precautions for this very eventuality? We know you, Deka. We have always known you, even before you took this form. All you are is an instrument, a food source to power us and a vessel to use as we desire. That is why we were so careful in cultivating you." Etzli snickers, an evilly human sound. "The Nuru." She laughs. "How easily you believed our lies. Do you know what the word means in the first human tongue? 'Pawn,' that's what it means."

I'm in such pain now, the cruelty of her words barely registers, but somehow, I'm not surprised by them. The past few weeks have been priming me for this, readying me for the betrayal I'm now experiencing.

Slurping sounds rise into the air, the necklace's blood-eaters making a feast of my body. "Yes, that's it, pawn," Etzli croons. "Feed us, give us your power."

She gestures, and something rustles inside my stomach—yet another new blood-eater taking shape. It bristles as it moves, those roots threading up into my chest, my throat. All my airways are blocked now, my ragged breaths futile. Is this what that deathshriek boy felt when he died? This fear, this pain? Despair overwhelms me. As does the irony: the mothers were supposed to be our saviors, our protectors, but they're worse than Oyomo, worse even than the Idugu who created his mythology. They called me their daughter, yet all this time, they viewed me as a pawn, have been feeding on me, draining me of my strength. This whole time, the Gilded Ones have been using me in every way they could.

A tear slips down the corner of my eye. I've been so stupid. Why didn't I see the Gilded Ones for what they were when they created entire jungles of bloodthirsty vines to kill their enemies, an entire lake of monsters to destroy them? Why didn't I suspect it when they sent me out time and again to destroy their enemies while they remained here, in the comfort of their temple? The entire time I loved them, worshipped them, they were false—monsters, just as Emperor Gezo warned—and I never saw it. Never even considered it. I thought I'd learned from my mistakes with Emperor Gezo, but I didn't learn anything at all. Now the Gilded Ones are going to destroy me here in the very chamber where I once freed them. I'm going to die here, and they're going to kill thousands more afterward. Perhaps even millions.

I've seen it in Etzli's eyes—the madness, the vengeance. Once she's done with me, she's going to go after my friends, all the people I love. She's going to murder them with the same relish she did that poor jatu boy.

NOOOOO! I shriek silently. I refuse to die here like this. I refuse to let Etzli get away with what she's done, what she's going to do.

DEKA! The door splinters as Ixa crashes into the chamber, Keita and Britta on his back, the others just behind them.

"Deka, wha's happened?" Britta gasps, jumping off him and running over.

A wall of vines drops, slithery as a mass of serpents as they constrict around her and the others.

"What is this?" Keita struggles against his new restraints, furious. "Mother Etzli, what are you doing?"

He inhales, and the blood tingles under my skin as I feel him

trying to summon his flames. They die before they reach the surface of his skin, leaving only red glows.

"Why can't I use my fire?" He struggles to face me, but the vines creeping over his body keep him in place.

"As if I would allow you to use such an obscenity in my presence," Etzli sneers. "A mockery of the gifts we bestowed only on our daughters." She whirls to me. "And you, our faithless, foolish child, dared to bestow it upon our sons as well!"

"I am not your child!" I shriek back.

She gives a look of such loathing, the vines in my body dig even deeper, roots sprouting, gray rot growing. I scream, pain blazing white over me. "Please, it hurts, it hurts!"

Deka! Ixa shouts, bursting into a larger size as he rips out of the vines covering him.

More of them arc toward him as he runs my way, but he dodges them, slides to a stop in front of me.

"The necklace," I rasp, tears falling from my eyes. "You have to root it out of me."

To my relief, Ixa doesn't hesitate. *Deka,* he says, and then he bites into my stomach and pulls.

White-hot pain explodes across my brain, and I scream as Ixa tugs even harder at those roots while the blood-eaters struggle against his efforts. As before, Etzli shrieks, her body pained by the damage Ixa is doing to the necklace. It's just as I suspected; the necklace is an extension of her too—an extension of all the Gilded Ones.

"Stop!" she roars, desperate. She gestures, and a mass of her vines slithers around Ixa's neck, pulling so tight, his throat rattles.

Even then, he doesn't give in to them. Instead, he digs in,

pulling harder, and the vines shriek as they wriggle out from inside my skin, my bones.

"Ixa!" I gasp, golden flecks of blood in my tears now, but he pulls one last time, using all his strength.

The necklace is ripped out of my body, chunks of my flesh following with it. It immediately slithers back, a serpent trying to wriggle its way back toward me, but I roll away, power returning to my body in a rush. A power I breathe out almost unconsciously, desperate to get away from that loathsome necklace. As it snaps at me, lunging ever closer, flames abruptly burst through it, all the vines in the room exploding as Keita's powers return to him as well. While he and the others quickly free themselves, I swiftly, painfully force myself to stand, to turn to the burning necklace still slithering determinedly toward me. The moment it rears up, ready to entangle me again, I stomp down, relief surging through me when the tiny flowers on it explode into little blobs of golden white blood.

As Etzli shrieks from the pain, slumping on her throne, my friends run over to me, their eyes wide with shock and worry. Keita glances worriedly at the goddess. She's just sitting there, her eyes seeming dazed and far away. But I'm not relieved by her sudden silence—in fact, it concerns me even more than actions. Because if she's silent, she's plotting something, doing something awful that I can't yet see.

Keita forces his eyes away from her. "Everything is as we feared, isn't it?" he asks.

"Worse," I say. "They've been eating male deathshrieks and who knows what else to gain power. They want the Idugu's army to come so they can eat them, return to full power. That's why the others are still asleep. Waiting to be fed."

Keita's eyes widen. Then swiftly narrow with determination. Dependable Keita, always taking things in stride. "What's the plan?"

"Prevent them from gaining full power. Destroy them." I glance from Keita to Britta, smile sadly. "We who are dead, correct?"

Britta echoes my smile. "We might very well be in the next second, but I'm always here with ye, Deka," she says, squeezing my hand.

"Me too," Keita agrees, embracing me.

Around us, the others nod. Belcalis, Li, Acalan, the twins, who have reunited, along with Mehrut, Lamin, Kweku, Rian. All my family, my home. Because they all know, as I do, that this might be our last few moments together—that we might all die here, in this very chamber, or worse, be trapped like Melanis was in a pit somewhere, suffering for the rest of eternity—but even so, they're prepared for it. Prepared to die or live with me, no matter the consequences.

Which is exactly why I must protect them.

I smile at my friends. A bittersweet expression showing my love, my gratitude. "Free the deathshrieks from Etzli's vines," I command for what may very well be the last time. "I'll go battle the gods."

38

◆ ◆ ◆

When I walk up the stairs toward the dais, Etzli is still silvery and pale. All that power she drank from me, and she's still weakened. So are the other goddesses, when I glance their way. Their statues are also covered by that silvery sheen. It seems that what happens to one truly does happen to the others. I can't help but wonder how far that extends. If I kill Etzli, does that mean the other goddesses will die—all of them? I glance at Anok, who has been like a grandmother to me—a dear friend, even. She's the one who set me on this path, showed me the truth hidden in the ansetha necklace, even though she surely knew it would end this way. And Beda—so gentle, it's almost inconceivable that she would ever join Etzli in her madness. Can I truly kill them both?

The closer I near Etzli's throne, the more my uncertainty rises. If I kill the Gilded Ones and the Idugu also die as a result, what will happen to Otera? Visions of earthquakes, volcanoes, a thousand plagues flash through my mind, but I force them back. The consequences of my inaction would be far worse. If I

do not kill the gods now, they'll break the entire empire in their quest for power. I've already seen the lengths the Gilded Ones and the Idugu will go to in their game for dominance over each other. Who knows what lengths they'll go to if they're left to prey, unfettered, on the unsuspecting citizens of Otera.

I need to speak with Etzli now, have the conversation I should have had months ago—the conversation that will determine how I will maneuver next against the creatures who once professed themselves to be my kin.

When I arrive at her throne, the goddess is hunched over, her posture rigid with pain. Severing the ansetha necklace from myself must have done something to her, something deep and visceral that compounded the pain she experienced when I stabbed her. I can't help but wonder if this is the first time she's ever been physically hurt by anyone. It would make sense. All those years of imprisonment by the jatu, but the jatu never once actually managed to injure the goddesses. Only gods can injure gods, which may explain why Etzli clutches her side like a wounded animal, her expression venomous as I stop in front of her.

"Deka," she hisses, "you dare to—"

"You lied to me," I say, cutting her off midsentence. "You lied to everyone. All this time, you said you were benevolent, better than Oyomo. And yet, here you were, eating your own children!"

I point to the floor, where the ashes of those vines remain in distinctly deathshriek-shaped bundles. The others have freed the remaining deathshrieks from them. By now, they will be taking them out to the equus, who will lead them to sanctuaries off the mountain. But Etzli has said nothing about that. The fact that she didn't try to stop them, that she hasn't moved or

432

spoken until now, when I'm standing before her, worries me. Etzli's almost certainly planning something. I must remain alert, must wait until she reveals to me what it is.

The goddess's jaw clenches, her expression mutinously human. "Their energy contains ichor," she explains. "It is the most potent food source."

She says the words so matter-of-factly. As if I'm the idiot for not being able to fathom such a thing. My brows gather. "You don't see a problem with that? Killing your own children?"

"They would have given us that energy through worship eventually. I just quickened the process."

"Would they have, really?" I stare at Etzli, allowing the disgust to show in my face even as I keep my eyes carefully pointed everywhere but at her eyes.

Annoyed, she tries a different argument. "All mortals die. It is a fact of their existence. Dying for our sake gives them a greater purpose than they would ever have had. We are their gods. You, of all people, should understand that, Deka."

Disgust sweeps over me, a burnt and ugly feeling.

"The only thing I understand is that you are monsters," I declare quietly. "And I am here to end you."

I raise my atikas, about to strike, but a tornado of white shoots into the room. Melanis, her wings already at the ready. "I am here, Divine Mother," she says breathlessly, as if Etzli just called. "The others are on their way as well."

Etzli smirks, pleased. So this was what she was doing as she sat here silently. Calling for reinforcements. She nods at Melanis, her expression solemn.

"The Nuru has rebelled against us, Daughter. She is plotting to replace us as your gods. Kill her. Kill the traitor Deka."

A pious smile slices across Melanis's lips. "It would be my deepest honor."

The Firstborn plows into me so swiftly, my head cracks against the steps and I see stars. I only just manage to evade the sharpened wingtip she sends hurtling my way mere seconds later, but it catches the edge of my armor, ripping it open like paper. Alarmed, I swiftly roll away, then catapult myself back upright, all my senses on the alert. I can barely hold my own against Melanis by herself. If more Firstborn show up, I'm done for.

Melanis seems almost impressed by my speed. "You've become much faster in the last few days, Nuru," she says, flapping up toward the ceiling. Then she dives at me again, her wings arced.

I manage to block their tips with my atikas, but that just gives her the opening she needs. Using her hands, she unsheathes her sword and stabs my side, twisting the blade so pain ricochets through my nerves. I jerk away, dart for the other side of the room, but Melanis swiftly follows.

As I run, I try to reason with her. "You shouldn't do this, Melanis," I gasp, dodging her strikes. "The mothers lied to you—they lied to all of us. They're not our sole parents; there are other gods as well—the Idugu, their male counterparts. The Gilded Ones have been manipulating us all this while as they fight against them for power. Even this battle, they're using it to feed on the jatu army. To eat them using blood-eaters."

"Marvelous!" Melanis crows. "I am even more impressed by our mothers."

She dives, wings flashing toward me, and I block them with one atika, then counter her sword with the other. I'm getting used to her fighting style now. Thrust and parry with a wing,

thrust and parry with a sword. I easily duck and weave, both my swords flashing so fast, they're a blur of wind and steel. The entire time, I talk to her.

"They've been eating their own children, Melanis! Do you not see anything wrong with that?"

"Only the males." Melanis shrugs. "Which is more than I can say for your other gods, who prey on those of our kind."

I stumble back, eyes widening. "You know about the Idugu?" I thought she'd have lost those memories by now.

Melanis slices a wing toward me. "Mother Etzli graciously returned my memories to me. I know all about the Idugu, the reasons our brothers rebelled."

"And you're all right with that? With the mothers lying to us, preying on us? Preying on innocents?" I stare into her eyes, hoping to see any sort of emotion or compassion there.

She was in the Oyomosin all those years, dying and reviving on those flames. Surely, she can empathize with what it is to be manipulated, abused. . . . An emotion surfaces in Melanis's eyes, and I lean closer, only for my eyes to widen as I discover what's there. There's no compassion in her gaze, as I had hoped; instead, there's something else—something deep, dark, and gleeful.

"Don't you understand it yet, Nuru Deka?" she crows. "I care nothing for our brothers. They are less than cattle. They are beneath us. I seek one world and one world only: a return to the times when our mothers and our sisters ruled. A world where the humans and men return to their rightful place—beneath our heels."

Melanis's wings rise again as she sneers down at me. "Any other world is unacceptable, honored Nuru."

She dives down, but I'm prepared for her this time. My sword goes up just as her nearest wing flaps down, and I slice clean through its joints, severing it in half. She falls to the floor, screaming, wind and blood gusting as she flaps uselessly there. Her movements are so extreme now, I almost don't see the others rushing back into the chamber, having shepherded the wounded deathshrieks to safety.

Britta's eyes widen when she glimpses Melanis, but she runs toward me, carefully avoiding the reach of the Firstborn's wings. "We've taken the deathshrieks out. They're fleeing the mountain as we speak."

I nod, then point to Melanis, whose wing has already begun sprouting a new bone. "Keep her occupied," I say, palming my atikas. "I have another task to do."

I continue back toward Etzli, who has remained sitting on her throne, watching me. She doesn't move when I approach her, doesn't even lift a finger, and now, caution is prickling down my spine. Why isn't she moving? This is how it was the other times I attacked her. She never moved far from her throne if she even moved at all. I frown, unnerved. If I truly pose a threat to Etzli, why hasn't she just disappeared from this chamber and taken her sisters to a safer location? Why hasn't she fled? Now that I think about it, the same thing must have happened when the jatu imprisoned her and her sisters. The Gilded Ones didn't flee, even when they could easily have done so.

The realization spurs other memories—the haze that coated the hallway, Etzli's surprise when I opened the door. *You weren't supposed to be able to penetrate our cloak,* she said. *How did you open the door?*

Yet more memories filter through my mind—all the times

the goddesses locked the doors, barred this hallway from their children, telling us that they were resting, that they didn't want to be disturbed. Suspicion rises inside me: What if there's something in this chamber that requires the goddesses to remain in place? To root themselves so thoroughly, they can't even escape when they're under threat?

The Idugu must have known about it, must have noticed this very pattern themselves. That's how they helped the jatu imprison the goddesses here . . . and that's how I will trap the goddesses as well.

I point my atikas at Etzli. "What's here?" I ask her. "What is it that keeps you and the others tied to this chamber?"

A sinister smile curls Etzli's lips. "Clever Deka. You always were a clever child. You're the first in a millennium to notice."

I'm immediately on edge. "Notice what?"

"This."

She gestures, and the ground crumbles beneath my feet.

39

◆ ◆ ◆

My fight with Melanis has primed me for surprises, so I react the moment the ground rumbles, jumping onto the stairs just below the dais. I do so just in time: all the ground in the center of the room is falling away, the collapse so sudden, Asha nearly goes tumbling in. Britta swiftly gestures, extending a slab of rock underneath her, but, to my shock, Asha bounces off it, a sudden wind propelling her upward. She jumps over the edge of the abyss, then floats back onto firm ground using that very same wind while Adwapa waits for her, eyes narrowed in concentration. The hairs on the back of my neck prickle in response to this new power the pair are suddenly displaying. It must be their divine gift, the one they've been hinting at. And it's not the only one in action. Melanis's one uninjured wing flaps hurriedly when the ground under her collapses. She uses it to leapfrog out of the abyss, then she swiftly falls back onto the chamber's floor, winded from the effort.

I turn back to the hole at the center of the chamber, unease

growing. The pit tunnels down to the very core of the mountain, dark and endless.

But not empty.

A cacophony of anguished hisses and growls rises into the air, the sound so wretched, it takes me only moments to understand what it is: The wails of the damned. I look down, horror clogging my throat when I see Etzli's vines binding thousands of distinctive purple figures to the abyss's walls, hissing blood-eaters wriggling over them. My body is so weak now, it's all I can do to remain standing. How many times did I wonder why there were never any male deathshrieks—why only females emerged from the eggs in the breeding lakes? Even when I saw the Forsworn accompanying the jatu, I wondered why they were so few, so rare.

Now I know the truth. Male deathshrieks aren't rare at all, they aren't some infrequent occurrence—they're just as numerous as the females, and they've been here this entire time, imprisoned under the Gilded Ones' feet.

The evil of it shatters me. No wonder the goddesses rarely leave this chamber, rarely leave their thrones. Worship may feed them, but it's suffering that truly gives them power. The suffering of their own children—the ones they've condemned to an eternity of misery.

My body is trembling now, every inch of me thrumming with fury, horror.

The deathshrieks' hisses and growls, they're blending into words—sentences. Pleas. "Free us. . . . Kill us. . . ."

The words blend together, a hurricane of pain bombarding my ears. How could the Gilded Ones stand this? How could they harden themselves to such suffering? No wonder the jatu

rose up. No wonder they did what they could to trap the goddesses. The Idugu may be evil and malicious, but their counterparts are exactly like them. Worse, even.

I continue gazing into that pit, unable to stomach what I'm seeing. Are these truly the gods I've worshipped for so long? The ones I've fought for all this time?

I whirl toward Etzli, who is still sitting there, a serene expression on her face. More of her vines are slithering around her, pulsating like leeches as they draw blood from the death-shrieks in the pit.

"Demon!" The word bursts from me, every breath filled with hatred. "You are the vilest of demons, and I will end you!"

I rush toward her, atikas raised, but Etzli fluidly rises and backhands me across the room. I land in the middle of the pit, the stone slab that Britta summons the only barrier preventing my body from plummeting into the abyss. The air Adwapa sends my way cushions my landing, so I'm able to bounce up as easily as a cloud.

"We've got ye, Deka!" Britta calls.

"Thanks!" I say, leaping onto the dais and running back to Etzli.

She's standing now, those disgusting vines creeping down her legs like roots and slithering into the abyss. Worse, the other goddesses are stirring beside her. I can't tell if it's because they've regained enough power, or because Etzli is waking them. It doesn't matter—either way, I have to stop them, have to sever them from the vines. That in mind, I leap toward Etzli, atikas primed, but she catches both blades one-handed, not even flinching when they cut into her flesh. I jump backward

440

before she can backhand me again, but as I angle myself for the next attack, a familiar voice rings through the chamber.

"What is the meaning of this?" White Hands demands, walking in.

Victory flashes in Etzli's eyes. She turns to White Hands, smiles welcomingly. "Beloved daughter, the Nuru has turned traitorous and is attacking us. Contain her."

My entire body stills, dread thrumming through me. White Hands is here, a sword at her side. If there's one person I don't want to cross swords with, it's her. She's been my mentor since the moment she rescued me from that cellar—almost a godmother to me, albeit a distant and sometimes cruel one. I don't want to fight her, but any hesitation on my part would be a fatal mistake. White Hands always fights to kill.

Always.

Beside her, Melanis is rising, staggering over, her wing still bleeding. "Come, Sister," she says, "I'll aid you."

When the pair walk toward Etzli, I raise my hands, the words blurting out of me in such a rush, I'm not even certain they make sense. "They've been killing the male deathshrieks, White Hands. All this time, the mothers have been killing our brothers just like the monsters they were accused of being. That's why the jatu rebelled, because they found out that there were male deathshrieks here and the goddesses were eating them."

I point to the abyss. "Look, see for yourself."

White Hands looks down, her brow furrowing. Annoyance? Anger? I can't tell. She turns back to Etzli. "Are those reborn jatu?" she asks casually.

Etzli waves the question away, unconcerned. "They are of

no consequence to us. Not like you and your sisters. You swore loyalty to us. You did not turn away from us, unlike them. They imprisoned us—caged us. They deserve their fate. Now, come—you are our daughter, are you not?" There's an implication in this question, one so subtle, I'm sure I'm the only one who sees White Hands stiffen.

Etzli does not notice. "You are our first. You must end this."

My heart falters when White Hands nods, unsheathes her sword. She climbs up to the dais, her eyes stern as she looks at me. "White Hands," I plead, tears coming to my eyes. *Please, please, please . . .*

But White Hands continues to approach, a resigned expression on her face. "I must do this," she says, then she leaps at me.

I steel myself, preparing for the impact, but then she twists midway, turning to Etzli. "They were our brothers!" she shouts, attacking the startled goddess.

"You dare!" Melanis rushes toward her, but White Hands parries so swiftly, she's disemboweled the other Firstborn before she can even lift her sword.

"Know your place!" White Hands barks before returning her attention to Etzli. Relieved gratitude explodes through me as she hammers at the goddess over and over.

"What are you doing?" the goddess rages, surging up. "How dare you attack me?"

White Hands doesn't acknowledge this rebuke as she continues striking her. She glances at me. "Are you waiting for an invitation, Deka? End her!"

I bolt forward, attacking Etzli from the other side, but the goddess fends us off easily. By now, she's absorbed so much power, her movements don't even resemble a human's anymore.

Multiple arms repel our swords; skin thickens to metallic hardness, then heats up like fire. Through it all, White Hands and I continue our attack. When one of us falters, the other takes over, hacking and slicing. We target Etzli's vines, try to sever them from her, but it's a futile effort.

"Help them!" a distant voice shouts.

Belcalis's.

She jumps into the fray as well, her entire body golden as she slices at Etzli with her daggers. The goddess screams in rage, her anger multiplying even more when flames roast her vines, courtesy of Keita. She creates more and more vines, all of them shooting out of her, slithering over the deathshrieks in the abyss like leafy black serpents to augment her power until she's fighting better with every second that passes. Even then, we hold our own: every time she knocks one of us toward the abyss, Britta is there, creating surfaces to catch us, while Adwapa and Asha help us land softly using the wind.

It's all of us against Etzli, but the goddess just eats more and more deathshrieks until finally I feel it—the telltale gathering of power as the other goddesses stir. Anok is already stretching, her shoulders rolling as her body changes from gold to its usual dark color. I glance over, my heart sinking. If Anok joins the fight, there's no way we can stand against her. But we have no choice now. She's rising, already awake.

Anok glances at our battle, thunderclouds gathering around her forehead as she takes in the chaos. Then she gestures, and a wall of clear glass thrusts up from the ground, separating White Hands and me from Etzli. "What is the meaning of this?" Anok asks calmly, glancing at Etzli.

"Our daughters have rebelled," Etzli replies, enraged. "They

seek to prevent us from consuming the army of the Idugu and gaining power."

At her words, fury explodes through my being, and all my anger and frustration come to the fore. "I am not your daughter!" I shout. "I never was, and you know it!"

Eyes the unfathomable darkness of the deep earth turn to me. "So you know the truth," Anok says quietly.

"All of it!" I rage. "I know that I'm somehow descended from the Singular, that you've been eating your own sons. I know that you are monsters, just like the Idugu! That all of you are corrupted!"

Anok nods solemnly. "Then you know enough to destroy us." That said, she turns to Etzli. "Sister," she says.

Etzli smiles. "Yes?"

Anok replies by gripping her by the neck and pinning her down on the floor. As I watch, shocked, she gestures to me. "Go, Deka," she says hurriedly. "I will hold the others off long enough for you to escape the mountain!"

I gape. "I don't understand—"

"The madness that consumes us will eventually destroy this world," Anok declares. "Find the rest of your power and use it to end us. Your mortal mother will know the way."

"My mother?" I thought what Father said about Mother being alive, about her telling him to come find me, was just a delusion. The last visions of a dying man.

Anok doesn't seem to think so because she says, "You already know where to find her."

Gar Nasim . . . Father's last few words float into my mind.

"Remember, Deka, you are the key, and soon your power will

awaken enough others to stand against us. Destroy us, child!" Anok cries. "Free us! Free this world from us."

Etzli struggles against her sister. "This is madness, Anok. Release me!"

But the darker goddess holds fast. "Go!" she roars at me. "Flee!"

I whirl toward the other side of the room. "Ixa, transform!"

Deka! Ixa agrees.

As I run across the abyss using the bridge Britta swiftly creates for me, the screams of the deathshrieks rush past my ears, all of them so filled with pain and anguish, my soul aches. My stride falters. Even if we escape, those deathshrieks will still be trapped here, their bodies fodder for the goddesses to use as they will. They will remain here for an eternity, trapped in this endless cycle of suffering. I can't allow that to happen. Can't allow these deathshrieks to endure more misery while the goddesses grow ever more bloated and powerful.

Your power will awaken enough others.... Anok's words sing in my head, reminding me that I'm not entirely powerless.

I can't free the deathshrieks in that pit by myself, but I can awaken the gifts of those who can. I turn to White Hands, who's rushing up behind me. How many times have I heard of her power, of the devastation she wrought when she was in her prime?

"White Hands, what was your divine gift?" I ask—a question that's also an agreement.

I can release White Hands's power only if she agrees of her own volition. Free will, just like Keita told me.

The Firstborn seems to understand, because she removes

her bone gauntlets as she walks forward. Underneath her gloves, her hands don't look extraordinary at all—they're the same dark brown as the rest of her, and they're on the smaller side, almost stubby now that her claws have been removed. Still, I know they contain power, the kind of power that once leveled cities.

"Ash," White Hands finally says, holding her hands out to me. "I once had the power to turn everything to ash."

"And you will have it again." I place my hands on hers and sink into the combat state, breathing out when I feel it, the ability hidden deep in her bones. The ability I hope to soon coax back to life.

I breathe again, concentrate, and within moments, it's like I'm sinking into her. Her hands are already shining brighter than the rest of her, her ability rising up to meet mine. I send my power traveling through my fingertips, arcs of starlight twisting and twirling around her being, heat and warmth rising from deep inside me. This is what it means to awaken power; this is what it feels like to help a divine gift rise once more.

I don't even flinch when I notice sores opening on my fingertips, the skin blistering, then splitting open in response to the power I've used. All I feel is exhilaration. White Hands's hands are gleaming now, power concentrated in each one of her fingertips.

I smile, relieved: I've done it, I've brought her gift to life once more.

Once I'm certain her gift is fully awakened, I step away, turn toward the abyss. "The vines," I say, pointing. "Can you destroy them?"

White Hands nods, then kneels next to the pit and places her hand on a blood-eater vine. Her hands seem to flash as the

power arcs out from them. Her gift, taking shape. "Heed my command," she whispers. "Become ash."

Almost immediately, the vine disintegrates, but it's not the only one. As I watch, astounded, White Hands's ash travels from vine to vine until all the blood-eaters in the pit are curling into gray and floating away.

"What are you doing?" Etzli rages from the dais, trying to wrest Anok off her. "You can't do this! No! No!"

But it's too late. The vines are all dying now, every single one of them faded to gray, which means there's only one thing left to do. As I mount Ixa, I turn to the others, ignoring the blood dripping from my fingertips. The sores that formed when I awakened White Hands's power haven't healed yet, but I didn't expect them to. The ansetha necklace shifted something deep inside me, a power I wasn't even aware I had. And now, I must deal with the consequences of it. I may be deathless, but perhaps this body isn't.

And that's if it is indeed my true body. After everything I've experienced, I can't discount the possibility that this body isn't my own, but that's a worry for another day.

I breathe back the pain as I speak to the others. "We have to destroy the temple. We have to bring it down, so they'll never use it to feed again."

"How?" Britta asks, glancing around. "The mothers—"

"Don't call them that," I say, shaking my head. "They are not our mothers any longer."

She absorbs this statement, then nods. "The Gilded Ones raised the temple from the earth itself. How do we destroy it?"

It takes me mere seconds to formulate an answer. "I'll share my power with you, make you stronger. You do the rest. We

can't leave those deathshrieks here to suffer. We can't leave anyone here to suffer."

Keita nods, his eyes already filling with flames. "I'll burn this place to the ground," he says. He turns to Adwapa and Asha. "Can you fan my flames?"

They nod.

Britta glances around again, thinking. "Perhaps I can collapse the temple into itself," Britta says. "Ensure that it'll never rise again."

"Do that," I say, extending my hands.

The moment Britta, Keita, Belcalis, and the twins place their hands on me, I sink into the combat state, calling my power up again. That same heat rises, sparking and building against their own. Calling to the power that's hidden inside them, and amplifying it to its greatest potential.

"Deka, your hand!" Britta gasps when more sores form, but I shake my head.

"They don't matter," I say. "Just a little bit more."

I fan and fan the power deep inside them until finally, I feel it. The potential that's there. The capacity for destruction. I breathe into it, glorying when it becomes an obliterating white light.

I step back. "You're ready now," I say, then walk over to Ixa.

As Ixa launches into the air, carrying us on his back, Keita gestures, and a pillar of flame tunnels into the abyss, scorching through the deathshrieks there. Adwapa's wind guides it, the force so powerful, it blasts the flame against the abyss's walls, turning everything there to ash, just as White Hands did the vines. The deathshrieks' cries rise up, but for once, they're not screams of pain but sighs of gratitude—relief.

"Thank you," I hear one deathshriek say as the flame scorches it. It smiles as its body burns to dust.

I watch it, tears running down my cheeks. Sadness, rage—a thousand broken emotions. All the love and hope I once felt for the Gilded Ones, for the Firstborn. All the hope I felt that I would make Otera a better place, a place where everyone was equal. When Britta's body vibrates beside me, the earth rumbling in response, I continue watching, numb. Power gathers, the earth bucking and twisting, and then the ground surges up like a wave, shattering through the Chamber of the Goddesses, sending a shrieking Melanis tumbling into the abyss below. Pieces of the ceiling are raining down on us, its wonders lost forever, but I don't care about them as we shoot up into the sky, where the haze has begun to dissipate under the light of early morning stars.

Abeya lies deserted below us, the children and humans long fled, most of the alaki and equus following behind them. The only people who remain are the mothers' most loyal children, the ones who attempted to come when Etzli sent out her call. They watch us with murder in their eyes, but we're too far up to reach.

As for the Idugu and their armies, they've long disappeared, retreated back to their temple, where they no doubt fled the minute I stabbed Etzli and, in doing so, stabbed them all. But they'll return soon. Of that I am certain. The gods of Otera will not end their war until one group has supremacy and the other is reduced to dust, even if they have to destroy the entire empire.

But I won't let them.

The determination surges through me, steely gray in its resolve. I will no longer sit back and watch as the gods rip Otera

from its foundations. I will no longer let them play with mortals as though we're wooden pieces in a cosmic board game.

Anok said I had the power to kill the gods, and I know this to be true. Somewhere deep inside me, the ember of the Singular lies, and I will seek it out, discover enough about it to make myself whole again; to protect the people I love, as well as the powerless, the weak. No longer will the gods trample Otera underneath their feet. No longer will I sit back, content to be only their emissary—their pawn. The time has come for me to fulfill my purpose. The time has come for me to kill the gods.

And I'll endure whatever I must to ensure that I do so.

◆

Later, as we're flying over the desert, the first leg of what will undoubtedly be our months-long journey to Gar Nasim, now that we no longer have access to doors, I rest my head on Keita's shoulder. Snores rise around us, everyone else so exhausted by the day's events, they can no longer keep awake. Only White Hands, Britta, Keita, and I are still alert, our eyes scanning the horizon for threats. The Temple of the Gilded Ones is far behind us, but who knows what lies ahead? Who knows what terrors, what wonders, this new journey will bring? The only certainty I have is that somewhere at the end of it, Mother is waiting with answers. I can't wait to find her; I can't wait to see her again.

Keita cups my chin in his hand. "You all right, Deka? How are your hands?"

I shrug, glance down at my fingertips, the sores there mirrored by the ones now dotting my arms. They haven't healed,

even though it's been hours since we fled, and I don't expect them to anytime soon.

Worry blossoms in Keita's eyes. "They're not getting better?"

I shake my head, already knowing why. When the ansetha necklace dug its roots into me, it shifted something inside me, something important. And then I compounded this loss by giving too much power to the others.

By making them stronger, I've made myself weaker. Much, much weaker. But it was worth it to free the Forsworn and bring that hateful temple crashing to the ground.

White Hands moves closer. "Let me see," she demands, holding out her hands, which she's covered in her gauntlets again.

I show her, not altogether surprised when she sighs in heavy resignation. "It's to be expected," she says. "The core is divine, but this vessel isn't yet so."

"Wha does that mean?" Britta asks.

"Deka's body is breaking down," White Hand explains. "The strain of giving us all that power—it was likely too much. It's even more imperative now that she reconnects to the part of her that's divine."

Britta frowns at her. "Still don't understand what yer sayin'."

"It's simple," White Hands says. "For Deka to fulfill her task and prevent her body from breaking down, she needs to reconnect to her divinity. In other words, she needs to become a god." Her eyes glance meaningfully over at me. "The newest god of Otera."

I slump beside Keita, her words taking what's left of my strength out of me. Their sheer weight presses down on me,

the pressure growing ever more insistent as Ixa finally lands in a small oasis at the edge of the desert and we dismount.

I need to become a god. The thought circles in my mind over and over again. How exactly does one do that? And if I do accomplish it, will I require worship, the way the Gilded Ones and the Idugu do, or will I become a remote and alien being like the Singular?

As I walk over to the water, deep in thought, two shadows slip up behind me—Britta and Keita. "A god?" Britta humphs, shaking her head. "It's never easy, is it, Deka?"

"No, it isn't," I say.

"But that's why you have us," Keita says, wrapping his arms around me and then resting his head on mine.

I smile gratefully when Britta joins in as well, her arms circling me. "Whatever happens, we're here for ye, Deka, all the way."

"Through thick and thin, in this world and the next, we're here for you," Keita adds.

"Always," Britta whispers.

Always . . .

The word washes over me, soothing me, pushing back my questions, my worries. I know the future will come faster than I imagine, and that it'll be filled with my new task: reclaiming my divinity, using it to fight the gods. But even though I'm frightened by it, I'm not daunted. Because I have my friends, all of them now powerful beyond imagining. When I falter, they'll be there to support and guide me. When I stumble, they'll be there to take the next step.

And even if they're not, I have myself.

If there's one thing the past few months have taught me, it's

that I'm more capable than I ever knew; that I'm more than just the quiet, naive girl I was in Irfut, foolishly hoping for others to accept me when I couldn't accept myself. I've conquered armies, battled gods—I know I can do anything that I wish. And what I wish now is to become a god myself, the new god of Otera. No—I shake away the thought. I want more than just that, more than just a predatory existence depending on worship, on sacrifice.

What I truly want is to be a blade—the blade that strikes down all the gods. The Gilded Ones, the Idugu—all the beings that wish to lay claim to the people of Otera. As I look up at the silver moon, White Hands's words from not so long ago echo through my mind: *Names are what give things power . . .* If that is true, I already have a new name for myself, a new title: the Angoro, slayer of the gods.

The Gilded Ones and the Idugu would do well to rest now and gather all the strength they can for the days ahead. Because I am Deka, the Angoro. And I am coming for the gods.

ACKNOWLEDGMENTS

❖ ❖ ❖

First I'd like to thank my fearless editor, Kelsey Horton. Thank you so much for believing in this story and for allowing me the time and space to tell it as it needed to be told.

To my critique partner, PJ, thank you for reading so many iterations of this book and bearing with me when I was going on about how I didn't know how to write it, etc. Thank you for listening to all my BS and always being my biggest cheer-leader.

To Alice S-H, thank you for believing in this series from the get-go and telling me that it was a story worthy of being told. I appreciate everything you've done getting this series world-wide.

To Johnny TaraJosu, thank you for yet another amazing cover. You are the cover god blessing this series.

To Ray Shappell, thank you so much for your work on this amazing cover. It's gorgeous and it is everything thirteen-year-old me could ever have wanted. Thank you.

To Cait, thanks for your continued and fearless efforts in getting this book and this series out in the world. It means